BLACK BRITISH CULTURE AND SOCIETY

A Text Reader

Edited by Kwesi Owusu

London and New York

First published 2000
by Routledge
11 New Fetter Lane, London EC4P 4EE

Simultaneously published in the USA and Canada
by Routledge
29 West 35th Street, New York, NY 10001

Routledge is an imprint of the Taylor & Francis Group

Typeset in Garamond by RefineCatch Limited, Bungay, Suffolk
Printed and bound in Great Britain by
TJ International, Padstow, Cornwall

British Library Cataloguing in Publication Data
A catalogue record for this book is available from the British Library

Library of Congress Cataloging in Publication Data
A catalogue record for this book has been requested

ISBN 0–415–17845–2 (hbk)
ISBN 0–415–17846–0 (pbk)

CONTENTS

CONTENTS

CONTENTS

CONTENTS

ILLUSTRATIONS

LIST OF ILLUSTRATIONS

ACKNOWLEDGEMENTS

I am deeply indebted to all the individuals who appear in this book and to many others who contributed to making it possible by sharing their insights and precious time with me. In particular, I would like to thank Nalu Binaisa for her diligence and support and Professor David Morley, Routledge's series editor, whose enthusiasm for my initial idea stayed with me throughout the project. It was a pleasure working with Rebecca Barden, the senior editor at Routledge. She played a constructive role throughout. I am also grateful to Alistair Daniel and other staff at Routledge.

David A. Bailey was helpful in locating some of the scholars at the beginning of the project. I am also indebted to many libraries, institutions and publications for giving me access to their collections and helping me to identify the sources of many obscure references in the notes and bibliographies. I would particularly like to thank the Institute of Race Relations, International Institute of Visual Arts, Third Text and Hiltrud Egonu for the privilege of seeing the rare collection of her late husband, Uzo Egonu, and for the prints that appear in this book.

All illustrations are by the author unless alternative information is supplied in the artwork caption. We are indebted to the people and archives cited for permission to reproduce the photographs. Every effort has been made to trace copyright holders, but in a few cases this has not been possible. Any omissions brought to our attention will be remedied in future editions.

And finally, this book is a dedication to two former teachers: Professor Donald McRae of the London School of Economics and Frank Warner who guided me through critical stages in my academic development and my friends from the 'radical school of 79' – Dr Cathie Lloyd, the late Dr Judy Kimble, Arnold Sibanda, Nadir Tharani, Dr Adotey Bing and Yao Graham, whose early insistence on developing 'relevant tools for a relevant scholarship', as well as initiating non-sectarian dialogues beyond the prescriptions of dominant narratives, are possibly the real genesis of this book.

Kwesi Owusu
London 1999

The old is dying and the new cannot be born.

Gramsci

There are many different kinds of metaphors in which our thinking about cultural change takes place. These metaphors themselves change. Those which grip our imagination, and for a time, govern our thinking about scenarios and possibilities of cultural transformation, give way to new metaphors, which make us think about these difficult questions in new terms.

Stuart Hall

The time is past when, in an effort to perpetuate the domination of people, culture was considered an attribute of privileged peoples or nations, or when out of either ignorance or malice, culture was confused with technological power, if not with skin colour or the shape of one's eyes.

Amilcar Cabral

The functionaries found commitment, if not profit, in ethnicity and culture, the intellectuals found struggle in discourse. That way they would not be leaving the struggles of the community behind but taking them to a higher level, interpreting them, deconstructing them, changing the focus of struggle on the sites of another practice, theoreticist this time.

A. Sivanandan

If the real lives of real blacks unfold outside the view of many whites, the fantasy of black life as a theatrical enterprise is an almost obsessive indulgence.

Patricia Williams

After three generations, being black has finally become a way of being British.

Henry Louis Gates Jr

The focus of this book is the African and Caribbean communities in Britain. The variable presentation of the terms 'Black' and 'black' is in keeping with the preferred use of the individual authors.

INTRODUCTION
Charting the genealogy of Black British cultural studies

This book features representative essays and new scholarship in Black British cultural studies as an introduction to this emergent and increasingly popular field of study. The impetus to this intellectual project, contemporary in its immediate concerns, yet passionately historical with its engagement of the past, lies primarily in an eclectic variety of factors associated with recent ontological and paradigmatic shifts in many academic disciplines. These factors partly reflect the impact of cultural studies, which on some traditional fields like sociology, literature and political science has been significant.

In many ways, cultural studies, the discursive ambit from which 'Black British "cultural" studies' has emerged, has itself been incredibly adept in reinventing critical traditions within its constantly expanding field – that is, constituting and reconstituting its objects of study and methodologies through borrowings from other sources and fields of study. Consequently, Black British cultural studies shares the legacy of its philosophical and theoretical borrowings.

These borrowings have ranged over a wide variety of intellectual sources, including; Althusser's structuralism imported into Marxism (Althusser 1968, 1969); Saussure's semiotics (Saussure 1974); Freudian psychoanalysis (Freud 1954); the range of feminist discourses on social theory and sexual politics including Weeks (1981), De Beauvoir, Firestone (1970), Rich (1977); Gramsci's reformulation of orthodox Marxian understandings of the state and civil society (Gramsci 1971); and the postmodernists – Foucault (1978, 1980, 1989), Baudrillard (1977, 1983), Derrida (1982, 1992), Lyotard (1984) and Fukuyama (1992). Add to these sources the rich tradition of critical writings on British postwar society as a result of cultural studies itself being a British invention: writings by Richard Hoggart (1957), Raymond Williams (1958, 1961), E. P. Thompson (1968), Stuart Hall (1958, 1964, 1967, 1976), Paul Willis (1977), David Morley (1980), Phil Cohen (1972), Dick Hebdige (1979) and Angela McRobbie (1978), to name but a few of the key contributors.[1]

This impressive legacy has been useful in mapping out the broad theoretical and ideological terrain within which Black British cultural studies has functioned as a critical discourse. Paradoxically, it has also proved to be its point of departure as the new discourse has engaged questions raised by the Black experience in postwar Britain, and indeed new configurations of racial politics from around the world. Significantly, the problematization of the Eurocentrism of much of the work in the field through new dialogues on 'race', nation, identity, post-coloniality, transnationalism, globalization etc., mostly initiated by a variety of new writers, many of whom are

represented in this book, has opened up new and lively conversations around contemporary culture.

The critical 'tensions' leading to the 'epistemological break' with British cultural studies, however, have deeper roots, lying as they are in the very origins of the discipline in the 1950s. In retrospect, the decade of the birth of cultural studies – significant also for the massive expansion of the postwar economy and state, extension of educational opportunities and the advent of American-influenced mass culture – to name a few of the concerns of the discipline's founding fathers – was also the decade of the historic disintegration of the British Empire and the arrival of large numbers of Caribbean and Asian workers in Britain.[2] Considering that all these factors were crucial to the postwar transformations of British working-class culture and politics (particular interests of the founding fathers), the marginalization of, if not virtual silence on, 'race' in the foundational texts of the discipline (Hoggart 1957; Williams 1958, 1961) is notable.

New metaphors of 'race'

The systematic engagement of 'race' and the Black presence within British cultural studies occurred in the 1970s and early 1980s, initially through the pioneering work of Stuart Hall (1970, 1972, 1978, 1980, 1981) and his colleagues and students at the Centre for Contemporary Studies (CCCS) in Birmingham. Other academics and scholars who played equally notable roles in this crucial enterprise, sometimes from outside the discursive terrain of cultural studies, included Homi Bhabha (1983, 1986), C.L.R James (1984), John La Rose, Clive Harris (1988), Winston James (1986), Colin Prescod, Gail Lewis (1978, 1985), Cecil Gutzmore (1975, 1983), A. X Campbell (1974–5), Amon Sakana (aka Sebastian Clarke), Amina Mama (1989) and Roxy Harris (see his essay, 'Opening Absences and Omissions: Aspects of the Treatment of "Race", Culture and Ethnicity in British Cultural Studies', Chapter 33).

The discourse of Black political struggle

Outside academia but having a significant impact on its debates was the work of A. Sivanandan. His alternative sequence of critical enquiries into racism and its impact on the British class system played a key role in *naming* the British 'race relations industry', that is identifying the politics that influenced its formation, as well as the organic structures that maintained it (Sivanandan 1976). His influential essay 'From Immigration Control to "Induced Repatriation"' (1978) also introduced a radical structuralism that attempted to transcend many of the methodological and ideological pitfalls of the liberal school of 'race' studies. Combining his experience of political campaigning and astute readings of the dynamics of racial politics within the state, he was one of the first to conceptualize the political position of Black people within the shifting strategies of the state. Stuart Hall distinguishes him as a scholar with the 'capacity to go directly for the seminal issue, and to give that issue an original formulation'.[3] His essay, 'From Resistance to Rebellion' (1990a) formalized within the sociology of race relations the radical critique of an all party consensus on 'race' and immigration: 'What Powell says today, the Tories say tomorrow and Labour legislates the day after' (1982).

Sivanandan is editor of *Race & Class*, a key journal for Black and radical scholarship

since the 1970s, and director of the Institute of Race Relations, which has led the field in race relations research in Britain for many years. In the interview published here, 'The Struggle for a Radical Black Political Culture', he recollects the transformation of the Institute from a conservative, neo-colonial think tank on race relations into a 'vanguard' resource of the anti-racist struggle, and discusses his views on the British postwar record on 'race'.

In the 1980s, Sivanandan led the devastating critique of institutional attempts to combat racism through 'race awareness training' (see 'Challenging Racism' 1990b) and 'RAT and the Degradation of Black Struggle' 1990c). In the early 1990s, he followed this with his analysis of the impact of new technology on the global division of labour (see *New Circuits of Imperialism* 1989) and contributions to the political debates of the New Left – how to develop an effective broad left opposition to Margaret Thatcher, in the face of her seemingly unstoppable advance. Sivanandan's essay 'All that Melts into Air is Solid: The Hokum of New Times' (1990) dissented strongly from the positions of Stuart Hall, Martin Jacques, Beatrice Campbell and other intellectuals then associated with the journal *Marxism Today*.

Stuart Hall and the new trajectory of Black Britishness

The important work initiated by Stuart Hall at the Centre for Contemporary Cultural Studies (CCCS) in Birmingham opened up new dialogues on Black cultural identity, effectively challenging the notion that British culture was quintessentially 'white'. (Hall was head of the CCCS from 1969 to 1979.) The pioneering scholarship was given further intellectual currency by his colleagues and students. The general richness of the research promoted by CCCS in the 1970s has been noted by During (1993). What I also find particularly worthy if not exciting – and this is perhaps only relevant within the context of the proverbial 'ivory towerism' of academia – is the extent to which the scholarship came to reflect key debates within the domain of national politics.

Many of the 'race' issues tackled in the published texts of the CCCS had become topical news in the print and electronic media and the foci of heated and often bad-tempered debate in Parliament – issues about 'blacks and crime', 'black youth and policing', 'rise of the fascist National Front', 'Mrs Thatcher's fear of being swamped by foreigners', 'Enoch Powell's legacy' and so on. The volatile racial politics of the late 1970s and 1980s made this scholarship compelling, its radical advocacy and 'interventionist' tone derived from a new intellectual confidence, also reflective of cultural studies' original commitment to radical political change. This commitment was in turn indicative of the discipline's intellectual roots in the British New Left movement.[4]

In 1982, the CCCS published *The Empire Strikes Back: Race and Racism in 70s Britain*, produced by a student group on 'race and politics', signalling what Hall has referred to as one of two 'interruptions' in the work of the centre (Morley and Chen 1996). The collection brought a critical Black perspective to the reading of a wide range of cultural texts, effectively extending the intellectual boundaries of a new discursive terrain for a Black British culture or what I at the time preferred to signify as 'Black culture in Britain'.[5] In cultural studies terms, it represented a paradigmatic shift away from the sociology of race relations that had hitherto dominated academic thinking on 'race' to new and radical perspectives, including Hall's influential analysis of the 'interplay

3

between moral panics over mugging, the drift into a law-and-order society and the advent of Thatcherism' (Mercer 1994).[6]

> Blacks become the bearers, the signifiers of the crisis of British society in the 1970s . . . This is not a crisis of race. But race punctuates and periodizes the crisis. Race is the lens through which people come to perceive that a crisis is developing. It is the framework through which the crisis is experienced. It is the means by which the crisis is to be resolved – 'send it away'.
>
> (Hall 1978)

Paul Gilroy, one of the collaborators in *The Empire Strikes Back*, further explored many of the theoretical and political premises of the collection in various articles (Gilroy 1981, 1983, 1985) and in his book, *There Ain't No Black in the Union Jack* (1987). Some of the other collaborators also made commendable interventions in their own right – Errol Lawrence (1981), Hazel Carby (1980), John Solomos (1989) and Prathiba Parmar (1981, 1984, 1989, 1990).

The new Black British avant-garde

Out of the discursive and paradigmatic engagements within cultural studies and related disciplines, a new academic scholarship on 'race' emerged, epitomized in its most popular form by the work of the aforementioned scholars. Within cultural studies itself, the body of new reflections on Black Britishness, took on a definitive signature in Stuart Hall's theoretical innovations on the British state and transformations within civil society, analyses not entirely divorced from the political project of the New Left.[7] The impact on the national media, particularly on alternative cultural networks – exhibition venues such as the Institute of Contemporary Arts, Ikon Gallery, Whitechapel Art Gallery and Cornerhouse, magazines such as *City Limits*, *Time Out*, *Camerawork* and Channel 4 Television – was impressive. Throughout the 1980s, Hall's writings came to have quite a pervasive influence on a group of young and mainly London-based artists and critics who came into national prominence as part of the Black British cultural renaissance of the 1980s – most notably, film-makers Isaac Julien, John Akomfrah and Martina Attille, photographers David A. Bailey, Mark Sealy, Ingrid Pollard, Sunil Gupta and Rotimi Fani-Kayode, visual artists Keith Piper and Sonia Boyce, and critic Kobena Mercer.

Hall's intellectual patronage of the predominantly experimental work in the visual arts and film was singularly focused and creatively rewarding – director Isaac Julien has told of Hall's support for and involvement in most of his films – *Passion of Remembrance*, *Looking For Langston*, *Young Soul Rebel*, *Black and White in Colour*, *The Attendant* and his docu-drama on Frantz Fanon (Julien and Nash 1996). Kobina Mercer also acknowledged the ideological debt to Hall in his collection *Welcome to the Jungle: New Positions in Black Cultural Studies* (Mercer 1994).

Hall's critical signature can also be 'decoded' in films such as *Testament* and *Handsworth Songs*, by the Black Audio Collective and directed by John Akomfrah, and *Dreaming Rivers* by Martina Attille, then of the Sankofa Film Collective. He was also influential in organizations such as the photographers' groups D Max and Autograph. It is worth noting, however, that this influence was not one-sided. Eventually, the

creative partnerships that emerged came to be symbolized by a common ideological quest – the search for what Hall termed the 'new metaphors of cultural change' – a critical riposte to a 'reductionist' cultural practice.

> Those [metaphors] which grip our imagination, and for a time, govern our thinking about scenarios and possibilities of cultural transformation, give way to new metaphors, which make us think about these difficult questions in new terms . . . Metaphors of transformation . . . allow us to imagine what it would be like when prevailing cultural values are challenged and transformed . . . They must [also] provide ways of thinking about the relation between the social and symbolic domains in this process of transformation.
>
> (Hall 1993)

If Hall made an impression on the artists, the reverse was also true. Looking back at the intellectual production of the 1980s, there are clearly qualitative shifts in emphases in Hall's writings on 'race' as a result of his involvement with the young artistic avant-garde. It may even be possible to read his reworking of the political theories of Gramsci – 'Gramsci's Relevance for the Study of Race and Ethnicity' (1986), and 'New Ethnicities' (1989), two of his best-known forays into the debate on 'race' and Black Britishness, as *discursive reportage* – attempts at addressing the theoretical and political contestations arising from his involvement with the new artistic wave. 'New Ethnicities', was originally delivered at the ICA conference *Black Film, British Cinema* and then published in ICA documents 7, edited by Kobina Mercer. Amongst other issues, Hall discusses the debate between himself and Salman Rushdie as a result of Rushdie's criticism of *Handsworth Songs* in the *Guardian* newspaper (12 January 1987). Mercer contributes to the controversy in his essay 'Black Art and the Burden of Representation' (Mercer 1994),[8] and in his joint intervention with Julien in *De Margin and De Centre* (Julien and Mercer 1988).

Such engagements, symbolic pronouncements in the critical domain of the national media, were very much in the spirit of the Gramscian concept of 'theoretical practice', predicated on the role of the 'organic intellectual' – one who functioned in the forefront of intellectual, theoretical work and at the same time was involved in politics. Curiously, Hall assigns this politically *engaged* function also to 'the project of Cultural Studies',[9] which, in spite of its radical credentials, is still essentially an academic enterprise: 'unless those two fronts are operating at the same time, or at least unless those two ambitions are part of the project of Cultural Studies, you can get enormous theoretical advance without any engagement at the level of the political project' (Hall 1992).

Hall's take on Gramscian praxis,[10] forging a link between academic scholarship and public debate, intellectual property and its wider social circulation, provided his collaborators with a new vocabulary of political engagement and a corresponding disposition to creative experimentation – all in the service of a new revisionism that foregrounded the experiences of Black people in Britain as a distinctly 'British' or 'English' experience. This revisionism had two possible targets: the racist New Right represented by conservative figures such as Enoch Powell and Margaret Thatcher, who excluded Blacks from the notion of 'Britishness' by portraying them as an 'outside force, an alien malaise afflicting British society' (Gilroy 1982) and a Black political

authodoxy that presented 'the black experience' as a singular and unifying framework (Hall 1989). A recurrent theme in this revisionism centred on the notion of the 'non-essentialist black subject', which, according to Hall and Bailey,

> opposes the notion that a person is born with a fixed identity – that all black people, for example, have an essential underlying black identity which is the same and unchanging. It suggests instead that identities are floating, that meaning is not fixed and universally true at all times for all people, and that the subject is constructed through the unconscious in desire, fantasy and memory.
> (Hall and Bailey 1992)

By the end of the 1980s, the Hallian movement in cultural studies and the impact of the political challenge posed by the work of A. Sivanandan, Homi Bhabha and others had shifted the foci of many of the debates within academia and the general cultural media at large. The transformatory decade also saw the creation of a wave of 'black' interest coverage, particularly in the press and on radio and television, and the institution of various reforms aimed at combating racism in public life. These developments had their own histories and dynamics, but they were given added impetus by the political drama caused by the Black-led inner-city civil disturbances of 1981 and 1985. One of the consequences of these unexpected explosions, both triggered off by racist police action,[11] was the emergence of a broad, radical movement of scholars, cultural practitioners, media personalities and politicians as the new intellectual voice of Black Britain.

This movement was complex and diverse in its political and ideological allegiances, but it was united in its commitment to challenging the postwar political consensus on 'race', and popular understandings of what it meant to be 'Black' in British society. Intellectually, it was tired of the old, patronizing narratives that had characterized official thinking on race relations and Black culture – from the early postwar debates on immigration (see the essay by Clive Harris, Bob Carter and Shirley Joshi, 'The 1951–1955 Conservative Government and the Racialization of Black Immigration', Chapter 4) to the arm-twisting policing of Black culture (see Cecil Gutzmore's essay 'Carnival, the State and the Black Masses in the United Kingdom', Chapter 28). It also addressed the shortcomings of liberal and radical discourses (see Hazel V. Carby's essay 'White Woman Listen! Black Feminism and the Boundaries of Sisterhood', Chapter 7). The movement's considerable creative and political energies, symbolized by the political unity of Africans, Caribbeans and Asians, led to the formation of many professional and political groupings – Black Media Workers Association, Organization of Women of African and Asian Descent (OWAAD), Brixton Defence Committee, Southall Black Sisters, Creation For Liberation, African Liberation Committee, Black Action for the Liberation of South Africa (BALSA), Black, Radical & Third World Book Fair, Campaign Against Racism and Fascism (CARF) and many others.

At the universities, the movement's intellectuals were for the most part bright students frustrated by restrictive study options and Eurocentric bias, or crusading lecturers, straddling the often deceptively liberal corridors of academia or chiselling away at the structures of consolidated disciplines and legendary departments. In spite of institutional inflexibility in many cases, and especially because they persevered, several hybrid fields of study were created at many universities and colleges in a

constant positioning and repositioning of discursive spaces – 'Third World Studies', 'Black Studies', 'Ethnic Studies', 'Black Women's Studies', 'Black History', 'Multicultural Studies', 'Race and Politics', 'Race and Law', 'Black Literature', and so on. The movement included Carter and Joshi (1984), Fryer (1984), Dyer (1988), Carter (1986), Garrison (1983), Gordon (1983), Gutzmore (1975–6, 1983), Ramdin (1986), Wilson (1978), Brah and Minhas (1984), Mirza (1986), Phoenix (1988), Mama (1989), Berry (1984), Johnson (1974, 1975, 1980), Rushdie (1983), White (1983), Burford (1986), Dhondy (1976), Dabydeen (1985, 1988), Araeen (1984, 1989), Jegede and Chester (1986), Owusu (1986, 1988), Sutcliffe (1982), Sutcliffe and Wong (1986), Sidran (1971), Rugg, Phillips, Dilip, Riley, D'Aguiar, Bryan, Dadzie and Scafe (1985).

Space does not permit us to explore the full range of intellectual registers underpinning this movement, but this book contains texts written by some of the key contributors: Amina Mama, Bob Carter and Shirley Joshi, Ferdinand Dennis, Gavin Jantes, Fred D'Aguiar, H. Mirza, Imruh Bakari, Cecil Gutzmore, Rasheed Araeen and others already mentioned. Suffice here to acknowledge the historical significance of this 'second wave' of predominantly Black intellectuals, emerging after the radicalization of Black politics and culture in the late 1960s and 1970s.[12] It is also worth noting the significantly increased volume of critical comment on the Black British experience generally, and by a majority of Black intellectuals.

The 1980s movement was singularly successful in the cultural domain, launching the second Black cultural renaissance in Britain in the postwar period.[13] In my book *The Struggle for Black Arts in Britain* (1986), I attempted a schematic sketch of its political imperatives, foregrounding some of the main historiographic absences in the dominant narratives, while *Storms of the Heart: An Anthology of Black Arts and Culture* (1988) explored the work of the participant artists and their collective impact. Apart from the multiplicity of creative ideas and artistic innovations at play, the volume of work produced by the movement in a range of media was impressive. It brought into sharp focus the work of the avant-garde film directors already discussed, as well as others like Imruh Bakari, Menelik Shabazz, Glen Ujebe and Sister Dennis (see Imruh Bakari's contribution here, 'A Journey from the Cold: Rethinking Black Film-Making in Britain', Chapter 19). It engages some of the thematic and political challenges of the 1980s by raising issues around contemporary developments. Rasheed Araeen's interview with visual artist Eddie Chambers revisits the ideological excitement of the period by probing the various political and creative tendencies. The interview introduces the striking polemics that became the hallmark of the small but engaging group of young artists initially mobilized around the Blk Art Group. This radical group included the late Donald Rodney, Keith Piper and Marlene Smith. They were later joined on the alternative gallery circuit – venues such as Black Art Gallery, the Institute of Contemporary Arts, Cornerhouse and Ikon – by Lubaina Himid, Sonya Boyce, Claudette Johnson, Tam Joseph, John Ohene, Gavin Janjtes and others. Janjtes's essay 'The Long March from "Ethnic Arts" to the "New Internationalism"', Chapter 22, explores the ideological challenge presented by Black visual artists and argues for a more inclusive national arts and cultural policy.

The 1980s also saw the emergence of an extensive network for Black performance poetry, with poets like Linton Kwesi Johnson, the African Dawn,[14] Jean Binta Breeze, Benjamin Zephaniah, Lemm Sessay, Anum Iyapo and others leading the field. (For a

discussion of the significant dialogues opened up by this movement, see Beth-Sarah Wright's essay 'Dub Poet Lekka Mi: An Exploration of Performance Poetry and Identity Politics in Black Britain', Chapter 23.) The Africa Centre, which hosted the launch of Soul II Soul, the remarkable Black British musical phenomena of the late 1980s, became a prime venue for performances, mostly organized by the African Dawn. Other consistent organizers of this poetry, precursor to the international explosion of rap and ragga in the late 1980s and early 1990s, were Apples and Snakes, Creation for Liberation, and, most important of all, organizers of the Black, Radical and Third World Bookfair, which featured international poets such as Kamau Brathwaite, Michael Smith, Imiri Baraka and Ntozake Shange.

The Africa Centre also became a popular locale for another significant development within the Black British renaissance – the transformation of the aesthetic profile of African literature, music and poetry by a prolific group of diasporan, African or exiled artists and intellectuals – Ben Okri, Dambudzo Macherera, Sheikh Gueye, Ngugi Wa' Thiongo, Micere Mugo, Nii Noi Nortey, Pitika Ntuli, Merle Collins, Mervyn Afrika, Julian Bahula, Wanjiru Kihoro, Emmanuel Jegede, Tunde Jegede, Nana Tsiboe, Lewis Nkosi, George Shire, Eugene Skeef, Nana Danso Abiam, Dada Lamptey and others. Through my work with African Dawn and advisory roles at Greater London Arts and the Arts Council of England, I became a creative facilitator and critical voice within this movement.

The impact of the writers on African literature was particularly fascinating; with Ngugi Wa' Thiongo, one of Africa's foremost novelists, leading the debate on the replacement of English as the main linguistic vehicle for creative writing and his collaboration with African Dawn, Dan Cohen and others on the British production of his classic play, *The Trial of Dedan Kimathi*. The late Zimbabwean writer Dambudzo Macherera also made a brilliant excursion into magical realism with his debut novel, *House of Hunger*, and the sequel, *Black Sunlight*. Ben Okri became the most coveted novelist in this genre by winning the Booker Prize in 1991 with *The Famished Road*. The radical reinterpretation within African literature of the magical realism which until then was more readily associated with García Márquez and other Latin American novelists was essentially a *diasporan* achievement facilitated by the creative environment of the Black British renaissance. Ato Quayson's essay 'Harvesting the Folkloric Intuition: Ben Okri's *The Famished Road*' acknowledges the significance of this diasporan conjuncture, but situates the genre's broader folkloric precedents within African literature.

Transformations within Black popular culture

Another significant development within the Black British renaissance was the consolidation of the annual Notting Hill Carnival into Europe's biggest street event, attracting well over two million revellers, at the end of the decade (see Cecil Gutzmore's chapter for a critical reading of its politically volatile relationship with the state). Carnival's dynamic fusion of apparently disparate artistic, social and political elements distinguishes it as an event of *high aesthetics* – a culturally *pronounced* ritual in celebration of urban life within the new British cosmopolitanism – achieved in large measure by the impact of Black cultures over the postwar period. With the disappearance of most local English festivals and recreations, many 'legislated out of existence' during

the Industrial Revolution and its aftermath, carnival is the *most powerful* contempo
symbol of the right to mass assembly and celebration. Its survival and growth there
have a special place in British cultural history.[15]

Other significant developments occurred in popular music, with the invention of the
uniquely British 'Lovers Rock', a reggae and soul hybrid, invented by producers
Dennis Bovill of Matumbi, Mad Professor (Neil Fraser) and singers such as Kofi, Karen
Wheeler, Sandra Cross, John Mclean, Carol Thompson, Winston Reedy, Janet Kay and
others. 'Black British jazz' was also invented by a group of young musicians, including
Courtney Pine, Gail Thompson, Julien Joseph and Steve Williamson. In reggae, the
appropriation of ska by Mods and other disaffected white youths in the 1960s and early
1970s was superseded from the late 1970s by a new Black radicalism led by a new
generation of Black youth. Inspired by Jamaican musicians such as Burning Spear, Bob
Marley, Peter Tosh, Bunny Livingstone, U. Roy and the Twinkle Brothers, the
rhythms of home-grown reggae became denser ('beating down Babylon'), the lyrics
about Black redemption and emancipation.

Groups like Aswad, innovators of the 1970s, continued their studio experiments in
'dub', still heavily influenced by sound systems such as Saxon, Jah Shaka, Coxsone and
King Sounds. These sound systems – mobile units of sound engineers, 'selectors' and
'dee jays', well known for their high decibel output at 'blues dances', created new
innovations in sound technology and music production. The popularity of mobile
discos in the late 1970s and 1980s followed in their stead, while they influenced
(without acknowledgement none the less) how the pop industry marketed and sold
records. The art of producing 'versions' of particular songs, each with its own creative
signature, came to be adopted as the 'remix', currently the standard issue in the mar-
keting and sale of pop records. In creative terms, the articulation of bass-driven sounds,
both freestyle and patterned around reggae's call and response idioms, proved to be
influential precursors to contemporary musics such as drum'n' bass, Euro rave and trip
hop, and the Bristolian sound associated with Massive Attack and Tricky.

The sound systems also influenced a wide range of musicians, including Misty in
Roots, Black Roots, Abashanti and Steel Pulse, whose ideological purchase of radical
Garveyism and Rastafari provided the musical 'soundtrack' to the Black youth rebel-
lions of the 1980s. Ferdinand Dennis, whose essay 'Birmingham: The Blades of Frus-
tration', Chapter 15, documents the conditions in the inner cities in the immediate
aftermath of the civil disturbances, draws our attention to a crucial contributory factor
– transformations within Black youth culture: 'By the late 1970s, the message in the
blues dance had changed, from nostalgia for the Caribbean islands, which represented
the immediate displacement of Africans to the more profound nostalgia for Africa. By
adopting Rastafari, the youth made the experience of exile a religion.'[16]

Unlike their parents, the second generation of Black youth did not see themselves as
'temporary guests' of Her Majesty's government. They were not here to work and
eventually return 'home' to the Caribbean or Africa. Britain was their home, and
according to one of the symbolic political slogans of the time, they were 'Here to Stay!'.
Consequently, they had little choice but to engage the class- and race-laden structures
of British society. Most became frustrated by racism and impatient for change: 'We
were born here and we should have been receiving all the benefits our white school-
mates were receiving, but this wasn't so. There were no jobs, bad housing and pure
pressure on the streets' (Brinsley Forde, Aswad).[17]

Aswad's self-titled debut album, including protest songs, such as 'Can't Walk the Streets', and 'Not Guilty', gave wide currency to popular youth discontent and mobilized social consciousness around the need for change. Their powerful dub, 'Warrior Charge', became a rallying anthem at blues dances. David Hines of the reggae group Steel Pulse testifies: 'Things were brewing for trouble – big time. The police was harassing us on the streets and putting many of the brothers behind bars on trumped-up charges. I left school with several O and A levels but couldn't get a job. Our album *Handsworth Revolution* came out in 1978, predicting explosion. In 1981, it happened' (David Hines, Steel Pulse).[18]

Steel Pulse followed *Handsworth Revolution* with *Tribute to the Martyrs* in 1979, and broadened their national appeal by performing at *Rock Against Racism* concerts, organized by a coalition of anti-racist organizations to mobilize public opinion against the National Front and other far-right parties. Despite opposition from the police and large sections of the white population, as well as from the first generation of Black postwar settlers, the Black youth redefined the character of Black British music, transforming reggae and its ideological bastion, the sound systems, into popular vehicles of protest and radical dissent. The symbols of Rasta culture – the colours, red, gold and green, the lion, Africa and reggae stars such as Bob Marley and Burning Spear – became the new icons of an anti-establishment movement with strong utopian tendencies. The blues party also became a significant focus for confrontations with the police, in effect contested zones in a prolonged urban 'war of positions': 'The blues parties were recreations of the "tea parties", which Claude McKay describes in his last novel, *The Banana Bottom* – people in the Jamaican hills brought out the drums and white rum and expressed themselves in a very African way till dawn. In the inner cities, the sound system replaced the drum. The music was very bluesy and nostalgic' (Ferdinand Dennis). [19]

Many of these 'blues parties', mostly unlicensed reggae clubs which stayed open all night, were raided:

> A Black youth being pursued by the police ran into a Jah Sufferer's dance in Cricklewood. Dennis Bovill was the dee jay and he so happened to be playing Junior Byles' song, 'Beat Down Babylon', when the Police forced their way in. In the ensuing confrontation, he was arrested with eleven others and later charged with inciting the crowd to riot. He was jailed for eighteen months but released after six months on appeal.
>
> (Linton Kwesi Johnson)[20]

Linton Kwesi Johnson himself emerged as the most articulate poet of this restless generation, releasing his *Dread Beat and Blood* album, a collaboration with Dennis Bovill, in 1977 and *Forces of Victory* in 1978. He was also one of the key organizers of the Black Radical and Third World Bookfair, Creation For Liberation and the New Cross Massacre Committee, formed to campaign for justice after the death of thirteen Black youngsters in a mysterious fire in south London.

The impact of the Black youth rebellion, portrayed aptly in films such as *Blacks Britannica* and *Handsworth Songs* but hysterically in the tabloid press, led to the collapse of the postwar consensus on 'race' and race relations.[21] This dramatic development, noted by Lord Scarman in his report into the Brixton riots of 1981, led to changes in

the welfare and social provision for the Black urban poor. If this was an achievement, it must be qualified by the fact that a new Black petty bourgeoisie, nurtured by the race relations industry, local government and Thatcherite economics became the real bene-ficiaries. As the cities went up in flames and the state responded with various reform initiatives, a new Black career stratum, some 'spokespersons' of the community, others sponsored by race and equal opportunity programmes climbed through the ranks of the city halls, the Labour Party, the media and corporate establishments, intensifying the class divisions within the Black communities. With this small but 'visible' class at the top and functioning within the media as the 'voice' of the 'Black community', the vast majority occupied the constantly shifting boundaries between work and the dole, while a highly volatile underclass (largely the product of the 1980s recession), creatively vibrant but with little stake in the system, explored every opportunity to make the system unworkable or yield to its lumpen tendencies.

The 1990s

The beginning of the 1990s marked a general downturn in the political fortunes of the Black communities. Culturally one of the most exciting achievements of the 1980s, the Black British renaissance came to an end. Ironically, it was at a time when the Thatcherite project which had brought it to its financial knees by abolishing the Greater London Council, its main funder in London, closed down its support estab-lishments and networks and transformed the whole ethos of arts production in the country, was showing serious signs of buckling under its own political contradictions. As public funds dried up for arts projects and groups, the exciting artistic collabora-tions which characterized the 1980s became unsustainable. Gradually, the movement's critical mass disintegrated. In the event, the complex constellation of creative and ideological forces, mobilized (with some effort), at the level of politics, to challenge the dominant Anglocentric cultural narratives and arts policies, splintered in all directions.

New agendas, mostly accommodatory to the brash ethos of Thatcherite individual-ism, emerged, the emphasis now on commercialism and its pedantic application to all things artistic. In artistic practice, subjectivity became a fashionable creative ploy. The best works of the period, not necessarily conforming to the political objectives of Thatcherism, introduced new conceptual spaces and open-ended methodologies into artistic and cultural practice. Within Black arts, these produced some exciting results, especially in photography and computer-generated montage. These have however been celebrated, rather hastily, as somewhat superior to the 'prescriptive practice' of the 1980s.[22]

The transition to the political doldrums of the early 1990s also saw a noticeable shift away from the grand globalizing themes of the previous decade: 'Black Britishness', 'Black art', 'the struggle', 'anti racism' etc. – indicators of a certain readiness to embrace political alliances across nationality and ethnicity. Significantly, the political unity between Africans, Caribbeans and Asians broke down. Why this development was so decisive is only now being debated. In my interview with Sir Herman Ouseley, Chairman of the CRE, he suggests that the demise of the Black parliamentary caucus at the close of the 1980s, partly a consequence of this split, was, among other factors, due to the 'scaling down of Black political aspiration', following the re-alignment of the centre and left field of British politics after the 1987 elections.

11

The debate on the African, Caribbean and Asian split is intricately bound to our understanding of the nature and dynamics of contemporary Black Britain. In this book, the two most formidable veterans of Black intellectual debate, Stuart Hall and A. Sivanandan, set the main ideological bench marks. In 'Frontlines and Backyards: The Terms of Change' (Chapter 11), Stuart Hall argues that it is no longer possible to mobilize 'Afro-Caribbeans and Asians' under 'a single political category' (Black). It is imperative that we should recognize 'the complex internal cultural segmentation, the internal frontlines which cut through so-called Black British identity'. A. Sivanandan disagrees. In spite of the fact that 'the objective conditions are no longer there for Afro-Caribbean and Asian unity – and therefore a Black politics . . . recognizing cultural segmentation is not to accept it. Cultural segmentation, like class segmentation, was always there – except that, yes, it is deeper and more complex today. But that is the more reason to fight it, before it becomes inward-looking and reactionary' (Chapter 35).

The ensuing debate also raises other questions about contemporary British culture, many of which are taken up in this book. Compared to earlier periods of immigration and settlement, there now appears to be a greater sense of a 'normalization' of race within many echelons of British society. This phenomenon is however characterized by an essential contradiction – high visibility of Black people, for example, in sports, the media, the entertainment industry, coupled with persistent racism. In celebrated cases such as those of Stephen Lawrence and Wayne Douglas, racism has a tendency to lash out as spurious violence on the streets. Ben Carrington's essay 'Double Consciousness and the Black British Athlete' (Chapter 12), takes up the dilemma of famous athletes such as sprinter Linford Christie and boxer Frank Bruno – 'called upon to represent both "the nation" and the "race" at a time when such a subject formation, and the conditions under which this is possible, is constantly being challenged and fought over from both sides'. Hugh Quarshie's essay 'Conventional Folly' (Chapter 24) tackles similar dynamics in the world of English theatre, probing how a Black actor can achieve an authentic voice working within questionable conventions. Issues around identity and self representation loom large within contemporary British culture, but they are not new. In 'Home is Always Elsewhere: Individual and Communal Regenerative Capacities' (Chapter 16) Fred D'Aguiar explores his personal sense of belonging to England as a boy growing up in the East End of London. Carol Tulloch's essay 'That Little Magic Touch: The Headtie and Issues around Black British Women's Identity' (Chapter 17) discusses similar themes, this time as an autobiographical engagement with the heady years of Black pride in the 1970s.

New discursive trends in cultural studies

Within cultural studies, trends emanating from postmodernist discourses (partly the result of the demise of the grand narratives of history – modernism, communism etc.) were taken over and politicized by a new 'post-coloniality' school, in the works of subaltern studies – Kwame Appiah (1993), Rey Chow (1993), Paul Gilroy (1993a, 1993b) Kobena Mercer (1994), Edward Said (1993) and Gayatri Spivak (1990). The new school, largely sidestepping Kwame Nkrumah's original thesis on 'neo-colonialism' – emphasizing *continuity* rather than *transition* from colonialism – represented, amongst other revisionisms, a critique of the efficacy of the nation state

as a unit of cultural analyses, and the recognition of 'globalization' as a significant historical and contemporary force.

Conclusion

From the early days of postwar immigration and settlement, when Black people in Britain saw themselves predominantly as 'guests' of British society, to current trends stressing citizenship, at the same time as 'diasporan' links are made with North America, Africa, the Caribbean and Asia, it often seems that we have come full circle – a fast-moving circle, with its complex patterns of junctions, crossroads and critical thresholds, all intricately bound to stories waiting to be told. It is my hope that this collection goes some way to illustrate how potentially rich these stories are, as we recognize their place alongside others, within a national tradition that has over just fifty years changed from what George Orwell in *The English People* (1948) mistakenly described as exclusively 'Celtic and Anglo-Saxon' to a new and vibrant cosmopolitanism.

Notes

1 For further reading on British cultural studies, see S. Laing, *Representations of Working-Class Life, 1959–64* (London: Macmillan); L. Grossberg, N. Cary and P. Treichler (eds) *Cultural Studies* (New York: Routledge, 1992); B. Schwarz, 'Where is Cultural Studies?', *Cultural Studies* 8, 3 (1994), 377–93; G. Turner, *British Cultural Studies: An Introduction* (London: Routledge, 1996).

2 The Second World War precipitated the processes of decolonialization in Africa and Asia, culminating in the collapse of the British Empire. India became independent in 1947, setting a trend across the colonial world. By 1960, countries in Asia and Africa still under colonial administrations were exceptions rather than the rule. Caribbean countries followed suit in the 1960s. The steamers *Ormond* and *Empire Windrush* arrived in Britain in 1947 and 1948 respectively, bringing in a total of 592 immigrant workers from the Caribbean. Many more were to follow. Thirty-six per cent of the first generation of Caribbean immigrants had arrived by the late 1950s: see T. Jones (1996). For a discussion of the impact of Black workers on the British labour market, the Trade Unions and the workers, see James W. and Harris C. (1993).

3 Stuart Hall Introduction, *A Different Hunger: Writings on Black Resistance* (London: Pluto Press, 1991).

4 The late 1970s was a highly significant conjuncture for 'race' in Britain, with the political backlash to Black immigration and racial attacks reaching their climax under the Conservative right led by Mrs Thatcher. The electoral gains of the National Front and other extreme right parties also raised the political temperature, with the anti-racist movement organizing against them. These developments gave a polemical edge to the 'race' scholarship produced by the CCCS.

5 In the introduction to my book *Storms of the Heart: An Anthology of Black Arts and Culture* (1988), I drew attention to the internationalist nature of the Black arts and cultural movement in Britain, exemplified by the work of practitioners such as Pitika Ntuli, Uzo Egonu, Rasheed Araeen and African Dawn. They created an ideological impetus that facilitated dialogue with centres of creative inspiration in Africa, the Caribbean and Asia. This produced tension with the ideologies of 'ethnic arts', 'minority arts', 'ethnic minority arts' etc., which attempted to ghettoize their work within the confines of the British nation state. This contestation is still valid, but the significant gains made by Black culture in Britain over the last decade validates 'Black British' as a relevant signifier of the arts produced by Black people in Britain today.

6 For influential texts in the sociology of race relations, see A. Richmond, *Colour Prejudice in Britain: A Study of West Indian Workers in Liverpool, 1942–1951* (London: Routledge & Kegan Paul, 1954); R. Landes, 'Preliminary Statement of a Survey of Negro–White Relationships in Britain', *Man*, 52 (September 1952); S. Patterson, *Dark Strangers* (London: Tavistock, 1963); N. Glazer and K. Young (eds), *Ethnic Pluralism and Public Policy: Achieving Equality in the United States and Britain* (London: Heinemann, 1983); R. Jenkins, 'Racial Equality in Britain', in A. Lester (ed.), *Essays and Speeches of Roy Jenkins* (London: Collins, 1967); M. Cross, *Ethnic Pluralism and Racial Inequality* (University of Utrecht, 1994); D. Brooks, *Race and Labour in London Transport* (Oxford: Oxford University Press, 1975).

7 See Morley D. and Chen K. (eds), *Stuart Hall: Critical Dialogues in Cultural Studies* (London: Routledge, 1996), for a comprehensive bibliography of Stuart Hall.

8 See also K. Mercer and I. Julien 'De Margin and De Centre', in D. Morley and K. Chen (eds), *Stuart Hall: Critical Dialogues in Cultural Studies* (London: Routledge, 1996).

9 The prefix 'British' is useful here since Hall has registered critical doubts on the political relevance of, for example American cultural studies. On the postmodern debate, he characterizes a significant volume of the American contribution as 'another version of that historical amnesia, characteristic of American culture' (Hall 1996), and is not particularly charitable to critics such as Fukuyama who believe that 'history' stops with us (see Fukuyama 1992).

10 The concept of the 'organic intellectual' is similar to Homi Bhabha's dialogic interpretation of Frantz Fanon's idea of the interrelationship between theory and practice, expounded in his influential essay 'The Other Question: The Stereotype and Colonial Discourse', *Screen* 24, 4 (1983). Bhabha was also a critical influence on this movement, although his concerns for the broader questions of post-coloniality and transnationalism made him less relevant to the immediate concerns of this largely British movement.

11 The Brixton riot of 1981 was sparked off by the shooting and wounding of Cherry Groce in her home. The death of Cynthia Jarrett triggered off the Broadwater Farm riot of 1985.

12 The 'first wave' of postwar Black intellectuals included scholars and activists such as Claudia Jones, Trevor Carter, John La Rose, Sam Selvon, E.R. Braithwaite, Erica Huntley, Eric Huntley and Beryl Gilroy.

13 The first Black cultural renaissance in Britain in the postwar period occurred in the 1960s and early 1970s, with the work of the artists and writers of the Caribbean artists movement – Kamau Brathwaite, George Lamming, John La Rose, Aubrey Williams, Errol Lloyd, Archie Makham, Ronald Moody and many others. See Anne Walmsley, *The Caribbean Artists Movement, 1966–1972: A Literary & Cultural History* (London: New Beacon Books, 1992) for a good account of the relevant developments.

14 The African Dawn, of which I was a member, included Wala Danga, Torera Mpiridzisi, from Zimbabwe, Sheikh Gueye from Senegal, Eduardo Pereira from Uruguay, Merle Collins from Grenada and Vico Mensah from Ghana. The group recorded four albums and toured extensively, leading the way in experimentations around art form fusions.

15 There are of course many other significant cultural events such as Glastonbury, Womad and other pop concerts. However, the wide artistic scope of the Notting Hill Carnival, its location within the urban landscape and the wide range of people who patronize it make it unique.

16 My interview with Ferdinand Dennis, 1998.

17 My interview with Brinsley Forde, Aswad, 1998.

18 My interview with David Hines, Steel Pulse, 1998.

19 My interview with Ferdinand Dennis, 1998.

20 My interview with Linton Kwesi Johnson, 1998.

21 This consensus saw the assimilation of the Black population into English culture and society as one of the cardinal objectives of immigration policy. The Scarman Report published after the civil unrest of 1981 indicated that this had failed. On 'race', the riots, though shocking at the time, made it clear to British society that the second generation Black youth were ready to make the inner cities ungovernable if their grievances were not addressed.

22 See Kobena Mercer, 'Witness at the Crossroads: An Artist's Journey in Post-colonial Space', in *Relocating the Remains: Keith Piper* (London: Institute of International Visual Arts, 1997). Whilst the change in the direction of visual artist Keith Piper's work in the early 1990s led to some innovative engagements, particularly within computer art, I am not as sure as others that this 'open-ended and contradictory puzzle of elements thrown into a heap to tease and irritate the spectator' represents so clear a qualitative leap over his 1980s work.

References

Althusser, L. and Balibar, E. (1968) *Reading Capital* (London: New Left Books).

Althusser, L. and Balibar, E. (1969) *For Marx* (London: Allen Lane).

Appiah, K. (1993) *In My Father's House* (London: Methuen).

Araeen, R. (1984) *Making Myself Visible* (London: Kala Press).

Araeen, R. (1989) *The Other Story*, exhibition catalogue (London: Hayward Gallery).

Baldwin, J. (1963) *The Fire Next Time* (New York: The Dial Press).

Baudrillard, J. (1977) *The Mirror of Production* (New York: Telos).

Baudrillard, J. (1983) *Simulations*, trans. P. Foss, P. Patton and P. Beitchman (New York: Semiotext(e)).

Berry, J. (1984) *News for Babylon: The Chatto Book of West Indian-British Poetry* (London: Chatto & Windus).

Bhabha, H. (1983) 'The Other Question: The Stereotype and Colonial Discourse', *Screen* 24.

Bhabha, H. (1986) 'Foreword: Remembering Fanon: Self, Psyche and the Colonial Condition', in F. Fanon, *Black Skin, White Masks* (London: Pluto).

Brah, A. and Minhas R. (1984) 'Structural Racism or Cultural Difference: Schooling for Asian Girls', in B. Bryan, S. Dadzie, S. Scafe, *Heart of the RACE: Black Women's Lives in Britain* (London: Virgo Press, 1985).

Burford, B. (1986) *The Threshing Floor* (London: Sheba).

Cabral, A. (1973) *Return to the Sources: Selected Speeches* (New York and London: Monthly Review Press).

Campbell, A. X. (1974–5) 'The Industrial Action of the Black Masses and the Class Struggle in Britain', *The Black Liberator* 2, 30.

Carby, H. (1980) 'Multiculture', *Screen Education* 34 (spring).

Carmichael, S. and Hamilton, C. (1968) *Black Power: The Politics of Liberation in America* (London: Cape).

Carter, B. and Joshi S. (1984) 'The Role of Labour in Creating a Racist Britain', *Race & Class*, 25 (winter): 53–70.

Carter, T. (1986) *Shattering Illusions: West Indians in British Politics* (London: Lawrence & Wishart).

Césaire, A. (1950) *Discourse on Colonialism* (New York and London: Monthly Review Press, 1972).

Chow, R. (1993) *Writing Diaspora* (Bloomington: Indiana University Press).

Cobham, R. and Collins, M. (eds) (1987) *Watchers and Seekers: Creative Women's Writing by Black Women in Britain* (London: The Women's Press).

Cohen, P. (1972) *Subcultural Conflict and Working Class Community: Working Papers in Cultural Studies 2* (University of Birmingham: Centre for Contemporary Cultural Studies).

Dabydeen, D. (1985) *Hogarth's Blacks* (Manchester: Manchester University Press).

Deakin, N. (1970) *Colour, Citizenship and British Society* (London: 1970).

Derrida, J. (1982) *Margins of Philosophy* (Chicago: University of Chicago Press).

Derrida, J. (1992) *The Other Heading: Reflections on Today's Europe* (Bloomington and Indianapolis: Indiana University Press).

Dhondy, F. (1976) *East End at My Feet* (London: Macmillan).

During, S. (ed.) (1994) *The Cultural Studies Reader* (London: Routledge).

Dyer, R. (1988) 'White', *Screen* 29, 4: 44–64.

Fanon, F. (1963) *The Wretched of the Earth* (New York: Grove Press).

Firestone, S. (1970) *The Dialectic of Sex: The Case for Feminist Revolution* (New York: Bantam).

Foucault, M. (1978) *The History of Sexuality. Volume One: An Introduction*, trans. R. Hurley (New York: Pantheon).

Foucault, M. (1980) *Power/Knowledge: Selected Interviews and Other Writings 1972–1977* (New York: Pantheon).

Foucault, M. (1989) *The Archaeology of Knowledge* (London: Routledge).

Freud, S. (1954) *Sigmund Freud's Letters to Wilhelm Fliess, Drafts and Notes*, ed. M. Bonarparte and E. Kris, trans. E. Masbacher and J. Strachey (New York: Basic Books).

Fryer, P. (1984) *Staying Power: The History of Black People in Britain* (London: Pluto).

Fukuyama, F. (1992) *The End of History and the Last Man* (London and New York: Penguin).

Garrison, L. (1983) *Black Youth, Rastafarianism and the Identity Crisis in Britain* (London: ACER).

Gilroy, P. (1981) 'You Can't Fool the Youth: Race and Class Formation in the 1980s', *Race & Class* 23, 2/3.

Gilroy, P. (1982) 'Steppin' Out of Babylon – Race Class and Autonomy', in CCCS, *The Empire Strikes Back* (London: Methuen).

Gilroy, P. (1983) 'Channel 4, Bridgehead or Bantustan?', *Screen*, 24, 4–5 (July–October).

Gilroy, P. (with J. Sim) (1985) 'Law, Order and the State of the Left', *Capital & Class* 25 (spring).

Gilroy, P. (1987) *There Ain't No Black in the Union Jack: The Cultural Politics of Race and Nation* (London: Routledge).

Gilroy, P. (1993a) *The Black Atlantic* (London: Verso).

Gilroy, P. (1993b) *Small Acts* (London: Serpent's Tail).

Gordon, P. (1983) *White Law, Racism in the Police, Courts and Prisons* (London: Pluto Press).

Gramsci, A. (1971) *Selections from the Prison Notebooks*, ed. and trans. Q. Hoare and G. Nowell-Smith (London: Lawrence & Wishart).

Gutzmore, C. (1975–6) 'Imperialism and Racism: The Crisis of the British Capitalist Economy and the Black Masses in Britain', *The Black Liberator* 2, 4.

Gutzmore, C. (1983) 'Capital, Black Youth and Crime', *Race & Class* 25, 2 (autumn).

Hall, S. (1958) 'A Sense of Classlessness', *Universities and Left Review* 1, 5: 26–32.

Hall, S. (with P. Whannel) (1964) *The Popular Arts* (London: Hutchinson, and Boston: Beacon Press).

Hall, S. (1967) 'The Condition of England Question', *People and Politics* (Easter).

Hall, S. (1970) 'Black Britons', Community 1 2/3.

Hall, S. (1972) 'Black Britons' in E. Butterworth and D. Weir (eds), *Social Problems of Modern Britain* (London: Fontana).

Hall, S. (with J. Clark, T. Jefferson and B. Roberts) (1976) *Subcultures, Cultures and Class: A Theoretical Overview: Working Papers in Cultural Studies* 7/8 (London: Hutchinson).

Hall, S. (1978) 'Racism and Reaction', in *Five Views of Multiracial Britain* (London: Commission for Racial Equality).

Hall, S. (1980) 'Race, Articulation and Societies Structured in Dominance', in *Sociological Theories: Race and Colonialism* (Paris: UNESCO: 305–45).

Hall, S. (1981) 'The Whites of Their Eyes: Racist Ideologies and the Media', in George Bridges and Ros Brunt (eds), *Silver Linings* (London: Lawrence & Wishart): 28–52.

Hall, S. (1986) 'Gramsci's Relevance to the Study of Race and Ethnicity', *Journal of Communication Inquiry* 10, 2: 5–27.

Hall, S. (1992) with D. A. Bailey, 'Critical Decade: Black British Photography in the 1980s', Introduction to *Screen* 4, 7: 3–4.

Hall, S. (1993) 'For Allon White: Metaphors of Transformation', Introduction to Allon White, *Carnival, Hysteria, Writing* (Cambridge: Cambridge University Press).

Harris, C. (1988) 'Images of Blacks in Britain: 1930–1960', in S. Allen and M. Macey (eds), *Race and Social Policy* (London: ESRC).

Hebdige, D. (1979) *Subculture: The Meaning of Style* (London: Methuen).

Hoggart, R. (1957) *The Uses of Literacy* (Harmondsworth: Penguin).

James, C. L. R. (1984) 'Africans and Afro Caribbeans: A Personal View', *Ten* 8, 16.

James, W. (1986) 'A Long Way From Home: On Black Identity in Britain', *Immigrants and Minorities* 5, 3 (November).

Jegede, T. and Chester, G. (1986) *The Silenced Voice: Hidden Music of the Kora* (London: Diabate Kora Arts).

Johnson, L. K. (1974) *Voices of the Living and the Dead* (London: Race Today).

Johnson, L. K. (1975) *Dread Beat and Blood* (London: Bogle-L'Ouverture)

Johnson, L. K. (1980) *Inglan is a Bitch* (London: Race Today).

Jones, C. (1985) *I Think of my Mother*, ed. B. Johnson (London: Karia Press).

Julien, I. and Mercer, K. (1988) 'De Margin and De Centre', in D. Morley and K. Chen (eds), *Stuart Hall: Critical Dialogues in Cultural Studies* (London: Routledge).

Lawrence, E. (1981) 'White Sociology/Black Struggle', *Multiracial Education* 9, 2.

Lewis, G. (1978) *Slavery Imperialism and Freedom* (New York: Monthly Review Press).

Lyotard, J. (1984) *The Postmodern Condition: A Report on Knowledge*, trans. G. Bennington and B. Massumu (Manchester: Manchester University Press).

Mama, A. (1989) *The Hidden Struggle: Statutory and Voluntary Responses to Violence Against Black Women* (London: Runnymede Trust).

McRobbie, A. (1978) 'The Culture of Working Class Girls', in A. McRobbie (ed.), *Feminism and Youth Culture* (London: Macmillan, 1991).

Mercer, K. (1994) *Welcome to the Jungle: New Positions in Black Cultural Studies* (London: Routledge).

Mirza, H. S. (1986) 'The Dilemma of Socialist Feminism: A Case for Black Feminism', *Feminist Review, Feedback: Feminism and Racism* 22 (spring).

Morley, D. (1980) *The 'Nationwide' Audience: Structure and Decoding*, BFI Television Monographs, 11, London: British Film Institute.

Morley, D. and Chen, K. (1996) *Stuart Hall: Critical Dialogues in Cultural Studies* (London: Routledge).

Nkrumah, K. (1965) *Neocolonialism, the Last Stage of Imperialism*.

Owusu, K. (1986) *The Struggle for Black Arts in Britain: What Can We Consider Better than Freedom* (London: Comedia).

Owusu, K. (ed.) (1988) *Storms of the Heart: An Anthology of Black Arts and Culture* (London: Camden Press).

Parmar, P. (1981) 'Young Asian Women: A Critique of the Pathological Approach', *Multiracial Education* 9, 2.

Parmar, P. (1984) 'Hateful Contraries', *Ten* 8, 16.

Parmar, P. (1989) 'Other Kinds of Dreams', *Feminist Review* (spring): 31.

Parmar, P. (1990) 'Black Feminism: The Politics of Articulation', in J. Rutherford (ed), *Identity, Community, Difference* (London: Laurence & Wishart).

Patterson, S. (1969) *Immigration and Race Relations in Britain* (London: Oxford University Press).

Phoenix, A. (1988) 'Narrow Definitions of Culture: The Case of Early Motherhood', in S. Westwood and P. Bhachu (eds), *Enterprising Women: Ethnicity, Economy and Gender Relations* (London: Routledge).

Ramdin, R. (1986) *The Making of the Black Working Class in Britain* (Aldershot: Wildwood House).

Rich, A. (1977) *Of Woman Born* (London: Virago).

Rose, E. J. B. et al. (1969) *Colour and Citizenship: A Report on British Race Relations* (London: Institute of Race Relations/Oxford University Press).

Rushdie, S. (1983) 'A General Election', from *Imaginary Homelands* (London: Granta Books).

Said, E. (1993) *Culture and Imperialism* (London: Chatto & Windus).

Saussure, F. (1974) *Course in General Linguistics* (New York: Collins).

Seale, B. (1970) *Seize the Time: The Story of the Black Panther Party and Huey P. Newton* (London: Hutchinson).

Sidran, B. (1971) *Black Talk* (Edinburgh: Payback Press).

Sivanandan, A. (1976) 'Race, Class and State: The Black Experience in Britain', *Race & Class* 17, 4 (spring).

Sivanandan, A. (1978) 'From Immigration Control to "Induced Repatriation"', *Race & Class*, 17, 1.

Sivanandan, A. (1990a) 'From Resistance to Rebellion', in *Communities of Resistance* (London: Verso).

Sivanandan, A. (1990b) 'Challenging Racism: Strategies for the 1980s', in *Communities of Resistance.*

Sivanandan, A. (1990c) 'RAT and the Degradation of Black Struggle', in *Communities of Resistance.*

Sivanandan, A. (1990d) 'All that Melts into Air Is Solid: The Hokum of New Times', in *Communities of Resistance.*

Solomos, J. (1989) *Race and Racism in Contemporary Britain* (London: Macmillan).

Spivak, G. (1990) *The Post Colonial Critic: Interviews, Strategies, Dialogues*, ed. S. Harasyn (London: Routledge).

Staples, R. (1985) 'Changes in Black Family Structure: Conflict Between Family Ideology and Structural Conditions', *Journal of Marriage and the Family*, 47.

Sutcliffe, D. (1982) *British Black English* (Oxford: Basil Blackwell).

Sutcliffe, D. and Wong, A. (eds) (1986) *The Language of the Black Experience* (Oxford: Basil Blackwell).

Thompson, E. P. (1968) *The Making of the English Working Class* (Harmondsworth: Penguin).

Weeks, J. (1981) *Sex, Politics and Society* (London: Longman).

Weiner, G. (ed.) *Just a Bunch of Girls* (Milton Keynes: Open University Press).

White, E. (1983) *Lament for Rastafari* (London: Marion Boyars).

Williams, R. (1958) *Culture and Society: 1780–1950* (Harmondsworth: Penguin).

Williams, R. (1961) *The Long Revolution* (Harmondsworth: Penguin).

Willis, P. (1977) *Learning to Labour: How Working Class Kids Get Working Class Jobs* (New York: Columbia University Press).

Willis, P. (1986) 'Gramsci's Relevance to the Study of Race and Ethnicity', *Journal of Communication Inquiry* 10, 2: 5–27.

Willis, P. (with D. A Bailey) (1992a) 'Critical Decade: Black British Photography in the 1980s', Introduction to *Screen* 4–7: 14–13.

Willis, P. (1992b) 'Cultural Studies and its Theoretical Legacies', in J. Grossberg, C. Nelson and P. Treichler (eds), *Cultural Studies*, New York: Routledge.

Wilson, A. (1978) *Finding a Voice: Asian Women in Britain*, London: Virago.

Section One

CLASSIC TEXTS FROM POSTWAR NARRATIVES

This section brings together classic texts in the postwar history of Black British culture and society. Each text explores a major theme or themes that highlight significant developments. The chapter by Clive Harris, Bob Carter and Shirley Joshi questions one of the main tenets of immigration literature – that the immediate postwar period was characterized by a policy of *laissez faire* (Rose et al. 1969; Patterson 1969; Deakin 1970) (references are to the bibliography at the end of the Introduction). By critically examining internal government documents, the writers argue that, public presentations notwithstanding, the British government had by as early as 1951 initiated a number of covert and sometimes illegal administrative measures to discourage Black immigration. The contributions by pioneer intellectuals George Lamming, Kamau Brathwaite and Claudia Jones respond to the crisis in Caribbean national identity as a result of the disintegration of the British Empire and the racist backlash to Black immigration to Britain. According to Brathwaite, this crisis intensified what he terms Caribbean 'root-lessness' – a psychological state of dislocation and unbelonging, further deepened by historical memories of slavery and exile. During the 1950s and 1960s, many Caribbean intellectuals and workers responded to it by looking back to the Caribbean as 'home' and 'detaching' themselves from aspects of British society. Claudia Jones takes this up in her chapter, bemoaning the reluctance of many Caribbean immigrants to participate in political activity in Britain.

The chapters by Obi Egbuna and A. Sivanandan argue for the radical alternative – a political struggle with the British state, informed by the campaigning notion, successfully articulated in the late 1970s and 1980s, that Black people as British citizens were 'here to stay!'. The texts, one fiery and written in prison, the other no less fiery but theoretically more reflective, highlight major themes in the literature of Black political struggle – racial pride, self-determination and political change. These reflect the long-standing tradition of radical Black writings, highlighted in the 1960s and 1970s by the Black Power movement and Third World liberation – Frantz Fanon (1965), Stokely Carmichael and Charles Hamilton (1968), Bobby Seale (1970), Kwame Nkrumah (1965), Amilcar Cabral (1973) and Aimé Césaire (1973).

Hazel Carby and Amina Mama focus on issues around 'race' and gender. The chapter by Carby articulates various theoretical positions within radical feminist literature. It is also a 'discursive polemic' in the highly charged debate between Black and white

19

feminists about the nature and dynamics of gender oppression across race and ethnicity. Mama's essay gives a shocking insight into the level of gender abuse within London's Black communities, while Beryl Gilroy writes reflectively on the impact of old age on Black women. Kobena Mercer's seminal essay 'Black Hair/Style Politics' challenges some 'sacred cows' within Black cultural politics, foregrounding a radical revisionism. Stuart Hall introduces crucial aspects of the current debate on contemporary Black Britain.

1

THE 1951–1955 CONSERVATIVE GOVERNMENT AND THE RACIALIZATION OF BLACK IMMIGRATION

Bob Carter, Clive Harris and Shirley Joshi

Introduction

The problem of colonial immigration has not yet aroused public anxiety, although there was some concern, mainly due to the housing difficulties in a few localities where most of the immigrants were concentrated. On the other hand, if immigration from the colonies, and, for that matter, from India and Pakistan, were allowed to continue unchecked, there was a real danger that over the years there would be a significant change in the racial character of the English people.[1]

In the discussion of postwar racism the role of the state is often ignored or treated as insignificant. Katznelson, Glass, Hiro and Foot for example have all argued that the state played a negligible role in the development of postwar racism until the 1958 'riots' (Katznelson 1976: 129–31; Glass 1960: 127–46; Foot 1965: 233; Hiro 1973). Katznelson's account is one of the most influential. He sees the 1958 'riots' as representing the demise of a 'pre-political' period during which 'race only touched the periphery of political debate'. This chapter will show that, on the contrary, the state took a major role in constructing black immigration as a 'problem' and in so doing reinforced a conception of Britishness grounded in colour and culture (as expressive of colour). Racist policies and practices were an integral part of this construction; the right of black people to enter and settle in the United Kingdom freely was circumscribed by government actions.

Another recurring theme of the literature is the portrayal of the 1940s and 1950s as an era of *laissez faire* immigration when unfettered market forces determined the movement of people from the periphery to the centre 'as and when the need arose' (Sivanandan 1982: 106; Freeman 1975; Foot 1965; Hiro 1973). For most writers *laissez faire* came to an end with the introduction of the first Commonwealth Immigrants Bill:

> The period 1961–65 saw the collapse of laissez faire policies regarding coloured immigration and the settlement of coloured immigrants. A laissez faire policy is very comfortable to follow: it meant doing nothing. And this is exactly what the Tory Government did regarding coloured immigration until popular anxiety forced its hand in 1961.
>
> (Hiro 1973: 201)

Against this we will show that the state went to great lengths to restrict and control on racist grounds black immigration to the United Kingdom despite a demand for labour by fractions of private and public capital. This points to a further weakness in the *laissez faire* argument, namely the portrayal of the state as homogeneous, as reflecting in a direct and unmediated way the interests of an equally homogeneous capital.

In short we wish to argue that well before 1955 the state had developed a clear policy towards black immigration.[2] This policy involved direct intervention on some issues and an apparent inactivity on others. For example, while the government was systematically collecting information about black people to support a draft immigration bill prepared in 1954, it was also opposing measures such as Fenner Brockway's bill prohibiting racist discrimination, despite growing evidence that discrimination was widespread. Successive governments not only constructed an ideological framework in which black people were to be seen as threatening, alien and unassimilable but also developed policies to discourage and control black immigration.

For many senior Conservative politicians in the Churchill government, black immigration raised the prospect of a permanent black presence whose allegedly 'deleterious effects' on the 'racial character of the English people' were regarded as a cause for concern.

Similar sentiments were expressed under Attlee's Labour government. Two days after the arrival of the *Empire Windrush* in June 1948 a letter was sent to Clement Attlee by eleven Labour MPs calling for the control of black immigration, since 'An influx of coloured people domiciled here is likely to impair the harmony, strength and cohesion of our public and social life and to cause discord and unhappiness among all concerned'.[3] The Labour government set up a Cabinet Committee in 1950 to review 'the further means which might be adopted to check the immigration into this country of coloured people from the British Colonial Territories'. On grounds of expediency rather than principle, the introduction of legislative control was shelved; it was felt that the administrative measures already in operation were a sufficient safeguard of 'racial character' (see Carter and Joshi 1984; Harris 1987a).

These administrative measures were inherited by the Conservative government elected in 1951. As the failure of such measures to curtail fare-paying black 'Citizens of the United Kingdom and Colonies' became apparent, the Conservative government returned to the possibility of legislative control. However the absence of an articulated public anxiety about black immigration, and a continuing demand for labour, made more acute by the petering out of the European Volunteer Worker scheme, required the government to build a 'strong case' for legislation. This 'strong case' was built around a racialized reconstruction of 'Britishness' in which to be 'white' was to 'belong' and to be 'black' was to be excluded. This chapter examines the early stages of this reconstruction in the policies of the 1951–5 Conservative government first to discourage and then to control black immigration.

'Holding the tide'

It is commonly argued that the 1948 Nationality Act conferred on colonial subjects rights of entry and settlement that did not previously exist. Those who expound the *laissez faire* argument present the Act as a device to facilitate the free movement of labour from the Caribbean and the Indian subcontinent to meet Britain's 'labour shortage'. (For a discussion of the concept of 'labour shortage', see Harris 1987b.)

This interpretation needs to be viewed critically. The Act's intention was to restructure in Britain's interests the empire as an economic and political force. The concept of a 'United Kingdom and Colonies' citizenship – as opposed to a separate citizenship for each territory – enshrined in the Act was meant to curb colonial nationalism rather than to concede rights of entry and settlement into Britain. This chapter makes it clear that the principle of free entry was not something over which the Cabinet agonized, and relinquished only with great reluctance. Indeed, when the lone voice of the Student Officer at the Colonial Office, J. Keith, sought unwisely in 1955 to reopen the debate about this principle[4] he was told that *the time for review of the question of principle has now passed.* There is indeed . . . no real question of principle involved, or if there is, the principle is that it is open to any country to take steps to control the composition of its own population'.[5]

By 1952 Labour and Conservative governments had instituted a number of covert, and sometimes illegal, administrative measures designed to discourage the one to two thousand black immigrants who came annually. These measures varied from territory to territory. In the case of West Africa, for example, they involved the 'laundering' from 1951 onwards of the British Travel Certificate issued for travel between the French and British colonies along the West African coast. This document by confirming that the holder was a British subject, could be used to enter the United Kingdom legally. 'Most men now realize', despaired one Colonial Office official, 'that a British Travel Certificate is the minimum document on which they can expect to be landed in this country.'[6] Accordingly arrangements were made in the latter half of 1951 – with the full agreement of the French government – to omit from the documents any reference to British subject status. A holder arriving in the United Kingdom could then be sent back as an alien, despite the fact that 'all concerned, including the Immigration Officer, know perfectly well that they almost certainly are British subjects'.[7]

In the West Indies, where local politics made the refusal of passports impolitic, other measures were required. Governors were asked to tamper with shipping lists and schedules to place migrant workers at the end of the queue; to cordon off ports to prevent passport-holding stowaways from boarding ships; and to delay the issue of passports to migrants. The last measure was adopted by Indian and Pakistani governments who also refused passports to the United Kingdom if migrants had no firm prospect of a job or accommodation. Police checks were carried out at the request of the Home Office to establish the basis of these prospects. Finally shipping companies were instructed by the Ministry of Transport to take steps to deal with 'one-trip seamen' who terminated work agreements on arriving in the United Kingdom. Henceforth, contracts would require companies to disengage workers at their 'home' ports.

These ad hoc administrative measures had their limitations; some were of questionable legality. Above all they failed to prevent black British subjects coming to the United Kingdom. By the early 1950s therefore some government departments had

come to favour restrictive legislation. The Welfare Department of the Colonial Office, for example, felt that 'it would be far better to have an openly avowed policy of restricted immigration than fall back on rather devious little devices'.[8] Such a move would also go some way to calm ministerial anxieties about dubious methods being exposed in Parliament. Legislation, however, required a convincing case to be made.

Building a strong case from broken reeds

Early in 1953 a confidential meeting of ministers took place at the Colonial Office. The case for legislative control, it was stressed, needed empirical demonstration. This meant gathering information about unemployment and National Assistance, 'numbers', housing, health, criminality, and miscegenation, which it was hoped would confirm that black immigrants posed insoluble problems of social, economic and political assimilation. The already widespread surveillance of black communities by the police was supplemented by surveys undertaken by the Ministry of Labour, the National Assistance Board, the Welfare Department of the Colonial Office, the Home Office, the Commonwealth Relations Office, the Departments of Health, Housing and Transport as well as voluntary organizations. A working party on 'The Employment of Coloured People in the UK',[9] set up by the cabinet in 1953, used the findings to produce a report which assessed the strengths and weaknesses of the 'strong case'. This report formed a central part of cabinet discussion in 1954–5 concerning the need to control black immigration, and was to be regularly updated throughout the 1950s.

Numbers

Early attempts to build a case which would be strong enough to focus public anxiety deployed the issue of *numbers*. Two concerns were prominent: the accelerating rate of black immigration and the size of the black population. Ministers were particularly alarmed that West Indian migration for 1954 was running at the level of ten thousand compared to two thousand in previous years. However, an examination of these figures by Betty Boothroyd at the Board of Trade revealed that while West Indian migration was 'going up pretty fast, the overall immigration from coloured empire countries has not increased in any dramatic way in the last few years'.[10] Nevertheless, in addition to the reports provided by the Ministry of Transport and Civil Aviation for arrivals at ports and airports, ministers and civil servants continued assiduously to collect newspaper clippings which suggested that Britain would have to brace itself for an influx of black immigrants who came in 'leaps from the islands and bounds to the UK without let or hindrance'.[11] Even the judicious *New Statesman* was of the opinion that, 'we must prepare ourselves either to accept no fewer than 200,000 immigrants in the next ten years – and possibly many more – or to face a political explosion in the Caribbean'.[12] The problem for ministers, however, was how to defend their inordinate interest in the 36,000 black immigrants who came between 1950 and 1955 when nothing whatsoever was being done about the 250,000 Southern Irish who arrived in the same period or the thousands of Italian and other European workers who were specifically recruited by the Ministry of Labour.

In 1953 too there was some uncertainty about the size of the black population, with figures of sixty and seventy thousand bandied about. These estimates were contradicted

by figures from the police and the Ministry of Labour. 'It is interesting,' noted one civil servant wryly, 'that the police estimate of the number of coloured people now in the United Kingdom gives a total of less than 25,000 colonials, as against our unofficial estimate of 50,000 to 60,000.'[13] Whatever the figure, it had to be admitted in late 1955 that 'Colonial immigration was not an acute problem at the moment'.[14] In conceding that 'the "coloured" problem in the United Kingdom remains a small one, e.g. in Lambeth there are said to be 650 coloured persons among a population of 230,105', Keith significantly went on to add that 'it would be better to stop the influx now to forestall future difficulties'.[15]

Such figures revealed the problems facing the cabinet in building a strong case solely around numbers. They therefore sought to extend the argument for legislative control by looking at employment, housing and crime.

Employment

Even before black workers had had an opportunity to respond to job advertisements in the United Kingdom, a propaganda campaign was launched in 1947 in the Caribbean to persuade them that these were not 'real jobs' but 'paper vacancies' and it was 'not in their interests' to migrate to the United Kingdom. In building its 'strong case' in 1953 the working party sought to show that those black migrants who did come were unemployable and represented a burden on public funds and to this end collected evidence from the Ministry of Labour and National Service and from the Ministry of Pensions and National Assistance.

In undertaking its survey the Ministry of Labour was careful to avoid the 'considerable risk of the enquiry becoming public knowledge and a smaller but still calculable risk of a violent reaction among coloured people against our Offices at certain Exchanges'.[16] Rather than adopt the 'dangerous procedure' of asking registrants questions 'which could arouse their suspicion', box clerks used 'visual methods' to spot the 'racial types'. To aid the Home Office to 'interpret' the findings of the survey a questionnaire was sent to area officers inviting their comments despite misgivings that they could 'only be based on hearsay, isolated incidents, or press reports'.[17] In the questionnaire and the responses one finds all those stereotypes which have since become part of popular commonsense:

> *Question*: Is it true that coloured people, or certain classes of coloured people, are work-shy?
> *Answer*: They cannot be said to be more work-shy than white people.
> *Question*: Is it true that they are poor workmen?
> *Answer*: Dutifully some responses alluded to the 'lack of stamina' of black migrants which made the latter 'unsuited for heavy manual work, particularly outdoor work in winter or in hot conditions underground'. Another allusion was to their 'inability to concentrate for long duration'. In the case of women, these images were particularly sharp. They were reported as being 'mentally slow' and ill-adapted to 'the speed of work in modern factories'. Curiously, if factory work was described as 'quite beyond their capacity', it was considered that such women were capable of giving 'fairly reliable service as domestics in hospitals and private domestic employment'.

Question: Is it true that they are unsuited by temperament to the kind of work available?

Answer: Despite the caveat that the evidence was 'not conclusive', reference was occasionally made to their inability to accept discipline, their volatility of temperament, easy provocation to violence, and quarrelsomeness.

Question: Can distinctions be drawn in this respect between particular races?

Answer: West Indians, particularly those from Trinidad and Guyana, were described as more 'stable' than West Africans. Unlike West Indians and West Africans, Indians and Pakistanis were said to be physically unsuited for medium and heavy work, but were reported to do well in light industry and capable of being trained to at least semi-skilled engineering standards. In contrast to Pakistanis who were said to be well-built, diligent and reliable workers – though with a slower tempo than their white workmates – Bangladeshis were described as 'of poor physique' and not well suited to industrial work.

Such stereotypes were to become the basis on which black workers were to be placed in jobs, denied promotion and kept off training schemes both by employers and labour exchanges. The attempt to portray higher levels of black unemployment as evidence of welfare 'scrounging' was scotched by the National Assistance Board Working Party representative. She pointed out that though some recent Caribbean migrants were, like sixty thousand Irish workers, in receipt of national assistance this was because of their ineligibility for unemployment benefits. In a joint report prepared by the Ministry of Labour and Ministry of Pensions and National Assistance for a major debate on black immigration in the House of Lords in November 1956, it was categorically stated that:

> Reference is made from time to time to the abuse of public funds by coloured people. It has no real foundation. West Indians cannot be said to be making undue demands on National Assistance and although an occasional rogue or workshy person is unmasked, this is no more frequent among West Indians than among other sections of the population.[18]

From the evidence of these surveys it was clear that Caribbean immigrants – the main focus of the survey – were not unemployable; neither were they 'scroungers'. The surveys did indicate however the extent to which racist discrimination channelled blacks into occupational ghettoes and the extent to which labour exchanges colluded in this practice.

Housing

Prospective migrants to the United Kingdom were issued with a document entitled 'Warnings to Intending Migrants' in which the problems of accommodation featured prominently. Undoubtedly there was an acute housing shortage in Britain during the 1950s but it was a product of government policies and market forces, not of levels of immigration. Many local authorities 'on a variety of pretexts but mostly via residence requirements' refused to house black people yet were not penalized by the minister of housing (Smith 1989: 53). Rather Macmillan, as housing minister in 1954, announced

a reduction in council-house building for the following year from 235,000 to 160,000.

For black people the alternative to council housing was the private sector, and here discrimination, made easier by the relaxation of rent controls in 1954, ensured that only areas designated for slum clearance and/or areas with short-lease properties were generally available. The difficulties of finding accommodation were underscored by the reluctance of local authorities to implement redevelopment programmes which might involve rehousing black tenants for fear of antagonizing white tenants who were on long waiting lists. This was made clear by the Birmingham City Council town clerk who was part of the deputation which met ministers at Westminster in early 1955:

> One of the areas scheduled for redevelopment happened to be where a section of the immigrant population had settled. Although there was very serious overcrowding in this area it was virtually impossible to proceed with redevelopment plans because of the difficulty of finding alternative accommodation. There was the additional risk that if alternative accommodation was found, ill feeling might be engendered among the white population at this apparent preferential treatment of coloured people while there were still 'local' inhabitants waiting for houses.[19]

For the same reasons they were reluctant to discharge their legal responsibilities under the 1954 Housing and Rent Act which obliged them to rehouse tenants living in overcrowded and insanitary conditions. As *The Times* bluntly put it:

> What are likely to be the feelings of more than 50,000 white would-be tenants in Birmingham, who have waited years for a decent house, when they see newcomers, no matter what their colour, taking over whole streets of properties?[20]

The failure of local and national governments to address the problems of housing reinforced the emerging 'commonsense' correlation between housing shortage, slums and black immigration. This 'commonsense' was luridly depicted by the concept of 'new Harlem' deployed by the Liverpool group of the Conservative Commonwealth Association in their 1954 pamphlet *The Problem of Colonial Immigrants*:

> Liverpool is admittedly one of the chief centres of coloured settlement and a new Harlem is being created in a decayed residential quarter of the city, where rooms in large and dilapidated houses are sub let at high rentals to coloured immigrants who exist in conditions of the utmost squalor. Vice and crime are rampant and social responsibilities are largely ignored. Hundreds of children of negroid or mixed parentage eventually find their way to the various homes to be maintained by the corporation, to be reared to unhappy maturity at great public expense. Large numbers of the adults are in receipt of unemployment benefit or National Assistance and many are engaged in the drug traffic or supplement their incomes by running illicit drinking dens or by prostitution.[21]

This document was circulated widely within the Conservative Party despite the feeling of some officials that the facts were 'overstated and had the worst construction placed

upon them'.[22] Landlordism, declining property values, spiralling rents, overcrowding, dilapidation and decay were cited as the inevitable consequences of black settlement. Black people not only created slums, it was argued, but these 'new Harlems' had their provenance in the 'racial character' of the inhabitants. Indeed, their very way of life was deemed to pose a fundamental threat to social order.

This racialized view that housing shortage and urban decay were a product of a black presence encouraged the cabinet to consider making adequate housing accommodation a condition of permanent settlement for black immigrants in its 1954 draft immigration bill. If the cabinet seized on the housing crisis as the 'easiest way' to build a strong case for immigration control, the Birmingham City Council deputation made it clear that control through certificates of accommodation would not be easy for local authorities to police. Within the Ministry of Housing and Local Government, too, there was lukewarm sympathy for assuming the role of social police:

> Clearly local authorities cannot go about looking for stray West Indians who
> have left their first lodgings, nor can they question them about their identity or
> the date of their arrival in this country and any other particulars that the Home
> Secretary thinks relevant.[23]

Despite their lack of enthusiasm, the Ministry of Housing and Local Government decided to invite local authority associations to a meeting in March 1955. At this meeting the latter expressed a willingness to cooperate with the home secretary's plan to control immigration but registered the reservation that the certificate of accommodation embodied in the draft bill could not be considered as a permanent solution.

Criminality

The undesirability of black migrants on grounds of a 'racial' predisposition to criminality had been a longstanding concern of government departments and Parliament (Harris 1988). In the House of Commons in November 1954, secretary of state for the colonies Alex Lennox-Boyd was asked by Sir Jocelyn Lucas 'what machinery exists to ascertain the proportion of Jamaican immigrants who have police or criminal records'.[24] Hansard is studded with questions of this nature. Likewise in the questionnaire sent to Ministry of Labour regional offices area officers were asked: 'Can any distinction be drawn between the coloured workers who come here as fare-paying passengers and those who come as stowaways or deserters?' The general tenor of responses was: Not enough evidence to make a judgment.

Behind this question lies a clear assumption that the manner in which the stowaway came to Britain was a confirmation of a criminal proclivity. No attention was given to the way in which increasingly stringent administrative measures introduced by Labour and Conservative governments criminalized the stowaway.

In an earlier survey of the black population of Stepney, Downing Street was informed thus:

> The police reports which we have had from time to time do not indicate that
> the incidence of crime amongst coloured people is abnormally high, but *it is
> known that these people's background renders them specially liable to temptation in these*

directions. The police, who are already fully aware of this, are being informed of the contents of the memorandum.[25]

It is the reports of this self-same 'aware' and 'informed' police in London and the provinces on which the working party was to draw heavily for its 1953 report. The police reports dwelt upon the size of the black population, the degree to which it had been assimilated and the extent to which it was involved in criminal activity. In Sheffield, for example, the chief constable had deputed two police officers to 'observe, visit and report on' the black population.[26] A card index was compiled, listing the names, addresses, nationalities and places of employment of the city's 534 black inhabitants.

This concern with criminality emphasized certain types of deviance, pre-eminently drug trafficking and living on immoral earnings, and the ways in which these endangered the social and moral fabric of British society. In its evidence to the working party the police claimed that there had been 'a marked number of convictions of coloured men for living on the immoral earnings of white women'.[27] The working party's own report hinted darkly that 'this practice is far more widespread than the few prosecutions indicate'.[28]

Such alleged criminality merged into a general condemnation of 'the associations formed between coloured men and white women of the lowest type'. Such associations were seen to violate the sanctity of a white British womanhood, the bearer of national culture.

Drug trafficking completed the picture of an alien wedge whose exotic features were graphically presented by Sheffield's chief constable:

> The West Africans are all out for a good time, spending money on quaint suits and flashy ornaments and visiting dance halls at every opportunity. The Jamaicans are somewhat similar, but they have a more sensible outlook and rarely get into trouble. They take great pains with their appearance and use face cream, perfume etc., to make themselves attractive to the females they meet at dances, cafés etc. One feels, however, that they only attract a certain type of female by reason of the fact that they have more money to spend than the average young Englishman.[29]

These stereotypes were not supported by any evidence that black people were involved in disproportionate amounts of crime. In his report to the working party, the chief constable of Middlesbrough noted that 'on the whole the coloured population are as well behaved as many local citizens'.[30] *The Times* similarly observed: 'Everywhere they have appeared the police and magistrates are ready to say that the West Indians make no trouble, which is more than some are ready to say of Irish workers'.[31] Despite this, such images continued to be used to justify discriminatory policing.

Summary

In struggling to impose some coherence on the information submitted to it, the working party found its report deprecated as 'unnecessarily negative' by the Lord President of the Council, the Marquis of Salisbury. The report, he complained bitterly, did not

appear to recognize 'the dangers of the increasing immigration of coloured people into this country'.[32]

These alleged dangers coalesced around the fear that the 'gathering momentum' of black immigration would bring about 'a significant change in the racial character of the English people'. The working party had failed to appreciate that the real issue for the cabinet was not merely unemployment, poor housing or levels of crime but the very presence of black people in Britain. This is the message that the Marquis of Salisbury tried to impress upon the cabinet:

> it is not for me merely a question of whether criminal negroes should be allowed in or not; it is a question of whether great quantities of negroes, criminal or not, should be allowed to come.[33]

On the evidence of the working party report, however, the home secretary was forced to admit to the cabinet that 'a case has not been made out' for legislation.

'The idea, I take it, is to conceal the purpose of legislation'[34]

The failure of the Conservative cabinet to garner empirical support for their 'strong case' did not deflect them from the conviction that a black presence could not be contained by administrative measures. Legislative action still needed to be pursued. In the absence of any evidence connecting black people with intractable social problems, a different kind of case had to be made which would convey to the public the deep anxieties felt by the cabinet about the threat to the 'racial character of the English'.

To this end home secretary Gwilym Lloyd-George proposed a committee of enquiry in November 1954. The colonial secretary supported the idea. He felt that 'although there are many signs that responsible public opinion is moving in the direction of favouring immigration control', there was still 'a good deal to be done before it is more solidly in favour of it'. A committee would have the double advantage

> of enabling us to postpone an announcement of our policy until nearer the time when the necessary legislation would be put in hand, and of enabling public opinion to develop further and be crystallized.[35]

The nature of the committee was explained to the prime minister by the cabinet secretary, Norman Brook, in a briefing note:

> Its purpose would be, *not to find a solution* (for it is evident what form control must take), *but to enlist a sufficient body of public support* for the legislation that would be needed.[36]

This purpose would be fulfilled only if the committee's terms of reference left no doubt that black immigration was the proper object of enquiry and if its report was unanimous. However, an invitation to consider discriminatory proposals had the disadvantage of leaving the committee open to charges of racism. The colonial secretary, Lennox-Boyd, met this criticism by proposing to widen the committee's terms of reference to include all immigrants. This

would not by any means prevent the committee from proposing discriminatory measures, if they saw fit to do so; and if they did, *without a virtual invitation*, we should be in a very good position to measure public opinion and parliamentary reactions to such proposals, *without the government having been in any way implicated in them.*[37]

There was no certainty, though, that a committee which would have to include opposition members and trade union representatives would unanimously support legislation. It was also clear that 'some of those who might acquiesce in such action might find it less easy to give public evidence in support of it before a committee'.[38] Consequently the idea of a committee was abandoned, in June 1955.

As 'a better basis for action', the cabinet instructed a working party to produce an 'authoritative statement of the increasing volume of immigration, and of the social and economic problems to which it was likely to give rise'.[39] This was intended for publication but was never released because, in the absence of firm evidence, it 'would not have the effect of guiding public opinion in any definite direction'.[40] Moreover, to issue such a statement 'with no indication of the government's intentions would be merely embarrassing'. Some ministers also felt that its release should be prefaced by a white paper giving details of controls on British subjects in the dominions and colonies. This would imply that the introduction of controls by Britain was merely a quid pro quo. A Commonwealth Relations official was more honest:

> It was apparently considered that by publicising the restrictions applicable to the entry of British subjects in other countries, public opinion might be influenced in favour of the introduction of restriction here.[41]

A Colonial Office official was even blunter: the white paper was an attempt to ' "cook" public opinion'.[42]

The white paper, like the 'statement', was never published. This was partly because it would have shown that India and Pakistan did not have restrictive controls on British subjects, but principally because it would have been embarrassing to reveal that ' "old" commonwealth countries are . . . operating immigration controls which discriminate against British subjects who are not of European race . . . Some of them might well prefer that the attention of the parliament at Westminster should not be directed in this way'.[43] Though this weakened the cabinet's position, it is doubtful, anyway, whether the growing momentum of the cabinet's case would have overcome in 1955 the political and economic reservations that were brought to the fore in the discussions surrounding Cyril Osborne's attempt in January of that year to introduce a private member's bill to regulate black immigration.

In discussions before the Commonwealth Affairs Committee it was pointed out that the measures proposed in the bill were difficult to reconcile with Britain's position as head of the commonwealth and empire. As the chief whip summarized:

> Why should mainly loyal and hard-working Jamaicans be discriminated against when ten times that quantity of disloyal [*sic*] Southern Irish (some of them Sinn Feiners) come and go as they please?[44]

The timing, too, created difficulties. With the forthcoming general election, there was a desire to avoid controversial issues which might improve the chances of a Labour victory. The celebration of Jamaica's three hundredth anniversary of British rule in 1955 also made it inopportune to present what would have appeared as an 'anti-Jamaican Bill'.[45] This was underlined by the feeling in some quarters that colonial development and not legislation was the solution to immigration. More importantly, the home secretary had prepared his own draft bill in November 1954 which awaited the outcome of cabinet discussion on the committee of enquiry. Osborne's bill was therefore rejected.

It was not until the beginning of the next parliamentary session in October 1955 that this draft was presented to the cabinet. The objections to Osborne's bill still applied. In the cabinet meeting of 3 November, other difficulties were noted. There was a recognition by the cabinet that despite the fact that the House of Commons showed itself to be increasingly sympathetic to the idea of control public opinion had not 'matured sufficiently'. Public consent could only be assured if the racist intent of the bill were concealed behind a cloak of universalism which applied restrictions equally to all British subjects.

A further difficulty was that: 'On economic grounds immigration, including colonial immigration, was a welcome means of augmenting our labour resources'.[46] This was the first time that arguments about the economic benefits of colonial immigration had figured in cabinet discussions despite the 'labour shortage' and the labour requirements of specific sectors of public and private capital. Black labour, the cabinet felt, by its 'racial' nature was unsuitable.[47] Some ministers too were of the opinion that full employment would not last and grave problems would be created by the presence of an 'unassimilable', black unemployed and unemployable population. These views provided a sharp contrast with the efforts that were made in the late 1940s to demonstrate the invaluable contribution that European Volunteer Workers could make to the British economy.

These objections compelled the cabinet to postpone the presentation of a bill to Parliament; the strong case required firmer support. A ministerial committee chaired by the Lord Chancellor was appointed to examine the obstacles to be overcome if legislation were to be introduced. In addition, a new interdepartmental working party was convened to provide the committee with bi-annual reports on the 'social and economic problems arising from the growing influx . . . of coloured workers'.

Conclusion

The evidence we have drawn on suggests that the common interpretation of the role of the state in the 1940s and 1950s needs to be revised. Specific measures to discourage and restrict black immigration rested firmly on a policy of preserving the homogeneous 'racial character' of British society. The passing of the 1948 Nationality Act intensified the contradiction between a formal definition of 'Britishness' which embraced black British subjects abroad and an increasingly racialized notion of belonging in which 'racial types' were constructed around colour. Even as the Act entered the statute books it was qualified by a series of 'devious little devices' designed to 'hold the tide' of black immigration. When these proved insufficient, legislative control increasingly became a favoured option among ministers and senior civil servants. For

public consent to be won for legislation, however, a 'strong case' had to be built. A consequence of this was an extension of the control and surveillance of the black population in the UK.

Black immigration, it was alleged, would create problems which were insoluble precisely because their provenance was 'racial' and not political. Black people were unemployed not because of discrimination, but because of their 'irresponsibility, quarrelsomeness and lack of discipline'. Black people lived in slums not because of discrimination and the unwillingness of government and local authorities to tackle the housing shortage but because they knew no better. Indeed, their very 'nature' was held to predispose them towards criminality. All of these stereotypes were evoked vividly in the concept of 'new Harlem', an alien wedge posing an unprecedented threat to the 'British way of life'. So powerful was this racialized construction that anti-discrimination legislation was seen as irrelevant to the 'social problems' of housing and employment. This was evident from the consistent opposition to Fenner Brockway's bill seeking to outlaw discrimination and the failure to heed the (Caribbean Migrant Services Division) Welfare Liaison Officer's warning that:

> A freedom of entry to the United Kingdom . . . is nevertheless an empty and vicious one as long as the right to equal employment, accommodation and social intercourse does not exist in practice.[48]

In building its 'strong case' for immigration control the state undertook nothing less than a populist political project which both reconstructed an image of a national community that was homogeneous in its 'whiteness' and racialized culture and defended it from the allegedly corrosive influence of groups whose skin colour and culture debarred them from belonging. This reconstruction simultaneously involved an attempt to de-racialize the Irish who 'are not – whether they like it or not – a different race from the ordinary inhabitants of Great Britain'.[49] Only by arguing 'boldly along such lines' could Irish exclusion from the 1955 draft bill avoid political censure. This line was not without its inconsistencies. As one CRO official minuted: 'This is poor stuff after Irish behaviour in the war and their departure from the commonwealth.' Moreover it ignored the contribution to the Allied war effort of black service personnel like those who had returned on the *Empire Windrush*.

The racialized reconstruction of Britishness also posed problems for Britain's image as the 'Mother Country' of a 'multiracial commonwealth':

> it may well be argued that a large coloured community as a noticeable feature of our social life would weaken the sentimental attachment of the older self-governing countries to the UK. Such a community is certainly no part of the concept of England or Britain to which people of British stock throughout the commonwealth are attached.[50]

While wishing to prevent black British subjects from entering the UK, the cabinet was concerned to preserve the right of white 'kith and kin' in the dominions to free entry.

Our argument clearly points to the need to recover the history of the state's central role in the construction of postwar British racism. This racism was not simply the

product of an imperial legacy, even less the consequence of a popular concern in the 1960s about numbers. Before black workers had begun to arrive here in significant numbers, black immigration was already being racialized. 'Race' was becoming a lens through which people experienced and made sense of their everyday lives. Black people came to be defined as 'a problem' whose solution lay in further and more restrictive control and surveillance. As the state's role in the racialization of black immigration intensified, so the repeated signification of black people's 'presence' and 'difference' as the 'problem' rendered the hand of the state yet more invisible. Any political strategy to combat racism must make the state a central focus of its analysis and campaigns.

Notes

1 CAB 128/29, CM 39(55), minute 7, Cabinet Meeting, 3 November 1955.
2 In Harris (1988), Carter, Harris and Joshi (1993) we show quite clearly that such a policy had been elaborated during the 1930s and 1940s
3 HO 213/244, J Murray et al. to Prime Minister, 22 June 1948.
4 Keith's concern in raising the subject of the principle of free entry was based on the fear of many CO officials that the Colonial Office would be railroaded into agreeing to controls which singled out – and therefore discriminated against – in an obvious way the [black] colonies. Controls, it was argued, should in principle be general, i.e. they should appear to apply equally to white and black territories.
5 CO 1032/121, minute, Carstairs 21 October 1955. Emphasis added.
6 CO 537/5219, minute, J. G. Thomas, 23 March 1950.
7 Ibid., minute, J. Williams, 27 June 1950.
8 CO 537/5219, minute, J. Williams, 27 June 1950.
9 The working party was also reconvened to examine the feasibility of introducing (a) a £25 deposit on migrants, and (b) powers to deport 'criminals' as a deterrent to migration.
10 CAB 124/1191, memorandum, Quirk to Marquis of Salisbury (Lord President of the Council), 29 October 1954.
11 CO 1032/119, Lord Glyn to Earl of Munster (Minister of State), 30 April 1954.
12 *The New Statesman*, 17 September 1955.
13 CO 1028/22, STU 91/143/01, minute, B. G. Stone, 9 December 1953.
14 CAB 129/29, CM 31(55), minute 4, meeting 15 September 1955.
15 CO 1028/23, STU 106/03, minute, J. Keith, 5 December 1952.
16 LAB 8/1898, minute, Marjorie Hayward, 24 March 1953.
17 LAB 8/1898, ibid.
18 CO 1031/122, memorandum by Mr Hardman and Miss Hope-Wallace, November 1956.
19 DO 35/5217, Deputation from Birmingham City Council, Report of Meeting, 19 January 1955.
20 *The Times*, 8 November 1954.
21 CAB 124/1191, Conservative Commonwealth Association, Liverpool Group, *The Problem of Colonial Immigrants*, January 1954.
22 CO 1032/119, minute, B. G. Stone, 13 March 1954.
23 HLG 117/10, minute, Ryan, 22 February 1955.
24 Hansard, vol. 532, 3 November 1954.
25 CO 876/231, J. Nunn to E. Cass, 23 January 1950.
26 CO 1028/25, Police Report upon the Coloured Population in Sheffield, 3 October 1952, enclosed in Town Clerk (Sheffield), John Heys to V. Harris, 8 October 1952.
27 CO 1028/22, STU 91/143/01, CWP (53) 10, 11 July 1953.
28 Ibid., Draft Report of Working Party on Coloured People Seeking Employment in the United Kingdom, 17 December 1953.
29 Sheffield Police Report.
30 CO 1025/25, Town Clerk (Middlesbrough), E. Parr to V. Harris, 14 October 1952.
31 *The Times*, 9 November 1954.

32 CAB 124/1191, minute, Marquis of Salisbury, 8 August 1954.
33 CAB 124/1191, Marquis of Salisbury to Viscount Swinton, 19 November 1954.
34 CAB 124/1191, Philip Swinton (Commonwealth Relations Secretary) to Gwilym Lloyd-George (Home Secretary), 16 November 1954.
35 PREM 11/824, C.(54) 354, Memorandum, Colonial Immigrants, Colonial Secretary, 6 December 1954.
36 PREM 11/824, Norman Brook (Cabinet Secretary) to Prime Minister, 14 June 1955. Emphasis added.
37 CAB 124/1191, Alan Lennox-Boyd to Gwilym Lloyd-George, 26 November 1954. Emphasis added.
38 CAB 128/27, CC 78(54), meeting 6 December 1954.
39 CAB 128/29, CM 14(55), minute 4, meeting 14 June 1955.
40 PREM 11/824, I. W. Hooper to Prime Minister, 14 September 1955.
41 DO 35/5220, minute, Morley, 24 January 1955.
42 CO 1032/83, minute, Carstairs, 12 February 1955.
43 Ibid., Norman Brook to Prime Minister, Colonial Immigrants, 17 February 1955.
44 Ibid., Summary of Commonwealth Affairs Committee meeting by Chief Whip, 27 January 1955, enclosed in Patrick Buchanan-Hepburn to Prime Minister, 27 January 1955.
45 There was a further irony here. Norman Manley, the Jamaican prime minister, had already conveyed to a visiting parliamentary delegation that his government would not object to restrictions on entry which 'were genuinely applied to the whole commonwealth' (Memorandum by Nigel Fisher, West Indian Migration to UK, PREM 11/824). So concerned was the British government to introduce discriminatory controls that this offer was not considered seriously.
46 CAB 128/29, CM 39(55), minute 7, meeting 3 November 1955.
47 If this view seems surprising given the 'labour shortage', it would be important to ask the question about which fraction of the capitalist class did the government represent. The suggestion is that it represented finance capital rather than industrial capital.
48 CO 1028/36, Interim Report of Conditions of Jamaicans in the United Kingdom, 1 January to 31 March 1954, Welfare Liaison Officer, Ivo de Souza.
49 CAB 129/77, CP (55) 102, Report of the Committee on the Social and Economic Problems Arising from the Growing Influx into the United Kingdom of Coloured Workers from Other Commonwealth Countries, 3 August 1955.
50 CO 1028/22, CWP (53), 6 August 1953.

Bibliography

Carter, Bob and Joshi, Shirley (1984) 'The Role of Labour in Creating a Racist Britain', *Race and Class* XXV (winter): 53–70.

Carter, Bob, Harris, Clive and Joshi, Shirley (1993) *No Blacks Please, We're British!* (London: Routledge).

Foot, Paul (1965) *Immigration and Race in British Politics* (Harmondsworth: Penguin).

Freeman, G. (1975) *Immigrant Labour and Racial Conflict in Industrial Societies: The French and British Experience 1945–1975* (Princeton: Princeton University Press).

Glass, Ruth (1960) *Newcomers: The West Indians in London* (London Centre for Urban Studies and Allen & Unwin).

Harris, Clive (1987a) 'British Capitalism, Migration and Relative Surplus-Population', paper presented at the conference on the Carribbean Diaspora, Centre for Caribbean Studies, Goldsmith's College, University of London, November 1984. Also printed in *Migration* 1, 47–90.

Harris, Clive (1987b) 'Racism, Sexism and the Industrial Reserve Army', paper presented at PEWS Annual Conference, State University of New York, Binghamton.

Harris, Clive (1988) 'Images of Blacks in Britain: 1930–1960', in S. Allen and M. Macey, eds, *Race and Social Policy* (London: ERSC).

Hiro, Dilip (1973) *Black British, White British* (Harmondsworth: Penguin).

Katznelson, Ira (1976) *Black Men, White Cities* (London: Oxford University Press for Institute of Race Relations).

Sivanandan, A. (1982) *A Different Hunger: Writings on Black Resistance* (London: Pluto).

Smith, Susan (1989) *The Politics of 'Race' and Residence: Citizenship, Servitude and White Supremacy in Britain* (Cambridge: Polity Press).

From Winston James and Clive Harris (eds), *Inside Babylon: The Caribbean Diaspora in Britain* (London: Verso, 1993).

2

THE OCCASION FOR SPEAKING

George Lamming

I want to consider the circumstances as well as the significance of certain writers' migration from the British Caribbean to the London metropolis . . .

Why have they migrated? And what, if any, are the peculiar pleasures of exile? Is their journey part of a hunger for recognition? Do they see such recognition as a confirmation of the fact that they are writers? What is the source of their insecurity in the world of letters? And what, on the evidence of their work, is the range of their ambition as writers whose nourishment is now elsewhere, whose absence is likely to drag into a state of permanent separation from their roots? . . .

The exile is a universal figure. The proximity of our lives to the major issues of our time has demanded of us all some kind of involvement . . . We are made to feel a sense of exile by our inadequacy and our irrelevance of function in a society whose past we can't alter, and whose future is always beyond us. Idleness can easily guide us into accepting this as a condition. Sooner or later, in silence or with rhetoric, we sign a contract whose epitaph reads: To be an exile is to be alive.

When the exile is a man of colonial orientation, and his chosen residence is the country which colonized his own history, then there are certain complications. For each exile has not only got to prove his worth to the other, he has to win the approval of Headquarters, meaning in the case of the West Indian writer, England. If the West Indian writer had taken up residence in America – as Claude McKay did – his development would probably be of a different, indeed, of an opposed order to that of a man who matured in England. One reason is that although the new circumstances are quite different, and even more favourable than those he left in the West Indies, his reservations, his psychology, his whole sense of cultural expectation have not greatly changed. He arrives and travels with the memory, the habitual weight of a colonial relation . . .

I have lately tried to argue, in another connection, that the West Indian student, for example, should not be sent to study in England. Not because England is a bad place for studying, but because the student's whole development as a person is thwarted by the memory, the accumulated stuff of a childhood and adolescence which has been maintained and fertilized by England's historic ties with the West Indies . . . In England he does not feel the need to try to understand an Englishman, since all relationships begin with an assumption of previous knowledge, a knowledge acquired in the absence of the people known. This relationship with the English is only another aspect of the West Indian's relation to the *idea* of England . . .

This *myth* begins in the West Indian from the earliest stages of his education . . . It

begins with the fact of England's supremacy in taste and judgement: a fact which can only have meaning and weight by a calculated cutting down to size of all non-England. The first to be cut down is the colonial himself . . .

This is one of the seeds which much later bear such strange fruit as the West Indian writers' departure from the very landscape which is the raw material of all their books. These men had to leave if they were going to function as writers since books, in that particular colonial conception of literature were not – meaning, too, are not supposed to be – written by natives. Those among the natives who read also believed that; for all the books they had read, their whole introduction to something called culture, all of it, in the form of words, came from outside: Dickens, Jane Austen, Kipling and that sacred gang.

The West Indian's education was imported in much the same way that flour and butter are imported from Canada. Since the cultural negotiation was strictly between England and the natives, and England had acquired, somehow, the divine right to organise the native's reading, it is to be expected that England's export of literature would be English. Deliberately and exclusively English. And the further back in time England went for these treasures, the safer was the English commodity. So the examinations, which would determine that Trinidadian's future in the Civil Service, imposed Shakespeare and Wordsworth, and Jane Austen and George Eliot and the whole tabernacle of dead names, now come alive at the world's greatest summit of literary expression.

How in the name of Heavens could a colonial native taught by an English native within a strict curriculum diligently guarded by yet another English native who functioned as a reliable watch-dog, the favourite clerk of a foreign administration: how could he ever get out from under this ancient mausoleum of historic achievement?

Some people keep asking why the West Indian writers should leave the vitality and freshness (frankly I don't believe in the vitality talk, as I shall explain) for the middle age resignation of England. It seems a mystery to them. The greater mystery is that there should be West Indian writers at all. For a writer cannot function; and, indeed, he has no function as writer if those who read and teach reading in his society have started their education by questioning his very right to write . . .

The historical fact is that the 'emergence' of a dozen or so novelists in the British Caribbean with some fifty books to their credit or disgrace, and all published between 1948 and 1958, is in the nature of a phenomenon . . .

There are, for me, just three important events in British Caribbean history. I am using the term *history* in an active sense. Not a succession of episodes which can easily be given some casual connection. What I mean by historical event is the creation of a situation which offers antagonistic oppositions and a challenge of survival that had to be met by all involved . . .

The first event is the discovery. That began, like most other discoveries, with a journey; a journey inside, or a journey out and across. This was the meaning of Columbus. The original purpose of the journey may sometimes have nothing to do with the results that attend upon it. That journey took place nearly five centuries ago; and the result has been one of the world's most fascinating communities. The next event is the abolition of slavery and the arrival of the East – India and China – in the Caribbean Sea. The world met here, and it was at every level, except administration, a peasant world. In one way or another, through one upheaval after another, these people, forced

to use a common language which they did not possess on arrival, have had to make something of their surroundings. What most of the world regard today as the possibility of racial harmony has always been the background of the West Indian prospect . . . The West Indian, though provincial, is perhaps the most cosmopolitan man in the world . . .

The third important event in our history is the discovery of the novel by West Indians as a way of investigating and projecting the inner experiences of the West Indian community. The second event is about a hundred and fifty years behind us. The third is hardly two decades ago. What the West Indian writer has done has nothing to do with that English critic's assessments. The West Indian writer is the first to add a new dimension to writing about the West Indian community . . .

As it should be, the novelist was the first to relate the West Indian experience from the inside. He was the first to chart the West Indian memory as far back as he could go. It is to the West Indian novelist – who had no existence twenty years ago – that the anthropologist and all other treatises about West Indians have to turn.

I do not want to make any chauvinistic claim for the West Indian writer. But it is necessary to draw attention to the novelty – not the exotic novelty which inferior colonials and uninformed critics will suggest – but the historic novelty of our situation. We have seen in our lifetime an activity called writing, in the form of the novel, come to fruition without any previous native tradition to draw upon. Mittelholzer and Reid and Selvon and Roger Mais are to the new colonial reader in the West Indies precisely what Fielding and Smollett and the early English novelists would be to the readers of their own generation. These West Indian writers are the earliest pioneers in this method of investigation. They are the first builders of what will become a tradition in West Indian imaginative writing: a tradition which will be taken for granted or for the purpose of critical analysis by West Indians of a later generation.

The novel, as the English critic applies this term, is about two hundred years old, and even then it had a long example of narrative poetry to draw on. The West Indian novel, by which I mean the novel written by the West Indian about the West Indian reality is hardly twenty years old. And here is the fascination of the situation. The education of all these writers is more or less middle-class Western culture, and particularly English culture. But the substance of their books, the general motives and directions, are peasant. One of the most popular complaints made by West Indians against their novelists is the absence of novels about the West Indian middle class.

Why is it that Reid, Mittelholzer in his early work, Selvon, Neville Dawes, Roger Mais, Andrew Salkey, Jan Carew – why is it that their work is shot through and through with the urgency of peasant life? And how has it come about that their colonial education should not have made them pursue the general ambitions of non-provincial writers. How is it that they have not to play at being the Eliots and Henry Jameses of the West Indies? Instead, they move nearer to Mark Twain . . .

Unlike the previous governments and departments of educators, unlike the business man importing commodities, the West Indian novelist did not look out across the sea to another source. He looked in and down at what had traditionally been ignored. For the first time the West Indian peasant became other than a cheap source of labour. He became, through the novelist's eye, a living existence, living in silence and joy and fear, involved in riot and carnival. It is the West Indian novel that has restored the West Indian peasant to his true and original status of personality.

Edgar Mittelholzer was born in British Guiana in 1909. He came to Trinidad in 1941; but he was a name to me before I left Barbados to live in Trinidad . . .

Mittelholzer is important because he represents a different generation from Selvon and myself. He had suffered the active discouragement of his own community, and he had had their verdict sanctioned by the consistent rejection of his novels by publishers abroad. And in spite of this he made the decision, before anyone else, *to get out*. That is the phrase which we must remember in considering this question of why the writers are living in England. They simply wanted *to get out* of the place where they were born. They couldn't argue: 'you will see'; and point to similar examples of dejection in earlier West Indian writers who were now regarded as great figures. There were no such West Indians to summon to your aid. We had *to get out*; and in the hope that a change of climate might bring a change of luck. One thing alone kept us going; and that was the literary review, *Bim*, which was published in Barbados by Frank Collymore. This was a kind of oasis in that lonely desert of mass indifference, and educated middle-class treachery.

This experience is true of Trinidad. The story is the same in Barbados. British Guiana would be no different. In Jamaica, with a more virile nationalist spirit, the difference is hardly noticeable. They murdered Roger Mais, and they know it. And when I was there in 1956, Vic Reid, their greatest performer in the novel, was talking to me about going to Britain. Whether for a year or for good, Reid needed to get out. And it's an indication of his thinking and feeling when he said to me that evening in the course of talk about the situation of the West Indian writers: 'You know somethin, George? Roger is the first of us . . .' I knew that Mais was dead, but it had never occurred to me to think of him as the first to die, meaning the first of the lot whose work appeared in England from 1948 to 1958. For that is the period we are talking about. This is the decade that has really witnessed the 'emergence' of the novel as an imaginative interpretation of West Indian society by West Indians. And every one of them: Mittelholzer, Reid, Mais, Selvon, Hearne, Carew, Naipaul, Andrew Salkey, Neville Dawes, everyone has felt the need *to get out*. And with the exception of Reid who is now in Canada, every one of them is now resident in England . . .

If we accept that the act of writing a book is linked with an expectation, however modest, of having it read; then the situation of a West Indian writer, living and working in his own community, assumes intolerable difficulties. The West Indian of average opportunity and intelligence has not yet been converted to reading as a civil-ized activity, an activity which justifies itself in the exercise of his mind. Reading seriously, at any age, is still largely associated with reading for examinations. In recent times the political fever has warmed us to the newspapers with their generous and diabolical welcome to join in the correspondence column. But book reading has never been a serious business with us . . .

The absence of that public, the refusal of a whole class to respond to an activity which is not honoured by money: it is this dense and grinning atmosphere that helped to murder Roger Mais. Mittelholzer survived it by fleeing the land; and Mr Vic Reid still breathes it, preparing, for all we know, to make a similar flight.

For whom, then, do we write?

The students at University College were always raising that question in their discus-sion . . . Many of the West Indian writers would have passed through the same cultural climate. But the West Indian writer does not write for them; nor does he write for

himself. He writes always for the foreign reader. That foreign does not mean English or American exclusively. The word *foreign* means other than West Indian whatever that other may be. He believes that a reader is *there*, somewhere. He can't tell where, precisely, that reader is. His only certain knowledge is that this reader is not the West Indian middle class, taken as a whole . . .

An important question, for the English critic, is not what the West Indian novel has brought to English writing. It would be more correct to ask what the West Indian novelists have contributed to English reading. For the language in which these books are written is English which – I must repeat – is a West Indian language; and in spite of the unfamiliarity of its rhythms, it remains accessible to the readers of English anywhere in the world. The West Indian contribution to English reading has been made possible by their relation to their themes which are peasant. This is the great difference between the West Indian novelist and the contemporary English novelist . . .

Writers like Selvon and Vic Reid – key novelists for understanding the literacy and social situation in the West Indies – are essentially peasant. I don't care what jobs they did before; what kind or grade of education they got in their different islands; they never really left the land that once claimed their ancestors like trees. That's a great difference between the West Indian novelist and his contemporary in England. For peasants simply don't respond and see like middle class people. The peasant tongue has its own rhythms which are Selvon's and Reid's rhythms; and no artifice of technique, no sophisticated gimmicks leading to the mutilation of form, can achieve the specific taste and sound of Selvon's prose . . .

The West Indian who comes near to being an exception to the peasant feel is John Hearne. His key obsession is with an agricultural middle class in Jamaica. I don't want to suggest that this group of people are not a proper subject for fiction; but I've often wondered whether Hearne's theme, with the loaded concern he shows for a mythological, colonial squirearchy, is not responsible for the fact that his work is, at present, less energetic than the West Indian novels at their best . . .

So we come back to the original question of the West Indian novelists living in a state of chosen exile. Their names make temporary noise in the right West Indian circles. Their books have become handy broomsticks which the new nationalist will wave at a foreigner who asks the rude question: 'What can your people do except doze?'

Why don't these writers return? There are more reasons than I can state now; but one is fear. They are afraid of returning, in any permanent sense, because they feel that sooner or later they will be ignored in and by a society about which they have been at once articulate and authentic. You may say that a similar thing happens to the young English writer in England. There is the important difference that you cannot enjoy anonymity in a small island . . .

In spite of all that has happened in the last ten years, I doubt that any one of the West Indian writers could truly say that he would be happy to go back. Some have tried; some would like to try. But no one would feel secure in his decision to return. It could be worse than arriving in England for the first time . . .

In the Caribbean we have a glorious opportunity of making some valid and permanent contribution to man's life in this century. But we must stand up; and we must move. The novelists have helped; yet when the new Caribbean emerges it may not be for them. It will be, like the future, an item on the list of possessions which the next

generation of writers and builders will claim. I am still young by ordinary standards (thirty-two, to be exact) but already I feel that I have had it (as a writer) where the British Caribbean is concerned. I have lost my place, or my place has deserted me.

This may be the dilemma of the West Indian writer abroad: that he hungers for nourishment from a soil which he (as an ordinary citizen) could not at present endure. The pleasure and paradox of my own exile is that I belong wherever I am. My role, it seems, has rather to do with time and change than with the geography of circumstances; and yet there is always an acre of ground in the New World which keeps growing echoes in my head. I can only hope that these echoes do not die before my work comes to an end.

From George Lamming, *The Pleasures of Exile* (London: Michael Joseph, 1960).

3

TIMEHRI

Kamau Brathwaite

The most significant feature of West Indian life and imagination since Emancipation has been its sense of rootlessness, of not belonging to the landscape; dissociation, in fact, of art from act of living. This, at least, is the view of the West Indies and the Caribbean that has been accepted and articulated by the small but important 'intel lectual' elite of the area; a group – call it the educated middle class – ex-planter and ex-slave – that has been involved in the post-plantation creolizing process that made our colonial polity possible . . .

'Creolization' is a socio-cultural description and explanation of the way the four main culture-carriers of the region: Amerindian, European, African and East Indian: interacted with each other and with their environment to create the new societies of the New World. Two main kinds of creolization may be distinguished: a *mestizo-creolization*: the inter-culturation of Amerindian and European (mainly Iberian) and located primarily in Central and South America, and a *mulatto-creolization:* the inter-culturation of Negro-African and European (mainly Western European) and located primarily in the West Indies and the slave areas of the North American continent. The crucial difference between the two kinds of creolization is that whereas in mestizo-America only one element of the interaction (the European) was immigrant to the area, in mulatto-America both elements in the process were immigrants. In mestizo-America, there was a host environment with an established culture which had to be colonized mainly by force – an attempted eradication of Amerindian spiritual and material structures. In mulatto America, where the indigenous Indians were fewer and more easily destroyed, and blacks were brought from Africa as slaves, colonizing Europe was more easily able to make its imprint both on the environment (the plantation, the North American city), and the cultural orientation of the area . . . In mulatto America . . . the process of creolization began to alter itself with the waning of the colonial regime. It simply fragmented itself into four main socio-cultural orientations: European, African, indigeno-nationalist and folk.

The problem of and for West Indian artists and intellectuals is that having been born and educated within this fragmented culture, they start out in the world without a sense of 'wholeness'. Identification with any one of these orientations can only consolidate the concept of a plural society, a plural vision. Disillusion with the fragmentation leads to a sense of rootlessness. The ideal does not and cannot correspond to perceived and inherited reality. The result: dissociation of the sensibility. The main unconscious concern of many of the most articulate West Indian intellectuals and

artists in the early post-colonial period was a description and analysis of this dissociation: C. L. R. James's *Minty Alley* (London: New Beacon Books, 1971), the work of George Lamming, V. S. Naipaul, Orlando Patterson and M. G. Smith's *The Plural Society in the British West Indies*. The achievement of these writers was to make the society *conscious* of the cultural problem. The second phase of West Indian and Caribbean artistic and intellectual life, on which we are now entering, having become conscious of the problem, is seeking to transcend and heal it.

My own artistic and intellectual concern is, I think, not untypical of this new departure in West Indian and Caribbean cultural life . . . I was born in Barbados, from an urban village background, of parents with a 'middle class' orientation. I went to a secondary school originally founded for children of the plantocracy and colonial civil servants and white professionals; but by the time I got there, the social revolution of the '30s was in full swing, and I was able to make friends with boys of stubbornly non-middle class origin. I was fortunate, also, with my teachers. These were (*a*) expatriate Englishmen; (*b*) local whites; (*c*) black disillusioned classical scholars. They were (with two or three exceptions) happily inefficient as teachers, and none of them seemed to have a stake or interest in our society. We were literally left alone. We picked up what we could or what we wanted from each other and from the few books prescribed like Holy Scripture. With the help of my parents, I applied to do Modern Studies (History and English) in the Sixth Form . . . and succeeded, to everyone's surprise, in winning one of the Island Scholarships that traditionally took the ex-planters' sons 'home' to Oxbridge or London.

The point I am making here is that my education and background, though nominally 'middle class', is, on examination, not of this nature at all. I had spent most of my boyhood on the beach and in the sea with 'beach-boys', or in the country, at my grandfather's with country boys and girls. I was therefore not in a position to make any serious intellectual investment in West Indian middle-class values. But since I was not then consciously aware of any other West Indian alternative (though in fact I had been *living* that alternative), I found and felt myself 'rootless' on arrival in England and like so many other West Indians of the time, more than ready to accept and absorb the culture of the Mother Country. I was, in other words, a potential Afro-Saxon.

But this didn't work out. When I saw my first snow-fall, I felt that I had come into my own; I had arrived; I was possessing the landscape. But I turned to find that my 'fellow Englishmen' were not particularly prepossessed with me. It was the experience later to be described by Mervyn Morris, Kenneth Ramchand and Elliot Bastien in *Disappointed Guests* (Oxford: Oxford University Press, 1965). I reassured myself that it didn't matter. It made no difference if I was black or white, German, Japanese or Jew. All that mattered was the ego-trip, the self-involving vision. I read Keats, Conrad, Kafka. I was a man of Kulture. But the Cambridge magazines didn't take my poems. Or rather, they only took those which had a West Indian – to me, 'exotic' – flavour. I felt neglected and misunderstood . . .

Then in 1953, George Lamming's *In the Castle of My Skin* (London: Michael Joseph, 1953) appeared and everything was transformed. Here breathing to me from every pore of line and page, was the Barbados I have lived. The words, the rhythms, the cadences, the scenes, the people, their predicament. They all came back. They all were possible. And all the more beautiful for having been published and praised by London, mother of metropolises.

But by now this was the age of the Emigrant. The West Indies could be written about and explored. But only from a point of vantage outside the West Indies. It was no point going back. No writer could live in that stifling atmosphere of middle-class materialism and philistinism. It was Lamming again who gave voice to the ambience in *The Emigrants* (London: Michael Joseph, 1954), and in *The Pleasures of Exile* (London: Michael Joseph, 1960). His friend Sam Selvon made a ballad about it in *The Lonely Londoners* (London: Allan Wingate, 1956), and Vidia Naipaul at the start of his brilliant career could write (in *The Middle Passage*, London: Deutsch, 1962):

> I had never wanted to stay in Trinidad. When I was in the fourth form I wrote a vow on the endpaper of my Kennedy's *Revised Latin Primer* to leave within five years. I left after six; and for many years afterwards in England, falling asleep in bedsitters with the electric fire on, I had been awakened by the nightmare that I was back in tropical Trinidad . . . I knew [it] to be unimportant, uncreative, cynical.
>
> (41)

For me, too, child and scion of this time, there was no going back. Accepting my rootlessness, I applied for work in London, Cambridge, Ceylon, New Delhi, Cairo, Kano, Khartoum, Sierra Leone, Carcassone, a monastery in Jerusalem. I was a West Indian, rootless man of the world. I could go, belong, everywhere on the worldwide globe. I ended up in a village in Ghana. It was my beginning . . .

Slowly but surely, during the eight years that I lived there, I was coming to an awareness and understanding of community, of cultural wholeness, of the place of the individual within the tribe, in society. Slowly . . . I came to a sense of identification of myself with these people, my living diviners. I came to connect my history with theirs, the bridge of my mind now linking Atlantic and ancestor, homeland and heartland. When I turned to leave, I was no longer a lonely individual talent; there was something wider, more subtle, more tentative: the self without ego, without I, without arrogance. And I came home to find that I had not really left. That it was still Africa; Africa in the Caribbean. The middle passage had now guessed its end. The connection between my lived, but unheeded non-middle-class boyhood, and its Great Tradition on the eastern mainland had been made.

The problem now was how to relate this new awareness to the existing, inherited non-African consciousness of educated West Indian society. How does the artist work and function within a plurally fragmented world? How can a writer speak about 'the people', when, as George Lamming dramatizes in *The Castle of My Skin*, those to whom he refers have no such concept of themselves?

> 'I like it,' I said. 'That was really very beautiful.'
> 'You know the voice?' Trumper asked. He was very serious now. I tried to recall whether I might have heard it. I couldn't. 'Paul Robeson', he said. 'One of the greatest o' my people.' 'What people?' I asked. I was a bit puzzled. 'My People', said Trumper. His tone was insistent. Then he softened into a smile. I didn't know whether he was smiling at my ignorance, or whether he was smiling his satisfaction with the box and the voice and above all Paul Robeson. 'Who are your people?' I asked. It seemed a kind of huge joke. 'The

Negro race,' said Trumper. The smile had left his face, and his manner had turned grave again . . . He knew I was puzzled . . . At first I thought he meant the village. This allegiance was something bigger. I wanted to understand it . . .

(331)

What kind of product will emerge from this gap and dichotomy; from conscious vision and the unwillingly envisioned? It is a problem that Derek Walcott, never leaving the Caribbean and aware of it from his very first lines in 1949, was increasingly to face . . .

In 'Hic Jacet' (1969), he seems certain in the knowledge that the source of his art was and is with the people, and now 'Convinced of the power of provincialism', he says: 'Commoner than water I sank to lose my name . . .'. But Walcott is a brilliant exceptional, creatively expressing through his work the pressures and dilemmas of his plural society. Here is a humanist in the sense that the scholars and artists of the Italian Renaissance were humanists. He is concerned with converting his heritage into a classical tradition, into a classical statement. But as the folk movement from below his outward-looking position begins to make itself felt, there is heard in the title poem of *The Gulf*, a growing note of alienation and despair . . . So the question of communal, as opposed to individual wholeness still remains. And returning to London late in 1965, I was more than ever aware of this. For there were the West Indian writers and artists, still rootless, still isolated, even if making a 'name'. It seemed that flung out centrifugally to the perimeter of their possibilities, our boys were failing to find a centre. Salkey's *Escape to an Autumn Pavement* (London: Hutchinson, 1960), and *The Adventures of Catullus Kelly* (1968), Naipaul's *The Mimic Men* (London: Deutsch, 1967), and Orlando Patterson's *An Absence of Ruins* (1967) were moving witnesses to this realization . . .

In 1966/7, two events of central importance to the growth and direction of the West Indian imagination took place. Stokely Carmichael, the Trinidadian-born American Black Power leader visited London and magnetized a whole set of splintered feelings that had for a long time been seeking a node. Carmichael enunciated a way of seeing the black West Indian that seemed to many to make sense of the entire history of slavery and colonial suppression, of the African diaspora into the New World. And he gave it a name. Links of sympathy, perhaps for the first time, were set up between labouring immigrant, artist/intellectual, and student. Sharing, as he saw it, a common history, Carmichael produced images of shared communal values. A black International was possible. West Indians, denied history, denied heroes by their imposed education, responded. From London, (and Black America) the flame spread to the university campuses of the archipelago. It found echoes among the urban restless of the growing island cities. Rastafari art, 'primitive' art, dialect and protest verse suddenly had a new urgency, took on significance. Walter Rodney published *Groundings with My Brothers* (1969); Marina Maxwell started the Yard Theatre; Olive Lewin's Jamaican Folk Singers began to make sense; Mark Matthews in Guyana . . . was doing with the dialect of the tribe what critics like Louis James had declared to be impossible. The artist and his society, it seemed, were coming closer together.

The second event, of late 1966, was the founding, in London, of the Caribbean Artists' Movement. The object of CAM was first and foremost to bring West Indian

artists 'exiled' in London into private and public contact with each other. It was a simple thing, but it had never happened before. The results were immediate, obvious and fruitful. Painters, sculptors, poets, novelists, literary and art critics, publishers, for the first time saw and could talk to each other . . .

Artists such as Orlando Patterson, Andrew Salkey and Marina [Maxwell] were concerned primarily with the ex-African black experience, slavery, the plantation, and their consequences.

But there was also Harris and Aubrey Williams, both black, both from Guyana, who were contributing if not a different vision, then at least a different approach to that vision. Coming from mainland South America, they found themselves involved not with the problem of mulatto-creolization, but with mestizo-creolization. Their starting point was not the Negro in the Caribbean, but the ancient Amerindian. Williams, speaking at a CAM Symposium in June 1967 had said:

> In art, I have always felt a wild hunger to express the rather unique, human state in the New World . . . I find there an amalgam of a lot that has gone before in mankind, in the whole world. It seems to have met there, after Columbus, and we are just on the brink of its development. The forces meeting in the Caribbean . . . will eventually, I feel, change this world . . . not in the sense of a big civilization in one spot, but as the result of the total of man's experience and groping for the development of his consciousness.

In articulating this faith in the Caribbean, and in emphasising roots rather than 'alien avenues', Williams was connecting with what many West Indian writers are now trying to do. And in emphasizing the importance to himself of primordial man, *local* primordial man, he, like Harris, was extending the boundaries of our sensibility. Most of us, coming from islands, where there was no evident lost civilization – where, in fact, there was an 'absence of ruins', faced a real artistic difficulty in our search for origins. The seed and root of our concern had little material soil to nourish it. Patterson's view was that we should accept this shallow soil, (we begin from an existential absurdity of nothing) and grow our ferns in a kind of moon-dust. Fertility would come later; if not, Naipaul refused to plant at all. He watered the waste with irony. But Williams, coming from Guyana, where he had lived intimately for long periods with the Warraou Indians of the Northwest District, had a more immediate and tactile apprehension of artistic soil . . .

For Williams, this central source is Amerindian. For others of us, the central force of our life of awareness is African. As black people in the Caribbean, that is how we feel it should be. But Williams's choice of the Amerindian motif does not exclude the African. For one thing, Williams claims ancestry from both peoples – he is spiritually a black Carib . . . Africa in the Caribbean at that time was still hidden and/or ignored. But what Williams's work has revealed – and what in my analysis of it I have largely unconsciously stressed – is that the distinction between African and Amerindian in this context is for the most part irrelevant. What is important is the primordial nature of the two cultures and the potent spiritual and artistic connections between them and the present. In the Caribbean, whether it be African or Amerindian, the recognition of an ancestral relationship with the folk or aboriginal culture involves the artist and participant in a journey into the past and hinterland which is at the same time a

movement of possession into present and future. Through this movement of possession we become ourselves, truly our own creators, discovering word for object, image for the Word.

From *Savacou* 2 (1970).

4

THE CARIBBEAN COMMUNITY
IN BRITAIN

Claudia Jones

Over a quarter of a million West Indians, the overwhelming majority of them from Jamaica, have now settled in Britain in less than a decade. Britain has become, in the mid-1960s, the centre of the largest overseas population of West Indians; numerically relegating to second place, the once superior community of West Indians in the United States.

This new situation in Britain, has been inimitably described in the discerning verse of Louise Bennett, noted Jamaican folklorist, as 'Colonization in Reverse'.

Immigration statistics, which are approximate estimates compiled by the one-time functional West Indian Federation office (Migrant Services Division) in Britain, placed the total number of West Indians entering the United Kingdom as 238,000 persons by the year 1961. Of these, 125,000 were men; 93,000 women; 13,200 were children, and 6,300 unclassified. A breakdown of the islands from which these people came showed that during the period of 1955–61, a total of 142,825 were from Jamaica; from Barbados, 5,036; from Trinidad and Tobago 2,282; from British Guiana, 3,470; from Leeward Islands 3,524; from the Windward Islands, 8,202; and from all other territories, the sum total of 8,732.

Distribution of the West Indian population in the United Kingdom indicates that, by mid-1962, over three hundred thousand West Indians were settled in Britain. The yearly immigration and the growth of community settlement illustrates the rate of growth of the West Indian settlement. For example, the emigration of West Indians to the United Kingdom in mid-1955 totalled 24,473 and by 1961 this figure soared to 61,749. Corresponding to the latter was the fear of family separation due to the then impending Commonwealth Immigrants Act.

In the industrial city of Birmingham, by mid-1955, 8,000 West Indians formed the community there, while in mid-1962 this figure stood at 67,000. Similarly in London, where in Brixton the largest settlement of West Indians exist; the mid-1955 figure of 85,000 had by 1961 grown to 135,000.

West Indians were also to be found in the North of England (Manchester, Nottingham, Wolverhampton, Derby and Leeds) and in such cities as Cardiff, Liverpool, Leicester, Bath, Oxford, Cambridge and in other provinces. *What constitutes the chief features of this unprecedented migration to Britain? To what factors may we ascribe this growth of overseas West Indians away from their original homelands?*

Emigration from the West Indies has served for over two generations as a palliative,

a stop-gap measure to ease the growing economic frustrations in a largely impoverished agricultural economy; in which under colonial-capitalist-imperialist relations, the wealth of these islands is dominated by the few, with the vast majority of the people living under unbearable conditions.

It was the outstanding Cuban poet Nicholas Guillen who, noting a situation (also observed by other West Indian writers) in which the young generation, most of it out of work, 'chafing at the bit', seeing as their only hope a swift opportunity to leave their islands, lamented thus: *'Scant, sea-girt land, Oh tight-squeezed land . . .'*

Indeed, as with all migrant populations here is mirrored in extension the existing problems of the nations and territories from which the migrants originally spring. West Indian emigration to the United Kingdom is no exception to this phenomenon. Furthermore, this emigration, as with many other Afro-Asian peoples, has occurred almost immediately prior to the achievement of political independence in two of the largest of the West Indies islands. *It is because prospects have not yet qualitatively improved for the vast majority of the West Indian workers and people, inhibited by the tenaciousness of continued Anglo-American imperialist dominance over West Indian economic life, that this emigratory movement of people from the West Indies continues.* History will undoubtedly evaluate this development as, in part, attributable to the demise of the West Indian Federation and the consequent smashing of wide hopes for the establishment of a united West Indian nation in which freedom of movement would have absorbed some of our disinherited, disillusioned, and unfilled people who were compelled to leave their homelands in order to survive.

Up to a decade ago, West Indian immigration was directed to America rather than to Britain. But this was sharply modified when, in 1952 the United States Federal Government enacted the racially-based McCarran-Walter Immigration Law, which unequivocally was designed to protect the white 'races' purity', and to insure the supremacy of Anglo-Saxon stock; limited to 100 per year, persons allowed to emigrate to the United States from each individual Caribbean territory. Henceforth all eyes reverted to Britain. This is not to imply that West Indian immigration to Britain was wholly non-reciprocal. Another influence, was that postwar Britain, experiencing a brief economic boom, and full employment, needed overseas and cheap labour to staff the semi-skilled and non-skilled vacancies, the results of temporary postwar economic incline. Britain sought West Indian immigration as an indispensable aid to the British economy; indeed, encouraged it!

The presence of West Indian immigrants (who together with other Afro-Asian peoples total nearly a half million people) represent less than one per cent in an overall Anglo-populous of 52 million. But even this small minority has given rise to a plethora of new sociological and analytical works such as 'Newcomers'; 'Colored Immigrants in Britain'; 'The Economic and Social Position of Negro Immigrants in Britain'; 'Black and White in Harmony'; 'Colored Minorities in Britain'; 'Colonial Students'; 'Report on West Indian Accommodation Problems in the United Kingdom'; 'Race and Racism'; 'Dark Strangers'; 'They Seek a Living, and the Like'.

Extreme manifestations of the racialism which underlies the present status of West Indians in Britain were graphically witnessed in late 1958, when racial riots occurred in Notting Hill and Nottingham. These events, which followed the as yet unsolved murder of a St Vincentian, Mr Kelso Cochrane, claimed world headlines. Clashes even occurred between West Indians and other Afro-Asian migrants with white Britons.

The firm handling of the provocateurs by the authorities, following the wide protests of immigrants, labour, Communist and progressive forces, and the intervention of the West Indian Federal leaders, for a time quelled the overt racialists, and the 'keep Britain white, fascist-propagandists'. But the canker of racialism was now nakedly revealed. It exposed also the smugness of official Britain, who hitherto pointed to racial manifestations in 'Little Rock' and Johannesburg, South Africa, but continued to deny its existence in Britain.

Today, new problems, underscored by the Tory government's enactment, and recent renewal of the 1962 Commonwealth Immigration Act (one which ostensibly restricts Commonwealth immigration as a whole, but in fact, discriminates heavily against coloured Commonwealth citizens) has established a second class citizenship status for West Indians and other Afro-Asian peoples in Britain. Accompanying the general social problems confronting all new migrant workers, West Indians, stemming as they do in large measure from African origins, are experiencing sharper colour-bar practices. In common with other workers, the West Indians take part in the struggle for defence and improvement of their working and living standards. But the growing intensity of racialism forces them, as it does other Afro-Asians, to join and found their own organizations. In fact, their status, is more and more a barometer of British intentions and claims of a so-called 'Multi-racial Commonwealth'. As put in one of the recent sociological studies of the absorption of a West Indian migrant group in Brixton, financed by the Institute of Race Relations and the Nuffield Foundation:

> Now that the whole equilibrium of world power is changing, and the Commonwealth is, by virtue of conscious British policy, being transformed from a family based on kinship, to a wider multi-racial familia, the presence of colored immigrants in Britain, presents a moral and a practical challenge. The people of these islands face the need not only to reformulate their views of Britain's role and status in such a Commonwealth, but also to apply the new relationships in their dealings with colored Commonwealth migrants here at home. And not only the color-conscious migrants themselves, but the newly-independent Afro-Asian countries and the outside world as a whole, show an inclination to judge Britain's good faith in international relations by her ability to put her own house in order.
>
> (From *Dark Strangers*, by Sheila Patterson)

The Commonwealth Immigrants Act

Far from heeding the advice even of sociologists whose studies themselves show a neo-colonialist bias in its precepts (the study is full of pragmatic assertions that xenophobia is the 'norm' of British life, and hence, by implication 'natural', etc.) the Tory government has shown utter disdain for putting its own house in order.

Faced with the coming general elections in October, having suffered from local government defeats, mounting criticism rises towards its ruinous domestic and foreign policies. Internally, these range from housing shortages and a Rent Act which has removed ceilings on rentals to the failures of providing new houses; high interest rates on loans to the rail and shipbuilding closures, mergers and the effects of automation.

The external policies of the present British Conservative government also suffer

similar criticism. As a junior partner it supports the United States imperialist NATO nuclear strategy, continuing huge expenditures for colonial wars in Malaysia, North Borneo and Aden. Its subservience to US imperialism is also demonstrated in the case of its denial of long-overdue independence to British Guiana, on whom it is imposing the undemocratic system of Proportional Representation which aims further to polarize and divide the political life in British Guiana in order to depose the left-wing, thrice-elected People's Progressive Party under Dr. Cheddi Jagan. As an experienced colonizer, shopping around for a scapegoat for its own sins, the British Tory government enacted in 1962 the Commonwealth Immigrants Act. The Act sets up a voucher system allowing entry only to those who have a job to come to. Some of its sections carry deportation penalties for migrants from the West Indies, Asia and Africa, whom it especially circumscribes. Its passage was accompanied by the most foul racialist propaganda perpetrated against West Indians and other Afro-Asians by Tory and fascist elements. Thus, it coincided with the futile efforts then engaged in by the British government to join the European Common Market. It was widely interpreted that these twin events demonstrated the dispensability in Britain's eyes of both the needs of the traditional market of the newly independent West Indian territories for their primary products, and the labour supply of West Indians and other Afro-Asian Commonwealth citizens. On the other hand, the doors would close on coloured Commonwealth citizens, while open wide to white European workers.

The pious and hypocritical sentimentality accompanying the 'bills' passage was further exposed when the Tory legislators removed the non-Commonwealth Irish Republic from the provisions of the Act, revealing its naked colour-bar bias. The result, following a year of its operation, showed that eighty to ninety per cent of all Indian and Pakistani applicants were refused entry permits; and West Indian immigration dropped to a little over four thousand qualifying for entry. The latter occasioned cautious queries, whether the West Indians had either turned their backs on Britain or had become bitter with the Act's passage.

What the figures showed, of course, was that the main blow fell as intended, most heavily on the *coloured* Commonwealth citizens. So much for the facile promises of the then Home Secretary, now Britain's Foreign Minister, Mr R. A. Butler, that *'We shall try to find a solution as friendly to these people as we can, and not on the basis of colour alone'* (my emphasis).

All Tory claims that the Act would benefit either Britain or the immigrants are, of course, easily refuted. The most widely prevalent Tory argument was that coloured immigrants were 'flooding Britain'. At the time of the Act's passage, the 1961 British population census showed a two and a half million increase, during the very period of the growth of the immigration of West Indians and Afro-Asians, and this increase was easily absorbed by the British economy. The coloured migrant is less than one in every hundred people. Yearly emigration of Britons shows that for every single person entering Britain, *three* leave its shores.

The shibboleth that 'immigrants take away houses and jobs', when viewed in light of Tory responsibility for high interest property rates and the Rent Act, makes this claim likewise ludicrous. As for new houses, there is no evidence that West Indians or other coloured immigrants have taken away any houses. Allowed largely only to purchase old, dilapidated short-lease houses, it is the West Indian building worker, who helps to construct new houses, who makes an invaluable contribution to the building of new homes.

Even the usual last retort of the racial ideologists that West Indians and other coloured citizens 'lower moral stands' also fails to stand up. The world knows of the exploits of Christine Keeler and the British Ministers of State, an event which occasioned a calypso in the widely read *West Indian Gazette*. There has been no notable increase in jobs as a result of this Act. In fact, rail and shipbuilding closures, mergers and automation, continue apace. It is widely admitted that withdrawal of coloured workers from transport, foundries and hospital services would cause a major economic dislocation in Britain, and that they continue to make a contribution to the British economy. Vic Feather, leading trade union official reiterated strongly, this view at an all-day conference recently in Smethwick, a Birmingham suburb, where a local election campaign slogan was that to elect Labour meant *'having a nigger for a neighbour'*. One finally observes regarding the asserted economic social burden of the migrant, that a 'tidy' profit has been made by the Ministry of National Insurance from contributions of the surrendered cards of thousands of immigrants who returned home after a few years in Britain.

In the eyes of the world, the Tory record does not stand any better when it is known that nine times they have blocked the Bill to Outlaw Racial Discrimination by the Labour member for Parliament from Slough, Mr Fenner Brockway. The main provisions of this bill would be to outlaw discrimination in public places, lodgings, inns, dance halls, and other leases; and also put penalties on incitement to racialism. The Bill has now gained the support of the Labour leadership who promised if they achieve office to introduce such a measure (although there are some indications that it may be watered down), as well as from leading Liberal MPs and even from some Tory MPs. Thus, there has been witnessed a reversal of the former open door policy to Commonwealth citizens, and speciously to coloured Commonwealth citizens. The result of all this has been a new degrading status and sufferance accorded to coloured immigrants who are likewise saddled with the responsibility for Britain's social evils.

There is a reluctance on the part of virtually all sections of British public opinion to assess the fundamental reasons for the existence of racial prejudice. The citizens of the 'Mother of Democracies' do not yet recognize that the roots of racialism in Britain are deep and were laid in the eighteenth and nineteenth centuries through British conquests of India, Africa and great parts of Asia as well as the British Caribbean. All the resources of official propaganda and education, the superstructure of British imperialism, were permeated with projecting the oppressed colonial peoples as 'lesser breeds', as 'inferior coloured peoples', 'natives', 'savages', and the like – in short, 'the white man's burden'. These rationalizations all served to build a justification for wholesale exploitation, extermination, and looting of the islands by British imperialism. The great wealth of present-day British monopoly-capital was built on the robbery of coloured peoples by such firms as Unilever and the East Africa company to Tate and Lyle and Booker Brothers in the Caribbean.

These artificial divisions and antagonisms between British and colonial workers, already costly in toll of generations of colonial wars and ever-recurrent crises, have delayed fundamental social change in Britain, and form the very basis of colour prejudice. The small top section of the working class, bribed and corrupted, and benefiting from this colonial robbery have been imbued with this racist 'white superiority' poison. On the other hand progressive opinion rallied with the migrants' protests at the

Commonwealth Immigrants Act, for the Labour Party leadership had voted in opposition to its enactment; yet allowing its subsequent renewal to go unchallenged, for fear of losing votes in the coming general elections. Labour offered the government an unopposed passage on the condition that it agree to place the Act with new and improved legislation drawn up 'in consultation' with the Commonwealth countries.

The government, which had itself tried this tactic before, to the negative response of West Indian and other affected Commonwealth Governments, refused to give these assurances. The Labour MPs, to the dismay of the overwhelming majority of immigrants, also stood for 'quotas' and 'controls'. In essence, this stand does not differ in principle from the attitude of the Tory government and the provisions of the Commonwealth Immigrants Act. With the sole exception of the British Communists, who completely oppose the system of 'quotas' and 'controls' for Commonwealth immigration, all political parties have capitulated in one way or another way to this racialist immigration measure. A recent statement of the Executive Committee of the British Communist Party declared its opposition to all forms of restrictions on coloured immigration; declared its readiness to contest every case of discrimination; urged repeal of the Commonwealth Immigrants Act; and called for equality of access for employment, rates of wages, promotion to skilled jobs, and opportunities for apprenticeship and vocational training. It gave full support to the Bill to Outlaw Racial Discrimination and pledged its readiness to support every progressive measure to combat discrimination in Britain. It also projected the launching of an ideological campaign to combat racialism, which it noted, infects wide sections of the British working class.

Some issues facing coloured immigrants

That the Tory colour-bar Commonwealth Immigrants Bill has been enacted at the time when apartheid and racialism are under attack throughout the world from the African Heads of State, at Addis Ababa, to the half million Civil Rights March on Washington; from the United Nations, and world criticism of South Africa and the demand for application of economic sanctions, to the condemnation of apartheid and Jim Crow racialist practices in the USA; bespeak the fantastic blindness of Britain's Tory rulers even to Britain's own national interests. But as with every exploiting class, as the example of Hitlerism shows, faced with a radical movement of the masses against their rule, they seek to split and divert this anger onto a false 'enemy'.

Added to the second-class-citizenship status foisted by such a measure, West Indians and other Afro-Asians are confronted in their daily lives with many social and economic problems. Forming several settlements in various cities, the overwhelming majority are workers, with a scattering of professionals. There are three thousand students.

Throughout Britain, the West Indian contribution to its economy is undoubted. As building workers, carpenters, as nurses, doctors and on hospital staffs, in factories, on the transportation system and railway depots and stations, West Indians are easily evidenced. Lest the younger generation be omitted (without commenting here on the social mores 'guiding' the cultural orientation of today's youth) one of the most popular current pop singers is a sixteen-year-old girl from rural Jamaica.

Indicative of their bid to participate in the political life of the nation was the recent success of a West Indian doctor on the Labour ticket as London County Councillor for

the second time in an area composed, though not solely, of West Indian migrants. For the first time many thousands of West Indian and Afro-Asian voters have registered and will be eligible to vote. It is not accidental therefore as reflected in an article entitled 'The Colour of Their Votes' in a leading Sunday periodical, that speculation is growing as to how they will use their vote. One such article entitled 'The Colour of Their Votes' concluded that they would vote 'according to colour' but in consonance with their class interests. But this observation is only a half-truth. For the *common* experience of all Afro-Asian-Caribbean peoples in Britain is leading to a growing unison among these communities as they increasingly identify an injury to one as being an injury to all. When added to this, one marks their pride in the growth of national-liberation achievements from the lands of their origin and among other nationally oppressed peoples, they are likely to be influenced by this bond as much as by their particular mode of production. Most pre-election polls have indicated their leaning, if critical, towards Labour and other Independents.

Many acute problems face West Indians who seek jobs and shelter. There is as yet no overall veritable picture of West Indians' skills. Results from sample polls are given here, bearing in mind the West Indian economic colonial background, to indicate scales in skills. One such poll revealed that of 608 persons sampled for their skills, by their own characterization, the results among West Indians were as follows: Professionals, 1%; other non-manual, 13%; skilled, 46%; semi-skilled, 13%; agricultural, 12%. In a further breakdown the professional and other black-coated workers predominated in the migrant groups from Trinidad and Tobago, while skilled workers were more numerous from Jamaica and Barbados. Considerable downgrading of skills frequently occurs and many unskilled workers have been unable to acquire skills, many from rural areas having formerly no industrial experience at all. But even where qualifications exist, many find it difficult to obtain jobs commensurate with their skills. Some employers have a secret quota system for the employment of coloured workers, based on the chauvinistic view that '*too many coloured workers*', even if qualified, will '*rock the boat*'. Others, even when inclined to take on coloured workers, have had to face English workers, in some cases, trade unionists, who have a definite policy of keeping out coloured workers. Even Government Employment Exchanges accept orders from employers not to submit 'coloured' applicants for work. But this too, is being resisted and demands are being made for the Ministry of Labour to rescind these instructions.

In the background is the country-wide pattern of industrial-labour relations; the traditional view of 'keeping the labour force small', the better to bargain with the employers, and the real fear by trade unionists that non-union labour will undercut wages. Then too, there is the ambivalent right-wing trade union view which seeks to reconcile the principles of trade union brotherhood and non-discrimination with the antipathies of a large and vocal proportion of its rank-and-file members.

Even in the early stages of the present West Indian immigration to Britain, struggles had to be waged for the acceptance of West Indian workers into the jobs they now hold. In the transport system, despite the agreements between the British Transport System and the Barbados Government to train and employ workers, sharp struggles by progressive trade unionists, led by Communists, had to be waged for hiring and upgrading of West Indian workers, for their right to work in booking offices, or as shuttle-plate workers in railway depots or for West Indian women to be employed as 'clippies' or bus conductors.

Many of these gains are today under fire. A recent vote by the London busmen served notice that they opposed the hiring of any more West Indian workers. What is more, a growing 'Blacklist for Jobs' exists, as an article in the *Sunday Observer* states. The article noted that thousands of West Indians born and educated in Britain will 'not be content to do shift work on buses' in a society which, 'despite their high academic levels treats them as less than human beings' (the article detailed the difficulties experienced by school-leavers particularly in white-collar jobs). In banks, sales staffs, insurance companies, and newspaper staffs, a policy of 'tokenism' is operative. As one executive put it: *'If you have one in an office and she's, she fits in, but you put two or three there and you may find yourself losing some of your white staff'*. Facing stiff competition for jobs, they have it both ways: if undertrained, and if efficient (the *too*-well-trained, may be rejected) in either case, they may face a colour bar.

Excluded from skilled jobs and forced into lower-paid ones, still another disability must be faced in the field of housing accommodation. In addition to the problems occasioned from the general housing shortage, the West Indian immigrant and other coloured Commonwealth citizens are widely rejected as tenants of advertised flats and lodgings on the basis of a colour bar, and are obliged to pay higher rents even than white tenants. *'So sorry, No Coloured, No children', 'European Only', 'White Only'* signs dot the pages of advertised flats and lodgings. A 'colour-tax' meets the West Indian purchaser of property, often inferior leasehold ones. No wonder estate agents, and unscrupulous landlords, some of them coloured themselves, have not been averse to exploiting for huge profits this housing shortage. 'Rachmanism' is a synonym in present-day England for this type of practice, alluding to the fortunes made by the man so named in North Kensington in the very area of racial riots of a few years ago. Through exorbitant rentals, resale of properties, the shortage of housing is widely exploited and the West Indian, Afro-Asian as well as white workers are the victims.

A Commons inquiry is now pending since the revelation of collusion of estate agents with Big Business when a restrictive colour-bar covenant was discovered in Loriel Properties on whose board of directors are two Tory Cabinet Ministers, a leading Conservative Member of Parliament, who led the racist attack in the House of Commons on the Commonwealth Immigration Act. This company has shareholders among the nation's leading universities at Oxford and Cambridge and most of the other directors hail from the Establishment. Thus, the real origin of colour-bar practices and policies stems from the City's imperialist financial barons to whom it is highly profitable, both ways. The Commons inquiry, it should be added, has been initiated by Mr Fenner Brockway, who has nine times tabled his anti-discrimination bill to ban discrimination in public housing, leases, inns, pubs, hotels, dance halls, etc. These and other examples more than confirm the urgency for this type of legislation in present-day Britain. Education policy is yet another field in which inroads are being attempted by the racial propagandists. Stemming from their central campaign now sanctioned by the Commonwealth Immigration Act to oust West Indian Immigrants from Britain, they have fastened on the growth of communities where children of Afro-Asian-Caribbean immigrants are at school. Encouraging the idea of schools segregation, they have attempted the organization of parents to get them to move their children to other schools. In Southall for example, where in two wards five thousand Indian families live, this type of segregation propaganda began to make headway and the local Council, despite the relatively good stand of the Board of Education began to weaken. Follow-

ing an appeal however, from the Education Committee to the Minister of Education, Sir Edward Boyle told four hundred parents, 'there will be no segregation in our schools'. A basis was adopted to spread the children over several schools so that there will be no more than one-third Indian children in the schools. Despite this, new calls are being heard for establishment of separate classes for coloured children on grounds of 'language difficulties', despite the well-known adaptability of children to become bilingual. This approach is being strongly resisted by West Indian, Afro-Asian, educational and progressive groups in Britain. For it is feared that such a wedge may establish an American 'Jim Crow' pattern of 'separate but equal education', an animal (as we have learned from the Negro liberation struggles) that just doesn't exist. This fear was confirmed anew when a recent White Paper issued by the Commonwealth Conservative Council suggested that children of immigrant parents be regarded as 'immigrants' despite being born in the United Kingdom.

Consequently, whether as tenants waging anti-discrimination struggles; clubbing together to purchase homes to house families the large majority of whom were separated for years until the necessary finances were raised: whether as workers fighting for the right to work, or to be upgraded: or as cultural workers engaged in the attempt to use their creative abilities on stage, screen or television, or to safeguard their children's right to an equal education; or as professionals, students, or in business pursuits, the West Indian immigrant community has special problems, as a national minority. While the workers are heaviest hit, the disabilities cut across class lines.

From B. Johnson (ed.), *Claudia Jones: I Think of My Mother*, ed. B. Johnson (London: Karia Press, 1985) © B. Johnson.

5

DESTROY THIS TEMPLE

Obi Egbuna

It is impossible to outline here a complete catalogue of the motives which compelled me to write a 'murder document'. Let me state at once that it has nothing to do with Enoch Powell as an individual. Nevertheless, I will not go so far as to share the view often expressed by certain Black intellectuals that Powell is 'a good chap, really, because he is not a hypocrite like the rest.' A punk does not cease to be a punk simply because he admits he is a punk. White conservative hopefuls have called Powellism 'White Blacklash', which is equally ridiculous. There has been no forward movement of Whites in England to lash back from. Others have tried to depict it as the White counterpart of Black Power, which is another way of saying that Black Power is 'Powellism in Reverse'. Many people have been fooled by this. I have received countless letters in this prison, both from Whites and Blacks, and most of them have argued that if Enoch Powell is allowed to be free to continue spreading his poisonous propaganda, they see no reason why I should be arrested and locked up behind bars. I must admit I feel flattered by the concern of so many people over my safety and the injustice of my plight. But I find this line of argument most distressing. To place me on the same racialist plane with Powell betrays a lamentable lack of understanding of my angle of involvement.

Mine is a rebellion of the enslaved man against men who make slaves of other men. But Powellism, on the other hand, is the rebellion of the slave-master against the slave. And when a slave-master starts revolting against the slave of his own creation, when a renowned Greek scholar and top politician begins to rave and rant in all seriousness that the Black rubbish-sweepers of British streets should be held responsible for the collapse of an Empire over which the sun never used to set, and that their repatriation to the East from whence they came will make the sun rise from the West, that state racialism is the answer to individual racialism, that the state must discriminate in order that the individual will not discriminate, then the contrast between the stupidity of this 'logic' and the brain of the man stating it is obvious.

I do not believe for one moment that Mr Powell cares one bit whether or not the Black man lives in England in hundreds of millions. I am convinced that Mr Powell is merely fulfilling a function. He is dutifully carrying out a political function allotted to him by the Establishment. And that duty is simply to strengthen the hands of the British government to abolish the Black Commonwealth status as a prelude to joining the European Common Market. Mr Powell is only a member of a team, playing a role assigned to him to the best of his ability. All the noise, his 'dismissal', and the pious

anti-Powell protestations in high places are only part of a well-planned drama to fool, once again, my people and the ever-gullible members of the British public. The prospect of becoming Prime Minister one day might have helped to induce Mr Powell to accept his role of the Hammer of the Blacks, but the real reason behind the eruption and the strategic timing of so-called Powellism is that members of the European Club have decreed the annihilation of the Black Commonwealth status a precondition for Britain joining the Market.

Every one of those men at the top knows this for a fact; for has it not been evident that Mr Powell only advocates, while the others implement? And with the same rapidity they condemn him in words. They go to Scarborough to decry Powell publicly as the iniquitous Guru and, while the echo of their jibes is still ringing in the air, they rush off to Gibraltar, pipe in hand, to out-Guru Powell in a Kith-and-kin Tiger talk with 'Rebel Smith', discussing the future of a country with 98 per cent of the population not represented because they were Black.

I have no quarrel with Powell as a man. For I am sure that, to Powell the man, I am as irrelevant as he is to me. Powellism is not a dialogue between Black and White. It is purely a communication between Britain and 'Europe'. Even at the height of his tirades, Powell, I know, was not talking to me. He was talking over me, to Europe. Even when he called us grinning piccaninnies, I was well aware he was talking about me, but not to me. He was addressing Europe. De Gaulle, on behalf of the Six, warned Britain long ago to 'do something' about her Commonwealth 'obligations', if she was serious about joining Europe, not to saddle the Six with 'it'. Powell is not a man; he is a reply, a manifestation of the European traditional attitude to my people. To fight Powell alone is to misplace my enthusiasm and my energy, to do what they want me to do. No, I refuse to be distracted.

'It has long been the belief of modern men,' writes Du Bois in *The World and Africa*,

> that the history of Europe covers the essential history of civilisation, with unimportant exceptions; that the progress of the white race has been along the one natural, normal path to the highest possible human culture . . . On the other hand, we know that the history of modern Europe is very short; scarcely a moment of time as compared with that of eternal Egypt. The British Empire is not more than two hundred and fifty years old; France in her present stature dates back three hundred years; the United States was born only a hundred and seventy years ago; and Germany less than one hundred years. When, therefore, we compare modern Europe with the great empires which have died, it is not far different in length of days from the empires of Persia, Assyria, the Hittites, and Babylon. Ethiopia ruled the world longer than England has. It is surely a wider world of infinitely more peoples that Europe has ruled; but does this reveal eternal length of rule and inherent superiority in European manhood, or merely the temporary possession of a miraculously greater brute force? Mechanical power, not deep human emotion nor creative genius nor ethical concepts of justice, has made Europe ruler of the world. Man for man, the modern world marks no advance over the ancient; but man for gun, hand for electricity, muscle for atomic fission, these show what our culture means and how the machine has conquered and holds modern mankind in thrall. What in our civilisation is distinctly British or American? Nothing. Science was built on

Africa and Religion on Asia. Was there no other way for the advance of mankind? Were there no other cultural patterns, ways of action, goals of progress, which might and may lead man to something finer and higher? Africa saw the stars of God; Asia saw the soul of man; Europe saw and sees only man's body, which it feeds and polishes until it is fat, gross, and cruel.

For thirty long years of my life, I lived in a trance. Like countless African students of my generation who were herded into Britain every year to 'receive education', I was living a lie.

I was told that Africa was a dark continent and that Europe was the only source of light. I was taught that nothing ever happened in any part of the world till the White man came along. I was made to believe that my people were a mere clay for moulding and my native land only a barren slate where every European had a divine liberty to come and engrave his notions of right and wrong. I was told that my mother was ugly because her skin was black, her hair curly, and her nose and lips unlike the White woman. It was drummed into the plastic mentality of my childhood, that, Blackness is incompatible with respectability, and that Black Beauty was only a horse. I went to school five times a week and also to church during the vital part of my developing years to see God and his Angels depicted as White men on Christian posters and the devil himself looking the spit image of my dad. I was stripped before the whole school and whipped with boiled chord till I bled every time I committed the 'mortal sin' of joining my people in our traditional juju chant at the Village Assembly Square; and of course had to cleanse myself through Confession, penance and the Holy Communion, before I was allowed into the Sacristy to serve Mass behind the White priest chanting and presiding over the 'holy' ritual of White religion. I was baptized into White Catholicism when I was only four days old and given the name Benedict because I was too young to protest. I learned to live with the cruel dilemma in which the Christian Bible which alone was ordained to offer me salvation had already condemned me from the time of Noah to eternal racial pariahdom through the famous 'Curse of Ham'. I was reared up to accept without question the alleged cultural insignificance of my ancestry and to look upon the European doxy as the only orthodoxy. I was told I was born ignoble and my only hope of atoning for the heinous crime of being African was to dedicate myself to the task of Anglicising myself in European institutions for the rest of my life. I was lied to, right, left and centre, till I couldn't wait to get away from home. And, naturally, at the earliest opportunity, I escaped from the 'jungle' of Africa to the promised Caucasian lustre of England where the White kiss of life would evolve me, under-developed as I am, into a real human being in civilized Europe.

I was to find out later that I had left one jungle for another. I had left 'uncivilized' Africa to come looking for a Shangri-La, only to discover a Powell-infested Babylon in which, in the words of Cecil Roberts in *Wide is the Horizon*, there is more sex and less love, more food and less flavour, more luxury and less comfort, more wealth and less satisfaction, more speeches and less sense, more creeds and less religion than anywhere else in the world. I came groping for explanation and found more intellectuals and less intelligent men, more theory and less practice, more liberals and less freedom, more peace-talks and fewer peace programmes, more Marxists and less revolution, more mechanization and less civilization, more laws and less justice. To paraphrase Lerone Bennett Jr paraphrasing Leslie Fiedler in *The Negro Mood*, I came to consult the White

oracle to demystify my Black abnormality, only to find that my celebrated White fountain of knowledge and normality spends his childhood as imaginary Indian, his adolescence as imaginary Negro, and his adulthood as *imaginary* White. Man, I had come in search of an Eldorado and found a Helldorado.

This realization was the beginning of self-redemption. But the discovery did not come at once. It took years of painful introspection.

The first painful truth I found out about myself in England was that I was a punk. Like every Black man or woman living in the so-called Mother-country, I had come here to be a beneficiary of the Anglo-Saxon capitalism that thrives on sucking the blood of my people back home in Africa. Some of us have come here to get better jobs and a higher standard of living. Others have come in search of higher 'education' which, in the long run, will give them the same rewards, better jobs and a higher standard of living. But England, a tiny country with nothing much more than coal for its natural resources, is only in a position to offer us these rewards because she loots it off the land of our people. It seems to me contradictory to call England an imperialist monster and, at the same time, be contented to live in England to partake of the fruits of the imperialist monstrosity of England.

I hated to admit this about myself but it was nevertheless the cruel truth. And I realized that to refuse to accept this truth was to apologize for, and even defend, my indirect living off the bloody looting of my people. For a receiver of stolen property, knowing that what he receives is stolen, is as much guilty of the crime of theft as the man who did the actual stealing; and even more so if the victims of the robbery are one's defenceless little brothers and sisters who have been rendered even more defence-less because one has run away from home, deserting home at the hour of need when nothing short of united defence could fend off the invader. I realized that unless I faced this ugly truth about my present treacherous historical role, I would never develop the moral courage to give me the revolutionary aptitude to change that role, that unless I came to terms with myself, I should have spent my childhood in Africa being an imaginary savage, my adolescence in England being an imaginary White man, and my post-college adulthood being a real savage. In short, I had come to England to feed fat on the fruits stolen from my father and nurtured with the manure of my mother's flesh.

It is true I did not come to England of my own choice. It is true that if the Chinese had colonized my country I should be in China today, not England. It is true I am only a tiny speck in the wind of history and that I come here, not because I enjoy slotting shillings for heat, but because the uninvited White man came to my native land first and created a one-sided economic wind that is still blowing me and my Black brothers to his shores. It is true that the Englishman is the last person to ask me what right I have to be here because he ought to know from his own history that he too is an immigrant here, that his claim to England is having enjoyed the usufruct possession of this island as a second-hand German immigrant, and that he therefore has no claim as an immigrant to arrogate to himself the right to demand of another immigrant, Black or non-Black, the right to come here and the power to regulate his numbers. It is true that all this is true, that it is an unchallengeable fact that I am not here of my choice but simply a victim of an unfortunate historical current that has carried me while still asleep from the shores of the have-nots to the land of the haves to make me a have at the expense of my people.

But is it not equally true that when a man is asleep in a boat by the seashore and

wakes up suddenly to find himself in the middle of the ocean where the wind has blown him with the current against his will, is it not equally true that he must fight hard to steer his boat back to his shores? Does a drowning man who finds that his boat has been capsized contrary to his will not fight the waves desperately to swim home to safety? These were the questions that tormented me night and day in those early days of realization.

But even in the middle of this resolve, I was very aware that older generations than mine have gone back to Africa after studying in England and, far from redeeming our people, have tightened the chains on their ankles. It becomes obvious that a physical return to Africa is meaningless unless it is preceded by a psychological return. This emphasizes the fact that something is desperately wrong with the 'education' we come to 'receive' in Europe. Some of us have claimed, in a way of apologizing for our attachment to Europe, that we have come over here to balance the economic and political equation which the White man has kept one-sided ever since the Portuguese set foot on Congo soil in 1495. But are we really balancing that equation? Or are we not indeed widening the gap of that economic imbalance by voluntarily remaining exposed to an 'education' designed by a man who wants to keep us perennially subordinate?

What power, pride and self-confidence can we, as Black people, hope to derive from a system of education in which, to use the words of Du Bois in *The World and Africa*, White 'National heroes were created by lopping off their sins and canonising their virtues, so that Gladstone had no connection with slavery, Chinese Gordon did not get drunk, William Pitt was a great patriot and not an international thief. Education was so arranged that the young learned not necessarily the truth, but that aspect and interpretation of the truth which the rulers of the world wished them to know and to follow.'

Since I could not obviously find the answer in European books, I turned to works created by the older generation of African writers themselves. I consulted the celebrated Heinemann's Library of 'African Educational' publications and its equivalents, in the hope that the award-winning Western-famed African novelists, dramatists, essayists and artists would put the African personality in focus for me.

My discoveries can best be summarized by a paragraph which appeared in Robert F. Williams's *Crusader* written – it is interesting to note – from his own independent observation:

> It must be borne in mind that a great portion of material produced by black intellectuals under the aegis of the white power structure is anti-black and pro-white. White publishers are the most forceful advocates of Americanism. With but a few exceptions they have seen to it that black works of art and literature comply with the white concept of the 'nigra's place in American life'. The white man's power to publish or not publish has deprived the black artist of the right to reflect black truth as it relates to savage America. Because of the racist white man's life and death control over the black man's art, it has become a vehicle of accommodation, steeped in racist clichés that surreptitiously debase our people and serve the cause of white supremacy.
>
> Too often, as a price of publication, the racist power structure has required the black artist to reduce himself and the entire race to a state of immoral clowns and idiots. The cunning racist white man, in a subtle effort to put the

black man down through his own works, requires the 'award winning' Afro-American novel, autobiography, cinema or theatrical production to be self-deriding exercises in negro crime, vulgarity, prostitution, dope addiction, homosexuality, incest, self-hate and psychopathic masochism.

A close examination of much of this work will reveal a thinly veiled attack on the integrity and intelligence of the race. It is not protest but the condemnation of black by black. The most tragic aspect of this whole affair is the fact that nigra intellectuals are inclined to judge the merit of their own art and literature on the basis of the white man's reviews, publicity or hypocritical glorification. If the black art is going to disembowel the race before the entire world, what greater instrument of justification does the enemy oppressor need to convince the world that he is truly the Christian benefactor and civilizer of the 'savage African?' Why should the racist devil object to a transfer of the means of black degradation to a different but more effective crew of white supremacy?

Though written with the black writer in America specifically in mind, it struck me that the home-truth of Robert F. Williams's analysis is even truer about the academic-titled literary Sambo-darlings of the West in Africa, with of course the exception of a core of a few courageous young 'extremists', 'racists' and 'too-political no-goods' who will, they hope, pass away unpublished, unknown, ostracized, rejected from script to script, dead and unremembered victims of the white King-maker's freeze.

It became apparent to me from then onwards that one must begin with the rejection of the definitions of the West. Power is the ability to define. I must put an end to letting the White man define me to myself. I must kill once and for all the five-hundred-years-old induced complex whereby my life has been controlled by the whims of the White imperialist. It is ridiculous to continue to accept Western definitions without question when I am in the sorry state I am today because the West has defined me as such. What I ought to do is, psychologically for a start, render the West irrelevant to my being. I am, therefore I am.

The emasculation of the Black man dated from the day he empowered a hungry buccaneer outsider to define blackness. The Black man became a Negro the day he was baptized by a preacher whose God was white and devil black. The Negro was the invention of a greedy speculator who invested millions of pounds on the self-hate and gullibility of Blacks. The African became 'the native' the day he called a stranger who arrived with an empty suitcase from Europe 'Bwana'. Africa became the 'dark continent' the moment the African accepted the insulting equation that Black = Evil + Savagery + Shame. And Europe became the Black Man's Burden the day they christened the Third World the 'White Man's Burden'.

The writing and interpretation of history must be done by those who genuinely aim to explain the past to elucidate the present, and never again by intellectual crooks hired by empire-builders to distort and efface their ugly past in order to justify their even uglier present. The ambition of every invader is to keep control of the territory he has captured. Everything he does, no matter how humane it seems on the surface, has this objective in view. His programme of aid and education, his divine mission of introducing the captive populace to a God godlier than theirs, his new laws, new politics, fine culture, and fine civilizing benevolence, will soon prove, on the day of reckoning,

to be no more and no less than a mere excuse and systematic plan to extend his stay and consequent extraction of booty. This is the story of my homeland in Africa.

The White man told us on arrival that we suffer from leprosy. True. That we exude malaria. Granted. But he conveniently forgot to mention that he suffers from maladies and neuroses our people have not even today heard about. He declared instead that we Africans have a monopoly of the diseases of the body. Beautiful. He never told us though that the viruses of the mind which plague his society back home in Europe are far more destructive of human personality than any bodily disease we knew before he came. He was eager to teach us that our infant mortality is astronomically high. But it eluded him that his suicide mortality is astronomically higher. In effect, what he was asking us to do was to get rid of one mortality and replace it with another.

The acceptance of this formula for national decay was the beginning of the woe of my people.

To support his view of the world, the White 'civilizer' dished out facts upon facts from his books to persuade my people.

And the unfortunate thing about it is that Fact, by definition, is not the whole truth. Fact is only an absence of contradiction. As such, it does not guarantee the whole truth. For example, if my landing officer in this prison were to ask me tomorrow morning what I was doing at this time of the night and I reply simply that I was writing a letter, I have stated a fact. It is a fact as indisputable as the existence of Brixton Prison itself. My landing officer might even pat me on the back for doing something as harmless as writing a letter. He might even extend my light-out time tomorrow night since I employ my time so usefully and innocuously, based on the indisputable fact that I am writing a letter. But what this fact does not reveal to him is that, knowing that a letter like this would never pass the censors, I am in fact writing it on stolen toilet rolls of paper soon to be smuggled out of this prison, contrary to regulation. In effect, I shall have told him a fact which has indeed concealed the truth.

What I am driving at is that facts can be used for two contradicting purposes: to impart information, and to conceal information. A few nights ago, the prison chaplain asked me if I found the copy of the Bible in my cell useful. I nodded enthusiastically and told him that I did indeed use it every single night. I went so far as to tell him that I could not go to sleep happily and peacefully without it. What I said to him was a fact of course. I cannot go to sleep peacefully without the Bible because all I do with it is put it under the bed-rug to use it as a pillow at night.

This proves that facts are not as reliable in assessing situations as we often suppose. There is nothing more dangerous than facts in the hands of the imperialist devil out to quote scriptures for his purpose. Hitler used facts to justify the murder of six million Jews. Lynch mobs in the United States of America used facts to justify the lynching and roasting alive of 3,397 black men and women between 1882 and 1938 alone. Capitalist economists use facts to destroy, even today, tons of edible food while two human beings out of every three in the world are dying of starvation. They used facts also to prove to me and my people that we had no culture, no history, no civilization. And we believed them. For countless years of my life, they have used facts to keep me living in a trance.

One day, I asked them to tell me why Britain was called Great. They boasted of an empire which was reclaimed from the sea of the blood of my people. I asked them why Britain was called Christian. They pointed out the epitome of British Christianity, St

Paul's Cathedral of course, which is festooned with the monuments, shields and swords of generals who acquired their saintly pinnacles by the number of men they beheaded. I asked them why Britain was called philanthropic and, having got wiser, they side-stepped Cecil Rhodes and pointed at Enoch Powell and the offer of two thousand pounds he has made us to keep our distance. I asked them for the evidence of their civilization. They gleefully pointed at the motor cars which, since they are producing more cars than roads to take them, will soon become illegal to drive freely on public streets, having already become illegal to park freely on the streets. They showed me factories roaring with the production of weapons of war. And, to bring me up to date, they indicated on the skyline of London their skyscraper Post Office Tower where grown-ups achieve the exciting and incredible feat of eating and moving in circles at the same time. This, to the skyscraping wise men of the West, is the acme of human happiness and civilization. It is also where I split.

Suddenly, I saw it all clearly. I was still frustrated but I was no longer blind. I knew I had to stop kidding myself in White colleges. My tour of America and my meeting with really 'aware' Black people in the ghettoes over there, as opposed to the affected but ineffective, Tom-intellectuated and cowardly, I-am-alright-Old-Boy and Oxford-accented-hustler-type Black 'Englishmen' one was then saddled with in Britain, gave me real hope. I came back to London fully convinced that the road to Black freedom did not lie through Oxford, Cambridge, or the London School of Economics. I realized, even then, that it was a thorny road which might one day run through Brixton Jail and beyond. There was no other way. All other alternative avenues led inevitably to Tranceville. And I was sick and tired of living in a trance, of living a lie, of living a death camouflaged as life.

But a realistic political organization of Black peoples in England seemed a wild dream. For the Black man in Britain was a victim of two things.

Firstly, he was a victim of self-deception. He had come to the 'Mother Country' to be a beneficiary of Anglo-Saxon capitalism, hoping in all good faith that through his own personal success he might 'exploit' back for his people at home what colonial England had exploited from his people. And there his logic ended and it might have been a fine logic had it not been that neo-colonialism had superseded colonialism, and that the rate at which he was 'exploiting' England was laughably minute in comparison with the rate the neo-colonialist West was looting our home country. The Black man in England thus occupies a unique position. He is an ambivalent being, the only ghetto bourgeois in the world. Even though he largely sweeps the streets of England, he occupies, in relation to his people back home, a curious position compatible to a relationship between the bourgeoisie and the proletariat. He sees himself, worker or student, as being 'better off' and, with a little encouragement from White 'Troubadour liberals' and permissively inclined flesh-crazy White girl friends, he genuinely sees Britain as a heaven and considers himself the luckiest and most privileged Black man in the whole wide world. The Black man in England, by definition therefore, is a Tom, with one eye on the House of Lords, if he is an 'intellectual' or a cricketer, and the other eye on the Lordship of some Lambeth property, if he is a 'ghetto bourgeois'. Anyone who was a Black political activist in Britain in the days when I returned from America knows how difficult it was to approach a man like that and even suggest that Britain, a White country that actually offered him his fat money packet every Friday, a house and White wife into the bargain, was exploiting him. He would call you mad, accuse you

of 'talking stupidness, man', and if you were reckless enough to ask him to join you in a political Black organization aimed to destroy the White system that gave him so much, he could kill you on the spot. I need not add here that I have learned this lesson to my cost since the reader is already aware that the printer who handed over my document to the police and who, apart from being responsible for my being in this prison right now, will also be the police key witness at the Old Bailey, is a Black man. More than that, he is my countryman and, if I remember correctly, my very last correspondence with him was the postcard greeting I sent him and his wife from Conakry. I was arrested a few days after I returned from that trip. Illusion is never the best friend of a revolutionary. And one illusion I have learned to do without is that Whites have a monopoly of indolent men.

Secondly, the Black man in Britain is a victim of what I consider the biggest and most publicized myth in the world. It is generally believed that there is very little racialism in Britain. The English have succeeded in fooling the entire world that they are the least racist and most tolerant beings in the world. And whenever a race rebellion occurs in America, the British politicians and journalists are always the first to address the world on TV or in newspapers from thrones of racial innocuousness on how 'this could never happen in this country' because England has very little racial problem and, at any rate, not as much as America. As any intelligent Black man and any honest White man in the country knows, this is the weirdest myth of this century.

I agree there is a difference between the racialism in America and the racialism in England. But I disagree when the Englishman tells me that it is worse in the States. I have been to both countries and studied and experienced the White man's attitudes toward me as a Black man. And I can state without equivocation that racialism in England is far worse.

I will explain myself. To compare the racialism in America with the racialism in England is like comparing a bad slave-master with a good slave-master. I prefer the bad slave-master any day. The bad slave-master at least makes the slave aware that slavery is evil. From his attitude, he can make the slave realize without being coerced that slavery is a wicked thing which must be destroyed at all costs. But the good slave-master is the sly one. He makes the slave think that slavery can be a good thing, that evil can be made palatable, that one can compromise with man's inhumanity to man. The product of good slave treatment is the Uncle Tom. His counterpart in the wicked household is the angry freedom-loving and uncompromising revolutionary.

America is like a wicked slave-master. England is comparable to a 'good' slave-master. In Mississippi, the White man tells you straight that he does not want you in his neighbourhood and you know where you stand with him. In Wimbledon, the Englishman will apologize most profusely when he refuses you accommodation on racial grounds: 'Room to let, sorry no coloureds, Irish or dogs.' When you confront him personally, it is never his fault, he of course never has racial prejudice, it is always the neighbour who is the villain. The American will lynch you and doesn't give a damn who knows it. But the Englishman always has enough residue of subtlety to lynch you with iron hands in velvet gloves. Challenge him with the murder he has just perpetrated and he politely points out to you with the tip of his rolled umbrella that there are no fingerprints on the victim of his 'gentlemanly' brutality to prove his guilt. This is how they have fooled the Black man in England to believe that there is little or no evidence of racialism in the Englishman. This is the centuries-old method they have

employed to make the unsuspecting Black Tom here actually enjoy his slavery. Is it any wonder that, at a time when America was producing the fiery Malcolms, Karengas, Carmichaels, Rap Browns and the very concept of Black Power itself Britain was still churning out Black Sambos to whom going to the House of Lords and having tea with the Queen was the vogue? Isn't it a marvel that, even in the field of art, while the 'ever so horrible' America could boast of her Leroi Jones, Jimmy Baldwin, Lerone Bennett, Sidney Poitier, Cleaver, Sammy Davis Jr, Nina Simone, and countless czars of jazz, our tolerant England, though still boasting of her kinder patronage of Blacks, cannot produce a single Black name to match up with the Black brothers in the States? England has succeeded so well in freezing out her Black talents that the very concept of a Black producer of above Tower Theatre scope is a joke. Songs that owe their origin to unknown Black back-street night clubs in the ghettoes of England have frequently appeared in the top ten under the names of soulless White 'stars'.

Yet we Black men in England would be the first to tell you that we are happy. To prove this happiness to ourselves we go to the Q Club every night of the week to dance till the early hours of dawn. I have been there myself. It was always a staggering experience to arrive at the Q Club at midnight, to see the miracle. A crowd of what must verge on thousands would crowd into one hall, belly to belly, dancing wildly to the most-deafening system soul beats you ever heard. The noise, the shrieking, the sheer compact of teeming humanity, enough to make you dizzy, in that dimly lit place in the basement, so jammed that you couldn't even force your way through jostles of sweaty and swaying and jumping Black bodies, never failed to fill me with awe. Never in my life had I seen so many Black people in one place. Some go there just for the experience of it. And you always marvelled that there were so many Black youth in this country.

But the most astounding part of it was that the only thing that got us all there together was the music. Nothing else could have done it. Nothing else could do it. Only music and dancing. And we danced and we danced and we danced. But we all danced till nothing else mattered, till all the sorrows in the world dissolved in the mist of our perspiration. Still we danced. We shook our heads, gyrated our hips, tears running down our eyes, while the girls, mini-skirted and nearly topless, danced in a frenzy till their nipples flicked out and their undies tore like sacks. We danced. We were like people in a trance. Which we were.

We had become Zorbas without realizing it. Like Zorba the Greek, we were dancing when we should be crying. Like Zorba the dreamer, we were signing our death warrant with the soles of our feet. At the funeral of his only son, Dimitri, Zorba had danced away while everybody else was crying. Asked why he danced, he said that it was the only thing that stopped the pain he felt in his soul. The test of every philosophy lies in the kind of man it produces. What sort of man is Zorba the Greek? He is a failure. He dreams lofty dreams which never ever materialise. He has gigantic ambitions which die stillborn. He watches every dream in his life turn into a nightmare. He has a Midas complex in reverse, with everything he touches turning to clay and crumbling to dust. He leaves destruction wherever he goes and ruins every man who takes him into his confidence, including the woman he marries, let alone himself. Zorba is a tragedy dancing on two legs, and he fails because he abuses pain.

The moral lesson to draw from Zorba's life relevant to me is that pain cannot be sublimated through dancing and laughter. And no man attempts it without caving in.

You cannot eliminate human tragedy by pumping laughing gas into the catastrophies of a long-suffering people. As I have said more than once, the primary function of pain, in a normal man, is to give the sufferer the hardihood to isolate himself psychologically from the men who cause him torture and fight them till he frees himself from them physically.

You cannot fight your tormentor with your feet. The shrewd White monopolists know this. That is why they grant the Black man the monopoly of 'soul'. That is why 'soul' has become a thriving Black concern and the one avenue of existence where the Black man can wear a crown. It is only in the pop world that we have a superabundance of Black 'Kings' and 'Dukes' and 'Barons' and 'Knights' and 'Queens' and 'Princes' and every conceivable acme of nobility. But there are no Black Kings alive today in the realm of reality. The only sort of King the Black man is allowed to be is the Zorba King. The White man knows that as long as we Black men dance, that as long as we continue to sublimate our revolutionary energy stamping the floor, he is safe. There is nothing wrong of course with the White man being safe. The only trouble is that as long as one's exploiter remains safe, and one does nothing but go through life dancing, singing, gasping, and screaming 'Baby, baby, baby', one might wind up a baby at forty. And a baby at forty is a baby forever. If a person spends too much of his life cooing 'Baby, baby, baby', he might lose the ability to be a man. He might even forget how.

Yet there we all were. Dancing, cooing, gyrating, saying it loud, and, in the final analysis, socking it to nobody but ourselves.

Those of us who suggested Black Power as the healthier therapy for our insecurity were hated like poison. We were hated because we reminded the black Zorbas of that aspect of their personality they wished to forget. The Black Zorba had come to England to forget his Blackness. Like the snake shedding off its unwanted skin, the Black Zorba had left his jinxed Black skin behind him in the colonies and had come to England to integrate into the security of Whiteness. And now, these Black Power 'rascals' had come along to ruin everything. We were despised, jeered at, and labelled 'trouble-makers'. To make sure they were in no way identified with us, we were ostracized, isolated, and referred to as the 'irresponsible minority who did not represent the major-ity of the British Black population. And to lend credibility to our 'irresponsibility', every sort of accusation was brought against us. We were called pimps, ponces, thugs, thieves, ghetto hustlers, exhibitionists, rapists, con men, publicity seekers, junkies, and every foul name in the world. Nothing we did was ever right. If we did not go out with White girls, we were called bloody racists. When we went out with White girls, we were called bloody hypocrites. From time to time, mysterious and often libellous leaflets were printed and circulated to 'expose' us in which the most virulent and far-fetched accusations were made. The psychology of the Black Zorba made him a heaven-sent gift to the police who were desperate for Black informers and especially Black saboteurs whose job was to infiltrate the Black Power movement and, exploiting the explosive internal contradictions often inevitable at the formative stage of any young political organization to foment splits, eliminate the 'dangerous' leaders by alienating them from the masses with malicious confidence-shaking gossips and rumours, and reducing Black Power activity to bickerings of frustrated and pathologic-ally ever-suspicious individuals and mere politics of impotence. There was nothing the Black Zorba wouldn't do to see the last of Black Power.

What he hated most was its policy of positive non-integration. He found this most detestable because it stood between him and the imaginary White man's status he had come to White England to attain through the bridge of integration. His favourite argument was always that 'England is not the place for Black Power.' And that no Black organization without White membership, patronage and blessing had any chance of survival in a White country.

Because we would not accept White members in the Black Power movement, we soon acquired the reputation of 'Black racists.' And the Black Zorbas found it a good excuse for redoubling their aversion towards us, because they would have 'nothing to do with racists, White or Black.'

But the fact remains that our objectives in the Black Power movement were far from racist. None of our policies was derived from emotional motivations. Our every policy was a consequence of a passionless analysis of the society in which we live and the history of revolutions.

From *The Voice of Black Power in Britain* (London: Granada, 1971). © HarperCollins Publishers 1971.

6

THE LIBERATION OF THE BLACK INTELLECTUAL

A. Sivanandan

> Wherever colonisation is a fact, the indigenous culture begins to rot. And among the ruins something begins to be born which is not a culture but a kind of subculture, a subculture which is condemned to exist on the margin allowed by a European culture. This then becomes the province of a few men, the elite, who find themselves placed in the most artificial conditions, deprived of any revivifying contact with the masses of the people.
>
> (Aimé Césaire)[1]

On the margin of European culture, and alienated on his own, the 'coloured' intellectual is an artefact of colonial history, marginal man par excellence. He is a creature of two worlds, and of none. Thrown up by a specific history, he remains stranded on its shores even as it recedes. And what he comes into is not so much a twilight world, as a world of false shadows and false light.

At the height of colonial rule, he is the servitor of those in power, offering up his people in return for crumbs of privilege; at its end, he turns servant of the people, negotiating their independence even as he attains to power. Outwardly, he favours that part of him which is turned towards his native land. He puts on the garb of nationalism, vows a return to tradition. He helps design a national flag, compose a People's Anthem. He puts up with the beat of the tom-tom and the ritual of the circumcision ceremony. But privately, he lives in the manner of his masters, affecting their style and their values, assuming their privileges and status. And for a while he succeeds in holding these two worlds together, the outer and the inner, deriving the best of both. But the forces of nationalism on the one hand and the virus of colonial privilege on the other, drive him once more into the margin of existence. In despair he turns himself to Europe. With something like belonging, he looks towards the Cathedral at Chartres and Windsor Castle, Giambologna and Donizetti and Shakespeare and Verlaine, snowdrops and roses. He must be done, once and for all, with the waywardness and uncouth manners of his people, released from their endemic ignorance, delivered from witchcraft and voodoo, from the heat and the chattering mynah-bird, from the incessant beat of the tom-tom. He must return to the country of his mind.

But even as the 'coloured' intellectual enters the mother-country, he is entered into another world where his colour, and not his intellect or his status, begins to define his life – he is entered into another relationship with himself. The porter (unless he is

black), the immigration officer (who is never anything but white), the customs official, the policeman of whom he seeks directions; the cabman who takes him to his lodgings, and the landlady who takes him in at a price – none of them leaves him in any doubt that he is not merely not welcome in their country, but should in fact be going back – to where he came from. That indeed is their only curiosity, their only interest: where he comes from, which particular jungle, Asian, African or Caribbean.

There was a time when he had been received warmly, but he was at Oxford then and his country was still a colony. Perhaps equality was something that the British honoured in the abstract. Or perhaps his 'equality' was something that was precisely defined and set within the enclave of Empire. He had a place somewhere in the imperial class structure. But within British society itself there seemed no place for him. Not even his upper-class affectations, his BBC accent, his well-pressed suit and college tie afford him a niche in the carefully defined inequalities of British life. He feels himself not just an outsider or different, but invested, as it were, with a separate inequality: outside and inferior at the same time.

At that point, his self-assurance which had sat on him 'like a silk hat on a Bradford millionaire'[2] takes a cruel blow. But he still has his intellect, his expertise, his qualifications to fall back on. He redeems his self-respect with another look at his Oxford diploma (to achieve which he had put his culture in pawn). But his applications for employment remain unanswered, his letters of introduction unattended. It only needs the employment officer's rejection of his qualifications, white though they be, to dispel at last his intellectual pretensions.

The certainty finally dawns on him that his colour is the only measure of his worth, the sole criterion of his being. Whatever his claims to white culture and white values, whatever his adherence to white norms, he is first and last a no-good nigger, a bleeding wog or just plain black bastard. His colour is the only reality allowed him; but a reality which, to survive, he must cope with. Once more he is caught between two worlds: accepting his colour and rejecting it, or accepting it only to reject it – aping still the white man (though now with conscious effort at survival), playing the white man's game (though now aware that he changes the rules so as to keep on winning), even forcing the white man to concede a victory or two (out of his hideous patronage, his grotesque paternalism). He accepts that it is their country and not his, rationalizes their grievances against him, acknowledges the chip on his shoulder (which he knows is really a beam in their eye), and, ironically by virtue of staying in his place, moves up a position or two – in the area, invariably, of race relations.[3] For it is here that his skilled ambivalence finds the greatest scope, his colour the greatest demand. Once more he comes into his own – as servitor of those in power, a buffer between them and his people, a shock-absorber of 'coloured discontent' – in fact, a 'coloured' intellectual.

But this is an untenable position. As the racial 'scene' gets worse, and racism comes to reside in the very institutions of white society, the contradictions inherent in the marginal situation of the 'coloured' intellectual begin to manifest themselves. As a 'coloured' he is outside white society, in his intellectual functions he is outside black. For if, as Sartre has pointed out, 'that which defines an intellectual . . . is the profound contradiction between the universality which bourgeois society is obliged to allow his scholarship, and the restricted ideological and political domain in which he is forced to apply it',[4] there is for the 'coloured' intellectual no role in an 'ideological and political

domain', shot through with racism, which is not fundamentally antipathetic to his colour and all that it implies. But for that very reason, his contradiction, in contrast to that of his white counterpart, is perceived not just intellectually or abstractly, but in his very existence. It is for him, a living, palpitating reality, demanding resolution.

Equally, the universality allowed his scholarship is, in the divided world of a racist society, different to that of the white intellectual. It is a less universal universality, as it were, and subsumed to the universality of white scholarship. But it is precisely because it is a universality that is particular to colour that it is already keened to the sense of oppression. So that when Sartre tells us that the intellectual, in grasping his contradictions, puts himself on the side of the oppressed ('because, in principle, universality is on that side'),[5] it is clear that the 'coloured' intellectual, at the moment of grasping his contradictions, *becomes* the oppressed – is reconciled to himself and his people, or rather, to himself in his people.

To put it differently. Although the intellectual *qua* intellectual can, in 'grasping his contradiction', take the *position* of the oppressed, he cannot, by virtue of his class (invariably petty-bourgeois) achieve an instinctual understanding of oppression. The 'coloured' man, on the hand, has, by virtue of his colour, an *instinct* of oppression, unaffected by his class, though muted by it. So that the 'coloured' intellectual, in resolving his contradiction as an intellectual, resolves also his existential contradiction. In coming to consciousness of the oppressed, he 'takes conscience of himself',[6] in taking conscience of himself, he comes to consciousness of the oppressed. The fact of his intellect which had alienated him from his people now puts him on their side, the fact of his colour which had connected him with his people, restores him finally to their ranks. And at that moment of reconciliation between instinct and position, between the existential and the intellectual, between the subjective and objective realities of his oppression, he is delivered from his marginality and stands revealed as neither 'coloured' nor 'intellectual' – but BLACK.[7]

He accepts now the full burden of his colour. With Césaire, he cries:

I accept . . . I accept . . . entirely, without reservation . . .
my race which no ablution of hyssop mingled with lilies can ever purify

my race gnawed by blemishes
my race ripe grapes from drunken feet
my queen of spit and leprosies
my queen of whips and scrofulae
my queen of squamae and chlosmae
(O royalty whom I have loved in the far gardens of spring lit by chestnut candles!)
I accept. I accept.[8]

And accepting, he seeks to define. But black, he discovers, finds definition not in its own right but as the opposite of white.[9] Hence in order to define himself, he must first define the white man. But to do so on the white man's terms would lead him back to self-denigration. And yet the only tools of intellection available to him are white tools – white language, white education, white systems of thought – the very things that alienate him from himself. Whatever tools are native to him lie beyond his consciousness somewhere, condemned to disuse and decay by white centuries. But to use white

tools to uncover the white man so that he (the black) may at last find definition requires that the tools themselves are altered in their use. In the process, the whole of white civilization comes into question, black culture is reassessed, and the very fabric of bourgeois society threatened.

Take language, for instance. A man's whole world, as Fanon points out, is 'expressed and implied by his language':[10] it is a way of thinking, of feeling, of be-ing. It is identity. It is, in Valéry's grand phrase, 'the god gone astray in the flesh'.[11] But the language of the colonized man is another man's language. In fact it is his oppressor's and must, of its very nature, be inimical to him – to his people and his gods. Worse, it creates alien gods. Alien gods 'gone astray in the flesh' – white gods in black flesh – a canker in the rose. No, that is not quite right, for white gods, like roses, are beautiful things, it is the black that is cancerous. So one should say a 'rose in the canker'. But that is not quite right either – neither in its imagery nor in what it is intended to express. How does one say it then? How does one express the holiness of the heart's disaffection (*pace* Keats) and 'the truth of the imagination' in a language that is false to one? How does one communicate the burden of one's humanity in a language that dehumanises one in the very act of communication?

Two languages, then, one for the colonizer and another for the colonized – and yet within the same language? How to reconcile this ambivalence? A patois, perhaps: a spontaneous, organic rending of the masters' language to the throb of native sensibilities – some last grasp at identity, at wholeness.

But dialect betrays class. The 'pidgin-nigger-talker' is an ignorant man. Only common people speak pidgin. Conversely, when the white man speaks it, it is only to show the native how common he really is. It is a way of 'classifying him, imprisoning him, primitivising him'.[12]

Or perhaps the native has a language of his own; even a literature. But compared to English (or French) his language is dead, his literature passé. They have no place in a modern, industrialized world. They are for yesterday's people. Progress is English, education is English, the good things in life (in the world the colonizer made) are English, the way to the top (and white civilization leaves the native in no doubt that that is the purpose of life) is English. His teachers see to it that he speaks it in school, his parents that he speaks it at home – even though they are rejected by their children for their own ignorance of *the* tongue.

But if the colonizer's language creates an 'existential deviation'[13] in the native, white literature drives him further from himself. It disorientates him from his surroundings: the heat, the vegetation, the rhythm of the world around him. Already, in childhood, he writes school essays on 'the season of mists and mellow fruitfulness'. He learns of good and just government from Rhodes and Hastings and Morgan. In the works of the great historian Thomas Carlyle, he finds that 'poor black Quashee . . . a swift supple fellow, a merry-hearted, grinning, dancing, singing, affectionate kind of creature' could indeed be made into a 'handsome glossy thing' with a 'pennyworth of oil', but 'the tacit prayer he makes (unconsciously he, poor blockhead) to you and to me and to all the world who are wiser than himself is "compel me"' – to work.[14] In the writings of the greatest playwright in the world, he discovers that he is Caliban and Othello and Aaron, in the testaments of the most civilized religion that he is for ever cursed to slavery. With William Blake, the great revolutionary poet and painter, mystic and savant, he is convinced that:

My mother bore me in the southern wild,
And I am black, but O! my soul is white;
White as an angel is the English child,
But I am black, as if bereav'd of light.[15]

Yet, this is the man who wrote 'The Tyger'. And the little black boy, who knows all about tigers, understands the great truth of Blake's poem, is lost in wonderment at the man's profound imagination. What then of the other Blake? Was it only animals he could imagine himself into? Did he who wrote 'The Tyger' write 'The Little Black Boy'?

It is not just the literature of the language, however, that ensnares the native into 'whititude', but its grammar, its syntax, its vocabulary. They are all part of the trap. Only by destroying the trap can he escape it. 'He has', as Genet puts it, 'only one recourse: to accept this language but to corrupt it so skilfully that the white men are caught in his trap.'[16] He must blacken the language, suffuse it with his own darkness, and liberate it from the presence of the oppressor.

In the process, he changes radically the use of words, word-order – sounds, rhythm, imagery – even grammar. For, he recognizes with Laing that even 'syntax and vocabulary are political acts that define and circumscribe the manner in which facts are experienced, [and] indeed . . . create the facts that are studied'.[17] In effect he brings to the language the authority of his particular experience and alters thereby the experience of the language itself. He frees it of its racial oppressiveness (black *is* beautiful), invests it with 'the universality inherent in the human condition'.[18] And he writes:

As there are hyena-men and panther-men
so I shall be a Jew man
a Kaffir man
a Hindu-from-Calcutta man
a man-from-Harlem-who-hasn't-got-the-vote.[19]

The discovery of black identity had equated the 'coloured' intellectual with himself, the definition of it equates him with all men. But it is still a definition arrived at by negating a negative, by rejecting what is not. And however positive that rejection, it does not by itself make for a positive identity. For that reason, it tends to be self-conscious and overblown. It equates the black man to other men on an existential (and intellectual) level, rather than on a political one.

But to 'positivize' his identity, the black man must go back and rediscover himself – in Africa and Asia – not in a frenetic search for lost roots, but in an attempt to discover living tradition and values. He must find, that is, a historical sense, 'which is a sense of the timeless as well as the temporal, and of the timeless and temporal together'[20] and which 'involves a perception not only of the pastness of the past, but of its presence'.[21] Some of that past he still carries within him, no matter that it has been mislaid in the Caribbean for over four centuries. It is the presence of that past, the living presence, that he now seeks to discover. And in discovering where he came from he realizes more fully where he is at, and where, in fact, he is going to.

He discovers, for instance, that in Africa and Asia, there still remains, despite centuries of white rule, an attitude towards learning which is simply a matter of curiosity,

a quest for understanding – an understanding of not just the 'metalled ways' on which the world moves, but of oneself, one's people, others whose life styles are alien to one's own – an understanding of both the inscape and fabric of life. Knowledge is not a goal in itself, but a path to wisdom; it bestows not privilege so much as duty, not power so much as responsibility. And it brings with it a desire to learn even as one teaches, to teach even as one learns. It is used not to compete with one's fellow beings for some unending standard of life, but to achieve for them, as for oneself, a higher quality of life.

'We excel', declares the African,

> neither in mysticism nor in science and technology, but in the field of human relations . . . By loving our parents, our brothers, our sisters and cousins, aunts, uncles, nephews and nieces, and by regarding them as members of our families, we cultivate the habit of loving lavishly, of exuding human warmth, of compassion, and of giving and helping . . . Once so conditioned, one behaves in this way not only to one's family, but also to the clan, the tribe, the nation, and to humanity as a whole.[22]

Chisiza is here speaking of the unconfined nature of love in African (and Asian) societies (not, as a thousand sociologists would have us believe, of 'the extended family system'), in marked contrast to Western societies where the love between a man and a woman (and their children) is sufficient unto itself, seldom opening them out, albeit through each other, to a multitude of loves. The heart needs the practice of love as much as the mind its thought.

The practical expression of these values is no better illustrated than in the socialist policies of Nyerere's Tanzania. It is a socialism particular to African conditions, based on African tradition, requiring an African (Swahili) word to define it. *Ujamaa* literally means 'familyhood'. 'It brings to the mind of our people the idea of mutual involvement in the family as we know it'.[23] And this idea of the family is the sustaining principle of Tanzanian society. It stresses co-operative endeavour rather than individual advancement. It requires respect for the traditional knowledge and wisdom of one's elders, illiterate though they be, no less than for academic learning. But the business of the educated is not to fly away from the rest of society on the wings of their skills, but to turn those skills to the service of their people. And the higher their qualifications, the greater their duty to serve. 'Intellectual arrogance', the Mwalimu has declared, 'has no place in a society of equal citizens.'[24]

The intellectual, that is, has no special privilege in such a society. He is as much an organic part of the nation as anyone else. His scholarship makes him no more than other people and his functions serve no interest but theirs. There is no dichotomy here between status and function. Hence he is not presented with the conflict between the universal and the particular of which Sartre speaks. And in that sense he is not an intellectual but everyman.

The same values obtain in the societies of Asia, sustained not so much by the governments of the day as in the folklore and tradition of their peoples. The same sense of 'family-hood', of the need to be confirmed by one's fellow man, the notion of duty as opposed to privilege, the preoccupation with truth rather than fact and a concept of life directed to the achievement of unity in diversity, characterise the Indian ethos. One has

only to look at Gandhi's revolution to see how in incorporating, in its theory and its practice, the traditions of his people, a 'half-naked fakir' was able to forge a weapon that took on the whole might of the British empire and beat it. Or one turns to the early literature and art of India and finds there that the poet is less important than his poem, the artist more anonymous than his art. As Benjamin Rowland remarks: 'Indian art is more the history of a society and its needs than the history of individual artists.'[25] The artist, like any other individual, intellectual or otherwise, belongs to the community, not the community to him. And what he conveys is not so much his personal experience of truth as the collective vision of a society of which he is part, expressed not in terms private to him and his peers, but in familiar language – or in symbols, the common language of truth.

In Western society, on the other hand, art creates its own coterie. It is the province of the specially initiated, carrying with it a language and a life-style of its own, even creating its own society. It sets up cohorts of interpreters and counter-interpreters, middlemen, known to the trade as *critics*, who in disembowelling his art show themselves more powerful, more creative than the artist. It is they who tell the mass of the people how they should experience art. And the more rarified it is, more removed from the experience of the common people, the greater is the artist's claim to *art* and the critic's claim to authority. Did but the artist speak directly to the people and from them, the critic would become irrelevant, and the artist symbiotic with his society.

It is not merely in the field of art, however, that Western society shows itself fragmented, inorganic and expert-oriented. But the fact that it does so in the noblest of man's activities is an indication of the alienation that such a society engenders in all areas of life. In contrast to the traditions of Afro-Asian countries, European civilization appears to be destructive of human love and cynical of human life. And nowhere do these traits manifest themselves more clearly than in the attitude towards children and the treatment of the old. Children are not viewed as a challenge to one's growth, the measure of one's possibilities, but as a people apart, another generation, with other values, other standards, other aspirations. At best one keeps pace with them, puts on the habit of youth, feigns interest in their interests, but seldom if ever comprehends them. Lacking openness and generosity of spirit, the ability to live dangerously with each other, the relationship between child and adult is rarely an organic one. The adult occupies the world of the child far more than the child occupies the world of the adult. In the result, the fancy and innocence of children are crabbed and soured by adulthood even before they are ready to beget choice.

Is it any wonder then that this tradition of indifference should pass on back to the old from their children? But it is a tradition that is endemic to a society given to ceaseless competition and ruthless rivalry – where even education is impregnated with the violence of divisiveness, and violence itself stems not from passion (an aspect of the personal), but from cold and calculated reason (an aspect of the impersonal). When to get and to spend is more virtuous than to be and to become, even lovers cannot abandon themselves to each other, but must work out the debit and credit of emotion, a veritable balance-sheet of love. Distrust and selfishness and hypocrisy in personal relationships, and plain cruelty and self-aggrandizement in the art of government are the practice of such a society, however elevating its principles. Government itself is the art of keeping power from the people under the guise of the people's will. And the

working people themselves are inveigled into acquiescence of the power structure by another set of middlemen: the union bosses.

In the face of all this, the black man in a white society – the black man, that is, who has 'taken conscience of himself', established at last a positive identity – comes to see the need for radical change in both the values and structure of that society. But even the revolutionary ideologies that envisage such a change are unable to take into their perspective the nature of his particular oppression and its implications for revolutionary strategy. White radicals continue to maintain that colour oppression is no more than an aspect of class oppression, that colour discrimination is only another aspect of working class exploitation, that the capitalist system is the common enemy of the white worker and black alike. Hence they require that the colour line be subsumed to the class line and are satisfied that the strategies worked out for the white proletariat serve equally the interests of the black. The black struggle, therefore, should merge with and find direction from the larger struggle of the working class as a whole. Without white numbers, anyway, the black struggle on its own would be unavailing.

But what these radicals fail to realize is that the black man, by virtue of his particular oppression, is closer to his bourgeois brother (by colour) than to his white comrade. Indeed his white comrade is a party to his oppression. He too benefits from the exploitation of the black man, however indirectly, and tends to hold the black worker to areas of work which he himself does not wish to do, and from areas of work to which he himself aspires, irrespective of skill. In effect, the black workers constitute that section of the working class which is at the very bottom of society and is distinguished by its colour. Conversely, the attitude of racial superiority on the part of white workers relegates their black comrades to the bottom of society. In the event, they come to constitute a class apart, an under-class: the sub-proletariat. And the common denominator of capitalist oppression is not sufficient to bind them together in a common purpose.

A common understanding of racial oppression, on the other hand, ranges the black worker on the side of the black bourgeois against their common enemy: the white man, worker and bourgeois alike.

In terms of analysis, what the white Marxists fail to grasp is that the slave and colonial exploitation of the black peoples of the world was so total and devastating – and so systematic in its devastation – as to make mock of working-class exploitation. Admittedly, the economic aspects of colonial exploitation may find analogy in white working-class history. But the cultural and psychological dimensions of black oppression are quite unparalleled. For, in their attempt to rationalize and justify to their other conscience 'the robbery, enslavement, and continued exploitation of their coloured victims all over the globe',[26] the conquistadors of Europe set up such a mighty edifice of racial and cultural superiority, replete with its own theology of goodness, that the natives were utterly disoriented and dehumanized. Torn from their past, reified in the present, caught for ever in the prison of their skins, accepting the white man's definition of themselves as 'quintessence of evil . . . representing not only the absence of values but the negation of values . . . the corrosive element disfiguring all that has to do with beauty or morality',[27] violated and sundered in every aspect of their being, it is a wonder that, like lemmings, they did not throw themselves in the sea. If the white workers' lot at the hands of capitalism was alienation, the blacks underwent complete deracination. And it is this factor which makes black oppression qualitatively different from the oppression of the white working class.

The inability of white Marxists to accept the full import of such an analysis on the part of black people may be alleged to the continuing paternalism of a culture of which they themselves are victims. (Marxism, after all, was formulated in a European context and must, on its own showing, be Eurocentric.) Or it may be that to understand fully the burden of blackness, they require the imagination and feeling systematically denied them by their culture. But more to the point is that, in their preoccupation with the economic factors of capitalist oppression, they have ignored the importance of its existential consequences, in effect its consequences to culture. The whole structure of white racism is built no doubt on economic exploitation, but it is cemented with white culture. In other words, the racism inherent in white society is *determined* economically, but *defined* culturally. And any revolutionary ideology that is relevant to the times must envisage not merely a change in the ownership of the means of production, but a definition of that ownership: who shall own, whites only or blacks as well? It must envisage, that is, a fundamental change in the concepts of man and society contained in white culture – it must envisage a revolutionary culture. For, as Gramsci has said, revolutionary theory requires a revolutionary culture.

But to revolutionise a culture, one needs first to make a radical assessment of it. That assessment, that revolutionary perspective, by virtue of his historical situation, is provided by the black man. For it is with the cultural manifestations of racism in his daily life that he must contend. Racial prejudice and discrimination, he recognizes, are not a matter of individual attitudes, but the sickness of a whole society carried in its culture. And his survival as a *black* man in white society requires that he constantly questions and challenges every aspect of white life even as he meets it. White speech, white schooling, white law, white work, white religion, white love, even white lies – they are all measured on the touchstone of his experience. He discovers, for instance, that white schools make for white superiority, that white law equals one law for the white and another for the black, that white work relegates him to the worst jobs irrespective of skill, that even white Jesus and white Marx who are supposed to save him are really not in the same street, so to speak, as black Gandhi and black Cabral. In his everyday life he fights the particulars of white cultural superiority, in his conceptual life he fights the ideology of white cultural hegemony. In the process he engenders not perhaps a revolutionary culture, but certainly a revolutionary practice within that culture.

For that practice to blossom into a revolutionary culture, however, requires the participation of the masses, not just the blacks. This does not mean, though, that any ad hoc coalition of forces would do. Coalitions, in fact, are what will not do. Integration, by any other name, has always spelt death – for the blacks. To integrate with the white masses before they have entered into the practice of cultural change would be to emasculate the black cultural revolution. Any integration at this stage would be a merging of the weaker into the stronger, the lesser into the greater. The weakness of the blacks stems from the smallness of their numbers, the 'less-ness' from the bourgeois cultural consciousness of the white working class. Before an organic fusion of forces can take place, two requirements need to be fulfilled. The blacks must through the consciousness of their colour, through the consciousness, that is, of that in which they perceive their oppression, arrive at a consciousness of class; and the white working class must in recovering its class instinct, its sense of oppression, both from technological alienation and a white-oriented culture, arrive at a consciousness of racial oppression.

For the black man, however, the consciousness of class is instinctive to his

consciousness of colour.[28] Even as he begins to throw away the shackles of his particular slavery, he sees that there are others besides him who are enslaved too. He sees that racism is only one dimension of oppression in a whole system of exploitation and racial discrimination, the particular tool of a whole exploitative creed. He sees also that the culture of competition, individualism and elitism that fostered his intellect and gave it a habitation and a name is an accessory to the exploitation of the masses as a whole, and not merely of the blacks. He understands with Gramsci and George Jackson that 'all men are intellectuals'[29] or with Angela Davis that no one is. (If the term means anything it is only as a description of the work one does: the intellect is no more superior to the body than the soul to the intellect.) He realizes with Fanon that 'the Negro problem does not resolve into the problem of Negroes living among white men, but rather of Negroes exploited, enslaved, despised by a colonialist, capitalist society that is only accidentally white'.[30] He acknowledges at last that inside every black man there is a working-class man waiting to get out.

In the words of Sartre, 'at a blow the subjective, existential, ethnic notion of blackness[31] passes, as Hegel would say, into the objective, positive, exact notion of the proletariat ... "The white symbolises capital as the Negro labour ... Beyond the black-skinned men of his race it is the struggle of the world proletariat that he sings".'[32]

And he sings:

I want to be of your race alone
workers peasants of all lands
... white worker in Detroit black peon in Alabama
uncountable nation in capitalist slavery
destiny ranges us shoulder to shoulder
repudiating the ancient malediction of blood taboos
we roll among the ruins of our solitudes
If the flood is a frontier
we will strip the gully of its endless
covering flow
If the Sierra is a frontier
we will smash the jaws of the volcanoes
upholding the Cordilleras
and the plain will be the parade ground of the dawn
where we regroup our forces sundered
by the deceits of our masters
As the contradictions among the features
creates the harmony of the face
we proclaim the oneness of suffering
and the revolt
of all the peoples on all the face of the earth
and we mix the mortar of the age of brotherhood
out of the dust of idols.[33]

Notes

1 Aimé Césaire, in his address to the Congress of Black Writers and Artists, Paris, 1956, reported in 'Princes and Powers', in James Baldwin, *Nobody Knows My Name* (London, 1961).
2 T. S. Eliot, 'The Waste Land', in *Collected Poems, 1909–1962* (London, 1963).
3 The British media uses the 'coloured intellectual', whatever his or her field of work, as white Africa uses the Chief: as a spokesman for his tribe.
4 Jean-Paul Sartre, 'Intellectuals and Revolution: Interview', *Ramparts* 9, 6 (December 1970): 52–5.
5 Ibid.
6 Jean-Paul Sartre, *Black Orpheus* (Paris, n.d).
7 Black is here used to symbolize the oppressed, as white the oppressor. Colonial oppression was uniform in its exploitation of the races (black, brown and yellow) making a distinction between them only in the interest of further exploitation – by playing one race against the other and, within each race, one class against the other – generally the Indians against the blacks, the Chinese against the browns, and the coolies against the Indian and Chinese middle class. In time these latter came to occupy, in East Africa and Malaysia for example, a position akin to a comprador class. Whether it is this historical fact which today makes for their comprador role in British society is not, however, within the scope of this essay. But it is interesting to note how an intermediate colour came to be associated with an intermediate role.
8 Aimé Césaire, *Return to My Native Land* (Harmondsworth, 1969).
9 'Black: opposite to white.' *Concise Oxford Dictionary*. 'White: morally or spiritually pure or stainless, spotless, innocent. Free from malignity or evil intent, innocent, harmless esp, as opp. to something characterised as *black*.' *Shorter Oxford Dictionary*.
10 Frantz Fanon, *Black Skin, White Masks* (London, 1968).
11 Paul Valéry, quoted in Fanon *Black Skin*.
12 Fanon, *Black Skin*.
13 Ibid.
14 Thomas Carlyle, 'Occasional Discourse on the Nigger Question', in *Latter Day Pamphlets* (London, n.d).
15 William Blake, from 'Songs of Innocence', in J. Bronowski (ed.), *A Selection of Poems and Letters* (Harmondsworth, 1958).
16 Jean Genet, Introduction to *Soledad Brother: the Prison Letters of George Jackson* by George Jackson (London, 1970).
17 R. D. Laing, *Politics of Experience and Bird of Paradise* (Harmondsworth, 1970).
18 Fanon, *Black Skin*.
19 Césaire, *Return*.
20 T. S. Eliot, 'Tradition and the Individual Talent', in *The Sacred Wood: Essays on Poetry and Criticism* (London, 1934).
21 Ibid.
22 Dunduzu Chisiza, 'The Outlook for Contemporary Africa', in *Journal of Modern African Studies* 1, 1 (March 1963): 25–38.
23 Julius K. Nyerere, *Uhuru na Ujamaa: Freedom and Socialism: A Selection from Writings and Speeches, 1965–67* (Dar-es-Salaam, 1968).
24 Ibid.
25 Benjamin Rowland, *Art and Architecture of India: Hindu, Buddhist, Jain* (Harmondsworth, 1970).
26 Paul A. Baran, and Paul M. Sweezy, *Monopoly Capital: An Essay on the American Economic and Social Order* (Harmondsworth, 1968).
27 Frantz Fanon, *The Wretched of the Earth* (London, 1965).
28 He may, of course, become frozen in a narrow cultural nationalism of his own in violent reaction to white culture.
29 Antonio Gramsci, 'The Formation of Intellectuals', in *The Modern Prince and Other Writings* (New York, 1957).
30 Fanon, *Black Skin*.

31 'Negritude' in the original French.
32 Sartre, *Black Orpheus.*
33 Jacques Roumain, quoted in Fanon, *Black Skin.*

From *Race & Class* 18, 4 (1977). First published as 'Alien Gods', in *Colour Culture and Consciousness* (London: Allen & Unwin, 1974).

7

WHITE WOMAN LISTEN!

Black feminism and the boundaries of sisterhood

Hazel V. Carby

The black women's critique of *his*tory has not only involved us in coming to terms with 'absences'; we have also been outraged by the ways in which it has made us visible, when it has chosen to see us. *His*tory has constructed our sexuality and our femininity as deviating from those qualities with which white women, as the prize objects of the Western world, have been endowed. We have also been defined in less than human terms.[1] We cannot hope to constitute ourselves in all our absences, or to rectify the ill-conceived presences that invade herstory from *his*tory, but we do wish to bear witness to our own herstories. The connections between these and the herstories of white women will be made and remade in struggle. Black women have come from Africa, Asia and the Caribbean and we cannot do justice to all their herstories in a single chapter. Neither can we represent the voices of all black women in Britain, our herstories are too numerous and too varied. What we will do is to offer ways in which the 'triple' oppression of gender, race and class can be understood, in their specificity, and also as they determine the lives of black women.

Much contemporary debate has posed the question of the relation between race and gender, in terms which attempt to parallel race and gender divisions. It can be argued that as processes, racism and sexism are similar. Ideologically for example, they both construct common sense through reference to 'natural' and 'biological' differences. It has also been argued that the categories of race and gender are both socially constructed and that, therefore, they have little internal coherence as concepts. Furthermore, it is possible to parallel racialized and gendered divisions in the sense that the possibilities of amelioration through legislation appear to be equally ineffectual in both cases. Michèle Barrett, however, has pointed out that it is not possible to argue for parallels because as soon as historical analysis is made, it becomes obvious that the institutions which have to be analysed are different, as are the forms of analysis needed.[2] We would agree that the construction of such parallels is fruitless and often proves to be little more than a mere academic exercise; but there are other reasons for our dismissal of these kinds of debate. The experience of black women does not enter the parameters of parallelism. The fact that black women are subject to the *simultaneous* oppression of patriarchy, class and 'race' is the prime reason for not employing parallels that render their position and experience not only marginal but also invisible.

We can point to no single source for our oppression. When white feminists

emphasize patriarchy alone, we want to redefine the term and make it a more complex concept. Racism ensures that black men do not have the same relations to patriarchal/capitalist hierarchies as white men.

It is only in the writings by black feminists that we can find attempts to theorize the interconnection of class, gender and race as it occurs in our lives and it has only been in the autonomous organizations of black women that we have been able to express and act upon the experiences consequent upon these determinant . . . Black feminists have been, and are still, demanding that the existence of racism must be acknowledged as a structuring feature of our relationships with white women. Both white feminist theory and practice have to recognize that white women stand in a power relation as oppressors of black women. This compromises any feminist theory and practice founded on the notion of simple equality.

Three concepts which are central to feminist theory become problematic in their application to black women's lives: 'the family', 'patriarchy' and 'reproduction'. When used they are placed in a context of the herstory of white (frequently middle-class) women and become contradictory when applied to the lives and experiences of black women. In a recent comprehensive survey of contemporary feminist theory, *Women's Oppression Today*, Michèle Barrett sees the contemporary family (effectively the family under capitalism) as the source of oppression of women.

We would not wish to deny that the family can be a source of oppression for us but we also wish to examine how the black family has functioned as a prime source of resistance to oppression. We need to recognize that during slavery, periods of colonialism and under the present authoritarian state, the black family has been a site of political and cultural resistance to racism. Furthermore, we cannot easily separate the two forms of oppression because racist theory and practice is frequently gender-specific. Ideologies of black female sexuality do not stem primarily from the black family. The way the gender of black women is constructed differs from constructions of white femininity because it is also subject to racism.

Black women are constantly challenging these ideologies in their day-to-day struggles. Asian girls in schools, for example, are fighting back to destroy the racist myth of their femininity. As Pratibha Parmar has pointed out, careers officers do not offer them the same interviews and job opportunities as white girls. This is because they believe that Asian girls will be forced into marriage immediately after leaving school.

The use of the concept of 'dependency' is also a problem for black feminists. It has been argued that this concept provides the link between the 'material organization of the household, and the ideology of femininity'. How then can we account for situations in which black women may be heads of households, or where, because of an economic system which structures high black male unemployment, they are not financially dependent upon a black man? This condition exists in both colonial and metropolitan situations. Ideologies of black female domesticity and motherhood have been constructed, through their employment (or chattel position) as domestics and surrogate mothers to white families rather than in relation to their own families. West Indian women still migrate to the United States and Canada as domestics and in Britain are seen to be suitable as office cleaners, National Health Service domestics, etc. In colonial situations Asian women have frequently been forced into prostitution to sexually service the white male invaders, whether in the form of armies of occupation or employees and guests of multinational corporations. How then, in view of all this, can it be

argued that black male dominance exists in the same forms as white male dominance? Systems of slavery, colonialism, imperialism, have systematically denied positions in the white male hierarchy to black men and have used specific forms of terror to oppress them.

Black family structures have been seen as pathological by the state and are in the process of being constructed as pathological within white feminist theory. Here, ironically, the Western nuclear family structure and related ideologies of 'romantic love' formed under capitalism, are seen as more 'progressive' than black family structures. An unquestioned commonsense racism constructs Asian girls and women as having absolutely no freedom, whereas English girls are thought to be in a more 'liberated' society and culture.

The media's 'horror stories' about Asian girls and arranged marriages bear very little relation to their experience. The 'feminist' version of this ideology presents Asian women as being in need of liberation, not in terms of their own herstory and needs, but *into* the 'progressive' social mores and customs of the metropolitan West.

Too often concepts of historical progress are invoked by the left and feminists alike, to create a sliding scale of 'civilized liberties'. When barbarous sexual practices are to be described the 'Third World' is placed on display and compared to the 'First World' which is seen as more 'enlightened' or 'progressive'.

For example, in an article comparing socialist societies, Maxine Molyneux falls straight into this trap of 'Third Worldism' as 'backwardness'.[3] Molyneux implies that since 'Third World' women are outside of capitalist relations of production, entering capitalist relations is, necessarily, an emancipating move. This view of imperialism will be addressed in more detail later in the chapter. At this point we wish to indicate that the use of such theories reinforces the view that when black women enter Britain they are moving into a more liberated or enlightened or emancipated society than the one from which they have come.

If we take patriarchy and apply it to various colonial situations it is equally unsatisfactory because it is unable to explain why black males have not enjoyed the benefits of white patriarchy. There are very obvious power structures in both colonial and slave social formations and they are predominantly patriarchal. However, the historically specific forms of racism force us to modify or alter the application of the term 'patriarchy' to black men. Black women have been dominated 'patriarchally' in different ways by men of different 'colours'.

In questioning the application of the concepts of 'the family' and 'patriarchy' we also need to problematize the use of the concept of 'reproduction'. In using this concept in relation to the domestic labour of black women we find that in spite of its apparent simplicity it must be dismantled. What does the concept of reproduction mean in a situation where black women have done domestic labour outside of their own homes in the servicing of white families? In this example they lie outside of the industrial wage relation but in a situation where they are providing for the reproduction of black labour in their own domestic sphere, simultaneously ensuring the reproduction of white labour power in the 'white' household. The concept, in fact, is unable to explain exactly what the relations are that need to be revealed. What needs to be understood is, first, precisely *how* the black woman's role in a rural, industrial or domestic labour force affects the construction of ideologies of black female sexuality; and second, how this role relates to the black woman's struggle for control over her own sexuality.

If we examine the recent herstory of women in postwar Britain we can see the ways in which the inclusion of black women creates problems for hasty generalization. In pointing to the contradiction between 'homemaking as a career' and the campaign to recruit women into the labour force during postwar reconstruction, Elizabeth Wilson[4] fails to perceive migration of black women to Britain as the solution to these contradictory needs.

Black women were recruited more heavily into some of these areas than others. Afro-Caribbean women, for example, were encouraged and chose to come to Britain precisely to work. Ideologically they were seen as 'naturally' suitable for the lowest paid, most menial jobs. Elizabeth Wilson goes on to explain that 'work and marriage were still understood as alternatives . . . two kinds of women . . . a wife and a mother or a single career woman'.[5] Yet black women bridged this division. They were viewed simultaneously as workers and as wives and mothers. Elizabeth Wilson stresses that the postwar debate over the entry of women into the labour force occurred within the parameters of the question of possible effects on family life. She argues that 'wives and mothers were granted entry into paid work only so long as this did not harm the family'. Yet women from Britain's reserve army of labour in the colonies were recruited into the labour force far beyond any such considerations. Rather than a concern to protect or preserve the black family in Britain, the state reproduced commonsense notions of its inherent pathology: black women were seen to fail as mothers precisely because of their position as workers.

One important struggle, rooted in these different ideological mechanisms, which determine racially differentiated representations of gender, has been the black woman's battle to gain control over her own sexuality in the face of racist experimentation with the contraceptive Depo-Provera and enforced sterilizations.[6]

It is not just our herstory before we came to Britain that has been ignored by white feminists, our experiences and struggles here have also been ignored. These struggles and experiences, because they have been structured by racism, have been different to those of white women. Black feminists decry the non-recognition of the specificities of black women's sexuality and femininity, both in the ways these are constructed and also as they are addressed through practices which oppress black women in a gender-specific but none the less racist way.

Black feminists in the USA have complained of the ignorance, in the white women's movement, of black women's lives. In Britain too it is as if we don't exist. The accusation that racism in the women's movement acted so as to exclude the participation of black women, has led to an explosion of debate in the USA.

US black feminist criticism has been no more listened to than indigenous black feminist criticism. Yet, bell hooks's[7] powerful critique has considerable relevance to British feminists. White women in the British WLM are extraordinarily reluctant to see themselves in the situation of being oppressors, as they feel that this will be at the expense of concentrating upon being oppressed. Consequently the involvement of British women in imperialism and colonialism is repressed and the benefits that they – as whites – gained from the oppression of black people ignored. Forms of imperialism are simply identified as aspects of an all-embracing patriarchy rather than as sets of social relations in which white women hold positions of power by virtue of their 'race'.

The benefits of a white skin did not just apply to a handful of cotton, tea or sugar

plantation mistresses; all women in Britain benefited – in varying degrees – from the economic exploitation of the colonies. The pro-imperialist attitudes of many nine-teenth- and early-twentieth-century feminists and suffragists have yet to be acknow-ledged for their racist implications. However, apart from this herstorical work, the exploration of contemporary racism within the white feminist movement in Britain has yet to begin.

Feminist theory in Britain is almost wholly Eurocentric and, when it is not ignoring the experience of black women 'at home', it is trundling 'Third World women' onto the stage only to perform as victims of 'barbarous', 'primitive' practices in 'barbarous', 'primitive' societies.

It should be noted that much feminist work suffers from the assumption that it is only through the development of a Western-style industrial capitalism and the result-ant entry of women into waged labour that the potential for the liberation of women can increase. For example, foot-binding, clitoridectomy, female 'circumcision' and other forms of mutilation of the female body have been described as 'feudal residues', existing in economically 'backward' or 'underdeveloped' nations (i.e. not the industrial-ized West). Arranged marriages, polygamy and these forms of mutilation are linked in reductionist ways to a lack of technological development.

However, theories of 'feudal residues' or of 'traditionalism' cannot explain the appearance of female 'circumcision' and clitoridectomy in the United States at the same moment as the growth and expansion of industrial capital. Between the establishment of industrial capitalism and the transformation to monopoly capitalism, the United States, under the influence of English biological science, saw the control of medical practice shift from the hands of women into the hands of men. This is normally regarded as a 'progressive' technological advance, though this newly established medical science was founded on the control and manipulation of the female body. This was the period in which links were formed between hysteria and hysterectomy in the rationalization of the 'psychology of the ovary'.[8]

These operations are hardly rituals left over from a pre-capitalist mode of produc-tion. On the contrary, they have to be seen as part of the 'technological' advance in what is now commonly regarded as the most 'advanced' capitalist economy in the world. Both in the USA and in Britain, black women still have a 'role' – as in the use of Depo-Provera on them – in medical experimentation. Outside of the metropoles, black women are at the mercy of the multinational drug companies, whose quest for profit is second only to the cause of 'advancing' Western science and medical knowledge.

The herstory of black women is interwoven with that of white women but this does not mean that they are the same story. Nor do we need white feminists to write our herstory for us, we can and are doing that for ourselves. However, when they write their herstory and call it the story of women but ignore our lives and deny their relation to us, that is the moment in which they are acting within the relations of racism and writing *his*tory.

Constructing alternatives

Concepts which allow for specificity, whilst at the same time providing cross-cultural reference points – not based in assumptions of inferiority – are urgently needed in feminist work. The work of Gayle Rubin[9] and her use of discrete 'sex/gender systems'

appears to provide such a potential particularly in the possibility of applying the concept within as well as between societies.

This concept of sex/gender systems offers the opportunity to be historically and culturally specific but also points to the position of relative autonomy of the sexual realm. It enables the subordination of women to be seen as a 'product of the relationships by which sex and gender are organized and produced'. Thus, in order to account for the development of specific forms of sex/gender systems, reference must be made not only to the mode of production but also to the complex totality of specific social formations within which each system develops.

What are commonly referred to as 'arranged marriages' can, then, be viewed as the way in which a particular sex/gender system organizes the 'exchange of women'. Similarly, transformations of sex/gender systems brought about by colonial oppression, and the changes in kinship patterns which result from migration, must be assessed on their own terms, not just in comparative relation to other sex/gender systems. In this way patterns of subordination of women can be understood historically, rather than being dismissed as the inevitable product of pathological family structures.

At this point we can begin to make concrete the black feminist plea to white feminists to begin with our different herstories. Contact with white societies has not generally led to a more 'progressive' change in African and Asian sex/gender systems. Colonialism attempted to destroy kinship patterns that were not modelled on nuclear family structures, disrupting, in the process, female organizations that were based upon kinship systems which allowed more power and autonomy to women than those of the colonizing nation.

In concentrating solely upon the isolated position of white women in the Western nuclear family structure, feminist theory has necessarily neglected the very strong female support networks that exist in many black sex/gender systems. These have often been transformed by the march of technological 'progress' intended to relieve black women from aspects of their labour.

In contrast to feminist work that focuses upon the lack of technology and household mechanical aids in the lives of these women, Leghorn and Parker[10] concentrate upon the aspects of labour that bring women together. It is important not to romanticize the existence of such female support networks but they do provide a startling contrast to the isolated position of women in the Euro-American nuclear family structure.

In Britain, strong female support networks continue in both West Indian and Asian sex/gender systems, though these are ignored by sociological studies of migrant black women. This is not to say that these systems remain unchanged with migration. New circumstances require adaptation and new survival strategies have to be found. However, the transformations that occur are not merely adaptive, neither is the black family destroyed in the process of change. Female networks mean that black women are key figures in the development of survival strategies, both in the past, through periods of slavery and colonialism, and now, facing a racist and authoritarian state.

Families do not simply accept the isolation, loss of status, and cultural devaluation involved in the migration. Networks are re-formed, if need be with non-kin or on the basis of an extended definition of kinship, by strong, active, and resourceful women. Cultures of resistance are not simple adaptive mechanisms; they embody important alternative ways of organizing production and reproduction and value systems critical

of the oppressor. Recognition of the special position of families in these cultures and social structures can lead to new forms of struggle, new goals.[11]

In arguing that feminism must take account of the lives, herstories and experiences of black women we are not advocating that teams of white feminists should descend upon Brixton, Southall, Bristol or Liverpool to take black women as objects of study in modes of resistance. We don't need that kind of intrusion on top of all the other information-gathering forces that the state has mobilized in the interest of 'race relations'. White women have been used against black women in this way before and feminists must learn from history. The WLM, however, does need to listen to the work of black feminists and to take account of autonomous organizations like OWAAD (Organization of Women of Asian and African Descent) who are helping to articulate the ways in which we are oppressed as black women.

Black women do not want to be grafted onto 'feminism' in a tokenistic manner as colourful diversions to 'real' problems. Feminism has to be transformed if it is to address us. Neither do we wish our words to be misused in generalities as if what each one of us utters represents the total experience of all black women . . .

In other words, of white feminists we must ask, what exactly do you mean when you say 'WE'??

Notes

1 W. Jordan, *White Over Black* (London: Penguin, 1969): 238, 495, 500.
2 My thanks to Michèle Barrett who, in a talk given at the Social Science Research Council's Unit on Ethnic Relations, helped to clarify many of these attempted parallels.
3 M. Molyneux 'Socialist Societies Old and New: Progress Towards Women's Emancipation?' *Feminist Review* 8 (Summer): 3.
4 E. Wilson, *Only Halfway to Paradise: Women in Postwar Britain 1945–1968* (London: Tavistock, 1980).
5 Ibid., 43–4.
6 OWAAD, *Fowaad* 2 (1979).
7 b. hooks, *Ain't I a Woman* (Boston, Mass: South End Press, 1981): 38.
8 B. Erenreich and D. English, *For Her Own Good* (New York: Doubleday Anchor, 1979).
9 G. Rubin, 'The Traffic in Women: Notes on the Political Economy of Sex', in R. R. Reiter (ed.) *Towards an Anthropology of Women* (New York: Monthly Review Press): 167.
10 L. Leghorn and K. Parker, *Women's Worth, Sexual Economics and the World of Women* (London Routledge and Kegan Paul, 1981): 44.
11 M. Davis Caufield, 'Cultures of Resistance', *Socialist Revolution* 4, 2 (October 1974): 81, 84.

This chapter is a series of excerpts from Centre for Contemporary Cultural Studies (eds), *The Empire Strikes Back: Race and Racism in 70s Britain* (London: Hutchinson, 1982): 212–35. First published in this form in H. Mirza (ed.), *Black British Feminism: A Reader* (London: Routledge, 1997).

8

WOMAN ABUSE IN LONDON'S BLACK COMMUNITIES

Amina Mama

Introduction

This chapter examines the form, severity and extent of domestic violence experienced by the black women in this study, and the time over which they are subjected to violence before seeking to escape it. It also looks at the strategies employed by the women in the study in their attempts to survive or otherwise cope with repeated physical assault and/or mental cruelty. The chapter is based on the results of in-depth interviews with over a hundred women, conducted in London over a period of twelve months (November 1987 to October 1988). This makes it the first detailed investigation of domestic violence in Britain's black communities. The content of the material is of a highly disturbing nature. This is evidenced by the emotional stress experienced by the interviewers taken on to assist with this aspect of the research. Out of four employed and trained to conduct interviews with the full support of the researcher, only two found themselves emotionally able to cope with the depressing and disturbing nature of the subject group's experiences. The two who remained had substantial experience and training (one as a medical doctor and the other as a social worker who had lived and worked in Women's Aid), which enabled them to cope with the task in a sympathetic and highly skilled manner. The material presented here should be considered in the context of the following methodological considerations.

Method note

Sample characteristics

The sample was not a random sample, which means that generalizations about the communities included cannot be drawn from the interview findings. The material reported here should *not* be used as a basis for constructing new, or supporting old, stereotypes about the Caribbean, Asian or African communities, about gender relations, or about the treatment of women by men in those communities . . .

All the women interviewed had been subjected to quite serious degrees of cruelty. As such it should be regarded as an extreme sample, and not representative of connubial relationships in the respective communities. It will become apparent that nearly all the women in the study had experienced high degrees of physical abuse, only two

having been subjected to emotional cruelty without physical violence. (In both cases emotional suffering drove them from their marital homes.) This rendered the definitional problems around more borderline cases irrelevant. The emphasis on physical abuse is not intended to minimize the suffering of women subjected to mental cruelty without actual bodily assaults, and we did not set out to exclude such women. In all cases the physical violence that women experienced was accompanied by mental and emotional cruelty, as will become apparent in the examples below.

All the women interviewed self-defined their relational experience as that of domestic violence. To reiterate, in the terms of this project this means physical and mental abuse by current or past emotional and sexual partners: husbands, cohabitees or men with visiting relationships.

Whereas much research has focused on violence against wives – 'wife-battering' – it became clear in the course of this research that a significant proportion of the women we interviewed at refuges had not been legally married. Furthermore, a significant proportion had not been cohabiting on a full-time basis with their partners during the period of violence, and some of the women never had. It was therefore decided to include these two last groups in this study, in contrast to existing research on domestic violence because growing numbers of women (and in this study, women of Caribbean descent in particular) had what we refer to as 'visiting relationships' with the men who assaulted them. Their assailants stayed with them on a part-time basis, while also retaining residential rights with their mothers, or with other women. Domestic violence is not restricted to any particular family form or structure. In a study of black women it was definitely necessary to also include relationships not conforming to the monogamous nuclear form generally depicted in publications that have in any case not dealt with the situation of black women.

No black lesbian women were encountered in the process of contacting people to interview. The problems faced by black women in violent lesbian relationships are not therefore addressed in this study, although it is apparent that lesbian relationships are not free from abuse and violence, and may well be treated even less sympathetically . . .

Marital status, class and ethnicity

It soon became clear that there were a variety of family forms in the sample. The hundred women who were abused by their sexual and emotional partners comprised women who had been married legally and/or according to their cultural tradition, as well as women who had cohabited or had visiting relationships. Some were escaping violent assaults by ex-partners.

Within each of these three relationship categories, numerous variations existed in terms of roles and expectations, duties and responsibilities. It was not possible to go into any finer analysis in this project, but this variation should be borne in mind.

The three relationship categories identified for the research purposes were not independent of ethnic background. In this sample, the women of Asian and African descent were all legal and/or traditional wives, while more than half of the women of Caribbean origin were cohabitees or were engaged in visiting relationships. This may bear some relation to the fact that the Caribbean sample were predominantly born and raised in Britain where a growing proportion of the population cohabit at some stage in their relationship (Barrett and MacIntosh 1982). It may also be strongly related to the

material circumstances of the working-class Caribbean communities in Britain. The economic and power relations are very different when one is considering domestic violence against a middle class but financially dependent wife, as compared to domestic violence against a single mother of three in a local authority flat, or violence against a professional working woman. Men who were violent to the women in this study also came from all socio-economic classes, ranging from businessmen rich enough to keep several homes (and women) to working-class men who had never been afforded the dignity of earning a decent wage. What was most striking is that women across a very diverse range of domestic economic relationships and situations can be forced to flee their homes to escape violence from their partners.

This fact raises a major theoretical question about previous research on domestic violence, which has often tended to regard it as part and parcel of male power and women's economic dependence on the men battering them. While this may be true for 'housewives' in the traditional white middle class nuclear family, it was clearly not the case for a significant proportion of the black women in this study. Many were in fact being beaten by men who were dependent on them, regardless of marital status. This and other issues raised by the research findings are taken up in the discussion at the end of this chapter.

Redefining domestic violence

The case material presented here illustrates the enormous diversity in the manifestation of domestic violence. Culture, material circumstances such as bad housing and economic stresses, drug abuse, childhood relational experiences, sexual insecurities and jealousies, deep mistrust and suspicion, misogynistic (woman-hating) attitudes, and lack of communication are just some of the recurring themes of the material. These factors are not specific to domestic violence between black people, since very similar themes recur in European and American literature on the subject (Dobash and Dobash 1980, Yllo and Bograd 1988, WAFE 1981). Orthodox clinical approaches to 'family violence' tend to treat social and economic factors as 'confounding variables' rather than as variables that should be integrated into the analysis of domestic violence (Bolton and Bolton 1987). Yet social and economic factors constantly appear in women's accounts of their partners' violence towards them as rationalizations and reasons given, as women struggle to comprehend their partners' behaviour.

On the matter of race, the existing research is contradictory, focusing on the non-issue of whether black and minority families are more or less violent than white ones and producing reasons for each side of the argument (Bolton and Bolton). Staples's work is more interesting on race and he utilizes Frantz Fanon's (1967) thesis on violence in colonial contexts to go into the analysis of black male violence (Staples 1982).

Cultural analysis does not appear to have been part of existing research on domestic violence, although it is another recurring theme in women's accounts. It seems to manifest itself most commonly in terms of husbands invoking 'tradition' or 'religion' to justify their expectations of and demands for subservient or obedient behaviour from their womenfolk. None of the world's major religious texts condones (or actively challenges) the abuse of women. Rather the issue seems to me to be more about men appropriating religion in their own exercise of power over the women with whom they live. There is certainly no justification for tolerating woman-abuse in black

communities on the basis of it being 'their culture', as appears to occur in racist and colonial contexts. In Britain, other crimes are depicted as 'black crimes' and are far from tolerated. For example in the case of 'mugging' or robbery with violence, a disproportionate number of victims are black women, but popular representations imply that it is a crime in which most victims are elderly white women attacked by violent black men (see Hall et al. 1978 for an extended discussion of this phenomenon).

The subject group were all volunteers and no working definition of domestic violence was imposed on the women by the researcher. In addition to their self-definition, women had also been defined as having experienced domestic violence by the agencies through which we contacted them (women's refuges and community groups), so that some filtering by these agencies had also occurred. Beyond this, the range and extent of violence described below indicates the degrees and forms of violence upon which the research project is based. As was noted above, it turned out that the vast majority had experienced at least some physical injury as well as considerable amounts of emotional anguish.

Although the initial research proposal also included the much broader and harder to define category of 'relationship breakdown', it was decided to focus on domestic violence because of the definitional complexities of the wider area of relationship breakdown and the practical constraints on the project. This was felt to be appropriate because of the central concern with housing policy and practice and because our preliminary research indicated that in the present housing climate, relationship breakdown was seldom grounds for rehousing. Where there were written policies on relationship breakdown, these were not being implemented at a time when only home-less persons are being housed in many boroughs. In any case, in terms of local authority rehousing practices and policies, domestic violence is often treated as an extreme instance of relationship breakdown.

Many women would not have been forced to tolerate violence if there had been any possibility of one or other of the couple securing alternative housing in the earlier stages of relationship breakdown. The high incidence of black male and female home-lessness resulted in many couples living together more through lack of options than through choice. Since single black men have no access to public housing at all, black male homelessness can be seen in a number of cases to have been a major factor in determining the decision to cohabit in the first place. In this context the nature of relationships themselves is affected. Sometimes men had simply moved in with black women who had local authority tenancies. Many of these had previously been staying with other women and/or their mothers on a semi-permanent basis and had never had tenancies of their own. As such they would constitute part of the 'hidden homeless' population that has no statutory right to housing. Local authorities (in theory at least) are statutorily obliged to house people who have dependent children living with them, so that parents (who do have their children living with them) have a means of gaining entry to public sector housing that is not open to women or men whose children are not living with them.[1] When relationships deteriorated, men in these living arrangements not only became violent, but quite often also refused to leave, so forcing mothers and children out of their local authority accommodation to join the long queues awaiting housing in hostels, reception centres and refuges.

In terms of the assailants, these fell into a number of categories: (a) husbands; (b)

cohabitees; (c) men with whom the woman had a visiting relationship; (d) ex-husbands, cohabitees or visiting partners.

A small number of women interviewed had been subjected to violence by other parties. If this was in addition to violence from their sexual partner, cohabitee or husband they were included in the study. Several of the Asian subjects fell into this category, having been multiply abused by in-laws as well as spouses. One older Caribbean woman was assaulted by her son when he grew up, after she had been subjected to years of violence at the hands of her husband.

If however their experience of violence did not include violence from the man they were having or had been in a relationship with, they were excluded from the data analysis. There were six such cases including for example, Lalita a Philipino domestic worker who suffered abuse at the hands of her employer, and Sharon, a twenty-three-year-old woman of European and African parentage who was sexually abused by her stepfather and step-brother and then violently assaulted when she matured and at the age of sixteen tried to resist having sexual intercourse with them. The others were Asian women who were assaulted by in-laws, like Neelim, the thirty-four-year old Asian woman who had her nose smashed leaving her face permanently deformed by her sister's husband, or the teenager who went into refuge with her mother, having been beaten by her father for trying to protect her mother.

While certain themes occur frequently in the data, others are more idiosyncratic. This is not the place to attempt a detailed study of the causes of domestic violence, or to go into the detail that an individual psychological understanding of would require. Rather the case material is presented to highlight some of the ways in which violence has manifested, as recounted by women who have been subjected to assaults by their male partners. These highly disturbing accounts are treated and discussed as authentic descriptive data. They are presented to illustrate the circumstances which lead women to approach existing statutory and voluntary agencies, or to desist from, or delay in approaching outside agencies, even when they are being subjected to extreme and often life-threatening behaviour. Within each unhappy tapestry there also lies a rich undercurrent of courage which testifies to the resilience and resistance these women have shown, often without any of the support that one might expect any humane society to offer, in the face of the most extreme degradation and brutality.

The violence

Domestic violence against women of Caribbean descent

SUKIE was staying at a women's refuge with her two young sons (aged six and three) when we spoke. When she was eighteen she moved into a council flat with the tenancy in her name. Eugene, a casual painter/decorator came to help with the decorating. They related to each other quite well, and a few weeks later he arrived at Sukie's flat, with his baggage and moved in. Things went well until after the birth of their first son, when Eugene started to feel bitterly jealous of the young infant, and Sukie became pregnant and had their second son. Arguments began and continued, with Eugene forbidding Sukie to have her brother visit, and accusing her of having affairs with other men. When she went to visit her aunt, she would return to find her clothes and pictures hidden and clear evidence that he had entertained other women in their bedroom:

these things were going on because he used to take the children's toys and hide them in the cupboard; take all my things off the dressing table and put them inside the drawer, and once he pretended that I was his sister . . . when I used to go down to my auntie's he sort of gave this as an excuse for bringing the women there because I wasn't there, which I thought was wrong. If he wanted to do anything I thought he should go outside of the house to do it, not do it inside my house – I've got the children staying there as well. So from there we started fighting every day. One night I had to run out and he came looking for me. While he was looking he got this knife from my cousin's kitchen drawer and slashed me across the face and tore Neville [son] away from me. I've got the scar here {Sukie still bore a number of scars}.

The violence got worse, as did her partner's extreme jealousy, with him waiting outside her workplace and deploying other people to trail her and monitor her movements.

He was possessive and the fact that I was working and saving my money really got to him because he's self-employed and every time he wants anything he wants me to help, so I was not getting any benefit out of working. He said that I was working and hiding my money from him, and that I bring up my kids too fancy – I shouldn't dress them up like that. Every time I visit my friends he said they were a bad influence on me, and he banned me from walking down that particular road. If I took the kids to my friend's house he would sort of trail me, and he got people to spy on me after work.

The thing is he wanted to be the ruler of the house. He said there can't be two kings in one house, and on one occasion he said that I musn't cook for the kids and don't cook for him, that he would buy separate shopping and sort of ban me from using the cooker. When we're fighting I wasn't to sleep on my bed, I wasn't to sleep on the kids' bed and I wasn't to sleep on the settee. One night he locked me in the toilet – sort of nailed it down.

When I was pregnant one time he said that he would see that Neville was born crippled.

Sukie's workmates observed what was happening through the heavy bruising to her face and arms, and she saw the doctor on several occasions with her injuries. She suffered from frequent nose bleeds, headaches, developed as a result of frequent blows to the head, and high blood pressure. She also called the police on several occasions and obtained ouster injunctions from the courts. Her reason for not leaving before this stage:

I've always said because of the kids – because of the kids I'll stay with him, so the kids can have a father.

She had left after Eugene had wrapped a cord round her throat in a strangle grip until she almost blacked out. She still bore the scars of that assault on her neck at the time of interview. After that episode, Eugene was convicted for grievous bodily harm and bound over for a year, but it was not safe for her to go near her flat, so she fled. Her

local authority acknowledged she was homeless as a result of domestic violence and placed her in a Bayswater bed and breakfast hotel where she bore filth, cockroaches and no cooking facilities for eight months in one room with her two sons, who repeatedly became ill. Eventually she moved into the women's refuge. A year later I met her again at a different refuge, still awaiting rehousing, thinner and even more worn-looking.

ROWEENA is twenty-six years old. She and her three children were staying in one room at a women's refuge at the time of interview. She moved away from him into her own council tenancy in 1983 after he began to drink heavily and subject her to violent attacks, but friends told him where she was. She has been fleeing from one place to another trying to escape the violent attacks of her children's father for the last five years. During that time she has been in four different women's refuges. She has also been rehoused twice, the first time in a flat abandoned by a black family before her who had been subjected to racial attacks by their neighbours. The same racist neighbours forced her to abandon her long-awaited home. She was subsequently rehoused in her ex-partner's old haunts, so that he located her and tried to burn down the flat by pouring petrol through the letter box. Again she went into a refuge. A year after we spoke, I returned to the same refuge and found she was still there, still awaiting rehousing.

CHARLOTTE is a thirty-three-year-old London-born woman who has lived with the father of her two young children for four and a half years. When they established their relationship she put all her own resources into a business with him, which failed – owing to his gambling habits. He became increasingly abusive towards her over the last two years, subjecting her to constant criticism and derision day and night, and then becoming sexually and physically abusive.

> there was mental abuse as well. There were a lot of bad vibes generally. Bad communication, lots of complaints about everything – he would keep me awake all night going on and on criticising everything about me, my family, what I did, how I spoke, how I reacted to everything. That created a sexual problem which would bring out the violence as well . . . he would – you know – rip off my clothes and . . . [in a lowered voice she explained that she was raped].

During her pregnancy with the youngest child she was subjected to extreme emotional and financial neglect. Another woman became pregnant by him at this point. His cruelty and neglect had deep effects on her during her pregnancy;

> It was very depressing. It leaves you inert and with no energy left to do anything. It took me a long time to realise the actual seriousness of the situation. That I was actually in that situation. Might sound funny but it took a long time for me to admit that it actually was a real nightmare.

In retrospect Charlotte describes her partner as suffering from insecurity, and burdened with debts he had incurred. Their flat was in her name, and she also owned the car (which he prevented her from using).

I think basically his problem is chronic insecurity, which is something I hadn't realised before . . . he comes over as quite arrogant and pushy actually. But he finds any type of rejection totally unacceptable.

She left on two occasions, but returned, having nowhere else to go. Eventually she had to call the police for the second time to escort her to a women's refuge when he became frighteningly irrational one night. One of the reasons she gave for leaving were his threats to kill their children.

ZOEY was twenty-three years old and struggling to start a different life for herself after spending six abusive years with a man much older than her, who operated as a pimp. She spoke clearly and insightfully about her life. Zoey had been raised by an English family in the country and came to London in 'search of the bright lights' at the age of sixteen. She started working as a hostess in Soho clubs, where she met her partner – an influential man, quite different from anyone she had ever met, and who gradually took over control of her life.

> I thought I was in control of the relationship. He never worked – has never worked, so it was a completely different way of life. And I thought it was exciting, free – he showed me all different things, all the runnings[2] and every-thing . . . He was willing to show me how I'm supposed to be, and where I come from, my roots. I was to stop putting on make-up. I had been very into myself – into makeup and clothes. He was nothing like that. I never thought I would go for a guy like him. I was looking for something different I must admit. But I thought he was sort of soft when I first met him, cuz that style I had never come across – the black man's style. I think I came unstuck because he was so smart. He really worked his brain on me. He was very patient, so he got what he wanted. Everywhere he went everybody just hails him up—he's very popular. That's what attracted me to him. When I first looked at him I thought no, I was just looking into his wrinkled old face. I don't know what it was – it was his style, and after a while . . .

Zoey had never experienced abuse prior to this relationship:

> The first time he hit me I left him. That's the kind of person I was. I was so shocked and appalled. But in the end I thought, well this is it. I'm in the bottom of hell, I can't get out of it. Now I'm the kind of person who gets beaten consistently and doesn't go, so I've gone mad between then and now. I'd gone mental, lost all contacts, and I had his child. And he knew all those things. He knew what he was doing.

She concealed the reality of her situation from her parents and sister:

> To my parents I was playing happy families. They never knew the truth at all. Oh no. It would have been too appalling, it would be like a horror movie to them. That's unreal.

Her partner was also violent to other women, and invoked the Old Testament in his general misogyny:

> He had no respect for women at all. He'd say that over and over again. Woman is Delilah, Satan. Woman is man's downfall and all this all the time. Woman is down there. He used to go on about Margaret Thatcher running the country – all these women running the country. When I took him to court I won an injunction. So he had twenty-eight days to get out, and all these things just confirmed that it was a woman's country . . . He's got to have somebody to belittle all the time.

The frequency of physical abuse varied:

> Sometimes it would be morning and night, morning and night every night for a week. If we was really at each other's throats, really arguing, and then he might not beat me for six months.

She suffered extensive bruising and cuts from punches, kicks and being hit with furniture and other objects that came to hand. On one occasion he broke his toe kicking her. On another she was hospitalized with her head split open, and had to go to casualty on yet another. The police were called approximately thirty times in five years.

Most of their fights centred around money:

> He wanted money from me, from my work. He said he wasn't interested in the house because he was a Rasta and he was going to Africa. But he'd be willing to sit down and let me do everything financially – the food, housekeeping, bills and everything. He used to get me to give him money in the beginning, he said he would pay me back because I loaned him some. But then it got out of hand. For years and years – I can't begin to weigh up how much – thousands and thousands.

She had a friend who was in a similar relationship:

> Me and my friend used to laugh, for about three years we'd come down and laugh at ourselves. In the end that was our only pleasure. To run ourselves down. When we faced them we'd know that we'd been cursing them stupid – it was like that.

Her friend left the scene and started a new life for herself some time before Zoey did.

> His word was God's to me and he knew best. He knew, you see? He was never supposed to be wrong. Whatever he'd encouraged me in, I would have done. That's why I'm here now. Because of sheer disgust in myself. Disgust. That's all I can say, in the end. Absolute disgust.

ELSIE is a twenty-five-year-old woman of Caribbean and European mixed parentage who grew up in a northern English town. She has a particularly extroverted and

dynamic character. The violence she was subjected to in her relationship was so bad that it drove her to attempt suicide. She had been in a relationship with Mike, the father of her child, for eighteen months at the time of interview. They had been living with his mother and his sister at his mother's small (two-bed) council flat for the period of their cohabitation. They attempted to get council accommodation of their own on numerous occasions, to no avail.

Elsie has held a wide range of domestic catering and sales jobs, while her partner is a musician who goes for long periods without work, but felt that Elsie should stay at home and be a full time housewife.

> He wanted me to be a housey woman and I ain't housey at all. I'd rather be out working – not barefoot and pregnant over the stove . . . He used to go out for days on end, yet if I go out for an hour, he used to say – 'where have you been?' I'd be wanting to ask him questions anyway, but alright. And when he comes in its 'Where's my dinner, why aren't my slippers being warmed by the fire?' and all that bit. While I would tend to go about my business. It's a double standard that's been in force since Adam and Eve. I joke about it, but at the time it's not funny at all.

Most of their fights began with verbal disagreements which escalated into him being violent towards her: kicking her in the legs and chest and punching her to the face and head. He fractured her nose twice and she has a number of scars rendered with an iron bar on her arms and legs. At other times he would strike out suddenly over minor issues. Despite the severity of her injuries, Elsie partly blamed herself:

> I'm a very stubborn person, even now. I was partly to blame. But I don't think it was worth getting slapped in the mouth for it. I mean if it was that I'd done something wrong he could have said – 'Elsie you shouldn't have done that,' and that would have been it, I would have just said, 'Yeah, alright then, I'll do it different next time', you know? It could be that I'd put too much salt in the dinner. That to him was a major mistake and I got a punch in the mouth for it. Such little things – okay, I was wrong about it, you know, but I'm not a cook, and I don't think that not being able to cook should get you a slap in the mouth . . . I'm stubborn and he's stubborn, so I wouldn't give in, because I'd been a single woman a long time before I met him, and like I moulded myself the way I like myself and I knew that. I told him before I moved in together that he was not going to like living with me.

The situation got worse after the birth of their daughter, ostensibly because he was jealous of her. When asked what used to spark off these fights, Elsie responded:

> Money and sex. I mean I think he expected it to be like it was when we first met. Even though we were going through a bad patch. He still – he would like hit me at half past nine and at half past eleven when we were in bed he be all lovey and 'Come on let's do it now?' and I'd say 'No', and he'd wonder – but why? What have I done? . . . He wasn't sorry for what he'd done, because he didn't believe he'd done anything.

Elsie explained her suicide attempt as being due to her partner's violence:

> It was hurting me that much I didn't want to give him the satisfaction of killing me, so I thought – well, I'd top myself. But it didn't work – I was unconscious and they tried to put this tube down my throat and I thought – 'Oh God, I'm going to die here.'

On one occasion when he was trying to force her over the balcony, the neighbours heard Elsie's screams of 'Help – he's killing me' and called the police. While she did not have any family support, she had met a number of Mike's friends; indeed he had introduced her to a particular woman friend of his who he had hoped would teach her the runnings, as he put it. As his violence became more and more extreme, his friends attempted to intervene, expressing strong disapproval of his behaviour towards Elsie, so that he refused to have anything more to do with them. Eventually, despite repeated visits and appeals to the council, unable to find anywhere else to live and trapped in a clearly life-threatening situation Elsie grew desperate and contacted the Samaritans for help. She was eventually referred to Women's Aid.

SARAH is twenty-seven and has an eight-year-old son. She had been in the refuge for nineteen months at the time of interview and there was still no sign of her being rehoused. She had been going out with Maurice for about three years when he arrived one day with his bags:

> He virtually just moved in. I mean we were going out, and one day a neighbour came and said – 'He wants you outside.' And when I looked out of the window, he had taken all his things out of the car. He just moved in. We had been going out for about three years, but that didn't entitle him to move in automatically the way he did. But I didn't really say much. I just sort of asked him, you know, what was happening. He said he thought that was what I wanted . . . Apparently he shared a flat with another woman who had a child for him. They had apparently broken up, so I thought – you know – 'what the heck?'. She threw all his clothes out and then he came and said he thought it was what I wanted.

Maurice was a self-employed decorator, while Sarah did full-time office work. Their relationship deteriorated after he had moved into her council flat.

> He started abusing me and being aggressive, you know. I mean he'd never done it before – he always said 'Oh I'll never hit a woman, I'll never hit a woman' and I always believed him. In all the three years I'd known him he'd never hit me before.

They fought over 'silly things' – if she used the car (which was hers) when he wanted to, or being five minutes late to collect him, for example. This resulted in unexpected consequences:

> I went up the stairs to close the door and I just felt one punch on the back of

my head. In my flat you go down as you enter the door, so I went flying down the stairs and crashed into the wall. He just started beating me and kicking and swearing – fucking this and fucking that. I couldn't understand it – that I was too out of order, that he don't know who I think I am and all this. Until I was knocked out unconscious. When I woke up I was so mad, I wanted to kill him, but because he was so big and tall I knew that if I hit him I was going to get twice the hit I gave him back. I thought I was due to die that day because Wayne [her son] was at his aunty's. It was just me and him in the flat. Wayne was gone for the weekend. I was just so mad – I started trembling, I couldn't stop myself, I couldn't control myself. I just started to shake and then he said 'Yeah, you fucking pretend you're sick, you go on and fucking pretend you're sick'. And I said – 'I want some water – can I have some water?' My lips just dried up and I was just trembling. He thought I was joking or something. Then he realised that I was genuinely shaking. I couldn't keep myself still. He ran to get the water and everything. And then they took me to the hospital – he took me to the hospital and everything – he lied to them and told them that I fell over and banged my head. I just told them that I didn't want him in here. He wouldn't leave because he knew that if he left me I would tell them.

Assaults of this sort had longer term effects on their relationship; not only was making up and saying sorry followed by other attacks, but the nature of their relationship changed:

After he started being aggressive I suppose I became afraid of him. But I always pretended – I never showed him that I was afraid of him. If he said anything, I always said it back, and that – 'I'm not frightened of you'. 'Not frightened of me? I'll give you fright' he'd say, and I'd be sitting there thinking, 'Oh God, please don't let him hit me'. He was always threatening before that incident . . . On the other occasion he didn't actually get to abuse me much because I jumped out of the window. I mean he would have killed me. He threatened and then slapped me in the face. I ran through the kitchen and locked the door and took the key. He ran round to come in through the front window, and I said to him you just put one foot through – he lifted his foot and I was over the balcony. I had on something skimpy, it was raining, I had nothing on my feet. Looked like a tramp. I didn't care – I just wanted to get away from him.

Sarah explains his violence thus:

I think he was insecure. He was jealous of the fact that – because I've always been independent, like now I'm a student and everything. I've been saving up money because I do people's hair at home and I charge them £50. I'd been saving up my money and I bought a car. He didn't like the fact that I always went out and got my things – whatever I wanted. He detested that you know – he always wanted me to have a baby for him. And I've always said no because I want my career first. 'Fucking career' – he didn't like it. He did not like the fact, he just wanted me to be a slave to him. I don't know. He just seems really insecure.

Things got worse as time went along. He just got over possessive – he wanted me to be under his spell – at his beck and call sort of thing. I don't know why. I suppose because his parents – his mother always cooked for him and washed for him even though he was living with this other girl, he always went to his mother's for dinner. At Christmas everyone goes to his Mum's and she spoils them. And that's what he expected of me. Cook dinner every day and make sure it's no rubbish.

Violence also had a negative effect on her son:

He was hyperactive. I had to take him to a child psychiatrist because of all the ups and downs; it disturbed him a little bit. Maurice would shout and Wayne was frightened of him. He used to say things like – 'I don't like Maurice because he hits my Mum', you know – things like that. Sometimes when he got violent Wayne would wet his bed. It was obvious that that is what it was. He was frightened for me. When we took him to the child psychiatrist, I didn't go in with him, and the things he told her – I couldn't believe it. At the time he was about five – I thought what does he know about this. He knows everything and it affects him. I cried when she told me that.

Meanwhile, the mother of Maurice's first child had another baby for him, much to Sarah's distress, since he had denied that he was continuing to have relations with her. She explains why she put up with him for as long as she did under those circumstances thus: 'I don't know. I must have loved him.'

MARY was interviewed at her council house in north London where she now lives with her three-year-old son. She has never stayed at a women's refuge. She is a thirty-two-year-old woman of Jamaican origin who had a strictly religious upbringing in her Pentecostal family. She entered the Church and engaged in missionary work in the Caribbean, and describes herself as having had very little experience of life when she met the man she married. She did not live with him before they were married, and they settled in Hackney. Since they could not find anywhere to live, they were grateful to be offered the use of Paul's sister's council flat. At that stage the relationship was far from violent. It was:

Great – wonderful! It really was. If he swore he used to apologize – It was always – 'oh I'm sorry!'. I think it was because prior to that I had spent seven years in the Church, so I was a total fool. He could see that, but I think that's the reason why he was so courteous and gentle – I think that had a lot to do with it. I jumped out of the Church and into his arms! [laughter].

After four years of highly sheltered married life, Mary found her life had ceased to have meaning for her. She left her husband and went to live in France for two years while they got a divorce. When she returned from abroad, she was again homeless, all her family having returned to Jamaica some time previously. She stayed with her now ex-husband for the time being. While she had been away he had met someone else, who

he continued to see – an older woman who kept him supplied with the drugs that he had developed a dependency on.

> He wanted both of us – he didn't want to choose. So he'd be spending some of the time with her and some of the time with me.

He went through violent mood changes and their relationship deteriorated again. On one occasion Paul took Mary's tape recorder to the other woman's house, and she angrily phoned him there. He returned and subjected her to her first serious assault:

> He came home, opened the door – I was in the kitchen and he just laid into me, left, right and centre. That was the very first time it had ever happened. I was in hospital for two days. I was traumatised and shocked. I had a lot of bruises – my eyes were out here, and I was just really lost. I was really dazed. My family had gone back to the West Indies. My mother had gone, my sister had gone – everybody had gone – I was completely alone. Well almost – I have a brother and sister here, but I couldn't really go to them – it was my younger sister and I don't think my older brother would have understood somehow. So I was alone – I did feel alone and more than that I felt ashamed, so I couldn't go to them. That was really bad. It was the shame more than anything. I couldn't understand it. I mean I had never experienced violence of that kind before. It had never happened – I've got five brothers and sisters – a large family, and I'd never known it to happen to them. I'd heard of violence, obviously, but as far as my father and mother – I'd never seen it. I'd never even met anybody who had experienced it. I think it was partly because I was in the Church, and led a very sheltered life. I'd never expected it.

After this painful experience, Mary reacted in a way not uncommon for isolated victims of domestic violence:

> When he realised where I was, where I'd gone, he turned up at 12.00 that night, but the nurse had told him to come and see me in the morning, and he came back the next day. After about three days, he was really contrite, he hadn't meant to do it and what have you. It sounds a really funny thing to say but, even though I knew what he had done, he was the only person I wanted comfort from. Do you understand what I mean? Although he'd put me in this position and what he'd done and what have you, he was the only person that I really wanted. I didn't feel to reject him. And I went back to him. And then I fell pregnant [laugh].

It was after this that she discovered her partner to be a user of hard drugs, and their relationship continued to deteriorate.

> There were instances when we'd be in the car, and he'd just get into a rage – 'why don't they get out of the way!', as if he wanted to kill everybody. Depending on his mood, I couldn't speak to him, without fear of being snapped at. He was on cocaine, and I think that had a lot to do with his violence towards me.

In the end, and after further violence, even in her pregnant state, he agreed to move out. Since it had been his sister's flat however, he continued to visit and disturb her. All Mary's desperate attempts to be transferred by Hackney council failed.

YVONNE is twenty-five years old and has three children. Her ex-partner, Roland, is a British Rail engineer. They cohabited for a couple of years, somewhat intermittently, after he moved into her council flat with her.

> He'd say I'm stepping out of line. I'm getting too big for my boots, I must remember I'm only little and things like that . . . I never had any broken bones, but I've been swollen up and bruised, which is enough. He was just sick. I remember one time I ran away, down to his Dad's house, and he even beat up his Dad so he could come in and beat me. He phoned the police. But by the time the police came he [his father] said – 'It's alright – he's calmed down now – it was a domestic affair, it's alright'.

The violent attacks to which Roland subjected Yvonne, particularly when he came out of prison after being remanded for other violent offences, were clearly life threatening. She was rehoused twice by the local council, and spent long periods in reception centres. He found out the address of her second home before she had even moved into it, from the housing department. Yvonne has essentially been trying to escape from his violence for the last four years; this has included being attacked on the streets when he has spotted her. Their youngest son was born two days before Roland was taken into prison on remand for a different violent offence. Roland appears to have had some mental disturbance:

> About two days after Mikey was born he went into prison. When he came out he goes to me – 'When did this take place? Where did this baby come from? It's not my baby'. So I said to him – 'During that space of time that you was in prison you have forgotten that I had a baby?'. I said – 'Obviously, as far as I know my two children got the same father, so if this one ain't yours, that one ain't yours'. He told me that it's either his Dad's child because he's got his Dad's name, or his brother's child. And then he started to name untold amount of his friends – it could be any one of them, so I was supposed to have laid down with all of them.

His hostile feeling towards their youngest child erupted in one of his violent attacks:

> He claims he never saw the water boiling. We were having an argument, I was in the kitchen making a bottle for Mikey. I'd just turned off the fire, and the water was still there bubbling and he come in and brought the argument from one room through into the kitchen, and picked up the water and flung it like that. I had Mikey in my arms, I had him in my hand. He didn't hold it over me – he held it over Mikey like that [demonstrates] and the water splashed upon me, but I didn't get burned. Mikey got burned from his head right down to his chest. All they did was give Roland a six months hospital order, and he kept running away, so he only served about three. After a while they said they didn't

want him there no more . . . I phoned the ambulance – and I mean this is how stupid he was – he said to me I must tell them I was giving the baby a bath. Now stupid as some women are, they don't put a baby in the bath head first. When the ambulance men came they asked what had happened and that's what he told them. I never said anything in case he thump the ambulance man down and then thump me down afterwards. He wouldn't let go of the eldest one. He said I must go to the hospital with Mikey and get myself treated and Mikey treated and then come back. The ambulance man said – 'It's alright love, I know what's happened', and he phoned the police on his radio thing.'

Perhaps the most alarming thing about Yvonne's case is the nature of intervention by the statutory agencies that were repeatedly involved in the case. Her experience highlights the complete lack of protection available to black women, even when their assailants have both criminal convictions for violence and have been subject to psychiatric orders . . .

Domestic violence against African women

MABEL is a thirty-three-year-old Ghanaian with two children: a five-year-old son and a four-year-old daughter. She ran her own small business and lived in a council flat and has lived in London since 1974. Nine years ago she met Kofi, a Ghanaian tailor, who shared her strong Christian faith, and after two years they were married. She attributes some of their problems to his family:

They didn't seem to get on with me. They interfered a lot, and I won't take that. I don't want anybody to tell me what I have to do in my own home and things like that. Kofi was pressurised by the family: they said I was having a good time, taking the money from him or whatever. I don't know what they were thinking of, because I always worked hard. Yes, most of the time I provided everything. And I didn't really demand of him. But because of the way they see me – I love to look good, that's me. So when they see me dressing up well, they think that it's from him.

Her husband's violence was irregular:

One week he's alright, and then the next he's like a monster. It was on and off for about ten months.

At other times he was:

a very nice man. A very nice father. He is wonderful. He really cares for his children. But when the monster comes, you know . . . Then he'd cry. Whatever he did, he'd start crying and asking – 'Why did I do it?' – talking to the little boy as if he was a big man and all that . . . He is a believer, a Christian, and he didn't believe in psychiatrists or whatever they call them. He always believed in – well – we do have demon spirits anyway, so that could come in. Like those

were behind everything. As far as I'm concerned, because he can be as nice as anybody and can be as nasty as a monster.

He would break down, he would kiss my feet like Jesus did and he would quote from the Bible – 'The Bible says this, the Bible says that'. But yet he'd do it again. I mean what can you do? 'How long would that go on', I always asked him, 'How long?'.

They turned to the Church and to prayer, but to no avail. Instead Kofi went on to inflict quite serious injuries to her, and she saw the effect this was having on her children:

I had to go to hospital for head X-ray. And I was taking tablets for migraines. He left me with bruises almost everywhere, bite marks and all that.

I didn't want my children to see us fighting all the time. It got to a time that whenever the two of us sat down to talk, my little girl, Suzie – at that stage she was only a year old – she would come and stand in front of us and sort of look at Mummy, look at Daddy . . . and the little boy, especially, when he was about four years old would start and shout – 'Don't shout at Mummy, Daddy, stop talking to Mummy, go away! Don't fight Mummy, you want to kill my Mummy!' I really felt sorry for my son because I didn't want him to grow up and have that kind of thing in his mind at all – that one time my Daddy wanted to kill my Mum, or that he was being Mum all the time. Otherwise he would probably – God forbid – grow up and behave like that. I just couldn't allow that to happen at all.

Mabel persuaded her husband to move out, but could get no peace from him. Eventually she abandoned her flat and her business and went into a women's refuge, where she was staying when we interviewed her.

IYAMIDE was brought over to England by her husband in 1977. He was much older than her, but she had known of him in her community for years. Since living in London she continued her career as a nurse, while he worked in a large department store. They lived in a house they rented from their local authority, once they had the children. Their relationship deteriorated from the time he brought her to England;

You know African men – when they've brought you here, they think that you are a slave. Especially when they are older than you. They want to make their power over you.

Her husband, a teetotaller himself, took exception to her drinking an occasional glass of wine. She found herself alone, without friends or relatives in this country. Her husband worked and they had no social life at all:

We go to work during the day. Then he goes to bed. I had nobody to talk to. We had no social life. It was a miserable life actually. Even if he came to sit down, he'd be over there sleeping. Since I joined him, we could never go out. He'd go to work, come and lie down and sleep.

On the other hand:

> If I introduced any friends to him, he would be after them. After I went back home to visit, one of my friends who used to come – we used to be very close – she just cut off. When I asked her what was wrong, what have I done? She said to me – 'Iyamide, you are very good to me, but all the time your husband is harassing me to make love to him'.

> I had three children for him, and the way he insults me! I can never stand it. Each time I thought about it I didn't want to make love to him.

She was beaten and kicked repeatedly, on one occasion until

> My eyes were bleeding. When he saw my eyes were bleeding, saw the blood, he called the ambulance. By the time the ambulance had come, he had washed everything, cleaned the whole corridor. He didn't want the people to see that. When the doctor attended me he asked if my husband did this – because of the way they saw my eye full of blood. I went back because of the children. Since 1980 I was staying because of the children. They love him so much.

Iyamide had to go to hospital three or four times, where she had X-rays. Her vision has been permanently damaged by repeated blows to her eyes and head.

> When the youngest baby was born he beat me. He tried to strangle me. My voice all went. I couldn't even talk. He was on top of me, holding my neck like this [demonstrates]. After that I just tried to hold on to something and I banged him on the head. Otherwise he would have finished me that day. From that time until today we never made love.

Iyamide left her husband shortly after this. I heard her disturbing account of what happened to her after that in what the council call 'temporary accommodation'.

PATIENCE is a Nigerian store manageress who has been in a relationship with Ransome for nine years. They have a young son and got married a year and a half ago. She has left him many times because of his cruelty to her and their child.

> Last Easter he took me and stripped me in front of his friends. He was beating me, punching me and pushing me about. I had come in from the kitchen because I heard him saying some nasty things in front of his friends trying to be funny by making fun of me. So I came out from the kitchen and I told him he would regret the things he was doing. As I was going out he started rough-handling me – shouting and pushing me. As he was doing all that my zip had come down, and my breast was coming out – I didn't even notice – I was busy trying to restrain things so as not to display anything to those people. He started slapping my breast and shouting 'Cover yourself!' All in front of his friend and the wife, while they were looking on.

Ransome has been consistently unfaithful to Patience. Probably partly because she grew up in a polygamous home herself, what disturbs her most is his degrading behaviour towards her and his taste for pornography. When she leaves, he begs and cajoles her to come back.

> He hasn't spent long in Nigeria. His Dad is here and he's spent most of his years in this country, yet he says to me 'Our tradition is that women should live with their men'. He is not serious!

She has been subjected to pressure from elders in her family (all men) who are concerned that she should have all her children with the one husband. For her own part she does not feel it would be in her interests to get a divorce from her student husband because as she put it, 'I have worked hard for him'. Custody or maintenance rulings in British courts would be of no use to her when they return to Nigeria, where (in her community) taking legal action against one's husband is not an acceptable way of solving marital problems. Her own friends have tired of advising her to permanently leave Ransome. Patience has been multiply abused; not only has her husband injured her on numerous occasions, but on one occasion when neighbours called the police to intervene, they took the opportunity to arrest her and subject her to racially and sexually humiliating ridicule and then assaulted her at the police station.

Discussion

A number of themes emerge from this material. The degree to which violence against women in their homes is tolerated in Britain has long been condemned by the women's movement here, but this has largely been from a Eurocentric feminist perspective. The class, race and cultural dynamics of agency responses to domestic violence have been grossly neglected by feminists, except for the more vociferous Asian women's organizations (such as Southall Black Sisters). Regarding women of African and Caribbean origin, community groups have focused on police brutality, rather than the more sensitive issue of woman abuse. Police brutality is less of a contentious topic within the black communities because it is an oppression delivered by the 'Other' – in this case the state. Woman abuse remains a shameful and buried phenomenon, like other forms of fratricidal behaviour, only made worse by its private nature. This privatization protects the abuser and facilitates further violence. The collusive silence around the issue has the effect of limiting the options that abused women have. Seeking help from the authorities is often regarded as an act of betrayal and several women in the sample who had been forced to seek police assistance as a result of serious violence, now live under threat of death for doing so (as in Roweena's case). Black women are expected to bear their beatings (as if these too were not a betrayal of humanity), and actually to understand that they are a result of the black man's oppression. Yet, as many survivors have pointed out, being beaten by the man one has taken as a sexual and emotional partner is itself a crude and degrading form of oppression.

In October 1988 a black community meeting, entitled 'Violence Within the System' (and billed as the first ever), was held on domestic violence. During this meeting participants exhibited something of a consensual understanding that black men beat black women because they themselves are brutalized by state repression. While it is

commendable that such a meeting was held and that discussions took place with seriousness, this kind of analysis can feed into the collective abdication of individual responsibility for brutal and anti-social behaviours. However, many people in the black communities recognize that it is now time to seriously address the problem of violence against black women in Britain, so that more organized collective responses can be developed.

Our findings demonstrate that high levels of violence and cruelty to women by the men they are or have been in relationships with, are being tolerated, by the communities themselves, as well as by statutory organizations.

The occurrence of domestic violence in all the cultural and religious groups we investigated was clearly demonstrated, and this evidence supports the observation that violence occurs in all creeds, cultures and classes. The fact that this practice may have culturally specific content is also evident in women's accounts. In the examples above we saw Muslim and Rastafarian men using religion to assert their patriarchal authority and misogyny.

Women also often referred to tradition, but in their case it was usually to describe how they had tried to conform – to become the ideal wife – only to find that nothing they said or did satisfied their spouse, or stopped the violence. While women of Caribbean origin referred less explicitly to established orthodoxies, it was clear that the men they were involved with often held quite unrealistic expectations about how 'their' women should behave and conduct themselves, and often felt they had a right to use violence to enforce these. Women (who may well have been born and brought up in Britain) were often criticised and beaten for the 'crime' of being 'too Western', sometimes by men who had also been brought up in Britain.

Others did not refer to religion or tradition, but simply held and tried to enforce expectations that the women found to be oppressive and unrealistic, for example not being allowed to have friends or go out, being expected to stay at home and cook and anger over the woman's cooking (as Elsie described) are just a few examples . . .

Within the communities, extended families sometimes intervened positively, although on some occasions, they did not feel able to intervene (for example where the woman's father was dead or absent). In other cases the woman's own relatives made the situation worse.

In some cases (women of African origin in this study) migration had meant being isolated from family and community support, so that violence reached dangerous levels. For example, in Iyamide's case violence began when her husband brought her over to England.

In-laws were often involved in exacerbating conflict (as in Mabel's case where they were jealous of her and wanted greater access to her husband's income), and sometimes as perpetrators of violence themselves, so that some young wives were multiply abused. In Elsie's case, her cohabitee's doting mother used to watch indifferently, so perhaps giving tacit approval, while her son assaulted 'his' woman . . .

In short, double standards which indulge abuse and neglect of women and wives are quite explicitly upheld by families and conformist elements within the black communities. This indulgence of sons of the community has detrimental effects on the women and children, who are expected to live with them while being denied many basic human rights in the name of 'respectability'.

Professionals within the black communities also often appear to condone violence.

Recalcitrant responses to domestic violence have been observed in the white community, so it is perhaps not surprising to find that black professionals too, often adhere to patriarchal values and fail to assist abused women. There were incidents in which women were told by doctors from their own communities that 'women should not leave their husbands' . . .

The lack of protection for women in the privacy of their homes and families emerges starkly. This applies even where the police have been, sometimes repeatedly, involved. In Yvonne's case, for example, it is clear that her assailant was mentally disturbed and a danger to both her and her children. Even when he badly scalded the baby, he was still able to return to continue terrorizing her. Other women were being battered by men who had drug addictions or criminal records for other crimes, yet few were encouraged to prosecute, and one woman who had attempted to prosecute (Yvonne, on a different occasion from the one cited here) had had her case thrown out.

This study also found that women are often unprotected from men they have ceased having a relationship with. Ex-husbands and ex-boyfriends were not deterred from assaulting women. This upholds the theme 'that once a woman has engaged in any form of sexual relationship with a man, his social dominance over her is assumed . . . and this includes the right to physically assault her'. In some cases indeed, the man only became more violent at the point when the woman tried to end the relationship or alter the terms on which it would continue. Yvonne and Roweena are only two of the examples where women had been coerced and intimidated for a long period (several years) after they had ended their relationships with assailants who kept seeking them out and returning to further terrorize them and their children.

The evidence from many of the women in this study (particularly those of Caribbean origin, but also from women of African and Asian origin) contradicts the Western feminist analysis of domestic violence which relates it to women's economic marginalization, and concomitant dependence on their spouse's income. Many had been assaulted by men who depended on them. This indicates that men continue to emotionally and physically dominate women even when they depend on those women. Indeed, the evidence is that this can be an exacerbating factor. Many women cited the fact that they were working and had some economic independence, as a source of antagonism.

At one extreme were a number of women whose men contributed nothing to the homekeeping or upkeep of children, and assumed they had rights to the woman's earnings. Recall that Sukie's partner actually resented her using the money she earned, to buy clothes and food for their children. Zoey's cohabitee never worked, but pimped and beat her, accusing her of cheating him while he sold her sex to obtain a car and other material needs for himself.

Not all these men were without incomes of their own, and some exploited the sexism of the cohabitation rule to collect and control social security payments to the family. Sarah's partner earned several hundred pounds a week, and started assaulting her after he had moved into her flat. Only then did he feel confident enough to violently express the resentment he felt towards her for having a career instead of having a baby for him, even while the mother of his two other children had a third for him. Charlotte put all her resources into a business with her man, only to be kept in a state of near starvation during her last pregnancy, while he impregnated another woman.

This material also shatters the stereotype of the 'strong' or 'castrating' black woman.

Rather, many black women are both providers and slaves whose labour supports men who then degrade and abuse them. It seems that when women have even a limited material advantage over the men they have relationships with, this in itself may in fact provoke those men to assert their male authority literally with a vengeance, through violence. This dynamic suggests that the frustration felt by men who are unable to conform to patriarchal standards, manifests itself in sadistic behaviour towards the women they live off. Thus we can see that socio-economic jealousy may operate in a way that parallels sexual jealousy and often links up with it.

Notes

1 Parents are not eligible if their children have been taken into local authority care (perhaps — in a cruel irony — because of homelessness or bad living conditions that threaten their health and safety), or are living primarily with the other parent, or abroad with relatives, for example.
2 'Runnings' is a Jamaican term for 'what's going on', and 'how things work' within a particular subculture.

Bibliography

Barrett, M. and MacIntosh, J. (1982) *The Anti-social Family* (London: Voso and NLB).
Bolton, F. G. and Bolton, S. R. (1987) *Working with Violent Families* (London: Sage).
Dobash, R. E. and Dobash, R. (1980) *Violence Against Wives* (London: Open Books).
Fanon, F. (1967) *The Wretched of the Earth* (Harmondsworth: Penguin).
Hall, S., Crichter, C., Jefferson, T., Clarke, J. and Roberts, B. (1978) *Policing the Crisis: Mugging, the State and Law and Order* (London: Macmillan).
Stapler, R. (1982) *Black Masculinity: The Black Male's Role in American Society* (New York: Black Scholar Press).
Yllo, K. and Bograd, M. (1988) *Feminist Perspective on Wife Abuse* (London: Sage).

From *The Hidden Struggle: Statutory and Voluntary Sector Responses to Violence against Black Women in the Home* (London: Whiting & Birch, 1996) (extracts). Courtesy of the Runnymede Trust.

9

BLACK HAIR/STYLE POLITICS

Kobena Mercer

Some time ago Michael Jackson's hair caught fire when he was filming a television commercial. Perhaps the incident became newsworthy because it brought together two seemingly opposed news values: fame and *mis*fortune. But judging by the way it was reported in one black community newspaper, *The Black Voice*, Michael's unhappy accident took on a deeper significance for a cultural politics of beauty, style and fashion. In its feature article, 'Are We Proud to be Black?', beauty pageants, skin-bleaching cosmetics and the curly-perm hairstyle epitomized by Jackson's image were interpreted as equivalent signs of a negative black aesthetic. All three were roundly condemned for negating the natural beauty of blackness, and were seen as identical expressions of subjective enslavement to Eurocentric definitions of beauty, thus indicative of an 'inferiority complex'.[1]

The question of how ideologies of 'the beautiful' have been defined by, for, and – for most of the time – *against* black people remains crucially important. But at the same time I want to take issue with the widespread argument that, because it involves straightening, the curly-perm hairstyle represents either a wretched imitation of white people's hair or, what amounts to the same thing, a diseased state of black consciousness. I have a feeling that the equation between the curly-perm and skin-bleaching cosmetics is made to emphasize the potential health risk sometimes associated with the chemical contents of hair-straightening products. By exaggerating this marginal risk, a moral grounding is constructed for judgements which are then extrapolated to assumptions about mental health or illness. This conflation of moral and aesthetic judgement underpins the way the article also mentions, in horror and disgust, Jackson's alleged plastic surgery to make his features 'more European looking'.

Reactions to the striking changes in Jackson's image have sparked off a range of everyday critiques on the cultural politics of 'race' and aesthetics. The apparent transformation of his racial features through the glamorous violence of surgery has been read by some as the bizarre expression of a desire to achieve fame by 'becoming white' – a deracializing sell-out, the morbid symptom of a psychologically mutilated black consciousness. Hence, on this occasion, Michael's misfortune could be read as 'punishment' for the profane artificiality of his image: after all, it was the chemicals that caused his hair to catch a fire.

The article did not prescribe hairstyles that would correspond to a positive self-image or a politically 'healthy' state of black subjectivity. But by reiterating the 1960s slogan – Black is Beautiful – it implied that hairstyles which avoid artifice and look

111

natural, such as the Afro or Dreadlocks, are the more authentically black hairstyles and thus more ideologically right-on. But it is too late to simply repeat the slogans of a bygone era. That slogan no longer has the same cultural or political resonance as it once did; just as the Afro, popularized in the United States in the period of Black Power, has been displaced through the 1970s and 1980s by a new range of black hairstyles, of which the curly-perm or jherri-curl is just one of the most popular. Whether you care for the results or not, these changes have been registered by the stylistic mutations of Michael Jackson, and surely his fame indicates something of a shift, a sign of the times, in the agendas of black cultural politics. How are we to interpret such changes? And what relation do changes in dress, style and fashion bear to the changed political, economic and social circumstances of black people in the 1980s?

To begin to explore these issues I feel we need to *depsychologize* the question of hair-straightening, and recognize hairstyling itself for what it is, a specifically cultural activity and practice. As such, we require a historical perspective on how many different strands – economic, political, psychological – have been woven into the rich and complex texture of our nappy hair, such that issues of style are so highly charged as sensitive questions about our very 'identity'. As part of our modes of appearance in the everyday world, the ways we shape and style hair may be seen as both individual expressions of the self and as embodiments of society's norms, conventions and expectations. By taking both aspects into account and focusing on their interaction, we find that there is a question that arises prior to psychological considerations alone, namely: *why do we pour so much creative energy into our hair?*

In any black neighbourhood you cannot escape noticing the presence of so many barbershops and hairdressing salons; so many hair-care products and so much advertising to help sell them all; and, among young people especially, so much skill and sheer fastidiousness that goes into the styles you can see on the street. Why so much time, money, energy and worry spent shaping our hair?

From a perspective informed by theoretical work on subcultures (Stuart Hall and Tony Jefferson 1976; Hebdige 1979), the question of style can be seen as a medium for expressing the aspirations of black people historically excluded from access to official social institutions of representation and legitimation in urban, industrialized societies of the capitalist First World. Here, black peoples of the African diaspora have developed distinct, if not unique, patterns of style across a range of cultural practices from music, speech, dance, dress and even cookery, which are politically intelligible as creative responses to the experience of oppression and dispossession. Black hairstyling may thus be evaluated as a popular *art form* articulating a variety of aesthetic 'solutions' to a range of 'problems' created by ideologies of race and racism.

Tangled roots and split ends: hair as symbolic material

As organic matter produced by physiological processes, human hair seems to be a natural aspect of the body. Yet hair is never a straightforward biological fact, because it is almost always groomed, prepared, cut, concealed and generally worked upon by human hands. Such practices socialize hair, making it the medium of significant statements about self and society and the codes of value that bind them, or do not. In this way hair is merely a raw material, constantly processed by cultural practices which thus invest it with meanings and value.

The symbolic value of hair is perhaps clearest in religious practices – shaving the head as a mark of worldly renunciation in Christianity or Buddhism, for example, or growing hair as a sign of inner spiritual strength for Sikhs. Beliefs about gender are also evident in practices such as the Muslim concealment of the woman's face and hair as a token of modesty.[2] Where 'race' structures social relations of power, hair – as visible as skin colour, but also the most tangible sign of racial difference – takes on another forcefully symbolic dimension. If racism is conceived as an ideological code in which biological attributes are invested with societal values and meanings, then it is because our hair is perceived within this framework that it is burdened with a range of negative connotations. Classical ideologies of race established a classificatory symbolic system of colour, with white and black as signifiers of a fundamental polarization of human worth – 'superiority/inferiority'. Distinctions of aesthetic value, 'beautiful/ugly', have always been central to the way racism divides the world into binary oppositions in its adjudication of human worth.

Although dominant ideologies of race (and the way they dominate) have changed, the legacy of this biologizing and totalizing racism is traced as a presence in everyday comments made about our hair. 'Good' hair, when used to describe hair on a black person's head, means hair that looks European, straight, not too curly, not that kinky. And, more importantly, the given attributes of our hair are often referred to by descriptions such as 'woolly', 'tough' or, more to the point, just plain old 'nigger hair'. These terms crop up not only at the hairdresser's but more acutely when a baby is born and everyone is eager to inspect the baby's hair and predict how it will 'turn out'.[3] The pejorative precision of the salient expression, *nigger hair*, neatly spells out how, within racism's bipolar codification of human worth, black people's hair has been historically *devalued* as the most visible stigmata of blackness, second only to skin.

In discourses of scientific racism in the seventeenth and eighteenth centuries, which developed in Europe alongside the slave trade, variations in pigmentation, skull and bone formation, and hair texture among the species of 'Man' were seized upon as signs to be identified, named, classified and ordered into a hierarchy of human worth. The ordering of differences constructed a regime of truth that would validate the Enlightenment assumption of European superiority and African inferiority. In this process, racial differences – like the new scientific taxonomies of plants, animals and minerals – were named in Latin; thus was the world appropriated in the language of the West. But whereas the proper name 'Negro' was coined to designate all that the West thought it was not, 'Caucasian' was the name chosen by the West's narcissistic delusion of superiority: 'Fredrich Blumenbach introduced this word in 1795 to describe white Europeans in general, for he believed that the slopes of the Caucasus [mountains in eastern Europe] were the original home of the most beautiful European species.'[4] The very arbitrariness of this originary naming thus reveals how an *aesthetic* dimension, concerning blackness as the absolute negation or annulment of 'beauty', has always intertwined with the rationalization of racist sentiment.

The assumption that whiteness was the measure of true beauty, condemning Europe's Other to eternal ugliness, can also be seen in images of race articulated in nineteenth-century popular culture. In the minstrel stereotype of Sambo – and his British counterpart, the Golliwog – the 'frizzy' hair of the character is an essential part of the iconography of inferiority. In children's books and vaudeville minstrelsy, the 'woolly' hair is ridiculed, just as aspects of black people's speech were lampooned in

both popular music hall and in the nineteenth-century novel as evidence of the 'quaint folkways' and 'cultural backwardness' of the slaves.[5]

But the stigmatization of black people's hair did not gain its historical intransigence by being a mere idea: once we consider those New World societies created on the basis of the slave trade economy – the United States and the Caribbean especially – we can see that where race is a constitutive element of social structure and social division, hair remains powerfully charged with symbolic currency. Plantation societies instituted a 'pigmentocracy'; that is, a division of labour based on racial hierarchy, in which one's socio-economic position could be signified by one's skin colour. Fernando Henriques's account of family, class and colour in post-colonial Jamaica shows how this colour/class nexus continues to structure a plurality of horizontal ethnic categories into a vertical system of class stratification. His study draws attention to the ways in which the residual value system of 'white-bias' – the way ethnicities are valorized according to the tilt of whiteness – functions as the ideological basis for status ascription. In the sediment of this value system, African elements – be they cultural or physical – are devalued as indices of low social status, while European elements are positively valorized as attributes making possible upward social mobility (Henriques 1953: 54–5).

Stuart Hall, in turn, emphasizes the composite nature of white-bias, which he refers to as the 'ethnic scale', as both physiological and cultural elements are intermixed in the symbolization of one's social status. Opportunities for social mobility are therefore determined by one's ranking on the ethnic scale, and involve the negotiation not only of socio–economic factors such as wealth, income, education and marriage, but also of less easily changeable elements of status symbolism such as the shape of one's nose or the shade of one's blackness (Hall 1977: 150–82). In the complexity of this social code, hair functions as a key *ethnic signifier* because, compared with bodily shape or facial features, it can be changed more easily by cultural practices such as straightening. Caught on the cusp between self and society, nature and culture, the malleability of hair makes it a sensitive area of expression.

It is against this historical and sociological background that we must evaluate the personal and political economy of black hairstyles. Dominant ideologies such as white-bias do not just dominate by universalizing the values of hegemonic social/ethnic groups so that they become everywhere accepted as the norm. Their hegemony and historical persistence is underwritten at a subjective level by the way ideologies construct positions from which individuals recognize such values as a constituent element of their personal identity and lived experience. Discourses of black nationalism, such as Marcus Garvey's, have always acknowledged that racism works by encouraging the devaluation of blackness by black subjects themselves, and that a recentring sense of pride is therefore a prerequisite for a politics of resistance and reconstruction. But it was Frantz Fanon (1970 [1952]) who first provided a systematic framework for the political analysis of racial hegemonies at the level of black subjectivity. He regarded cultural preferences for all things white as symptomatic of psychic inferiorization, and thus might have agreed with Henriques's view of straightening as 'an active expression of the feeling that it tends to Europeanize a person'.

Such arguments gained influence in the 1960s when the Afro hairstyle emerged as a symbol of Black Pride and Black Power. However, by positing one's hairstyle as directly expressive of one's political awareness this sort of argument tends to prioritize self over society and ignore the mediated and often contradictory dialectic between the

two. Cheryl Clarke's poem, 'Hair: A Narrative', shows that the question of the relationship between self-image and hair-straightening is always shot through with emotional ambiguity. She describes her experience as implicating both pleasure and pain, shame and pride: the negative aspects of the hot-lye and steel-comb treatment are held in counterpoint to the friendship and intimacy between herself and her hairdresser who, 'against the war of tangles, against the burning metamorphosis . . . taught me art, gave me good advice, gave me language, made me love something about myself' (Clarke 1982: 14).[6] Another problem with prevailing antistraightening arguments is that they rarely actually listen to what people think and feel about it.

Alternatively, I suggest that, when hairstyling is critically evaluated as an aesthetic practice inscribed in everyday life, *all* black hairstyles are political in that they each articulate responses to the panoply of historical forces which have invested this element of the ethnic signifier with both social and symbolic meaning and significance.

With its organizing principles of biological determinism, racism first politicized our hair by burdening it with a range of negative social and psychological meanings. Devalorized as a 'problem', each of the many stylizing practices brought to bear on this element of ethnic differentiation articulate ever so many 'solutions'. Through aesthetic stylization each black hairstyle seeks to *revalorize* the ethnic signifier, and the political significance of each rearticulation of value and meaning depends on the historical conditions under which each style emerges. The historical importance of Afro and Dreadlocks hairstyles cannot be underestimated as marking a liberating rupture, or 'epistemological break', with the dominance of white-bias. But were they really that 'radical' as solutions to the ideological problematization of black people's hair? Yes: in their historical contexts, they *counter*politicized the signifier of ethnic and racial devalorization, redefining blackness as a desirable attribute. But, on the other hand, perhaps not: because within a relatively short period both styles became rapidly *de*politicized and, with varying degrees of resistance, both were incorporated into mainstream fashions within the dominant culture. What is at stake, I believe, is the difference between two logics of black stylization – one emphasizing *natural* looks, the other involving straightening to emphasize *artifice*.

Nature/culture: some vagaries of imitation and domination

Our hair, like our skin, is a highly sensitive surface on which competing definitions of 'the beautiful' are played out in struggle. The racial overdeterminations of this nature/culture ambivalence are writ large in this description of hair-straightening by a Jamaican hairdresser:

> Next, apply hot oil, massaging the hair well which prepares it for a shampoo. You dry the hair, leaving little moisture in it, and then apply grease. When the hair is completely dry you start *cultivating* it with a hot comb . . . Now the hair is all straight. You can use the curling iron on it. Most people like it curled and waved, not just straight, not just dead straight.
>
> (quoted in Henriques 1953: 55)

Her metaphor of 'cultivation' is telling because it makes sense in two contradictory ways. On the one hand, it recuperates the brutal logic of white-bias: to cultivate is to

...orm something found 'in the wild' into something of social use and value, like ...mesticating a forest into a field. It thus implies that in its natural given state, black people's hair has no inherent aesthetic value: it must be worked upon before it can be beautiful. But on the other hand, all human hair is 'cultivated' in this way in so far as it merely provides the raw material for practices, procedures and ritual techniques of cultural writing and social inscription. Moreover, in bringing out other aspects of the styling process which highlight its specificity as a cultural practice – the skills of the hairdresser, the choices of the client – the ambiguous metaphor alerts us to the fact that nobody's hair is ever just natural, but is always shaped and reshaped by social convention and symbolic intervention.

An appreciation of this delicate 'nature/culture' relation is crucial if we are to account both for the emergence of Dreadlocks and Afro styles as politicized statements of pride *and* their eventual disappearance into the mainstream. To reconstruct the semiotic and political economy of these black hairstyles, we need to examine their relation to other items of dress and the broader historical context in which such ensembles of style emerged. An important clue with regard to the Afro in particular can be found in its names, as the Afro was also referred to, in the United States, as the 'natural'.

The interchangability of its two names is important because both signified the embrace of 'natural' aesthetic as an alternative ideological code of symbolic value. The 'naturalness' of the Afro consisted in its rejection both of straightened styles and of short haircuts: its distinguishing feature was the *length* of the hair. With the help of a pick or Afro-comb the hair was encouraged to grow upwards and outwards into its characteristic rounded shape. The three-dimensionality of its shape formed the signifying link with its status as a sign of Black Pride. Its morphology suggested a certain dignified body posture, for to wear an Afro you have to hold your head up in pride, you cannot bow down in shame and still show off your 'natural' at the same time. As Flugel pointed out with regard to ceremonial headdress and regal crowns, by virtue of their emphatic dimensions such items bestow a sense of presence, dignity and majesty on the wearer by magnifying apparent body size and by shaping bodily movement accordingly so as to project stature and grace.[7] In a similar way, with the Afro we wore the crown, to the point where it could be assumed that the larger the Afro, the greater the degree of black 'content' to one's consciousness.

In its 'naturalistic' logic the Afro sought a solution that went to the roots of the problem. By emphasizing the length of hair when allowed to grow 'natural and free', style countervalorized attributes of curliness and kinkiness to convert stigmata of shame into emblematics of pride. Its names suggested a link between 'Africa' and 'nature' and this implied an oppositional stance *vis-à-vis* artificial techniques of any kind, as if any element of artificiality was imitative of Eurocentric, white-identified, aesthetic ideals. The oppositional economy of the Afro also depended on its connections with dress styles adopted by various political movements of the time.

In contrast to the Civil Rights demand for equality within the given framework of society, the more radical and far-reaching objective of total liberation and freedom from white supremacy gained its leverage through identification and solidarity with anticolonial and anti-imperialist struggles of emergent Third World nations. At one level, this alternative political orientation of Black Power announced its public presence in the language of clothes.

The Black Panthers' 'urban guerrilla' attire – turtlenecks, leather jackets, dark

glasses and berets – encoded a uniform of protest and militancy by way of the connota-
tions of the common denominator, the colour black. The Panthers' berets invoked
solidarity with the violent means of anti-imperialist armed struggle, while the dark
glasses, by concealing identity from the 'enemy', lent a certain political mystique and a
romantic aura of dangerousness.

The Afro also featured in a range of ex-centric dress styles associated with cultural
nationalism, often influenced by the dress codes of Black Muslim organizations of
the late 1950s. Here, elements of 'traditional' African dress – tunics and dashikis,
head-wraps and skullcaps, elaborate beads and embroidery – all suggested that
black people were contracting out of Westernness and identifying with all things
African as a positive alternative. It may seem superficial to reread these transformative
political movements in terms of style and dress: but we might also remember that as
they filtered through mass media, such as magazines, music, or television, these styles
contributed to the increasing visibility of black struggles in the 1960s. As elements
of everyday life, these black styles in hair and dress helped to underline massive
shifts in popular aspirations among black people and participated in a populist logic
of rupture.

As its name suggests, the Afro symbolized a reconstitutive link with Africa as part
of a counter-hegemonic process helping to redefine a diaspora people not as Negro but
as Afro-American. A similar upheaval was at work in the emergence of Dreadlocks. As
the Afro's creole cousin, Dreadlocks spoke of pride and empowerment through their
association with the radical discourse of Rastafari which, like Black Power in the
United States, inaugurated a redirection of black consciousness in the Caribbean.
Walter Rodney drew out the underlying connections and 'family resemblances'
between Black Power and Rastafari (Rodney 1968: 32–3). Within the strictures of
Rastafari as spiritual doctrine, Dreadlocks embody an interpretation of a religious,
biblical injunction that forbids the cutting of hair (along the lines of its rationale
among Sikhs). However, once 'locks were popularized on a mass social scale – via the
increasing militancy of reggae, especially – their dread logic inscribed a beautification
of blackness remarkably similar to the 'naturalistic' logic of the Afro.

Dreadlocks also embrace 'the natural' in the way they valorize the very materiality of
black hair texture, for black people's is the only type of hair that can be 'matted' into
such characteristic configurations. While the Afro's semiotics of pride depended on its
rounded shape, 'locks countervalorized nappy-headed blackness by way of this process
of matting, which is an option not readily available to white people because their hair
does not 'naturally' grow into such organic-looking shapes and strands. And where the
Afro suggested an articulating link with Africa through its name and its association
with radical political discourses, Dreadlocks similarly implied a symbolic link between
their naturalistic appearance and Africa by way of a reinterpretation of biblical narra-
tive which identified Ethiopia as 'Zion' or Promised Land. With varying degrees of
emphasis, both invoked 'nature' to inscribe Africa as the symbol of personal and polit-
ical opposition to the hegemony of the West over 'the rest'. Both championed an
aesthetic of nature that opposed itself to any artifice as a sign of corrupting Eurocentric
influence. But nature had nothing to do with it! Both these hairstyles were never just
natural, waiting to be found: they were stylistically *cultivated* and politically *constructed*
in a particular historical moment as part of a strategic contestation of white dominance
and the cultural power of whiteness.

117

These styles sought to liberate the materiality of black hair from the burdens bequeathed by racist ideology. But their respective logics of signification, positing links between the natural, Africa and the goal of freedom, depended on what was only a *tactical inversion* of the symbolic chain of equivalences that structured the Eurocentric system of white-bias. We saw how the biological determinism of classical racist ideology first politicized our hair by burdening it with 'racial' meanings: its logic of devalorization of blackness radically devalued our hair, debarring it from access to dominant regimes of the 'truth of beauty'. This aesthetic denegation logically depended on prior relations of equivalence which posited the categories of *Africa* and *Nature* as equally other to Europe's deluded self-image which sought to monopolize claims to human beauty.

The equation between these two categories in Eurocentric thought rested on the fixed assumption that Africans had no culture or civilization worthy of the name. Philosophers like Hume and Hegel validated such assumptions, legitimating the view that Africa was outside history in a savage and rude 'state of nature'.[8] Yet, while certain Enlightenment reflections on aesthetics saw in the Negro only the annulment of their ideas of beauty, Rousseau and later, in the eighteenth and nineteenth centuries, romanticism and realism in the arts, saw Nature on the other hand as the source of all that was good, true and beautiful. The Negro was none of these. But by inverting the symbolic order of racial polarity, the aesthetic of 'nature' underpinning the Afro and Dreadlocks could negate the negation, turn white-bias on its head and thus revalorize all that had been so brutally devalorized as the very annulment of aesthetics. In this way, the black subject could accede – and only in the twentieth century, mind you – to that level of self-valorization or aesthetic idealization that had hitherto been categorically denied as unthinkable. The radicality of the 1960s slogan, Black is Beautiful, lay in the function of the logical copula *is*, as it marked the ontological affirmation of our nappy nigger hair, breaching the bar of negation signified in that utterance from the Song of Songs which Europe had rewritten (in the King James version of the Bible) as, 'I am black *but* beautiful'.[9]

However radical this countermove was, its tactical inversion of categories was limited. One reason why may be that the 'nature' invoked in black counter-discourse was not a neutral term but an ideologically loaded *idea* created by binary and dualistic logics within European culture itself. The 'nature' brought into play to signify a desire for liberation and freedom so effectively was also a Western inheritance, sedimented with symbolic meaning and value by traditions of science, philosophy and art. Moreover, this ideological category had been fundamental to the dominance of the West over 'the rest'; the nineteenth-century bourgeoisie sought to legitimate the imperial division of the world by way of mythologies that aimed to universalize, eternalize and hence 'naturalize' its power. The counter-hegemonic tactic of inversion appropriated a particularly romanticist version of nature as a means of empowering the black subject; but by remaining within a dualistic logic of binary oppositionality (to Europe and artifice) the moment of rupture was delimited by the fact that it was only ever an imaginary Africa that was put into play.

Clearly, this analysis is not to write off the openings and effective liberations gained and made possible by inverting the order of aesthetic oppression; only to point out that the counter-hegemonic project inscribed in these hairstyles is not completed or closed, and that this story of struggles over the same symbols continues. Nevertheless, the

limitations underline the diasporic specificity of the Afro and Dreadlocks, and ask us to examine, first, their conditions of commodification and, second, the question of their *imaginary* relationship to Africa and African cultures as such.

Once commercialized in the marketplace, the Afro lost its specific signification as a 'black' cultural-political statement. Cut off from its original political contexts, it became just another fashion: with an Afro wig anyone could wear the style. Now the fact that it could be neutralized and incorporated so readily suggests that the aesthetic interventions of the Afro operated on terrain already mapped out by the symbolic codes of the dominant white culture. The Afro not only echoed aspects of romanticism, but shared this in common with the 'countercultural' logic of long hair among white youth in the 1960s. From the Beatles' mop-tops to the hairy hippies of Woodstock, white subcultures of the 1960s expressed the idea that the longer you wore your hair, somehow the more 'radical' and 'right-on' your lifestyle or politics. This *far-out* logic of long hair among the hippies may have sought to symbolize disaffection from Western norms, but it was rapidly assimilated and dissimulated by commodity fetishism. The incorporation of long hair as the epitome of protest, via the fashion industry, advertising and other economies of capitalist mediation, culminated at one point in a Broadway musical that ran for years – *Hair*.

Like the Afghan coats and Kashmiri caftans worn by the hippy, the dashiki was reframed by dominant definitions of ethnic otherness as 'exotica': its connotations of cultural nationalism were clawed back as just another item of freakish exoticism for mass consumption. Consider also the inherent semiotic instability of militant chic. The black leather jackets and dark glasses of the Panthers were already inscribed as stylized synonyms for rebelliousness in white male subcultures from the 1950s. There, via Marlon Brando and the metonymic association with macho and motor bikes, these elements encoded a youthful desire for freedom, in the image of the American highway and the open road, implying opposition to the domestic norms of their parent culture. Moreover, the colour black was not saturated by exclusively 'racial' connotations. Dark, sombre colours (as well as the occasional French beret) featured in the downbeat dress statements of the 1950s boho-beatniks to suggest mystery, 'cool', outsider status, anything to alienate the normative values of 'square society'.

The fact that these white subcultures themselves appropriated elements from black American culture (rock 'n' roll and bebop respectively) is as important as the fact that a portion of the semiotic effectiveness of the Panther's look derived from associations already embedded by previous articulations of the same or similar elements of style. The movement back and forth indicates an underlying dynamic of struggle as different discourses compete for the same signs. It shows that, for style to be socially intelligible as an expression of conflicting values, each cultural nucleus or articulation of signs must share access to a common stock or resource of signifying elements. To make the point from another point of view would amount to saying that the Afro engaged in a critical dialogue between black and white Americans, not one between black Americans and Africans. Even more so than Dreadlocks, there was nothing particularly African about the Afro at all. Neither style had a given reference point in existing African cultures, in which hair is rarely left to grow 'naturally'. Often it is plaited or braided, using weaving techniques to produce a rich variety of sometimes highly elaborate styles that are reminiscent of the patternings of African textiles and the decorative designs of African ceramics, architecture and embroidery.[10] Underlying these practices

is an African approach to the aesthetic. In contrast to the separation of the aesthetic sphere in post-Kantian European thought, this is an aesthetic sensibility which incorporates practices of beautification in everyday life. Thus artifice – the agency of human hands – is valued in its own right as a mark of both invention and tradition, and aesthetic skills are deployed within a complex economy of symbolic codes in which communal subjects recreate themselves collectively.[11]

Neither the Afro nor Dreadlocks operate within this context as such. In contemporary African societies, such styles would not signify Africanness ('locks in particular would be regarded as something 'alien', precisely the tactical objective of the Mau Mau in Kenya when they adopted such dread appearances in the 1950s); on the contrary, they would imply an identification with First-World-ness. They are specifically diasporean. However strongly these styles expressed a desire to 'return to the roots' among black peoples in the diaspora, in Africa *as it is* they would speak of a modern orientation, a modelling of oneself according to metropolitan images of blackness.

If there was nothing especially 'African' about these styles, this only goes to show that neither was as natural as it claimed to be. Both presupposed quite artificial techniques to attain their characteristic shapes and hence political significance: the use of special combs in the case of the Afro, and the process of matting in the case of 'locks, often given a head start by initially plaiting long strands of hair. In their rejection of artifice both styles embraced a 'naturalism' that owed much more to Europe than it did to Africa. In this sense, the fate of the Afro in particular might best be understood by an analogy with what happened to the Harlem Renaissance in the 1920s.

There, complementing Garvey's call for repatriation to Africa, a generation of artists, poets, writers, musicians and dancers embraced all things African to renew and refashion a collective sense of black American identity. Yet, when rich white patrons descended on Harlem seeking out the salubrious spectacle of 'the New Negro', it became clear – to Langston Hughes at least – that the Africa being evoked was not the real one but a mythological, imagined 'Africa' of noble savagery and primitive grace. The creative upsurge in black American culture and politics marked a moment of rupture and a reconstruction of black subjectivity *en masse*, but it was done, like the Afro, through an inverted reinscription of the romanticist mythology created by European ideologies. As Langston realized, 'I was only an American Negro – who had loved the surfaces of Africa and the rhythms of Africa – but I was not Africa. I was Chicago and Kansas City and Broadway and Harlem'.[12] However strategically and historically important, such tactics of reversal remain unstable and contradictory because their assertion of difference so often hinges on what is only the inversion of the same. . . .

Notes

Versions of this article have been critically 'dialogized' by numerous conversations. I would like to thank all the seminar participants at the Centre for Caribbean Studies, Goldsmiths' College, University of London, 30 April 1986; and, in thinking diaspora aesthetics, thanks also to Stuart Hall, Paul Gilroy and Clyde Taylor.

1 *The Black Voice* 15, 3 (June 1983) (newspaper of the Black Unity and Freedom Party, London SE15): 1.
2 See C. R. Hallpike, 'Social Hair', in Ted Polhemus (ed.), *Social Aspects of the Human Body*

(Harmondsworth: Penguin, 1978): 134–46; on the veil, see Frantz Fanon, 'Algeria Unveiled' (1965): 21–52.

3 Such anxieties, I know, are intensified around the mixed-race subject: 'I still have to deal with people who go to touch my "soft" or "loose" or "wavy" hair as if in the touching something . . . will be confirmed. Back then in the 60s it seemed to me that my options . . . were to keep it short and thereby less visible, or to have the living curl dragged out of it: *maybe then you'd look Italian . . . or something*' (Derrick McClintock, 'Colour', *Ten.8* 22 (1986): 28).

4 George Mosse, *Toward the Final Solution: A History of European Racism* (London: Dent, 1978): 44.

5 On the ideology and iconography of minstrelsy see, Robert C. Toll, *Blacking Up: The Minstrel Show in Nineteenth-century America* (New York: Oxford University Press, 1974). See, also, Sylvia Wynter, 'Sambos and Minstrels', *Social Text* 1 (fall 1979).

6 See, also, *Hairpiece: A Film for Nappy-headed People*, director Ayoka Chinzera, 1982, USA.

7 See John C. Flugel, *The Psychology of Clothes* (London: Hogarth Press, 1930).

8 See Sander Gilman, 'The Figure of the Black in German Aesthetic Theory', *Eighteenth Century Studies* 6, 4 (1975): 373–91, a critical examination of how central ideas about 'race' were to the development of Western philosophical discourse on aesthetics in Hume, Hegel, Burke, Kant and Herder.

9 On Africa as the annulment of Eurocentric concepts of beauty, see Christopher Miller, *Blank Darkness: Africanist Discourse in French* (London and Chicago: University of Chicago, 1985). On systems of equivalence and difference in hegemonic struggles, see Ernesto Laclau (1980) and Ernesto Laclau and Chantal Mouffe (1985).

10 Esi Sagay, *African Hairstyles* (London: Heinemann, 1983).

11 See Victoria Ebin, *The Body Decorated* (London: Thames and Hudson, 1979); John Miller Chernoff, *African Rhythm and African Sensibility* (Chicago: University of Chicago, 1979); and Victor Turner, *The Forest of Symbols: Aspects of Ndembu Ritual* (Ithaca: Cornell University Press, 1967).

12 Langston Hughes, *The Big Sea* (London: Pluto Press 1986 [1940]): 325. On the social context of the Harlem Renaissance, see also Nathaniel Huggins, *Harlem Renaissance* (New York: Oxford University Press, 1968), and David Levering Lewis, *When Harlem Was in Vogue* (New York: Oxford University Press, 1979).

References

Clarke, Cheryl (1982) 'Hair: A Narrative', *Narratives: Poems in the Tradition of Black Women* (New York: Kitchen Table/Women of Color Press).

Fanon, Frantz (1970 [1952]) *Black Skin, White Mask* (London: Paladin).

Hall, Stuart (1977) 'Pluralism, Race and Class in Caribbean Society', in *Race and Class in Post-colonial Society* (New York: UNESCO).

Hall, Stuart and Tony Jefferson (eds) (1976) *Resistance Through Rituals: Youth Subcultures in Post War Britain* (London: Hutchinson).

Hebdige, Dick (1979) *Subculture: The Meaning of Style* (London: Methuen).

Henriques, Fernando (1953) *Family and Colour in Jamaica* (London: Secker & Warburg).

Laclau, Ernesto (1980) 'Populist Rupture and Discourse', *Screen Education* 34.

Laclau, Ernesto and Chantal Mouffe (1985) *Hegemony and Socialist Strategy: Towards a Radical Democratic Politics* (London: Verso).

Rodney, Walter (1968) *The Groundings with my Brothers* (London: Bogle L'Ouverture).

First published in *New Formations* 3 (winter 1987) (extracts).

10

BLACK OLD AGE . . .

the diaspora of the senses?

Beryl Gilroy

I am thinking about my being black and growing old in Britain. Will my old age, I wonder, be a calamitous plunge deeper into the underclass, or simply part of the general heritage of the struggling old, regardless of race or class?

Some white old people face old age with resentment. They are, however, part of the dominant tribe, and when push turns to shove they will assuredly be taken care of against all comers.

Everything is valid in the fight with the ravages of old age. Implants, cosmetic surgery, hair transplants, dyes and other concoctions are part of the confrontation between body and time. Most of this is beyond the reach of the poor and aged black, so old age has its way with us.

For most of us, death can be both sudden and close, and so reaching the allotted lifespan of three score years and ten is a time of rejoicing and pleasure. However, in this society only youth is given validity. It does not matter how efficient or committed a woman has been in her working life. On her sixtieth birthday and retirement she is assumed to have undergone some comprehensive deterioration. Experience becomes irrelevant to future generations who need to learn. Knowledge built up over a lifetime is thrown away, and senility and mental sterility are thought to have been acquired in quantity.

Western societies have developed various ways of casting aside the lives of the old. Let us therefore look, and only very briefly, at our African heritage prior to the cult of the gun, famine, drought and economic destabilization. We must not forget the machinations of the multinationals or the part played by the trading nations in the destruction of African cultural values, with more vigour since so many gained independence. The culture contained an ideology of old age which was taken to the West Indies by the slaves, who restructured it. There were no bona fide family members for committed care. No age-grouped members of the gender rituals like circumcision. Therefore kitchen communism, community care, societies and begotten or adopted children ensured care for the aged. The explicit tenets of responsibility for the old, made indigent by neglect, overwork and cruelty, were thus maintained.

African old age brought ancestral spirits through custom, behaviour and ritual into the lives of both young and old. Life allowed rebirth of the dead time after time to bring back the wisdom of the sages.

Old age marked the passing of time and it was time alone that allowed the harvesting of wisdom which permitted the advising of others. Living life co-ordinated moments of time and space.

True, today technologies have ensured that all old people have time on their hands, but there is not always the will or the resources to bring zest to endeavour. We are patronised by word and gesture and given minimal thought in the distribution of resources.

Black old people – men mostly – appear only briefly on television. The grandfather in *EastEnders* tries desperately to give reality to the pointless part he plays. And the old man in the *Why Pay More?* ad is as stereotypic as ever as he shouts his unconcern with helping his wife to the viewing world. Like the true black stereotype he has found a warm place to sit down and be busy. The woman is a shrieking voice – ignored by her man and addressed as 'woman'.

In old age we no longer run for cover from the racists of society, but we remain vulnerable. Some seek us out at election time. We are visible only then, for they are seeking power through politics. Promises! Promises! Promises! Forget them. During the long day we shop a little, walk to the park, feed the ducks, and look at the photographs with all their memories. There is no need to hurry back home. You are alone. The children have grown up and flown the nest. They visit when they can, and when they can, provide extra necessities. Your partner too has been lost to time.

> As sweet youth fades
> And age weaves its cobwebs
> Into limbs and hair and lively life,
> We wonder what rare metaphor will come
> After the dancing years, the loving time,
> The labouring time
> The body-for-others time,
> And we look back and rake the past
> And ramble over thorns and roses
> Seeking those who were with us then.

So I thought while I was waiting for my bus. It did not come but the piles of chewing-gum so liberally strewn upon the pavement stuck to my shoes and made me wonder at its cause. My bus still had not come several minutes later, but a 'sister' I had not seen before approached me. She was over the middle-age mark and neatly dressed in mourning. She spoke to me softly, at first, and then suddenly she released the tensions in her throat in a strangled scream.

'Me affe tell you', she said. 'Me husban, he dead. He electrocute last week. The good Lord take 'im. I miss 'im. I miss 'im so much me head going mad.'

As she spoke even the pores on her face dripped tears. Her body had become a graveyard of sadness and disconsolation. Her movements too, showed anger and grief running through them like a thick cord, lassoing me to her need. I could find nothing appropriate to say to this stranger, bound to me only by colour, but she took me by the hand and led me to her flat around the corner.

By now my bus had come and gone, so I sat and listened as she poured out her torment, her loneliness and her pain. She talked of the empty hours she could not now

fill, the changes she knew she must make. I listened as I had never done before, and as the hours passed I wished that I could stay with her, for what she needed most was another of her kind.

From whichever island of the Caribbean she had come, she would have been surrounded by her friends and relatives at home. As a woman sick with grief she would be tended and cared for. Words from the Good Book would be offered for comfort and spiritual presence, and in a final effort to give up feelings of loss and accept that the spirit of the person had passed on, the women would gather on the ninth day after the burial, and by rhythmic clapping and singing woo her into dancing away her grief in the Ritual Nine Night Wake.

This was usual in the village in which I grew up. Ritual was important. At funerals women carried well-worked wreaths of twigs and dried flowers to celebrate the passing of the old, and children carried green branches when the young passed away.

Now there was this old black woman all alone. A solitary widow. 'Few black people live round here,' she said. 'So near the depot. So near the trains. We had no choice.' Like mine her widowhood was sudden and owned only by herself. 'God never gave me children.'

They could not all gather around to channel away her pain. For her, only the church existed. Her grief underlined the seeking, the searching for a better life that is immigration, and which sometimes leads to isolation and despair. She was content to sit and quietly clutch her memories, and show me her photographs of a life I could not imagine, with a man I could never now know. But she had her quota of laughter and 'Laugh stories' and the myths, proverbs and dreams that kept our forebears sane in slavery and which now comforted her. 'Tank God I can remember', she said. 'We must all open our eyes to memory. He did good mostly. Nothing tempted him too far.'

How right she had been about memory. It is able to double-take, leave out, accentuate and change. It brings together mind, body and brain. We can wear it like an extra jumper in the winter or like a sunshade in the summer. We can do what we like with the chameleon of memory.

Memory begins before words appear. As babies we recognise those we love through touch and smell. Memory helps us know what goes on inside us before we are able to speak. Edmund Gosse, an English writer, tells an incredible story in his autobiography. It shows the power of memory. He was all alone in his high chair while he waited for the family to arrive for lunch. Their pet, a large and greedy dog, dashed in from the garden and carried off the leg of lamb which was to be served. He could not tell what had happened to the meat because he had not yet learned how to talk. Many years later when the incident once more surfaced he was able to explain the fate of the meat by recalling the buried memory.

Memory can provide the oil that is poured upon troubled waters, or stoke smoking fires to flame. Memory is a child of the guts and the emotion, of the brain and the heart and the lips. It is the dresser of time – in silks or satins or bruising flax which our forefathers wore during the diaspora. Memory makes us laugh and cry in turn. We cannot escape it.

Black communities on the whole take responsibility for their old and their elderly parents but this can be changed by the pressure of distance, unemployment and illness. These are different times. Boys no longer feel it their duty to look after their mothers, and in order for the women to do so, they must themselves work and leave the children

to grandparents, already worn out by lived life. We must find the skill, patience and endurance to cope with the young and so allow ourselves to be trapped in the historical role. We are living longer, and as a consequence are discovering lots of exciting things to do. We are asking questions about the roles we play and what we need out of this life which is hardly a rehearsal for a better one here on earth. My friend, recently retired, has rejected traditional roles of baby-sitting and child-watching and opened a health shop for the elderly. She is enjoying many wonderful moments.

Yet it is not an all-or-nothing relationship between us and our grandchildren. Most grandchildren eulogize their grandparents and understand when they do not want to be the main care-giver. Many of us keep enlightened contact with our grandchildren by refusing to buy into their affections, and by never supporting the consumer-monster activities at which so many young people excel. Like them we enjoy life, or strive to, but we think of death and they do not.

Death is the truth that divides the old from the young who think that they are indestructible and say so. And since only the old readily and easily die, there is guarded affiliation between youth and old age. When my granddaughter said, referring to us, her grandmothers, her mother and herself, 'There are two old ladies. One young mother and one little girl', I felt troubled. I had never been described as that before.

Segregation by age is something I have yet to get used to. Life and its times were for everyone in my village. Everyone had fun. The silly fun and the sensible fun.

I can remember when I encountered the word 'baby-sitter', wondering what it was. The closest was 'nurse', and children with nurses had no mothers, we believed. There was never any parcelling out of people into sections and groups. Old age meant respect, regard and consideration. Today the culture is global and led by America with all its light and shade, its preference for whiteness and the associations it gives to it. Americans are generous people, giving what is needed and what is not to the poor. What is of no use in the developed countries, or is merely self-indulgence, is freely offered as aid to the underdeveloped peoples of the world. The other day a seventy-one-year-old grandmother who had just returned from one of the 'aided countries' told me how a Teddy bear of enormous size nearly gave her relation a heart attack. 'Nobody knew what to do with it. An ugly ting like dat. The man push it to the child and kept on saying "Teddy bear, Teddy bear" and kissing it. But we never trust it because it could turn magic when the white man went home.' Affluence can be the father of ignorance.

This is a strange society; stranger still is the rest of the world. It made us – the patient, providing mother – dispensable. The children are a gift to life as old age would make us a gift to death. Yet life has validated us as mother, wife and friend. Thoughts of the past occupy our minds but the past has gone. Whatever its colour, we cannot retrieve its texture or its momentum. We have gained and lost.

Practically, we have gained personal freedom, peace of mind and the right to an individual identity. We are ourselves without encroachment from family or community. We are given an extra £10 at Christmas and receive it with as much unconcern as your forebears received their extra rations of flour, corn and salted beef in the bad old days, also at Christmas. We agree that £10 is the bounty of a caring government or a loving social worker. There are other concessions too – like the annual gift of a pound of butter from the EC. But we must know the venue and wear spurs on our elbows. Old age is and can design impoverishment as well as self-sufficiency. An inadequate pension, for example, can generate its own kind of poverty trap.

My most prized concession is my bus pass – a cold dark green this year. A proportion of my poll tax has been recycled to pay for it. It is not really free! Nor is the eye test which so many of us need. According to the minister it should cost £10, but the optician's secretary assures me that the minister meant from £10, and demands another four. But no matter. I have my bus pass which I highly prize. It *is* a cold dark green this year and my poll tax *has* helped to pay for it, so true to old age I repeat myself.

I catch the 10 a.m. bus – the 'Geriatrics Express', as it is called – and find nubile women and burly males (school students I presume) looped around the seats set aside for the elderly or the handicapped. Black or white, they watch the 'Shrinklies', as we are described, lurch about as we stand, grasping for support in the speeding bus, and gasping with the effort. When the lurching stops and someone can recover enough to ask one of those compassionate youngsters, 'Are you old or handicapped?', their guilty smiles even turn to laughter.

Life has taught them to sit and watch. We also watch. What do we see? We see that some of our young black people have lost cultural respect for old age and the ability to recognise the needs of the aged. The past means nothing to them. All responses are generated by their present. Some of these young people have learned neither faith, nor hope, nor charity in our affluent society. Love and loving are sexual mores to them, as their rap, so-ca and other musics decree.

For us, to work was to love. Work wove the threads of effort into experience – a tangible thing, which once saved us as a race from extermination. As women, experience helped us towards resistance to people who attacked those wisdoms we once knew – wisdoms of people who overcame all efforts to destroy us as wives, mothers and workers. We were able to love then, and continue to do so now. We have shown this quality in all that we have been asked to do. Today even work has died on us.

Old age celebrates our ability to survive, and eventually comes to a place where we can be grandmothers with gentleness and certainty. For black women, life with all its spikes and its countless thorns has always been lived. Will our old age be yet another diaspora? The diaspora of the senses?

Have no fear. We won't let that happen. We would not let ourselves be discarded, abandoned or left to fall into the pits of life like sediment.

We resolve

> to keep as active as we can;
> to treat each day of life after three score and ten as a gift;
> to share, to love, to affirm;
> to create in ourselves all that is joyous;
> to know and enjoy the intangibles of creation – such as valour and sacrifice.

We are a whole people. We have survived. And when the years pass and everyone else has succumbed to mindless change, we shall be the same. Black.

From Melba Wilson (ed.), *Healthy and Wise* (London: Virago, 1994).

11

FRONTLINES AND BACKYARDS

The terms of change

Stuart Hall

I want to think about Black culture and identity as organized around its own sense of frontlines and backyards. I am fully aware that it is dangerous to take this idea for a walk and there are many aspects I will not have time to deal with. I am aware that there is a lot invested in these terms and that to begin to describe the culture one inhabits is already to have set up a certain object of desire. I am going to take the risk of saying that I think that something as distinctive as a new ethnicity, a new Black British identity is emerging, and I want briefly to try to sketch its lineaments.

Now perhaps I should begin by saying that I am largely speaking about the trajectory of an Afro-Caribbean identity in Britain, and I am conscious here, looking at the age of this audience, that I have been present through three generations in the making of this identity and so some of the differences, between one decade or generation and another might seem more striking to me than they do to you.

One of the key differences is that had I been speaking to you a decade ago I would not have entered this caveat. Afro-Caribbeans and Asians were treated by the dominant society as so much alike that they could be subsumed and mobilized under a single political category. But today that is no longer the case. Today we have to recognize the complex internal cultural segmentation, the internal frontlines which cut through so-called Black British identity. And perhaps where these internal divisions are most acutely registered, where these lineaments of change are explored most vigorously concerns young people and their cultures.

Black British culture is today confident beyond its own measure in its own identity – secure in a difference which it does not expect, or want, to go away, still rigorously and frequently excluded by the host society, but nevertheless not excluding itself in its own mind. Blackness in this context may be a site of positive affirmation but is not necessarily any longer a counter identity, a source of resistance. The political resonance of Black identity has shifted dramatically in the last fifteen years. There is no sense that Britishness is an ideal to which we might want to subscribe or assimilate. We are fully confident in our own difference, no longer caught in the trap of aspiration which was sprung on so many of us who are older, as part of the colonial legacy described in Fanon's famous phrase as Black skins, white mask. Black identity today is autonomous and not tradable.

In the high moment of its assertion through the counterlanguages of reggae and

Rastafarianism in the 1970s, the idea that Black people could be perfectly comfortable with their Blackness might have been a hope, but that it would be so as a settled fact, that people could think of themselves as just going on, as being both Black and British was something undreamt of in those days. Yet for very many Black people, and especially the younger people, it is today simply taken for granted as an aspect of life. It is something they feel perfectly comfortable with, certainly not all of them – and certainly there are plenty of white people who don't feel at all comfortable about what has happened, but nevertheless we have lived through this massive change.

Now being in the world in the 1990s is increasingly a question of style and of settlement in ones own body, and here I want to remind you of the extremely contradictory position in which young Black people find themselves. In economic terms they continue to be at the receiving end of systematic structures of deprivation and victimization because of their race; by which I mean they are doubly disadvantaged, firstly because many of them are poor and unemployed, and then that is doubled up because of the specificity of race. And yet in that same moment their stylization of their own bodies is a remarkable feature which has made them the dominant defining force in street-oriented British youth culture. Without them white youth culture would not exist in the form it does today.

It is partly because this culture is a culture of enforced glamour and sexuality that the exotic character of the Black body has taken on such a powerful charge within it. So you have this contradiction of young Black people who hardly know how they're going to get into tomorrow, if they're going to get lucky and put their hand in their pocket and find a pound coin, nevertheless finding themselves at the centre of the host culture as its object of desire

The majority of these young people have come of age in the post-Thatcher world. This world is not, in its general political character, wonderfully receptive to Black people but nevertheless a minority of Black people have been able to occupy the interstices of the enterprise culture; it certainly was not designed for them but they have a certain way of making themselves at home with the mobile phone – there is a certain symbiosis between the hustling culture and the enterprise culture. Every now and again it looks like almost the same thing. You may not be trained in it, but if you bring to it some of the skills you've learnt at the margins and learn how to move with them you can make waves; you will not of course get to the top, you will not get into real positions of power, but nevertheless you will find some kind of living room there.

This generation are strong on their own rights, hopeful in advancing themselves; they are saying in effect this is what is due to me; they are not reliant on any kind of corporate or collectivist culture to make a life for themselves. We have to understand this development in its context. In the last two decades, the majority of Black people have seen the decline of the welfare state; the political culture which supported more collective aspirations to a better and more secure life has withered away. If they had spent the 1980s hanging around waiting for it to come back they would have got absolutely nowhere. They had to go out and carve something out for themselves. In the process they had to make this Black British identity take on a certain individualist cast. As a consequence, the period when Black politics was the politics of community struggle is profoundly in recession. I don't say that because I think it is a good thing, or because it gives me any pleasure, but because it is descriptively the case.

If it means they've got to have a job, and go to night school, and on top of that take

a qualification and do something at weekends, if they have to have three or four jobs and on top of that run the family and look after their kids and if the price of all that is that they won't have a dead end job and might just begin to have some kind of lower administrative position with a bit of interest and responsibility then they will take that route. And they will not wait to bring everyone along with them. This is a Black British identity which is not waiting for collective political struggle to achieve its goals. It has been obliged to find another way through.

One of the lines of distinction which seem to run through this identity is that between Black men and Black women. Women have, on the whole, been more successful in managing the transition to this newly aspirant world. Women are better convinced of their ability to achieve more than they are offered by white society, to go further, to learn more, to be promoted, than men. And let me stress that they do not want to fill these positions because they are 'white positions', but simply because they want to be successful and Black. So that is one way in which the function of race in structuring the avenues of relative achievement is shifting as compared to two decades ago.

Another concerns the issue of public visibility. In some areas of our public life Black faces have become increasingly *de rigueur*. Of course they are not in boardrooms, they do not take the real decisions in the backrooms of power where the real deals are done, but they are on the front lines of representation in terms of their currency in the culture. This is happening in music, in sport and in many other spheres. The point I want to make is that these are shifts which allow people a different relation to their own Blackness, whilst at the same they remain profoundly inscribed and marked by racism.

At one time in the 1960s the images which would have fuelled that relationship would have come with an African or afrocentred mark on them; in the same period to connote the Caribbean worked in much the same way. It accessed a source of identity which was authentically not white. But a distinctive feature of the new Black British identity is the extent to which it has been americanized. Its ideal images, its stylistic reference are very powerfully Black American. Even though the style may have been indigenized, given a British home-grown stamp, all the leads come from Afro-America. The lines of Black transatlantic communication grow ever more complex and intense. And that too has consequences for the relation to Blackness.

I hope that in the conference we may be able to explore what some of these consequences are. I hope we will risk some description of these lineaments of change, some mapping of this newly habitable identity because I feel we really do need to know more about it. In conclusion, I must stress again that we are always dealing here with a minority success story. A fuller analysis would have to set against it the evidence of ever more exclusive and excluded Black worlds, worlds which remain defensively closed to the kinds of influence I've tried to sketch. We have, for instance, to take full account of 'attitude', and what is at stake in this refusal of aspiration. That is another front line of distinction, another backyard where the relation to Blackness is being transformed, another story waiting to be told.

Section Two

CRITICAL ELEMENTS OF A BLACK BRITISH CULTURAL DISCOURSE

PART 1: CULTURAL IDENTITY AND SELF-REPRESENTATION

Issues around Black cultural identity and notions of Britishness represent some of the most contested areas of debate in contemporary British society. Whilst the political right, led by figures such as Norman Tebbit, Margaret Thatcher and the late Enoch Powell has argued for an exclusive white national identity, there is now widespread recognition of the multiracial nature of British society; the result of demographic and cultural transformations throughout the period following the Second World War. The essays gathered here (Chapters 12–16) explore what this new multiracialism means, especially to the Black subject. Henry Louis Gates Jr, the American scholar, offers his 'outsider's' view of Black Britain, highlighting its influences on the society at large, as well as presenting us with his choice of the main 'movers' and 'shakers'. Ben Carrington's essay on Linford Christie and Frank Bruno, arguably the two most popular Black Britons, explores one of the central themes of this book: Black Britons' claim to nationhood. This is interrogated historically in Maya Jaggi's interview with writer Caryl Phillips, and in Fred D'Aguiar's autobiographical essay. Ferdinand Dennis's account of Black life in Birmingham in the aftermath of civil disturbances of 1981 investigates the social impact of urban decay and the widening cultural gap between many Black Britons and British society.

PART 2: BLACK ARTS AND CULTURAL MEDIA

Part 2 (Chapters 17–24) interrogates the Black arts and cultural media, focusing on the problematics of self-representation. These are explored in a broad range of media including cinema, theatre, performance poetry, and the visual arts.

PART 3: CRITICAL SCHOLARSHIP

Part 3 (Chapters 25-8) brings together texts that highlight how a new critical scholarship is engaging issues of contemporary relevance and concern. Heidi Mirza intervenes in the controversial debate on 'race' and social intelligence, while James Nazroo revisits the racialization debate in the sociology of health. Karen St Jean's essay responds to the idea, publicized by the Black press, that Black economic success is now a significant feature of the national economy. The essay also discusses the impact on the Caribbean. Cecil Gutzmore explores the politics of the Notting Hill Carnivals, highlighting its artistic and policing paradoxes.

PART 4: NEW PERSPECTIVES IN GENDER DEBATES

The texts gathered here (Chapters 29–32) take a challenging look at issues around sexuality and gender. Carolyn Cooper focuses on the romantic world of reggae music and the controversial lyricism of the 'dancehall' (ragga), making a defence of singer Shabba Ranks against charges of sexism. Aminatta Forna's essay raises the issue of motherhood within feminism. She makes a case for the recognition of the African concept of motherhood common to most Black cultures around the world. Clare Alexander shifts the emphasis to the study of young Black men and their relationships with Black and white women. Richard Majors, Vincent Wilkinson and Bill Gulam examine the problematic position of young Black males within British society. Their focus is a unique mentoring project in Manchester that is trying to provide an alternative to the wasteful cycle of miseducation, joblessness and prison.

12

DOUBLE CONSCIOUSNESS AND THE BLACK BRITISH ATHLETE

Ben Carrington

Fifteen years ago we didn't care, or at least I didn't care, whether there was any black in the Union Jack. Now not only do we care, *we must*.

(Stuart Hall, 'New Ethnicities')

Introduction

This chapter seeks to address some of the implications of Stuart Hall's remark, in the late 1980s, concerning the politics of Black Britons' claims to nationhood, by tracing the problematic and complex positioning of Black athletes within contemporary British society. If we want to talk seriously about aspects of national identity and the place of Black Britons, then we cannot do so without some understanding of the importance of sport, for top-performance competitive male sports, in particular, continue to hold a central symbolic place within the popular-nationalist consciousness.

I explore these issues by providing a brief genealogy of, arguably, the two most famous Black people in Britain at the end of the 1990s, namely Linford Christie and Frank Bruno. The fact that these two people are both Black sportsmen is itself instructive in highlighting the restricted opportunities that continue to be available to Blacks living in Britain and can be seen as evidence of both Black achievement *and* continuing racial discrimination within British society.

I argue that we can map on to the lives, careers and mediated-public personas of these two athletes something about the condition of Black people living in Britain, and of British society itself. Both men, in admittedly limited ways and not without contradictions, offer a response to contemporary cultural racisms that posit the inherent incompatibility of 'Blackness' and 'Britishness', and provide at least the beginnings for more progressive positionings for Black Britons in an increasingly hostile environment.

The Black British athlete, however, is placed in a seemingly impossible position in being called upon to represent both 'the nation' and 'the race' at a time when such a subject formation, and the conditions under which this is possible, is constantly being challenged and fought over from both sides. We might suggest, following Du Bois (1994: 3), that the Black British athlete simply wishes to make it possible for a Black Briton to be both Black and British, without being cursed and spat upon by their fellows, and without having the doors of opportunity closed roughly in their face.

Where's the white in the Union Jack?

In looking at contemporary sports (athletics and boxing in particular) we might pro-vocatively ask, reversing Gilroy's (1987) appropriation of the far right chant, where's the *white* in the Union Jack? It has long been acknowledged that the very presence of Black athletes wrapped in the Union Jack still provides a distressing sight for the far right in visibly and publicly challenging the claim that 'there ain't no Black in the Union Jack'.[1]

Currently, the 'fact of racism' is a phenomenon that dare not speak its name in many spheres of British society. Blacks, and Black athletes in particular, will be rewarded if they subscribe to the view that racism is non-existent within British society, or at least that it is a minor aberration, or better still if they avoid the issue altogether. But the athlete who highlights racism, or even dares to *suggest* that racism *might* be a factor within contemporary British life is immediately labelled as being paranoid, over-sensitive, bitter, ungrateful and troublesome. This ultimately affects how easily they are accepted as 'British'. As Dave Hill pondered, somewhat perplexed:

> In this country, those who award membership to the sporting True Brit club frequently get it wrong. Frank Bruno, that tireless self-parody of relatively limited boxing achievements, has been wholly accepted, yet Linford Christie, a committed national team captain and arguably the greatest British sportsman of our era, has never really been made welcome.
>
> (1997: 9)

What Hill fails to realize is that it is *the very rules* upon which Blacks are accepted into the 'national family' (or the sporting True Brit club) that are the key to under-standing Christie's and Bruno's differing public and media receptions. Christie pres-ents a problem to the British media because by publicly mentioning the fact of racism he begins to disrupt the normative codes within which Black athletes are supposed to work, and is thus seen as 'a problem'.

Bruno, on the other hand, works prodigiously to endorse a conservative conceptual-ization of the nation, supposedly at ease with itself and free from racial antagonisms, and is thus accepted unquestionably into the nation. Bruno is thus presented as the acceptable face of Black masculinity, supposedly symbolizing what Blacks as a whole could achieve if only they would stop 'whingeing' about racism and commit themselves more fully to being 'British'.

There are numerous striking parallels and contrasts between the two men. Both were born in the early 1960s to Caribbean migrants (Christie was born in Jamaica, Bruno in England) and both achieved their sporting goals in their chosen careers. Both men are often presented in a similar way when their life stories are told. The under-lying narrative is one of the dysfunctional Black male on the verge of crime and delinquency (Bruno was sent to a borstal home for 'disruptive boys' during his teenage years and Christie too left school with few qualifications, both having numerous, short-term, manual jobs before 'finding sport') as a result of weak Black family structures without strong male figures. (Bruno's father died when he was fourteen and Christie's grandmother appears to have had the strongest influence on his upbringing).

Christie and Bruno are seen essentially as having been 'saved' by sport from the abyss

of Black ghetto life (evidence of the myth of sport as a 'way out of poverty') and, significantly, by *white male* 'father figures' (Bruno's former manager Terry Lawless, and occasionally the commentator Harry Carpenter, perform this 'father-like' role for Bruno; Ron Roddan, his coach, for Christie). White patriarchs and sport are therefore cast as the only means by which the excesses of Black masculinity can be controlled and refocused towards more socially beneficial aims.

Linford Christie: 'I want them to treat me as *a man*, not as a Black man'

Christie occupies a paradoxical place within the public imagination, both challenging and reinforcing dominant ideologies about Black Britons, often in equal measure. Unlike Bruno, Christie has never fitted comfortably within the narrow parameters within which a Black man is supposed to conform (docile, loyal, deferent). As a result his relationship with the British media, especially the print media, has been, 'turbulent, to put it mildly' (Profile 1996: 3).

The dominant media view is that, unlike other Black athletes, Christie has never been truly grateful to those (athletics/the media/the British public) who gave him the opportunities to gain the wealth he now has. Christie is thus constructed very much like the 'uppity nigger', ungrateful, rebellious and paranoid about his persecution. Most commentators are careful to avoid directly positioning Christie in this way and therefore often code their language, usually using criticisms of Christie by other Black figures, sometimes taken out of context, to justify their comments and to side-step any simple charges of racism. It is virtually impossible to read a commentary on Christie without a quote from the alleged remark made by Derek Redmond. The *Sunday Times*'s profile of Christie is typical:

> even his colleagues recognise the volatile, prickly and hyper-sensitive side to his nature. Derek Redmond, the former British record holder at 400 metres, famously described his running mate as 'perfectly balanced because he's got a chip on both shoulders'. One chip at least, is his belief that he has been continually misrepresented by the press.
>
> (1996: 3)

Never has a Black athlete been quoted as often as Redmond. If Christie signifies a particular view of Black masculinity we can see how the 'volatile, prickly and hyper-sensitive' narratives become transposed on to Black men in Britain more generally, reinforcing popular representations about the supposed inherent instability of Black masculinity.

Black sprinter, white laughs

Christie's penalty for his refusal to accommodate to the media and his assertion of an identity not reducible to the safe image of the 'good black' was to be subjected to a racialized discourse of sexualization that sought to undermine his achievements by reducing him, with an almost pathological fascination, to discussions about the size of his genitalia. Frantz Fanon (1986) reminded us long ago that the central component to

the emasculating discourses of racism is an attempt simultaneously to dehumanize and to sexualize the Black male body, in effect denying him his humanity.

The Black man is thus reduced to his biological essence: 'The Negro symbolizes the biological' (Fanon 1986: 187). The logical conclusion to this sexualized discourse is that, via the process of objectification, the Black man is effectively reduced to the phallus: 'one is no longer aware of the Negro but only of a penis; the Negro is eclipsed. He is turned into a penis. He *is* a penis' (1986: 170). Fanon continues to suggest that there 'is one expression that throughout time has become singularly eroticized: the Black athlete' (1986: 158). Thus, of all the colonial fantasies about the Black male, it is the Black athlete who has to carry the full burden of white fantasies about the Other (and who other than the Olympic sprint champion could lay claim to being *the* ultimate athlete).

The ambivalent and contradictory fascination with the Black male sporting body has nowhere been more clearly displayed than on the body of Christie himself, which has become the site for white male fears and fantasies about the sexual excesses of Black masculinity.

In the days and weeks following his success in winning the 1992 Olympic 100 metres Gold, Christie was subjected to an intense and systematic process of objectification and sexualisation. Following Christie's Olympic success, the *Sun* ran a feature under the heading '10 WAYS TO PACK YOUR LUNCH BOX LIKE LINFORD':

LINFORD CHRISTIE is way out in front in every department – and we don't just mean the way he stormed to victory in the 100 metres in Barcelona. His skin-tight lycra shorts hide little as he pounds down the track and his Olympic-sized talents are a source of delight for women around the world. But the mystery remains . . . just what does Linford, 32, pack in that famous lunchbox? The Sun . . . decided to pack model Lawrence Jean-Baptiste's lycra shorts with a variety of goodies to achieve that look. You may notice that we have featured only nine ways to create the look. The tenth way is to be born like Linford.

(6 August 1992: 15)

Significantly, the model chosen to wear the various items that were put down his lycra shorts was Black. As Christie and his 'lunch box' have come to signify Black male sexuality, *any* Black person could have accompanied the piece, the assumption being of course that 'all Black men are essentially the same'. What is clear from this account is that it is the *Sun*'s white male readership, and the male reporters, *and not* 'women around the world', who are the ones actually interested in Christie's 'Olympic-sized talents'. It is the white male homoerotic fascination with Black male bodies that is at play here, disguised by pretending such features are for a female audience. The last line clearly places the white male readership as the focus of the piece – the only way to have a penis the size of Christie's 'is to be born like Linford'. Thus after all the jokery in placing cucumbers, bananas and Mars Bars down your shorts, we all know that the only way to have a penis *that big* is to be born Black.

The extent to which Christie and 'the lunchbox' have become almost interchangeable can be seen in a more recent article in the tabloid press which read: 'MY QUICKIE SEX WITH THE LUNCH BOX' (Bowness 1996: 5). The story alleged

that a 'SIZZLING Sport stunna', called Michelle, had had sex with Christie prior to his Barcelona success. Michelle recalled, 'His body was gorgeous and he had a real animal magnetism . . . I couldn't believe how big he was'. Apart from the ridiculousness of the story ('Michelle' was also supposed to have had affairs with various other sportsmen including Imran Khan) and the obvious play on notions of Black sexuality and animalism, it is striking how Fanon's psychoanalytical analysis actually materializes in the mediated persona of Christie. It is not sex with *Christie's* lunch box but sex with *the lunch box*. Thus Christie is metonymically reduced to his genitals: he actually becomes, as Fanon foretold, his penis.

'Linford's lunch box' is now such a commonly used phrase that it is an unremarkable expression, yet the 'lunch box' discourse is clearly a coded attempt to talk about the myths of Black male sexuality. The degree to which the term has entered into the public realm and its continued use is testament to its deeply embedded cultural significance. What is instructive is that when Christie has exposed the underlying racist logic of the 'lunch box jokes', the media have generally turned on him, often appearing surprised that he should mind, confirming their perception that he suffers from racial paranoia. In most accounts, Christie is portrayed as being a bit 'touchy' and unable to take a joke. Thus reporters adopt the position of the bemused onlooker to Christie's incomprehensible over-sensitivity.[2] Christie himself is quite clear how he sees his portrayal.

BC: How do you feel you were treated, your body was portrayed?
LINFORD CHRISTIE: Well, you see, I took that as racism, and nobody can tell me anything different, and it wasn't only just racism it was sexist because white people built up a myth. There is two myths going around. There is the myth that Black man got bigger dicks than they have and we're this 'stud' kind of thing and that's why in slavery days they used us as such, then there's this other myth that we can run faster than they can and we can't swim! All these myths have been disproven . . . I don't think it's funny about Linford Christie's lunch box, I don't think it's funny. And I still meet Black people on the street who will still ask me, 'How's your lunch box?', because they think it's funny . . . You know, people make a thing about it. Like I met this woman and she said, 'OK can I stick a rosette on you?' and she went to stick it on my dick! And I didn't really want to *blast her*, you understand me? I just looked at her, I smiled and I walked off, because it's not her fault in a way, you understand what I'm saying? But if I'd have got mad and said, 'Listen blah, blah', they'd have said, 'Well, he's touchy, he's this, he's that', so I just tried to be as diplomatic as I could and let her know that I didn't approve of it, and that was the end of it.

(personal interview, 13 December 1995)

Fanon's work highlights the psychological strain that racist discourses place on Black subject-formation. Given this, we might ask how Christie himself has coped with the pressures, given his success and public pre-eminence. During *Question in Sport*, a television talk show in the build-up to the Atlanta Olympics in 1996, the issues came to a dramatic head.[3] The show was presented by the former footballers Ian St John, and Jimmy Greaves, with Patrick Collins, a journalist from *Mail on Sunday*. The other guest was boxer, Chris Eubank.

AUDIENCE: BLACK MALE ADDRESSING QUESTION TO CHRISTIE: The way I see things with the British press is that, like, yourself and Chris for example, you say things *you* want to say. There are other sportsmen out there, they just say what they think the public want to hear and what the press want to hear and that makes them popular. And they did things, needless to say, like pantomime [laughter from the audience] and things like that and that makes people happy. I just think you *do* get a bad press and there's no disputing that, and I just feel that's because you both say what you want to say.

CHRISTIE: . . . The media believe they make you or they break you. They don't make me, I make myself [applause].

IAN ST JOHN: . . . Patrick, our media-man here tonight, getting a bit of flak here. How would you reply to that?

COLLINS: I think Linford's paranoid about these things, I don't think Linford gets a bad press at all [audience laughs in disagreement, cut to Christie smiling and shaking his head]. I think in many ways . . . I don't think he's got the praise he deserves, I think when you look at his record over the years he's done the most extraordinary things over the past decade and nobody's done things like it. But I think Linford seizes on the bad publicity he gets which is largely from the down-market tabloids and believes that represents the media view of him, I don't think that's right.

CHRISTIE: Well, can I just say, I read this Sunday, for example, in the *Observer*, I mean reference to my 'lunch box'. Now I take that personally because, at the end of the day, it was the day after I won the Olympic Games, the greatest thing a sportsman can win, and all they can say about it is Linford Christie's lunch box! Now is that respect? [audience applause] And that was in a broadsheet paper!

GREAVES: Can I make a point here though? I mean, you have advertised that lunch box quite a lot . . .

CHRISTIE: [angrily] No! I have not, I have not . . .

GREAVES: Well, why do you wear the shorts then, why don't you wear something more suitable?

CHRISTIE: But Jimmy, that's a stupid question you've just asked me. At the end of the day, what's suitable? [applause]

GREAVES: You're offended by it . . .

CHRISTIE: I go out there to run, you should be watching my form when I'm running, the fact that I'm winning, not what's in my shorts! . . . [conversation becoming more heated]

GREAVES: Well, unfortunately that's what the issue's become . . .

EUBANK: Why?

CHRISTIE: Why? Why?

GREAVES: Well, well, a lot of women are fascinated by it for starters [smiles].

CHRISTIE: Stereotyping the Black man!

GREAVES: No, no, no. I don't accept that, I won't accept that Linford . . .

AUDIENCE: ANOTHER BLACK MALE: Jim, what do you want him to wear then, a kilt? [laughter from audience; Christie looks on, pensive]

GREAVES: No, don't talk daft. I'm just saying that *maybe* there was a time when Linford might have changed the shorts that he was wearing, *if* he's been offended by it. He's never offended me with it, I can tell you!

SAME QUESTIONER: The types of shorts Linford wears protects his hamstrings. Why should he endanger his own health in order for the press not to latch on to stupidness? [applause. Eubank defends Christie: 'You're not paying him the respect he deserves'. Eubank gets into a heated argument with Greaves]

GREAVES: [pointing at Eubank] You should have walked into the ring with a towel over your shoulders and boxed! Not gone in to 'Simply the Best' and all that rubbish . . . [some applause]

CHRISTIE : [interjects] Why should he be what *you lot* want him to be? . . . Because he doesn't conform to your rules, then why shouldn't he not do it? . . .

COLLINS: I think that when Linford uses the word 'media', he takes it in a broad sweep from the *Sun* to the *Guardian* and I don't think you can do that.

CHRISTIE : Well Patrick, I've read a story in the *Sun* that was exactly *word-for-word* in the *Times*, now come on! I mean what's the difference?

COLLINS: Same owner.

CHRISTIE: [Looking increasingly exasperated] At the end of the day, I mean, I'll give you an example today. One of the broadsheet papers, they wrote a story about me over the weekend praying for me to retire, you know, what's the point? Do you lot want me to retire? [Looking at Collins, voice raised] I mean, I'm at the stage where I'm so fed up of it all that I can walk out of the sport any day [voice begins to break]. I mean it doesn't mean that much to me any more. I used to love it but . . .

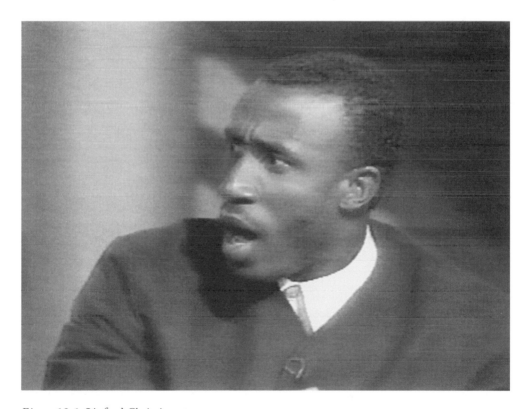

Figure 12.1 Linford Christie
Source: Reproduced courtesy of Carlton Television

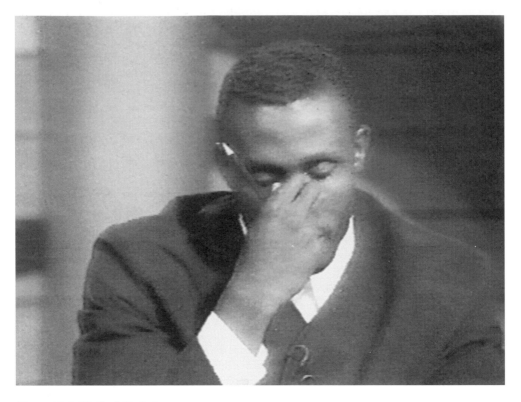

Figure 12.2 Linford Christie
Source: Reproduced courtesy of Carlton Television

[can't finish sentence, shakes head]. I can't take it any more, I just can't. And every day I get up and I want to walk away from the sport because . . .

GREAVES: [now in sympathetic voice, realizing Christie is upset] Is that because of the press, just the press? Or is it other things?

CHRISTIE: No, no. As an athlete we go through a lot of pressure. You don't realise, when you're on that line, if you blink you're left, ok? We have to go through it . . . excuse me [barely audible] I can't handle this [stops speaking, holds his shaking hands to his face]

(*Sport in Question* ITV, June 1995)

Many aspects of this controversy are beyond the scope of this chapter but a few points are worth mentioning. Greaves adopts the position of the white working-class male who 'tells it as it is' and rejects out of hand Christie's suggestion that his treatment was because of his position as a Black man. Instead he sees the whole matter as a joke – it is insightful that Greaves suggests that it is women who are interested in Christie's 'lunch box' but later concedes his own fascination: 'he's never offended me with it, I can tell you!'. Collins tries to differentiate his newspaper from the 'down-market tabloids' as he knows that the basic thrust of Christie's claim is correct (he partially acknowledges that Christie's achievements have not been fully appreciated

but offers no explanation as to why this might be).When Christie points out the similarities between the tabloids and broadsheets, Collins has no real answer.

Also interesting is Christie's intriguing response to Greaves's suggestion (echoing white complaints about earlier Black boxers such as Jack Johnson and Muhammad Ali) that Eubank should enter the masculine arena of boxing with more deference and respect (like Bruno?), to which Christie angrily responds, slightly ambiguously, by questioning the authority of 'you lot' (the media? whites? the white media?) to say how a Black man should behave.[4]

Reporting and commenting on the talk show at the time, most of the media focused on Christie's 'announcement' that he was going to retire, and therefore would not be defending his Olympic title, completely sidestepping his complaint of media racism. Most sections of the Black press were however largely sympathetic to Christie's arguments (see Wambu 1995 and Francis 1995). Michael Eboda (1995a: 20), writing in the *Weekly Journal*, noted:

> The problem with the white press is that they don't understand Black sports stars. Ask any Black sports journalist and they will tell you about how nervous the middle-aged white reporters get whenever they have to do a piece on a Black man who is not a coconut with a cockney accent. Linford must understand that these people will never mean him any good because, by and large, they hate the fact that the best sportsmen in this country look and act so unlike them.[5]

However, the journalist Tony Sewell launched an extraordinary, if not puzzling, attack on Christie. The *Voice*'s front page carried the header, 'Tony Sewell: Is Linford Just A Big Girl's Blouse?'. Inside, under the headline 'QUIT THE WHINGEING', Sewell criticizes Christie and other famous Black men, for 'moaning' about their plight, making no mention of the reasons for Christie's comments or the context within which they were made. Sewell trivializes Christie's case and questions his masculinity, his only concern being that he should break down in public: 'You celeb-guys make me ashamed to be called "a Black man". You'll be wearing high heels next – oh, you are Carl Lewis' (1995: 13).

More significant than the article itself perhaps, and instructive about how British media racism works, is how the mainstream media used Sewell as evidence that Christie's critique of it was unjustified – rarely has a Black journalist been quoted so often in the mainstream press. Unsurprisingly, Eboda's article was nowhere quoted. The *Sunday Times*'s profile, mentioned earlier, finished with a quote from Sewell's article to justify its argument that Christie 'has not, actually, had a bad press at all' (1996: 3).[6]

For many, the fact that Christie relies on and benefits from the media somehow invalidates *entirely* his basic argument that he has not been treated fairly. Even liberal commentators, perhaps out of a misplaced desire to protect their profession from accusations of bias, end up endorsing the *Sun*'s line of 'it's only a joke':

> Their [the *Sun*'s] page on 'Linford's Lunch-Box', following his Barcelona Olympic sprint victory, was in the paper's inimitable bad taste. But three years later, Christie cannot forget it. And, more to the point, still refuses to see the funny side.
>
> (Butcher 1995: 4)

Needless to say that the *Guardian* profile included the predictable quotes from Sewell and Derek Redmond.[7] Owing to such encounters with the media, Christie has long believed that he has not had the 'respect' he deserves. This call for 'respect' has often been derided as another example of Christie's paranoia, but on another level Christie talks on behalf of a wider Black population whose contributions to British society are constantly underplayed and undervalued. I want to suggest that we can read Christie's notion of 'respect' via Fanon's (1986) notion of *recognition* and the claim to Black masculinity analysed in *Black Skin, White Masks*, as a response to the emasculating ideologies and practices of racism.

The objectification and sexualization of Christie's body is a form of symbolic castration that denies both his masculinity and agency, in an attempt to render the Black male body, once again, controllable by white supremacist patriarchy (cf. Mercer 1994; cf. hooks 1994). For Fanon, the 'claim to manhood', as a response to white racism, is realized via a claim to *Black* manhood because his masculine identity is denied because he is Black: 'All I wanted was to be a man among men' (Fanon 1986: p. 112).

Confronted with denial, lack of recognition, Fanon continues, 'I resolved, since it was impossible for me to get away from an inborn complex, to assert myself as a BLACK MAN.' (p. 115). Or as Christie puts it: 'I want them to treat me as *a man* not as a Black man, you understand what I'm saying? That's the thing that we are fighting for' (personal interview, 13 December 1995).

The problem with Christie however, is that it is not always clear to what extent he is prepared to speak on behalf of a wider community beyond himself. His critique of the way in which he has been positioned by colonial myths and stereotypes about Black sexuality is correct but he fails to follow through these personal insights into a broader understanding of the social conditions of Black Britons. This is nowhere as clear as when he talks about racism.

Unlike many other high-profile Black athletes, Christie *is* prepared to acknowledge his Blackness in open and sometimes uncompromising ways. The opening chapter in his autobiography, *To Be Honest With You*, is, for example, suggestively entitled 'Hey! I'm Black!'. This can of course be read in two ways: either as a positive assertion of Blackness or in the sense of surprise.[8] None the less, the fact that one of Britain's most successful athletes is prepared to open his autobiography with an account of life in Jamaica, and his first experiences of racism coinciding with coming to Britain (discovering his 'Blackness'), is a significant cultural manoeuvre with wider political resonance. In such instances, Christie disrupts simple narratives of nationhood.[9]

Christie is also prepared to talk about racism beyond its simplistic conceptualisation as personal prejudice; i.e. between people who just happen to look different:

> It is also very clear to me that racism, especially in Britain, has become institutionalized. That's how I honestly see it . . . In Britain racism is ingrained so cleverly that you can't do anything about it. If you are Black and complain, the first thing they say is that you have a chip on your shoulder. There is no way round it. I know it exists; I know I am Black, I don't have to go out and shout about it.

> (1995: 263)

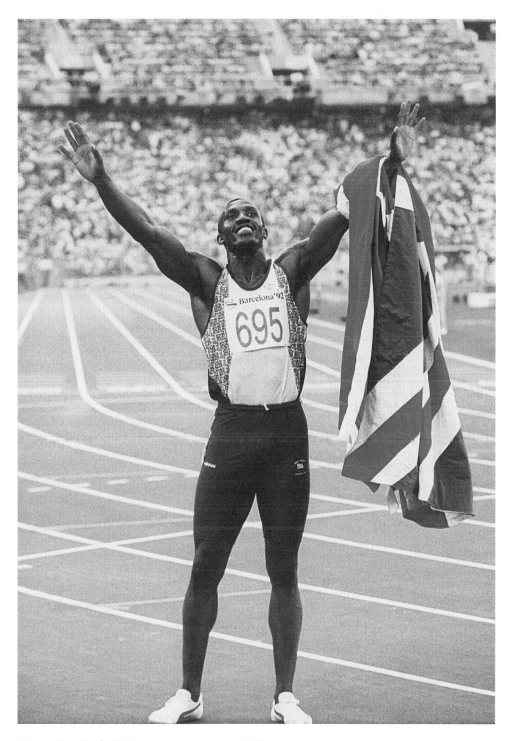

Figure 12.3 Linford Christie in Barcelona (1992)
Source: © Mark Shearman

Yet Christie is also capable of arguing, in the same breath, that racism is inevitable when 'more than one race or creed try to live together' (p. 263), a statement that would make any racist apologist proud. Christie has been subject to police harassment (he won damages) but his analysis of the problematic relationship between young Blacks and the police is merely reduced to 'respect' – respecting your elders and authority figures, including the police. Significantly, the progressive aspects of Christie's views get lost in his exaltations of 'Jamaican, Victorian values', collapsing a potentially radical critique of structural inequality within Britain into the personal attitudes of young Blacks.[10]

These contradictions are also played out in Christie's attitudes to Britain as a nation. He often talks about the deferential ways in which Britain is viewed by certain generations of older Caribbean migrants:

> Perhaps that's why my being British team captain seems to mean a great deal to the older generation of West Indians. They've got this thing about being British. They call the Queen 'Mrs Queen'; it is a mark of warmth and respect. To the West Indians, it is the highest honour to be captain of the British team. The younger generation perhaps do not see it that way but their elders understand the true value.
>
> (Christie 1995: 6)

Whilst such views may be an over-generalization, they reflect Christie's own attitudes, which barely recognizes the reasons why young Blacks in particular seem to be wary of 'British institutions' or why they have developed a healthy scepticism towards the dominant notion of Britishness.

Christie often endorses an uncritical version of the national that many Blacks in Britain do not share.[11] He occupies a position of Black Britishness that proclaims both identities in equal measure. Paradoxically, he often finds himself in the curious position of being seen as 'too Black' by the dominant society and 'too British' by many in the Black community who question his unproblematic embrace of the flag.

Frank Bruno: 'I love my people, I'm not an Uncle Tom!'

Franklyn Roy Bruno is a remarkable phenomenon. During a period when the political right was in the ascendancy, when Britain was polarized by class and 'race', with overt expressions of racism and violent disturbances in the inner cities, a young Black man from south London came to embody much of what Thatcherite Britain came to stand for.

Bruno often claimed to be politically non-partisan, but he was consistent in his promotion of individualism and meritocracy, assuring white audiences that institutionalized racism and class inequalities did not exist in sport or in Britain. So long as Bruno disavowed or repudiated his Blackness, he was proof that Blacks could exist within a right-wing conceptualization of the nation.[12]

This conceptualization emphasized the role and status of the 'individual', seen as the repository of 'true Englishness'. 'Individuals' looked after themselves and were self-sufficient. Any notion of the 'common good' was frowned upon as undermining the

sovereignty of the individual. The only extension of a moral responsibility beyond the self was the family, here imagined in its narrow, nuclear form. According to Thatcherism, society did not exist, only individuals preoccupied with their families and making money.

Bruno's autobiographies are full of 'family snaps', illustrating how he not only fits this right-wing conservative agenda, but actively promotes it.[13] Bruno sharply distinguishes himself from Christie on questions of racism, which is a key factor in determining who is accepted into the 'national family'. Barely bringing himself to acknowledge it, racism only features in Bruno's accounts when it is directed towards his family – such as the racist hate-mail he has received – and often he seems to have no conception of 'the Black community' or his relationship to it:

> I hope to have got enough money together to live a comfortable life. There are some cranks out there who hate the thought of Laura [his white partner] and me making a go of it. The occasional nasty letter comes in among the hundreds of letters that I receive from genuine fans who have supported me all the way to my world championship fight. It's just stupid prejudice from people who know no better. They can't understand that Laura and I are among the majority of people who don't see black or white, only human beings. The good Lord created us all equal.
>
> (Bruno 1987: 62).

The juxtaposition of talking about his hopes to make himself a wealthy man and racism is revealing. The latter is seen simply as a barrier preventing him from making money. Bruno's understanding of racism amounts to it being a little more than the views and prejudice of a few extremists on the fringes of 'good society'. Further his claim not to 'see black or white' is a form of 'colour blindness' which is actually a claim not to see racism. In his autobiography, *Eye of the Tiger*, racism appears in three pages of a two-hundred-page book, under the index heading of 'racial prejudice'. In the chapter entitled, 'A Lady Called Laura', he expounds:

> As far as Laura and I are concerned, the colour of our skin has never mattered. If there is any problem, it is in the minds of other people – not with us. When I was at school there was a marvellous hit song by Blue Mink called 'Melting Pot' which summed up the way we think about the race issue. Its message is that a lot of the world's problems would be settled if we could all be mixed together in a great big melting pot.
>
> (1992: 95)

Bruno's endorsement of the assimilationist model is central to the political right's explanation of how to deal with the 'race issue' or the 'colour problem'. The problem, so the argument runs is with those in the population who continue to 'hark on about where they have come from' and refuse to 'assimilate', thereby ignoring the systemic patterns of inequality reinforced by racially exclusive cultural notions of the nation, such as Norman Tebbit's infamous 'cricket test'. The expulsion of difference into a homogeneous notion of the nation is on the terms of the 'dominant culture'. Thus acceptance into 'Britishness' can be achieved only when Blacks are willing to give up

any claims to their own cultural history or identity and dissolve themselves into the nation.

Supping with apartheid

The one time Bruno was publicly confronted with his political views on racism was in 1986 when he fought the South African, Gerrie Coetzee. Despite widespread calls for Bruno to respect the cultural boycott against South Africa and refuse to fight, he did so.

In *Eye of the Tiger* he justifies his decision. It is one of the few occasions Bruno has spoken at length on the issue of 'race' and sport:

> The Anti-Apartheid Movement put me under enormous pressure to pull out of the fight. Terry [his manager] and Laura did their best to protect me from the shower of hate mail that poured my way, and I put my head down and tried to ignore the distractions. This was a subject for politicians, not sportsmen . . . I could not see how fighting Coetzee in England would either harm or help the battle against apartheid. If I had thought my not going through with the fight would have made a jot of difference to the Black struggle for equality in South Africa I would, without hesitation, have pulled out. But in Coetzee the pro-testers had picked on the wrong target. Mickey Duff knew Coetzee well and he reassured me that he was anti-apartheid and had dozens of Black friends . . . I weighed up everything very carefully before deciding to go through with the fight. If I had refused to box Coetzee it would have not caused the slightest change of heart in South Africa (where P. W. Botha was still in charge before the welcome rise of F. W. de Klerk). In the end I took what could be inter-preted as the selfish decision of agreeing to box. The way I saw it, if the protesters had got their way and had the fight cancelled it would have been me who was being punished because of the colour of *my* skin. I had fought my heart out to get to within punching distance of a world championship fight, and it would have set me back a year if I had refused to take part in this vital eliminator At a meeting of anti-apartheid protesters I was described as a traitor who had betrayed his brothers. As far as I was concerned, I would have been betraying my family if I had not gone through with the contest.
>
> (1992: 31–2)

Bruno retreats into the old adage used by athletes that sport should not be con-sidered political in any sense. The systematic oppression of Blacks in South Africa (or indeed elsewhere) as far as Bruno was concerned was not a matter for sportsmen (Black or otherwise), because sport and politics occupied separate spheres.

The problem with this view, or what it deliberately overlooks, is that the apartheid regime systematically used sport to promote the 'acceptable face' of the country abroad, never more so than during the 1980s, when the ANC called for a boycott. Bruno's comment that he would have pulled out of the fight if by doing so the situation in South Africa would have improved is not credible. His suggestion that anti-apartheid protesters had chosen 'the wrong target' because Coetzee had lots of 'Black friends' begs belief. Is he really saying that if Coetzee did not have 'Black friends' and *had*

supported apartheid he would have pulled out? How does that square with his view that sport and politics should remain separate?

Bruno failed to understand or refused to accept that the personal views of Coetzee were largely irrelevant. The issue was the symbolic significance of allowing a South African to compete in the international arena of sports as a way of legitimizing the racist regime.

The argument for the 'rights of the individual' to make money wherever they could, regardless of the ethical considerations or social consequences to others, also lay behind the political right's support for cricket tours to South Africa in the 1980s. Bruno's political position therefore allows him to be portrayed as a victim of the struggle against apartheid since, by not fighting, he would be losing his right to earn money for his family or jeopardizing his career. In this episode, Bruno confirms his endorsement of a conservative form of personal politics that sees no other responsibility for a Black public figure beyond his or her immediate family.[14]

When Frank met Maggie

Bruno is also a great supporter of a version of monarchist nationalism which marks him out from the majority of the Black communities of Britain: 'I am a fiercely patriotic Royalist, and consider myself a Britisher to the bone' (1992: 140). His unabashed admiration for Margaret Thatcher and her political views is also well known:

> I was a dedicated fan of Maggie Thatcher's when she was at No. 10 Downing Street. I have never met anybody as strong-minded and as confident as she was. Just by her very presence she could make you feel a foot taller at the thought of being British. When I shook her hand I almost expected her to break into a verse from 'Land of Hope and Glory'. I have also had the honour of meeting John Major, and have been tremendously impressed. He has not quite the same aura about him as Maggie, but he has a quiet confidence that gave me good vibes.
>
> (1992: 140)

It becomes clearer why Bruno has been unequivocally accepted as 'Our Frank' by the 'British public', and at the very same time failed to engender the same response from Black Britons. His well-publicized relationship and subsequent marriage to his long-term girlfriend Laura may be of some relevance here. Laura is white, but this fact does not seem to meet with the degree of white hostility that might otherwise be encountered. Indeed 'making an honest woman of her', actually seems to have *aided* Bruno's acceptance by the British public rather than deter it; leading to the view that 'he's not *really* Black, he's one of us'.

It is notable that on the front cover of Malcolm Severs's (1995) *Champion of the World! The Frank Bruno Story*, apart from Bruno, the only person in the photograph is Laura. She does not figure prominently and clearly is not meant to but she is neverthe-less there, completing the picture. It is almost as if the figure of Bruno alone (the autonomous Black male gladiator) cannot be adequately represented within a conservative nationalist discourse unless there is also a 'significant white'. As Gilroy (1993: 92) notes: 'The fundamental image of domestic harmony which surround Frank, Laura and

their daughters enables the national community to be presented as an extension of the Bruno clan – one, big happy family'.

Bruno's image and persona (his triumphs and failures) have become the site for racial and national contestation. Curiously, he seems to be loved by the mainstream when he loses, perhaps even *because* he loses – providing some sort of deep-seated psychological comfort to the battered white male ego against Black success in sport? (cf. Mercer 1994).

The *Daily Mail*'s leader after Bruno's heavy defeat to Tyson is striking for what it reveals about why Bruno has been adopted as a 'British institution':

> As Mike Tyson was pummelling Frank Bruno senseless, it is highly likely that he knew it wasn't just another British heavyweight he was rendering horizontal but a British institution. American television had sold Bruno as more British than Big Ben, and while the world heavyweight title was his principal objective, the supremely irreverent Mr Tyson will have derived additional satisfaction from dismantling a monument to the establishment. Any establishment. *What he will not have realised is that by reducing Bruno to a blood-spattered ruin, he has restored him to a state of grace in his own land.* America idolises winners but Britain adores a certain kind of loser. *Tyson has given us back the Bruno we know and cherish, an institution we almost lost when he outpointed the out-to-lunch Oliver McCall to win his world title six months ago.*
>
> (*Daily Mail* leader, quoted in Bruno 1997: 194, emphasis added)

In the conservative white imagination, Bruno can only be recentred, that is be a true icon for Blacks, when he *loses*! The successful Black athlete (Christie) becomes potentially disruptive and destabilizing whilst the battered and beaten Bruno is more reassuring and comforting. This may partially explain the Black communities' deep ambivalence towards him, not to mention what many see as his apparent complicitness with the self-mocking, and some would say degrading, portrayals of Black people outside the ring. Bruno often seems to fit the stereotypical figure of the 'Uncle Tom', one who remains loyally subservient to the wishes of his 'master' even as he is abused and mocked – Bruno's deep, slow, voice and his 'catch phrases' only add to this perception.

This mediated image is clearly invoked by profiles which suggest that Bruno 'likes to please his public. Endlessly affable, endlessly accommodating, Bruno's public persona is flawless' (Brown, 1995: 30). The all-smiling, cheerful, and infantile, and therefore asexual aspects of the negro (or 'Sambo' in Western iconography) all seem to be invoked when we see Bruno on our television screens endorsing products such as HP Sauce, a quintessentially English sauce, with his cheeky grin – a role normally filled by children in such advertisements. Then there is of course Bruno as the pantomime performer (sometimes dressed in drag), laughing happily at the jokes, despite normally being on the receiving end of them.

The images invoked here are of the clumsy, but crucially, *non-threatening*, gentle giant (see the Kleenex advertisements which play on this theme), lacking the intelligence to do any real harm: 'he's too nice, doesn't have the killer instinct to be a boxer' is an often-heard refrain about Bruno.

Bruno comes out

An interview between a Sky Sports commentator, and Frank Bruno, seconds after winning the WBC World Heavyweight Championship. The camera is focused on Bruno's face and torso for the whole interview. Bruno is physically, and mentally, exhausted after the 'biggest fight of his life' and is sweating profusely, his huge frame fighting for breath, with beads of sweat running down his body, and the occasional droplet of blood running down his bruised face. Union Jacks wave in the background as Don King and Frank Warren, the fight promoters, look on.

INTERVIEWER: Frank, many, many congratulations on behalf of the *whole* country for what was a fantastic performance. Has it sunk in yet? You're the World Heavyweight Champion!

BRUNO: Thank you, thank you very much. It hasn't sunk in as yet, but I just thank God I won. I've got this belt around me, it's like a dream come true. All the years I've been dreaming of this; I've persevered and I went with Frank Warren and he gave me this opportunity and Don King [camera pans out to show Warren and King, smiling boldly, behind Bruno in the ring], I thank them, I thank George, I thank Keith, I thank my brother, I thank . . . [Bruno lists off various names] I thank everybody that's watching television and I thank my wife [voice begins to

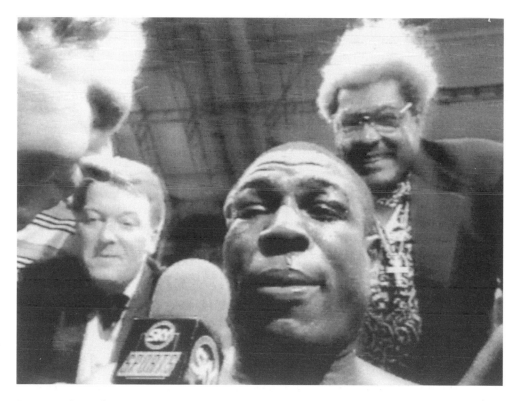

Figure 12.4 Frank Bruno
Source: Reproduced courtesy of Polygram Video/Pictorial Press

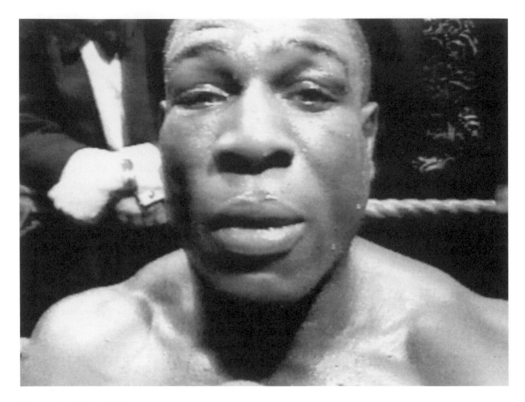

Figure 12.5 Frank Bruno
Source: Reproduced courtesy of Polygram Video/Pictorial Press

break], I thank my mum, I thank everybody for taking the opportunity of standing behind me [appears to be on the verge of crying]. And it was tough in there but I done it, you know, I done it.

INTERVIEWER: You confounded the critics, Frank, because they said you could never last twelve rounds, that your stamina would go, but you proved them wrong.

BRUNO: But I did it. It was tough in there, it was tough there, but I done it, you know. It's hard to put it into words because I'm busting up at the moment, but I'm just over the moon because I'm so happy [interviewer begins to ask next question but Bruno keeps talking]. I'm not an Uncle Tom, I'm not an Uncle Tom, no way, I love my brother, I'm not an Uncle Tom . . .

INTERVIEWER: [appears to ignore Bruno's unsolicited outburst] There were a lot of silly words spoken in the build-up to the fight, what were you saying to him afterwards?

BRUNO: I just said, I didn't say nothing about his dad, I would never say something about someone's dad and I'm not an Uncle Tom, I love my people, I'm not an Uncle Tom, I'm not a sell-out. That's all I said, true, you know [interview continues with talk of a big-money fight with Tyson. Bruno continues to thank people including his family].

INTERVIEWER: Frank, well done tonight. I've been at ring-side for every fight you ever had, we're emotional for you too, well done . . .

BRUNO: [interrupts] I'm no Uncle Tom, I'm no Uncle Tom, believe that, please, please, just believe that I'm no Uncle Tom, but thank you very much for everyone for getting behind me . . .

INTERVIEWER: [somewhat bemused] Well, I don't think anyone is seriously saying that you are . . .

The context for these comments demands some analysis because issues relating to 'race' are generally not part of the mainstream media news agenda and particularly not the sports media. Blatant examples of racism (or what the press prefers to label as 'race rows') intermittently feature as salacious exclusives but there is rarely any acknowledgement of the underlying racial signification of sport – i.e. the inherent racial meanings that are invested into competitive sport encounters.

As argued earlier, Bruno's racial and national status are contested issues within the Black communities is known, yet the mainstream media has never found it appropriate to ask him about these questions. When Bruno fought McCall, his African American opponent broke the unwritten rule that such issues should not be raised. In the pre-fight war of nerves, and possibly to unsettle him, McCall called Bruno an 'Uncle Tom' and openly played on his 'servile' reputation. (Lennox Lewis had previously made similar comments but retracted under legal threat.)

At the most triumphant moment of his boxing career ('all the years, I've been dreaming of this'), Bruno breaks down over the issue of his Blackness! The interview is turned almost into a confessional. But who exactly is Bruno addressing when he repeatedly says, 'I'm not an Uncle Tom'? Clearly there seemed to be two different conversations going on simultaneously: the interviewer's predictable questions and congratulatory patter and Bruno's amazing confessional pleading to, I would suggest, the Black British audience.

What is interesting about Bruno's outburst is the way the interviewer refuses to engage the persistent denials, until the very end and only reluctantly. His finest hour of glory as a British hero also becomes the moment of his 'racial outing' – a moment of unabashed patriotism with Union Jacks flattering and *Land of Hope and Glory* belting out of Wembley! How did the national press respond to this profound moment of national and racial reconfiguration? With near absolute silence.[15]

Black? British? Or Black British?

That Bruno and Christie powerfully announce that there *is* some *Black* in the Union Jack is clear. The problem, however, is the basis on which admission into the 'national club' is achieved. Bruno does it by adopting conservative ideologies and the assimilationist model of 'race relations', which in the current climate amounts to little more than a disavowal of Black cultural identity and any notion of Black empowerment.

Christie, on the other hand, disrupts the assimilationist model by acknowledging that his Blackness is not negotiable – i.e. something to be denied in order to be accepted. This is in spite of the fact that he holds conservative views that ultimately fail to transcend dominant ideologies. None the less, he presents like most Black

athletes a necessary step on the road towards a more comfortable subjectivity for Black Britons.[16] In my interview with him, he contests that:

> A lot of Black people lost their lives in the war for this country, you know, and so because we haven't got no sense of that we're not made to feel like we do belong. So when people say 'go back home' we say, 'alright, this is not our home'. But *this is* our home, you know, a lot of our Black people are born here, we fought for this country, and then helped build this country to where it is now, so therefore by going out there and doing what we're doing we're making those people feel, like our parents and other people that have been here all that time, that they're a part of this country.
>
> (personal interview, 13 December 1995)

The media's fascination with Bruno has dimmed somewhat since his retirement from the ring. Recently, however, he hit the headlines again for allegedly beating his wife. The *Sun* ran a front-page 'World Exclusive' headline 'BRUNO "BEAT UP WIFE"' (21 November 1997). The tabloid reported that Laura Bruno had filed for a court injunction due to her fear that Bruno *might* harm her, although there was no suggestion that he had.[17] This was clearly a shock to the national psyche, and the media seemed unsure what tack to take on their hero. Was Bruno reverting to racial type – joining the long history of 'volatile' and 'dangerous' Black men who attack white women, from Othello through to O. J. Simpson?

Once it was confirmed that Bruno had not physically abused Laura, the story changed to one of reconciliation, the whole saga becoming a metaphor for the nation to 'pull together', an attempt to reconstruct the imagined national community as 'one big happy family'. As the *Sun* put it, using a boxing metaphor:

> The Brunos are going through a rocky patch . . . Everyone in Britain will wish them well because Frank is one of our best-loved characters. So come on, Frank and Laura. Together you can sort out your problems. It's one fight you've just gotta win.
>
> (*Sun* leader, 5 January, 1998: 8)

Conclusion

This chapter has shown that, despite the contradictions of their position, Black athletes offer a powerful symbolic challenge to contemporary cultural racisms, by demonstrating that there *is* Black in the Union Jack. However, what is missing is any *conscious* attempt to radically redefine what constitutes Britishness itself, and to link such critiques to wider questions of social exclusion and disadvantage. The danger we face now and in the near future is that many high-profile Blacks will accept inclusion into the 'national club' without questioning the rules of admission.

The challenge facing contemporary Black athletes is how to articulate a notion of Black Britishness that allows them to embrace their Blackness, and at the same time contribute to a new model of what it means to be British today. Given the central position of Black athletes within the nationalist imaginary in Britain, we can no longer afford to ignore their situation. Twenty years ago most of us did not care about what

Black athletes had to say about racial politics in Britain. Now not only do we care, *we must*.

Notes

The author would like to acknowledge the critical comments received from Kwesi Owusu, Tracey Reynolds, Alan Tomlinson and Garry Whannel which helped to improve this chapter. I take most of the responsibility for what remains.

1 The concerns expressed by the secretary of the Rugby Football Union, Dudley Wood, that the high number of Black athletes competing for Britain would drive away spectators, and Robert Henderson's (1995) racist diatribe against 'Negro's' supposed lack of commitment to English cricket teams, show the continuing and deepening anxiety that Black success in sport can have for racist nationalisms. Similarly, it is no surprise that the 'inter-racial' couples earmarked for attack by British and Scandinavian far-right groups were nearly all athletes of one kind or another (see Statewatch 1997). It is not just that these people are public figures, but that they are *sporting* public figures who are supposed to represent the racially homogeneous nation, so their relationships are seen as not only 'diluting' the 'white race' but undermining the nation too.

2 See for example an article in the *Daily Mirror* (Weaver 1992: 26–7) entitled, 'Don't Mention the Lunchbox!': 'dare to mention the word "lunchbox" and the 6ft 2in hunk will get himself into a right old stew. For the jokes about the Olympic torch he keeps hidden in his clingfilm-tight shorts are falling as flat as a pancake. They started after he pounded down the track to Olympic victory in the famous Spandex shorts which left little to the imagination. But Linford's not laughing. He's livid . . . "Linford feels that he should be treated with more respect for what he achieved in Barcelona rather than suffer these sorts of jokes" explains Ron' [Roddan, Christie's coach] (p. 26–7).

3 Christie was also facing other pressures at the time, such as his protracted negotiations with the British Athletic Federation over a salary dispute and the serious illness of his mother. She died shortly afterwards.

4 The incident is also revealing for the way in which Black people talk within the white public sphere about 'race' and racism coding their remarks in such a way as to not mention directly the white 'Other'. Thus Christie can have a conversation with two Black audience members in a (white) public space and talk very clearly about white racism and the limits put upon Black expressive behaviour without ever explicitly mentioning the fact that the conversations are clearly, in my reading at least, about the 'Other', i.e. the white public.

5 Bruno is constantly used within Black vernacular as a signifier for 'inauthentic' blackness against which 'real Black men' are judged, even when, as with the questioner in the audience and again in this quote, he is not referred to by name. To be clear I do not mean to endorse such 'racial insiderism' promoted by terms such as 'coconut', which inevitably leads to a problematic hierarchy of Blackness against which we are supposed to rank people's racial credentials. I merely wish to highlight its use.

6 Such incidents have left Christie somewhat bitter in his now long-running feud with the *Voice*, which he claims he has tried to help in the past, only to be undermined, whilst the *Voice* claims that Christie has turned his back on the Black press. Christie himself said: 'How can I turn round and say to people like the *Sun*, and people like that, that, you know, "you're discriminating against me because I'm Black" when the *Voice* does these things? And then, you see, what they do, they get a copy of the *Voice*, you know, Tony Sewell . . . And what can I say? You see the thing is, what they [white journalists] do is they cut that out, a lot of the guys will cut that out and keep it. So when I say anything to them they show me; they take pleasure in showing me!' (personal interview, 13 December 1995).

7 See for instance Mihir Bose's (1996) account of the episode. Whilst rightly pointing out the contradictions in Christie's endorsement of 'Jamaican Victorian values', Bose fails to recognize that the basic thrust of Christie's critique of the media is correct, even if his motives may be questioned (Bose does not acknowledge his own vested interests in 'defending the

media' as a journalist). Bose, in true fashion, finishes by quoting at length Sewell's article, including Sewell's typically masculinist views on Black women, whom he described previously as being 'the biggest whinges in town' – for a relatively rare assessment of Christie that does not hold to this line see Williams (1995a, 1995b). For a less sympathetic assessment of Christie's relationship with the media see Mackay (1995).

8 On being told by a young white child in a school playground, soon after arriving from Jamaica, that she could not play with the young Linford because of his colour, Christie reflects; 'I thought, "I'm Black!" I was only about eight years old but to this day, I can still hear her voice and remember exactly what she said. I went back to my mum and dad and said "Hey! I'm Black!" I didn't even realize I was coloured' (1995: 10) – see also Christie (1989: 13–14). This passage bears a striking resemblance to Fanon's vivid portrayal of being marked by the look of the Other in chapter five (translated in English not entirely accurately as 'The Fact of Blackness') of *Black Skin, White Masks*, though Christie himself had not read the book.

9 Compare this with most other sports autobiographies where Black athletes will relegate aspects of racism to a paragraph, or normally a small chapter, within the book (ironically almost a compulsory appendage these days), but where the discussions of racism rarely extend beyond the personal experiences of racism suffered by the authors within their particular fields of sport. Ian Wright's autobiography is a good example of this. Despite his self-awarded mantle of being Black Britain's equivalent of Ali – 'I want to be recognised as someone who never sold out; as someone who made Black people proud and was fearless in the same way Malcolm X was' (Emmanus 1996: 17) – his analysis of racism, when he has produced one, is inconsistent and in many ways politically regressive. See for example the confusion Wright gets himself into in managing to misread Marley on to an implicitly right-wing explanation of racial inequality: 'People tell me I'm a role model for the Black community and I'm proud to be seen as that. But sometimes I wish the Black community would have a bit of pride in itself and see that there are greater things it can achieve. Slavery may have been abolished but a lot of Black people are still living in mental slavery. It doesn't matter how high a Black lawyer, doctor or even sportsman has gone in his profession, if he's the only Black face in a room, he still feels like the little jumped-on nigger. You can't blame white people for that all the time because there are just as many bad Black people as there are white; it's a case of self-pride and self-worth. We have to break free of those bonds. As Bob Marley put it, we have to emancipate ourselves' (1996: 105).

10 In Christie's earlier autobiography he talks at length about the realities of police harassment and violence that Black communities face: 'when I am kicked in the groin in my father's house, when I am taunted and called "nigger" and "Black bastard", when I am arrested as a result of police harassment, at those times I am ashamed to be British. And because I am in the public eye it is important that I fight back, that I show the world that the police are not infallible and that the rotten apples in the barrel must be exposed. Obviously I am not saying that all policeman are racist but there seems to me to be enough evidence for a nationwide enquiry into such harassment to be held' (1989: 54–5). By the time Christie comes to write his second autobiography, the graphic accounts of police harassment are reduced to a few lines, with Christie's anger considerably 'toned down' too: 'People sometimes ask me about the problems my family had with the police when they came into our home more than twenty years ago and gave us a bad time for no reason. I was very angry at the time but you can't sit back and think about things like that for ever. Life has to go on . . . I have realized that just because someone has done you wrong, not everyone else is the same. Yes, we had a problem with the police but that was only a minority in the force and I don't believe the majority should suffer as a result. There are some great policeman' (1995: 35–6). Apparently unable to make the connections between his own treatment and the continuing levels of racism experienced by young Blacks in particular, Christie argues that in order for young Blacks to be made to feel more 'British' there should be a stronger emphasis on traditional British values: 'We should start straight away with the younger generation; the kids should stand up in school each morning and sing the national anthem, be proud to be British' (1995: 34).

11 See for example his rather extraordinary claim to have been inspired to compete in his last

Olympics in Atlanta after witnessing the wave of nationalism generated by Euro 96. This is in contrast to many of Britain's Black population, who moved between general ambivalence and out-right rejection of supporting the England team owing to the xenophobic excesses of the tournament's coverage – see Datar (1996), and also Carrington (1998).

12 Recall the Tories' 1983 campaign slogan, analysed by Gilroy (1987), which portrayed a smartly dressed young Black male with the caption, 'Labour Says He's Black. Tories Say He's British'. Although this was not intended, the poster inadvertently implied that the young Black man could not speak for himself, a powerful example of how the voiceless subalterns were viewed – as a problem over which only Labour and the Tories could decide 'his' fate.

13 One of the problems with sport autobiographies in general is that it is difficult to tell how much influence the 'ghost writers' have had. Given that almost all such writers are white males, it would be interesting to explore the dynamics involved in their relationships with Black athletes in advising them about what would be 'a good read' and the extent to which Black athletes themselves have control over how they are represented. This, of course, is even more the case with Bruno, who until very recently had limited reading and writing skills.

14 Compare for instance Viv Richards, when he states in his autobiography, 'you cannot evade the point that playing cricket is in itself a political action. You can not get away from that. During my career the question of South Africa has, sadly, occurred many times. It has been widely reported that I have received all kinds of offers to play in South Africa and these reports have been true. Once I was offered one million Eastern Caribbean dollars, and there have been all kinds of similar proposals. They all carried a political burden and in each case it was a very simple decision for me. I just could not go. As long as the Black majority in South Africa remains suppressed by the *apartheid* system, I could never come to terms with playing cricket there. I would be letting down my own people back in Antigua and it would destroy my self-esteem' (1991: 186–7).

15 Eboda (1995b), writing in the *Weekly Journal*, noted: 'After the fight, Bruno made much of the fact that McCall had called him an Uncle Tom at a prefight press conference. "I'm not an Uncle Tom, I'm not a sell-out, I love my people," said Bruno who thought that the reason McCall had called him that had to do with the colour of his wife. It doesn't. Many Black people have said similar things about Bruno. What they are referring to is the way in which he comes across on television when he often seems culturally naive and almost never says anything in praise of Black people. Rightly or wrongly many Black people see Black celebrities as representing . . . the whole community. It may well be the case that Bruno does a lot for Black people privately and out of the glare of the media. But he is hardly ever seen at Black events or functions. So no matter what he is doing, people will always criticise him unless he is seen to be doing it. It will require more than just words for Frank to be as loved by the Black community in Britain as he is by the white community' (p. 20).

16 The entry of Black female athletes into sport may also provide a welcome opportunity to disrupt some of these ideologies further, and provide a different set of cultural possibilities for Black Britons in challenging some of the masculinist assumptions of nationalistic sports politics. However, present evidence does not suggest that this will happen. In September 1997, the sports magazine *Total Sport* featured heptathlete Denise Lewis on its front cover, perhaps a first for a Black British female athlete. She was shown completely naked, except for red, white and blue 'body paint'. The soft-porn full-length photographs inside (nearly thirty of them) showed Lewis ('an extraordinarily beautiful woman') in various positions; jumping about, spreading her legs, gazing into camera and even holding a javelin, which, in one picture, had 'speared' an apple which she was seductively eating. The pictures were simultaneously shown in a number of tabloid papers (see for instance the colour double-page spread in the *Express*, 'Denise Puts on Daring Strip Show', The Sport, 1 August 1997: 8–9). The fact that the only way for a Black female athlete to get on to the front cover of a major sports magazine is by appearing naked, painted in the colours of the Union Jack, is demonstrative of the ways in which contemporary racism and sexism still powerfully operate within the sports media, and the difficulties facing Black female athletes in challenging such practices.

17 Despite mis-reporting Bruno's alleged physical abuse (they later apologized and corrected the headline), it did not stop the Brunos selling their story to the *Sun* weeks later. The

description of Bruno was interesting, carrying with it allusions to the terrifying Black savage frightening colonial whites. The *Sun*'s front page carried the sensational headline: 'WILD-EYED FRANK MADE ME QUAKE IN TERROR' (5 January 1998).

References

Bowness, M. (1996) 'My Quickie Sex With The Lunch Box', *Sport*, 29 July: 5.

Bose, M. (1996) *The Sporting Alien: English Sport's Lost Camelot* (London: Mainstream Publishing).

Brown, M. (1995) 'Nice One Frank', *Daily Telegraph*, October: 26–30.

Bruno, F. (1987) *Know What I Mean?* (London: Stanley Paul).

Bruno, F. (1992) *Eye of the Tiger: My Life* (London: Weidenfeld & Nicolson).

Bruno, F. (1997) *From Zero to Hero* (London: Andre Deutsch).

Butcher, P. (1995) 'The Race for Respect', *Guardian 2*, 31 July: 4–5.

Carrington, B. (1998) 'Football's Coming Home, But Whose Home? And Do We Want It?: Nation, Football and the Politics of Exclusion', in A. Brown (ed.), *Fanatics! Power, Identity and Fandom in Football* (London: Routledge).

Christie, L. (1989) *Linford Christie: An autobiography* (London: Stanley Paul).

Christie, L. (1995) *To Be Honest With You* (London: Michael Joseph).

Datar, R. (1996) 'Black and White TV', *Guardian 2*, 5 July: 11.

Du Bois, W. E. B. (1994[1903]) *The Souls of Black Folk* (London: Dover Publications).

Eboda, M. (1995a) 'Christie is Right to Gripe', *Weekly Journal*, 15 June: 20.

Eboda, M. (1995b) 'Frankly Speaking, Bruno Deserves It', *Weekly Journal*, 7 September: 20.

Emmanus, B. (1996) 'The Interview', *New Nation*, 18 November: 17.

Fanon, F. (1986[1968]) *Black Skin, White Masks* (London: Pluto Press).

Francis, V. (1995) 'US Track Star Supports Christie's TV Outburst', *Weekly Journal*, 15 June: 1.

Gilroy, P. (1987) *There Ain't No Black in the Union Jack: The Cultural Politics of Race and Nation*, (London: Routledge).

Gilroy, P. (1993) *Small Acts: Thoughts on the Politics of Black Cultures* (London: Serpent's Tail).

Hall, S. (1996[1987]) 'New Ethnicities', in H. Baker, M. Diawara and R. Lindeborg (eds), *Black British Cultural Studies: A Reader* (London: University of Chicago Press).

Henderson, R. (1995) 'Is It in the Blood?', in *Wisden Cricket Monthly*, 17: 2: 9–10.

Hill, D. (1997) 'When the Union Jack Is Not All Right, Just Plain Daft', *Observer*, 6 July: 9.

hooks, b. (1994) 'Feminism Inside: Toward a Black Body Politic', in T. Golden (ed.), *Black Male: Representations of Masculinity in Contemporary American Art* (New York: Witney Museum of American Art).

Kitching, A. (1992) '10 Ways to Pack Your Lunchbox Like Linford', *Sun*, 6 August: 15.

Mackay, D. (1995) *Linford Christie* (London: Weidenfeld & Nicolson).

Mercer, K. (1994) *Welcome to the Jungle: New Positions in Black Cultural Studies* (London: Routledge).

PolyGram Video (1995). *Bruno: His Finest Hour*.

Profile (1996) 'Going the Extra 100m for Glory: Linford Christie', *Sunday Times*, News Review, 7 July: 3.

Richards, V. (1991) *Hitting Across the Line: An autobiography* (London: Headline).

Severs, M. (1995) *Champion of the World! The Frank Bruno Story* (London: Virgin).

Sewell, T. (1995) 'Quit the Whingeing', *Voice*, 4 July: 13.

Statewatch (1997) 'Nazis Send Letter Bombs to UK', 7, 1 (January–February).

Wambu, O. (1995) 'Time to Get Back on Track', *Voice*, 20 June: 16.

Weaver, T. (1992) 'Don't Mention the Lunchbox!', *Daily Mirror*, 19 August: 26–7.

Williams, R. (1995a) 'Christie Still Chasing Respect', *Guardian*, 14 June: 21–2.

Williams, R. (1995b) 'Lap of Honour', *Guardian Weekend*, 11 November: 12–21.

Wright, I. (1996) *Mr Wright: The Explosive Autobiography of Ian Wright* (London: CollinsWillow).

<div style="text-align: center;">

13

THE FINAL PASSAGE
An interview with writer Caryl Phillips

Maya Jaggi

</div>

Introduction

Ten years after Caryl Phillips's novel[1] *The Final Passage* was published, he adapted it as a two-part serial for Channel 4 television, which he co-produced with the director, Sir Peter Hall. It was shot on location in London, St Lucia and Trinidad, and its budget of £2.7 million for two seventy-five minute episodes made it one of the highest-budget dramas commissioned by the channel. In it a West Indian couple, Michael and Leila, join the mass migration to Britain with their baby son Calvin. The serial was first screened on Channel 4 on two consecutive nights in July 1996. This interview took place as the film was being shot.

MJ: What made you decide to do a television adaptation of your novel *The Final Passage?*

CP: Around the beginning of 1993 it became clear to me that the *Windrush* generation of people who came over here in the 1950s was dying. My brother Tony was planning a Radio 4 documentary about an old people's home in Yorkshire that was full of West Indians – old Black ladies who were veterans of that period. Also, I found myself talking to taxi drivers around here in London, many of whom were still talking about going back. Most were in their sixties, guys still trying to behave as though they were fresh off the boat, but actually had not only children but grandchildren.

It seemed clear a whole generation was on the way out. That made me think it would be good to tell that story. It struck me as being the most important change in the social fabric of Britain in the second half of the twentieth century, and though it had been done in fiction – Sam Selvon (*The Lonely Londoners*); George Lamming (*The Emigrants*);[2] *The Final Passage* – it hadn't been seen on the most potent medium in Britain – television.

The book was written in a spirit of, I hope, generosity, paying tribute to my parents' generation and trying to recapture the major contribution that was being denied by certain politicians – undermined, trivialized. Migration from former colonies has transformed Britain in the past fifty years. Caribbean migration has made a phenomenal impact – it's not just Moira Stewart and Trevor McDonald – whether it's the music on Top of the Pops, or football.

<div style="text-align: center;">

157

</div>

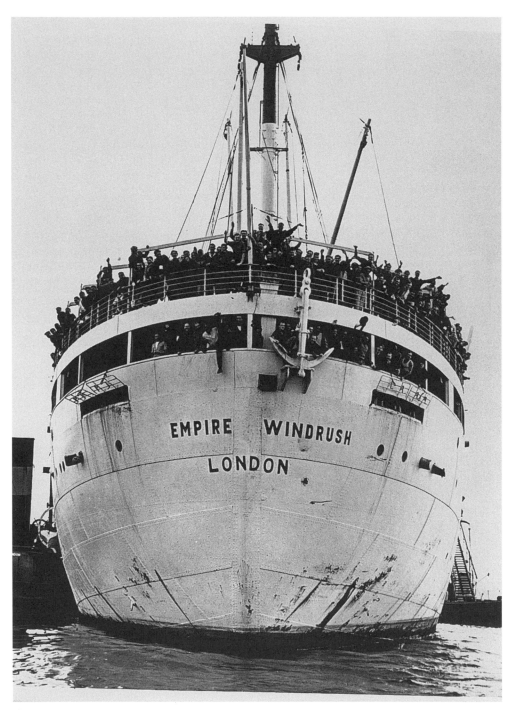

Figure 13.1 The *Empire Windrush*
Source: Courtesy of the Museum of London © Camera Press

The evidence of sea changes in British society is becoming overwhelming and undeniable. There's no major football team in this country that doesn't have a player who's a descendant of the people who stepped off those boats. There's no major industry – the Post Office, British Telecom, British Rail, the health system – that's not staffed by their children. But people don't know their origins. They don't understand because it goes back to that moment in the 1950s.

MJ: So do you see this as the British *Roots*?

CP: No. As you know, this is not the story of the advent of Black people in Britain. Black people have been continuously present here for five centuries; the first wave connected with slavery, the second with empire. You'd have to trace the family in more detail for a longer time. You'd have to begin in a city like Liverpool or Cardiff or Bristol – the slave ports – with a family that's been there at least since the nineteenth century, prior to mass immigration, from a time when numbers were so small that maybe there wasn't so much of a problem. Or if you were in Cardiff there were race riots before the First World War. Then you had the servicemen in two world wars. That to me would constitute the British *Roots*. This is not so much that as the last, or penultimate, episode.

MJ: Much of your work is a kind of subversive, revisionist history. What's your intention here?

CP: It's to recalibrate British people's perception of the main narrative of British history to include people whom they naturally exclude. I've got a book on 1950s Britain that's 250 pages long but makes no mention of Black people. I want it to be impossible to write books like that in the future.

MJ: The story is set in 1958, the year of riots in Notting Hill and Nottingham. But they are mentioned only obliquely. Why?

CP: I wanted to keep the story on the personal. Television is a reductive medium, and you subvert expectations by *not* giving people what they want. They want race riots and pseudo-documentary, so you work against the grain. I think you get more resonance out of the personal. If I hadn't had the incident with the kids throwing bottles and bricks and shouting 'spades', or Gary the racist son, it would have been ridiculous, because you have to put the context in. But people's lives were not characterized by the fact that in 1958 there were riots in the streets. When you think back to 1976, you know that, although there were riots in Brixton, Toxteth, Handsworth, Moss Side, our lives were not determined by them. It's a myth to look back and think that was the sole topic of conversation. So a few months after the Notting Hill riots, for Earl to mention them to Michael in passing is fine.

MJ: How autobiographical was *The Final Passage*?

CP: It follows a parallel in so much as 1958, when it's set, is when I came to this country, and my parents left a small Caribbean island. But my father had a job – he worked on the railways before he became a social worker – and my mother worked occasionally as an accounts clerk, then taught at Bradford College of Further Education. My parents didn't split up as soon as they came here. They had three other kids then split up in the mid- to late 1960s. I used to go and stay with my father in the school holidays, and I lived with him between the ages of fourteen and eighteen – split between both parents.

The novel, like any first novel, is underpinned to some extent by the details of your own life and your family's life. But there's probably more about my extended

family – my uncles and aunts – than there is about my immediate family. My mother had a sister over here before her, who came at sixteen. My father had his younger brother here before him – in Leeds and Bradford. So if anything, I got as much of the story from listening to not my mother or father but aunts and uncles, and watching the details of their lives. There are one or two little in-jokes. I do have an uncle called Earl. I did live in a street called Florence Road. It's a stabilizing mechanism. But my mother's a very different type of woman from Leila, and my father's a different type of guy from Michael, actually. He's not on his broken-down heels by any means. And my mother's not wistfully looking out of the window; she's an incredibly busy woman. She's as bad as me – she's always got six things on the go.

MJ: What made you add a present-day frame to episode two, with an adult Calvin as a lawyer, that's not there in the novel?

CP: I wanted it to connect to now, with a deep feed into what's happening on the streets today, not just be seen as a historical love-in. Episode two should be a jolt to the system. When I started writing the screenplay in a hotel in Honolulu, I sat there for three days, thinking it was going to look like a West Indian *Jewel in the Crown* unless I could find a way of making people realize it had a contemporary resonance. That was important to me so that it couldn't be dismissed as a nice, albeit expensive, period piece. I want the kids of my generation and below to realize this isn't just a costume drama about people who came over in the 1950s with strange hats; this is actually about their own lives. Even if their parents haven't talked to them about this, this is a way of maybe opening up the conversation.

Every single one of the Black actors said after they read the script they got straight on the phone to their parents and had conversations with them they'd never had before; that it triggered them into talking about stuff that lay dormant – and a couple of the white actors did as well, and the crew. They said they talked to their parents, or their family, about what it was really like in the 1950s when all these Black people were coming over.

MJ: The novel seems bleaker than the screenplay. Did you deliberately lighten it?

CP: I don't think the novel is bleaker than the screenplay, except in the ending; it should be at least as painful. But I didn't want to leave it as a downbeat ending. You can't really do that in television, you have to offer some slightly positive – not glossy or romantic – sense of the future. The screenplay shows it wasn't just a tragedy, that Leila survived, she endured and to some extent she thrived. She managed to do what she had in her mind all the time: make a life for her kid, and by extension all sons and daughters of that generation. At the end of the novel you don't know that.

MJ: Is there a danger of people looking at this film complacently, saying there was racism in the 1950s but now it's fine because, whatever the sacrifices of their parents, people like Calvin are lawyers?

CP: There is a danger. But the condition in which Michael is living at the end suggests everything is not okay, there is a generation that's been neglected. His bedsit was dressed down simply because of what you say. But I'd have had to write another scene. I did think about showing Calvin as a lawyer in his clinic for Rastas who are being picked up on trumped-up ganja charges, but it just became too complicated, another story. Let's not suggest that everyone lives in a nice bungalow like Leila

does today. But I know exactly what you're saying, and you're right: some people will say, it's all okay now. But short of someone lobbing a brick at Calvin's BMW, I didn't know what to do.

MJ: You show Leila making a conscious choice to stay. Did people really have the option to return to the Caribbean?

CP: Some people did go back, a lot of my family left. My great-uncle, who still to this day lives and works in the shop I was born in, left in the 1960s.

MJ: You were born in a shop?

CP: A rum shop in the poorest village in St Kitts, in the far north. It was also the village that's produced two of the three prime ministers: a Labour village with a strong left-wing union, because they're all cane-cutting people, very poor. My mother's family owned the rum shop, and I was born in the rum shop, which has been in my family for hundreds of years. My father's village was a few miles away. His father was a groom, and he used to tend the horses for the plantation. My mother's family were rum shop people and calypsonians – bad calypsonians. My great grandmother, the first thing she did when I was born, I was crying so much, she gave me some rum.

MJ: What reception are you hoping for with the serial?

CP: I hope when people go to work the next day and look at the person they've been working with for twenty-five years who is from Dominica originally or Grenada or Antigua, that they understand them a bit better. And I hope the West Indians of that generation when they go to work and see the guy who's been sorting mail next to them for twenty-five years, an East End guy in his late fifties, maybe they understand that guy a bit better. Because as difficult as it was for West Indians in the 1950s with all those expectations they brought to Britain, English people only thirteen years after the end of the last war had no idea what the fuck was going on with all these black faces arriving. And to some extent they never have had it explained to them what those West Indians brought in their hearts and souls, their knapsacks and cardboard suitcases.

Nobody explained to them the hope, the joy, the love of Britain that they brought with them, the genuine desire to help the mother-country at a time of serious overemployment, the desire to provide their children with a start in life they could never get in the Caribbean, because the received wisdom has been they came to take our jobs, to take our women, to drive up the prices of our houses, to undercut our wages. I just hope the white guy will look at the Black guy and think, ah, I didn't know that was the spirit in which you came. And I hope the Black guy looks at the white guy and thinks, shit, I didn't know, no one actually explained to you that we were British and we were invited here. If that happens, Hallelujah, I can hang up my biro.

MJ: What do you hope Black Britons will feel about the film?

CP: I hope they feel proud to see a part of their story that has been written out of British history, I mean totally ignored. This country has a serious historical failure of memory, and I hope they feel they can look at it and say, that's part of my life, or that's what happened to my brother, or my sister, or that person reminds me of Aunty so and so. I hope they feel connected to Britain; that it provides them with an umbilical cord to feel that this society is the place they've invested their lives in, because they have. It needs to be acknowledged. They're not going to get a letter

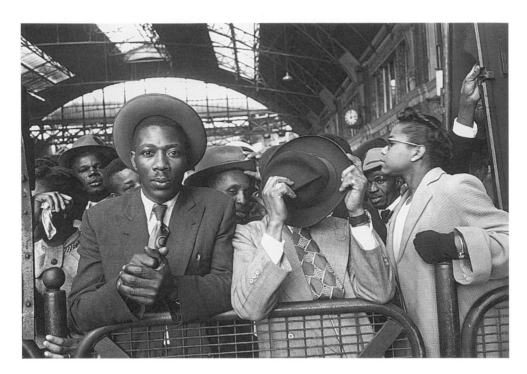

Figure 13.2 Victoria Station
Source: Courtesy of Hulton Getty

through the door that says you've got the OBE, or someone asking them to march on Remembrance Sunday at the cenotaph.

They're going to get no one who says we value your contribution to this society because it's been absolutely crucial to the development of Britain in the last fifty years. What do they get? They get morons like Paul Condon, [the Commissioner Metropolitan Police], telling them their children are muggers. They get people like Margaret Thatcher telling them we don't want to be swamped by you. They get people on the television and radio every day condemning their kids as criminals and psychopaths and drug addicts. So I want that generation to know, no, your contribution to this country has been remarkable. That's the generation I want to speak to first – the generation that came over.

I'm also interested in speaking to their children – people of my age amd younger – because I want them to understand that as much frustration as they're suffering in this society, and as much as they think this is Babylon, it's not their parents' fault. Because their parents came here in a different era, with damned good reasons for coming.

As far as the white community is concerned, anything's a bonus. I see TV series set in Bristol and Liverpool that don't have no Black people in them, and I wonder what those white writers were thinking. I do hope this tells both sides of the story, but I wish people who were writing stories and films in cities which have had a continuous Black population for over two hundred years might think about that. It's the same as Woody Allen setting films in Manhattan with no

Black people in them. It's a disgrace. I don't care how funny they are, that isn't Manhattan.

MJ: Do you see this as as much white people's history as West Indians' history?

CP: It's principally about West Indian history, but I've never been one to just peer over the fence in one direction. I always like to have a little squint back in the other direction, too. It's always struck me as daft not to try to understand what it looked like to English people. It's maybe a privilege of my generation: I went to school here, I grew up with English people. To all intents and purposes I was a northern working-class kid. So I was always privy to the paranoia and anxieties of white people about the Other. I include a little glimpse of what they might be thinking – though not to dominate the picture, because I'm not interested in 'balance'.

MJ: With the white characters, there's a contrast between the women, who are welcoming, and the men who maybe feel threatened and are more hostile. Do you think that reflects a historical reality?

CP: Yes, because Britain is a terribly patriarchal society, and it may be hard for our generation to realize the degree to which in the last forty years women have achieved some kind of toehold on the bottom rung of power. Forty years ago, there were few women in parliament, there were no women in industry. So the disenfranchizement of women, I've always felt, made them more tolerant than the men. Also, men were the people who worked. If a mass number of West Indians were arriving today, I don't think it would be as easy to characterize a split, because women would feel their jobs were threatened as well.

The two principal white women in this film are not with men. If they were, they wouldn't be allowed to hang out with Leila and Michael because, it seems to me, the men would be saying, no fucking way. Funny things happen when you look at the same material ten years later; you want to heighten and sharpen it because a film is necessarily reductive. The women are a bit more confident in the film. Stella and Mary have businesses; they're not threatened by this guy. It's not true to say that there weren't racist women. There's plenty of bloody racist women. But I'm interested in class and gender splits. The class I teach at Amherst [in Massachusetts] is called 'British fiction: class, race and gender'. I'm interested in the connection between all of these things. And to me, the gender split between the view of the 1950s arrival is not as simple as saying they all want to fuck the exotic Black guys.

MJ: There isn't as much sexism towards white women among your West Indian male characters as in, say, *The Lonely Londoners*. Were you underplaying it because of the audience? Was Selvon overplaying it?

CP: I'm sure he was playing it absolutely right. I think the guys *are* pretty sexist, but it's not the story of a group of lads who are without women, which is *The Lonely Londoners*. This is the story of a guy who arrives with his wife. When Michael is with his friend Earl, you get a bit of nudge, nudge, wink, wink, this is what the girls are for: 'England's number one pleasure'. The house Earl is ostensibly managing would be riddled with that sort of talk. But Michael never goes into Earl's world, the world of the clubs, where Black guys are trying to pick up women. And the police coming in, the guys throwing bottles at Michael and Stella, are not in the novel; they were added to show there was a real tension that Black guys were suddenly going out with white women. There's no self-censorship, because I

remember from my own childhood single male uncles who used to turn up with women. I know what went on.

But it's not explored because it's really the story of Michael's break with his wife and movement towards this other woman. There's no intervening period of being rogue guy around town. I was more interested in the destruction of the family unit, which is basically the event from which modern Black youth in this country are still trying to recover from.

MJ: Is Michael the picture of the irresponsible male, with his two women in the Caribbean, then a third in London?

CP: In the Caribbean context that's not a big deal. I wouldn't criticize him at all for that. There's a certain honesty to island societies where the place is so small everybody knows what's going on – but nobody wants to know. In a society like that, if you're going to have a mistress, or another woman, there's no point trying to be clandestine about it. Leila knew; she still married him. Beverly knew about Leila; she still had Michael back. It's not morally commendable, but I wouldn't sit in London and say he's a bad guy. Michael's behaviour there would have been unquestioned. Nobody would have to say, what the fuck are you doing, having two women with two kids. The nature of those 'outside women' and 'outside children' would be acceptable, in the same way as there's no French politician of any magnitude who doesn't have a mistress.

The problem is when you come to England, it's a different set of rules. There is anonymity, but paradoxically, that means you've got to come clean; because there's the potential to hide, there's more pressure on you to be open. In London, Michael makes a clean break, packs his bag and goes, because he can't do the same, 'here I am, there I am', thing that worked in the Caribbean.

The family aspect is the thing that bothers me more, because there are children. Studies of West Indian marriages show there was an unbelievable fatality rate of marriages, largely centred on the irresponsibility of the man. One of the principal reasons people came was to give their children a better education. But they entered a world of neon and glamour, and people were blinded by the lights. But if you lose sight of the children and engender in them a sense of an unstable family – where the kids have no point of contact with their grandparents and can't stabilize themselves with an extended family – you've messed up the game for two or three generations. I don't want to be too hard, but if you indulge in that degree of selfishness and irresponsibility, all you're doing is making it more difficult for the next generation to reap the benefits of this migration. Instead of a stable background that would allow them to participate and excel in the society, they're brought up between people, worrying about who they are.

MJ: Darcus Howe was once asked about fathering five children by three women, and said: 'I am West Indian, that means I make children all the time. It's not odd; my brothers and I have different mothers and my father was an Anglican priest.' The comment caused an uproar.

CP: I don't think it makes any sense. The Caribbean doesn't have the same social, cultural patterns as Britain. When you come to a country that has a totally different way of working – where a young child goes to school who doesn't know his father or his mother, who has a different name from his brother or sister – these things matter. There's a certain arrogance to assume that you can just import without any

refining thought a pattern of behaviour that works in Kingston or Port of Spain, dump it in London and say, what is your problem? Those social, cultural or marital patterns are not going to work here. And even if you, as a male, think they are, there's no way the women who arrive here from Kingston or Karachi will think so. They're going to absorb the ideas of the dominant culture.

I do think it's naive to come into a society and, along with your cardboard suitcase, bring a set of values you think society must somehow accommodate. Every migrant into a country thinks about that country's patterns of behaviour, social mores. You have to think, okay these are the things that matter to this society and these are the benefits it can offer me, I'm going to challenge it to this point. That seems to me to be the story of everybody who passed through Ellis Island. You change by degrees. There's a bit of give and play for any immigrant, because you're coming into something that's bigger than you. You have to take it into account. We all want Britain to be a wonderfully multiracial, multicultural, heterogeneous melting pot. But the fact is it isn't.

MJ: What do you think of attempts to explain that kind of sexual behaviour with reference to Caribbean history and plantation slavery?

CP: I think that's a load of bollocks, because you get the same kind of behaviour from people who are about as close to being a slave as I am to being ET. They have no slave, diasporan – African or otherwise – history. I just think some people want it all, and think they can have it all, and some societies allow you to have more than others. Here they close you down – with alimony. Michael's driven by ambition, and ambition is founded on some primary wound, some sense of rupture in your life; it's certainly not limited to the West Indian community. Michael thinks he's got something to prove. He's got more talent than the community he was born and brought up in would ever allow him to develop.

MJ: What would you say to someone who might object that his television portrayal risks pandering to stereotypes?

CP: They're asking me to be politically correct, redress the historical balance in one book. For every Michael there's a Bradeth, a terrifically responsible person, but I'm not a social engineer. Novels are not social engineering. They reflect the larger picture, but they're not the whole picture. They can never be. That's why one thing I hope for, and have hoped for ever since I began to write, was that there'd be more people of my background – West Indian growing up in England – writing, because that takes pressure off you. I've never felt oppressed by this, but you wouldn't have people making silly statements about your work, saying, why don't you paint us in a better light. The work would be contextualized by a body of work. It's not a matter of my not wanting the competition; I would welcome the company.

MJ: Though I've asked a lot about Michael, it's really Leila's story?

CP: Yes, it is. I know why you talked about Michael, because that's an area of contention. Some people will be thinking, that's how they all behave, and other people will be annoyed because they'll want to see Harry Belafonte or Sidney Poitier – 'I'm as good as you.' But that's not the truth.

The story of migrants in the twentieth century is of family tension, crisis, split. It's about the hopes and dreams you bring with you, but you enter Disneyland. People grow up very fast, they change very quickly, and often it's the woman who is left literally and metaphorically holding the baby. It's too easy to demonize the

father. But the pattern happens time and time again – and it's not culturally specific to the Caribbean. I teach students of all backgrounds: Chinese, Hispanic, Korean, West Indian. When one examines their family history – they're first- and second-generation migrants – there are often problems in the bosom of the family, partly exacerbated by the migration passage.

MJ: Did you say Disneyland?

CP: Even when it was shit it was good. Look at the end of *The Lonely Londoners*: it's a magnificent celebration of London, walking by the side of the Thames. It's one of my favourite pieces of literature. It doesn't mean it wasn't harsh; that novel is largely about poverty, struggling hand to mouth, six guys in a room. But the prevailing tone is in the last ten pages: a terrific evocation, a love song to London. And I feel the same about my characters in the 1950s.

MJ: The Channel 4 editor who commissioned the serial, Peter Ansorge, told me this was the first time the Caribbean had been depicted in British television drama 'not just as rum and coke and sandy beaches but as somewhere you might want to leave'.

CP: One of the first notes I gave to Peter Hall said, you have to make the Caribbean look like a place you want to leave, and London in the 1950s look like a place you want to be: that's a hell of a job. If at any moment in the film, the Caribbean looks like a place you want to go on holiday to, we're fucked. On location I told the cameraman, Nick Nolan, who shot the film *Playing Away*: You've got to make this place look shit. He said, but it's great. I said, I know it's great, St Lucia is stunning. But film is not a verbal medium. I can write that Bradeth says, isn't this a shit place, and Michael says, yeah, look at that fucking terrible sunset. But if the camera pans over this magnificent sky, it's all over.

MJ: Why did you decide to audition in both Britain and the Caribbean?

CP: I thought it was important to have a group of actors that was as mixed as possible. It's a story about Britain and the Caribbean. I thought we should go and explore what acting talent is there. Accent didn't bother me, but it was the idea of making the actors, the crew, the whole project as Anglo-Caribbean as possible – taking West Indians from Britain who'd never been to the Caribbean out there; casting some actors from there who'd never been to Britain. So you got it both ways; the set remained alive with people who were discovering something.

The lead actress [Natasha Estelle Williams] has a Trinidadian father and English mother, and she'd never been to the Caribbean. The lead actor [Michael Cherrie] is Trinidadian and had never been in Britain. Shooting in St Lucia and Trinidad, there was a number of not insignificant parts played by local actors, so it became something less than a colonial expedition. Peter and I did endless auditions in Trinidad and St Lucia, to have as fully integrated a cast as possible. We were restricted to an extent by the budget – we couldn't fly everyone out – but I like to think it was also an attempt to reflect in the cast the nature of the story.

It was also an absolute condition of my involving Peter in a joint production that the film had to reflect in the crewing the multiracial nature of its theme. To me it was important that as many people as possible around the set – including the trainees – should be young Black people.

MJ: Peter Hall told me this was a 'celebration of immigration, of difference'. Is that your view?

CP: No it's not. There's nothing glamorous about immigration, it's usually made by

people under duress. You don't leave India or Ghana to celebrate; you leave because there's something wrong with where you are, and it's usually something painful for you to digest and deal with, politically or economically, or both. In the Caribbean there was a sense of a glass ceiling, that you could only go so far. It didn't matter how educated or bright you were; ultimately, there was always some white guy in a bri-nylon shirt above you. The kind of waste you see on the streets on London, any major British city now – young people finishing school with qualifications who you know are going to be permanently unemployed – that kind of waste was a fact of life in the Caribbean, and has been for most of this century.

To uproot from family and friends is painful. Only the people who are in the host country can say, oh this is a celebration. Fuck that. We didn't come here to civilize you. We came because we couldn't remain where we were. What talents and skills we brought with us we will share, of course, put them at the disposal of the new country, but we didn't come here in the spirit of missionaries. This country should recognize, if they're confident enough, the qualities that people bring that can enrich the society, but what is there to celebrate? My screenplay is primarily about the pain of leaving; that's more pronounced than the problems and triumphs of arrival. Throughout there are references to the pain of what one has lost: you can't stay in the country you would have loved to remain loyal to, and that pain will colour the rest of your life.

MJ: In the screenplay Leila's dying mother tells her: 'You're a West Indian. You've only got one home, and one home is all you'll ever have.' But thirty-five years on, Leila tells her son Calvin: 'This England is your home, and as long as it's your home, it's my home too.' How do you see that shift?

CP: Throughout the text, the word *home* is played time and time again. Home, and different conceptions of it, is really what this screenplay – and all my work – is about. That's crucial in my conception of what happened between 1985, when the novel was published, and 1995, when I wrote the film. For that generation, we weren't sure how many would go home. We didn't have any Black MPs back then, no Black footballers in the England team, barely one or two in the cricket team. But it became clear in those ten years that this is becoming a permanent home for those West Indians of that older generation – because they're now beginning to witness their children making inroads into society. As you heard Oscar [James – who plays Earl] saying on the set, watching the young Black crew, they've been able to witness in their lifetime changes that are visible and tangible.

It's been a terrifically important ten years because this country has plunged economically – some might say intellectually and morally too – but there has been a real growth in confidence. I don't give a fuck what Condon or any of those wankers in the Metropolitan police force think, this country has in the last ten years seen the emergence of Black people in all sorts of fields – politics, the media, music, sport. You never used to see Black guys in suits and ties and Black women, power-dressed with their briefcases on tube platforms waiting to go to work. But you do now.

Also, the reality has overtaken the dream, because it's bloody expensive to live in the Caribbean, and here you have a pension after you've paid into the system for forty years. So it's important to get across the idea that it's okay to say this is home now, and one shouldn't regard that with a sense of failure, of being marooned in England.

Notes

1 Caryl Phillips was born in St Kitts in 1958 and came to the north of England with his parents at the age of twelve weeks. His first novel, *The Final Passage* (1985), broke ground in its portrayal of his parents' generation of West Indians who journeyed to Britain in the 1950s in search of a better break. He has since written five more novels – *A State of Independence* (1986), *Higher Ground* (1989), *Cambridge* (1991), *Crossing the River* (1993) and *The Nature of Blood* (1997), which chart the spectral triangle of Britain, Africa and the Americas. He is the author of the travel book *The European Tribe* (1987), as well as plays, screenplays and radio and television documentaries. His anthology *Extravagant Strangers* (1997) assembled work by British writers born abroad, from Olaudah Equiano and Joseph Conrad to Salman Rushdie and Ben Okri. He teaches at Columbia University in New York, and is the editor of the Faber Caribbean Series.
2 Sam Selvon, *The Lonely Londoners* (London: Allan Wingate (1956); George Lamming, *The Emigrants* (London: Michael Joseph, 1954).

14

A REPORTER AT LARGE: BLACK LONDON

Henry Louis Gates Jr

About twenty-five years ago, I took a job at the London bureau of *Time*. New in town, I had set out on foot from Bayswater Road for the Time-Life Building, on New Bond Street. Soon I was desperately lost and desperately trying not to show my desperation. It was that time of the morning when the only people around were those who actually worked on the street, and they all seemed to speak an alien tongue. This was my first time in England, where I was to live for the next few years, but I might as well have been in Vladivostok: I couldn't understand a word anyone was saying. Then I saw a black face and, out of habit, eagerly approached: at last, in this strange land, a *brother*. The man was cleaning the sidewalk outside a men's clothier's, dousing the concrete with soapy water and sweeping it over the curb. I gave him a prayerful look: Could he possibly tell me how to find New Bond Street? The man stared at me quizzically, and when he opened his mouth he sounded exactly like every other workman I'd encountered.

I was dumbstruck; it was as if the voice were the work of an unseen ventriloquist. Though I must have known better, I had, on some level, always assumed that my black compatriots *sounded* black because there *were* black: I'd assumed (I cringe to relate now) that the shape of our African lips had something to do with our characteristic consonants and vowels. Black comedians like Godfrey Cambridge could 'do' a white voice – they delighted in it – but you didn't think they could really keep it up for very long. I spent the next weeks studying first-generation English blacks as they spoke, mesmerized by the sight of protuberant lips forming sounds – whether plummily RP or blurry and filled with glottal stops – that were indistinguishable from those of their white counterparts. It took a while for the novelty to wear off. My initial travels through black London, then, were for me a succession of spit-takes: black people who sounded English without even trying.

What bliss it was to be black and living in London! How free you felt from the mundane prejudices of race-obsessed America! Here was a country where the boundaries between the races had been erased. Or so, for a time, I could imagine. I eagerly sought out London's island immigrants: the Trinidadians in Ladbroke Grove; the Barbadians in Finsbury Park, Notting Hill Gate, and Shepherd's Bush; and the Jamaicans (who then made up – as they continue to do – more than two-thirds of the West Indian population) concentrated in Brixton. As I soon learned, the history of Britain's West Indians – as a substantial presence, rather than the occasional

anomaly – went back only to 1948, when a boatload of nearly five hundred Jamaicans docked at Liverpool. Postwar England had a pressing need for manual labour, and the West Indians provided a convenient source. There had, of course, been people of African descent in England for centuries; the National Portrait Gallery currently has an exhibition devoted to Ignatius Sancho, who corresponded with Sterne and was painted by Gainsborough; and, long before Enoch Powell, Queen Elizabeth I demanded that all the blacks in England pick up and leave. But this was the first time they had established themselves as a collective presence, in numbers that grew to two hundred thousand within a decade and a half. Black London – and it was in London that the great majority of them pooled – was born. The Jamaican poet Louise Bennett called the process 'colonization in reverse'.

The presence of the black *Gastarbeiter* inevitably caused a certain unease among the natives. You wanted to be good hosts, of course, but you were hard pressed to know what to do when the guests forgot that they *were* guests. And that was the trouble with those postwar West Indians. You'd welcomed them into your home (*so* nice they could stop by), but now the hour was getting late. And, though you'd turned up the lights, noisily switched on the Hoover, even asked if you could call them a cab – done everything you politely could – they still didn't get the message: *You can all go home now.* That's when the sense of panic began to rise.

The blacks arrived at a time of 'overemployment' but, as the 1960s wore on, over-employment turned to underemployment, and a new and newly disaffected generation found itself out of luck and out of place. If many of them had no jobs, though, they did have their folkways; and in the contest of cultures bangers-and-mash was no match for curry goat. That sense of cultural difference was itself the cause of further unease. Britain had always had its own internal ethnic clashes, but they were familiar and, for the most part, unthreatening, the stuff of music-hall caricatures – 'When Ah take a couple o' drinks on a Sa'day night, Glasgow belongs tae me!'

Gradually, my enthusiasm for the Afro-Saxon diaspora soured into frustration at its marginality and powerlessness. I'd arrived from a land where James Brown and Jimi Hendrix – and Miles Davis and John Coltrane – ruled; where an entire generation, so it seemed, had with pen and brush taken up the task of self-representation. In London, the only cultural vitality appeared to come from forms that were borrowed, essentially unmodified, from the Caribbean. I would visit London's leading black bookstore, the New Beacon, and find that nearly everything on the shelves was from the West Indies or America. 'How can they be English?' John La Rose, the poet and publisher who ran the store, used to say to me about his fellow-expatriates. 'Their entire culture is West Indian.'

On Saturdays, the younger generation of Britain's recent immigrants would gather at some vacant house that had recently been 'liberated' for the occasion, the electricity and gas reconnected for an evening's bacchanalia. It was called 'goin' blues', and, although the site changed from week to week, you rarely had to ask where it was being held: you could hear it half a block away, as the reggae thudded through the adjoining council housing. You paid your twenty pence at the door and entered into sweltering, Caribbean heat. The floors trembled from the enormous bass loudspeakers. Upstairs, people queued for hot food and for Johnnie Walker served in Coke cans. Everybody was smoking ganja; you could get high just from breathing. But what always struck me was how joyless it all seemed: nobody spoke or even laughed. Expressions were hard,

affectless. The only white man I ever saw at a blues party was the one who distributed cocaine and ganja. 'Him not white,' an acquaintance told me. 'Him da *pusher* mon, dat all.' Otherwise the only words you'd hear spoken all night were in the imperative mood: 'Pass da ganja' and (if you accidentally brushed by someone in the crowded room) 'Don't touch me, mon.' Not jubilation but escape was the order of the night. And their language itself was another means of escape. 'Da rotted kayan' were the police; 'da monkeys' or 'da natives' were the English; 'Babylon', with a pleasing semantic symmetry, could refer to either England or to Jamaica. There was even a peculiar nomenclature for cognition: a Jamaican friend used to tell me, 'Da monkey understands. But da black mon overstands.' The one thing they could all overstand was that, no matter how many drinks on a Saturday night, London did not belong to them.

Twenty-five years later, a culture that is distinctively black *and* British can be said to be in full flower, both on the streets and in the galleries. 'What we had before was the Afro-Caribbean presence in Britain', says Stuart Hall, a professor of sociology at the Open University, who is, among other things, black Britain's leading theorist of black Britain. 'But the emergence of a black British culture can now be seen. For the first time, being black is a way of being British.'

This development is partly a reflection of social engineering: in the aftermath of the riots that swept Brixton and other black neighbourhoods in 1981, employment measures like Section 11 were adopted, accelerating the placement of blacks in public-sector jobs and helping to create something of a black middle class, however tiny. It's partly a reflection of the entrepreneurial ethos of Thatcherism itself. And it's partly a reflection of the liminal status of a new generation that was always looking both ahead and behind. 'You know that if you go into a smart boutique on Oxford Street,' Hall says, 'one of the things you will find is a very smart, good-looking black woman. Blacks become objects of desire in curious ways, with some secret umbilical connection to what's cool or exotic or sexy, or to the body or to music – all the things that Puritan English culture both reviled and desired. They've turned marginality into a very creative art form – life form, really – and they've done so at the level of youth culture, of music, of dress. They've *styled* their way into British culture. Which isn't hard, of course – it's one of the most unstylish places in the world.'

Among those who have styled their way into British culture is Ozwald Boateng, the first black tailor, he says, to hang out his own shingle on Savile Row, and, at thirty, the youngest. His parents came from the Ashanti region of Ghana, and he has a West African's dark-chocolate skin, though at six feet three he's tall for a Ghanaian. More than Boateng's blackness, his brashness makes him an anomaly on the street: Slick Rick meets Paul Stuart. Even the shop's décor – the mustard-yellow walls, the purple carpet, the cerise velvet that drapes the freestanding dressing room – seems a deliberate affront to the staid establishments that surround it. But what makes him so subversive, sartorially speaking, is his conservatism. 'Balance' is Boateng's rallying cry as a maker of men's suits, and I'm impressed, too, by his ability to strike a balance between bland assimilation and strident racial self-assertion. He tells me that he's a big believer in being Ashanti', but he also declares, 'I love the whole pompous cast of English tradition.' He recounts an annual occasion when the tailors from Savile Row have a formal, sit-down dinner. 'And all the Lords, and everyone – it's a men's club. Really a staunch British organization. And every so often there would be a toast to the Queen, so you'd

stand up: "The Queen, the Queen!" It's like totally fantastic.' You sense in Boateng a deliciously camp devotion to the ways of little England: he finds them – well, fetching. And how, I inquire, did he dress at this congregation of the sartorial centurions, the last guardians of tradition? Did he wear grey flannel? Boateng appears to be aghast at the possibility. 'Actually,' he says, squaring his shoulders, 'I wore a black velvet suit with a *slight* glitter in it.'

To see what's new here, it helps to talk to someone who has succeeded under the terms of the older covenant, and can remind you that in the more rarefied circles of London society you're still unlikely to encounter a black face. The dress designer Bruce Oldfield, whose clients include the Princess of Wales, was adopted as a child by a white woman who lived in rural England. 'I don't think I really saw black people *en masse* until I was about twenty-one, when I came to London and lived in Brixton,' he says. At any rate, the visible signs of Oldfield's Jamaican heritage are pretty discreet. 'I have a great rapport with Arabs, because they think *I'm* an Arab', he tells me, with a low, mischievous chuckle. 'Which is handy, because they've got a lot of money, and they like buying flashy frocks.' These days, Oldfield has left Brixton far behind, and the London he inhabits is essentially colour-free. 'I mean, if I go into a trendy restaurant, like the Caprice or the Ivy, I don't see many black people', he says. 'I just don't see black people where I go. I'm rarely in a house where there's another black person, socially.' He speaks of all this matter-of-factly, and yet it's clear that he sees himself, finally, as an interloper in the circles he moves through. 'English society is very compartmentalized', he says. 'There are black people who cross over, obviously – there'll be an interior decorator, a designer, people like me.' Yet there's all the difference in the world between thinking that you belong and thinking that you've crossed over. Oldfield doesn't quite manage a smile when he tells me, 'I cross over because I'm amusing and witty and charming.'

As you'd expect, a lot of the recent cultural ferment associated with black London happens much closer to street level. You feel that energy when you page through some of the black newspapers, like the weekly *Voice* (which claims to have two hundred thousand readers) and the more bourgie *New Nation* (which has been publishing only since November and hopes to reach thirty thousand). And you feel it even in the crudely satiric *Skank*, which is produced by and addressed to younger blacks. *Skank* has a less than reverential attitude toward black celebrities (devoting an entire page to the splayed nostrils of the Birmingham based black boxer Chris Eubank, which it likens to King Kong's); and it spoofs such historic episodes of black resistance as the 1981 Brixton riots, by offering 'the Brixton Riots '95 role playing game'. ('Feel the tension as you try to light that petrol bomb! Feel your pulse race as you try to find a hiding place for that brand new 48 inch Dolby stereo, laser colour TV and video you happily found lying in Dixons!') Then, there was a scabrous cartoon sequence entitled 'Lunch Box Christie', which focused on the runner Linford Christie's supposedly outsized endowment. (Christie sued the magazine, but only because the cartoon also implied that he took drugs to increase his athletic performance.)

Skank is published by the X Press, which is otherwise exclusively a book-publishing house. The press's founder, Dotun Adebayo, was born in Nigeria and came to the UK when he was six; his father taught physics at the University of London, though he has since retired and returned to Nigeria. The Adebayos are a textbook story of upward mobility: during one period, Dr Adebayo had five children at university in England at

the same time. Dotun Adebayo himself studied philosophy at the University of Essex; his brother Diran, a successful novelist, attended Oxford. Dotun Adebayo, like others of his generation, has a strong sense of mission – the familiar first-generation drive to fulfil the longings of the immigrant parents. 'I drive a very old car, but it happens to be a Jaguar', he told me. 'The reason I have it is my father, and his dream. He always wanted a Jaguar XJ-6. My father came back over to this country recently, and I didn't even tell him I had this car, I just told him I'd pick him up. He was so proud. He said, "Ah, Dotun. When I lived in England, I always wanted this car." It didn't matter that he'd spent thirty years here without achieving what he wanted to achieve – he had actually achieved it for the next generation. So that the onus is now on us to do something.'

Adebayo's first big score as a book publisher was Victor Headley's *Yardie* – pulp fiction about Jamaican gangster life. 'Basically, we postered the whole of Brixton', he recalls. 'You woke up one morning and everywhere you looked in Brixton it said "Yardie." Within a few weeks, we'd sold thousands and thousands of copies.' The X Press has now published fifty-one titles, most by black British authors, and most delightfully lurid and action-packed. (The titles include *Rude Gal*, *Curvy Love-box*, and *The Ragga and the Royal*.) The success of these books shows that there is a black reading public – though Adebayo would argue that black London is something that is in the process of being created. 'You need to go outside London and see the other inner cities, and then you will realize there is a black London', he told me. 'The black people in Manchester are Mancunians first, black people second. There's no link point over there. In the circles I move in – and I move in circles from ragamuffin kids to intellectuals, or what have you – there is definitely an urge to create a black London.'

In the main, the black London that existed in the 1960s and 1970s was bound by what Stuart Hall calls a 'transistor culture' – by certain kinds of music and the radio stations that played them. Though blacks in Britain have always been known for the music they brought with them from the islands (like ska and reggae and its rougher offspring, ragga), it is only relatively recently that these musical styles have evolved beyond their precursors. Today, the mores of the black British club scene have drifted far from those island moorings.

You can get a sense of just how far at Rampage, a movable feast held one recent Friday at the SW1 Club, near Victoria Station. By a quarter past ten, there's already a line of young working-class blacks all the way down the block and around the corner. They queue relatively quietly, chatting in small groups. Inside the small foyer, everyone is halted for a serious security check, scanned by metal detectors and thoroughly patted down by bouncers with headsets. Then they pay their £8 cover charge and proceed up a flight of steps and into a large rectangular room. It is furnished sparely, with just a few tables and chairs – nowhere near enough to accommodate a crowd that will grow to a thousand or more by midnight, but by then everybody will be bumping and grinding to Garage and House, hip-hop, Jungle, and even some R&B. At first, men face each other, dancing, but in postures that are menacing rather than erotic. It's as if they were shadowboxing to the heavy bass beat. Few couples dance together; instead, the genders divide and watch each other, with the men engaged in active display. A man moves in and out of another man's space, mimicking and exaggerating the other's moves. Again, it's pretend sparring; occasionally a shoulder knocks a shoulder.

The hair stylist Daniel ('Er, I still use "Daniel X",' he says sheepishly, 'but my friends tell me it's *such* a cliché') fluently explains the vitality of the popular-music scene to me. 'I was really disturbed when I first heard Jungle, because they took some of my favourite reggae tunes and just speeded them up', he says. 'The vocals sounded like Mickey Mouse. I was like "That tune's sacred! How dare you play it at that speed?" They'd double the speed, sample stuff, then put a chant over it, like "I'll kill your mother". It took me a little while to come around.' Now Daniel speaks of Jungle music with the zeal of a convert. He distinguishes with scholastic precision between Jungle (the drum-and-bass kind of thing that has crossed over, to the point where fifty-year-old David Bowie has a couple of Jungle tracks on his new album) and *Jungle* Jungle, which remains hard-core and all black. But that's not the point. The point is that Daniel himself is about to put out a Jungle track in a couple of months, on his label, Ticking Time Records. Daniel sees a musical world rife with possibility; and should he fail there are multitudes behind him.

In no small measure, black culture simply *is* youth culture in London today. Bizarre as it first seems, speaking with a Jamaican inflection has become hip among working-class white kids. If blacks are only 1.6 percent of the population, the percentage of wiggers – white wannabes – seems considerably higher. It would be a mistake, though, to come to any hasty conclusions. Imitation and enmity have an uncanny ability to coexist. Paul Gilroy, a leading theorist of black British culture, and a professor at Goldsmith's College, at the University of London, tells me about white skinheads who beat up blacks and then go home and listen to the rap group Public Enemy. It's as if they can't decide whether they want to bash blacks or be blacks.

And there you have the central contradictions of post-Thatcherite England: the growing cultural prominence of black culture there doesn't mean that racism itself has much abated. The police recently bugged the apartment of the young white thugs suspected of killing a seventeen-year-old black student, Stephen Lawrence, and found them hashing over various ways of killing blacks – even demonstrating the right moves with their kitchen knives. Just last week, a report by the Office of Public Management found that the Royal Navy has 'a level of awareness of cultural diversity which is 10 or 20 years behind that of society at large and which can reasonably be said to constitute institutional racism'. The same investigation concluded that in the RAF blacks are routinely excluded from honour-guard or VIP details: 'An unwritten rule summarised as "no blacks, Pakis, spots or specs" governed basic assumptions about how things should "really" or "normally" be.'

Nor are the better-off necessarily better disposed. At a dinner party at a Suffolk manor house, a group of fairly well-to-do Englishmen discuss their hopes and fears for post-election Britain while a fly-on-the-wall documentary-maker named Paul Watson films the group he has convened. The guests – a sales director at a real-estate company, a Lloyd's insurance broker, a restaurant owner, and so forth – talk spiritedly about, *inter alia*, the disagreeableness of blacks. ('I would encourage the black minorities to move back to their country of origin', one says.) Controversy ensues when the documentary is shown on Channel 4, but the participants have few regrets: one of them, a baronet's son named Henry Erskine-Hill, says, 'I would think our opinions are representative of the views of a great many people.' Erskine-Hall was asked by a newspaper if he was a racist. 'It depends what you mean by racism', he sagely replied.

What's clear is that British identity itself remains, as Stuart Hall would say, a contested space. A few years ago, Norman Beresford Tebbit, who was one of Margaret Thatcher's ministers and a one-time chairman of the Tory Party, complained that, when Britain's cricket team played one of the West Indian teams, 'our blacks' tended to root for the wrong side. How could they be truly British if they weren't rooting for the British team? And it's perfectly true that most black Brits fail the so-called Tebbit test; collective allegiances don't always align themselves altogether neatly. In Britain, the challenge is to figure out a vocabulary for addressing the intersections of racial and national identities.

'The trouble is, all of our language on race and race relations has always been borrowed from the United States, and there are reasons why that's wrong', Trevor Phillips, a long-time television broadcaster and producer, complains to me, in crisp Oxford English with just the faintest lilt to it. (He spent his childhood between Guyana and North London.) 'Effectively, Caribbean Americans behave in the United States as classical immigrants do and succeed as classical immigrants do – Koreans, say. Here we behave like black Americans in northern cities. Our experience is just the same as that of the blacks who migrated from the South to Chicago – all the way down to welfare dependency, and so forth.'

The statistics *are* pretty dire. The unemployment rate among Afro-Caribbeans in Britain is around 25 per cent, and in some parts of London it's closer to 50 per cent. The fraction that belongs to the professional class is only 2 per cent. Despite the fact that Afro-Caribbeans make up only 1.2 per cent of the population, moreover, a recent survey indicated that there may be as many as sixty-one thousand racially motivated assaults against Afro-Caribbeans over the course of a year.

Phillips, a man whose velvety burnt-sienna skin is accented by copper-framed glasses, is the chairman of the Runnymede Trust, and is regarded by many black Brits as a leading cultural broker. As influential as he is at present, he is likely to become more so in the near future. For one thing, he's a friend of Tony Blair's and is said to be in line for a position of some importance. Rumour has him as the chairman of the London Arts Board – or even, once the city's council system of governance is over-hauled, as mayor. The possibility of his being raised to a peerage has also been mentioned. Perhaps not surprisingly for such an insider, he doesn't see how separatist ideologies will ever prosper among English blacks. 'I think most black people in this country are embarrassed by the idea of being separate,' he says. 'Our neighbours don't come to lynch us, by and large. And, you know, we go out with their daughters, for Christ's sake.' The saving grace of a class-bound society, after all, is that the right class credentials can often override other obstacles.

'The one thing that saves me on the street with the police', Dotun Adebayo tells me, 'is they hear my accent and then they think, Hang on, this isn't your typical black bus driver or minicab driver, and take you a bit more seriously. And class is distinguished more by the way you speak than by anything else. In fact, the most tangible racism you'll find here is from the working classes. They're the ones who are going to fight you on the street. Whereas with the middle classes it can be "Oh, gosh, you went to Oxford as well? Oh, jolly good."' The novelist Caryl Phillips, who grew up between St Kitts and England, where he studied at Cambridge, tidily describes the relationship between sociolect and skin colour: 'In the States, until I open my mouth I look as if I fit in. In Britain, it's only when I open my mouth that I fit in.'

That situation can lead to some cultural contortions. Yvonne Brewster, the artistic director of the black theatre company Talawa and a recent OBE ('for services in the arts'), tells me about what she dubs 'the raffia ceiling'. She says, 'Linford Christie will say to you, "I cannot drive my Porsche." The man is a millionaire, but he could get arrested for stealing the car. That's why someone like the boxer Chris Eubank dresses up like a kind of antediluvian English toff, with plus fours and a monocle, so he is easily identifiable. You know, there's method to his madness. Even if they stop him with his Mercedes-Benz, they say, "Ah, it's Chris Eubank – drive on." In this country, there's absolutely no chance of burning that raffia ceiling. If you put your head above the parapet, you're likely to get it cut off.'

For Yvonne Brewster, a member of Jamaica's 'mulatto elite', there was never anything abstract about the vagaries of race and class in her new country. 'My father had two farms, one in Portland and one in St Thomas, and there was a man who used to do the horses in St Thomas', she recalls. 'He used to call me Miss Yvonne. Anyway, he came over here as a migrant, because there was no future for him in Jamaica and he didn't have any education. I was over here studying, and I was at Tottenham Court Road underground station and he saw me and came up and hugged and kissed me.' That the labourer should have presumed on the solidarity of colour and acquaintance horrified her, and, in her vulnerable state, she recoiled. 'I suppose what flashed through my mind was that in Jamaica this man wouldn't even come within six feet of me', she says. 'Anyway, I never saw the man again.' She breaks off, and I notice that there are tears in her eyes.

Yet if the barriers of class seem higher in England, those of race seem far more permeable. I'm always struck by the social ease between most blacks and whites on London streets. I was recently near the Brixton market, across the street from the entrance to its open-air section, and two men – tall, coal-black, muscle-bound – came loping towards a small young white woman who was walking by herself in the opposite direction. What happened then was – well, nothing. The needle on the anxiety meter didn't so much as quiver. Throughout the area, blacks and whites seemed comfortable with one another in a way that most American urbanities simply aren't and never have been. 'The advantage we have here in England is that you are more likely to be accepted for who you are', one black Londoner tells me. 'People don't judge you by who your partner is or who your friends are. I have this white girlfriend who lives in Brixton. We were going shopping in a market, and I met some Lisson Grovers' – the 'ruffneck' denizens of a large housing project – 'who had never seen me with a white woman. They took it really well. They were like "Yeah, OK."' Annie Stewart, the editor of the *Voice*, says, 'I think something like 40 per cent of our men have a relationship with a white woman. You find a second generation of blacks here who are more integrated than the first generation.'

Some of this sense of belonging is simply a result of racial dispersion. The Labour MP Bernie Grant points out, 'Even in my area, Tottenham, housing is mixed among the various races – blacks are mixed with whites and Asians and people from Cyprus, and it's all one big cosmopolitan bundle.' Americans who imagine Brixton to be analogous to Harlem are always surprised to see how large its white population is. London is where 70 per cent of Britain's blacks reside, but its blackest neighbourhoods are almost never more than two-thirds black, and usually they're substantially less.

All this sounds like a good thing, and yet blacks in London often speak enviously of the salience of race in America. 'I love going to New York, because I can walk down the street and the place is full of black people', says Ekow Eshun, who is the twenty-eight-year-old editor of *Arena* – a sort of English *Details*. 'A lot of the identity of the city is forged on the basis of that. The whole young black generation – the whole hip-hop thing – is very, very alive in New York, and it has a marked effect on the character of the city.' So part of the romance with America that you find in black Britain has to do with a sense that America has, racially speaking, a critical mass.

The allure of America isn't just that of indelible blackness, though. It's also the allure of class mobility. Of all the black Londoners I've spoken to, Trevor Phillips delivers the most impassioned homage to America, and it's in precisely these terms: 'I think the thing about the West Indians in the United States – and I know it's probably not fashionable to say this – is the openness of American society. There is, I think, genuine social mobility if you're ready for it.' He's convinced of this because of his father's fortunes. His father left school at thirteen and had never learned to write other than in block capitals; in England, he worked in the post office. Trevor remembers visiting his father at work one day, in a large sorting office manned largely by blacks. 'They were all wearing Post Office uniforms, blue jackets with red piping, and then across the floor comes a white man wearing a suit, a grey suit, and my father said to me simply, "That's one of the guv'nors", meaning that it was one of the bosses. The way he said it signified two things: that this man is completely separate from us, and that no matter what I, George Phillips, do – no matter how much people respect me, no matter how well I know my job – I will never be one of them.' Then his father came to New York, got a job as a security guard to Columbia University, and decided, for some reason, to go to night school and learn bookkeeping. 'In a year, I think, he had become the treasurer of a little think tank at Columbia called the American Assembly. This guy goes to the United States, he gets some education at the age of fifty-seven, gets his qualifications, and he ends up signing for Henry Kissinger's expenses.' Phillips is practically swelling in the recitation – there's a nearly evangelical fervour to his voice now – and he looks at me as if to say, How can you not love a country like that?

Like many other British blacks, it must be said, he has a slightly romantic view of black America. 'The idea that my children could grow up in a place where all kinds of rich people, the people who call the shots, who feel comfortable in their skins, are black – that's the greatest advantage I could give them', he says. It's a seductive image, this land where blacks call the shots, and one I often hear yearningly invoked by black Brits. They'd disavow it, of course, but I detect an implicit fantasy of black America as a Cotswolds village populated by Oprah Winfrey, Bill Cosby, Michael Jordan, Terry McMillan, Spike Lee, Michael Jackson, Quincy Jones, Vernon Jordan, and dozens more of their ilk. ('Yo, Trev – sorry this is kind of last-minute, but Oprah, Cos, and Colin were thinking about snagging a bite at Georgia Brown's and then maybe popping over to the Senate to try and talk some sense into them about the new education bill. Care to join us?') *That's* their American fantasy, and it seems unsporting to demur.

What's curious is that, while black Londoners look yearningly across the Atlantic, their American counterparts in the arts increasingly turn to them for inspiration. Thelma Golden, a curator of contemporary art at the Whitney Museum, in New York, is voluble on the subject of how much more vibrant – how much more advanced – the

new black arts scene in London is compared with its New York equivalent. 'In a way, I'd much rather be a black curator in London than in New York, because the excitement and sophistication there is extraordinary, way ahead of what's happening here in New York', she told me.

'Most thinking people don't know that there is a huge creative upsurge going on in the young black generation', Stuart Hall says. Hall was born and educated in Jamaica, came to England in 1951, as a Rhodes Scholar, and has watched three successive generations learn what it means to be black and British. But clearly the word is getting out, in part because of people like Hall himself. A soft-spoken man in his early sixties, with warm light-brown skin, a close-cropped grey beard, and a gentle manner, he is a tutelary figure for dozens of artists who constitute, in a free-form way, a postmodern black arts scene. He himself has played a central role in this development; indeed, for some he has a nearly guru-like status. The black photographer David A. Bailey says of him, 'People will say, "Tell us your stories, Obi-Wan Kenobi."' But Hall's characteristic tone is far from oracular. What he brings to London's black arts scene is really a set of emphases; for him, identities are things we make up, but not just out of any old things. As he puts it, 'identities are the names we give to the different ways we are positioned by, and position ourselves in, the narratives of the past'.

Today, Hall and his wife, Catherine, live on Mowbray Road, in Kilburn, in a three-story yellow brick Victorian house. Hall has a high-ceilinged book-lined study on the second floor; on the way to it you pass by a patrician-looking portrait of his nearly white grandfather. Amid the Jane Austen and Henry James are books with titles like *The Photographs of Rotimi Fani-Kayode* and *Race and the Education of Desire*. There's a poster for Isaac Julien's 1986 film *Looking for Langston*, and another for the fiftieth-anniversary staging of a C. L. R. James play, produced by Yvonne Brewster. Hall's movements are cautious, and he uses a cane to get around – he's in chronic pain – yet he grows animated when he talks about the coalescence of the new artistic vanguard in black London, one that's devoted to reinventing the very idea of British identity.

He shows me some photographs of the late Rotimi Fani-Kayode, who belonged to a prominent Yoruba family in Nigeria and settled in London, and, Hall says, managed 'to use all the elements of his cultural heritage with a kind of equal weight and yet at the same time to transform each by the presence of the other'. Still, it isn't insignificant that Fani-Kayode's principal subject was the black body. 'What's happened with the new generation is that they've begun to acknowledge their own blackness', Hall argues. 'They've begun to paint and photograph their own bodies. They can live with their own bodies – this is a very important turning point.' This inward turn has meant leaving behind a 'progressive' convention of the 1980s: using 'black' to refer indifferently to all non-whites, including South Asians. 'People don't use "black" in quite that way any longer, because they want to identify more precisely where they come from, culturally', Hall says. That moment of self-reflexivity plays out in all sorts of ways: Sonia Boyce's four-panel drawing *Lay Back, Keep Quiet, and Think of What Made Britain So Great* (1986) positions her own brown visage in a wallpaper pattern that was designed to mark the fiftieth year of Victoria's reign; film-makers like Isaac Julien and John Akomfrah produce visual meditations on memory and migration; multimedia artists like Keith Piper use computer-abetted installations to reflect on the politics of image. All these artists acknowledge their indebtedness to Hall, and yet for him the real significance of the new black arts scene is that it isn't, any longer, a black arts

scene. 'It's reached the point where a lot of artists who began by identifying themselves with ethnic minority groups have fought off the "burden of representation" – the idea that they have to speak on behalf of their entire race. They're moving outward into engaging in a more culturally diverse mainstream. They're questioning and diversifying that mainstream.'

The challenge of questioning and diversifying the mainstream is something that Lord Taylor of Warwick knows intimately, and, as we sat in the Peers' Guest Room of the House of Lords, he told me about the contrasts between his own career and that of his father, Derief Taylor. His father was a champion cricket player from Jamaica who went on to play for Warwick; he was also a qualified accountant. When he retired from the playing field, however, he could only find work doing menial labour. 'He was always striving to improve himself,' Lord Taylor says, 'and then he reached a kind of ceiling and began to sort of see his ambitions through me.' Taylor, for his part, went on to become the first black to be head pupil at Moseley Grammar School, in Birmingham, and the first black to win the Gray's Inn Advocacy Prize, and – when the Criminal Evidence (Amendment) Bill is enacted – he will be the first black to create British law.

'Some tea, milord?' a florid-faced servant murmurs. Lord Taylor – England's only, though not its first, black Lord – graciously murmurs assent.

And yet the story of his ennoblement – he has enjoyed this salutation for less than six months – isn't an altogether edifying one. It seems that when the Tory Party put him up for a vacant seat in Cheltenham, vociferous protests came from the Party locals – retired colonials and other stalwarts, who had a hard time seeing themselves represented by the son of a Jamaican cricketer and labourer. He was forced to stand aside. That episode embarrassed the national Party, and Prime Minister John Major sought to make the best of things by arranging for him to receive a peerage. 'None of the parties have a good record on race, one has to be honest about that', Lord Taylor admits.

Ultimately, though, he believes that black Britain's destiny belongs to black Britain – something that does give him pause. 'Trevor's right – I think the aspirational thing is part of Asian culture, but it certainly is not part of the Afro-Caribbean culture here', he says. 'If you read the Afro-Caribbean newspapers, week by week it tends to be gloom and doom – deaths in police custody, unemployment, some black person taking her company to the industrial tribunal because of being sacked or not getting the right job, and all that sort of thing. And we all identify with it. Just because we're professionals, we all identify with it.'

As is true of so many of black London's illuminati, Lord Taylor has a corresponding fascination with the global pre-eminence of America's black superstars. 'We have media and show-biz people who have made it, but they're few in number – no more than ten or eleven – and they don't have the global standing of their American counterparts', Lord Taylor says. He goes on to tell me that as a child in England he took inspiration from a magazine for American blacks. 'Many of my positive black role models came from *Ebony* – people like Muhammad Ali, Martin Luther King, Jesse Jackson, Quincy Jones. You know, it was always the elitism, but that encouraged me, because I could see that there were and are successful black people. That was the sweet part of it. The sad part of it was they were all American. They were untouchable in that sense.' Having long cherished a fantasy of appearing in *Ebony* himself, Lord Taylor says

he was jubilant to learn recently that *Ebony* would be featuring him and his family in its May edition.

There are moments – for me, this was one – when an American visitor to black London feels caught in a time warp. Their numbers are small, their achievements still, somehow, measurable. 'Just a few weeks ago,' Lord Taylor recalls, 'an editor at *Ebony* calls me and says "Lord Taylor, could you fax me a list of the fifty top black chairmen of companies in England?" I just fell about laughing, and he couldn't understand what the joke was, and I said, "I can try to get you five", because they just don't exist. The big companies do not have black directors. That's the whole point.' Ekow Eshun says, 'The frustrating thing about Britain is that the black presence in this country is decades behind America, especially in terms of high culture.' I see what he means, and yet that isn't my reaction. So I'm left struggling to understand why black Britain seems to me at once twenty years behind the times and twenty years ahead, somehow both pre- and post-nationalist. No doubt both temporal impressions are illusory. Yet perhaps what is most heartening about black London is the hope it offers of a consciousness that is cultural rather than racial – that has the capacity to acknowledge difference without fetishizing it, the freedom to represent without having to be representative. In the unending *Kulturkampf* between irony and solidarity, irony seems to be ahead in black London, at least on points.

As Lord Taylor of Warwick could attest, may things have changed since the 1960s, when a Tory parliamentary candidate could triumph with the slogan 'If you want a nigger neighbour, vote Labour.' And many things haven't. 'I'm also going into business,' Lord Taylor had told me when we spoke. 'I'm going to be a sort of corporate headhunter, joining one of the top firms in the world.' He was girding himself for the challenge, which he discussed with Dale Carnegie gumption: 'A lot of it will be networking – meeting the right people.' Even after being raised to the peerage, he'd had more than his share of meeting the wrong people. He recalled an encounter with a woman at a formal cocktail party a few months ago. 'So you're Lord Taylor?', she said, studying him coolly. 'I'll bet you do a good limbo.' Today, Taylor's entry in the latest edition of Dodd's parliamentary guide appears directly above that of another life baron, one Norman Beresford Tebbit. Make of that what you will.

From *The New Yorker*, 28 April and 6 May 1997.

15

BIRMINGHAM: BLADES OF FRUSTRATION

Ferdinand Dennis

The train journey to Birmingham was uneventful. A long night of playing pool at Mack's had left me exhausted, sleepy and a little irritable. The heat in the carriage and the uniform flatness of the Midlands landscape contributed to my drowsiness. Only a more rugged terrain – like the Pennines – would have kept me fully awake. Consequently, much of the journey passed in a nether-world: unexciting blurred images; the seemingly whispered conversations of my fellow passengers. It was the sight of old, disused engine workshops in Derby which brought me back to the real world. As the countryside resumed, I realised I was feeling apprehensive about my next stop. Birmingham and I were no strangers. I had lived and worked there for almost a year. It had been a profoundly disturbing experience.

In 1980, after six uncertain months out of university, I finally secured a job. A national charity concerned with penal matters employed me as an educational researcher. I was attached to a project in Handsworth, Birmingham. My brief was to write a report on the educational background of its clients – young black offenders. My duties seemed simple enough. It was not exactly the career I had in mind, but like many graduates from working-class backgrounds, I had no definite career planned. And I was young, enthusiastic and filled with that youthful optimism which owes much to a lack of worldly experience. In short, I was prepared to try my hand at almost anything.

As part of my induction I spent a morning in Birmingham's Victoria Law Courts. The first case involved a white petty criminal. To the magistrate he showed deference, remorse and had to be restrained from making endless apologies. He had been caught committing a crime and was resigned to being punished. He affected a humility that was intended to win a light sentence. Part of the legal game. The black defendants, however, refused to play the game. Without exception, they were young, Rastas and fiercely defiant. It was clear, to me at least, that they did not recognize the court's authority.

The first Rasta defendant was charged with burglary. He dismissed the magistrate as an 'agent of Babylon' unfit to pass judgement on him, a child of Zion. Soon, he warned, Babylon would be destroyed by thunder and lightning, brimstone and fire, and 'the downpressors of Jah's children' would perish. The court ushers hauled him away, and the stony-faced magistrate wearily called for the next case. This, too, involved another Rasta. His mother was in the gallery. She was middle-aged and clearly distraught,

holding a handkerchief to her face. The boy looked on disdainfully as the lawyer attempted to convince the magistrate that his client came from a decent Christian home. He was granted bail and a probation report ordered in time for his next appearance. All the subsequent defendants that morning were black.

Back in the office, a little terraced house on the edge of Handsworth, I daily interviewed youngsters who had been to borstal, detention centre or prison. Incarceration is supposed to rehabilitate as well as punish. None of my interviewees showed any signs of repentance. They had simply endured their punishment as part of the expected 'wickedness of Babylon'. A recurrent complaint was that certain institutions forced them to shave off their dreadlocks. Rastafarianism was not a recognized religion. Punished, but neither repentant nor rehabilitated, they drifted back into the lifestyle that had led them to jail. Their separation from the black community had begun when they became Rastas. Now they were ex-criminals as well, living in communal squats which subsisted on dole-cheques and stolen food. Babylon, they believed, owed them a living. Spiritual sustenance was provided by collective Bible-reading sessions.

They had all left school, some prematurely, without any qualifications. This meant they were ill-equipped to compete in a shrinking job market. Not that they were interested in work. They made a conscious effort not to 'toil for Babylon system' and described their hardworking parents as 'brainwashed servants of Babylon'.

Imprisonment was, perhaps, the mildest form of punishment. Worse was internment in a mental home. Handsworth is served by All Saints', a manorial building looking out on to landscaped gardens. It had a fearsome reputation. Those who ended up there, it was widely believed, were condemned to a lifetime of insanity. If you went in sane, you came out crazy; and if you went in crazy, you came out crazier.

None of the custodial institutions I visited compared with All Saints'. Mental home internees are known as patients, not prisoners. It is a misleading euphemism. Many black people end up in mental homes through the courts. Insanity is as much a legal as it is a medical condition.

I once visited a boy who had been sent to All Saints' some weeks after I met him. He was barely recognizable. The drugs used to keep him docile had blown him up like a rubber ball. His eyes were vacant, his mouth frothy, and he had difficulty staying awake.

Prison or mental hospital: that was the choice which seemed to face the first generation of Afro-Britons. Explanations and accusations were plentiful. The police, the magistrates, the prison warders and the doctors were condemned as racists by radical critics. But they deflected criticism by blaming the schools which had turned these youngsters loose. The schools in turn blamed Afro-Caribbean parents for not exercising enough discipline at home. And the parents? They were simply baffled.

But there was one area of agreement between the police, the courts and black parents: Rastafarian ideas and practices were opposed to law-abiding behaviour. It encouraged a type of non-conformity which led to criminal actions.

I was less ready to blame Rastafarianism. To do so seemed more like an exercise in prejudice than an explanation of the problem. But I could offer no alternatives. Maybe I was too close to the project's clients. Less than five years separated me from them; and we came from similar cultural backgrounds. I had also experienced the anger that marked black adolescence, that inspired rebellion against white authority; that made

Rastafarianism appear attractive. What was it about being black and young in a white society which encouraged rebellion? An answer eluded me.

Initially, I felt like a nurse in a battle zone. It was my duty to repair the lives of young men engaged in a mysterious war against society. I tried doing my best, though I believed that the only way to end the flow of decimated lives was for the war to end. That was beyond my power. And, each passing day, I became more disillusioned, more convinced that I was temperamentally unsuited for this kind of work. My working environment exacerbated this feeling. All my colleagues were, like me, black and university graduates. Our secretary suffered from eczema and her sensitive skin condition was a barometer of office tension. She became increasingly bedridden.

The project leader's conduct kept staff morale low. He was a woefully inadequate leader. He commanded little respect and his efforts to exercise authority heightened his unpopularity. One day I had to intervene to prevent him being beaten up by another colleague.

The frustration of the job, compounded by internecine office conflict, created an intolerable strain, whittling away my enthusiasm. I began to yearn for the day when my contract would end. I did not want to be in Handsworth, witnessing the tragedy of a generation, lives destroyed before they had been lived. But Handsworth's problems were not unique to it. They were happening in most black communities. Within a year of my departure, the inner city riots erupted all over Britain.

White, unevenly spaced tower blocks appeared on the horizon like giant up-ended domino pieces. Minutes later the train came to a smooth halt in the gloomy, white-washed interior of New Street Station. I remained seated until the carriage was empty, mentally preparing myself for a visit which was long overdue. The knot of apprehension in my stomach had begun to loosen with my recollections. The station concourse was so brightly lit that it hurt my eyes. My bag handle was causing me a minor discomfiture. I dropped the bag on the marble floor. By standing still the swishing crowd, of which I'd been part, suddenly seemed to slow down. To my right, I noticed a heated argument between a middle-aged Asian and smartly dressed young black man.

'Give me my money, now', the Asian insisted. 'Four pounds, please'.

'I told you I was just gonna get some change, didn't I', the black man said. His long white coat and tilted, broad hat gave him a vaguely American appearance. It contrasted with his black British working-class accent.

'Why were you going for the platform?' the Asian said. 'I saw you. Give me my money now.'

The black man grinned and looked around furtively, as if contemplating flight. 'All right, all right, come with me, then. Bloody hell, it's only a few quid. Why would I want to skank you a few quid.' He led the way towards the booking counter, the Asian stuck close to him. I suspected that the Asian was a mini-cab driver, the black man his passenger.

I picked up my bag and walked to the escalator. Above New Street Station is a shopping complex. Entering it now, I recalled the many altercations I had witnessed here between unemployed youngsters, black and white, and security guards. Its bright lights, warmth and window displays of clothes, furniture, tropical holiday scenery – all the things the unemployed cannot afford – made it a popular place for loitering. The guards tried to keep them moving. As I made my way to the exit, I noticed several groups of youngsters who were clearly loitering. The security guards, though, ignored

them. It seemed that the Bull Ring was no longer an area for conflict between the have-nots and the guards of the haves.

Birmingham has both improved and deteriorated since 1980, when it shattered my youthful optimism. Then, factories were closing down every day, and unemployment figures could be likened to the temperature of a fever-ridden patient; frighteningly high, and still rising. It gave this city of workshops – many of which dated from the industrial revolution – an atmosphere of desperation. But Birmingham appears to have survived the worst. A new civic pride prevails. The many construction sites in central Birmingham threaten to enhance further the city's futuristic appearance. Looping underpasses and flyovers form a concrete maze that can confuse a stranger. Even taxi-drivers here seem a little uncertain of directions. With its international airport, giant exhibition centre, its mushrooming conference venues, its symphony orchestra, Birmingham takes its 'second city' status seriously.

Reminders of Victorian Britain are all over Birmingham. It acquired its city charter a year before Queen Victoria's birth. A modest, but centrally located statue of the Queen who, for many Britons, personifies all that was good and great about Britain, watches over the city from Victoria Square. The older public buildings around it are grand, imposing. Their architectural styles reflect the national confidence that marked Queen Victoria's reign; the decades when the red, white and blue of the Union Jack fluttered over more than half the globe.

On my second day in Birmingham I broke my glasses and took them to be repaired. The optician, a smooth, voluble man of indeterminate age, suggested I visit the canals. There, he said, I would see the factories and workshops built in the decades when 'Birmingham was the workshop of the world'. He often took his family on canal walks, and they would try to imagine the lives of the people who used to work there, making the trinkets and buckles and guns that earned Birmingham its industrial fame. 'Sixteen-hour working-day then', he said. 'We're lucky to be living now and not then.' He was one of the first ordinary Englishmen I had met in years whose romance with the past was counterbalanced by an awareness of its more unpleasant aspects.

I said I would get to the canals, but, regretfully, never did. The cafés and dives and inhabitants of a part of Birmingham of which my optician acquaintance confessed total ignorance – except through media reports – were far too absorbing. That part of Birmingham was Handsworth; and its character also owes much to the age of Empire.

Handsworth begins about a mile from central Birmingham. Former colonial subjects and their British-born children are everywhere in Birrningham. But Handsworth is the city's main immigrant quarter. In fact, it is the largest single concentration of Asians and Afro-Caribbeans in Britain. Handsworth's fame, or infamy, rests mainly on its volatile Afro-Caribbean population. But they are outnumbered by Asians. A main shopping area is Soho Road. This is a mile-long stretch of shops where Asian-owned take-aways, restaurants, greengrocers and cheap novelty shops create the strongest impression. Windows full of sweets and Indian clothes create a riot of colours. Beside them the native-owned shops are unremarkable, easily forgotten.

When some schools close in Handsworth, the pupils who stream out of their gates are overwhelmingly Asian. Elsewhere in the neighbourhood, old churches and other large buildings now house Hindu and Sikh temples and Muslim mosques. Here, as in most places where they have settled, Asians are an exclusive group. Deeply divided by

caste and religion among themselves, they are none the less impenetrable to outsiders. Their exclusivity is a strength. But it is also a weakness because it arouses hostility in people whose culture is more accessible, like the Afro-Caribbeans.

Thousands of miles from the colonies, decades after colonial rule, the ex-colonials act out on the streets of Handsworth an old conflict. Mutual suspicion and mild contempt mark the relationship between Afro-Caribbeans and Asians.

I experienced the gulf between these two occupants of the same inner city space many times. One afternoon, as I strolled through a Handsworth back street, noting its suburban-type houses – pockets of Handsworth can appear quite out of place – an Asian woman gave me a disturbing look. She had sensed my presence late. She pulled her two young children close to her, and I saw fear in her eyes, as if she was expecting me to attack.

Afro-Caribbeans resent the Asians' exclusivity. At times I heard remarks which echoed sentiments I heard on a visit to Nairobi, Kenya, in 1985. 'The Asian shop-keeper overcharges.' 'He only employs his family or fellow Asians.' And, of course, 'Don't look at their women. They'll come for you with daggers.'

The Asians' highly developed and self-contained culture has contributed to their startlingly impressive commercial success. But some of their British-born children probably find it too rigid. Its rejection is not unusual. I had seen Asian punks in Birmingham city centre, and in Handsworth I saw an Asian Rastafarian. And a young Asian taxi-driver shocked me when I asked him to turn down the music in his car. It was reggae, and it was far too loud. He replied: 'Wha' 'appen? The I don't like the music? No problem, man.' An act for my benefit, or a genuine instance of cultural migration?

In years to come Handsworth could resemble Caribbean islands like Trinidad and Tobago. In those places Asians have mixed with their African neighbours, contributing to the creation of a unique island identity. But for now the two races are divided by suspicion and fear. A latent conflict simmers below the surface. Handsworth still bears the ugly scars of September 1985 when that conflict exploded, when the muted resentment of blacks was given violent expression.

Over two nights black youths clashed with the police. In their rampage, the rioters singled out Asian shops. Several were burnt down. On Lozells Road, rows of shops end abruptly at wastelands where Asian-owned shops once stood. Otherwise Handsworth life is back to normal.

Lozells Road is the heart of black Handsworth. It teems with people throughout the day. Social care agencies appear at regular intervals along with Afro-Caribbean take-away food shops and mini-cab offices. By day BMW cars, the ultimate symbol of inner city success, cruise up and down. Many bear red, gold and green pennants beside the national colours of particular islands. Jamaica's yellow, green and black is most common. Occasionally, you see the Rasta colours next to the Union Jack, signifying, perhaps, a dual allegiance, an emergent sense of being both black and British, with all the contradiction and tensions that go with such an identity.

The Nightspot Café is the busiest on Lozells Road. I remembered it as a tidy little place where I sometimes ate lunch. It has changed almost beyond recognition. Food is still sold there, and lots more. Everybody seems to carry knives, which they brandish about like toys, creating a tense, violent atmosphere. The knives are used. Many people, young men at that, bore scars, on foreheads, on cheeks, on chins and, in one

instance, across a neck. Death, I suspected, was a common visitor. And madness, too. One young man stood against a wall staring into space with bulging, flame-red eyes. Nobody saw him. He was an invisible man. Around him quick furtive deals were struck under the benign gaze of Jamaica's national heroes on a poster – Marcus Garvey, Paul Bogle, George William Gordon, Bustamante and Norman Manley. The two pool tables were never unoccupied. They were stages for performers crying out to be seen and admired. The pool table made or broke reputations, conferring a limited fame on steady winners, and shame on luckless losers. Sometimes its electric light illuminated the blade of frustration and the blood of discord.

At night the pace slows down on Lozells Road. The cafés close and those who make their living in the shadows retire home or hang out in the blues dances. There, it is said, you can tell the cocaine sniffers because they are the only ones still dancing at seven and eight in the morning.

I haunted these dives and cafés for a few days in the hope of coming across some familiar faces. That was how I met two former clients on Lozells Road. One had shaved off his dreadlocks. With his grimy face and blue overalls, he was a picture of the working-man. He was hurrying back to work on a building-site, so we didn't get much chance to talk. The other was still committed to Rasta, at least in appearance. He didn't remember me. I had to prod his memory.

'Oh yeah, what was that project called again?'

I reminded him and asked what he was doing with himself. He'd been friendly so far, but now his tone changed. He said bluntly: 'Well I don't rightly know that I should tell you that, cause I hear that you guys used to work for the police. All that talk 'bout helping black youths was a cover-up.'

I was shocked, wounded with indignation. I, who'd perceived myself as a helpless nurse, was now viewed by the people whom I'd tried to help as an agent of their enemy.

'Who told you that?' I demanded.

'Well as I is not a informer, I can't tell you that. Is what I hear. But is not everything I hear I believe, know what I mean?'

I was relieved but far too upset to continue the conversation. We'd met walking in opposite directions. And that was the way we went. I simply told him: 'It's a good thing you don't believe everything you hear.'

I couldn't remember his name or exactly what dealings I'd had with him. But for the next few days his accusation troubled me. It forced me to begin thinking about 1980 not from the perspective of a personal ordeal, but from that of my so-called clients. The youngsters I worked with in 1980 belonged to the first generation of British-born blacks. That so many seemed to get in trouble with the law reflected a crisis which was partly located in British society, and partly a legacy of Afro-Caribbean culture.

Britain in the 1970s was a nation struggling to come to terms with its loss of Empire and diminished world stature. Without the controlled markets of the Empire, its industries were proving unprofitable. They were unable to compete in a freer international market. National self-confidence was at a low ebb. A crisis of moral, social, economic and political dimensions had set in.

This national climate generated different responses from different groups. Nationalism and racism, kindred spirits reared their ugly heads amongst whites. Fascist political movements committed to keeping Britain white proliferated. Whites became more paranoid about immigrants than they had been in the previous decade.

This upsurge in British nationalism and racism had very real repercussions on Afro-Caribbeans. Their responses took many forms. Some West Indians who had been here for decades returned home. A black travel agent in Handsworth told me that between 1979 and 1983 Caribbean shipping and travel agents enjoyed a minor trade boom.

'Business hasn't been as good since', he lamented. 'One week in 1982 we had over fifty people making enquiries about returning home. That's a lot. Maybe half of them came back and completed the procedures. Now I can't remember the last time I had a customer returning home for good.'

The returnees were mainly workers who had been made redundant. Their redundancy payments and early retirement provided the means for the return journey. Their motives for leaving Britain were complex. Many had only seen Britain as a temporary home. Five years was the standard time immigrants gave themselves to mine Britain's street of gold. The hostile national climate of the 1970s probably served to remind many that they had over-stayed.

Equally disturbing to older West Indians was the conduct of their British-born children. Rejected by a Britishness which excluded blacks, the first generation of Afro-Britons retreated into a blackness which rejected Britain. That blackness was Rastafarianism. Back in Jamaica, Rastas were the outcasts, the dregs, the insane of society. To see their children embrace this apparently bizarre cult drove many older West Indians to distraction. The movement that captured the imagination of a generation is no longer so popular on the streets. But its outward trappings – hairstyle, language and colours – are still common features in Handsworth.

After some searching I managed to find a group of Rastas, as opposed to those who merely assume Rasta style. They were part of an international organization known as Twelve Tribes. I met them in a youth centre in Winson Green, which neighbours Handsworth. Their spokesman was called Captain. He had the most beautiful eyes: brown, clear and sparkling. His parents were Jamaican and he was obviously a mixture of African and Indian. Captain was reluctant to talk about Twelve Tribes, insisting he had no authority to speak on behalf of the organization. But he was prepared to speak in a personal capacity.

He had been converted to Rasta in 1979, when he was sixteen. A Twelve Tribes meeting in a local park convinced him that the movement should be taken seriously. Since then he had lived for Rasta. The brethrens met twice a week, and once a month they organized a function, which included music and 'reasoning sessions'.

While we spoke other members filed into the room. The men formed small groups. The women occupied a distant corner.

'Twelve Tribes', Captain said, 'doesn't deal in racial divisions. Anybody can join.' As if in response to this statement, a white girl entered. She wore a long, colourful skirt, and her head was covered. She joined the other females, who, from what I could make out, were exchanging recipes.

Captain reaffirmed the basic tenets of Rastafarianism: the Bible is the book of life, Africa is the motherland and all Rastas should be repatriated there. He himself was looking forward to the day when South Africa was freed, and, ideally, would like to live in Ethiopia.

'There's nothing, nothing here for us', he said, his bright eyes smiling. 'The West is heading for disaster. Reagan and Thatcher are just two signs. It's all in the Bible.

So is repatriation we dealing with. Africa. Cause we don't want to be here when Armageddon come.'

Much of what the Rasta leader had to say I had heard over the years. It was all stale, clichés from another decade. For a moment it seemed to me that everybody in that room was trapped in time. The 1980s, with its emphasis on materialism and making it, had left them untouched.

The hours I spent in the Rastas' company reminded me of just how powerful the movement was once. Afro-Britons now entering their adolescence are less likely to embrace Rastafarianism. But they will enter a world in which the movement has had a lasting impact.

Captain's repeated reference to Africa provides the key to understanding why West Indian parents were so uncomfortable with Rastafarianism. The British national climate of the 1970s generated the need for a defence of blackness. That it took the form of Rastafarianism was a consequence of certain peculiarities in Afro-Caribbean culture.

The 'West Indian' immigrant regarded Britain as the mother country with a passion unrivalled by any other postwar immigrants. Asian immigrants were merely exercising their legal right as British colonial subjects to reside in Britain. On the whole they retained a sense of loyalty to a culture which owed little to British influence. The 'West Indies', on the other hand, believed they were exercising a birthright. Not just a legal right. And in a crucial respect they were correct. For the West Indian was a British creation. They were the bastard offspring of a violent encounter between a young, vigorous nation of avaricious maritime merchants, Britain, and an ancient continent, Africa.

A people, like a nation, are their memories, Afro-Caribbeans no less. An Afro-Caribbean is a descendant of those African slaves transported to Caribbean islands between the middle of the sixteenth and the early part of the nineteenth century. West Africans from diverse ethnic backgrounds were involved – Yorubas, Ibos, Mandingoes, Ashantes and so on.

From the moment of capture the African ceased to be a human being with a language, a history, a culture. He became a piece of property, branded with, for instance, Liverpool's famous DD mark. The physical horrors of the Middle Passage and the relentless cruelty of the slavery regime are well documented. Even I, generations from it, find it painful to learn about.

Slavery was also a psychological ordeal. That aspect has been given less thought. But we know that the African – the Yoruba, the Ashante, or whatever – ceased to be what he was. The slave regime forced him to speak his master's tongue. He answered to a name given him by his master. Later he came to worship his master's god. And because all men make God in their own image, he worshipped his master. With each new generation the slave's collective self-esteem appeared to erode. New slaves arriving from Africa were derided by those they met on the island. An African was a person to be mocked. In mocking the new arrival, of course, they were also mocking themselves.

In *The Middle Passage*, the Trinidadian writer V. S. Naipaul quotes Anthony Trollope's observation on post-slavery West Indians:

> They have no religion of their own, and can hardly as yet be said to have, as a people, a religion of adoption. The West Indian knows nothing of Africa except that it is a term of reproach.

Naipaul himself observes: 'This was the greatest damage done to the negro by slavery. It taught him self-contempt.'

My own father, at times, exhibited a similar trait. In moments of anger he would admonish me as a 'Kwaku'. For years I regarded Kwaku solely as a term of disapproval. Until I met a Ghanaian called Kwaku. Amongst the Ewes in Ghana, I learnt, it's a day name given to boys born on a Wednesday.

Somewhere in Jamaica's distant past, Kwaku was a newly arrived African slave. Those born into slavery probably considered his behaviour foolish, troublesome, awkward. And so the name Kwaku became a term of reproach: its original meaning lost in the slave culture that was forging a new personality. Yet my father couldn't be described as a man lacking in self-pride. He is dark, powerfully built and self-consciously handsome. Self-hatred or blind emulation of whites were never a part of my upbringing. Does that make Naipaul's observations supported by several nineteenth-century European travellers wrong? Not entirely.

The harrowing process, lasting almost three centuries, that transformed the African slave into a West Indian colonial was bound to have deep and long-lasting effects. The most serious was that it left the African, now 'West Indian', with a profound ambivalence towards his Africanness. His was a divided personality, the product of a violent and divided culture. Events in the 1970s forced an examination of that past, that culture. Racial memories were stirred up.

One afternoon I went to meet the owner of a pirate radio station. Music Master, as he is known, runs the People's Community Radio Line. A Jamaican in his early forties, he told me of his long running efforts to get black music played on local commercial and public stations. Frustrated by the station manager's intransigence, he decided to start his own. In the station's five-year history it has been raided over a hundred times, losing thousands of pounds' worth of equipment to the police. But the station enjoyed such widespread support, that he always managed to return to the air within a few hours. On one occasion, a Birmingham vicar even allowed the station to broadcast from the belfry.

Music Master, the radio pirate, was an example of persistence and commercial cunning. His DJs were young blacks who could never get work on mainstream radio, and his advertising customers were local businesses who could not afford the mainstream rates.

As I left the building, I was struck by a poster near the entrance. I had seen the picture in a book, but never on anybody's walls. It was an eighteenth-century slave auction advert, depicting an African slave with a grotesque, four-pronged shackle around his neck. After listing the slave's qualities, the poster enumerated various commodities for sale, like sugar and rum.

My host had disappeared to resume his work. I asked his young assistant, who stood beside the poster, why anybody would want to use an image of that terrible phase in history as decoration. She replied, 'That's what we were, innit?'

Slavery did not completely destroy the African's attachment to Africa. During slavery the idea of Africa became synonymous with freedom, dignity, resistance. It inspired many slave rebellions. This explains another side to the West Indian personality: an irrepressibly powerful urge for Africa, a spiritual yearning for the land from which he had been forcibly exiled.

The Cuban writer Alejo Carpentier, in his *Kingdom of This World*, based on the San

Domingo revolt, provides a moving description of the slave's attachment to Africa. A slave revolt leader has gone into hiding. The slaves await his return:

> One day he would give the sign for the great uprising, and the Lords of Back There, headed by Damballah, the Master of the Roads, and Ogoun, Master of the Swords, would bring the thunder and lightning and unleash the cyclone that would round out the work of men's hands. In that great hour . . . the blood of the whites would run into the brooks . . .

A violent imagery for a violent situation. This urge for Africa was given innumerable expressions in folklore. For example, it was believed in the Caribbean that when a person died his spirit would return to Africa.

Caribbean spiritual songs, evoking biblical imagery, similarly reflected this longing. One such song, set to a disco beat, was an enormous hit in the pop charts in the 1970s:

> By the rivers of Babylon, there we sat down
> And there we wept when we remembered Zion.
> For the wicked carried us away into captivity
> Required of us a song,
> But how can we sing King Alpha's song
> In a strange land.

The same pop group, comprising Afro-Caribbeans, had an equally successful chart hit with another folk song –'Brown Girl in the Ring'. This expressed the other side of the 'West Indian' personality. Its refrain went:

> Brown girl in the ring tra-la-la-la
> There's a brown girl in the ring tra-la-la-la
> And she looks like a sugar in a plum.

The brown girl was the 'mulatto'. Closer to European standards of beauty, she was admired by her black – and by West Indian definition – less fortunate playmates. The lighter you are in complexion in the Caribbean, the more privileged you are likely to be. That was so yesterday, and it remains so today.

The 'West Indian's' dual personality is most evident in literary writing. The work of Claude McKay, a Jamaican novelist and poet, who came from a peasant background, is an excellent example. McKay was one of the first poets to use Jamaican dialect, precursing the dub-poets of the 1970s by almost seventy years. But where dub-poetry has radical artistic and political connotations today, in McKay's usage it expresses a colonial's yearning for 'Old England':

> I've a longin' in me dept's of heart dat I can conquer not,
> 'Tis a wish dat I've been having from since I could form a t'o't,
> Just to view de homeland England,
> in de streets of London walk,
> An' to watch de factory chimneys pourin' smoke up to de sky,
> An' to see de matches-children, dat I hear 'about passin' by.

McKay's imaginative sojourn reaches its climax in a visit to 'de lone spot where in peaceful solitude, rests de body of our Missis Queen, Victoria de Good.'

Eight years later, though, having moved to America, McKay has adopted a more orthodox style and now makes a soul-felt plea for his race and Africa:

> Oh, when I think of my long-suffering race,
> For weary centuries, despised, oppressed,
> Enslaved and lynched, denied a human place
> In the great line of the Christian west;
> And in the Black Land disinherited,
> Robbed in the ancient country of its birth,
> My heart grows sick with hate, becomes as lead,
> For this my race that has no home on earth . . .

This complex, contradictory West Indian personality, torn as he was between the mother country of his master, and the motherland of his ancestors, came to Britain in the postwar years. His panama hat, sunshine smile and cardboard suitcase concealed a wounded psyche, a divided self.

'West Indian' writers accorded monumental significance to the migration. The Barbadian writer George Lamming speaks of Caliban coming to meet Prospero. 'Yet Prospero is afraid of Caliban. He is afraid because he knows that his encounter with Caliban is, largely, his encounter with himself.'

Lamming perhaps exaggerates. But he points us in the right direction. The West Indian and British personalities were inextricably entwined. Their encounter on British soil, in a more enlightened age, would expose each other's weaknesses. Illusions and fantasies would be tested.

Britain in the 1950s was unfit to receive the West Indian immigrant other than as a unit of labour. He had no history beside British history, no culture beside British culture. And the West Indian, desperate for work, fleeing rural poverty for the bright metropolitan lights wanted to believe that he was British. The racial attacks of Nottingham and Notting Hill in 1958, the racial prejudice that confined him to the poorest parts of city and gave him the lowest paid, and least secure work – these were the rewards of patriotism. But the West Indian immigrant could withstand it all. He could look forward to the day when he could return to the West Indies.

His children were another matter. The West Indies, for those born there and brought here at a young age, were nothing more than vague, fragmented memories. For those born here, it was a place learned from stories told over paraffin-heaters in one or other British city. The British-born or British-reared black, inheritor of a slave legacy that involved both self-contempt and a longing for Africa, began to graduate from British schools from the late 1960s. However strong his inherited love for the mother-country (i.e. Britain), it could not be sustained. Only the most determinedly self-destructive person could continue to believe unquestioningly that he was British. For the most part, mother and child embraced and recoiled in horror.

For Britain also had a legacy, a legacy of slavery and empire that determined how it viewed all non-whites. That legacy pervaded every aspect of British life. It was ingrained in the British personality. Schools taught British imperial history which denigrated Africans, Asians and Chinese. Books which had educated and entertained

Britons contained insulting stereotypes of non-whites. Television and newspapers daily portrayed grossly derogatory images of foreigners. And the darker their skin, the worse the image.

Wherever the black British youngster turned he was confronted by hideous reflections of him or herself. It was as painful as walking barefoot on broken glass. It was a lonely, alienating childhood, a baptism of fire.

Adolescence is a difficult period for any child. It can be an age of many searching questions and too few answers about the world that you have inherited and your place in it. The questions asked, the answers found, are part of the passage to adulthood.

The black adolescent's questions invariably focus on identity. Either he can accept society's ugly reflection of himself and become resigned to taking up the role it has allocated him – that of a menial worker – or he can challenge both reflection and future role.

The school-leavers of the late 1960s and early 1970s were immeasurably assisted in mounting that challenge by Afro-American civil rights and black power movements. The literature, music, films and so on were imported into Britain. Sometimes they came via the Caribbean. For instance, a popular reggae adaptation of an Afro-American tune, 'Message from a Blackman', had the lines: 'I am black, that's no reason to hold me back. You're white, that doesn't make you right.'

But rebellions are seldom exportable. And Black Power and the Civil Rights movement, however relevant to black Britain, were American phenomena. They were the political expressions of a people who, rightfully and confidently, believed in their entitlement to a share in the American dream. America, a nation of immigrants, was as much theirs as other ethnic groups'. The Afro-Caribbean migrant's belief in his Britishness was far less secure. Nevertheless, the Black Power influence was beneficial. It encouraged educational pursuits. And for those who doubted that there would ever be an opportunity to make use of their education in Britain, there was always the option of returning to the Caribbean.

Black Power was, however, short-lived in Britain. It was quickly overtaken by an intimately related, but quite distinct, phenomenon – Rastafarianism. As the 1970s progressed, an increasing number of black youngsters, now British-born, fell under its influence. It promised answers to all their questions of identity. And it did so from within a West Indian slave tradition. It was the most powerful modern expression of the urge for Africa.

Black Power made political demands and encouraged political organization. Black Power followers also looked to Africa for inspiration. The Afro-hairstyle, the dashiki pilgrimages to Africa were a few ways the Black Power adherents acknowledged their African heritage. But Africa wasn't just acknowledged in Rasta ideology. It was the utopia to which they sought physical repatriation. Babylon, the west, was beyond redemption. It was inexorably headed towards Armageddon. On that judgement day, the Rastas would be free to return to Africa. Meanwhile, Rastas simply opted out. One of the Rastas I talked to when I was working in Birmingham told me how he would get to Africa on that great day: 'By foot, bus, some will fly. Jah will guide. 'Cause I-man know that Africa will be free by 1983.'

This fatalism was what most disturbed me about Handsworth in 1980. I could understand the forces that made Rasta attractive. I'd experienced them myself. But, having grown up in the shadow of the 1960s and Black Power, I believed in the

possibility of change, of a better tomorrow. Here, in Handsworth, it was as though a whole generation had lost all hope in that difficult transition from boy to man, girl to woman.

But Rasta was never without its virtues. It forced the British-born black person to confront a part of his heritage which his parents had largely shunned. It shattered the West Indian's British identity, releasing an urge for Africa that had been long repressed. For those who did not succumb to the fatalism inherent in Rasta's mystical vision of racial redemption, it was a cathartic experience: a spirit freed.

The Rasta revolution was nothing more than a generation's awakening. Here in Handsworth it has stirred a flowering of artistic talents. Birmingham is richer for it. Freed to explore the African aspect of their culture, the first generation of Afro-Britons have tapped a creative source of immense potential. Poets, painters, sculptors and musicians abound in Handsworth. At least two African drum and dance companies originated in Birmingham in the late 1970s and early 1980s. Though repertoires are based on rhythms and movements acquired on journeys to the Caribbean and Ghana. In central Birmingham one Saturday afternoon I noticed a group of Rasta artists selling their wares outside the Bull Ring. A popular poster depicted Bob Marley, John Lennon and Marvin Gaye.

But on the other side of this coin of collective self-discovery are criminality and mental disturbance. The Handsworth frontline is also a thriving ganja market, a twenty-four-hour affair. Conducted openly in cafés and on the streets, it invites regular police raids. There is something suicidal about overt defiance. As one Jamaican mini-cab driver told me: 'Mahn, I know those guys have to make a living, but to do it so openly. They just asking for trouble.'

Mental disturbance is less obvious but just as serious. The self-discovery that Rasta prompts can also be a route to mental disorder. Not every individual can survive a rude awakening. In embracing the Rasta ideals some are driven by a mania for evangelical conversion. They become prophets. And Handsworth, I was told, overflows with modern race redeemers.

It is possible that during my stay the appalling weather kept these self-styled prophets off the streets. I saw only one. Dressed in ill-fitting trousers, no socks, a woollen hat that looked like a stove pipe, he stood on a street corner muttering something about the wrath of God.

But my informant, a social worker, didn't exaggerate. Almost 30 per cent of the inmates in Birmingham's All Saints' hospital are black. The national average for black inmates of mental hospitals is 17 per cent. Both figures are very alarming when you consider that Britain's Afro-Caribbeans are less than 3 per cent of the population.

The culturally and legally determined criteria of mental disturbance undoubtedly play a part in producing these figures; inner city poverty also. But perhaps more attention should be given to the peculiarly extreme dilemma that is intrinsic to Afro-Caribbean culture. Africa and Europe seem to have been at war within it for four hundred years. Every person of Afro-Caribbean origin carries that conflict within him or her. In the moments when there is a retreat into blackness – whether or not it takes the form of Rasta – the African's past and present conditions in the west can assume a deadly importance. Black self-realization so easily becomes ensnared in yesterday's humiliations, yesterday's shame. The resultant anger is sometimes immensely creative. But it can also swiftly progress to an uncontainable rage against all whites.

And by definition it is also directed inwards. For like the person of more immediate mixed-blood white hatred is tantamount to hating a part of one-self. We all walk a tightrope of normality, but for a black person the risks of slipping – or being pushed – are greater, the fall more precipitous. Maybe that is why one of the most common words in black street talk is 'Pressure'. It has social and economic connotations, but it also refers to the powerful psychological struggle involved in holding the two, often warring sides, of the one personality together. . . .

From *Behind the Frontlines* (London: Gollancz, 1988). © Victor Gollancz and Jane Conway-Gordon.

16

HOME IS ALWAYS ELSEWHERE
Individual and communal regenerative capacities of loss

Fred D'Aguiar

My parents left me in Guyana when I was very young. During that time I missed them every day even as I loved the countryside of Airy Hall, a village forty miles along the east coast from Georgetown, Guyana's capital. I loved the sense of a country that was limitless to my child's eyes and legs. The sea seemed at least a half-day away. The savannah another half-day in the opposite direction. Wild bushes just over the fence at the bottom of the field. The sky was remote, high and flung wide from the farthest point reachable by land. The place was captivating but my thoughts were elsewhere. My parents were in London. I knew, given an opportunity, I'd swap all that abundance and beauty that Guyana offered to me for a moment in London with my parents.

London was everything Airy Hall was not. The sky seemed encroaching. The trees in the parks were too sparse, there was never any wildness in the ordered streets and houses shouldering each other upright. The sun was a rare glare, then grey light but mostly it was draped by cloud and reduced to a drizzling light.

Guyana became remote. Ideal. My parents were not together after all those years of longing to be reunited with them. My mother gathered us all in East London under one roof minus my father. We ventured on foot then on bikes from our street to another, then to the local park, then the nearby wasteland used as a rubbish dump. Traffic was treacherous and the stories were rampant of children whom we'd seen from a distance and who, because of traffic, would never be seen again. Saturday afternoons we stayed in the house to avoid the marauding groups of West Ham supporters. We heard the voices that emanated from the stadium a few streets away when a goal was scored or just missed. Saturday mornings we went to the cinema. There was a short film and then the feature. We bought crisps and chocolate bars or little chewy sweets called 'mojos' or licorice (which I now hate). I missed the idea of a father then forgot about my need for one.

The city seemed interminable. I got to know a small portion of it in East London. When we moved south to Blackheath Hill, I explored the area around Greenwich Park and Charlton School near the industrial estate where the Woolwich barrier is located. Throughout my time at Charlton School the barrier was under construction. Huge trucks had to be avoided as they ferried materials to the site at the river. We spent lunchtimes in the park, playing football or just walking around. I loved the simple

routine instilled by the place. The parks were wonderful, the traffic to be avoided, the hours watching television induced a state of absence from the immediate surroundings. Dusk would fall then evening and the room would brighten with the flickering light of the television and its spell would be broken when someone walked into the darkness and flicked on the light. A rush of objects would crowd around the television and it would shrink down to furniture size again and lose its sense of a Grand Canyon into other spaces and places.

I had this accent that was not East London, nor South London. Because I spoke rapidly too it was Guyanese, more commonly referred to as West Indian. It made being understood difficult. My English was broken – shortened words and collapsed phrases, verb-driven and therefore active, yet incomprehensible because of its idiosyncratic grammar. I felt apart from the other children in my school (Black children included, since they spoke with a Cockney accent) and developed an acute sense of my difference when a white boy called me a 'nigger' with such vituperativeness that even though I'd not heard the word before and had to ask him to repeat it – which he was very obliging to do but with less intensity and a trace of puzzlement – I knew it had to be bad, awful, worse than any accent, worse than speaking incomprehensibly.

Why did I feel like the only 'nigger' in the world when there were other Black kids around? My accent, my sense of newness in the school and area, my lone status that set me apart from the little groups of boys (a boys' school), my reserve. Other Black kids knew the rules of football and spoke in a way that fitted in. I knew cricket but my new school only played football. I studied the rules of football in earnest and soon understood them but then there was always something else to learn, some new code that I was ignorant of up to the moment when it would become clear that everyone else knew it and I did not – like wearing a football scarf to school when the local team was Charlton and the scarf was Chelsea's colours. (I lost that scarf in a hurry!)

I wasn't a doer, I was a watcher. I didn't 'steam' into other kids, as the gang parlance of the time would have it, nor sit at the back of the school bus and pull the stuffing out of the seats or spit out the windows at pedestrians, nor scale over the playground wall at break to skip school for the rest of the day. I just drifted to school and stayed there and left at the end of the day. All the time I felt away from home (Guyana) and never quite in step with the rhythm of London. The sense of being out of step faded with time and London grew familiar and my longing for Airy Hall lessened. But my new sense of belonging to a resented, even hated and despised Black minority, heightened. In Guyana I was the majority, or at least felt I was.

Huge portions of that London inner-city past are lost to me, not because my child-hood was anything like Larkin's, 'forgotten boredom,' but it has more to do with spending those times disengaged from them as they were happening or absenting myself from this uncontrollable reality in preference to a Guyanese past that I loved and felt exiled from and dearly wanted to be reconnected to. Running concurrently with this sense of disengagement from London was a process of falling in love with it. Guyana became more remote with time and, as it shrank in my mind, London took root. London was strange as time passed but only because I explored further reaches of it, making it strange as portions of it became second nature to me.

What I retained on this parallel track was a feeling of apartness. The moments when I felt love for the place were far outstripped by the times when I felt removed from it,

or felt nothing – crossing Blackheath Hill in a sprint without feeling the tarmac underfoot or really believing those cars and trucks coming down its steep gradient would actually connect with my body and break it beyond repair. (This, even after my young brother was hit by a car and came into the house with a bandaged head and a dazed look, succeeding for a few minutes in distracting us from the television as we questioned him about the experience.)

London was spoiled for me by my belief that one day I would return to Guyana, and when that was no longer true, by a feeling that London did not belong to me, could never belong to me on account of my race, my minority status. A white majority made me aware on a daily basis that I was a visitor, a guest whose invitation to the club could, at a moment's notice, be withdrawn and the friendly standoffish bouncers would suddenly turn menacing.

Literature saved me from my sense of isolation, of complete aloneness in the world. Unbelonging, in-betweenness were articulated by others, not necessarily consciously, but as a tone, running through the poems, films, novels and plays that I ran into between ages twelve and nineteen. The tone made me feel intensely about much that I was reading without comprehending the argument or story. I was a bundle of nerves wandering through these idioms and stories without any ability to filter them, and I was totally at their mercy in terms of what I felt and how intensely I felt it.

I never cried outwardly or even laughed but inside I was twisted this way and that by every sentence, colon, shape of what I heard, saw or read – a Dada exhibition with a urinal, a Gay Sweatshop production of a play about Edward Carpenter, Ian Mckellan in *Bent* at the Royal Court Theatre, Marvin Gaye's albums, *Let's Get It On* (every single track on it in that sequence) and *What's Going On*, Bob Marley's album *Exodus* too for the same sequence and cumulative intensity, then lightness then love. *Kes*, a grainy black and white film for school based on the novel of that title. The list is long, and it varies with each recollection: Wordsworth's 'Tintern Abbey', Coleridge's 'Rime of the Ancient Mariner', and pop songs that I'm too embarrassed to list because they are mawkish without the music, which adds to the emotional meaning, and sentimental now but at the same time held some truth for my heart and spine, if not for my head, some deep appeal.

Perhaps it is to arrest this sense of being at the mercy of feelings that I have procured this detachment. I am really distanced, not from society, but from myself and my nervous system. Society provides the stimuli so I have it in my sights, but my real target is my body. I am voting for a life of the mind over the body since the body ruled all my early life at the expense of clear, cool thought. Unbelonging is to my body. In-betweenness is balanced in the middle of my mind and body – twin demands, twin loyalties, and therefore a twin disobedience or at least resistance to both.

In my most recent novel, *Feeding the Ghosts*,[1] the main character, Mintah, discovers her status of in-betweenness or unbelongingness when she is forcibly taken from the place she knows and loves – Africa and transported to an alien landscape – America. Her in-betweenness or unbelongingness becomes a permanent condition, a brand of destabilized stability; a spirit-level condition or balancing act of three unstable elements: her sense of self, of place and her desire to be creative. She deliberately forgets aspects of her past life in order to control her despair about her removal from it. Forgetting also helps in her efforts to begin a new life. Memory and imagination become interchangeable. Forgetting creates in her the sensation of not having known a

place well enough to feel despair at her loss of it. Yet she retains sufficient memory of her past to arm her for her life in the new world.

For Mintah, there are degrees of belonging and unbelonging. Occasionally, she manages to find ways to belong and ignore those patterns of unbelonging that may make themselves known to her. But mostly she is unable to find these toeholds in a culture, city, country that prove sufficient to sustain her. She lives in the place but never settles there. She gets to know it but it never gets to know her. She remains strange to it, not out of any wilfulness or stubbornness but because she is a stranger to herself. Mintah is comprised of facets that continually surprise her and remain disguised to her. She discovers new aspects to herself when she moves. Two forced migrations, away from the known to the unknown, unearth these strangers in her, making them familiar. Physical strangeness leads to psychical familiarity, distance in the former results in proximity in the latter. This might account for her need to travel at least in her head since in movement there is the discovery of self or the invention of something new brought about by a correspondingly new environment. It is a sensual awakening first of all that brings about this inner discovery. The senses are exercised and made alert in a strange place. The strange place raises from deep inside the body and mind equally strange aspects of the self. Strangeness, newness, physical and environmental changes are the stimuli for these psychic and sensory processes.

Of course there are correspondences between Mintah's life and mine, at least in terms of this changing of landscapes.

Race is another. A Black minority in a white majority culture. An individual who cherishes privacy from the tribe, from outward demonstrations of tribal loyalty, is isolated to begin with. This isolation is compounded by movement as a minority from one majority culture to another. But the isolation from the tribe is a vote of sorts of no confidence in skin colour as a reliable measure of group loyalty, and a mistrust of any simple cause or factor that can account for the person or the soul.

Race is present but Mintah refuses it as a refuge from the onslaught of an aggressive majority culture which demands various public demonstrations of servitude to it by denigrating her minority group roots. A kind of invisibility is necessary before the majority culture approves of someone like Mintah, who tries to distinguish herself by individual acts of creativity.

Race becomes important at precisely this point whereas before it was just a necessary evil to be mirrored in her daily life if that life was to be meaningful in creative terms. Once the race is under attack Mintah is forced to demonstrate her allegiance to the tribe, to the minority group, if only because it is in need of defence. Love of race, racial pride is then mixed up with love of self and love of life, of humanity. Race, in fact, is subsumed by life and humanity. What a minority status does to life and humanity is make them poor cousins of race. Race is promoted at the expense of the other two. Mintah, who has to contend with a general unease to do with place, then finds that race is another frontier. The unsettledness of being in society of having to fit in or not and agitated in her body by this state, is compounded by her race when she is told by the majority culture that the struggle to belong or not is first of all a racial one, when all along she was sure it was human and that there were others belonging to the majority group who felt the same way and moved across the landscape with a similar sense of unease.

She cannot make a style out of this condition, to do so would calcify it. The moment

it becomes a fashion it loses its meaning and meaningfulness. It becomes a pose. It rings false and is really quite shallow even as it tries to symbolize and represent and be depth. The contradiction is that Mintah needs to study this condition as a function of her sense of herself as a creative animal. Just as she needs to know what her condition is that makes her tick so it is that the condition must resist being known and imitated or mimicked as a system, style or fashion.

What has to happen is close to Zen, in that it requires a degree of unselfconsciousness or a negation of the ego on the part of Mintah if it is to last. The moment she thinks that she is in the state of unbelonging or in-betweenness and begins to revel in it, that state slips away and is lost. Unbelongingness is that condition: a nervous disposition coupled with a psychic tremulousness or sense of inadequacy in relation to time and place.

To make sense of it as an act of contemplation when it is the contemplation itself (or at least relies on the same mechanisms) is the physical equivalent of trying to cup light in her hands. The physical impossibility of cupping light has to do with the fact that light defies the shape of the hand in the first place and so can't be perceived as separate from that hand. The thought of cupping light in the hand might prove sufficient as an act to complete the idea, since the concept is the act when the act as a physical thing cannot be achieved.

Unbelongingness, in-betweenness is gauged by certain acts of love and creativity. It is known after the fact. The condition may not be knowable at the time of its occurrence, but it is certainly familiar as retrospective knowledge, as knowledge gained miles after the event. So an examination of it is not necessarily an attempt at style or fashion. Looking for a deeper understanding of a recurring event in her life is permissible. Understanding through retrospection is unavoidable since the will to remember is part and parcel of her sense of herself in the world.

The condition of being in the world is unknowable as it occurs, since it is happening a hundred percent to her, mind and body, her sense of the world can be gained by a return to memory and by imagining within that state or condition of being in the world.

A sense of self escapes her minute by minute because she is involved wholesale in it, but with memory and imagination she is able to find instances of herself in the world that make it seem as if they were happening as they occur to her. She gains a sense of unbelonging and in-betweennes because she remembers previous states and uses them as a basis to imagine others. Her sense of self may be plural and shifting but she retains aspects of it even as new ones are revealed to her. The strangers who surface in her in a strange place become familiar and past selves recur. A city may never wholly welcome her but there is a part of her that would never welcome being welcomed. She likes strangeness and distance or as a minimum she has grown to like them or view them as a necessary condition if she is to function as a living, loving person.

Neither Mintah, nor I for that matter, was born into in-betweenness or unbelonging. I was made that way. I insist that my status of removal is real in terms of geography, since there are maps I can point to and say I have lived there and there and there and I have never felt at home. Or more likely I felt at home but the feeling never lasted, it soon wore off or was spoiled by some other, less salutary experience, or some thought more critical than appreciative of my place. A skinhead in the form of a football hooligan impersonating the grunts of an ape while scratching both armpits

199

with his hands, his elbows akimbo, or three white men in a passing car shouting at my white companion, 'Don't stay with him, he'll kill you.' (fallout from the O. J. Simpson double murder trial); racists have the ability to morph into all sizes and ages; they vandalized a large part of my romance with London.

I say London. Not Inverliever, Oban, Galway, Cardiff, places where I've visited for short spells without duress. Luckily these disparaging remarks never resulted in an exchange of actual violence, yet violence was done to me. I felt pain inside and anger then grief. If no punches were thrown it was because I did not hang around to find out about their intent. I'd heard enough to know my continued presence among them would not do me any good.

London was spoiled by a parsimonious government when it came to race policy and running the inner city. The Greater London Council was abolished and had it not been for the widespread riots of the 1980s nothing would have been done to stop its decay. Not only government legislation was to blame for this inner city ruin but a police force who used their position to practise their racial bias. More Blacks arrested, beaten, harassed, stopped and searched, even verbally abused as a routine form of questioning and many more killed in police custody or while being arrested. Other government agencies, such as the Civil Service, followed the lead of the police, and this bias spilled over to the private sector, who recruited very few Blacks during those boom years.

Basically, London was spoiled by a definition of Britain which never took my presence into consideration. As if I were expected to disappear just because the country's appraisal of itself excluded me. All the above merely seemed to confirm my own feeling of unbelonging and in-betweenness anyway. A feeling that was there and fuelled by private notions of its own was compounded by these social and political, that is, external circumstances.

I never hated myself for being Black in Britain, I hated Britain for not accommodating me. I never sang along with James Brown when he said, 'Say it loud, I'm Black and I'm proud' – though I danced to the song's funky rhythms – because I'd had enough pride for several lives from my Guyanese past and had known enough about Black history (from reggae celebrations of slave rebellion leaders and of Marcus Garvey, Haile Selassie and others; and calypsos about key incidents in Caribbean history or satires of the regions politicians) to be able to draw sustenance from more detailed and analytical sources than a pop song, such as history books and novels. I could see the importance of the song, its mantraic necessity to shore up the spirit against the corrosive negativity of white contumeliousness against Blacks.

This does not mean that I belong to no group, no past, no country. My allegiances are shifting, severed, conjoined, emotional, largely unaccountable and, therefore, possibly irrational. I wake up and for several seconds I do not know what I am, where I am, who I am. The facts I rehearse to assemble myself are banal: name, age, sex, country, date, purpose. Still I do not belong, not quite. I am in-between. With my first cup of coffee, I begin to belong, at least to myself, my body, if not entirely to my mind. My head is still stuffed with cotton wool. Thinking grinds to a standstill almost. I am simulating a hangover but not from alcohol or any other drug of indulgence, but from life, from the day before, from the effort of trying to belong somewhere for some of the time. This happens to my head whenever I exert myself in the direction of belonging at the expense of unbelonging. It's as if I've moved away from myself to a place where I'm not only a stranger to myself but estranged from myself.

The company of a stranger, when that stranger is yourself, can lead to some interesting guesswork – milk or no milk in your coffee? It means I forget whether I like coffee at all and I'm not sure how to go about bringing the result of a steaming cup so that I can decide over the conundrum of Black or white. On these days stillness is my only option, movement can lead to catastrophe. I have to avoid mirrors. They startle me at the best of times. But on these days they are a puzzle. I bring my hand up to my face and tell myself this gesture is to feel. That face is mine, I tell myself. Yours, a voice repeats. No, mine, I have to assert before the exchange develops into a full-blown psychosis between a spilt and splintering self or a discourse in which I am responding as if at a conference where I play all the parts, audience, speaker, moderator, sound technician.

The problem with in-betweenness is its unease with history. Big history is untrustworthy, small or biographical history, that of memory and family is fragmented. A movement away from the history of my country or countries and from Black people is really exile from the oxygen of ideas to do with writing in history. Once out of history, that is, no longer engaged with it as a deliberate choice, it is hard to function as anything other than a splintered animal. The self, or any notion of it, disintegrates once out of the clutches of the gravity of history. It leaves history's orbit and floats away and loses all bearings, and questions the most basic things that it knew and took for granted before, when it was in history, within that sphere of things history had told it all about.

History has a debt attached to it. A look into it means the writer has to write a cheque on behalf of some group or cause. Imagination is hijacked by history every time it returns to history. There is no negotiation, there is only dictation. History, because it is so bad, so full of mistakes, can be approached by a working conscience only in one way – as a place to set things right. So the self that is fragile about now, that has a weak sense of the tribe, that covets its own sense of independence, starts to resent looking at history, positively lives in fear of engaging with it.

The result is always the same. History demands recompense. The dead have to be served because the manner of their death was unjust. Circumstances were pitted against them, they died miserably so the story goes, as if anyone ever dies contented – as if the soul has any other option than to 'rage, rage,' as exhorted by Dylan Thomas, who understood the lie of acquiescence and wanted to explode it. Their only recourse is to the living who are willing to return and examine their case as story or academic paper or anthropology.

What is really happening, unless the writer is astute, is a squandering of the gifts of the writer if that writer returns to history on a mission of redress. There can be no redress. Those who belong to history and who suffered in it belong to an irrecoverable past as far as recompense or redress is concerned. That aspect of history is dead. What lives about history is what the living entertain about it. History's lessons are salutary only in so far as they remind us of how our ancestors fucked up and were fucked up in turn. The heroes in it did what they had to do with no notion that they might be serving the gods of return. They were preoccupied – and quite rightly so – with the villains of their time.

The in-between self knows all the dangers of that aspect of history and so avoids that history as a mistake that is remade if that history is engaged. This does not mean that the writer should be, or even can be, ahistorical. History cannot be ducked. The nature

of the present militates against any act of avoidance. Instead engagement has to be on new terms. A greater sense of the individual in history is necessary if a return is to bear fruit. Unbelongingness means I go back without any allegiance. History is somehow able to speak to me as an individual. Stories emerge with their own truths, freed of the agenda of the tribe or debt of return. Memory dovetails into imagination. The question becomes therefore, not whether a story is true because it happened or false because it is imagined but does its tone persuade a reader. History proves that the state of unbelongingness and in-betweenness was always a feature of individualism, though with varying degrees of difficulty attached to it. Movement was always there along with memory and forgetting and the struggle for balance between them.

I need to forget in order to continue, but I must remember if I am to survive. Continuity is about repetition. To repeat something that is unpleasant or dangerous requires both the impulse of pretending that this time is the first time and the memory of knowing how to proceed with care. Remembering and forgetting come into play at different stages but both know they are in the service of the individual who would never settle for one at the expense of the other. They struggle against each other for dominance but neither wants the destruction of the other. History is successfully mediated by the two. Some notion of truth in history prevails. History is engaged with wonder. This is not to say that the injustices of the past are unreal or that they should be ignored unless they surrender that aspect of themselves which inspires awe. Of course injustices are there and they cannot be wished away. Nor should they be ignored. What this non-aligned approach to history gives is a stronger sense of the story as a vehicle for change. Whatever injustices are there in the past should be made manifest through story. A return to history should therefore preoccupy itself with getting the story told and trusting in the mechanisms of story-telling to display lies, deceits and injustices.

Finding the individual story in that multitudinous past is the test, since the story needs the engine of character if it is to be any good at working with history on its own terms. Part of my preparation for this return came with the years spent away from one place and trying to get to know a new location. I had to rely on memory and forgetting. Distance was commonplace but so was the need for engagement. I had, simultaneously, to lose and find the place I had left in order to begin to belong to the new place. Losing meant forgetting about it, lessening its hold on me; finding it meant I had to hold on to the essentials about it, those facets about it that refused to go away and that gave me sustenance.

Even the consciousness that is detached from the sense of itself as one person among a group finds ways of belonging. But the predominant condition is in-betweenness. A double removal from the self and from the world. A sense of floating, gravitiless, free from any cause. The United States filled me with an acute sense of unbelongingness. I was glad for the intensity of the feeling, the clarity of its tone, yet appalled too that I would not be able to function at all, that I'd be immobilized by the very condition that I fed on as a writer.

The five-college community at Amherst, Massachusetts, was an enclave from the disparateness of London. Libraries, speakers, readers, performances were staple but mostly it was a time of quiet and space in my life. Hours of silence and thought and work. Early mornings scribbling, late nights too. And the fascination of getting to know the routine and rhythm of a place and people. For ages I resisted writing about

it, though I made copious notes, more to satisfy my sight, to fulfil my capacity as witness, than notes towards some grand project. I didn't write too because I was afraid of sounding like a tourist. Of lambasting the usual vulgarities that strike an English ear and eye, of responding to the generalities at the expense of a deeper understanding.

England became clearer to me. Bits of it would float into focus and, isolated from the bigger picture, make astonishing sense to me, whereas before it was chaos or seemed irrelevant. There was a rhythm to life in London. Lots of activity and lengthy periods of being too busy to think about what I was doing or why, followed by days of discombobulation or hostility towards the place and myself with one exchange after another adding to the sameness of my mood.

If two years at Amherst College allowed me to find my bearings within a realm of general insecurity, then a year in Maine took me to an extreme. A winter in Maine was enough to make it clear to me what it was I was going through. Geography from the past collided with maps of the present. I saw myself splinter across these landscapes and multiply into plural selves. My sense of a race, other than the human race, dwindled, with just five thousand Black people in the entire state, and the likelihood of seeing one Black face in a week became remote. Race was replaced by other characteristics. A friendly face, a kind word, from whatever source meant a lot. At certain poetry readings, everyone present in that small gathering belonged automatically to a republic of romantics.

Miami swung the needle of loyalty from one remote corner to an opposite extreme. According to the light which seemed to penetrate everything, I was back in Guyana. The vegetation too was tropical. The sea was bright and vast and the sky remote and infinite like Guyana. But it was a Guyana with investment, with good roads, drinking water and reliable electricity. Miami and Guyana were joined by this sea and vegetation and light but the money remained on the Miami side of the water. I was a stranger again. I was in between as always, but now with a working knowledge of my condition I was more accepting of feelings of being lost, alone and disconnected. I understood that this new geography was the latest pearl in a string of pearls that would eventually at the end of my life comprise a valuable necklace of experiences. I positively embraced it. Unbelongingness, in-betweenness, was the first certain sensation and tone I expected to experience when I arrived. A renewed sense of it. The gaps in my timetable when nothing was meant to happen and nothing much did, were looked forward to and savoured. I was lost but I was found too – in the condition of loss which was strange and familiar in its strangeness. It wasn't either, or, but both, just like the good old days.

Other reasons to celebrate: I was back in the sun and near the sea. I started to look ahead to the days when I would feel a staleness creeping up on me, a tiredness with the routine and an itch to procure my in-betweenness, my unbelongingness again. But not yet, not yet. Right now I was lost in the moment. I was too busy living, or as Bob Dylan put it, 'Those not busy being born are busy dying.'

When I finish a book and before I start another (or idea that founders on itself, falls short of a book but pretends for weeks that it may result in something positive and near-complete) I am in-between selves: the self that thrived as it completed a book, a self unified by the struggle, by being lost in the process, and the new self that will be embraced, explored and which may result in another book, essay, filmscript. The new self is a stranger that emerges from the old enabling the old self to die or be sloughed off or perish in a fire that renews even as it reduces to cinders.

In-between old and new there is a process of renewal, of catching up with the ordinary, even the mundane aspects of life – things to fix, new shoes to buy, or old ones to reheel and resole. I seek out people I'd spent weeks studiously avoiding. I enjoy films and music that during my spell of working I'd had no patience viewing or hearing.

Just when I thought unbelonging was geographical, cultural, psychic, I find it is creative too, that I lose selves along the way and acquire new ones, not only as I write but as a function of writing and because of it. Is my personality like an onion, multi-layered, with my peeling away at myself as a necessary act of living? If so each layer retains the capacity to function as a self looking back and ahead even as one part of it faces extinction and another rebirth.

The problem with the onion analogy is that it is a stable, albeit multifarious, condition. There is a whole thing with these layers which are revealed over time. It will not do. Since it fixes in time some enduring whole which I think is shattered by movement and by writing. So, not a peeling away of layers or a sloughing off of skin or even a renewal in some artistic fire, though all add a much-needed element of metaphor and therefore 'thinginess' to what is an otherwise amorphous, nebulous condition. Yet they prove insufficient as an account for what is happening in this life where unbelonging-ness and in-betweenness permeate all thought, movement, feeling.

What's the answer to born or made? Mostly made, clearly, but what is apparent to me now is that a small but significant portion of who I am or purport to be is innate, ascribed before birth, handed down by the union of parents who were similarly dis-posed. The problem with unbelongingness, in-betweenness, is that love, routine, sta-bility – all the staples of a long and healthy life – are thrown into suspicion under its light. Love can't last; routine stultifies; stability becomes synonymous with stasis. The very features that would allow such a life to explore the conditions that go into making it are themselves challenged by it. Unbelongingness, in-betweenness, struggles against itself, its own well-being. It agitates for change because it must, not because it is necessarily good for it. Another thing to help ground the condition – jello, turned out of its container after it is formed, if struck with the back of a tablespoon, trembles for an age – that condition of trembling, that near-nebulous shape best typifies the unbelonging, in-between mind, body and soul.

Mintah is taken by her mother from her village in eighteenth-century West Africa to a coastal fort. But the fort is attacked and Mintah ends up a slave. She is sold to a ship bound for Jamaica but ends up in Maryland. Mintah left the fort literate and numerate. She quickly distinguishes herself and after a few years manages to buy her freedom. After many years of free living in Maryland, circumstances force her to leave Maryland for Jamaica in her old age in time for the 1833 emancipation (forced apprenticeship rather than true freedom) celebrations. All her life she is haunted by her Atlantic-crossing.

The point about all this is that she spends a life on the move. She never settles for a new home for more than a few years before an enforced departure. She retains a memory of a place where she grew up and spends years longing for it then not caring any more for anything but peace of mind. Mintah as a character had unbelongingness, in-betweenness forced on her. Her life is defined by leaving and never really arriving to a place where she can relax. Her memories are partly to blame for her unsettled nature but her status as a free Black woman in a slave system is a major factor. She is driven by a need to account for all those 131 souls, plus ten, lost abnormally in the Atlantic.

Her father was a wood-carver. She picks up the craft and spends her little spare time carving figures akin to each person on *The Zong*, who was fed to the sea. Mintah never really disembarks from that ship. Her life and her memory, remain at sea. She loves Africa and Africans but she is separate from both. She tries to find a life for herself in Maryland and Jamaica but slavery surrounds her like another sea. Slavery is this sea. She is in a ship, her mind and body, adrift on this sea. There is no end to the voyage, no port to offer respite. Only death ends it. In-betweenness is a way of life, is her life; she does not belong anywhere on this sea, cannot belong and so her unbelongingness becomes a permanent state.

Her wood-carvings attest to a condition in flux. The figures are reaching up or out or both, with their hands. Their feet are positioned in various postures of being on the move. Even their spines are arched in this flux and their faces show exertion, not peace, but concentration and effort, all attitudes of overcoming. These figures surround her in her hut. They are her attempt to use her art to get her beyond the flux into some more settled state. But she only succeeds in defining her condition, not overcoming it. Art here is not cure. Art is not even therapy. Art merely serves to reflect and define what she already knows. The only difference between her knowing and her art is that the latter externalises her knowledge, makes it more of a thing than her thoughts and feelings, becomes a conduit for the two. Her art leads her to some form of engagement rather than stasis. It literally keeps her idle hands and mind preoccupied with the very worry that would serve to immobilize both and keep both idle. Art also heightens her awareness of her condition. This is dangerous since what you don't know can't hurt, while what you get to know may be unbearable, too much knowledge or pain for one life to bear. Is Mintah worse off with her art? No. But the benefits are not immediately apparent. Art serves as a rehearsal of her dilemma, her pain. This is tough for Mintah who is already at sea, already in pain, in slavery, and disconnected from her roots. She is in no condition to plant new emblems of belonging, of having arrived.

Her carvings articulate all these to her and the knowledge hurts. In-betweenness hurts. She seeks solace in the elements and finally achieves an uneasy settlement there, rather than in a new community or by a return to Africa. Mintah is not alone in her dilemma. The society at the time was about uprootedness and forced relocation. She was one among millions. Their condition of unbelonging was prevalent at that time, though no government or council presided over it, and each citizen of in-betweenness had to rely on private, solitary, internal resources and processes to cope. Besides this, the majority of displaced peoples were slaves and too busy serving or thinking up ways to get around slavery to explore the finer points of their existential predicament.

If it was difficult to think outside of slavery, then it was impossible to conceive of a life in which unbelongingness, in-betweenness would be embraced as a way of being in the world. Yet Mintah's wood-carvings attempt to do precisely that, namely, explore the notion of the self as an entity split between the land and the sea and no longer at home anywhere; they seek to define a self whose decisive moment was a sea voyage where a mass murder took place. As if that were not enough she also contends with her separation from her parents and village and country.

This makes her condition many-layered, multifaceted. No single solution, apart from death, is possible. Unbelongingness, in-betweenness cannot be resolved. It is too complex. It has to be endured or embraced as a way of life. But first all those sensations, confusions to do with it have to be recognized or else the subject feels mad or else is

driven mad by them. Her art helps her in this process of recognition and in the acceptance – not a fight *à la* Dylan Thomas, but a process of comprehending something difficult and integral to her nature and making a life out of the duress that it inevitably represents. Race as a refuge is a short cut from dealing with the condition. So long as the individual uses race as the first and last port of call to escape the panic caused by feeling and thinking unbelongingness, in-betweenness history will invoice their imagination, life will demand redress, when all along it is the art that calls for it.

Note

1 *Feeding the Ghosts* (London: Chatto & Windus, 1997).

17

THAT LITTLE MAGIC TOUCH

The headtie and issues around Black British women's identity

Carol Tulloch

The 'image and language of the clothed body' has been credited with wielding enormous social influence. The inanimate objects employed to create the clothed body are physically destitute of life, yet clothes have the conflicting ability to initiate and confirm change; to broadcast the political conflict or status within a community; and to be a metaphor of domination and conversely opposition (McCracken 1990: 61). Accessories are not to be forgotten. They are the 'little magic touch' deployed by professional and amateur stylists to perfect a desired look. Generally it is the body, that is the torso, that is primed as the place of action for the clothed body (Calafeto 1997). Accessories which dress the head, hands and feet can, in their own right, supply a narrative of cultural and social issues.

The focus for this essay is the relationship between the individual and an accessory at a particular moment in history, that of young Black British women of Caribbean descent and the self-assembly headtie they wore during the 1970s. The work considers how this relationship was simultaneously affected by Black British women's social values and cultural identity, which was shaped by their existence in Britain, and the transnational influence of African Americans.

I wish to argue that in their feminist-cultural discourse, Black British women used the headtie to identify themselves as 'Womanist' (Walker 1991: xi), to be seen and taken seriously. The term was 'engineered' by the African American author Alice Walker. In the first instance, Walker proclaims a 'Womanist' to be: 'A Black feminist or feminist of colour' a woman who has moved away from 'girlish' things into the heady responsibility of womanhood; a Black woman thirsty for knowledge, a Black woman who wants to take control of her life and is purposeful and steadfast in this pursuit. But Walker maintains that it can also refer to all women regardless of race and sexual orientation.

This apolitical slant on the term has caused consternation amongst Black feminists in America and Britain (Charles II: 280–4). This chapter proposes that Black British women employed the term *womanist* as part of their engagement in cultural and political debates through affective application of their clothed bodies. I further propose that the headtie, as part of Black British Women's search for a new, expressive cultural identity in the 1970s, consciously tied them closer to the cultural aesthetic of African

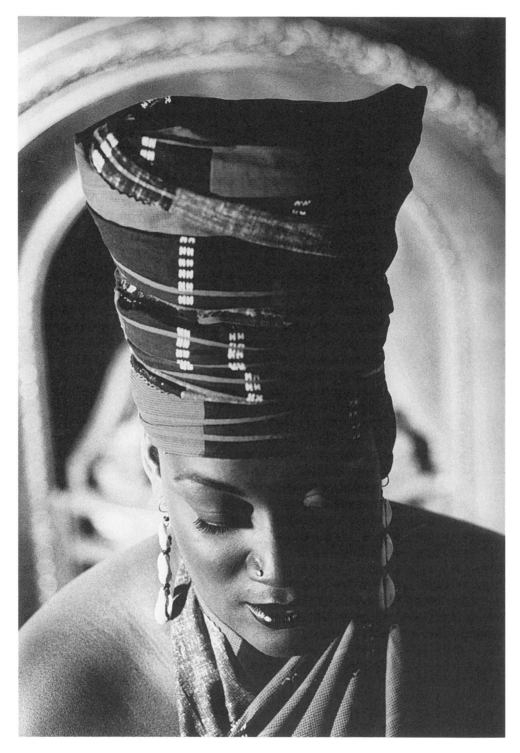

Figure 17.1 Contemporary headtie
Source: Courtesy of Sharon Wallace

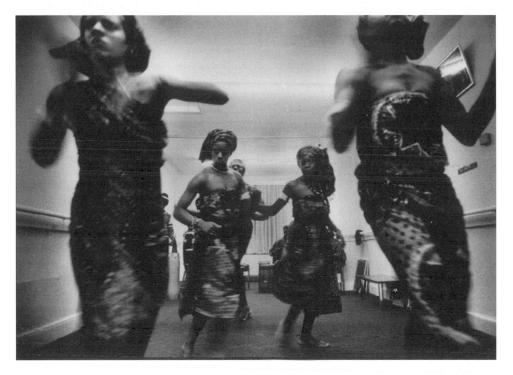

Figure 17.2 Reclaiming the heritage, Kokuma Dance Company
Source: Courtesy of John Reardon

America and Jamaica, formidable players in the development of the African diaspora aesthetic.

The 1970s was a momentous period in the development of the African diaspora and Black identity, when the cumulative activities of the Civil Rights, Black Power and Black consciousness movements had a crucial influence. African Americans looked at their segregated world with new eyes. In 1968 they were encouraged by Black activists and musicians to 'Think Black, Talk Black, Create Black, Buy Black, Vote Black and Live Black' (Gilroy 1987: 176–7).

Thus the African American community aimed to take control of and impose their own cultural disunion, a people who were all too well aware of the crippling emotional, social and economic effects of the official American segregation laws. This reversed, self-imposed form of segregation came at a time when the segregation laws were being dissolved. It was a strong, deliberate backlash, designed to create a solid countercultural identity based on being 'Black', which at the time translated to mean of African origin, not a displaced, invisible 'negro'. This resulted in an electrical charge of creativity on all cultural levels for the community, not least through dress and self-image.

The Black street styles which sprang from this situation placed African Americans around the Western world as possessing perhaps the highest level of street credibility in terms of dress, music and language. During the emergence of 'Black Bohemia' in the late 1950s (Kelley 1997: 343), the Black Freedom Movement and African Liberation, and the early stages of Black Pride, African American youths appeared to lead the way

209

in asserting 'Blackness', which was viewed with confusion, suspicion, and amusement by their older, conservative African peers. The younger and more outspoken saw the change not only as symbolic but as an emphatic proclamation of an oppressed people's psychological reorientation (Powell 1997: 121).

The 1970s was the high point of anti-fashion. Valerie Steele claims that it covertly diffused the political radicalism engaged by a series of movements across Europe and America in the 1960s, to reach the masses in the 1970s. She suggests that the 1970s produced two periods. The first phase, what she defines as a mix of 'late hippie diffusion', a leftover from the late 1960s, lasted from 1970 to 1974 and included a distinctive African American style of dress of African influences such as the African dashiki, as worn by the 'Black Moses', African American soul artist Isaac Hayes; a penchant for urban guerrilla dress of leather immortalized by the Black Power movement; and the pimp-inspired, ostentatious, eye-popping style of platforms and gargantuan flares, and body-hugging poloneck sweaters epitomized by the likes of Black screen god Shaft (Steele 1997: 280–1).

The second phase, of 1975–9, was shaped by the ambiguous presence of the highly aggressive dress of punk and the exacting conservatism of 'Dress-for-Success uniformity' (Steele 1997: 281). The headcloths worn by African Americans during the 1970s, Steele suggests, were worn partly because of their strong links with Africa as 'a more overtly politicized version of the wider interests in "ethnic" style' (Steele 1997: 287).

This distinctive form of African American radical chic was the antithesis of the image presented in mainstream films featuring African American women up to 1970, and through skin colour association extended to all Black women of the African diaspora. Hollywood perpetuated a demeaning image of Black womanhood. Throughout the gradual global domination of the American film industry at the beginning of the twentieth century, the predominant roles Hollywood offered African American actresses were the three (often combined) low-status characters: slave, servant or 'Mammy'. Stephen Bourne recounts the latter category of stereotyped Black women as 'a passive, one-dimensional, comical, non-threatening, docile caricature of Black womanhood' (Bourne 1993: 30). For Bourne, in spite of this stereotype, the appearance of African American actress Hattie McDaniel in seventy-odd screen portrayals of the Mammy was imbued with depth, intelligence, wit and sass, a combination immortalized in the 1939 Hollywood blockbuster *Gone With the Wind*.

In her myriad roles as Mammy, McDaniel wore a variety of headtie designs: from the clinical, neatly trussed style she wore in *Gone With the Wind*, where a small piece of fabric is secured closely to the head, and the ends are tied, rolled upwards and tucked in tightly at the front, to the exuberant style with a floppy knot at the front of the head, generally associated with the caricatured image of the Mammy, as worn by her in *Show Boat*.

Intensive distaste for these representations of Black womanhood was high amongst the African American community. During the Second World War, African American servicemen claimed that McDaniel's screen image in *Gone With the Wind* lowered their morale (Bourne 1993: 31). The irony was that on the home front the style of headtie featured in the film had acquired a high fashion status among white munitions workers and civilians committed to the war effort in both America and Britain. It was worn as protective headwear, as well as a fashion feature and signifier of patriotic fervour.

The stereotyped screen attire and image of African American female characters

during the first fifty years or so of American cinema belied their offscreen image of high-fashion sophistication and modernity as exemplified by such icons as the Jazz artist Billie Holiday. Black women, then, were represented as a homogeneous entity, devoid of an individual identity, devalued and servile. In this context the headtie signified the delineation of perennial inferiority.

In 1972, African American artist Betye Sarr's composition 'The Liberation of Aunt Jemima' attempted to salvage the Mammy image. It features a large figurine of a Black woman in complete Mammy regalia: bowed headtie, a bandanna around her neck, a rifle in one hand, a broom and grenade in the other. In front of this figure is a framed picture of another Mammy. She stands behind a picket fence with one hand on her hips, and a white baby under her other arm. This image of 'liberation' is punctuated by a large Black fist – a symbol of the Black Power Movement. Behind the figurine is a Warholesque head repeat of a 'grinning' Black woman; her only form of decoration is a headband. The work is an effective *memoria technica* of Black female existence and opposition despite adversity.

Since the 1970s Black British women have fashioned themselves to produce aesthetic identities based on the fusion of their own experiences as members of a Black counter-culture which operates within the white hegemony of Britain, with all the political and cultural complexities this combination entails. These women were part of a historically significant group, first generation postwar Black people born in Britain thanks to the great number of Caribbean and African men and women (and children) who emigrated to Britain between 1948 and 1962, as a result of Britain's positive immigration policy.

The parents of these young men and women came from predominantly Black-populated countries that had maintained their specific form of Caribbean or African culture. The diaspora experience of, for example, Jamaican parents and their British-born children was, inevitably, different and frequently difficult. None the less, in the Black conscious fervour of the 1970s, the diaspora identities created by Black British women as part of a feminist-cultural discourse were based on and celebrated the diaspora experience. This resulted in a 'diaspora aesthetic' that drew on ideas and 'traditions' that developed during slavery, and reconfigured continuously. Stuart Hall has argued that the diaspora experience 'is defined not by essence or purity, but by the recognition of a necessary heterogeneity and diversity; by a conception of "identity" which lives with and through, not despite, difference; by hybridity. Diaspora identities are those which are constantly producing and reproducing themselves anew, through transformation and difference' (Hall 1990: 235–6).

The tie that binds

I have chosen to focus on the headtie as it is one of the few pieces of apparel worn by Black women throughout the African diaspora that can be traced back to their African cultural heritage from the mid eighteenth century continuously to the present (Bradley 1995: 216). The headtie enabled African-born slave women and their descendants throughout the African diaspora to maintain links with their African cultural heritage. The use of the headtie in public by Black British women from the 1970s onwards, has a particular resonance.

Whether worn as a tower of fabric bound tight around the head, a folded square or a triangle of cloth bound tight to the head and secured at the back, front or side in a

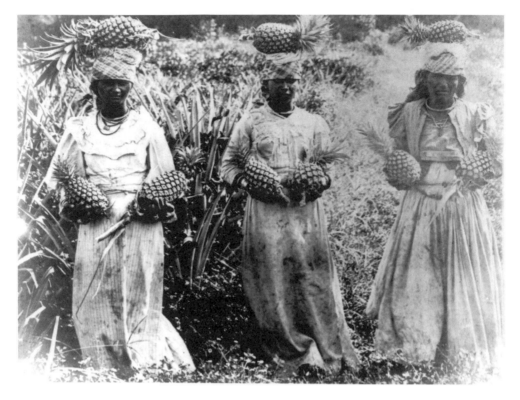

Figure 17.3 East Indian Women, Jamaica 1894
Source: Courtesy of the National Library of Jamaica

tight, neat knot; or the luxurious fabric wrapped around the head, the ends left free to cascade down on to the body, the headtie enabled Black British women to engage in a public embrace with African American, Caribbean and African women, and symbolized the ambitions and potency of the term *pan-African*.

The head covering is known by a variety of names: 'turban', 'headwrap', 'bandanna', 'headrag', 'head handkerchief', 'tie head' and 'headtie'. I find that the latter is the most appropriate to consolidate the historical bond between the accessory and the wearer in America and the Caribbean, and its use by Black British women of Caribbean descent during the 1970s. Patricia Hunt's study of the American towns of Georgia and South Carolina shows that they had a large concentration of slaves who were central to the production of cotton prior to and following the American Civil War. The headtie was worn by Black women at both conjunctures.

There was a life cycle of cotton from seed to plant, and from fibre to cloth, which in turn supplied slave women with 'headwraps' (Hunt 1994). This process exemplified the lack of distinction between the use of the cotton cloth by female slave plantation workers and their intrinsic role in the production process of cotton for human consumption. This symbiosis intensified the invisible position of female (and male) slaves, as their true identity had been suppressed by the plantation or slave owner through the removal of their language, their traditions and their original family name.

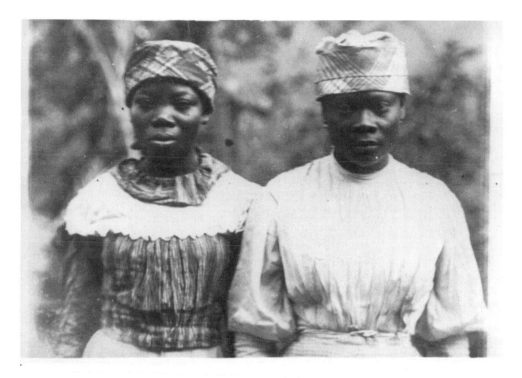

Figure 17.4 African Jamaican women, 1990
Source: Courtesy of the National Library of Jamaica

I suggest that the headtie symbolized the tie between the slave and the production of cotton on the plantation. It was a metaphor for the inextricable tie between the plantation owner and the slave-owner. Furthermore it was an allegory for the volatile and transient tie between master and slave. These relationships were not exclusive to America. Slaves in Jamaica also endured the same form of controlled tie. Within these historical contexts, the headtie acted as presage.

In Jamaica the headtie was omnipresent during the late nineteenth and early twentieth century. This was a period of extensive reconstruction and modernization following emancipation from slavery in 1834 and the Morant Bay Rebellion in 1865 which resulted in a Crown Colony government. The British colony was dominated by four main ethnic groups: African Jamaicans, white Jamaicans, mixed race and Indians. The market trader or higgler, domestic servants and agricultural workers, all had the headtie as a central feature of their regalia. In the case of the higgler, the headtie provided extra padding along with the cotta to support goods they transported on their heads. Agricultural labour was dirty and arduous and for these women the headtie was a necessary protective item from nature's various forms of residuum.

British and American travel writers promoted African-Jamaican working-class women as a homogeneous entity. They concentrated on the functional detail and styling techniques to categorize the dress style of a class and race: the Black peasantry. The group was dissected further by the writers. They placed 'the bright bandanna women' (Caffin 1899) embodied in the higgler, as a subculture. Travel writer Mabel Blanche

Caffin likened the African Jamaican peasantry to the London Cockneys in their misuse of the English language, a comparison that drew cultural similarities in the dress of the African Jamaican higgler and the Cockney costermongers.

These subcultures of the British Empire compiled a uniform that focused on accessories and styling, for example the headtie and golf cap, popularly known as the flat cloth cap. This example demonstrates how attention to detail and styling by men and women transformed such features into characteristic symbols of their respective countercultures. Caffin was so taken with the headtie that she suggested them as souvenirs to the plutocratic tourists – an example of a nineteenth-century subcultural item being adopted by members of the dominant culture.

In reality the headtie was worn by African Jamaican and Indian women as part of occupational and fine dress. It was a considered socially acceptable at weddings, church meetings or for market day. From the 1880s onwards, a series of headtie shapes emerged that invites the consideration of style trends. A closely bound, unstructured style, a forerunner of the late twentieth-century small 'bandanna' headtie, the ends tied at the back towards the nape of the neck, provided an even surface to transport goods. A turbanesque shape, loosely bound with ties brought round to the front of the head and knotted towards the crown, making use of a large expanse of fabric, appears to have been reserved for leisure. There were also a structured design incorporating sharp folds and creases to frame the head, which sits like a hat, revealing the ears, and is secured by knotting the ends together high above the back of the neck; and a plain flat fronted headtie with a burst of fabric at the nape of the neck, making full use of the 'handkerchief', a square metre of woven fabric. A wide variety of cloths of multifarious designs were used. The majority of the headties were formed from the South Indian Real Madras handkerchief. The history of the fabric has particular resonance to the relationship between the Indian and African Jamaican peasantry during the period.

Prior to the abolition of the slave trade in 1808, the Real Madras Handkerchief was a currency of slavery, with the 'triangle of trade'. It was manufactured in southern Indian villages, then transported to London to be auctioned to either the Royal Africa Company or private traders, and finally the cloth was used to barter for slaves in West Africa and to clothe slaves in the West Indies. This system of trading continued following abolition. The Real Madras Handkerchief, now defined as a 'prohibited good' by Britain, benefited from the practice of rescinding duties on re-exports from London. The West Indies remained one of the markets where the cloth was sold alongside the British-produced imitation Madras Handkerchief (Evenson 1994: 11).

Despite variations, the generic style of the headtie established a group identity. The Black peasantry were bound together in the adoption of an accessory, and more specifically in the use of the Real Madras Handkerchief, whose history dates back to the slavery period. It is impressive that an apparently humble object can possess such a complex historical and cultural influence. The headtie symbolized the tie between African Jamaican women, and the emergent tie between African Jamaican women and Indian women as 'Other', despite the vast cultural and linguistic gulf that divided them. In the headtie, there had developed a relationship 'between masses, areas, forms, lines and colours' (Teague: 51) In its longevity the headtie acquired an aura of simplicity that embodied a community relationship based on history, historical roots, colonialism and difference.

A decade in the life of . . .

Patrizia Calefato has deconstructed the close relationship between clothes, dress, fashion and style, and placed fashion as the medium which 'turned the body into a discourse, a sign, a thing . . . A body permeated by discourse, of which clothes and objects are an intrinsic part, is a body exposed to transformations, . . . a body that will feel and taste all that the world feels and tastes, if it simply lets itself open up.' Alternatively clothing forms the material components of dress, the intrinsic tool which 'exposes the body to a limitless metamorphosis' (Calefato 1997: 72).

Catherine King's reading of the three-dimensional clothed body, and the very act of dressing, adorning and styling is 'the skilled production of more or less lasting objects and visual images' that equates with 'art-making' (King 1992: 15). Style, on the other hand, edits the flimflam of the various, and sometimes confused messages transmitted through fashion, and cuts to the chase of the central point being visually discussed between clothed bodies.

The biography of things – objects and the clothed body – at a particular time and space can reveal the identity of the users and 'make salient what might otherwise remain obscure' (Kopytoff 1986: 67). Igor Kopytoff has argued that people and objects are constructed both by society and by the social world they inhabit, and are therefore not separate – objects as commodities and people as individuation. The social patterns and structures of 'complex societies' such as Britain are the same as those which affect the commodities produced and used in those societies and thereby perpetrate the 'uncertainty of identity' in 'complex societies'. In such a situation there is leverage for dynamic interaction between the inanimate and animated (Kopytoff 1986: 90). This ability of the body to change with the application of clothing in a structured, premeditated way, as surmised by Calefato, is fraught with hidden meanings and questions.

What is the identity of the clothed body in relation to the clothing and styling it adopts, and does it bear any relation to the wearer's real cultural identity? The course of cultural identity formulation within any culture is not a smooth progression. In the case of young Black British women during the 1970s, the process is profound and compounded by the didactic power of British hegemony – the media, current trends and peer pressure – from Black and white people – to conform to the 'established' cultural norm. My own experience of, and reasons for, wearing the headtie during the 1970s act as a microscopic insight into the experiences faced by Black British women to excavate a cultural identity. By drawing on specific points of an identified relationship with an object, and within the wider context of their combined social relationship, an 'autobiography' of their relationship can present some semblance of a 'collective address' (Ahmed 1997: 151–5).

I was born in Doncaster, South Yorkshire, of Jamaican parents who emigrated to Britain in the mid-1950s. Between the age of five and sixteen I lived a dual existence. My public and private worlds were shaped and kept separate by two different cultures: British society in the public, and a Christian Jamaican creole culture alongside the images and influences from television, the radio, newspapers and magazines, infused my private world. Only sporadically did the Jamaican culture inform the British influences.

The dress and hairstyles of my early teens were influenced by these two worlds. In the main, I wore the latest European-inspired fashion trends. I processed my hair, a

method of 'controlling' Black hair, which was a vain (in both senses of the word) attempt to keep in line with European hairstyles. Like many of my Black and white peers, I eventually flirted with subcultural, that is white, subcultural dress. My identity was essentially that of a 'coloured' girl in European guise. In the home, I would often wear a headtie, as my mother and grandmother had always done while housekeeping or as part of our laborious hairdressing techniques.

The headtie was worn tied close to the head and secured with a small knot at the nape of the neck, or the ends brought round to the front and tied very tightly, or in the mammy style, with a large bow, but this was frowned upon by my mother. This style signified for her too much of the 'negro', too much servility, as depicted in the Sunday afternoon films we watched as a family between morning and evening church service. To the older generation, the 'Black headtie' was a utilitarian garment to be worn only in the home, as a form of 'undress'.

In public my mother and grandmother wore the respectable establishment headscarf as worn by Queen Elizabeth II and their fellow working-class white neighbours and workmates. The silk or acetate square was folded and secured on to the head by tying the triangle under the chin. Within working-class tradition, the style has been worn by Whitby Fisher women as documented in the evocative nineteenth-century photographs of Frank Meadow Sutcliffe, European peasantry and post-Second-World-War charwomen, but became a universal style adopted in particular by British upper-class women residing in the country.

From my mid-teenage years onwards, the mood shifted gear dramatically. Black culture, specifically the diaspora cultures of Africa, America and Jamaica infiltrated both my public and private worlds, in what appears to have been an instant. Black music – soul, funk and reggae – and musicians, 'Blaxploitation' films and actors, political activists such as the Black radical icon of the 1960s, Angela Davis, who had not lost her potency in 1970s Britain, the emergent Rastafarians and sports personalities were in abundance and visible in all forms of the media. I no longer wanted the European look. I wanted to copy Aretha Franklin and the Jackson Five, the superfly film characters Cleopatra Jones and Shaft.

On visits to what I believed to be Britain's Black utopia, Brixton, a district in London, I jealously admired the young Black women I saw on the streets. They appeared to me as enlightened, majestic women, light years ahead of me in terms of style and Black consciousness. I wanted the Afro and Afro puffs hairstyle. Most poignantly, I wanted the elaborately styled headties I saw worn with pride on the streets by Black women, or by the Black celebrities I watched on television. The headtie had been liberated, it was no longer hidden from the world of street dress, but an essential glamour item, using swathes of fabric to create a variety of styles that towered upwards, or wrapped close to the head with long trains left free to cascade down the wearer's neck and body.

These eloquent designs resonated the new-found confidence felt by Black women throughout the diaspora during this time of cultural awakening: they now had the strength in numbers to rely on and expose their 'Blackness' ; they acquired the confidence to draw from their history for inspiration. Conversely, the mammy style was prohibited from encroaching on public space as it was, in the minds of Black women, imbued with the painful memories of servitude and degradation endured by Black women (and men) from slavery to the middle of the twentieth century.

In the 1970s, the headtie expanded the repertoire of style images available to Black women. It's fashionability during this explosive period of Black expression in Britain swept through the generational ranks of Britain's Black counterculture; grandmothers and mothers joined their daughters and adopted the style in public, thus reducing the age gap and thereby achieved a level of 'Oneness' through the use of a particular apparel.

Through an exuberant, politically charged act of visual arbitration over the question of Blackness, Black identity and equal rights, the headtie became for Black women one of the most potent, subversive visual statements of the now global Black consciousness movement. The seemingly innocent function of what was just a length of cloth, qualified by its established profile as a humble utilitarian apparel, belied the headtie's subversive message of Black consciousness, and the acceptance of Blackness as a cultural force, and finally Africa as the epicentre of Black culture.

The headtie, the Afro and dreadlocks during this period offered conscious Black women throughout the African diaspora a solution to the tug of war between natural and artificial Black hairstyles which engendered a duality of insecurity in Black identity. Kobena Mercer has argued that the historical importance of the Afro and dreadlocks hairstyles provided a liberating and radical feature to Black lives – 'they counter-politicized the signifier of ethnic devalorization, redefining Blackness as a positive attribute' (Mercer 1987: 40–1) – but their incorporation into mainstream fashion in a short period of time depoliticized the hairstyles.

The same fate befell the elegant headtie designs described above. These could be found on the fashion pages of such tomes of Western high fashion as *Vogue* and *Harpers & Queen*. None the less, the seed had been planted and the myriad African fabric designs, whirled into a crowning tower of glory by Rastafarian women from the mid-1970s in devout adherence to their religious teachings that a woman should not have her hair uncovered in public, redeemed the headtie from the realms of commercialization, back into the traditions of African diaspora dress and identity.

The headtie then, acquired the status of headdress: a simple or complex artistically arranged structure, permanent or temporary, intended for reuse and preservation. A headdress acts as a cultural or individual signifier of aesthetic improvement of appearance, mood reflections, honour, ethnic or sub-ethnic identities, disguise, protection, healing properties, transition and change of social personality, political or social, initiatory experiences.

What had filtered down to me in Doncaster was the resultant effects of the Civil Rights and Black Power movements from the 1950s to the 1970s. The movements were motivated into high-profile political action, to confront and redress the negation of African American existence by American society. To counteract this, African Americans adopted pan-African ideology in the early 1970s to reclaim their cultural heritage, and to sharpen the visibility of their 'new' identity. The skilfully blended elements of African cultural traditions and dress, with contemporary African American trends, spread to Britain and Jamaica to create an African diaspora cultural identity and aesthetic.

With hindsight, my decision to follow the lead of other Black women in Britain, Jamaica and America and to wear the headtie in public was a subconscious way of participating in the advancement of Black culture and politics. Here was an example of an individual identity born out of a collective identity. Owing to strict matriarchal

control, I was not allowed to be a vocal activist at the front line of the Black consciousness movement, only a silent supporter. Dress and my clothed body were the only tools I had for engagement with this transnational movement. Now I realize that dress had empowered me to also become womanist, to take responsibility for and claim some level of control over my identity, by choosing to amplify my 'Otherness'.

Not until the 1980s and in my mid-twenties as a mature fashion student living in London did I have the courage to wear the 'mammy' style in public (often with men's second-hand suits) to define my own individual aesthetic diaspora identity. My practical training and experience to assemble and redefine the clothed body, to go to history and to draw on one's personal memory and image-bank, for potent and provocative symbols of cultural comment, equipped me with the impetus for such a personal transition. Hall has remarked that the production of a cultural identity is based on the retelling of the past, the imaginative rediscovery based on a shared culture, a 'Oneness' which underpins all other superficial differences. The 'significance of difference', results in 'what we really are and become' owing to the intervention of history are concepts focal to the empowerment and creativity of essentially marginalized and invisible people (Hall 1990: 223–5).

Cultural identity, an evolutionary force with a soul, exists engaging the politics of identity into the cultural discourse. The formulation of a cultural identity by Black British females, as with African American and Caribbean women, is not an unbroken line from some fixed origin (Hall 1990: 226) but framed by the cultural exchange within host societies, and between members of the African diaspora based on a shared experience, to legitimize the dual dynamic of the cultural identification of 'Black British'.

References

Ahmed, S. (1997) 'It's a Sun-tan, Isn't It?: Auto-biography as an Identificatory Practice', in H. Safia Mirza (ed.), *Black British Feminism: A Reader* (London and New York: Routledge).

Bourne, S. (1993) 'Denying Her Place: Hattie McDaniel's Surprising Acts', in P. Cooke and P. Dodd (eds), *Woman and Film* (London: Scarlet Press).

Bradley, G. H. (1995) 'The West African Origin of the African-American Headwrap', in J. B. Eicher (ed.), *Dress and Ethnicity* (Oxford and Washington, DC: Berg).

Caffin, M. B. (1899) *A Jamaica Outing* (Boston, Mass.: The Sherwood Publishing Company).

Calefato, P. (1997) 'Fashion and Worldliness: Language and Imagery of the Clothed Body', *Fashion Theory: The Journal of Dress, Body & Culture* 1, 1 (March).

(Charles), H. (1997) 'The Language of Womanism: Re-thinking Difference', in H. Safia Mirza (ed.), *Black British Feminism: A Reader* (London and New York: Routledge).

Eicher, J. B. (ed.) (1995) *Dress and Ethnicity* (Oxford and Washington, DC: Berg).

Evenson, S. L. (1994) *A History of Indian Madras Manufacture and Trade: Shifting Patterns of Exchange* (unpublished Ph.D. thesis).

Gilroy, P. (1987) *There Ain't No Black in the Union Jack* (London, Melbourne, Sydney, Auckland and Johannesburg: Hutchinson).

Hall, S. (1990) 'Cultural Identity and Diaspora', in J. Rutherford (ed.), *Identity: Community, Culture, Difference* (London: Lawrence & Wishart).

Hunt, P. (1994) 'Swathed in Cloth: The Headwraps of Some African American Women in Georgia and South Carolina During the Late Nineteenth and Early Twentieth Centuries', *Dress: The Costume Society of America*, 21.

Kelley, R. D. G. (1997) 'Nap Time: Historicizing the Afro' *Fashion Theory: The Journal Dress, Body & Culture*, 1, 4 (December).

King, C. (1992) 'Making Things Mean: Cultural Representation in Objects', in F. Bonner, L. Goodman, R. Allen, L. James and C. King, *Imagining Women: Cultural Representations and Gender* (London and Cambridge, Mass.: Polity Press).

Kopytoff, I. (1986) 'The Cultural Biography of Things: Commoditization as Process', in A. Appadurai (ed.), *The Social Life of Things: Commodities in Cultural Perspective* (Cambridge, New York and Melbourne: Cambridge University Press).

McCracken, G. (1990) *Culture and Consumption* (Bloomington and Indianapolis: Indiana University).

Mercer, K. (1987) 'Black Hair/Style Politics' *New Formations* 3 (winter) (extracts in Chapter 9 above).

Powell, R. (1997) *Black Art and Culture in the 20th Century* (London, Thames & Hudson).

Steele, V. (1997) 'Anti-Fashion: The 1970s' *Fashion Theory: The Journal of Dress, Body & Culture* 1, 3 (September).

Teague, W. D. (1946) *Design This Day: The Technique of Order in the Machine Age* (London: Studio).

Walker, A. (1991) *In Search of Our Mother's Gardens: A Womanist Prose* (London: Women's Press).

From Amy de la Haye and Elizabeth Wilson (eds), *Defining Dress: Dress as Object, Meaning and Identity* (Manchester: Manchester University Press, 1999).

18

BLACK PHOTOGRAPHIC PRACTICE

An interview with Faisal Abdu' Allah

Mark Sealy

Introduction: the dark room

The darkroom is that magic space where images can come to life for the first time. Darkrooms can also be scary, insecure environments, full of anxiety. Black artists who choose to investigate issues relating to identity through photography place themselves in highly vulnerable positions. The door is basically wide open for 'getting it wrong'. It is difficult to remember, when dealing with issues relating to race and representation, that there is not one correct discourse, that there is no correct formula for investigating personal experience. This is what makes the work of many Black practitioners so intriguing.

The word *identity* has over the years been systematically volleyed around the cultural playing fields with the occasional goal being scored. However, as most of the central defenders in the field of study are aware, in this game it is about not only moving goalposts but contesting every blade of grass.

Through photographic processes, artists such as Faisal Abdu' Allah and Joy Gregory have become important players in this perpetual contestation of definition. Photographers like Ajamu, Maxine Walker and Peter Max Kandhola have also been in the vanguard of attempting to disrupt and challenge the media's monolithic representations of Black people. Key to many Black photographers' concerns is placing the *self* within the construction of the work – literally placing themselves within the frame.

A recurrent theme within Black British photographic practice is the desire to invert the gaze and to use the camera as a tool of investigation – to articulate the emotional and physical terrain of the Black subject. Dave Lewis consistently uses himself as a model to deconstruct the Black subject, thus leaving the viewer with a variety of impressions of who the Black subject really is. Needless to say, this is never definitive.

The Black body and representations of it have been a constant source of *dis-ease* and *fascination* amongst artists such as Rotimi Fani-Kayode and Roshini Kempadoo. Personal conduits have been explored to articulate the polymorphic nature of being Black. Notions of a homogeneous Black experience have consequently been thrown into crisis. Sunil Gupta and Ingrid Pollard work actively and purposely to reveal the complex nature of what constitutes the Black post-modern subject. Sunil Gupta's photography now resides primarily in the world of Photoshop whilst Ingrid Pollard has moved progressively towards installation.

Faisal Abdu' Allah

I first encountered *I Wanna Kill Sam Coz He Ain't My Motherfuckin' uncle*, Faisal Abdu' Allah's steel portraits, in November 1994, as part of the *Presences* exhibition at the Photographers' Gallery in London. The five pieces on show were two metres tall and a metre wide, comprising black silk-screen ink prints on mild steel. A series of young Black men who looked as if they had just emerged from a Los Angeles rap music video production had etched themselves on to the gallery wall.

I remember thinking that this was a very brazen body of work, full of cheek and boldness. It was refreshing at the same time because it exuded a confidence which was endorsed by the cold and precise production values incorporated within the work.

One of the portraits in particular interested me, *Raham* (figure 18.1). Out of the cold steel comes this Black man dressed in baggy jeans, hooded sweat shirt, denim jacket and big military-style boots. He's standing sideways, pointing a silver handgun out of the frame, and directly at the audience. His eyes are focused down the barrel of the gun where he fixes the viewer in his sights. The ring on Raham's finger is engraved with the star and crescent of Islam, an identification which intensifies the drama.

Raham, the image, is 'not safe'. Through him, Abdu' Allah constructs many of the anxieties and tensions historically associated with images of Black men. He is armed and therefore presumed dangerous. Apart from the whites of his eyes, Abdu' Allah denies us access to any other facial attribute. Raham's fist and gun become his face, which is literally in ours. However, the process of printing the work on steel softens the initial impact. The Black and steel-grey tones are not sharp. They fragment the image and create the effect of a figure emerging or disappearing into a heavy cold fog. Raham appears before us in the guise of a grey haze – an urban nightmare.

The confrontations set up in the work are, however, not just about the potential for physical violence. The issue of psychological damage also lurks in Abdu' Allah's intentions. For a brief moment, Raham allows us to feel threatening. Then he displaces the danger by allowing us to get a sense of what it feels like to be under threat – a pyschological state not unfamiliar to many young Black men. Raham plays on a diverse range of anxieties, ultimately asking – who is frightened of whom?

The uncluttered surroundings also forces us to pay attention to the details of Raham's clothes and fashion accessories. The image is also very much about style. Abdu' Allah takes Raham out of the urban setting and attempts to construct distinctive symbolism using the conventions of the fashion shoot. To those who identify with the rap scene, Rahman is a classic archetype, delivering many of the genre's clichés. To those who have an investment in politically correct images of Black men, Raham would probably be read as failing to offer 'dem Black youth' a good role model. To those who fear Black people, Raham is a worse case scenario. Abdu' Allah's work rests on these multiple and contradictory readings.

Paradoxically, the success of Raham as an image rests on what is supposed to be a negative portrayal of Black young men – the play on violence epitomizes this. However, if we look past the gun, we can see that Raham is isolated. He seems contained in his cold steel environment, and asking us to back off – to leave him alone. After all, he comes from a history that necessitates defensive postures – physically, psychologically and culturally.

The pursuit of 'knowledge' is key to Abdu' Allah's concerns. In my interview with

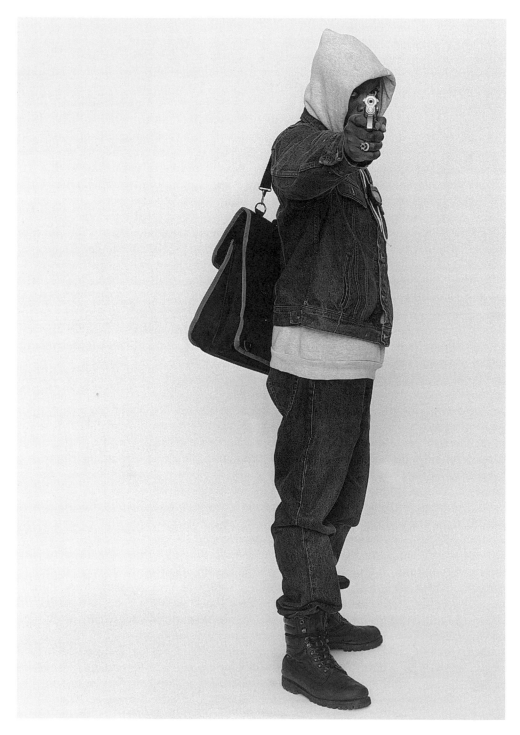

Figure 18.1 Faisal Abdu' Allah, *Raham* (1994)
Source: Courtesy of Faisal Abdu' Allah

him, he said 'My work questions perceptions of race, culture and history. It puts the viewer in contact with both physical and mental aggression, the latter forced on us by the media.' Raham can therefore be seen as a contestation, one that also rejects the notion that the Black artist has to always carry the 'burden' of 'representing his race'.

Faisal Abdu' Allah is confident about what he wants to say and is very much a product of the 1990s. He doesn't come from the generation that 'keeps an eye on the prize'. He is quite happy to stare directly at the 'prize', place both hands on it and carry it off.

Ultimately the strength of his work lies in his uncanny knack of placing burdens back on his audience. You either subscribe or you don't.

The following interview is based on an exchange of letters during 1997.

MS: A few years ago I heard you speak at the Photographers' Gallery in London. You talked about the movement you had made from 'Nigger to Nubian'. This is obviously a very important transformation. Can you tell us the impact this has made on your work?

FA: Very few people know the real truth about the African diaspora that existed pre European history. Public museums, libraries and a vast proportion of educational institutions devote research and practice to affirming a Eurocentric history. My journey began with a period of study in the United States with the intention of acquiring a greater *overstanding* of *self*. My studio work was quite abstract prior to my departure and more about the formal factors of picture making (line, form, colour, etc.). To my disgust, I uncovered conclusive facts that were to change the life of that nineteen-year-old romantic bohemian artist who was called Paul Duffus at the time.

'Nigger to Nubian' came at quite a prophetic time in my creative development. I returned to Britain more affluent and confident intellectually and spiritually. The phonetics of language and history became the backbone of my prophetic creations. Also influential was rap music with its lyrical content, its dexterity and appeal, to guide the disenchanted Nubian souls. I began to contextualize the notion of what a *nigger* is (used commonly in rap) and then to equate it to this new form of descriptor discovered on my journey – *Nubian*.

Nigger – what I was, was not in the least concerned with the socio-political and economical positioning of *Nubians* in this culture. (All men are equal, prejudice doesn't exist and Black activists have a chip on the shoulder, etc.)

Nubian – was a professional practitioner armed with historical *overstanding*, utilizing iconography to disrupt and destroy historical bureaucracy that has kept a people mentally dormant for centuries. By embracing and propagating a new definition of Blackness, this gives my people a geography denied (Nubia) and a skin definition – Buni (Arabic for brown) – thus evoking a sense of pride and resilience in ourselves.

MS: I have had conversations with several people about the content of some of your work. What I think concerns many people is the potency of the opposition you portray. The image of the pig's head on the Union Jack for example caused a few problems for a major London gallery. Do you think people and curators in particular have problems getting past a superficial reading of your work?

FA: Good curators have no problem with my work. It's only imbeciles who are in it for

Figure 18.2 Faisal Abdu' Allah, *I Wanna Kill Sam Coz He Ain't My Motherfuckin' Uncle* (1994)
Source: Courtesy of Faisal Abdu' Allah

Figure 18.3 Faisal Abdu' Allah, *The Last Supper*, 1
Source: Courtesy of Faisal Abdu' Allah

Figure 18.4 Faisal Abdu' Allah, *The Last Supper, 2*
Source: Courtesy of Faisal Abdu' Allah

financial gain who have a problem getting past superficial readings. They have no knowledge of our history and the atrocities inflicted upon us. As a Nubian living in the west, I have seen the need to adopt to the practice of reading literatures foreign to my way of thinking. Curators can do likewise by learning about us.

I am opposed to why the *nigger* sidekick always dies in the movies. I am opposed to Benetton, British Airways and Marlboro advertisements. I am opposed to television adverts and soaps that merely include Black faces for political correctness.

There is no opposition in the works that I produce. They're simply a portrayal of the *real*. But then we all know that the truth always causes offence. In our colourful past, a number of *house niggers* have softshoed and smiled their way into our hearts, creating a behavioural mode we're all supposed to conform to. If conduct is an issue then I'm opposed to media stereotyping . It is incumbent upon me as a practitioner to portray Nubian people in so many different narratives that it desensitizes the public's preconceived notion of who we are.

MS: The 'Scientists of Sound' are a group of US rap artists who seem to have had a great influence on you.

FA: I had the good fortune of meeting the 'Grave Diggers', who portray a nonsense image to the media. These guys are serious centres of information who disseminate it on a *need to teach* basis. They have seen the need to ground themselves intellectually within the scientific facts of the universe, embracing the arts, science, mathematics, religion and philosophy. With so many rap icons of our time not practising what they preach, the scientists serve as political assassins who *testify* and *inspire* their listeners.

MS: Is it fair to say that your work is only grounded in racial dynamics? Do you ever feel you are in danger of having a rather banneristic approach to art?

FA: In the past I have been accused of being an angry, racially motivated artist. In hindsight, my inability then to make a defence about the dynamics of my work always kept me quiet. To say that my work is only grounded in racial dynamics is far too simplistic. It creates a veneer of intellectual miasma that critics can hide behind, so as not to expose their own insecurities. That charge is not so much about race as about control. My work is truly inspired by my interaction with the world as I see it. The only banner I'm flying is, *this nigger's keeping it real*.

MS: Some of your work has addressed the past. Looking ahead, no one can obviously predict the future, but I'm always curious to know where artists ideally see themselves ending up. Do you have an ultimate agenda?

FA: My agenda is, firstly, the commodification of the visual and audio sound of Blackness which embraces science, philosophy, religion and politics and, secondly, to establish an institute of information which documents the story of my people, utilizing my work as a source. When the Nubian man and woman comprehensively *overstand* the history, science and mathematics of themselves, then we would have rediscovered our goal.

MS: You recently completed a commission for Stonebridge Adventure Playground (1997) in north-west London. Tell us about the ideas that informed the work.

FA: I was commissioned by Harlesden City Challenge to create a public art piece for an adventure playground. It came at quite an interesting time because a number of works had already been commissioned around the Brent area. I was inspired to

Figure 18.5 Faisal Abdu' Allah, *Prophesy*
Source: Courtesy of Faisal Abdu' Allah

create a piece that reflected the aspirations of the people involved. I decided to create portraits of the children that attended the playground, portraying the photographs as if they had taken the pictures themselves.

Each photograph was blown up to approximately two metres square with a full-length landscape shot of the entire group. This took three large panels to display. I then lined the panels up against the walls of the playground, transforming the entire space. The photographs elevated the self-esteem of the models as they invited their parents and friends to view their immortal existence.

MS: I have noticed that your work is becoming increasingly influenced by African philosophical concepts. For instance, in the exhibition, *Out of the Blue* at the Gallery of Modern Art in Glasgow (July 1997), you used the image of the tetrahedron, which, as Robert Beckford pointed out in his essay published in the catalogue,

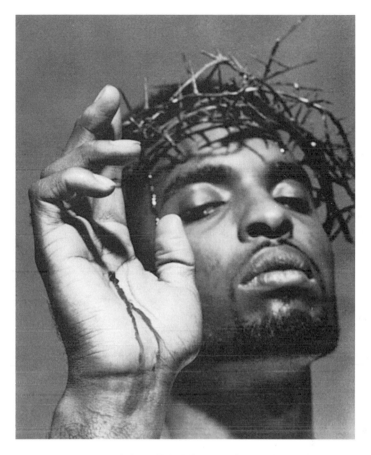

Figure 18.6 Faisal Abdu' Allah, *The Struggle is Ordained*
Source: Courtesy of Faisal Abdu' Allah

represents 'the totality of human experiences'. Is this how you see your work progressing?

FA: The human mind suffers from a condition of selective memory. Geometry has always been an integral part of my work, a vehicle for me to express my *overstanding* of geophysics. The only assumption I make about the progress of my work is that it comprises two elements – concept and construction, as for example, *Last Supper* (Figures 18.3–4) – concept, *Silent Witness* – construction.

All of my work is governed by the mathematics of the number nine, nineteen and the science of the tetrahedron – the highest of all spiritual powers activated through nature and the hormones. Nine to the ninth power of nine is the highest of supreme mathematics similar to the number nineteen which governs the Holy Qur'an. And the science of the tetrahedron governs the universe.

Note

The original interview was commissioned and published by the Chiltern Sculpture Trust.

A JOURNEY FROM THE COLD
Rethinking Black film-making in Britain

Imruh Bakari

Towards new approaches

The recognition of Black[1] film-making in Britain and the associated notion of a Black British cinema is a phenomenon of the 1980s. During that decade, the politics of race and ethnicity, of diversity and difference, emerged as signifiers of the ways in which Britain had to confront its colonial and imperialist history. Before 1980, Black film-making in Britain existed on the periphery of both the 'mainstream' and the 'independent sector'. The pioneering careers of Edric Connor and Lloyd Reckord (*Ten Bob in Winter*, 1963) were short-lived. Lionel Ngakane, who made *Jemima and Johnny* (1964), was not able to make another film as a 'British' director.[2] Horace Ove, who made his first film, *The Art of the Needle*, in 1966 is the only film-maker of that generation to continue making films.[3]

This, however, does not mean that Black images have been absent from British film and television. As Jim Pines suggests, a certain kind of 'white insider' has always ensured the existence of a Black presence.[4] Though important changes have occurred over the years, this phenomenon is indicative of the institutional relationships which have helped to define Black British cinema in the 1980s, in the context of an evolving politics of race in British society.

Significantly, the parameters of the institutionalized discourse on race relations have set the agenda for the critical approaches to Black film-making. By 1988, a paradoxical situation was apparent. As Judith Wiliamson noted,[5] in contrast to the mainstream indifference to films by African Caribbean and Asian film-makers, there was a tendency among those who subscribed to 'oppositional cultural theory' to celebrate uncritically those films that could be accommodated within their orthodoxies. These, she argues, are 'as rigid as the orthodoxies of the dominant cinematic practice we're meant to be against'.[6] As a result, the development of a critical approach to Black British film-making has been significantly inhibited and narrowed in favour of those discourses that reinforced the preferred 'evaluative criteria'.[7] Williamson refers to this as the '*Screen* theory', which crudely suggests the following dichotomy: 'Realist, narrative mainstream cinema – *bad*; non-narrative, difficult, even boring, oppositional cinema – *good*'.[8]

Judith Williamson's intervention at the ICA's Black Film/British Cinema conference in 1988 indicated an important attempt to reclaim a meaningful critical perspective. In pursuing this objective, she went into some detail to argue for an approach that

engaged with the politics of oppositional film-making itself. Her stated principle factor was that 'audiences do matter'.[9] Two years earlier at the Third Cinema conference held at the Edinburgh International Film Festival in 1986, Black film-making in Britain was introduced by way of a contentious debate regarding the notion of 'community' and how this was perceived in relation to the role of film-makers.[10]

Postwar influences

Particularly since the Second World War, Black people have made a significant impact on British political life and contemporary culture. In films such as *Sapphire* (Basil Dearden, 1959) and *Flame in the Streets* (Roy Baker, 1961), however, they have been depicted as intrusive and disruptive. An alternative perception frames them as transgressive, oppositional and subcultural. This partly responds to the idea that the existence and the participation of Black people in British society is an issue of contention and, sometimes, systematic denial. Here, the underlying influences of subcultural and postmodern theory are apparent with references to associated notions of 'cultural fragmentation' and 'displaced selfhood'.[11]

These notions have been used principally to privilege the idea of a Black British identity and related cinema in terms of an African Caribbean discourse. Consequently, the tendency has been to marginalize, if not to deny, the existence of an Asian dimension.[12] This is partly the failure to come to terms with the distinct and influential Asian experience of cinema and its diasporic dimensions.

Unlike the African Caribbean community, Asians have a long and established legacy of self-representation, industry and art in cinema. The Hindi cinema and film industry has no equivalent within African Caribbean cultures. Equally, the traditions of independent film-making evident in Satyajit Ray, Guru Dutt, Ritwick Ghatak for example, though comparable to more recent developments in Africa and the Caribbean, remain specific to the institutionalized cinematic experience of Asian peoples. This difference which is often masked by the term *black* is of significance in developing a critical perspective on the complex and varied artistic choices made by Black film-makers, and the responses of Black audiences (in particular) to their films and television programmes.

The Asian experience invites a critical perspective which questions the reductive debates around the core of ideas of diaspora and hybridity, and the notion of identity. These debates, in relation to African Caribbean people, tend to be approached in terms of loss or a lack rooted in the experience of slavery. But as Gurinda Chadha's film *Bhaji on the Beach* (1993) suggests, the project of Black film-making in Britain is not simply about the contestation of Britishness but equally about the diversity and intrinsic dynamic that constitutes an Asian, or indeed an African-Caribbean identity.

A decade after the ICA conference, the workshop sector within which most Black British films were produced during the 1980s has ceased to exist and the orthodoxies have proved to be unsustainable. Currently, the British film and media industry appears to have reinvented itself almost overnight with the relatively secure base of finance from the National Lottery. However, within the new institutional arrangements and thinking there is a distinct absence of any meaningful perspective on Black film-making. Has Black film-making been democratically incorporated into the general notion of British films, or is there a new politics of marginalization? Considering the current state of arts

and media policy, an anticipated response seems to suggest the latter. This needs to be addressed, and within a critical reappraisal that takes on board both the question of independent film-making and the wider concerns about Black film-making. In effect, the dominant ideas of the 1980s have proved to be inadequate in developing a critical understanding of the political economy within which Black film-making has to exist.

Lola Young suggests a summary of these concerns when she writes:

> Questions of audience are marginalized from much theoretical work on Black film, so the matter of pleasure and identification become peripheral: there is also the question of mainstream popular cinema and Black audiences' relation to that, not to mention televisual forms.

She goes on to emphasize that:

> The material conditions in which films are produced also need to be considered, not as apologies for poor work but in order to be able to understand adequately how a text acquires meaning in the context in which it is produced and consumed.[13]

Significantly too, Black film-making has brought into sharp focus strategic notions related to the politics of the media in British society over the decades: notions of 'independence' , 'representation' and 'diaspora'.

Deconstructing diaspora

Stuart Hall's definition of the term *diaspora*,[14] which has become a core concept within Black British cultural debate, is in need of radical reassessment and redefinition. In contemporary times, *diaspora* has come to define the condition of any people globally dispersed or scattered. It has gained particular significance in reference to the ethnic or national identities which have been globalized in the processes of movement and migration ostensibly linked to the expansion of capitalism. Most prominent here are the experiences of African peoples forged by their encounter with Europe and, in effect, modernity. While a multiplicity of diasporas may be acknowledged, the African diaspora is regarded as an archetype of the modernist notion signifying dislocation, syncretism and hybridity.

For Hall, the Caribbean as part of the 'New World' (*Présence Americaine*) is the primordial 'beginning of diaspora – of diversity, of hybridity and difference'. 'Présence Americaine' is theorized as the site of this disjunctive reality, a 'terra incognita' within which the native Caribbean inhabitance does not exist, and the 'Afro-Caribbean' is the homogeneous signifier of the 'new world'. Hence diaspora becomes synonymous with 'Black', and 'diaspora aesthetic' with an 'Afro-Caribbean' dislocated identity. The implicit logic of this paradigm of hybridity and difference rests on the first pillar – 'présence Africaine', which is 'silenced beyond memory by the power of the experience of slavery'. In other words, Africa as 'the site of the repressed' is relegated to a static otherness outside of history. Diaspora is consequently aligned with modernity whilst Africa is regarded as a homogeneous (primitive) presence which has been 'silenced' and de-historicized.

Hall's notion of 'présence Africaine' serves to legitimize the second pillar in his paradigm, 'Présence Europeane', which is constructed as a homogeneous and omnipotent antithesis to the mythological and effectively lost 'Présence Africaine'. Diaspora is therefore defined by 'the recognition of a necessary heterogeneity and diversity; by a concept of "identity" which lives with and through, not despite difference; by hybridity. Diaspora identities are those which are constantly producing and reproducing themselves anew, through transformation and difference', writes Hall.[15] From this perspective the process of diaspora identity is motivated by a sense of loss or indeed a 'lack'. For the Black film-maker in Britain this post-colonial and postmodern experience has been theorized in terms of a 'diaspora aesthetic'.[16]

Racial conflict in British cinema, writes Young,[17] 'often provides a backdrop against which the main protagonists work out their emotional, sexual or social relationships'. Similarly in Black British films, the 'Caribbean' and the 'immigrant' is often signified by quaintness or exoticism, a thing of the past which serves much the same function. In *Dreaming Rivers* (Martina Attille, 1988), for example, the narrative centres on an archetypal African-Caribbean mother who is visited on her deathbed by her three children who typify the ethnic diversity of the African-Caribbean community. The children are, however, concerned with debating their own identities and the relevance of the heritage symbolized by the mother. The mother has to enact the process of her own rite of passage while the children are otherwise preoccupied.

The film's discourse suggests a necessary negation of the Caribbean (and Africa) in the construction of an assumed unique 'Black British' identity. Both *Pressure* (Horace Ove, 1974) and *The Passion of Remembrance* (Isaac Julien, 1986) also provide examples of the sense of 'lack' in the notion of a Black British identity. This is signified in the generational conflicts which these films depict. *Dreaming Rivers* and *The Passion of Remembrance* in particular, depict a strong sense of a 'British' identity constructed through alienation and in opposition to a Caribbean 'other' with nothing to pass on. In the case of *Dreaming Rivers* 'we can infer, through the mise-en-scene, that the subjects, the young people, are reacting to the object, the mother, as a corpse'.[18] A comparable discourse is evident in relation to the Asian experience in *Majdhar* (1984) where the idea of a secularized modern identity is privileged in opposition to notions of a fundamentalist tradition.

In the case of African Caribbeans, diaspora is rendered as a postmodern notion constructed to counter the essentialist or absolutist notions propagated by certain 'Black nationalists'. These nationalist ideas fall generally in the frame of some 'Afrocentric' theory in which Africa is imagined as a primordial location with a noble past violated by waves of invasion over centuries.[19] Both Hall and the Afrocentric approach fail to recognize that the notion of Africa is a modern invention,[20] and that African identities are in themselves hybrids. There is the equally significant omission that migration has played, and continues to play, a formative role in the narratives of identity which define African ethnicities.

Welcome II the Terrordome (Ngozi Onwourah, 1994) is probably the most obvious example of a counter perspective to Hall's idea of diaspora. In contrast to the paradigm in which the defining principle is signified as 'slavery', this film locates the defining moment of diaspora at the juncture of refusal depicted in the opening sequence. Here a group of chained captive Africans are brought face to face with the slavocratic Europeans at that border territory, the beach. The moment of slavery should be the

next logical stage in the narrative, but it does not happen. Instead the captives refuse to be integrated into the slave regime and instead choose a redemptive path, walking back into the sea. It is an act of resistance which sets in motion a set of processes through which the diaspora experience is played out in what might be termed a politics of 'fulfilment' and 'transfiguration'.[21] Diaspora in this construction becomes not simply a notion of 'Caribbean' hybridity but part of the continuum of African subjectivity, at the historic moment of its encounter with modernity. *Welcome II the Terrordome* is therefore as much a 'Black British' film as it is an 'African' (or a Nigerian or an Ibo) film.

Hall's notion of diaspora, however, informs much of the writing on Black British film-making, which is preoccupied with 'the experience of cultural fragmentation and displaced selfhood'.[22] The challenge therefore is to engage with the new ways in which the idea of diaspora has been reconstructed and reformulated incorporating notions of 'tradition' and 'memory'.[23] The core idea in pursuing this challenge is an understanding that all cultures, traditional, primitive, modern, or postmodern, are hybrids forged through syncretism, regardless of the ways in which their identities may be imagined at any particular historical moment.

Traditions of independence

The idea of 'independent' film-making is also of paramount importance to any notion of Black film-making in Britain. The ways in which this idea has been understood and mobilized as a critical practice provide the framework for assessing both the films produced and the debates around these films. A number of issues need to be addressed relating to, first, Black film-making in the context of the film and media industry; second, the films as part of changing ideological formations; and, third, the films as part of the wider debates around film aesthetics and film form.

In Britain the left-wing films of the 1930s and the Free Cinema movement of the 1950s loosely suggest a specific British independent cinema tradition.[24] Particularly since the 1960s, an institutional framework has been provided by a number of organizations. The British Film Institute (BFI), founded in 1933 principally to encourage the development, study and appreciation of film and later television, and the Independent Filmmakers Association (IFA), formed in 1974, can be seen to have played formative roles. The IFA provided an arena for debate, and helped to institutionalize a notion of independent film-making as part of the wider political and ideological response to the 'economic changes and the social policies of the post-war years'.[25] At the core of this response was the idea of the 'workshop', implicitly a subsidized space where there would be access to facilities and equipment for alternative work practices, viewing and debates unhindered by the demands of the industry.[26]

Parallel to this tradition of independence is another, expressed through the Black experience of anti-colonial struggles for national independence in the Caribbean, Africa and Asia. These struggles provided a discourse for the political and cultural activism of 'immigrant' communities in Britain in the process of pursuing social justice and a social identity. In Britain, one focus for this tendency was the Caribbean Artist Movement (CAM). Between 1966 and 1972, CAM provided a forum for artists mainly from the Caribbean, who began to engage with the modern predicament of the 'Caribbean' people and the expression of their diaspora experience.[27]

It is in this sense that the individuals involved became 'part of a wider movement for change in Caribbean society', and a significant definer of African Caribbean cultural activity in Britain particularly up to 1982. This activity was motivated by a sense that the 'power' of the artist was somehow linked to the power of the 'community'.[28] CAM undoubtedly signified the mood within which Black arts and cultural activity emerged as an entity within British cultural life in the 1970s. As a catalyst for the influential report by Naseem Khan, *The Arts Britain Ignores* (1976), CAM can also be seen as having an influence in significantly opening up the debate concerning the role of Black arts, and the relationship between Black artists and the 'mainstream'. This debate reflected an awareness of the institutional demands that compromised Black arts. However, while CAM influenced significant developments in Black publishing in Britain, it provided no institutional framework for the development of Black film-making.

By the 1980s, the idea of Black arts had been subsumed within the race relations industry through the rhetoric of terms like 'ethnic minority' and 'multicultural' arts. This ideological approach set the agenda for the way in which both African Caribbean and Asian cultural products were to be regarded. The debates around Black film-making therefore were located in terms of Black arts and their 'subordination to the dominant British culture', and equally their separation and dislocation from Africa, the Caribbean and Asia.[29] Within this mindset, stereotypes concerning 'Blackness' and 'Asianness' were invoked along with categories like 'Black British', which in film and television functioned to define and determine the acceptable Black media presence.[30]

Channel 4 Television (C4) began broadcasting in 1982. This company was also a product of the 1970s. Its launch signalled a new era in British film and television, one which redefined the relationships within the media industry. It also signalled the era in which the issue of the Black presence in Britain – its role and its representation – was brought into the mainstream of media debates. It can also be argued that C4 instituted a notion of independence as a structured hierarchy which differentiated the independent film-maker or producer or company from the workshop. With this came the idea of a 'Black British cinema', made urgent by the urban uprisings by the Black underclass in British cities from the mid-1970s to the early 1980s. It was, however, a cinema located around the privileged and often exclusive London-based workshops which came to be regarded as the *de facto* appropriate site designated by the media industry.

The effective instrument of this arrangement was the Grant-Aided Workshops Production Declaration (1982). The 'independence' instituted by the Workshop Declaration and Channel 4's commissioning mode had a definitive influence on the idea of a Black British cinema. Since this independence emerged as it did within the ideological climate of Thatcherism,[31] certain films acquired significant political capital as part of an oppositional strategy. The public debate between Stuart Hall and Salman Rushdie on *Handsworth Songs*[32] is therefore an indicator of a wider debate concerning the idea of independent film-making and a politics which problematizes its relationship with the mainstream on the one hand, and with audiences on the other.

Rushdie challenges the uncritical acclaim given to the film. He alludes to the way in which a dominant dislocated voice is privileged in contrast to the obvious absence of the multiplicity of voices which make up the Handsworth (Black) community. 'We don't hear Handsworth's songs', he says.[33] Hall's position is in support of a 'struggle which [the film] represents, to find a new language'.[34] For Hall, the central concern is

the quest for a 'new language' which articulates 'the Black experience as an English experience'.[35] Rushdie's position suggests the futility of this preoccupation when the 'living world' of Handsworth is ignored or silenced.[36]

At the level of critical practice, this debate suggests some of the major failings of British independent film-making that have been uncritically incorporated into the theorizing of Black British cinema.[37] This would extend to the absence of a perspective on the traditions of independence and spectatorship in Asian cinema, and the failure to discuss adequately those African Caribbean films which were dismissed as 'realist' texts: *Jemima and Johnny* (1966), *Pressure* (1974) 'banned for about three years',[38] *Burning an Illusion* (Menelik Shabazz, 1981), *Playing Away* (Horace Ove, 1986), *Big George is Dead* (Henry Martin, 1987), for example. The debate also implicitly calls into question the 'anti-essentialist interventions' in support of avant-garde, non-realist or dialogic films, which should, as Young writes, 'provide more insight than those which exclusively privilege class, "race", gender, or sexual orientation because they avoid the fixity of monolithic essentializing critical discourses, and are able to analyse the interconnections and "dialogic strategies" '.[39]

Framing representation

The Rushdie/Hall debate brings into critical focus the radical claims that can be made for any film in the Black British cinema. The debate frames both the ideas of a politics of representation and the 'burden of representation' as discussed by Mercer.[40] These issues are of significance in developing a critical perspective on the work of Black film-makers, and as an indication of the ways in which the African Caribbean and Asian experiences have been negotiated in British society. Representation in film asks questions about production, and equally about the conditions of exhibition and the reception of film texts. The central issue concerns the ways in which audiences are engaged and affected by particular images in the act or process of looking.

Within the history of cinema, 'scientific' notions of race and ethnicity have given legitimacy to certain kinds of images as representations of Black peoples, and have privileged a particular way of looking at these images. These tendencies have come into play through accepted notions of order and rationality framed by colonialism and the imperialist projects of anthropology and ethnography. Many images constructed here became the stereotypes that fed into the first vocabulary of blackness. It can be argued that in the formative years of the 1930s British cinema, as differentiated from Hollywood, was defined through the depiction of a Britishness which was national in terms of class and global in terms of race.

Films like *Sanders of the River* (Alexander Korda, 1935) and *The Drum* (Zoltan Korda, 1938) may stress the primitive and the exotic, whilst others like *The Proud Valley* (Penrose Tennyson, 1940) and *Men of Two Worlds* (Thorold Dickenson, 1946) are reflective of a humanist tendency. In social-realist films like *Sapphire* (1959) and *Flame in the Streets* (1961), the depiction of Blackness conforms to the notion of a socially disruptive presence. In an avant-garde film like *Leo the Last* (John Boorman, 1969) there is a more complex, and possibly radical depiction. All these films however, privileged a way of looking, a certain colonial and imperialist gaze which has determined the dominant discourse on the Black experience. They frame the Black presence in Britain

in a subordinate and dehistoricized structural location in relation to the white subject and society. The representation of Black people is not simply racist but a complex discourse of power and ideology.

The idea of a Black British cinema as a counter-discourse to this dominant regime is obliged to engage with the central question of 'how might Black film-makers problematize the look and its significance as an indication of differential access to the power to define'.[41] The situation presents its own complexities. Here again, the fundamental distinction between the African Caribbean and the Asian experiences is important. In each case, the respective historical experience of having 'access to the power to define', and in turn of 'looking', is of critical significance.

The diverse historical locations of cultural identity are also as important as the consideration of ethnicity, class, and gender within contemporary British society. The politics of representation therefore involves a number of complex processes which impact upon both the production and the consumption of images. Hence, the notion of the 'burden of representation' signifies another dimension of this politics. It concerns the role of the film-maker to produce texts around which aesthetic and political debates can be engaged. This suggests wider issues concerning the subject position of the film-maker and the claims they make for the text.

In the final analysis, questions have to be asked about theoretical perspectives which imply a dubious convergence of the 'postmodern' and the 'postcolonial'. Is Black British film, as a diaspora cinema, simply a 'cinema of appearances';[42] or are cinematic representations indicative of a more complex diversity of hierarchies, subjectivities and histories within which the politics of representation as depiction and the politics of representation as delegation or substitution are inextricably bound?

Notes

1 The term 'Black' is used here inclusively to indicate African Caribbean and Asian communities. For specific reference the terms African Caribbean or Asian are used.
2 See Jim Pines, *Black and White in Colour* (London: BFI, 1992); also Stephen Bourne, *Black in the British Frame* (London: Cassell, 1998).
3 Pines, *Black and White*: 121–31.
4 Ibid., 10.
5 Judith Williamson, 'Two Kinds of Otherness: Black Film and the Avant Garde' (ed.), in Kobena Mercer *Black Film British Cinema* (London: ICA Documents 7, 1988).
6 Ibid.
7 See Kobena Mercer, 'Diaspora Culture and the Dialogic Imagination: The Aesthetics of Black Independent Film in Britain', in Mercer *Welcome to the Jungle* (London: Routledge, 1994); see also Mbye Cham and Claire Andrade-Watkins, *Blackframes* (Cambridge, Mass.: MIT Press, 1988). Lola Young, *Fear of the Dark* (London: Routledge, 1996) provides a critique of Mercer's approach with particular reference to *Burning an Illusion* (p. 157).
8 Williamson, 'Two Kinds of Otherness'.
9 Ibid.
10 See Jim Pines and Paul Willemen, *Questions of Third Cinema* (London: BFI, 1989); Clyde Taylor, 'Quick Takes From Edinburgh', *Black Film Review* (fall 1986); David Will, 'Edinburgh Film Festival, 1986', *Framework* 32/33 (1986); Michael Chanan, 'The Changing Geography of Third Cinema', *Screen* 38, 4 (Winter 1997).
11 Mercer, *Black Film*: 5.
12 See Parminder Dhillon-Kashyap, 'Locating the Asian Experience', *Screen* 29, 4 (1988); Sarita Malik, 'Beyond "The Cinema in Duty"? The Pleasures of Hybridity: Black British Film in

the 1980s and 1990s', in Andrew Higson (ed.), *Dissolving Views: Key Writings on British Cinema* (London: Cassell, 1996); *Black Film Bulletin* 2, 3 (Autumn 1994), 'Navigations – Asian Diaspora Issue'; Avtar Brah, *Cartographies of Diaspora* (London: Routledge, 1996).

13 Young, *Fear of the Dark*: 191.
14 Stuart Hall, 'Cultural Identity and Diaspora', in Jonathan Rutherford (ed.) *Identity* (London: Lawrence & Wishart, 1990; also published as 'Cultural Identity and Cinematic Representation' in Mbye Cham (ed.) *Ex-Iles* (Trenton: Africa World Press, Inc., 1992).
15 Hall, 'Cultural Identity'.
16 Ibid.; see also Mercer, *Black Film*, and Mercer, 'Diaspora Culture'.
17 Young, *Fear of the Dark*: 184.
18 See Manthia Diawara, 'The Nature of Mother in *Dreaming Rivers*', *Third Text* 13 (1990/1): 76.
19 See for example Chancellor Williams, *The Destruction of Black Civilisation* (Chicago: Third World Press, 1974).
20 See V. Y. Mudimbe *The Invention of Africa* (Bloomington: Indiana University Press, 1988).
21 See Paul Gilroy, 'It Aint Where You're From, It's Where You're At . . . The Dialectics of Diasporic Identification', *Third Text* 13 (1990/1).
22 Mercer, *Black Film*: 5.
23 See Gilroy, *The Black Atlantic* (London: Verso, 1993); Gilroy *There Aint't No Black in the Union Jack: The Cultural Politics of Race and Nation* (London: Hutchinson); Brah, *Cartographies*; Teshome Gabriel, 'Third Cinema as Guardian of Popular Memory' in Pines and Willemen *Questions of Third Cinema*; Gabriel, 'Ruin and the Other: Towards a Language of Memory', in H. Naficy and T. Gabriel, *Otherness and the Media* (Chur: Harwood Academic Publishers, 1993); Imruh Bakari, 'Memory and Identity in Caribbean Cinema', *New Formations* 30 (1997).
24 See Sylvia Harvey 'The "Other Cinema" in Britain: Unfinished Business in Oppositional and Independent Film, 1929–1984' in Charles Barr (ed.), *All Our Yesterdays – 90 Years of British Cinemas* (London: BFI, 1986); and Sheila Whitaker, 'Declaration of Independence', in C. Auty and N. Roddick (eds), *British Cinema Now* (London: BFI, 1985).
25 Harvey in Barr, *All Our Yesterdays*: 236.
26 Ibid., 237.
27 See Anne Walmsley, *The Caribbean Artists Movement, 1966–1972: A Literary and Cultural History* (London: New Beacon Books, 1992).
28 Ibid., 306. Kamau Brathwaite is quoted in reference to the relationship between CAM artists and the 'community'.
29 See Kwesi Owusu, *The Struggle for Black Arts in Britain* (London: Comedia, 1986): 47–66.
30 See Paul Gilroy, 'C4 – Bridgehead or Bantustan?', *Screen* 24, 4–5 (1983).
31 See Lester Friedman, *British Cinema and Thatcherism* (London: UCL Press, 1993).
32 See Mercer, 'Songs Doesn't Know the Score', in *Black Film*: 16–18. Salman Rushdie, *The Guardian*, 12 January 1987.
33 Ibid.
34 Ibid.
35 Ibid.
36 The issues raised by the virtual banning of *The Peoples' Account* (1986) by the Independent Broadcasting Authority adds an important dimension to this debate. See Mercer, *Black Film*: 58–9.
37 For a critical assessment of British 'independents' see Sheila Whitaker, 'Declaration of Independence' in Auty and Roddick, *British Cinema Now*.
38 Pines, *Black and White*: 124.
39 Young, *Fear of the Dark*: 188.
40 See Kobena Mercer, 'Black Art and the Burden of Representation', in Mercer, 'Diaspora Culture'; also in *Third Text* 10 (1990).
41 Young, *Fear of the Dark*: 132.
42 Reece Auguiste in Pines and Willemen, *Questions of Third Cinema*: 216.

20

BLACK ART
A discussion with Eddie Chambers

Rasheed Araeen

RASHEED ARAEEN: Eddie, to begin with, thanks for coming over to have a chat together about various issues *vis-à-vis* black art. One of the reasons why I wanted to talk to you was the fact that you were perhaps the first person in Britain to use the term 'black art' in a definitive manner, in 1981, and since then you have been writing to explain what is black art. Your position has been consistent with your practice as a politically committed radical black artist.

It would be useful to start this conversation with your own definition of black art, but it would not be fair to ask you to clarify your position now. Perhaps I should start by explaining what I understand your position has been; and then you may respond to it.

Your perception of black art was within the political struggle of black people, here in Britain as well as abroad, which in the beginning was confined within the context of what you called pan-African connection. This was perhaps because you were committed to the pan-African struggle, and you worked with people who were of only African origin. But later you began to include Asians in your definition of 'black', while maintaining a radical political position.

It seems that your position has now become broad and eclectic, which is clear from the recent show you have curated, *Black Art: Plotting the Course*.[1] Am I right in my observation that your position has changed, so much so that you can now put together all black artists irrespective of the nature of their work?

EDDIE CHAMBERS: I think, to a certain degree, yes. Between 1981 and 1985 I was involved with other artists who were of Afro-Caribbean origin, but later I began to work with Asian artists as well. But I'm not sure if my definition of black art has changed. What has happened is that I have become aware of other definitions, and I now respect other positions as well. You have to take on board other people's realities, you know, other people's perceptions even when they are different from your own. I realized that there were other definitions of Black art which did not correspond to my own early definition, and there was no question of a confrontation of ideologies or positions. I'm now quite happy with this change, working with all artists of both Asian and Afro-Caribbean origin.

RA: This takes us back to the early definition of 'black art', which was located historically as a movement *vis-à-vis* black struggle. How would you define black art now within the present context?

239

EC: I would define Black art as art produced by black people largely and specially for the black audience, and which, in terms of its content, addresses black experience. It deals with in its totality the history of slavery, imperialism and racism, which affects the position of black people here in the West as well as other parts of the world – in the Americas, and in Africa itself. The function of Black art, as I saw it a few years ago, was to confront the white establishment for its racism, as much as to address the black community in its struggle for human equality. I think Black art has still that role to play.

RA: You have raised some important issues here, and one of them is the relationship between the black artist and the community. I agree with you that one of the functions of black art is to raise consciousness among the black community, but I don't see why it should limit itself to addressing black audiences only.

EC: The issue here is one of priorities, and I think the priority for the black artist is to address black people. Until we are in a position to talk to each other about our collective experiences, about our specific problems, I don't think we can jump the gun, or whatever, and begin to address the whole society. Having said that I'm aware that this creates problems in relation to gallery spaces or outlets which are run by white people, and thus you enter into a situation which perhaps is full of contradictions. I suppose if you are realistic and you are concerned with the black community, you need venues which are located within and recognized by our own community. I'm aware of all these problems, but we cannot escape our responsibility to the community.

RA: One of the concerns of black people in general, and the black artist in particular has been to struggle against marginalization. But if we are going to put black art in a specific category with specific and limited functions, don't you think we are ourselves marginalizing the role and function of the black artist in this society?

EC: No, I don't think so. Black art is about something specific and is different from art practice in general. It is difficult to compare it with anything else or to put it in a wider context, because its basic function is communication with black audiences. The issue of marginalization is something else. It is a different issue, and it should not be confused with the priority of Black art to build a bridge between the individual black artist and the community.

RA: But that is only one function of so-called black art, and I don't understand why you keep on insisting on that function. Why can't it rise above that function and also address the whole society? You cannot reduce art to only one specific function.

EC: Well, I think, that's probably where we differ in our views.

RA: If we perceive black art only in those terms, there is a danger of its being separated from the main body of this society. If black artists are going to address only the black community and white artists address white society, it seems to me to be a recipe for a cultural bantustan.

EC: I don't think so. The struggle to build a bridge between black artists and the black community is not an exclusive struggle. It does not exist at the expense of other things. I do recognize the validity of the struggle *vis-à-vis* white institutions. My own approach now, which may be pragmatic, in curating exhibitions is to place Black art in white gallery spaces. There is a kind of duality to the whole situation, but unfortunately there is no correlation between the two. It may be dangerous to

generalize, but the fact remains that the black community is not interested in what goes on in the mainstream galleries.

RA: Even then, I don't think it is a contradiction for black artists to seek access to these spaces, which to me are not necessarily white spaces. The institutions of this country must belong to all the people, and if they are dominated by whites only then it is the right of black artists to demand their share of the pie.

EC: I don't want to appear as if I'm dogmatic or pedantic, but I do think it's important to stress that art institutions in this country are very *white*, and it's not incidental that they are *white*. I do accept the argument that we should have access to the mainstream gallery spaces, but I don't underestimate the fact that they are white spaces because the whole structure is white.

RA: Are you then suggesting that we should have alternative institutions or organizations which are run by black people themselves?

EC: No, no, not necessarily, because it can be argued that the Black alternatives do not necessarily alter the situation. I have never asked for separate gallery spaces. In the past I did support the existence of some black galleries, but not any more. They did serve some useful purpose in terms of showing young Black artists who would have not otherwise been exposed, but that did not automatically lead to an improvement in the general situation. I'm critical of white institutions, but that does not mean that I'm in favour of separate Black organizations.

RA: To get back to the definition of black art, do you make a distinction between what you call 'Black art' and art produced by black artists in general?

EC: Definitely. I think the difference is fundamental. Not every Black artist produces Black art, and I used to castigate those artists who showed no interest in it. Now I don't.

RA: So you recognize that there are black artists who are not part of the black art movement, and their work should be looked at in accordance with the nature of the work.

EC: Definitely.

RA: So, that makes the definition of black art different from the category in which every artist of Afro-Asian origin is put in together by the general public as well as by the establishment – particularly by the funding bodies. However, it's still difficult to distinguish what is black art and what is not.

EC: Don't you think the difference is obvious?

RA: Theoretically, yes. In some cases the difference is obvious, particularly when the rhetoric of black struggle is explicitly expressed. But there are also artists who claim to be producing black art but it is not clear from their work.

EC: Then it is a misuse of the term.

RA: No, I don't think so. It's not just the question of 'a misuse of the term', but there are reasons which are complex and which make the young generation of black artists identify with black art. It seems that it also makes it easier for them to have access to some gallery spaces.

EC: I don't think that's necessarily the case.

RA: Let me put it differently. Maybe it's not correct to say that it makes it easier for them to find certain venues. But we cannot deny the fact that the black artist does have a sense of insecurity in this society, to say the least, and the identification with black art can make things easier, particularly when most of the funding is available

under the category of 'black art'. This is particularly true for the young generation of black artists. It's not a question of opportunism, but there are very few choices available.

EC: That may be so. But it can also be argued that the opposite is true. In fact, if you are ambitious you must keep away from the idea of Black art; and this is clear from the fact that those Black artists who have been successful in recent years do not like the term. If you look at their work, you would know why.

RA: I'm not saying they should. It must be up to the artists themselves to contextualize their work, and we should respect their position and look at their work within that context. But we must, at the same time, recognize that there exists a general perception which puts all the artists of Afro-Asian origin within the same category: if you are a black artist then you produce black art. The objective of the show *The Essential Black Art*[2] was to clarify this confusion. I distinguish black art on ideological and political grounds, but that does not mean that I believe in propaganda art. Political issues must be incorporated within the articulation or expression of other things which make the work of art a work of art, and this goes for those works which express anti-racist or anti-imperialist positions.

You know that there were nasty reviews of the show, which included a review by a black writer who accused me of misrepresenting black art because I had emphasized the fact that the basic context of black art was political. It emerged as part of black and Third World movements, and its specific formation (which is historical) should not be confused with other things. That's why we need a clarity about what we mean by black art; and if we take a broad or eclectic view of it we might also fall into the trap in which every black artist is thrown in the name of diversity and difference.

My real worry here is that your own position is moving towards a broader concept of black art in which it would be very difficult to distinguish between black art as a specific historical formation and the general category recognized and promoted by the establishment. In the catalogue essay of the show *Black Art: Plotting the Course*, which you recently selected and curated; you have taken this position. What is the nature of the shift here?

EC: What I tried to do in this exhibition was to go beyond what I thought to be the limitation of *The Essential Black Art*. My main objection to your view is that it was limited in terms of historical period, and you make no connection with Black Arts movement in America which to me is very important. I have argued that there is a definite link between what happened in America and subsequently in Britain, and the connection goes back to the Harlem Renaissance of the 1920s.

RA: I will take up later the questions of what you consider to be the influence in Britain of 'American Black Arts movement'. At the moment I want to stay with the issue of what you now consider to be black art. I'm particularly concerned with some of the works you have included in your exhibition, such as of Gurminder Sikand, John Lyons, Errol Lloyd, Shanti Thomas . . . , which present a problem for me. How am I to consider them as examples of black art?

I'm not saying that they are not good works of art. It's not the issue here. These works (reproduced here) give no indication of what you yourself would consider to be black art. When I look at *The Domino Players* by Errol Lloyd or *The Roti Maker* by Shanti Thomas, for example, what I see is the theme or subject of the way of life of

Figure 20.1 John Lyons, *My Mother Earth is Black Like Me* (1988)

African or Asian people. This is something which could have been painted by any artist, and there is a history of such themes being painted by white artists. How do you justify these works as black art?

EC: Firstly, I should make it clear that much of the premise on which *Black Art: Plotting the Course* exists centres on the notion that there is a wider constituency of artists whose practice criss-crosses the ideology of Black art. The artists you have mentioned are not necessarily the artists one would associate with Black art movement, but there are specific works by them with which I would have no problems in classifying as Black art.

RA: Let us look at *The Roti Maker* by Shanti Thomas (figure 20.2). It shows an Indian woman kneading dough before breadmaking. You have yourself often implied, if not asserted, that black art is the expression of a particular experience what we call black experience – an experience of black people living in a racist society or subjected to imperial domination. I don't see how the Indian way of breadmaking has anything to do with racism or imperialism.

EC: What you say is true. But that is not what *The Roti Maker* is about. I would argue that this painting is an expression of certain aspects of black experience. I should also make it clear here that Black art is not only about protest against racism or imperialism, but it can also be reflective of our existence as black people.

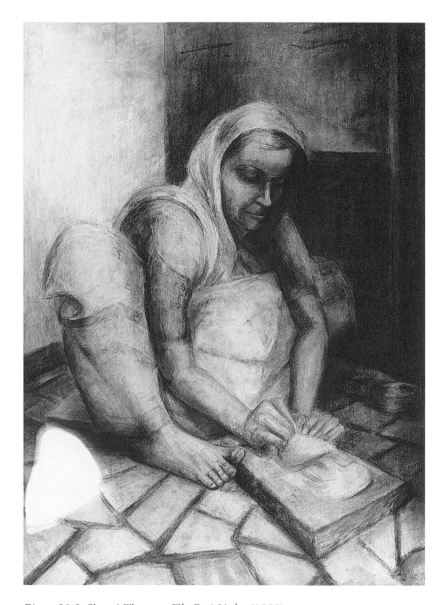

Figure 20.2 Shanti Thomas, *The Roti Maker* (1985)

RA: *Roti*-making has been done in the Indian subcontinent, as well as in the Middle East, from time immemorial, and it has very little to do with the experience of Western colonialism.

EC: You can say that apparently it has nothing to do with racism or imperialism. But I think it does have a lot to do with sustenance: who feeds and sustains the family, particularly in adverse circumstances? What Shanti Thomas is trying to say is that Indian woman is the provider, a fact which is often overlooked.

RA: I agree that the role of the woman in the sustenance of the family in our parts of

244

the world is extremely important. But I still don't see how this role has anything to do with black experience, even if we see it as a metaphor. My feeling is that you consider every activity or experience of peoples living in their own countries in Africa, Asia or the Caribbean, as black experience.

EC: Yes, definitely.

RA: But I have come across people even from Africa who on arrival in England were surprised that we here call ourselves black people; because their experience of living in their own countries had not been the same as we have in this country. How can we sitting here, define their experiences?

EC: Yes, but, who can deny the brutality of life of majority of people in Africa, Asia and the Caribbean.

RA: Nobody is denying that . . .

EC: That is exactly what the black experience is about.

RA: That may be so, if you are implying that the social condition of people in these parts of the world is the result of imperialism. Even then there are human experiences or social activities which are not formed by these conditions – and the Indian way of breadmaking is an example. This distinction is important if we are to understand the specificity of what we call black experience.

EC: Of course, I wouldn't disagree with you there.

RA: We have our own traditions still surviving in Asia and Africa, and even in many other parts of the world where Afro-Asian people live, and these traditions have very little to do with the experience of imperialism. These traditions exist today in music and dance, literature, painting, sculpture, etc. and they cannot be defined in the socio-historical context of black experience, which is of course global but with peculiarities specific to black peoples living in the Western Metropolis, unless these traditional art forms have undergone transformations resulting from this context.

EC: My position is based on the premise that whatever Black peoples do, wherever they are, is important. And it's important to see this in the overall context of the experience of black peoples. Let us take the example of the painting *The Domino Players* by Errol Lloyd (figure 20.3). It is about how West Indian men socialize among themselves; how they play domino; what domino means to them *vis-à-vis* the Caribbean experience. And the Caribbean experience is an important part of Black experience.

RA: So, in other words, a painting about white people playing darts in a pub would be an example of white art.

EC: Well, if it's painted by a white artist, I suppose it had to be.

RA: Why couldn't it be painted by a black artist? And if it was painted by a black artist would it become black art?

EC: Well, if it was really painted by a Black artist, I would approach it differently, expecting to find things there which would indicate more than just white people playing darts in the pub. I think the various works you have mentioned here are not just illustrations of some black themes or activity. They contain more than the objects or images you see . . .

RA: The next topic I would like to discuss with you is what is called 'Black aesthetics', a term which has been frequently used by Black American writers, but it has also been the concern of African and Afro-Caribbean intellectuals in postwar Britain. This term is now being used very frequently by almost everybody involved in the

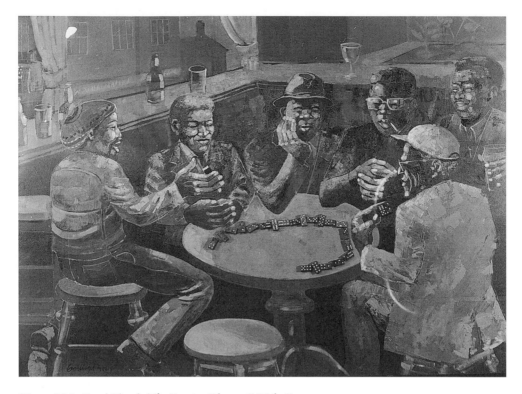

Figure 20.3 Errol Lloyd, *The Domino Players* (1986–8)

black arts scene here. You have yourself said many times in your writing on black art that one of the objectives of black art is to create black aesthetics. To be honest with you, I don't really understand what you mean by this.

EC: Perhaps the easiest way to understand this would be to imagine a visual equivalent of Black music. While listening to music, one can easily pick up if it is jazz, reggae or calypso. So in visual arts, our objective is to create what can be recognized as Black art forms, in the same way Black musical forms are reconizable. It is really to do with the development of a Black visual language with its own distinct features. As for its relationship with Black art, I must confess there is a lot of confusion around, which was evident in a seminar on Black aesthetics organized a few years ago by Creation for Liberation. Aubrey Williams gave a paper which was totally confused. So it's a term which is often used without an understanding.

RA: I think your example of jazz is very good, and this example has in fact been often used by black intellectuals to define what they understand by black aesthetics. I remember Tony Morrison once saying that she wanted to create literature which was distinguishably black like jazz. But is this really possible in the visual arts? I don't see any evidence of it yet, not even in the works of those who claim to be concerned with it.

If there is anything to learn from the history of jazz, then we must recognize that mere anti-racist rhetoric is not enough in the development of an artistic language. My understanding of the history of jazz is that it did not in its development reject

what was dominant music. While jazz has strong roots in African music, with all its specific structure and sensibility, it also made use of European traditions. It can be said that jazz is not African music,[3] even when it is produced by African people in diaspora. It was the black American experience which was important to the development of a specific musical form we know today to be jazz. The reason I'm making this point is because of its implication to our present situation *vis-à-vis* black visual arts. What is clear from this analogy is that concern for language is fundamental to the development of aesthetics. And when I look at the available examples of works of art which claim to be aiming at black aesthetics, I'm disappointed.

EC: This raises a number of questions, and the most important question is: is it possible to create something which can be called Black aesthetics? Black American writers and artists have been talking about it for decades, and here in Britain Keith Piper has been very concerned with the issues of Black aesthetics, but we have not reached anywhere near. It may be that it is not possible to create an art form as sophisticated as to be able to distinguish itself aesthetically from other prevailing art forms.

RA: The main problem seems to be of the dominant culture: how to approach it and deal with it. There are many who argue that this is a waste of time, and we should stick to doing our own things. This is understandable, given the nature of our relationship with the dominant culture, but can we really turn our back on it and create our own art forms by returning to African or Asian roots?

Historically speaking, we can refer to something which can be recognized as African aesthetics, and you can find this specifically in African sculpture as well as in music. Specific aesthetics also exist in Chinese, Indian, Islamic and pre-Columbian civilizations, but in most cases these specific formations or concepts took place before the expansion of Western culture. Our problem is very different today, in the context of Western culture casting shadow all over the world; and it's very difficult to ignore this shadow. My own view is that there is no need to run away from it (where to?), because it can be dealt with creatively and imaginatively; and only when we begin to deal with it critically, may we one day tumble upon something which may be recognizable as black aesthetics.

EC: There are many Black cultural practitioners, in literature, in music, visual arts, who do not have anything to do with the language or art forms of the dominant culture. They do not use the mode of expression of Western culture because they recognize that if they take on board the oppressor's language, they would be worst off. The language of the Western, dominant culture is inherently anti-black.

RA: Come on, Eddie, you can't make that statement. Of course the dominant language is dominant and it serves the purpose of the dominant culture. And I'm not suggesting that we should follow or imitate the dominant language. It's a question of critical deconstruction, so that the dominant language is changed in such a way that it can express our own condition. The dominant language of the visual arts, which is our main concern, is the dominant language of our time, and mere rhetoric against it is not enough. If you look at the work of those who have been speaking *against* using the forms of Western culture, you will find that they are in fact influenced by its radical tradition; and the obvious example is Keith Piper. I'm mentioning Keith Piper in a positive manner, because he has, to some extent, been able to deconstruct the dominant language to suit his purpose.

EC: Yes, I know it's very difficult given the fact that Western culture has penetrated every corner of the earth. It's difficult to imagine a situation in which an artist could produce something which is not influenced by Western art, and that's a very unhappy conclusion to come to. But I think there are attempts being made which deal with this situation critically, and an attempt to develop Black aesthetics is part of this whole thing.

RA: It's not really the question of being able to produce something which is not influenced by the dominant culture. There are still traditional practices which have nothing to do with it. But what is their function in relation to contemporary social experience? Can they, in their 'pure' forms, reflect this experience? I agree with you that it's not a happy situation when we think that we cannot avoid the dominance of the dominant culture; but at the same time an alternative which claims total detachment from it is not really a solution.

EC: The quest to develop Black aesthetics is not really based on the idea of a mere rejection of white culture. If we do reject white culture, it's only to increase communication between the Black artist and Black people, and that's important in the development of Black aesthetics. You can't deny the fact that there exists a gap between the black artists and the Black community, and that has to be bridged. You don't hear Black musicians talking about such problems, because there is no gap to fill. The question here is of communication and how to increase it.

RA: But that is a very complex and difficult problem. It's not just related to the question of black aesthetics, but the nature and function of art in capitalist society, and whatever we do we cannot avoid this context. What you are implying is that the dominant forms are elitist and do not address the need of the masses, and when these forms are adopted by a black artist it increases the communication gap in relation to the black community.

EC: That's a very important issue for us, and it can only be dealt with by the development of Black aesthetics.

RA: You mean to say that the relationship with the community is fundamental to black aesthetics.

EC: Yes, exactly. And that's why when Aubrey Williams talks about Black aesthetics I can't grasp anything, because the context he uses is very different.

RA: He might have articulated his views in such a way that they were not clear. But if you read his interview in *Third Text 2* you would recognize his passionate interest in black aesthetics, and just because his views are different we cannot dismiss him. Aubrey Williams's achievement as an artist is unique, and I wish I could say the same thing for many of the young black artists who spend so much time making noises against the establishment.

The ambition to create black aesthetics is of course laudable, and I'm very interested in the idea of a new visual language with its own distinguishable features. But I'm still not clear what it is. I know what it is in relation to jazz, but when I look at those contemporary art works which claim to be concerned with black aesthetics; I don't find anything there which would convince me of its presence or development. Perhaps I'm showing an impatience, because what we are talking about may take a long time to develop. But if we can't look for the results now, we should at least have some theoretical clarity.

Could we therefore discuss some of the works from D-MAX exhibition which

you initiated, and although you disassociated yourself from its final showing at the Photographers' Gallery, London, you did write a lengthy introduction in which you outlined its objectives:

> In terms of aesthetics, our second objective is to contribute to the development of something which could be referred to as a Black aesthetics in British photography. Here, the use of the word 'Black' does not particularly refer to the content of the photographs. After all, it could be argued that anthropological and sociological photographers such as John Reardon and Derek Bishton have, in their coffee-table effort 'Home Front', produced a form of 'Black' photography. Instead, the word Black refers to the photographers themselves, rather than images of Black people. In Britain at the moment, there is a sizeable number of Black photographers, but nothing exists that can visibly be identified as being a collectively-created Black aesthetic. One of the most positive aspects of this project is that it attempts to make these photographers more aware – creatively aware – of each other's existence.[4]

This is a confusing stuff, particularly when you say that the word 'Black' does not refer to the content of the photographs. My understanding had been that these photographs had been selected and legitimized as 'Black photography' not only because they were taken by black photographers but also their contents were about black life or experience. It is common sense to say that in the end we will have to look at the work, whatever it is meant to be about, or says.

EC: First thing to say here is that we should allow some scepticism about the notion of Black aesthetics, because there aren't any obvious examples that can be seen to clearly embody Black aesthetics. And I think that's where the problem lies. I admit that Black artists and photographers have not yet been able to move away from the dominant aesthetics. What I was therefore trying to do in the introductory essay was to outline an alternative programme. I thought that the first step towards this would be to gather Black photographers together, in order to generate regular discussions between them as well as to show them in the public venues. The first concern was how to deal with the negative or stereotype images of Black people in dominant photography, and that's what the D-MAX group has been doing.

I think a photographer like Vanly Burke, who uses the same camera, same lenses, same chemicals and paper, as white photographers, produces something which is very different, and some of the photographers in D-MAX exhibition were looking for similar results.

RA: We don't have Burke's photographs here, but let us look at the work of Marc Boothe whom you admire. Here is a photograph of a New York street with a young black boy in the foreground. Looking at this photograph, how do we know that it has been taken by a black photographer? You would perhaps accuse me of de-contextualizing the work not only in terms of isolating one work from the whole body of the artist's work as well as ignoring those questions which need to be taken into consideration while reading any work of art. But from the point of representation, is it possible to ignore the question I have asked? What I'm suggesting here is that this photograph could have been taken by a white photographer, because there

is a tradition of photography in which black people have been used as a subject. And I don't accept the general notion that black people have always been represented negatively or as stereotypes within this tradition.

EC: I think that there is some misunderstanding about what I was getting at in my essay. Obviously, it would be simplistic – and even stupid – to say that images of black people taken by white photographers would always be negative. You would remember that I was critical of the exhibition *Black Experience* organized in 1986 by the GLC, because most of the photographs in the exhibition were based on Black themes.

RA: But there were some good photographs . . .

EC: Yes, there were a few. But a large number of them were not positive at all. So it's not the case of saying that Black photographers necessarily create positive images of Black people. The issue is really very complex.

RA: But you have stressed the point that these photographs have been taken by black photographers, and your aim was to show them together, so that their work could be discussed publicly. Of course black photographers or artists must have a chance to show their work. But, in the end, we will have to look at the work itself in terms of what it says or represents, and only on this basis can we evaluate the work specifically and critically. Of course, the question of authorship is central to the evaluation and legitimization of works of art in our contemporary culture, and it's only in the case of white authorship that its position is guaranteed, both socially and historically. It's the invisibility of black historical subject that we are forced to construct our visibility as part of the process of making things. If we are making specific claims on the basis of black authorship then it seems that it has to be inscribed in the work. And that's perhaps the reason why the work of David A. Bailey and Ingrid Pollard looks interesting. However, this is not the end of the story, and the complex issue of black aesthetics remains unresolved.

What worries me, personally, is that we are making claims on a basis which does not yet exist; and we would perhaps end up promoting mediocre works – which is not an unusual situation in the black arts scene today. And to tell you the truth, I was very disappointed by the D-MAX exhibition. It's time we pay some attention to the question of quality.

EC: Perhaps you don't know that we had serious differences within the group, and not all the photographers agreed with my idea of Black aesthetics. What in fact I wanted to do was to give some political direction, but not all of them were interested in it.

RA: You have been very unhappy about the role of what you call white institutions. Who wouldn't be? You have in fact been writing about this, often with anger, particularly in relation to the black art shows organized by these institutions. What is the basis of your criticism?

EC: My main criticism is that white institutions have no serious commitments to the work of Black artists, in the same way as they have towards white artists.

RA: That's a valid criticism, and I do agree with you that most of the exhibitions which we saw in the last few years were of a tokenistic nature. But what else can you expect from them? None of the institutions, public or private, have shown any commitment to the radical change that has been taking place in this society since the war, and the question of culture is very complex in this respect because it affects

institutions at the level of ideas. What has happened, in my view, is that many public spaces responded to political pressures, particularly at community level, and the paradox of the matter is that although political struggle cannot be separated from cultural demands, politics do not always have a positive approach to cultural matters. And that's what happened at the GLC, and it was the GLC which promoted this kind of tokenism.

EC: I don't personally think that public galleries are so sensitive to political pressures. There are in fact galleries which would never entertain the idea of showing Black artists or putting on Black art exhibitions. There have been all sorts of reasons for the exhibitions we had in the last few years; many of them have been put on at short notice because there were gaps in their usual programmes. Sometimes they are due to some liberal posturing to win credibility among the local Black community.

RA: There is a general feeling that we shouldn't expect much from the established institutions or public venues, and that we should have our own alternative organizations run by ourselves. In fact, we do now have some of these alternatives established. There are publicly funded art galleries, art centres, cultural organizations, etc. which are exclusive to black peoples and are run by black peoples themselves. Do you think this is the right alternative?

EC: In a word, I would say no. Although I should quality when I say 'no', but the proof of the pudding is in its eating. When you think of the farce of something like The Roundhouse, which was supposed to be an international Black arts centre, it makes you run away from the whole notion of Black organizations. After spending more than £3 million we are nowhere near its realization. There is no evidence that the existence of some Black galleries – which are of course underfunded – have improved the situation for the Black artist. Here I'm going to stick my neck out and say that Black curators are no better than white curators. We should have good curators, who are informed and are competent, and who also recognize the cultural needs of this multiracial society. I'm critical of white galleries but I also have reservations about any kind of separate alternatives.

RA: There are of course areas of work where we have no choice but to do it ourselves, and I'm sure we can do it effectively. But when I look at most of the self-run black organizations, which are publicly funded, they don't seem to be doing much useful work. The Roundhouse is not the only disaster we have faced, there is a pattern of failures which repeats itself again and again. There are of course exceptions, but they are very few, and most of the visible profile we have is not very encouraging. It would be foolish to put all the blame for this on our own people; to imply that the incompetency is the characteristic of emerging black bureaucracy only. The point here is that we cannot afford any incompetence and the resulting wastefulness of the limited resources we have. And yet we don't have any (black) consensus with which to deal with this problem. There is an unusual tolerance on the part of the establishment towards this situation and a silence among the black intelligentsia.

EC: I don't agree with you that Black people are not unhappy with the situation. I think you are being a bit harsh. I'm pretty sure you would not get anybody who would stand up and defend what happened at The Roundhouse.

RA: But we haven't yet learned anything from The Roundhouse and we keep on blaming others. The fact is that The Roundhouse project was heading toward this

kind of end right from the beginning, because of the way it was conceived and handled. I know it because I was on the Steering Committee, and I had warned both Camden Council and the GLC, but they refused to listen to me. In the end I lost the support of most of the Steering Committee members as well, because they thought I was being too critical. So I resigned. And now everybody says I was then right. But what is the point now? The point is that The Roundhouse is not the only example of our failure. There are many black organizations which are not doing any worthwhile work, and they are being publicly funded. But when it comes to the nature and quality of their work, we don't ask any questions.

Let us take the example of MAAS,[5] which is supposed to be a black art organization and is funded by public money. They have proper premises and black staff to run it. But what do they actually do? The work they do, is it worthwhile? For whom? When you look at their art publication *Artrage*, what do you get from it? Is it not depressing?

EC: I don't have any argument against what you are saying. But I'm not sure if you are right when you say that we are not being self-critical.

RA: But why are we allowing such useless organizations to continue to exist? They waste most of our valuable resources – public funding – and it's done in the name of our community.

EC: I think you are being idealistic. You and I can criticize these organizations, but there is nothing more we can do. We don't have a real power.

RA: You may be right about my idealism, but the issue is not as simple as it may appear. What I was trying to get at is that this situation is not incidental or is due to what may appear to be black incompetence. The underlying reason is much more sinister, and can only be grasped within the context of neo-colonial situation within this country. I'm not suggesting that there is a conspiracy behind this situation, but we must recognize that such useless black organizations can undermine our struggle. To justify everything in the name of black community, without questioning the nature and quality of the work we do, is not only an insult to the intelligence of black people but it also represents a new kind of racism about which we ought to be aware.

EC: The community is very useful in propping up funding application forms, and without it not many organizations or individuals would get any money. I don't really want to comment upon what you have been saying, except that the situation *vis-à-vis* black art organizations is only a microcosm of a larger situation. Where I live in Bristol, St Paul, there is a community centre which has received, since the riots in the early 1980s, thousands and thousands of pounds (perhaps millions), but what useful work do they do? I don't know.

RA: What is then the future of black art? I'm particularly interested in this question because you have recently curated a show called *Black Art: Plotting the Course*; that means you are indicating some future. There is also another exhibition called *Black Art: Future Directions* which is going to open in two weeks' time. So what are these future directions?

EC: I don't think that Black art is like fashion, whereby you have new colours for new seasons, changing form from one year to another. So I'm dubious about all these new directions. What I tried to do with my own show was to show some black

artists together whose work was inspired by the Black art movement and whose work I personally found interesting. But as far as the future of Black art, I don't think it's very healthy – I mean ideologically.

RA: Why do you think that the future of Black art is so bleak? Is it because black art as a radical movement is no longer there? Or is it because the term 'black art' has become a broad category which is being used by everybody irrespective of the nature of the work?

EC: Even if that is true, and Black art has been diluted and lost its direction, that should not indicate the end of its radical movement. Black art could still be a powerful force.

RA: You mean to say that even when the term 'black art' has been appropriated by the establishment, and is being used as a category, black art movement could still maintain its earlier dynamic . . .

EC: Yes.

RA: But why has it lost its earlier momentum?

EC: I don't really know. It has been encountering hard times, and somehow it fell to the ground.

RA: I'm very surprised that you should say that. The exhibition you have curated is still around and is travelling. You must be optimistic, otherwise you would have not been involved in this exhibition.

EC: There are still Black artists whose work I admire, and in whose work I have hope. The only way I could have shown their work was in a large context with other artists. The fact that their work might not otherwise have been shown, is not very encouraging. And it's difficult to say what the future is, because the situation is no longer in our own hands. Yesterday you said that Black art was very popular. I don't think that's the case . . .

RA: I'm sorry to interrupt you, Eddie, but it was you who said that black art was fashionable.

EC: No, no. I was only talking in reference to Black artists; Black art as a politicized form of expression is very unpopular amongst Black artists.

RA: I would agree with you there, given the nasty reactions we had in the past . . .

EC: But I'm not talking about its being unpopular among the white audience or critics. I'm not really bothered by them. I'm only concerned with Black practitioners themselves. There are very few artists who would seriously accept the political framework of Black art and would also accept this framework for their own practice.

RA: You mean there is a lack of political commitment.

EC: Yes. There is a lot of ambition for getting into the galleries, but there is no political commitment as far as the work is concerned.

RA: But, Eddie, we must recognize that art is a profession. It has an economic base. The only outlet available to the artist, whether you are white or black, is through the established structures. If you say that black art is something which is meant for and addresses only the black community, while the black community has no economic power to support its artists, then the black artist is lost.

EC: I do appreciate what you are saying. But what I'm saying is different: there are a lot of Black artists whose only concern is to gain access to the white gallery space, which is a legitimate struggle but they are not concerned with the issues involved

in it. There are many Black artists who will tell you about their experiences of racism while dealing with the galleries, but they will do nothing about it as far as their work is concerned. The struggle to gain access to the galleries has superseded the struggle to create art forms which relate to the experience of Black people.

RA: I don't think we are talking about different things. My own view abut black art movement is that it has lost its earlier momentum because it had no support from the black community itself. I'm not saying that the black community did not show any interest, but to show an interest only is different from supporting its artists economically. The black community does not have economic power to support its artists. I may be repeating myself here, but I think it's important to emphasize. The only alternative, then, is to turn to the established system, whether one likes it or not, and to make demands within it. It has contradictions, particularly when one is engaged in a radical practice, but that's the way things are. I'm not suggesting that we should give in to the market forces, but it's an issue which we cannot ignore.

EC: There are a number of problems with that analysis, and I can't agree with that fully. I would have liked to go into it again, but I must go now.

Notes

1 *Black Art: Plotting the Course*; Oldham, Wolverhampton, Liverpool, 1989–9.
2 *The Essential Black Art*, Chisenhale Gallery, London, 1988. The catalogue is available from Kala Press.
3 It can though also be argued that jazz is African in the same way that mainstream music in America is considered white and European.
4 Eddie Chambers, introduction to the original catalogue for *D-MAX* exhibition whose first showing took place at Ikon Gallery, Birmingham, July–August 1987.
5 Minorities Arts Advisory Service, London.

This article was originally published in *Third Text* 5 (1988) © Rasheed Araeen.

<div align="center">

21

TER SPEAK IN YER MUDDER TONGUE

An interview with playwright Mustapha Matura

Michael McMillan

</div>

Introduction

In 1962, Mustapha Matura came to England from Trinidad in a period of dramatic cultural and political shifts which transformed the austere 1950s and saw the emergence of the Civil Rights and Black Power Movements in the United States. These movements provided an ideological backdrop to activists and cultural practitioners in an emergent Black arts movement in Britain. They would experience what the first wave of postwar immigrants had to endure as 'dark strangers' in a hostile racial climate.

Matura's emergence as a playwright signified a wider challenging and transgression of the aesthetic values inscribed in British art practices. Particularly, his use of West Indian Creole, his own nation language, as an instrument of defiance became dovetailed with a plethora of 1970s avant-garde interventions from Happenings to Laboratories to Performance Art: 'the intellectual realisation of our history and how you could perceive yourself had changed. I had to write about that political change: the metamorphosis happening to me and others around.'[1]

One of his first interventions in British theatre was the play *Black Pieces*, directed by Roland Rees and produced by Ed Berman's InterAction as part of the Institute of Contemporary Arts' series on Black and White Power plays in 1970. After that, he was commissioned to write *As Time Goes By*, which he describes as his first mature play. It opened at the Edinburgh Festival in 1971 and played at the Royal Court, winning him the John Whiting and George Devine Awards.

In 1972, Mustapha returned to Trinidad after twelve years' absence and found the voice for a number of subsequent works: 'I left just before independence and returned after independence . . . As an exile it was quite a wonderful journey to make . . . Trinidad was in a world of its own . . . I saw a life ahead of me.' On his return to London he wrote *Play Mas*, for which he was voted the 'most promising playwright' by the *Evening Standard* newspaper.

During the 1970s, the Institute of Contemporary Arts, InterAction, Royal Court Theatre Upstairs, Soho Poly and Open Space began to produce more plays by Black playwrights. Also, the emergence of Black-run companies such as the Black Theatre of

<div align="center">

255

</div>

Brixton, The Dark and Light Theatre Company, Temba Theatre Company, the Drum Centre and the Keskidee Centre led to the emergence of the Black theatre movement. Matura became one of its leading lights. Apart from making the experiences of Black people more visible in the media, Matura says that the movement was also informed by a strategy to create space for young theatre practitioners – to train as directors, writers, designers, technicians etc. In 1980, his play *Welcome Home Jacko* gave a significant impetus to this vision with the formation of the Black Theatre Co-operative (BTC).

Together with contemporaries such as Jamal Ali, Michael Abbensents, Linton Kwesi Johnson and Edgar White, Matura's writing provided powerful commentaries on the contradictions between the generations of Caribbean settlers and white British society and the attendant tensions. In the process, he became one of the most exciting and accomplished satirists of the British theatre.

Interview

MMc: When did you come to England?

MM: I came to England in 1962 from Belmont, a rich and poor multiracial suburb of Port of Spain in Trinidad. I had an exciting and wonderful childhood. In fact, I couldn't hope for any better. There were Chinese, Indian, Black, Portuguese and Spanish people. The whole idea of racism never occurred; people called each other 'nigger' or 'coolie' and that was that. There wasn't the kind of institutionalized racism you experience in Britain. It was a very superficial thing.

When I came here I could not believe the ignorance of the people – their lack of sophistication and behaviour towards other human beings. We grew up in the Caribbean thinking of England as civilized, whatever that means. To us, it meant good manners, good behaviour, consideration for other people, a sense of the arts, an ambition and aspiration for learning – enlightenment, evolving and bettering oneself as a human being. That is what we perceived England to be. Whether we were fools or not is another question. But I don't think so. What finer conditioning to have – these are great values to aspire to. Better than robbing people or disliking them simply because of the way they look. A lot of Caribbean people of my generation grew up with these values.

I should say some English people in the Caribbean had some of these values but what contact did we have with them? I didn't meet the Governor! Occasionally, you come across members of the English upper classes, civil servants or those who could afford to travel. Our perception of the English was therefore largely from the media, the colonial institutions, our parents or peers. It was accepted wisdom that the English were fair, just and civilized. So you can imagine the culture shock, to come to England and realize that all these values were just myths.

Writing for theatre in the radical 1960s

MMc: Tell us about your attempts in the 1960s to establish your artistic and creative credentials.

MM: Initially, I spent a year in England with some Trinidadian friends – Horace Ové, Stephan Kalipha and Benito Fernandez. Then Horace and I went to Rome to try and get work in films. I ended up working in theatre as an assistant stage manager,

pulling the curtains. I was hired by some Black Americans doing Shakespeare in Harlem, a play by Langston Hughes. I had met them before in London. Each night, I watched a fringe play without a conventional set or design. That greatly influenced me, but I eventually got pissed off with the Italian gay scene and the games you had to play in order to work.

I returned to England, got married and moved to Surbiton. I lived away from the London scene for nearly fifteen years, watching the radical political changes here and in the USA through newspapers, books and television. You could see clear parallels, and seeds started sprouting. Michael De Freitas, or Michael X as he became known, started saying things. I couldn't identify a hundred per cent with him because he was the 'full monty', but I admired what he was saying. Then I switched on my television one evening and saw my friend Stephan on David Frost's programme on Black Power. His hair was shaven and he was wearing a black jacket associated with the Black Power activists – things were definitely going on.

I returned to London. Horace was now an aspiring film director and Stephan was acting. They were also doing plays and knew people on the fringe theatre scene. Michael X had a flat in the same house as Horace in West Hampstead. The two were close and I saw the political and artistic links merging – one feeding into the other. The politics gave the creative expressions enormous energy. I would go round to Horace's house and meet American writers and activists such as Calvin Hurton and the other brothers passing through London. They'd drop in to see Michael and then see Horace and I'd meet them. I was picking up on all the happenings – seminars, political meetings, readings, plays in fringe theatre spaces etc. etc. They confirmed many of my thoughts at the time. The emerging consciousness was unbelievable; you could touch and feel it.

A scene developed. After a play, you'd go back to somebody's pad, smoke, talk, rap, try and pull or get pulled. A creative and sexual dynamic was going on. I tried to explore the mix of personal and political contradictions in *Party*, a segment of my play *Black Pieces*.

C: Cool it na man, yer freaking the chicks, an yer see that guy over there, he's thinking of making a film on our people, man, an if you start coming all this Black Power business, he am might not go through with it.

Z: Yer mother ass, mother mother big ass, yet sit down here, fraid ye lose yer focking white woman, mediations, meditate on South Africa, meditate on Biafra an all de Black people suffering, you go an tell dem dat is their Karma, that ying and yang working fer dem? . . . So what part you go play in this film, a Black man? Boy, you must be a good actor to do dat.[2]

People would say things and through discussion we would feed on each other's ideas, and raise consciousness. This sharing still happens but people are far too cynical these days.

MMc: So you became a playwright through these creative interactions?

MM: Yes. First I wanted to paint, but then I started to go to theatre. Some of the early plays I saw included Edward Albe's *The Death of Bessie Smith* with Earl Cameron, a Black American actor who played her boyfriend. He also had a part in *The American*

Dream at the Royal Court Theatre. I also saw John Osborne's *Luther* with Albert Finney.

The idea of Stephan as an actor made a considerable impression on me because at one time I also wanted to become an actor. Horace was a director. I didn't want to do the same things as they did, so I became a writer. I particularly liked the image of a writer as an outsider – observing, and not necessarily engaged – I preferred feeling things in the background. So, I borrowed a second-hand typewriter and just started writing. At the time, I wasn't really sure what was going to happen to the plays because people weren't really interested in my characters. They didn't speak the Queen's English. They spoke in dialect. It may not seem a big deal today, but at the time, writing in dialect was an important political act. The creative benefits were also significant. I found that once I started writing in dialect, the dialogue just flowed.

THELMA: It en bad but yer car beat Trinidad. How you like it?

BATEE: I don't like it. I dying ter go back home, it too cold de people don't like me, dey tink we is dirt an' de treat we like dirt, dey lazy an' dey say we lazy, dey dirty an' dey say we dirty, dey bad an' dey say we bad, how yer could like a place like dat?

THELMA: Well I heard a lot of stories but I only just came so I carn't say.

BATEE: Well take my word fer it. Dat de way it is an't don't stay a minute longer dan yet have ter stay, is a evil kinda ting dat does rub off on yer if yer stay too long. You look like a nice girl, you go back home an' tell anybody who tinking a coming here dat. Tell dem do' bother it en worth it.

(As Time Goes By)[3]

MMc: The spontaneity of the dialogue clearly restores a certain verbal dexterity to the characters. *Dialogue*, one of the segments of *Black Pieces* reflects this very much. How did that evolve?

MM: *Dialogue* was about three guys; A, B and C. I didn't give them names. A was conscious, B was semi-conscious and C was unconscious. I just imagined them hanging out one night. B says, 'Bwoy I bought ah red shirt', A asks him, 'Why yuh buy ah red shirt, yuh should ah buy ah Black shirt'. 'Well red nice', replies B. A says, 'What's wrong wid Black?' The dialogue just develops.

MMc: In *Indian*, the other segment of *Black Pieces*, your characters take on more formal political concerns – in this case, one of the controversial issues of the 1960s – Enoch Powell's call for a halt to Black immigration and their possible repatriation.

INDIAN: I was thinking how smart Enoch Powell is. He want to send we all back with some money you know, is the Government money, an who is de Government, de people, and who is de people we, So you see how clever he is.

FRANCIS: Look na man you thinking bout Enoch Powell he belly full yu no, he en have to worry bout food, he must be sitting down to a nice fat turkey and a big bottle of wine . . . coming?

(Indian from *Black Pieces)*[4]

MM: When I finished writing *Black Pieces*, I showed it to Horace and the group of

friends. I wanted them to act it. You could do that sort of thing in the 1960s – you write a play based on people you know and get them to act it. You can't do that today. It's lost its magic and spontaneity. The play got some excellent reviews when it opened at the ICA. Then I wrote *As Time Goes By*, which was a folksy conventional Caribbean play. The female character, Batee, hated England. That was so unusual for people then. The myth was that immigrants didn't say things like that. All they wanted was a job, a car and a house. It was commissioned by Michael White, the film producer who was a friend of my agent and a fringe groupie at the time. I was pleased to write it, but in the end Michael didn't produce it, which really pissed me off.

MMc: Do you think that the cultural and political shifts taking place in Britain at the time affected the aesthetics of your writing?

MM: England was quite backward at the time. We were actually in the forefront of a new cultural movement. Another prominent Caribbean playwright working at the time was Errol John. He wrote *Moon Over a Rainbow Shawl*. In the heat of the cultural and political explosion of the 1960s, we all thought he was an 'Uncle Tom'. It was only after I encountered obstacles myself that I realized that he was quite a remarkable man. He fought a lot of racism and shit which sent him round the bend. He simply refused to take it lying down, uncompromising – more like a Jamaican than a Trinidadian. He was considered a trouble-maker, which meant that his work wasn't done.

Then there was Barry Reckord, who wasn't really dealing with the Caribbean experience, or the Black experience in Britain as such. He wrote a play called *Skyvers*, about school, but I don't think I ever went to see it. At the time, I was so rebellious and opinionated. Michael Abbensents was the next big thing happening in Black writing. He wrote *Sweet Talk*, and later the ground-breaking soap opera *Empire Road*. There were also the Black Americans – Leroi Jones (Amiri Baraka) who wrote, *The Dutchman*, and Ed Bullins, the writer of *Electronic Nigger*.

MMc: At the end of *As Time Goes By*, the disillusionment of Batee with England is complete. 'Is five years I here and every night a go ter bed a pray dat when a open me eyes in de morning a go see de sun shinning, home. An' every morning a pray dat dis is me last day here . . . ' By the late 1970s, this disillusionment had become quite widespread within the Caribbean community. Did you feel vindicated?

MM: No. By that time I had moved on but personally I had also come to the conclusion, and as impractical as it may sound, that this country was a prison and that Caribbean people should return home. I don't think English culture is particularly helpful to Black people from the Caribbean. That is a tragedy. We seem to be stranded here. We came here to improve our lives but I feel that the Caribbean spirit is stifled here.

Returning to the Caribbean

FRANK: Look, Man, you is a DLP all yer Indian bound . . . all yer just want ter see Black people foolish an working fer allyer, an Indian driving bout in big car, well dem days done, dis man is a Trinidadian who come ter help we, an who

come ter tell we how ter better we selves, all yer Indian all right allyer en' need no help, all yer children go be lawyers or doctor, while we beg for shit, so do' tell me bout notting.

(*Play Mas*)[5]

MMc: You wrote *Play Mas* after returning to Trinidad in 1972. You had been away for twelve years. Were you trying to reclaim some sense of identity?

MM: Post-independence Trinidad was in a world of its own. Remember, I had left just before independence. As an exile, it was quite a wonderful journey to make. I was particularly fascinated by how multilayered the place was – all the cultures and peoples. *Play Mas* explored the social and political vacuum left by the transition from the white colonial power to the Black bourgeoisie, and how they were fucking things up. It also explored the significance of carnival and its influence on the people. After that, I wrote *Meetings* and *Independence*. They further explored the ironies and contradictions of independent nationhood. These plays were important to me because hitherto all my plays had been located in England.

HARPER: It is always hot in this country, Brother Allen. It has always been hot in this country, Brother Allen. Temperature has not fluctuated more than a total of ten degrees, Brother Allen, and the People's Republic has gone to great expense to furnish you with a jacket, designed in London, to incorporate with the tone of this Leisure Centre and you have refused to wear it. Might I remind you the cost of your jacket equals a bag of cement, which in turn roughly equals the wall of a village school room.

(*Independence*)[6]

MM: I wanted to explore colonialism as a state of mind as well as a political reality, and to examine the conflicts generated by its legacy. In the play, the characters of African origin, although no longer living under colonial rule, still bear the burden of its unresolved problems.

HARPER: Brother Allen you are no longer an employed person, you are a burden to the Republic you are an idler and a anti-social elements. (ALLEN laughs) You have no means of supporting you'self, and the Republic cannot allow you to live off the sweat of other hard-working citizens labour, is de camp for you, yer criminal.

ALLEN: Harper, I am capable of supporting myself as you will certainly discover, wen your spies from de Social Security Department come to snoop, dey will see a farmer at work, a man, a free man at work doing de most natural ting in . . .

(*Independence*)[7]

MM: In *Meetings*, we meet the people independence benefited – a rich business man and his wife. The island is overflowing with 'petrodollars', and this couple shop in Miami, own a magnificent house and everything money can buy. In fact, they are a perfect copy of any successful couple in London, Paris or New York but something important is missing. They are essentially living outside their landscape, and they have problems which neither wealth nor their political inheritance can solve.

HUGH: . . . How yer cigarette ting going?

JEAN: . . . Some a de people say it making dem cough a lot, but dat is ter be expected, wit anyting new. We do' know if it just dem country people trying a ting on we, dey smart yer know, yer car' beat a country bookie fer smartness although dey look simple, dey quick, but I do know wat dey want. If dey want we ter give dem more, an dat go keep dem happy, I tell de American guy dat before he left, he say: You know your market. A tell him dam right, dat's wat he hired me for.

HUGH: Elsa had ter go home too.

JEAN: Why?

HUGH: Her people an dem sick, dey coughing.

JEAN: Right, yer see wat a tell yer, everybody catching it now, yer know how Trinidadians follow fashion, one person do something all a dem want ter do it.

(*Meetings*)[8]

MMc: *Welcome Home Jacko* was my first encounter with your work. How did that come about?

MM: It was inspired by a visit I made to Sheffield. They were doing one of my plays but it got cancelled. I was already up there, so they decided to take me round to see various places, including a youth club called The Hub. The place was so desolate and hopeless and seemed to me to be just a terminus for young Black men moving in and out of prison and struggling to discover some kind of Black identity. The club was run by this maternalistic white woman. On the night we were there, one of the kids was being released from prison. To celebrate, she had made the kids some dashikis (Afro shirts). She seemed well-meaning but not really adding anything of real value to the young lives.

Rasta was happening at the time, so I used it as the swagger in the play. I didn't know much about it then, and I thought it was superficial and politically unhelpful. But I'm much more sympathetic to Rasta now. The tragedy of the young people's lives was that it was so aimless and wasteful, which is the whole shit about England. This welfare thing, giving you just enough to be dependent. The play provoked some strong reactions, which was quite surprising, but we were lucky to have a good cast – Victor Romero Evans (figure 21.1), Chris Tummings, Vaz Blackwood, Trevor Laird and the other guys.

MMc: Was this the beginnings of Black Theatre Co-op?

MM: Yes.

MMc: What was the idea behind it.

MM: I had been to America and seen the Negro Ensemble Theatre Co. I thought, if Black people created their own company, first, white people would want a piece of it and, second it would make the Black acting community and theatre more self-sufficient. In other words, you don't have to be dependent on the man to give you a job. I knew it could be done because I saw it happening in New York. It was also a good idea to have more Black actors, lighting technicians, publicists and stage managers. Whilst there were a few Black theatre companies around – Keskidee, Temba Theatre Company, The Dark and Light Theatre Company etc., Black Theatre Co-op signified the expression of a generation of British Black youth whose

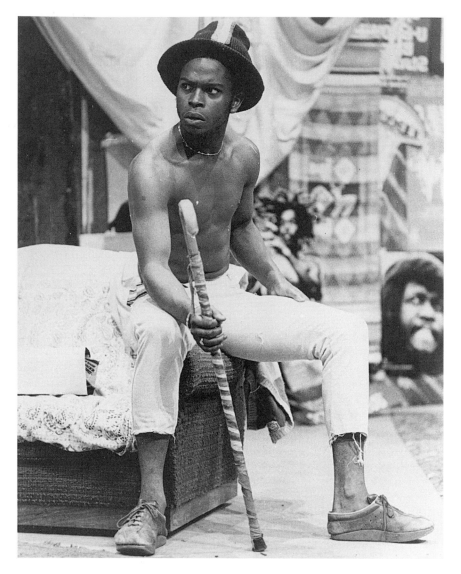

Figure 21.1 Victor Romero Evans in *Welcome Home Jacko*
Source: Photo by Amrando Atkinson. Courtesy of Black Theatre Co-operative

voices had been silenced at home, at school, in the media and on the streets through the Sus laws and police brutality.

At that time, nothing on television was dealing with young Black people and their problems. I remember a lot of parents coming up to me after the performances and saying, 'What do I do with my son?' I didn't know. I couldn't tell them that my son was just like theirs. The good thing though was that people like them were going to the theatre. We built a wide audience and a reputation, which was very unusual at the time.

MMc: Did that give the impetus to *No Problem*, the Channel 4 Television comedy series?

MM: Yes. Humphrey Barclay, the producer, came to see *Welcome Back Jacko* and later gave us some money to do a workshop for a situation comedy. *No Problem* emerged from that and he liked it. But it lost its way. We idealized it and poured a lot into it. We didn't realize that it was just a job. Then some of the actors started believing the characters they were playing. The writers, myself and Farrukh Dhondy also tried to make the show new, different, interesting and so on, but I don't think we thought it through, to be honest.

Many people identified with the show – wrote letters and so on – but this raised its own problems because people expected us to provide answers to all sorts of issues and concerns within the Black community. Someone would come up to me and say, 'Bwoy, I tink dat programme is so good', then another would say, 'Dat is de biggest insult to Black people in dis country. How can ah guy live in ah tent in ah garden wid animals? What kinda message is dat saying bout Black people?' In the theatre, you got the feeling that people didn't take the issues so seriously, but television was powerful stuff. The series was supposed to carry the burden of representation but it couldn't. It wasn't meant to – it was just a situation comedy. The problem was that *No Problem* was only one of a few Black television programmes at the time. Unfortunately not much has changed for Black writers since then.

MMc: How do you see your role now?

MM: I have a conflict, and that is whether I write about the same old things. I don't mind telling a child to stop behaving like a child, but telling that to a grown-up is a different proposition all together. I ask myself whether it would make any difference and whether I should still be doing it. That answer to both is no.

MMc: What are you left with?

MM: Trying to pay the bills. What I would like to see is a Black theatre workshop where out-of-work actors can come and work and develop their craft. I'm also interested in training young Black people who want to act. This training has to come from a Black perspective informed by Black aesthetics. It's so pretty grim out there. There are so many Black actors out of work. What do they do during the day? Where do they go? If they have some money, they'd go to Joe Allen's restaurant and feel that they're still part of the theatre scene, but most people don't want to do that.

MMc: What does the future hold?

MM: At one time there were people interested in the Caribbean and Caribbean plays, but the theatre scene in this country has got worse. Unless there is an independent Black arts movement, it will go back to the days when Black actors would only get work to play waiters and muggers. Maybe one or two might make it through the system, but I don't know where we are represented in mainstream television. Have you ever seen Black people in *Have I Got News For You* or in a discussion about Iraq?

Notes

1 Michael McMillan, Interview with Mustapha Matura, in *Passports to Possibilities: Black writers in Theatre Television, Film and Video* (London: New Playwrights Trust, 1995).

2 (*Party* from *Black Pieces* in *As Time Goes By* (London: Calder and Boyars 1972).

3 *As Time Goes By*, Act 2, Scene 4.
4 *Indian* from *Black Pieces*.
5 *Play Mas* (London: Methuen, 1982).
6 *Independence* (London: Methuen, 1982).
7 *Independence* (London: Methuen, 1982).
8 *Meetings* (London: Methuen, 1982).

22

THE LONG MARCH FROM 'ETHNIC ARTS' TO 'NEW INTERNATIONALISM'

Gavin Jantjes

There is a desire in Europe for political, economic and cultural unity. The word 'Europe' is being conceptually stretched to describe a new cultural space which is filled with the actions, words, and achievements of people that supposedly have a common foundation.

As the borders opened in 1993, Europe has taken the first steps into a new reality of national interrelationship. The question of who is a member of this new European family and who is not hangs heavily in the air. Europe has opened a debate about its identity and has through it revealed some amazing self-truths. European progress toward this new, imagined identity has its metaphor in Marcel Duchamp's *The Bride Stripped Bare by Her Bachelors Even*. In the passionate race to embrace the object of their desire, the action of stripping, i.e. the removal of the barriers on route to the goal, becomes an act of self-revelation and a disturbing discovery that the desired object is more than the imagined pleasure dream of the European male; that it is filled with the cultural mechanics of the twenty-first century and is adrift and free-floating in its relationship to authority.

The aphorism that any definition of the self must include a definition of the 'other' is an explosive subtext to Europe's concerns with its newness. In defining who and what is European, one has also to say who and what is not. Suddenly the comfort of the old, loose, and general definitions of Europeanness, which avoided a clear description of the European self, has shrunk to become tight-fitting and precise. Claiming something as European in 1993 makes it feel awkward and uncomfortable. It has made politicians and cultural bureaucrats become uneasy and self-conscious as they shift position in the debate about identity. Every affirmation is qualified by a subterfuge of pat phrases and hollow promises.

Those on the political right want this tight fit to resemble the skin around a sausage. They desire the *Kulturwurst* definition of European culture, want its skin to be White and its contents impervious to contamination. Others desire a return to the loose-fitting comfort that allowed them to intellectualize a liberal internationalism which in the last eighty years denied the modernity of the other.

Contemporary arts and cultural policy in Europe has to take into account the

shifting nature of the cultural, political and economic environments. A starting point for an 'open' European communality could be the hybrid nature of its various national cultures. No European culture is ethnically pure. The debate on a new European identity will reveal cultural reciprocity, syncretism and hybridity to be the very stuff of cultural history. As one unravels the polarized arguments of cultural purity on the one hand, and liberal internationalism on the other, there emerges a maxim that all cultures are multicultural phenomena. Any new European cultural identity will be one perforated with the complex interweaving of cultural differences and similarities.

One can begin to think of Europe not as a classical novel whose realities are stable and fixed, but as a collection of heterogeneous narratives, which together describe a new European position.

As the nations in Europe shape their cultural policy around the issue of cultural difference, they have to make choices about the direction such policy will take. The determining factors are the historical circumstances, the levels of knowledge, the desire to change, and the will to share. The route taken in England (for that is an example I can narrate with some authority) was from paternalistic dictate to a dialogue about sharing; from 'ethnic arts' to 'new internationalism'.

Making cultural policy which leads to change is a slow, delicate, and cumbersome job. It is like turning a sailing ocean liner 180 degrees in bad weather, before it leaves the harbour. One is asking for great helmsmanship, patience, trust that the engines will deliver the power to complete the manoeuvre, and that all the passengers don't mutiny, or jump the ship in terror.

Let us look back just ten years at the situation in Britain. There was an active Black arts community.[1] There were cultural activists with leadership skills. There was abundant artistic production, some of it of a very high order. Yet none of this had a place in the mainstream of British cultural life. Very few artists were functioning as professionals, which means that all their income was earned from their creative talents within a particular artistic discipline. Most functioned as semi-professional and amateur artists, even though the latter term discredits the quality of their work.

It was clear that the systems of support given to the mainstream White British artist was not given to the art and artists in the other sector. It was not that the artists had refused or not sought support, the history of their struggle was twenty years old. They were simply being ignored by a system that had neglected its political duty to help them. Some of them had lived in Britain for more than twenty years. A large number of these artists were not immigrants, they were by birth citizens. Their parents paid taxes and what they produced as artists was technically speaking a part of the national culture, yet as a cultural product quite distinct and different. Here lay the initial problems, those of language and of definition.

The activists' battle with the establishment had forced the creation of a division of art subsidy called the 'arts of ethnic minorities' or 'ethnic arts'. It was an appeasement, a laurel wreath, thrown to an angry Black constituency by a reluctant cultural establishment; an action to disclaim the charges of years of racist inactivity. The syntax and semantics of the discourses around 'ethnic arts' were clearly about denial. The denial of an identity, of opportunity, and, most damaging of all, the denial of modernity. The

Establishment had created a two-world structure. Them over there, and us over here. It institutionalized a binary system of oppositional or antagonized representations which inevitably accepted the dominant Western/Eurocentric position dictating the nature and terms of its relationship with otherness.

The definition of 'ethnic arts' was created by the mainstream that controlled what was to be done, who was to do it, with how much money, etc. It ventriloquized a voice for this sector and demanded gratitude. It spoke of these artists as immigrants, as outsiders, as foreigners, as guests. All definitions to separate the 'other' from the mainstream. This was not a democratic policy, it was just a continuation of disgusting and paternalistic colonial methodology.

It was also clear that the level of knowledge about the artists and about their achievements was shallow, and in part non-existent. If change were to happen it would require extensive retraining of racist officers in the cultural institutions or their replacement with skilled and knowledgeable public servants. The institutions lacked representatives and advisers who could initiate and sustain a change in attitude about cultural difference from within. The system of cultural support itself had many facets and branches. It required an attitudinal shift in as many of them as possible if there were to be any hope of a new cultural position.

Art education in schools and academies was vital to the status quo. Questions of value, aesthetics, innovation and history were built upon a volume of knowledge rooted in Western/Eurocentrism. Alternatives were needed, and cultural policy had to assist in their construction. New audiences were another dimension of the system. The existing audience had to develop a pallet for the art they had been denied, in order that they could engage and support it as part of their national culture. There were the Black communities themselves who had to realize that, when the new work was presented, the fact that it related to their experiences and their attendance to it was a valuable cultural exchange worth spending time and money on.

The other realities Britain faced were the desire to change, and the need to share. It was clear that what needed changing was the national consciousness about the arts. Britain had to understand that it had become a multicultural society as a result of its own historical actions (colonialism) and the actions of others (immigration). Britain was a postmodern culture long before that term entered the artistic debate. The problem was that the British were educated to ignore this cultural reality; or to think of it as a fringe benefit of colonialism, rather than a change to the foundations of British national culture itself.

If one stood at Piccadilly Circus in London hungry for a meal, one could choose to eat anywhere in the world by walking no more than four hundred paces in any direction. The inner cities of Britain were microcosms of the world Britain had once colonized, and one could not traverse them without brushing up against this diversity. In the arena of sports and personalities, there were people who carried the British banner to amazing victories and it was never a question that they were not part of the nation. If Black people could make distinctive contributions to the nation's sporting culture then why not to its artistic culture?

The myth of British culture being insular and racially specific was slowly crumbling under the evidence of cross-cultural mixing with both European and extra-European cultures. What had once been the periphery had come home to roost in the centre and

the centre now had to change to contain a spontaneous internal combustion which had erupted in Brixton Toxteth and Moss Side in the early 1980s. Britain had to engage in a dialogue with the cultural other in its midst, in order to gain a perspective on the future. It had to construct policies which allowed that dialogue to develop into plans for action. It had also to accept the national culture as a heterogeneous and kinetic organism in which individuals and groups negotiate their positions and identities. The national culture no longer had one central tap root but had become rhizomatic.[2]

The desire for change meant a reassessment of the way national resources for the arts were being shared. One could not have the one without the other. One could not expect this new sector of the culturally diverse arts to survive with any great success if it was not properly funded. In a time of Thatcherite stringency, no new money was expected and it meant that the changes had to be made on existing budgets. A tough task, requiring of the nationally delegated institutions that they did their obligated duty as managers of artistic policy.

An assessment of the situation in Britain ten years ago made clear the need for policy changes that would have to work in conjunction with timetables for action. The policy had to generate a national debate about the need for change. It had to spell out the benefits to the nation resulting from the policy shift. The communities directly bene-fiting from the change had to feel that they were a part of the policy making decisions. They wanted their voice to be heard and hoped to register institutional support for that voice in the debates about change.

What all of this meant to an institution such as the Arts Council of Great Britain was the inclusion of the nation's diversity into all of its thought and actions. The advisory panels of the council were restructured and appropriate people appointed. The council itself improved its membership by admitting Black people to it and giving them not just the specific task of advising on cultural diversity but on all matters affecting arts subsidy and policy. In order that a clear and timetabled policy was created, the council set up a special committee to advise it on policy. It was given political authority, a working budget, and reported to the council on a regular basis about its findings. This meant that the question of cultural diversity was constantly on the top table of the nation's most important arts institution and that the debate was led from there.[3]

The organizations in receipt of council subsidy (those who took taxpayers' money to make and present art) were asked to inform the council on how they intended to spend 4 per cent of their budgets on cultural diversity over a period of two years. These reports were assessed by the officers of the Council, with support from advisers and the special committee, and, where they found it lacking, the Council offered help to the organizations in the form of advice and personnel. Specialists went into these organiza-tions to work with them and help them develop their ideas on cultural diversity. No organization was bullied into doing something it felt it could not do.

This meant that existing 'White' institutions were slowly moving to support Black artists, but the Council itself had to answer the question of how independent Black arts organizations were to receive direct and sustained support. In the forty years of the Arts Council creating arts venues in Britain – and by that one means buildings – none was for a Black or multicultural organization. The fear of creating a cultural apartheid with separate and special institutions for Black or multicultural arts arose. The Council

decided to support Black organizations on the advice it received from the Black arts sector in the dialogue it had established with them. The Council responded boldly to a recognized need and desire by Black people to set up and run their own organizations. It understood that these organizations aimed not to distance themselves from the mainstream but to install a working platform from which to launch their particular art forms into it.

What Black artists were saying at this juncture was that they were not confident that the mainstream institutions were going to deliver the opportunities they needed in order for them to make an impact on the national culture. They were talking from experience, for the history of the struggle for Black arts showed that, in the early 1960s, at the time of the creation of the Commonwealth Institute in London, there was a keen interest in the arts of others. However this never developed into any programme for real change in the national culture. After a few attempts at presenting cultural difference, the vogue lost its momentum and the institutions returned to their old ways. The artists were left without the support structure to make that great leap forwards into the mainstream and sustain a presence there.

Cultural diversity and difference also pose a critical alternative to the supposed monopoly of truth the mainstream believes it has. It would be difficult to argue such a critical alternative in an arena where the rules and regulations were controlled by those who at times still believed in that monopoly of truth. The Arts Council's decision to support Black organizations was therefore an affirmation for the freedom of expression, and for the democratic rights of artists.

Opposition to the council's decision came from two quarters: those who saw no separatism in the previous years of Western/Eurocentric exclusivity, and thus no need for new organizations; and those who felt that the mainstream was being given an excuse not to perform according to the policy of cultural diversity – in short, that Black organizations were there to do their multicultural work for them.

The council took the latter criticism seriously. It was aware of the enormous difficulty of forcing its recipient organizations into supporting any policy willy-nilly. It installed a system of controlled assessment of its clients' spending on cultural diversity. This would give a minimum assurance of support by all for the policy. Every client now has to publish its spending on cultural diversity.

As Britain goes into the new 'open' European 1990s, it can look back at a fair level of success in terms of policy development around the issue of cultural diversity. It can point to examples of good practice, and to strategies of controlling and supporting equality in the future. However, the story of Britain's march is not over. Britain is not yet a multicultural haven free of racism. There is still much to be done to pilot this giant ship out of the harbour. The dynamics of postmodernism in the arts, the on-rushing millennium, have along with other factors become part of the kinetic process of change. Artists are affected by this dynamism and bring their own innovative and visionary sensibilities to it. The result has been a critical rethink in Britain of the whole question of diversity and the political and cultural strategies used to implement it.

In the visual arts, for example, artists have moved from multiculturalism to the dynamic idea of New Internationalism. The Arts Council is helping to set up the Institute of New International Visual Arts (INIVA), which will become an institution

with four equal branches of activity [INIVA is now well established in London – Ed.]. Research, exhibitions, publications, and education are departments to be housed in its building in central London. The concept of New Internationalism is inclusive as opposed to the exclusive, modernist internationalism of old. Its thesis is the contemporary work of artists from all over the world, with emphasis on the art neglected by art history because of race, gender and cultural difference. Its task is not only to question but also to broaden our knowledge of art history and the practice of art today.

What this means in terms of policy is that the national culture is being placed in relationship to the global. The questions of Black arts and cultural diversity will be subsumed by the new position and will function in a more balanced and reciprocal relationship within it. The Arts Council is moving closer to Paul Ricoeur's observation that: 'When we discover that there are several cultures instead of just one and consequently at the time that we acknowledge the end of a sort of cultural monopoly, be it illusory or real, we are threatened with the destruction of our own discovery. Suddenly it becomes possible that there are just others, that we ourselves are an "other" among others' (Ricoeur).

Arriving at this point in its policy development has not been easy nor painless. Yet it is an example of openmindedness others in Europe will want to emulate. They may believe that it would now be possible to use the British example as a vaulting pole with which to jump over the middle ground between 'ethnic arts' and 'new internationalism'. One can only advise against this, for there is no short cut to the generative dialogue each European state will have to seek with its diverse cultural constituencies. The British example is a map, nothing more; those who use it still have to walk the long and difficult road into the future.

Notes

1 The term 'Black' is used here to describe people of colour, those who suffer cultural discrimination and those who have a cultural root different to the European mainstream.
2 Deleuze and Guattari have taken the principles of biological (plant) growth and applied them to philosophy. They set out six principles which outline the characteristics of a rhizome. (A rhizome is a rootstock, like a ginger root, that grows in a multiple growth system.) The key difference between the centred, or tap root, logic and rhizomatic logic is that the first is a trace of something that has fixed rules of growth, arising from a traditional core of knowledge, while the second is a form of map-making, a process of creative and novel description of knowledge as it arises. Applying this to cultural development, there are tap-rooted cultures and rhizomatic cultures. The first uses knowledge from a fixed or centred source, the second develops cultural knowledge through experimentation.
3 The committee was known as the Monitoring Committee. It was set up in 1986 and published a final report of its findings *Toward Cultural Diversity* in 1988. This report was accepted by the Arts Council of Great Britain and became the framework for its policy on cultural diversity.

From Ria Lavrijsen (ed.), *Cultural Diversity in the Arts: Art, Art Policies and the Facelift of Europe* (Amsterdam: Royal Tropical Institute, 1993).

DUB POET LEKKA MI

An exploration of performance poetry, power and identity politics in Black Britain

Beth-Sarah Wright

Dub poet lekka mi
Dub poet lekka mi
which paart ah eart
yuh evva ear ah
Dub poet lekka mi?

Dub poechree is ah paart ov de oral tradishan
its chanted by de ooman and its chanted by de man
ittah cum way back from innah Afrika lan
if yuh tink ah any lie jus ask anyone
who no about de griot who will tell yuh bout fe wi histree
ah nuh de same ting wi ah dhu innah dub poechree
coz wi ah taak bout great Black man an woman
who fite fi wi libahrayshan wi ah taak bout Black peepul
condishan way dung ere innah Babilan
wi ah taak bout troot an rites and tings dattah gwaan innah
wi everyday life.

(Moquappie Selassie)[1]

Current social anthropological discourse tends to assume that Afro-Caribbean cultural practice in Britain does not constitute a 'proper' object for anthropological research.[2] Investigations into Black British life are principally relegated to the realm of sociology crystallized around issues of racism and social disadvantage, thereby disregarding the dynamism and vibrancy of Afro-Caribbean cultural life. Often the practices within this community are described in terms of negatives and absences, i.e. the lack of discernible institutional arrangements and social patterns which help to authenticate the work of the anthropologist. The shape of Afro-Caribbean cultural identity, similar to other communities in the Black diaspora, is characterized by a fluidity and an advanced capacity to negotiate and shift in the face of change. Caribbean community fundamentally challenges the theoretical canon of the discipline. In what ways then can Afro-Caribbean cultural practices be adequately subsumed within social anthropological thought?

In what follows, I will suggest an alternative approach to the understanding of Afro-Caribbean cultural practices in Britain and argue that the notion of performativity and performance is pivotal in the perception of Black cultural identity. In this context, performance is understood as constituting a body of strategic instruments used to organize and affirm notions of Black identity and feelings of belongingness. The concept of performativity refers to the deployment of this body of tools to achieve three core elements in the struggle for identity.

The first involves the revocation of typecast images of Blackness and metaphors of Blackness, and the articulation of images informed by an historical experience characterised by dis-location, fragmentation, alienation and exclusion. The second element involves the interdependence of social memory and performance, where narratives of the past are re-visioned and past experiences are transformed through the re-enactment of cultural forms, especially those invested in speech, gesture, customs, rites and rituals collectively known as orature. The final element presents a potentially contestatory alternative mode of communication and perceptual orientation based on the preservation of aspects of an African oral aesthetic.

I will focus on one particular kind of performance art – performance poetry, a derivative of orature which inventively encapsulates the three aforementioned areas of identity struggle. Within this examination, it serves as a cultural prism or keyhole perspective into the wider realm of Black performativity. It provides an ideal conduit to engage with Black performativity owing to its orality, its capacity to equivocate between the aesthetic and social functions of performance and its popularity within Black communities; and it furthermore satisfies the three proposed conditions for a performance-oriented approach to culture: the particularities of human action, language as spoken and ritual as performed.[3]

Human action refers to what the poet brings to the performance in terms of his or her artistic style and dramatic connoisseurship, shaping a distinct 'look' and set of objectives. Second, performance poetry is often cast in the language of the vernacular, 'street language' or the language of the Black British experience, which is stipulated as 'the creative development of an Afro-American tradition in a new environment, integrated, complex and distinctive, despite constant adaptation'.[4]

Finally, in addition to its entertainment value, performance poetry also possesses efficacious qualities which transforms the performance into ritual. It engenders a collective, holistic atmosphere in which the audience participates instead of merely watching, where the audience 'believes' the words of the poet-performer (the truth-teller) as opposed to appreciating his or her work, and where an underlying objective is to elicit responses, even criticism and to effect transformation in some degree for the listening community.[5] The confluence of these three features, in addition to the central role of music – either played as an accompaniment to the recitation or woven into the lyrical structure of the poem – distinguishes performance poetry from other poetic genres.

It is difficult to define performance poetry in any one way as it metamorphoses with changing contexts and environments, and manifests in different rhythmic styles. It has been described by practitioners of the art as 'the echo of the people', 'poetry within the reggae tradition', or 'African poetry'.[6] Depending upon what musical styles are appropriated, the category shifts, hence the terms 'jazz-poetry', 'carnival art', 'rap-poetry', 'rapso' and the well-known and most researched 'dub poetry' amongst others.

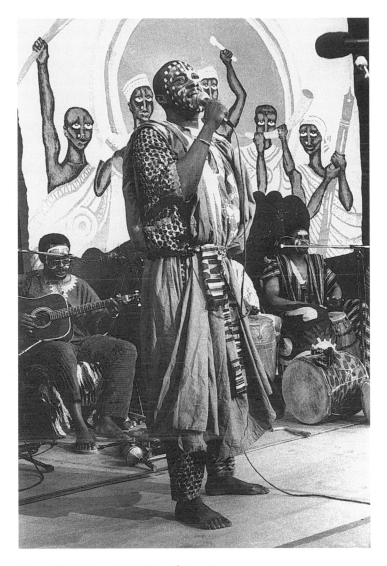

Figure 23.1 Ahmed Sheikh, African Dawn
Source: © Jak Kilby

Even this term, 'dub poetry', has presented difficulty in capturing this rather elusive art form. '"Dub" . . . can't be roughly clarified by looking into a dictionary. For "dub" is not a word but a phenomenon, a movement, musical hypnosis, bass & drum, the heartbeat of the people.'[7]

In the same way, I would argue that performance poetry on a whole is an authentic phenomenon, a movement born out of a particular historical experience and reality. Black British poet Moquappie Selassie in his poem 'Dub Poet Lekka Mi!'[8] captures, with that deceptively simple statement, the impressive profundity of this art form. It makes a definite claim of poetic territory, identity and power, both in the uniqueness of

Black British 'talk' and in the alleged unity of dub poetry and his ontological being –
dub poet lekka mi!

The notion of power in performance poetry, subsumed within the politics of iden-
tity, is most strikingly evident in the immediacy of performance, or the 'powers of
presence'. In his seminal collection of dub poets from England and Jamaica, Christian
Habekost emphasizes this inimitable power embodied in the performer him or herself:

> When Benjamin Zephaniah recites his famous 'Dis Policeman' on stage, then
> one can see what is meant by 'power'. Of course, it is possible to get the
> meaning of the poem when reading it, the Black experience of 'law and order'
> inside the ghettos of democratic England. Listening to the recording of the
> poem, one can even get an oral impression too, the provocative rhythm and the
> different shades of the voice come across. But these are not the poet on stage
> with flying dreadlocks, an angry expression on his Black face, murderously
> kicking into the air with his motorbike-boots just as the police boots kicked
> him. Only then does one realize what is really going on:
>
> > Like a thief in de dark he take me to de place
> > where him just left
> > and when him get me in der
> > he is kicking me to death.[9]

Primary oral art such as this poetry is also commonly situated within the arena of
struggle,[10] and the consequent empowerment of its exponents. As will be shown in
this examination, performance poetry is multifaceted and engages with confrontations
with issues of class, race, sex and other forms of social injustice and oppression. Herein
lies another dimension of power, or rather the empowerment of people in the face of
discrimination and difference. The term 'power' in the title of this chapter therefore is
not meant to be an isolated analytical unit but rather a metaphor for these instances
and the overarching persistence and agency of performativity in Black identity
formation.

Now that we have explored the theoretical underpinnings of Black performance
poetry and its potential place in the various dimensions of struggle for cultural identity
and certitude in the Black British community, the aesthetic dimension must now also
be presented to substantiate these claims. My exposure to performance poetry has been
wide and diverse, as I have had a long-term interest in the art both as an observer and a
performer, in Jamaica, the United States and Britain. The ethnography in this chapter
focuses mainly on a performance in Birmingham produced and directed by Shomari
Productions called 'Black Men Talking',[11] which included four male poets with indi-
vidual styles, and a solo performance in London at the Jazz Café by female poet Dana
Bryant (24 March 1997).

'Black Men Talking' was part of the Birmingham Readers and Writers Festival,
1997. It was unique in that I not only witnessed and recorded the actual performance
but also attended its only rehearsal, participated in the preparatory exercises for the
show and interacted informally with the performers outside the capacity of the show. I
felt privileged to have been present at its first organizational meeting in which the
direction, choreography and objectives of the performances were discussed with all

the participants. I attended Dana Bryant's performance in the capacity of an audience member, and, directly following her performance, managed to arrange to meet and interact with her privately to discuss her work and her feelings on that night's performance.

The time constraints for this project limited the scope of ethnography; however, these performances proved fruitful and added considerably to the observations and thoughts processed over a period of my investigation outside the framework of this particular project. Furthermore, being able to share in the experience of 'performer' encouraged intimate and profound dialogues with fellow poet-performers, which lent great insight to artistic idiosyncrasies and nuances.

The chapter is structured in four theoretical movements. 'The Question of Performance' introduces the notion of performativity and performance in terms of identity formation and the Black diaspora. It is followed by 'Anthropology, Black Britain and Performance as Text', which discusses performance as anthropological text and its applicability to studying Afro-Caribbean cultural practices in Britain. 'Orality, Identity and Performance' continues the conversation of orality, and 'Social Memory and Performance' explores how narratives of the past are re-visioned and past experiences are transformed through performance.

The question of performance

young Black people in London today are marginalized, fragmented, unenfranchized, disadvantaged, and dispersed. And yet, they look as if they *own* the territory . . . what is it about that long discovery – rediscovery of identity among Blacks in this migrant situation which allows them to lay a kind of *claim* to certain parts of the earth which aren't theirs, with quiet certainty? I do feel a sense of . . . envy surrounding them . . . a very funny thing for the British to feel at this moment in time – to want to be Black! (*emphasis added*)

(Stuart Hall)

The particular, if not unique, history of Blacks in the New World has shaped the basis of a Black ontology, oriented towards establishing a sense of place and belonging in this webbed Black diaspora. Inherent in this experience is the persistent commitment to increase visibility and recognition, by delineating boundaries and carving spaces, much in the same way young Black Londoners have seemingly created a space or 'territory' for themselves, in spite of their obvious dispossession. Much of this process draws on a fecund creative intellect, for in many ways, from the era of slavery to the present, Blacks in the diaspora have had to invent or reinvent themselves, their identity. The same ingenious stratagems and cunning intellect slaves employed to outwit the oppressor[12] and to affirm a sense of self bear a strong legacy for the young Black Londoners, say, to negotiate and claim a resting place in their geopolitical landscape.

That 'long discovery–rediscovery' of identity among Blacks involves the utilization of these creative tactics emerge from within the domain of performance and orality, such that the Black youth in London, with whom it is said Black British culture lies, *perform* their ownership of territory, whether it be through language or physical behaviour, emitting a potentially enviable sense of belonging and self-knowledge.

In no small measure, Black culture simply *is* youth culture in London today. Bizarre as it first seems, speaking with a Jamaican inflection has become hip among working-class white kids. If Blacks are only 1.6 per cent of the population, the percentage of wiggers – white wannabes – seems considerably higher. Imitation and enmity have an uncanny ability to coexist.[13]

Although the term *performance* most frequently conjures images of theatricality or the performing arts, it actually embodies a wide range of human behaviours, ranging from popular and traditional forms of performing arts to body politics, the dynamism and evolution of language, celebration of rituals, or oral artistic expressions, which together engender a 'certain kind of way', distinct and reflective of a Black ontology, that is, the metaphysical nature of existence or being.[14]

This phrase is taken from Antonio Benítez-Rojo, who depicts it in a colourful quasi-mythical form: 'two Black women passed in a "certain kind of way" beneath my balcony. I cannot describe this "certain kind of way"; I will say only that there was a kind of ancient and golden powder between their gnarled legs, a scent of basil and mint in their dress, a symbolic, ritual wisdom in their gesture and their gay chatter'.[15] This rather poetic articulation of the concept actually alludes to a fundamental function of performativity, that is to beget a distinctive representation of self and cultural personality.

Because performance represents human behaviour, it provides a conduit through which cultural intercourse can be interrogated and understood. It is more precisely delineated as 'behaviour heightened' or 'twice behaved behaviour' within the academic realm of performance studies,[16] implying its repeatability and capacity to be rehearsed and recreated in any given moment. In this way, performative behaviour becomes what literature was, the repository of history, cultural discourse, 'index and symbol, multiple truths and lies . . . [and the] arena of struggle'.[17] Performance possesses the power to engage participants on the level of collective experience, to retell or revision historical narratives, to provoke emotional responses, and to generate socio-cultural change. A fruitful example is the effective Black American music, particularly the blues, which is argued to be reflective of the Black American sensibility.[18] Evidently, cultural performances present critical sites of study within the Black community, for they encourage visibility and recognition of self in contexts where these simple aspects of human spirit are negated, primarily because of race.

Throughout the Black Atlantic,[19] performativity percolates into everyday life and aids in the socio-political, cultural and identity struggle by articulating oppositions to hegemonic discourse, launching social criticisms and subverting power. Black popular music is said to be one of the most powerful vehicles for the expression of social dissatisfaction and cultural resistance in Black communities. Ben Sidran, in his exposition on music and the oral continuum of Black America, expounds on this by demonstrating how the Black American is able to create a 'psychological territory', defended as tenaciously as physical territory, as a factor in the peculiarly American character of the Black oral tradition.[20]

Similarly, the Caribbean identity in many ways is characterized by a certain performance persona. The overarching aesthetic experience of Caribbean people draws upon the collective, the community, in a historically conscious, improvised way, which shifts and alters with the dynamic and changing structures of the Caribbean.[21] In

Figure 23.2 Jean Binta Breeze
Source: © Jak Kilby

addition to the more subversive actions, performance enables people to shape their existence, to account for their fragmented history and to represent their kaleidoscopic ethnoscape, in an inimitable 'certain kind of way'. And surely, this unique stamp is made visible not only through a variety of vibrant artistic cultural expressions catapulted from the Caribbean in a global trajectory but also in the practices of localized quotidian life. This particular 'way' is also evident in the repeated use of proverbs which act as moral guides to cope with certain situations,[22] or the special manner in which a basket is carried on the head. The unconscious loam of past civilizations emerges through these formulated cultural forms, expressing the contribution these cultures have made to the formation of a Caribbean identity. These creative acts forged collectively over time, or by individual protagonists, become indispensable as prime sources of energy in the vital quest for cultural certitude.[23]

> the only thing that walking, dancing, playing an instrument, singing, or writing 'in a certain kind of way' are good for is to displace the participants towards a *poetic territory* marked by an aesthetic of pleasure, or better, an aesthetic whose desire is nonviolence.[24] (*emphasis added*)

To what extent there exists a general desire in diasporic communities for a space marked by 'nonviolence' is questionable, but the concept of carving out an independent

territory in which to thrive and flourish by any means necessary, captures the functions of behaving in this 'certain kind of way'.

Surely these performance forms act accordingly in the struggle for identity. However, this investigation aims to show performance as a governing concept of being, going beyond its theatrical implications. As creatures of subjugated experiences, Blacks have had to formulate innovative and ingenious modes of resistance and articulations of counter-knowledges to challenge hegemony in fervent efforts of self-assertion and identity affirmation: 'It is the assertion of an "I am" . . . precisely in the face of others who are saying that "you are not".'[25] It is "smadifyin", a process connected to myriad aspects of struggle, three of which figure prominently in this exposition.[26]

On one level, it is a cultural struggle which repudiates pejorative images of 'blackness' and articulates positive ones, a process delineated as the 'politics of representation' in Black British cultural studies. Second, it involves a moral struggle in terms of using social memory to revision and retell narratives of the past. And finally in a fundamental way, it involves an epistemological struggle which seriously contests the legitimacy of orality as an alternative mode of communication and perceptual orientation. And all these levels are engaged within the larger umbrella of performance.

Performance here refers to a body of strategic instruments and cultural practices which characterize the fixed 'Blackness', to use Hall's conceptual terminology, which helps to organize identity and a sense of belongingness in these diverse environments. Black performance poetry in Britain provides a keyhole perspective into the wider articulation of performance in Black cultural and ontological behaviour. As an artistic genre, it ingeniously captures the convergence of both the social and aesthetic functions of performance as applicable to the Black experience.

First, the unique and peculiar styles and images the poets portray, and how they position themselves within their communities as insider-outsiders, effectively engages with the politics of representation. Second, the poetic themes often confront issues of historical racism, discrimination, contemporary politics, but not so much to document events, rather to, emotionally and quite obtrusively, relive moments and memories with the willing audience, in effect writing the history of the present. And lastly, the effervescent nature of performance, the power of the spoken word and its dialogic qualities intensify the challenge of approaching diasporic Black culture as one embedded in orality. Orality does not imply a direct opposition to a literate culture, but simply magnifies the difference in the degree of stress placed on oral modes of perception and communication, and highlights the contemporary significance of orality in society.[27]

However, one cannot divorce the external contexts from which performance poetry emerges, to penetrate and make general conclusions about the performativity of Black culture. In order to comprehend fully the significant roles which performance and poetry play in determining Afro-Caribbean self-recognition and sense of place, we must first explore the anthropology of the overall situation of being Black in Britain.

Anthropology, Black Britain and performance as text

I've been living here since 1963, since I was 11 years old, I've put down roots in this country! Whether we want to accept it or not, our children and grandchildren are Europeans. I don't mean that in a racial sense, I mean that in a geopolitical sense. We are Europeans and we are part of Europe. In the same way

Figure 23.3 Linton Kwesi Johnson
Source: © Jak Kilby

one can speak about African-Americans, one can talk about Black Europeans, because we're part of Europe. Europe will never be white again. Never.[28] British-born Jamaicans cannot look forward to return home, because they are home. Neither Jamaican nor fully English, they often look to their Blackness as a basis for identification.[29]

'Neither Jamaican nor fully English' accurately captures what Paul Gilroy terms the 'double consciousness'[30] of the experience of the Afro-Caribbean presence in Britain. They occupy a liminal territory, where they find themselves persistently challenging the imagined borders of belongingness and homogeneity. As Europeans, in a geo-political sense, they seek to locate a 'resting place', an authentic social position in a nation, a United Kingdom, that 'stands almost always *united* against Blacks and metaphors of Blackness,'[31] making the term 'Black Briton' a virtual oxymoron. None the less, young Blacks 'claim the territory' and it is said of contemporary Black Britain that, 'after three generations, being Black has finally become a way of being British'.[32] This implies that a culture that is distinctively Black and British does exist. But the anthropological explorations of Blacks in Britain has not reflected this.

Much of the British anthropological discourse on ethnic cultures 'at home' has taken little account of the authenticity of an Afro-Caribbean 'culture'.[33] Instead, frequently considered 'problematic objects of investigation', Afro-Caribbeans are assumed more

relevant as subjects of political issues or issues of racism and social disadvantage, that is, sociological investigation.[34] This approach unfortunately blinds the investigator to the fertile cultures Afro-Caribbeans possess. The anthropologists' commitment to the canons of the discipline, the vindication of an organic view of culture focused on fixed structures or patterns, does not accommodate the vicissitudes and constant re-evaluation and reinvention inherent in Black culture's interface with white society:

> the assumptions of boundedness and of the possibilities of mapping predictable patterns of institutional connection fit well with questions of caste, religion, marriage systems and so on. They do not fit well with what is generally understood to be the shape of African-Caribbean cultural practices . . . seen to be fragmented or disordered.[35]

In the histories of migration of peoples, forced or free, the stamp of historical violence and rupture is always discernible. The fragmented past of Blacks in the diaspora has meant that Afro-Caribbean culture tends to exhibit structural patterns easily adaptable to changing which effectively are not so easily detected by the inquiring observer. And that is perhaps an essential character of this diasporic community, the ability to negotiate and engage with contradictory and fluctuating socio-political and economic circumstances, in a parody of the ultimate quest for cultural certitude.

Evidently, people in the African diaspora, despite the historically violent rupture with Africa, remain connected with the African past in ways 'often unrecognised, often only in practice, often unreflected, often not knowing that people were practising within a tradition'.[36] This tradition linking Blacks with the culture of their past 'imagined community', to use Benedict Anderson's term, is couched within 'orature', those cultural forms invested in speech, gesture, song, dance, story telling, proverbs, customs, rites, and rituals.[37] If, as observed, orality has been preserved throughout the diaspora in a consequential way, then these communities can be examined using an alternative cultural discourse which challenges the way that naturalized aspects of 'Englishness' are understood as 'expressions of a pure and homogenous nationality'.[38]

> For it is essential in perceiving the existence of a culture of subordinate groups to see that this is a culture in which the life histories of its members have a different rhythm and that this rhythm is not patterned by the individual's intervention in the working of the dominant institutions.[39]

If, as Cornel West argues, the dilemma of the Black diaspora is invisibility and namelessness, the act of speech, of 'talking back' and naming oneself, should create a sense of recognition and visibility. That act of voice from the exploited, the marginalized, the disenfranchised, is no mere gesture of empty words but a liberatory move to boost one's existential reality.[40] Being on the periphery lends itself to such pronounced creative activity and cultural production. bell hooks identifies marginality in fact, as a space of resistance and radical possibility being able to produce a counter-hegemonic discourse through artistic creation and expressions of power.[41] It is not surprising to learn that Black lesbians in Britain, a group triply marginalized by virtue of being Black, women and homosexuals, make their voice heard through performance poetry. In fact the majority of Black lesbian literature is performed rather than published,

giving their expression a unique essence.[42] The ultimate intention hooks clarifies is not so much to move into the centre but to cling to the marginal space which nourishes the capacity and imaginative impetus with which to resist. It offers the unique perspective from which to observe and imagine an alternative reality.[43]

> The writers of the Harlem Renaissance did not wish to be located and ghetto-ised as ethnic artists only able to speak on behalf of a marginal experience confined and immured in the past, locked out of the claim to modern life. What they said was, the experience of Blacks in the new world, their historical trajectory into and through the complete histories of colonisation, conquest, and enslavement, is distinct and unique and it empowers people to speak in a distinctive voice.[44]

There is something to say about this 'strategic marginality', that is maintaining a privileged position of perception and the analytic tools with which to launch criticism. However, it can be said that the ideal intention is to achieve both: to become central and yet retain the privileged position of marginality. A plausible example of this duality is evident in the work of poet-performer Adisa, who employs his poetry in children's workshops in some British schools to supplement the educational process. His emphasis is less on the teaching of poetry and more on what poetry has to teach the individual. He utilizes poetry to increase young people's understanding and awareness of the world, to increase their quality of life and in turn the quality of their contribution to society.

> The individual using the artistic expression of poetry whether five or sixty-five, who writes or speaks about the details of everyday living, and shapes them by matching sound and sense will develop a strong sense of self. After all words are tools used to externalise experience. When in our poetry workshops we get our children looking for relationships and correspondences, evolving similes and metaphors, what we really are doing is helping to exercise and develop that faculty of the imagination on which artistic, scientific and technical progress depend. Surely this is what education is all about.[45]

Similarly, performance poetry is used in the curriculum at an Historically Black College/University (HBCU) in the United States.[46] Professor Janet DeCosmo success-fully uses performance poetry, both on audiotapes and in print, to provoke under-graduate students' interest in their own history and culture as descendants of Africans, as well as a means through which to introduce them to issues and concepts they might not otherwise have been inclined to think about. Professor DeCosmos shows how the poetry is helpful to understand the way history and poetry are conceptualized, the Western capitalist/imperialist system, secular Calvinism and Social Darwinism, pan-Africanism, issues of identity and race (in light of the effects of neo-colonialism and eurocentrism), women's issues, nature and the universal feelings of alienation, root-lessness and homelessness in modernity.[47] Using dub poetry, a marginal art form, to explicate universal issues, alludes to its power and potential to permeate the centre and locate a justifiably appropriate position there.

Exploring performance and the creative productions from this marginal space then allows the possibility of entering into people's own discourse about their social world.

Moreover, by attending to what people say about themselves through the compelling and immediate refraction of performance poetry, we can gain insight into how people locate themselves in society. Texts like this can lead into the core of a community's self-conception and, in this case of a 'marginalized' community, the ways in which Afro-Caribbeans actively engage their marginality by reinterpreting, revisioning and even empowering their historical 'exclusion', and developing a counter-modernity.

> It is a vernacular modernity, it is the modernity of the blues, the modernity of gospel music, it is the modernity of hybrid Black music in its enormous variety throughout the New World. The sound of marginal peoples *staking a claim* to the New World.[48] (*emphasis added*)

Interpreting cultural texts which engender meaning as such requires the already recognizable ideological shift in anthropological analysis: that is, the move from the paradigm parallel to dissecting an organism, diagnosing a symptom, deciphering a code, or ordering a system – the dominant analogies in contemporary anthropology – to that paradigm of penetrating literary text.[49] Texts such as performance and orature which gauge this counter-modernity offer new conduits for further cultural penetration. As explained before, the social atmosphere from which these texts emerge do not provide mere 'social background' but represent the very condition of their capacity to have meaning. They offer a way into understanding a society's system of ideologies and world view. However, simultaneously, they are forms of art with their own specific gravity and appeal, and their own manner of existing as texts. What they tell us about a society they can only articulate through their particular textuality and form.

This interpretivist approach to the culture is most affiliated with the work of Clifford Geertz (also other influential writers such as Victor Turner, Mary Douglas and Edmund Leach, to name a few) who embrace culture as an ensemble of texts and its capacity to produce meaning. In approaching the Balinese cockfight,[50] Geertz proposes that popular cultural forms can be 'read' in the same way a critic reads *King Lear* as text – and furthermore, that the literary interpretation is meant audaciously to create an opportunity for the 'Balinese to think and rethink and feel and feel again what being Balinese means'.[51] However, a grave danger in the interpretation of the cockfight, say, in this way, is its understanding as a grand metaphor for social organization.[52] Geertz apparently does not explore the cockfight from other perspectives, including the view of women who are excluded from it, or what the Balinese themselves imagine the cockfight to be about, and his work is criticized as being 'less a disquisition on Balinese cockfighting, subjectively or objectively understood, than on interpreting – reading – cultural data.[53]

Throughout this investigation, performance poetry is taken as a locus, a condensed embodiment of strategic elements which are employed by Blacks in the diaspora to gain power and fashion an identity politics. It does not profess to represent Black social organization in Britain as much as it provides a refractive lens through which a broader Black ontology is conceived. Furthermore, as oral texts, performance poetry is fully realized only in the moment of and power of performance. Therefore, instead of the temptation to interpret the poetic activity in isolation, as 'reading cultural data', it must be apprehended as a cultural and social process rather than as a fixed pattern, in the full context of orality and performance.

Orality, identity and performance

Afro-Caribbeans, as well as other communities in the diaspora, have managed to preserve this fundamental feature of their heritage, which suggests the real potential of an alternative way of being and mode of thought within a predominantly literacy-based society. This exploration of the contemporary significance of orality does not accept a binary opposition between the two modes of communication as transcendent categories as such. But rather, as Joseph Roach proposes, it rests upon the conviction that they have produced one another interactively over time, and that their historic operations may be usefully examined under the rubric of performance, as manifest in the genre of performance poetry.[54]

Such a mode of communication coexistent within a dominant literate-based society surely implies a particular set of social and value structures and mode of perceptual orientation capable of supporting this alternative modernity or a 'counter culture which reconstructs its own critical, intellectual, and moral genealogy in a partially hidden public sphere of its own'.[55] Jack Goody clearly articulates in his work *The Domestication of the Savage Mind* how differing modes of communication bear significant implications on systems of knowledge, memory, history and world views of a society. Instead of perpetuating the vague 'ethnocentric dichotomies' between primitive and advanced, wild and domestic, myth and history, high and low culture established in the work of Claude Lévi-Strauss, he focuses on the essential features of 'difference' of the human spirit in literate and oral societies.

> In looking at the changes that have taken place in human thought, then, we must abandon the ethnocentric dichotomies that have characterised social thought in the period of European expansion. Instead we should look for more specific criteria for the differences. Nor should we neglect the material concomitants of the process of mental 'domestication', for these are not only the manifestations of thought, invention, creativity, they also shape its future forms. They are not only the products of communication but also part of its determining features.[56]

Goody's work is particularly insightful for encouraging students of the British Afro-Caribbean experience to consider the theoretical possibility of an alternative conception of culture and means of transmitting knowledge, especially within the rubric of performance. If culture itself is a series of communicative acts or an assemblage of texts, the way in which these acts are produced must influence the way people perceive themselves, construct their society and gain knowledge about themselves.

The immediacy of orality, free from the intervention of a book or written medium, creates a direct relationship between oral humans and their surrounding environment through various communicative acts which make the message the medium. This perceptual orientation allows the oral human to be at all times emotionally involved in, as opposed to intellectually detached from, the environment, resulting in a superior sense of community, a heightened 'collective unconscious' and 'collective awareness' of a people's shared existence.[57] Collective identity and knowledge of history, then, are effectively constructed for Black Britons through these acts of creative orature. Oral sources tend not to report events as much as they interpret and give them meaning.

Their value lies in the areas of language, narrative, perception and subjectivity, the very qualities needed to guide identity formation in Black culture.

> The fact is, 'Black' has never been just there either. It has always been an unstable identity, psychically, culturally, and politically. It, too, is a narrative, a story, a history. Something constructed, *told, spoken*, not simply found.[58]

Cultural identity does not lie in the past to be found, but rather is located in the future, to be constructed. The cultural resources which enable people to produce or re-produce identities are 'those historical experiences, those cultural traditions, those lost and marginal languages, those marginalized experiences, those peoples and histories which remain *unwritten*, (emphasis added).[59] To paraphrase Karin Barber, if literary form makes knowledge memorable and therefore transmittable, then all of the inherited knowledge in oral cultures is 'literature'. It is in poetry and narrative, she claims, that history, philosophy and natural science are encoded and through their forms that knowledge is therefore organized.[60] And this is certainly applicable to Black performance poetry in its capacity to sanction the retelling of history and the manner in which Blacks 'are positioned by, and position themselves within narratives of the past'.[61] And if we maintain the notion that the organization of knowledge and perception in the Black diaspora is governed by orature and speech, then one of the significant means of transmitting information and knowledge of the past is through performance.[62]

Social memory and performance

This revisioning of the past through performance is particularly noteworthy because of the paradoxically characteristic 'loss of history' of diasporic Blacks. The very characteristic of the 'migrant condition' of Blacks in Britain, the intrinsic uprootedness and inevitable metamorphosis, alludes to inconsistencies and subsequent reimaginings of history. Because of its ability to re-create and repeat, performance acts as the bridge connecting the past, present and even the future on a temp-oral continuum. The rudiments of role play dictate that, if we are to play a believable, authentic role before an 'audience' of relative strangers, we must produce or at least imply a history of ourselves: 'an informal account which indicates something of our origins and which justifies or perhaps excuses our present status and actions in relation to that audience'.[63] In this light, where for many Afro-Caribbeans being Black in Britain had a considerably different meaning than in their respective host countries, a revised history or counter-narrative had to be performed to 'justify' their presence in Britain and empower this marginalized group in the face of discrimination and racism.[64] In so doing, Blacks contest their marginality by repudiating pejorative images and affirming positive, more diverse Black imagery; by retelling and appropriating history in their terms, and by demonstrating the simultaneous existence of an alternative and potentially contestatory system of knowledge and being, couched in orality and performance.

This re-presentation of the Black self and narrative of modernity is unthinkable without reference to slavery, a symbolic Africa and the subsequent movements, dislocations, migrations peculiar to Black peoples of the diaspora. The system of slavery fostered a complex system of 'incomplete forgetting' which has critically shaped the

ways in which narratives of the past are constructed in diasporic societies today. Its dimensions included the implementation of aspects of 'organized forgetting',[65] the systematic denial of many aspects of African history and culture. Also, it involved ingenious schemes to displace, refashion and transfer the memories of the system, to representations more amenable to those who wielded the 'pencil and eraser'.[66] Moreover, the vast project limited the degree to which the enslaved Africans, who had the greatest motivation to, were able to forget those persistent memories. A society gains its knowledge of human behaviour and activities of the past through a knowledge of traces, that is 'the marks, perceptible to the senses, which some phenomenon, in itself inaccessible, has left behind'.[67] The indelible 'trace' of injustices which have shaped present structures, leaves Blacks to engage in behaviours which, subconsciously or not, are dedicated to transforming those experiences through renewed cultural and performative forms.

> Africa leaves its historic traces amid the incomplete erasures, beneath the superscriptions, and within the palimpsests of more-or-less systematic cultural misrecognition. But diasporic Africa also leaves much more than historic traces; it regenerates the living enactments of memory through orature – and more recently through literature, which now links the perimeter of the circum-Atlantic world (American, Caribbean, African) with lyrics, narratives, and dramas of world-historical prominence.[68]

Re-enacting memory through orature implies a different way of perceiving history and time. It suggests a cyclical mode of thinking as opposed to the linear manner in which archival history is documented. So the very construction of meaningful shapes, and the emergence of details, will be different, as they are inserted in an essentially different kind of narrative home. Both modes of cultural transmission are efficacious in their own ways, but the narratives of the past obviously arise from distinct perspectives, that is, on the one hand, the observer-participant, 'the dancer who has danced the dance' and, on the other, the isolated critical reader of history. Whereas textual knowledge apparently remains intact and fixed over time, the re-enactment of memory alters and metamorphoses depending largely upon cultural context and situation. With this understanding, it is the concept of performance which elucidates the chasm between the two.[69]

What we recognize as performance poetry today derives from the structure and roles of the griot of western Africa, described as 'the living memory, a walking cultural encyclopaedia of his community'.[70] But the contemporary cultural variations do not reflect direct recreations, but represent repetitions of the original 'with a difference'. In Jamaica, for example, performance poetry generally takes the form of dub poetry embedded in reggae *riddims* distinctive of this Caribbean island. Trinidad also sports 'rapso', a version characterized by calypso *riddims*, indigenous to this culture. The performance poetry of Afro-America embraces a jazz-oriented shape, reflecting the familiar groove of the Afro-American sensibility and its cultural development. And in Black Britain, where there is no autochthonous Black cultural repertoire per se, elements are sampled from these other diasporic energies, to create unique and eclectic sounds and patterns, demonstrative of this migrant situation.[71] Over time, many elements of Black American 'works of Blackness' and Caribbean cultural sensibility

have been reaccentuated and reappropriated in Britain. The British poet Levi Tafari alludes to the cultural intimacy and commonality across the Black Atlantic in the following excerpt when he acknowledges the work of the American Last Poets:

> In dhe sixties we had Jazzoetry from dhe Last Poets
> Black Revolutionary
> I can relate to dhat wid Duboetry . . .
> Cos we might be living inna different country
> but dhe struggle is dhe same where ever we may be . . .
> Word Sound and Power come to set we free! Set we free![72]

Cultural form and meaning may change depending upon the socio-cultural environment in which they emerge, but the essential structure remains intact and memory is regenerated. The shared tradition of performance poetry throughout the diaspora signifies its appropriate place in Black identity-formation. There is great importance in the study of Black performance poetry. Even greater are the implications it presents for an understanding of Black ontological behaviour. As a genre heavily imbued with both orality and performative techniques, it embodies a sensory modality capable of evoking strong collective responses, challenging assumptions of historical authenticity, disseminating knowledge and heightening cultural awareness.

Notes

1 Permission has been given by the poets to have their work reproduced in this investigation.
2 Sue Benson, 'Asians Have Culture, West Indians Have Problems: Discourses of "Race" and "Ethnicity" In and Out of Anthropology' (unpublished).
3 Barbara Kirshenblatt-Gimblett, 'Objects of Ethnography', in Ivan Karp and Steven D. Lavine (eds), *The Poetics and Politics of Museum Display* (Washington, DC and London, 1991): 430.
4 David Sutcliffe, *British Black English* (Oxford: Basil Blackwell, 1982): viii. For further reading on this subject see David Sutcliffe and Ansel Wong (eds), *The Language of the Black Experience* (Oxford: Basil Blackwell, 1986).
5 Richard Schechner, 'Ritual and Performance' in Tim Ingold (ed.), *Companion Encyclopaedia of Anthropology: Humanity, Culture and Social Life* (London: Routledge, 1994): 622.
6 Christian Habekost, *Dub Poetry: 19 Poets from England and Jamaica* (Germany: Michael Schwinn, 1986): 13.
7 Ibid.
8 'Dub Poet Like Me!'
9 Habekost, *Dub Poetry (1986)*: 36: 'Like a thief in the dark, he takes me to the place / where he just left / and when he gets me there / he is kicking me to death.'
10 Walter Ong quoted in Paul Beasley, 'Vive la différence! Performance Poetry', *Critical Quarterly* 38, 4, (1997): 28.
11 For further information, contact Martin Glynn c/o Shomari Productions, 1 Blake Lane, Bordesley Green, Birmingham, B9 5QT.
12 See Rex Nettleford, *Mirror, Mirror: Identity, Race and Protest in Jamaica* (William Collins and Sangster, 1970), on the concept of 'marronage', and Henry Louis Gates Jr, *The Signifying Monkey: A Theory of Afro-American Literary Criticism* (New York, 1988).
13 Henry Louis Gates, Jr, 'A Reporter at Large: Black London', *The New Yorker*, 28 April and 5 May 1997 (excerpted in Chapter 14 above).
14 See Ben Sidran, *Black Talk* (Edinburgh: Payback, 1971).
15 Antonio Benítez-Rojo, *The Repeating Island* (Durham, NC and London: Duke University Press, 1992): 10–11.

16 See Richard Schechner, *The Future of Ritual: Writings on Culture and Performance* (London: Routledge, 1993).

17 For further expositions on theoretical approaches to performance and performativity see the following: Schechner, *The Future of Ritual*, Joseph Roach, 'Culture and Performance in the Circum-Atlantic World', in Andrew Parker and Eve Kosofsky Sedgwick (eds), *Performativity and Performance* (New York: Routledge, 1995), and Sue-Ellen Case, Philip Brett and Susan Leigh Foster (eds), *Cruising the Performative* (Bloomington and Indianapolis: Indiana University Press, 1995).

18 See Leroi Jones, *Blues People* (William Morrow, 1976).

19 Paul Gilroy uses this term to refer to a structure of cultural intimacy and exchange built up between the triangular geopolitical spaces which were key points in the trade of sugar, slavery and capital. See Paul Gilroy, *The Black Atlantic: Modernity and Double Consciousness* (Cambridge, Mass.: Harvard University Press, 1994). I would like to suggest too, however, that the cultural exchange extends also to the Black diasporic communities throughout Central and South America.

20 Sidran, *Black Talk*: 26.

21 Benítez-Rojo, *The Repeating Island*: 23.

22 See Sutcliffe, *British Black English* for more on the centrality of proverbs in Black British communities and the striking similarities with African proverbs.

23 Rex Nettleford, *Inward Stretch, Outward Reach* (Hong Kong: Macmillan, 1993): 91–2.

24 Benítez-Rojo, *The Repeating Islands*: 21.

25 Charles W. Mills, 'Smaddifyin', paper presented at Conference of Caribbean Culture, University of the West Indies, Mona, Kingston (May 1996): 14. See also James C. Scott, *Weapons of the Weak* (New Haven: Yale University Press, 1985) and Abner Cohen, *Masquerade Politics* (Oxford, 1993).

26 The term 'Smaddifyin' is a Caribbean Creole term referring to an ontological reality of Caribbean people. At a glance, the word may be translated as 'becoming somebody' in English. Charles W. Mills, in his essay on the concept suggests that: 'it should be thought of as the struggle for, the insistence on, personhood, or, more accurately . . . the struggle to have one's personhood *recognised* in a world where, primarily because of race, it is denied.' ('Smaddifyin'): 2.

27 Sidran, *Black Talk*: xxiii.

28 Interview: Linton Kwesi Johnson Talks to Burt Caesar, *Critical Quarterly* 38, 4 (winter 1996): 76.

29 Nancy Foner, 'The Jamaicans: Cultural and Social Change Among Migrants in Britain', in *Between Two Cultures* (Oxford: Basil Blackwell, 1977): 120–51.

30 Gilroy, *Black Atlantic*: 2.

31 Houston Baker, Jr, Manthia Diawara and Ruth H. Lindeborg (eds) *Black British Cultural Studies: A Reader* (Chicago: University of Chicago Press, 1996): 4.

32 Gates, 'Black London'.

33 Sue Benson argues that it wasn't until the 1970s that an anthropological 'voice' emerged with regards to the question of race relations in Britain with a series of publications produced under the auspices of the SSRC Research Unit on Ethnic Relations at Bristol in the work of Wallman (1979) and Saifulla Khan (1979), and with the publication of James Watson's influential collection, *Between Two Cultures* (1977). None the less, the 'voice' remained fixed in traditional anthropological discourse of cultural boundedness and questions of authentic and inauthentic cultures. See Benson 'Asians Have Culture'

34 Benson, 'Asians Have Culture'.

35 Ibid.

36 Stuart Hall, 'Negotiating Caribbean Identities' (1995): 7.

37 Ngugi wa Thiong'o quoted in Roach 'Culture and Performance': 45.

38 Paul Gilroy quoted in Baker, Jr et al. *Black British Cultural Studies*: 6.

39 Paul Connerton, *How Societies Remember* (Cambridge: Cambridge University Press, 1989): 19.

40 Cornel West, 'The New Cultural Politics of Difference', in *Out There: Marginalization and Contemporary Cultures* (Cambridge, Mass: MIT Press, 1992): 27.

41 See Anna Tsing, *In the Realm of the Diamond Queen* (Princeton: Princeton University Press,

1993) for an exposition on how women, in the making of an Indonesian marginal culture, the Meratus Dayaks, use poetry to express their social position and their views on the hegemonic society.

42 Valerie Mason-John (ed.), *Talking Black: Lesbians of African and Asian Descent Speak Out* (London: Cassell, 1995): 151–86.

43 bell hooks, in *Out There* (1992): 341.

44 Hall, 'Negotiating Caribbean Identities': 11.

45 'Adisa: One Who Makes His Meanings Clear', promotional brochure. Available through Dais Productions, PO Box 12101 London N5 2RQ.

46 Janet L. DeCosmo, 'Reggae in the Classroom: Using Elements from Popular Culture as a Teaching Strategy at an HBCU (Historically Black College/University)', paper presented at Conference for Caribbean Culture at University of the West Indies (May 1996) (unpublished).

47 Ibid.

48 Hall, 'Negotiating Caribbean Identities': 11.

49 Clifford Geertz, 'Deep Play', in Chandra Mukerji and Michael Schudson (eds), *Rethinking Popular Culture* (Berkeley: University of California Press, 1991): 266.

50 Ibid.: 239.

51 Mukerji and Schudson, *Rethinking Popular Culture*: 21.

52 For criticism on Clifford Geertz see Vincent Crapanzano, 'Hermes' Dilemma', in James Clifford and George E. Marcus (eds), *Writing Culture* (Berkeley: University of California Press, 1986); Mukerji and Schudson, *Rethinking Popular Culture*: 22.

53 Crapanzano, 'Hermes' Dilemma': 75.

54 Roach 'Culture and Performance': 45.

55 Gilroy, *Black Atlantic* (1994): 37.

56 Jack Goody (1977): 9.

57 Sidran *Black Talk*: 3.

58 Stuart Hall, 'Minimal Selves', in Houston A. Baker, Jr et al. 'Black British Cultural Studies': 116.

59 Hall, 'Negotiating Caribbean Identities': 14.

60 Karin Barber (1991): 4.

61 Stuart Hall, 'Cultural Identity and Diaspora' in *Colonial Discourse and Post-colonial Theory* (Krauss International, 1978).

62 See Connerton, *How Societies Remember*, who expounds on a similar theme. His main thesis contends that 'images of the past and recollected knowledge of the past are conveyed and sustained by ritual performances and that performative memory is bodily'. See also Barber (1991), and Roach, 'Culture and Performance'.

63 Connerton, *How Societies Remember*: 17.

64 See Gilroy, *Black Atlantic*; and Baker et al., *Black British Cultural Studies*, and Dilip Hiro, *Black British, White British* (London: Grafton Books, 1971).

65 Connerton, *How Societies Remember*: 14.

66 Roach, 'Culture and Performance': 49. The image of the 'pencil and eraser' refers to a Yoruba proverb which states: the white man who made the pencil also made the eraser.

67 Connerton, *How Societies Remember*: 13.

68 Roach, *How Societies Remember*: 50.

69 Connerton, and Roach, 'Culture and Performance': 47.

70 Eugene Lange, *It's in the Mix* (unpublished) and Habekost, *Dub Poetry*: 31.

71 Christian Habekost, *Verbal Riddim: The Politics and Aesthetics of African-Caribbean Dub Poetry* (Cross/Cultures, 1993).

72 Levi Tafari, 'Duboetry' quoted in Eugene Lange, *It's in the Mix* (unpublished).

24

CONVENTIONAL FOLLY
A discussion of English classical theatre

Hugh Quarshie

I had the benefit of early instruction in the conventions that govern casting and inter-
pretation in the English theatre. I was first asked to play Othello when I was fourteen,
and still at school. There were two other Black pupils, but I was honoured to be the
only one asked. *Othello*, as you may know, is the story of a distinguished, Black general
employed by the Venetian government to protect the colony of Cyprus against a
Turkish invasion. He is tricked by a trusted aide into believing that his white wife,
Desdemona, has been unfaithful and murders her in a jealous rage. Of course, I was not
old enough, or experienced enough; nor, as it turned out, was I Black enough. I am
brown-skinned, but the convention holds that Othello is 'black'. Accordingly, the
make-up supervisor, the wife of the physics teacher, ruled that I should be 'blacked up',
literally. But when I kissed Desdemona, the blackness rubbed off on her, and so this
particular convention was short-lived. However, even without the aid of the black face,
I attained a peak of grotesque absurdity with a faithful imitation of the accent Laurence
Olivier used when he played Othello. As I recall, I was highly commended in school
assembly.

It was the theatrical equivalent of a Black man telling *Rastus* jokes. But, at the time,
I was concerned to demonstrate how well I had assimilated the English theatrical
tradition, and its conventions. Such naked idiocy is rare today; but my encounter with
the physics teacher's wife sowed a seed of doubt about some of the conventions and
tastes of the classical theatre.

'Convention' is sometimes used interchangeably with 'rule', 'custom', 'tradition',
'ritual' and sometimes 'cliché'. They all have at their core the idea of a standard pro-
cedure, normal behaviour, common or correct practice. In the case of a convention, a
question of taste is dressed up as a rule of propriety. Clearly, some conventions are
based entirely on historical or doctrinal peculiarities. Why are some priests celibate?
Why do some Jews dress in funereal black? Why do some Muslim women wear veils?
Why do some British pop stars sing in American accents? Why do some theatre
directors argue that behavioural naturalism is anathema to Shakespearian theatre? And
why do so many actors act as if this were self-evidently true?

The text has primacy in the classical theatre, and a style of acting has evolved to
serve it, characterized by vocal mannerisms and affectations. It is still conventional in
the classical theatre to mask regional accents with a notionally 'neutral' accent; except,

of course, when playing peasants or 'rude mechanicals'. Actors and actresses acquire distinctive vocal tones when performing the classics: actors tend to pitch a tone higher, and actresses a tone lower, often with the addition of a *vibrato*.

There is a characteristic over-enunciation of text, which results in a sort of literary literalness: a person sneezes, a writer attempts to render this onomatapoeically, resulting in an actor saying 'ah-choo!'. In a Shakespeare text, 'Is't e'en so' is commonly pronounced to rhyme with 'pristine snow', 'e'er' with 'ear' or 'air'. It seems clear to me that Shakespeare attempted, particularly in his mature work, to evoke the way people spoke and behaved. But a misguided reverence for the written word leads to a vocal and behavioural hybrid encountered only in the theatre.

Of course, behavioural naturalism is itself loaded with conventions and outright clichés: rapid eye movement to signal thought; twitching facial muscles to signal physical tension; whispering hoarsely and staring without blinking to signal menace; stuttering to signal guilelessness or confusion; and cigarette smoking to signal, well, cigarette smoking. This is acting by gestures, and lends itself to parody as readily as classical verse speaking. But in as far as it aims at greater credibility in performance and closer emotional contact between actor and audience, behavioural naturalism should still be our aim. Like the concepts of justice or democracy, it is an elusive and perhaps unattainable ideal for which we should nevertheless strive.

In spite of my lingering doubts, I have worked quite hard to learn the prevailing conventions, if only to demonstrate that I could. But simply proving one's talent, skill and aptitude does not automatically lead to a whole-hearted welcome into the ranks of the classical theatre. When I have played principal classical roles – Hotspur, Antony, Banquo – eyebrows have been raised, heads have been shaken, doubts have been voiced: does it *make sense* for these roles to be played by a Black actor? Were there any Black people in Elizabethan England, let alone in medieval Scotland or ancient Rome?

Such questions arise whenever the historical context of a play is emphasized, and are not easily answered by claiming that Shakespeare himself took huge liberties with history, and that, anyway, 'history' is often no more than myth or self-projection. As Goethe has Faust say:

> Die Zeiten der Vergangenheit
> Sind uns ein Buch mit sieben Siegeln;
> Was ihr den Geist der Zeiten heisst,
> Das ist im Grund der Herren eigner Geist,
> In dem die Zeiten sich bespiegeln.[1]

(Past times are, to us, a book with seven seals; what you call the 'spirit of the times' is really only man's own spirit in which the times are reflected.)

But I contend that even where there is no overt historical context, the conventions that govern classical theatre are themselves historically specific, just as much as they are in classical ballet, or morris dancing. And were a Black man to dance the Nine Men's Morris, an audience might well ask itself 'What is wrong with this picture?'.

But my scepticism about the ruling conventions is not simply explained by race or colour. It may, in part, be a matter of education. Never having been to a drama school, I am largely self-taught as an actor, and therefore have a teacher no wiser than the

pupil. My theatrical education has huge gaps, from Artaud to Zabaleta. I am inclined to question any assertion that poses as a convention or passes as a golden rule. But I am still learning. In part, it is a matter of temperament and taste. There is an enormous appetite in English theatre for acting that looks like acting. At its best, it is called 'bravura'. Otherwise, it is known as 'ham'. Theatre audiences reared on a diet of this theatrical spam have developed a strong sentimental attachment to it, and seem unwilling to change to more nourishing fare. I used to be quite partial to it myself, but have lost the taste for it lately. Perhaps it is less a matter of appetite than of attitude, or aptitude.

In part, it is a generational issue. A younger generation influenced by television and films, particularly American films, lays greater emphasis on the behavioural dimension of character; the older generation on the literary and linguistic aspects. Waiting in the wings of the Royal Shakespeare Theatre for Caesar's triumphal first entrance, under cover of the fanfare, older actors would clear their throats and hum sustained musical notes to warm up their 'instruments'. The younger actors would jog on the spot, do press-ups, stretch their ham-strings and adjust their G-strings. But don't pin too many hopes on the younger generation: if they had had more to say, they too would have joined in the humming chorus.

But it is mainly a matter of faith. I'd like to believe that the arts, especially the theatre, can succeed where religion has failed in bringing socially atomized individuals together, to remind us that what we have in common is of greater value than that which appears to divide us. I do not believe that this is possible under the conventions which govern casting, interpretation and performance in the English classical theatre.

The physics teacher's wife came unbidden to mind in my last season with the RSC, sometimes when I was on stage, but also when I was in the audience. The convention of going to the theatre is as empty and ritualistic as going to church: we may go faintly hoping to get closer to God, Shakespeare or one's fellow man, but not really expecting to. Productions are illustrated essays on the plays, which rarely shed much light on the human condition. It does seem perverse that a supposedly communal event like watching a play can be as solipsistic an experience as a tube train journey.

The classical theatre establishment, embodied in the RSC, imposes a massive authority on forms and meanings. But there is rarely any meaningful discussion about the morality of theatre, and whether there are any commonly agreed first principles. Whom does it benefit? Does the theatre have any social responsibility? Do we need theatre? What is good in theatre? What is the point of theatre when we have film?

As with religion, there is a core orthodoxy against which dissidents take their positions. This orthodoxy has been fashioned over many years by directors, critics, actors and the audiences who can afford to and have the leisure to go to see a Shakespeare play. But in seeking to define an approach to the classical theatre, they confine it. As in religion, the conventional forces of the theatre exclude all but the faithful. Dissidents are commonly dismissed as uneducated or uncultivated, mavericks, *enfants terribles* concerned only to *épater le bourgeois*; but sometimes they are persecuted, as Michael Bogdanov can witness.[2]

A word about English critics. There is a small number of critics who still value theatre as an art more than a business, and who genuinely attempt to increase understanding of the art. But we should not expect too much from the majority: they are performers in their own right, playing to their readers and taking direction from their

arts editors, often having to give instant, ill-considered opinions, passing off subjective prejudice as principled objectivity. They are happier to settle for the *bon mot* rather than search for the *mot juste*. Such critics have more in common with gossip columnists than with art criticism or social theory. And they must bear some responsibility for perpetuating the deadening conventions of 'The Deadly Theatre', described by Peter Brook thirty years ago.[3]

Conventions of meaning and interpretation in Christianity are questioned with increasing urgency as the church is perceived to be increasingly irrelevant to modern consciousness. Shakespearian conventions have persisted longer, perhaps because Shakespeare has not enjoyed the same authority or the power to oppress. Though in Britain, Shakespeare is often put on the same level as the Bible, as in *Desert Island Discs*, when guests are invited to choose one book and one luxury, having already been given the Bible and the Complete Works of William Shakespeare, whether they want them or not.

Religion and theatre merge in the magisterial form of Sir Peter Hall, the Moses of the modern Royal Shakespeare Company, the High Priest of the histrionic arts in English classical theatre. An iambic fundamentalist, he lays down the law with pharisaical severity. This is the law: Feeling must fit the Form: only the five beats in the iambic pentameter can be stressed; respect the caesura but never break a verse line; when a verse line is begun by one character and finished by another, there must be no break in rhythm; if you breathe anywhere, breathe at the end of the line, regardless of punctuation; respect the integrity of the verse line, not the sentence; a monosyllabic verse line must be spoken *largo*, a polysyllabic line *allegro*; the end of the line must have an upward inflection; never shy away from the rhetorical flourish demanded by alliteration and repetition; and you must never cut Shakespeare's text, no matter how incomprehensible or unnecessary it appears to be. For Sir Peter, after a lifetime in the theatre, the rules are not simply heuristic, for the guidance of actors, but must be strictly observed. His aim is to contain emotional vitality within the forms set down by Shakespeare; though I have heard him say that if he had to choose between a badly spoken production full of passion, danger and motorbikes, and a scrupulously well-spoken but lifeless production, he would always choose the motorbikes. As a veteran of his battle with *Julius Caesar*, I wish we had had some motorbikes.

It is desirable that there should be some comprehensive education in the rules of verse speaking and classical acting. If everyone were simply to do their own thing and speak the verse as they felt, it would hardly help to stop the trend towards social atomization. But Sir Peter's rules by themselves do not make for popular theatre, accessible to that crucial audience seeing a Shakespeare play for the first time. By themselves, the rules do not lead to the emotional, psychological and behavioural veracity which a modern, young audience recognizes. Sir Peter has an aesthetic agenda which favours formality over behavioural naturalism in poetic drama. In his production of *Julius Caesar* the characters tended to relate more to the audience than to each other, as if they knew they were in a theatre. His is not a populist agenda.

I believe there was a time when the priority for the RSC was to examine life outside the theatre through the prism of theatre. Under Trevor Nunn, the theatre was a signpost pointing to a non-theatrical reality, in a way which has been characterized as 'humanist'. The aim was to encourage audiences when they left the theatre to think about life not theatre. Under Adrian Noble, the priority now appears to be theatre

itself. The RSC aims to 'create mighty experiences . . . to do poetry, make living the experience that poetic drama can give', as he writes somewhat opaquely in the RSC document *Why We Do What We Do*.[4] This is a theatre which has been described as 'expressionist'; but, in practical terms, it is a theatre where characters do not inhabit environments but actors walk on sets and 'act' rather than 'behave'.

The acting/behaving distinction has been made before. I have heard Ben Kingsley say that you can *act* on stage but you must *behave* on film. Noble has complained that the drama schools teach *behaviour*, not *acting*; so that when young actors join the RSC they have to learn how to *act* the classical roles. Like everybody else, actors vacillate between what they think they are and what they think they ought to be. But under pressure from directors who insist on 'acting', critics who canonize it and audiences who applaud it, it is hardly surprising that actors collude in perpetuating questionable conventions. Like knowing which way to pass the port, the observance of a convention is a sign of theatrical know-how.

The audience has its part to play, as at a wrestling match: everybody knows we're faking it, but as long as we more or less skilfully stick to the conventions, they will boo, hiss, cheer and applaud when they should, and no one gets hurt. This is convention as ritual. Or perhaps it is more like tolerating the incongruous, as when we pretend not to notice a hairpiece on a man's head, even when it is a comically different colour from what remains of his natural hair.

Some conventions are simply good manners and may often be helpful, as the audience keeping quiet when the actors are speaking on stage. But others may encourage a mistaken view of humanity, or, possibly, of Shakespeare. When Portia exclaims, 'I have a man's mind but a woman's might. / How hard it is for women to keep counsel' in *Julius Caesar*, are we to interpret it as an expression of character, a comment by the author, or as a comedic moment, given that the part would have been played by a young man? When spoken by a youth with a five o'clock shadow, such lines acquire a comic edge, as the actor strives to persuade his audience to think of him as a woman. When spoken by an actress, the convention changes from comedic to pathetic, if we recall that this is Cato's daughter and Brutus's wife, who has earlier said, 'Think you I am no stronger than my sex / Being so fathered and so husbanded?' Had the part originally been played by a woman, I wonder whether she might have told the author in rehearsal, 'I don't think my character would say this'.

There is a story of a certain Black actor who actually did say this in rehearsal for a production of *Othello*. While the other actors suppressed their mirth, the director patiently explained that the character would say whatever Shakespeare had written. I have some sympathy for the hapless actor. I suspect he may have had some difficulty with the line, 'Her name that was as fresh / As Dian's visage is now begrimed and Black / As mine own face.' He may have thought: 'you don't hire Ruud Gullit to play for your team and ignore what he has to say about football; and you don't hire a Black man to play Othello without listening to his experience of living in a white, racist society. Shakespeare would almost certainly have had script conferences with his actors; and if there had been a Black actor in his company, and not just a white actor with a "blacked up" face, Shakespeare would have listened to him and possibly amended the script in light of his comments'. But Shakespeare is dead; and the convention is that he is always right. The actor must put Shakespeare first, and his personal history and political agenda second. And anyway, Shakespeare might well have replied, 'Look, you

arsehole, he's a character, not a racial stereotype.' I wonder whether anyone said that to Laurence Olivier.

Tastes change, but conventions seem to evolve slowly. Tim Robbins wrote recently in *The Guardian* that, when watching Sam Fuller's films, he felt that Fuller had experienced life before putting it on film; whereas with so many other directors, he had the feeling that they had simply seen a lot of other directors' films.[5] It is similarly true of actors. What can young actors bring to a role apart from their enthusiasm, their personality and their training? By the time they graduate, few of them will have any experience of life outside home, school, drama school and the theatre. They are so many Eliza Doolittles learning from directors and older actors about the rules, rituals, traditions, customs, conventions and clichés of the theatre. Learning about life takes a little longer.

In the future, we may be able to experience interactive Shakespeare on a CD-ROM. This will be as solitary an experience as reading a novel. Socially atomized individuals in front of their PCs or digital television sets may be able to cast, light, design and direct their own Shakespeare productions, and possibly even 'act' in them. They can test the old conventions and create new ones. They will not have to cede responsibility for interpretation to anyone. But, paradoxically, this may be good for the theatre; for, if we still go to the theatre, the only convention that will matter is the one defined as 'a coming together', a convention of informed Shakespeare enthusiasts. Then, perhaps, we'll be able to gauge just how much the old conventions obscured our view of Shakespeare and ourselves.

Notes

1 *Faust*, part 1, 'Night' scene between Faust and Wagner.
2 Michael Bogdanov was prosecuted for obscenity in a case brought by Mary Whitehouse following his production of Howard Brenton's *The Romans in Britain* at the National Theatre in 1982. She had objected to a scene depicting the simulated anal rape of an ancient Briton by a Roman soldier.
3 Peter Brook, *The Empty Space* (London: Pelican Books, 1972).
4 *Why We Do What We Do*, Royal Shakeapear Company document.
5 Tim Robbins, *The Guardian*.

RACE, GENDER AND IQ

The social consequence of a pseudo-scientific discourse[1]

Heidi Safia Mirza

A natural state of affairs?

Why does the visible matter so much in this world? Why does everything seem to come down to what we see, to what is skin-deep, to what is on the surface? No matter what anti-racist science says, and it currently says we are all the same, from the same common ancestor 'out of Africa', in Britain young Black people, those marked by physical, phenotypical, external, visible difference – those with dark skin, curly hair, almond eyes, full lips, proud noses – do not enjoy the same opportunities as young white people.

I know this because research shows that 30 per cent of young Black and Asian people are unemployed compared to 12 per cent of white youth – and when they do get a job 20–50 per cent earn under the minimum wage (CRE 1997a). I know this because it is three times harder to get a job interview if you are Asian, and five times harder if you are Black (CRE 1997b). I know that, even though ethnic minorities are more likely to have a higher educational qualification than their white peers, the unemployment rate is twice as high for them (9 per cent) as among similarly qualified whites (4 per cent) (*Guardian*, 4 February 1997).

And the list goes on. Young Black people are four times more likely to be excluded from school (Gillborn and Gipps 1996). They are two and a half times more likely to be stopped by police (*Guardian*, 4 February 1997; see also CRE 1997c). Asians are fifty times and African-Caribbeans are thirty-six times more likely than whites to be the victims of racial violence (Kirby et al. 1997: 200; see also CRE 1997d).

Is this a natural state of affairs? Is this just the way things are? We say we live in a free and equal society, we say we are fair-minded, open. We have noble ideas of equality, that we are all the same, or even, if different that at the very least we are all equal . . . well if this is the case, why does this belief in equality not match the facts of inequality? I am confused by this contradiction, this tension in the difference between what we say and what we do. How do I explain the daily racism that floods my senses when I go about my business of researching in schools or teaching at university. Where does it come from?

I need to understand the origin of the words of teachers when they tell me, 'These

Black girls have absolutely no motivation . . . most of them will never succeed . . . they are just unable to remember. They can't make it at this level never mind what is demanded in higher education.' I need to understand the origin of the thoughts of a university professor who says, 'Black men take up so much space, I'm not being racist – I mean no offence . . . but they are so big, when we are all in the same room I can't possibly tell them what to do . . . they might react.' What does it mean when a woman of God, a Catholic nun, a teacher in a school, says, 'You can't have a sports day, things just wouldn't be fair. All the Blacks will win the prizes and that would cause trouble.' What propels a well-known 'African expert', an anthropologist, to say to me, 'Africans haven't reached our levels of education yet . . . their writing isn't as good, so I make allowances in publishing their work. I don't apply the same standards.' How do I explain the motivation of a primary teacher who says to a young Black child that she's been cheating when she gets all her sums right? Where do the monkey noises come from when a Black boy enters a classroom? Who ignites the fire of hate which burns in the letter box of an Asian pensioner? Who ties the laces of the boot that chases a young Black mother and child down a dark alley? I need to know.

The racial discourse in which we are so deeply embedded is a confusing moral maze. On the one hand there is colour-blindness, a deracialization of the discourse. No one wants to speak of difference, though it is one of the most observable phenomena in our global fast, mixing and matching world. Colour-blindness is the polite language of race (Williams 1997). It is not polite to see the physical differences. In its well-meaning false optimism it proclaims, 'we all the same under the skin'. It says, 'some of my best friends are . . .' It hears all our children sing, 'we are the world, we are the children', as they hold hands and float up to the sky in a cloud of peace and love. 'We're all human', it says, ignoring the realities of racism and social divisions.

Shit through a letter box, 'it's only youthful high spirits'. Sorry we have no seats left, 'you're being oversensitive'. They won't give me a job, 'you're imagining it, my dear'. But when I look there is no chip on my shoulder.

But the Catch-22 of colour-blindness is that while it wants to distance itself from biological essentialist racism – that overt racism that preys on physical difference – it does not challenge racism. In so doing it maintains the status quo, it validates inequalities, which in turn fuels the arguments of biological racism.

On the other hand we are told we are all different. We are encouraged to celebrate our differences. Revel in our multicultural diversity. Be ethnic and interesting. Be tolerant of our differences. Put on our saris, and dance the dance of the exotic and desirable, because in this melting pot, in this world of colour and spice, aren't we after all different but equal? But when we celebrate these differences, when our backs are turned in pleasure, the worm crawls out from under the stone. The voice of racism whispers, 'of course you are different, culturally different, nationally different, inherently different, essentially different. Difference is in the blood. Being British is in the blood. Blacks can't be British – we know, we've given them the "cricket test".'[2]

In the postmodern world of difference we talk of foreigners, Englishness, aliens. Cultural boundaries are drawn around who belongs or not. The way you speak, the way you look, the way you dress, it is in the blood. It is obvious, you cannot learn to become what you are intrinsically not! In these boundaries, within these paper walls of difference, racial hatred breeds – harassment flourishes. What Gayatri Spivak calls chromatism (Fuss 1989: 92), and Frantz Fanon 'epidermalization' (Hall 1996: 20) –

the inscription of race on the skin – lingers under the cloak of culture. Both Black and white are caught in the drama.

But where does the drama start? I need to know. The question I want to ask is this: Why is there a lingering desire among us to name racial and cultural difference as in the blood, in the genes, as natural? I want to know whether the dangerous words of the marginal racist pseudo-scientists with their biological theories keep alive popular arguments of innate sexual and racial inferiority. I want to know whether their access- ible commonsense explanations of social difference reflect or play on public ideas and beliefs about racial difference.

Ruth Frankenberg in her excellent book *White Women, Race Matters* (1993) a book about the social construction of whiteness, that invisible but powerful position of normative race privilege – argues that ontological, essential biological difference, a discourse that dominated race thinking for more than five hundred years, is still an absent presence. She explains, because biological racism marked the inauguration of race as meaningful difference, contemporary commonsense articulations about racial identity, whether culturally constructed or not, still have to engage with it. She writes:

> Essentialist racism has left a legacy that continues to mark discourses on race and difference in a range of ways. First precisely because it proposed race as a significant axis of difference, essentialist racism remains the benchmark against which other discourses on race are articulated.
>
> (Frankenberg 1993: 139)

I would agree, but would like to take this one stage further. I want to argue that biological racism is more than a term of reference for the manifestations of our con- temporary racial discourse – manifestations such as anti-racism, colour-blindness or cultural racism. Because biological racism has not been exorcized from our vocabulary, from our mental maps, our ideas of 'them and us', essentialist notions of race – those notions of innate inherent difference – remain intact. I want to suggest that essentialist thinking actually occupies a far more central and sinister place in our social under- standing of differences than our polite, civilized sensibilities would like to acknow- ledge. Thus despite the apparent 'writing out' of essentialism in the new postmodern academic discourse on identity and difference as a fiction, I would argue good old-fashioned biological racism is alive and well and living in a place near you.

Science fiction: social fact

It is no accident that gender and race, two visible differences, two physical ways in which we are marked as different, have become two characteristics that are firmly linked in the equation of modern inequality. When we crack open the sinister box of the pseudo-science of race and gender, the picture is disturbing: we see a tangled mass of contradictions where cultural prejudice is shaped and honed into scientific fact.

From the mid-nineteenth century, evolutionary biology built fictions, which were woven into narratives of scientific fact (Haraway 1992; Young 1995). At the heart of fictions of empire, of racial superiority and inferiority, were analogies. Such analogies were made between the criminal and shiftless poor, childlike, uncivilized savages and

infantile sexually promiscuous women. Nancy Leys Stephan (1990) tells us of a German scholar of race, who in 1864 claimed:

> the female skull approached in many respects that of the infant, and in still further respects that of the lower races, whereas the mature male of many of the lower races resemble in his 'pendulous belly' a Caucasian woman who had many children, and in his thin calves and flat thighs the ape
>
> (Stephan 1990: 40)

Racial inferiority was attributed to the lower orders of society – the 'dangerous classes'. The racialization of social and class differences within European society were transposed on to exotic different 'other' populations external to European society. Such 'races apart' symbolized all the white civilized male feared he was not. Powerful metaphors which likened the so-called lower races and women to anthropoid apes or children seeped into the logic of science. In an effort to construct human nature, choices were made in the study of human differences. Brains of women were deemed smaller, selectively ignoring that their body weight was also less. The African similarity to apes through measuring the jaw was asserted, ignoring white men's similarity to the animal on the basis of thin lips. In the selective construction of physical data, commonsense analogies were confirmed. Arbitrary relationships were made to seem as 'natural phenomena'. In this way unconscious representations were turned into self-conscious theory. During this time, 150 years ago, Frederick Douglas, the African American philosopher observed:

> When men oppress their fellow men the oppressor finds, in the character of the oppressed, a full justification for his oppression . . . by making the enslaved a character fit only for slavery, they excuse themselves for refusing to make the slave a free man.
>
> (quoted in Gates 1995: 94)

But this was 150 years ago. Surely we don't think like this now? Let us consider how these myths of rationalized racism are given form and shape in twentieth-century racist and sexist pseudo-science. In *The Bell Curve* (Herrnstein and Murray 1994), a best-selling book on race and intelligence in America, we have a prime example of the social construction of a pseudo-scientific discourse. Here, as in their nineteenth-century counterparts, myths, intuition and social prejudice are all laid into the bedrock of so-called scientific method.

In 1994 Herrnstein and Murray, two hereditarian psychologists, unleashed *The Bell Curve*, an 800-page tome of statistical and social analysis. They claimed that high levels of hereditary genetic intelligence correlate with success in school; that high IQ and therefore ultimate job status naturally leads to membership within the 'cognitively entitled' establishment. Logically it follows, in their argument, that low intelligence is the cause of America's immediate and observable social problems, the underclass – those that, because of their culturally deficient behaviour and low IQ would besmirch the social fabric with their poverty, educational failure, unemployment, illegitimacy, chronic welfare dependency and crime.

In a mass of what has since been publicly denounced as statistically unsound and

misleading data (Drew et al. 1995; Fischer et al. 1996; Fraser 1995), Herrnstein and Murray produce a bell curve – the graphic illustration of the normal distribution of intelligence. It is in there, in the curve, that we can find the racial subtext that fuels their agenda. The authors argue that African Americans score on average 15 points lower than whites on IQ tests and that one Black in five scores below 75, the borderline of mental retardation.

Women, poor women of both races, are particularly demonized (Jones 1995). They write: 'going on welfare really is a dumb idea, and that is why women who are low in cognitive ability end up there' (Herrnstein and Murray 1994: 201). In their analysis, unwed mothers are the root cause of everything that plagues the nation. They argue these women produce low birthweight babies with low IQs who will themselves grow up to become chronic welfare recipients and abusive parents: a natural causal cycle, a cycle of poverty, a cycle of deprivation. Their message is plain and simple: don't waste taxpayers' money on affirmative action or educational initiatives, welfare handouts or anti-discrimination legislation – these folks are dumb, culturally and intellectually predetermined, and social spending will make no difference.

For Herrnstein and Murray differences in intelligence and therefore differences in attainment are natural, genetic, ordained by God – each is in their appointed place. Given this natural state of affairs they conclude with the advice that 'It is time for America once again to try living with inequality, as life is lived' (551). In this un-stoppable 'cognitively partitioned society', the poor and dispossessed will naturally be driven to inhabit a different world from the rich, cognitive elite. In their second-class world, Herrnstein and Murray benignly argue that these wretched citizens can create a valued place for themselves in spite of their meagre intellectual gifts.

But in classic pseudo-scientific tradition *The Bell Curve*'s argument confuses observation with explanation, it muddles selective correlation with purposeful causation. Here in the world of pseudo-science, socially constructed difference becomes hardened into ideological fact from which biological truths are then exacted. Like their nineteenth-century counterparts, Herrnstein and Murray take commonsense observation and culturally, racially biased intuition as a so-called self-evident truth and then seek to verify their beliefs statistically. Social prejudice becomes scientifically legitimated. The narratives of 'truth' they weave appear organic, natural, until fiction becomes fact. But, like their nineteenth-century counterparts, what Herrnstein and Murray choose to leave out is more telling than what they choose to put in.

In Herrnstein and Murray's racist pseudo-science they choose to tell us that intelligence is more important than socio-economic status in determining jobs. But they choose not to tell us that IQ rises with educational opportunities, nutrition and environment (Fischer et al. 1996; Gardner 1995). Herrnstein and Murray choose not to tell us that IQ and eventual social success appear to go together because both are consequences of other causes. For example, family background rather than IQ is the overwhelming reason why an individual ends up with a higher than average income. Strong performance on IQ is simply a reflection of a certain kind of family environment and access to certain types of schooling. Thus a correlation may appear near-perfect intuitively, such as IQ and social success, but have little or no causal relation. In an effort to show that statistical correlation is not the same as causation, Stephen Jay Gould, author of *The Mismeasure of Man* (1981), a relentless critique of pseudo-scientific claims on intelligence, gives an example of a near-perfect correlation between his age

and the expansion of the universe, demonstrating that correlations can be made between anything (see also Kohn 1996: 92).

In racist pseudo-science they choose not to tell us that IQ tests are culturally loaded to measure specialized skills (Rose et al. 1984: 89). Tests measure culturally specific vocabulary. They measure culturally specific class judgements. They measure socially acceptable behaviour. They also embody racial assumptions. In the IQ test I was given and failed when I was ten, I even remember being asked which doll was prettier, when given a choice between a Black doll and a white one.

High IQ scores have a strong correlation with whether individuals were raised in a setting which habituated them to the kinds of mental processes the tests assess (Hacker 1995). One-a-minute multiple choice demands that you have a matrix in your mind that mirrors a multiple-choice format. The very design of the test determines who will do well. IQ tests are not an independent predictor of social success. The varied tests have been standardized to correlate well with school performance. They measure acquired knowledge, not innate intelligence. The notion that they measure intelligence as a fixed potential is simply a justification to validate them.

In racist pseudo-science they tell us that there are greater differences between racial groups than within any one particular racial group (Eysenck 1973; Jensen 1973; Herrnstein and Murray 1994). However, Rose, Lewontin and Kamin in their superb and now classic book *Not in Our Genes* (1984) demonstrate convincingly that geneticists have shown that 85 per cent of all genetic variation is between individuals within the same local population. Only 7 per cent of genetic variation is between the major races. Similarly as Marek Kohn in his book *The Race Gallery* (1996), a meticulous unveiling of racist biological determinism, explains, in any one population the range of differences are so great that no common assumptions can be drawn about the innate capacities of a race. In considering the arguments for African sporting prowess he explains:

> Africans are not all alike . . . Africa encompasses the greatest variability in its human populations. To take visible characteristics alone, the tallest and the shortest people on Earth are found there; as are people with the thickest and the thinnest lips . . .
>
> (Kohn 1996: 82)

In racist pseudo-science they choose to tell us that there is such a thing as innate hereditary general intelligence, called g. g, they tell us, is the general factor of cognitive ability on which humans differ as measured by IQ tests. In fact the whole credibility of racist pseudo-science depends on the very existence of g. But g is no more than a statistical artefact, meaning that it is made up out of thin air (Kohn 1996). g is derived from the factor analysis of dubious IQ test scores. It has been shown to appear and disappear according to manipulation of the data (Gould 1995). Thus pseudo-scientific race studies follow all the apparent precepts of scientific investigation, but here's the catch: the object of their study, g, doesn't exist, it has no external reality. Quite simply, general intelligence upon which their entire science of social and racial difference is based is not a verifiable immutable thing in the head.

Herrnstein and Murray warn that governments should wake up and recognize the correlation between race and IQ as a 'smoking gun', a social timebomb in their midst.

They argue that soon Americans will have a custodial state on their hands, one that will resemble 'a high tech more lavish version of the Indian Reservation' (Herrnstein and Murray 1994: 526). But the relationship between race, IQ and social difference is just a pack of cards, a confidence trick, a house of straw, a puff of smoke, poof!

Popular persuasion

If racist pseudo-science is so clearly the work of the crackpot fringe, whose scientific claims have been globally denounced, then why is it so popular? *The Bell Curve* made the front cover of *Newsweek*. It was on the *New York Times* best-seller list for thirty weeks (Drew et al. 1995). Why were four hundred thousand copies printed in two months? Why do we morbidly crave biological explanations for social phenomena? Why do we yearn to quantify and qualify our differences in essential terms? Why do we still say, 'it is all in our genes'?

We live in a climate when the public love affair with genetic determinism: easy, televisable, reportable, bizarre almost paranormal explanations, seize the public imagination. We like to hear the anecdotal tales of the Minnesota Study of twins, who though genetically similar, but raised apart, end up sharing the same habit of flushing the toilet before as well as after using it (see Kohn 1996: 103). It would seem that this new age of gene science appears to be able to accommodate a new popular version of biological determinism. Our physical visible differences have become popular public spectacle.

In 1997, on the front page of our newspapers we can read that, by extracting the DNA from ancient bones, as the *Guardian* headline announces, 'We're African, No Bones about It' (*Guardian*, 11 July 1997). We are drawn into the unfolding racial drama that this finding has triggered. We can read the counter-claim by racial scientists that this still does not mean we are equal. Pseudo-science has an Ice Age theory that whites have a higher IQ because they had to adapt to the cold. It would appear from their theory that Native Americans and Innuit Indians did not get quite cold enough (*The Times*, 10 August 1997). DNA testing is just no match for pseudo-scientific logic.

We can read more socially acceptable racial theory about the possibility of genes for sporting prowess in headlines about Linford Christie proclaiming, 'Can Blacks Run Faster than Whites?' (*Sun*, 17 August 1993). The racial drama is played out, images are captured in our minds as we can see that with the right cultural opportunities and personal dedication 'white men can also jump' (Kohn 1996: 82–3). Turn on the television, open a newspaper. In a time of AIDs, when public fears are heightened, the public is reassured that there is a gay gene – so don't worry, homosexuality is not contagious. In an age of stress, depression and Prozac, the papers reassure us there is a gene for happiness. In a time of crisis of family values we are even told that there is now a gene for divorce (*Guardian*, 17 June 1997).

In public discourse, the search for the 'truth' about the issue of innate gender differences is reoccurring as front-page news. The received wisdom of sex differences is that cerebrally females live with language in the left hemisphere and males live in the visual-spatial in the right hemisphere. This, we are told, explains why boys are mathematically skilled and more aggressive and hence more successful than girls. In a free society, we are told, gendered job choices are merely a reflection of this innate

psychology, a natural ability. When this 'safe' commonsense wisdom is challenged by the current awareness of female success in schools, it sends the press into a feeding frenzy. It's news! Over the last few years headlines have reported the panic. 'Male Brain Rattled by Curriculum Oestrogen' (*Times Education Supplement*, 14 March 1997). 'Go Ahead Girls Leave Experts with a Mystery' (*Sunday Times*, 22 May 1994). The cause for the fuss is that examination results for GCSE show that girls are outperforming boys in nearly every subject. Girls do well especially in English, where they outperform boys by 15 per cent, but not maths, where the gap is closing but still stands at 2 per cent.

The safe parameters of natural social order are upset by the statistical research showing a closing of the gender gap in educational performance. Research by the Equal Opportunities Commission (Arnot et al. 1996), the Institute of Education (Elwood and Comber 1995, 1996) and South Bank University (Weiner et al. 1997) shows that the difference is due to a complex range of factors that bring girls back into the classroom picture. Changes in exam technique, the move towards more course work and preference and confidence in subject choices all affect educational performance of the different sexes. Changes in school culture together with equal opportunities are making a difference. Thus it is not so much that the boys are failing, as the panicked headlines exclaim, but rather that the girls are beginning, for the first time, to have access to learning experiences previously not available to them socially and materially.

On the surface, in the public discourse on gender differences, the evidence of the influence of policy changes should suggest that biological determinism should be in retreat. But quickly you learn there are never winners. In the cultural war of difference, biological reductionism always finds a new path. It would appear that, in this age of genetic technology, the old gender nature/nurture debate lives on, only now it is a case of old wine in new test tubes. Here the backlash can be witnessed in recent sensational headlines which read, 'X Certificate Behaviour' (*Guardian*, 12 July 1997); 'Genes Say Boys will be Boys and Girls will be Sensitive' (*Guardian*, 14 July 1997). This front-page news reports the latest piece of sexist pseudo-science. Here the universal evidence for women's intuition and social deftness, and men's oafishness and lack of social skills, was deduced from a sample of eighty children with a rare condition, Turner's Syndrome. With Turner's Syndrome the children inherit only one X chromosome rather than the usual XX for girls and XY for boys. What the headline never told us is that this so-called genetic result was deduced from inconclusive test scores calculated from questionnaire data. The questionnaire data included responses from parents who were asked questions like, 'Does your child lack an awareness of other people's feelings?' and 'Is your child difficult to reason with when upset?'. Quite simply, the researchers assert the existence of the physical presence of genes for gender differences from a process of commonsense social deduction from personality questionnaires. Shades of IQ testing: can we call this science?

It would seem that the persistence of racist and sexist pseudo-science is the outcome of a deep underlying tension that marks contemporary society: the tension between the ideology of equality and universal humanity — the foundation of our liberal right-minded thinking — and the continued persistence of material, economic social inequality. Kenan Malik in his masterful and challenging analysis of racial discourse echoes this line of thinking in his book *The Meaning of Race* (1996) when he argues:

The discourse on race did not arise out of the categories of Enlightenment discourse but out of the relationship between Enlightenment thought and the social organisation of capitalism. The disparity between the abstract belief in equality and the reality of an unequal society slowly gave rise to the idea that differences were natural, not social.

(Malik 1996: 225)

I would argue further that this contradiction – an ideology of equality and the social reality of inequality – has opened up a space in the discourse, a festering wound, which has allowed the continued thinking that differences, whether cultural or physical, are innate, fixed and immutable. The 'New Right' have set up shop in this intellectual vacuum, this space of irreconcilable tension. They claim they carry the banner of good sense, they are the courageous vanguards of sensible thinking who are brave enough to speak the unspeakable truth about social difference. Like Herrnstein and Murray, they proclaim, 'the truth will out'. They inform us, albeit regrettably, with deep pathos, that the pseudo-facts of their pseudo-findings propel them to tell the pseudo-truth no matter how much they are beaten back by the waves of political correctness and loony left censorship. Thus the focus on inherent, heritable difference has become a quick fix, an easy explanation, a way of 'blaming the victim' when faced with the material reality of privilege and wealth and racially structured political and economic inequality.

The underclass 'litmus test'

If we were to employ the logic of commonsense pseudo-scientific assumptions about race and gender and let them arrive at their 'natural conclusion', then we would be compelled to find that Black females, those marked by double inferiority of skin and sex, should hardly even register on the intelligence scale. These gendered and racialized nitwits, these wretched beings, who as Herrnstein and Murray suggest are 'really dumb' because of their cultural and social predication to be unwed, single, teenage mothers, should, in their reckoning, be relegated to the dustbin of society.

But you don't have to be a member of the 'crackpot racist fringe' to believe the female-centred pathology of what is considered to be the mainly Black underclass. The unredeeming picture of Black women in Britain and the USA is that of the unmarried lone mother. Scrounging on the welfare, having babies to manipulate and bribe their way into council accommodation. Man haters, man lovers, trying their best, but oh so many babies, not very clever, a drain on society. Such pervasive images seep into our minds when we pass through the decrepit, seething inner city. We pity the poor women trapped in their council flats, those harassed souls who stuff their screaming ungrateful kids into very expensive pushchairs (how *do* they afford those? we ask).

We need a 'War on Poverty,' we are told (*Times Educational Supplement*, 22 July 1997). And as fast as lightning the government's solution is a unified crusade to get single mothers back to work. But haven't they heard, the 'War on Poverty' is not a very novel idea? It has been the rhetoric of empty government vessels in America for years. In 1989, Murray even came to England on a messianic mission to seek out the under-class (Murray 1994). After a few hours on a council estate in Peckham, he declared to the *Sunday Times*, that like the plague the disease of the underclass has spread from America and would, in five years' time, overrun the UK. I understand he has been back

periodically in a blaze of New Right publicity to check on his failing prophecy (Lister 1996).

If I didn't know better, if I was not one of 'them', one of those dumb and hopeless women, I might even be persuaded by the fear produced by the rhetoric of the underclass cancer in our midst. But I was one of them. I did and still do live in the inner city, I went to school in Brixton, I was a teenage mum. I am a lone mother – hey I must be stupid, of course I am, remember I failed my IQ test! But this is just anecdotal evidence, not real research. Anyway, as I am always reminded by those who do not want to upset the comfortable parameters of their social order, 'you are an exception to the rule, not like the others, the one that got away'. But I am not different. It is the myths that structure our ideas of social reality that are the problem. Myths about teenage mothers, who become lone mothers. Lone mothers who cannot read and write, who are themselves poor parents and whose children without love and care go on to join the ranks of the educational under-achievers. That is the unabiding logic, the mythical cyclical causation that lies at the heart of the Black underclass debate.

We need to apply the 'litmus test' to test the salience of these myths. The underclass myths grounded and fuelled by the common sense of racist and sexist pseudo-science. These paper myths that construct a social problem until we all believe it, even though it isn't really there. The litmus test I propose lies in the disclosure of the facts about the Black female condition in Britain. Seeing the world from a different perspective, a Black feminist perspective, rather than the dominant political perspective can produce a very different picture. Let us dip the blood-red paper of the racist pseudo-science claims into the cauldron of the Black underclass debate and see what happens. If the paper turns transparent, if it becomes invisible, vanishes into thin air, then there is no truth to their claims.

First, let us litmus-test the issue of Black teenage mothers. Teenage mothers both Black and white make up less than 5 per cent of lone mothers in Britain (Phoenix 1991). And if lone mothers make up only 14 per cent of all mothers (Reynolds 1997), this leaves the number of Black teenage mothers so small that it is hardly calculable. Research by Ann Phoenix, in her authoritative book on the subject, *Young Mothers?*, shows that teen mothers are not necessarily lone mothers, and many are married. Also teenage mothers are not a breed apart, they make highly rational choices which are not dissimilar from older mothers'. They do not get pregnant to get on to welfare. Poverty is not an aspiration of young people. The litmus paper vanishes in a cloud of dust.

Second, we need to litmus-test the myth of the Black lone mother. To begin, we need to get the numbers of Black lone mothers into perspective. Surprisingly, only 7 per cent of lone mothers in Britain are Black (Reynolds 1997). Again, if lone mothers make up only 14 per cent of all households in the UK we are talking about a very small group of women. So why does the image of the Black lone mother have a larger than life presence? Why do politicians, newspapers and television all ride upon their breaking backs? What the last census shows us is that the Black community (African-Caribbean) suffers from a disproportionate number of lone mothers. Black women are three and a half times more likely than white women to be in a female-headed household (Reynolds 1997). This phenomenon has caused an outcry concerning the crisis of the Black family. The failing Black family we are told, is classically dysfunctional. The weak and marginal male is absent, feckless, lazy and emasculated. He is left to dwindle on the fringes of family life while the domineering matriarch, that insatiable

workhorse, that larger than life 'superwoman', heads the household, pushing all aside in her singleminded, determined quest for self-satisfaction. What a classic pathology! But, oh, what good news for the papers! It has been a central obsession of the Black and white press for some time. It has led to stories of love, hate, rejection, blame, and even, God forbid, mixed marriage!

But the current census figure of 49 per cent of lone mothers within the Black community does not tell us the whole story (Reynolds 1997). Considering the life cycle of relationships, at any one time a significant proportion of these women, in fact 79 per cent actually have a male partner and live in a stable conjugal union (Mirza 1992). In my book *Young, Female and Black* (Mirza 1992), I suggest that the progressive and alternative ideology of seeking compatibility between partners rather than economic security through marriage explains the high incidence of lone mothers among Black families in Britain. In what I have called the relative autonomy between the sexes in Black African-Caribbean families, a woman is allowed a great deal of independence and freedom to determine her own circumstances of work and mothering. Such relative autonomy can be seen as a crisis of family values only if female self-determination is viewed from the seat of a fragile patriarchal familial structure under siege.

I want to make one last point with regard to Black lone mothers. There has been a somewhat shameful silence concerning an important phenomenon associated with the disproportionate number of Black female-headed households – that is the disproportionate incarceration of Black males in prison. Though Black men make up 0.5 per cent of the British population (Mason 1995) they constitute 18.5 per cent of the prison population (Kirby et al. 1997: 200; see also CRE 1997e). What has come to be called Black male absenteeism needs careful analysis before cries of dysfunction fall from the lips of the moral majority. Thus in the matter of the mythical construction of lone mothers, pseudo-scientists fail the litmus test again.

The third myth propelled by popular pseudo-science, the one that completes the circle of deprivation and dysfunction within the underclass, is the myth of Black underachievement. And here, in the analysis of Black underachievement, we find the *pièce de résistance*, the triumph of all triumphs, the ultimate litmus test against pseudo-scientific claims of a deficit Black IQ. Young Black women are relatively successful in education. In my own research I found that Black girls did approximately 6 per cent better than any of their working-class white male and female peers in the same school at GCSE level (Mirza 1992). National statistics show that 47 per cent of young Black women (aged sixteen to twenty-four) are in full-time education compared to 32 per cent of young white women (CRE 1997c); and overall a greater proportion of these young women have further and higher qualifications (53 per cent), than their white counterparts (43 per cent) (Modood et al. 1997). I feel excited, elated, as I search but cannot find those the pseudo-scientists promise me I will. Those with low genetic cognitive ability, those racially and sexually predetermined dumb folk. The pseudo-science litmus test on Black and gendered IQ has failed yet again.

The reason that so little is known about young Black women's success is that Black women fall between two discourses that valorize visible difference separately. On the one hand, there is the feminist discourse with its focus on white women, femininity, marriage and reproduction. And on the other, there is the race discourse with its focus on Black males, aggression, masculinity and exclusions. This dichotomy explains the blind spot – the invisible location that leaves the complex messy and untidy issue of

Black women's success unaddressed. Black female success upsets established clean-cut ways of thinking about race on the one hand, and gender on the other. But let us rupture the fixity of these discourses and sing a new song. It's about time. Black female success must be understood as a process of transcendence, resistance and survival. It must be understood in the context of racism, discrimination and poor conditions. These young women do well compared to their peers in their run-down, poorly staffed, chaotic, failing schools. They strive to do well.

In *Young, Female and Black*, I show how it happens (Mirza 1992). I argue that the young women employ a range of strategic acts which enable them to rationalize their restricted opportunities. Classrooms were no places to learn. Much of the education was custodial, to keep them in off the streets. But the girls worked on their own, at the back of the chaotic classrooms, at home in crowded rooms. Teachers had had enough – 'they have no motivation: they can't learn, send them back', were some of the things I was told by those charged with the responsibility for their minds. But the young women learned to avoid subjects taught by racist teachers. And within those constraints, and without support, they carefully chose subjects that would allow them access to further and higher education.

They would accept the 'realistic careers' they were guided towards as carers, nurses and office workers only because at the end of it all it meant a chance of going to college. They would tell me that it was not that they wanted to be a nurse and clean bedpans like their mums, but that it meant that maybe this would lead to learning, real learning, in an atmosphere of trust and respect. Maybe an access course in social studies, then a diploma in social work, and then several years down the road the ultimate goal, a university degree! They had ingeniously worked out a system of 'backdoor entry' into further and higher education. It was a sad indictment of the pervasiveness of their circumstances that it had become an unspoken norm among the young women that racism would not allow them the normal route into university. Unlike their Black male counterparts, young Black women could move ahead by rationalizing the racist and sexist assumptions of the labour market which, at the moment, has opportunities for low-paid women's work in caring and administration for them to fit into and work their way out of.

The story of the Black struggle to gain access to educational privilege that others take for granted can be told at many levels. Recent statistics for university entrance show that in relation to population size ethnic minorities are overrepresented in the new universities compared to the white population. For example, African-Caribbean students are overrepresented by 42 per cent, Asians by 162 per cent and Africans by 223 per cent. This compared to the white population, which is underrepresented by 7 per cent (Modood and Shiner 1994).

I have also been involved with documenting the growing phenomena of Black African Caribbean community schools (Reay and Mirza 1997). Run by volunteers, and funded by the Black community itself, these schools are mushrooming in churches, empty classrooms and even people's front rooms. We know of sixty such schools in inner London, where over 50 per cent of the Black community lives. In their relentless effort to sidestep the perpetual hum of racism that marks their lives, Black parents are involved in a covert educational movement for change.

The irony is that, no matter what successes are achieved, our sensibilities are swamped daily by talk of Black underachievement. Young Black people are pulled

down and sucked under in the air of pessimism and hopelessness it produces. Teachers, politicians and parents are all caught up in a web of trying to find the cause. Thirty years ago, in the 1960s, experts said that underachievement was caused by low IQ. Twenty years ago, in the 1970s, the explanation was the need for ethnic minorities to assimilate and lose cultural and linguistic markers. Ten years ago, in the 1980s, the multicultural programmes stressed that underachievement was caused by low esteem, and feelings of negative self-worth among Black pupils.

Now, in the 1990s, OFSTED's latest report on the subject, entitled *Recent Research on the Achievements of Ethnic Minority Pupils*, articulates a new take on the debate (Gillborn and Gipps 1996). Underachievement now wears the new clothes of anti-racist post-modern difference. We are told that schools have been colour-blind, differences and diversity must be addressed, racism is to ignore differences. It sounds right, it sounds good. But then, I worry, I think to myself, 'differences ... making distinctions between groups, was that not the cause of all our problems in the first place?' How can we progress out of this moral maze?

Conclusion: the new post-biological syndrome

We call the current way we talk about race the 'cultural discourse on race'. In this discourse, using film, text and autobiography, we focus on identity, representation, subjectivity and the 'discursive effects' of cultural racism. But I want to rethink the cultural discourse on race, as a 'new post-biological discourse' on race. I do this because I believe ideas about innate, genetic, scientifically provable difference are still at the heart of our thinking about race. We need to come back from identity construction and look at the ugly face of scientific thinking straight in the eyes, because that is where commonsense everyday race-hate breeds: the kind of hate that cold-bloodily stabbed Stephen Lawrence, brutally stomped on Quddus Ali, and cowardly suffocated Joy Gardner.[3]

In the late twentieth century it is just the words of the discourse on race that have changed, not the deeds. Culture has become 'biologized', the process being ably assisted by the popular and pervasive work of racial pseudo-scientists, who thrive on turning social inequality into respectable scientific difference. In our polite and civil-ized way, we do not talk of Negroids, Caucasoids and Mongoloids any more. Now in the new culturally acceptable language of race we talk of Asians, Chinese, Africans, Arabs. Sometimes we talk of Muslims, Hindus and Jews. Sometimes we talk of Pakistanis, Somalis, the English, Scottish and Welsh. We give these geographical, regional, religious, national, cultural and ethnic categories meanings – clever at maths, good at sport, 'love' family life, likely to commit crime, fervently irrationally religious, breed like rabbits, downright lazy, sneaky and sly, noble and generous, mean and murderous. And through our systems of classification, official surveys and ethnic monitoring – which ironically we now need to ensure social justice – our differences nevertheless become qualified, quantified, measured and ascertained. Our academic failures, familial patterns and working habits become scientific fact.

In the new post-biological discourse on race, we talk of the inner-city poor and the underclass, welfare mothers, the illiterate and marginal, the dispossessed and the alien-ated, and mean those who are different – behaviourally, culturally and socially innately different from us: us the moral majority. In the new post-biological discourse on race

our civilized sensibilities tell us, 'but surely we don't believe in innate inferiority now, not now, not among us anyway, not here in this room, now that we are approaching the twenty-first century. Not now in this age of science and progress when we can clone a sheep from a single cell,[4] extract DNA from bone two hundred thousand years old.[5] Not when we have the Human Genome Project[6] and the Adam and Eve Project[7] to preserve and protect us from extinction and disease in the future. Now when nano-technology can take us on journeys beneath the skin – where we can see that we are all the same, under the skin!' Or maybe that is why we need biological reassurance more than ever – to reassure us that we are not all the same under the skin.

The spectacle of biological pseudo-science plays out before our very eyes. On the stage we are all the players . . . and whiteness, that silent pervasive, place of power and privilege – 'The Thing' that propels us to dwell on visible cultural Blackness, quietly directs the show. The performance is kept alive by our innermost fears about who we really are. We must be ever vigilant. The logic of racist and sexist pseudo-science has spread through our social bodies like a poison in the blood. It has seeped into our veins, and we can hear it on our lips – it whispers, 'boys are logical, girls are emotional, Blacks are physical'. And while it is not a new discourse on difference it remains omnipresent. Like a vicious dog, its teeth are sunk into the haunches of our minds; it clings on to the fabric of our society. I know I've heard it in the classroom, in the supermarket, on the bus, in the Tube, I've read it in the tabloids. The possibilities of biological determinism still wafts through our minds, limiting possibilities for us all Black and white, male and female to achieve our potential.

Notes

1 This paper is the 1997 Lister Lecture, presented at the British Association of Science, Annual festival of science, University of Leeds, 10 September 1997.

2 In the late 1980s Norman Tebbit, a senior Conservative politician, publicly suggested that an appropriate test of Britishness was which national cricket team a person supported.

3 While many, both Black and white, have lost their lives in needless racial violence (CRE 1997c), these three cases are well known for the mass mobilizations that they evoked. In 1994 Stephen Lawrence, a seventeen year-old African-Caribbean young man, was stabbed while waiting at a bus stop by a group of white youths who have never been convicted. In 1993 Quddus Ali, a young Bengali man, was chased, brutally beaten and permanently disfigured by a gang of white youths in the East End of London, where racial attacks increased by three hundred per cent after the local election of the (facist) British National Party. In 1993 Joy Gardner, a Jamaican woman staying with her British mother, husband and son, was suffocated to death by the immigration police who manacled and gagged her while carrying out an order to deport her. They were found 'not guilty'.

4 On 23 February 1997 Dolly the sheep was introduced to the scientific community and press. The public debate that has ensued raises the ethical issue of human cloning (Observer, 2 March 1997).

5 Advanced DNA tests on Neanderthal bone by German researchers added to one of the hottest issues in the debate on human evolution (see Kohn 1996). Their findings suggest that modern humans are descendants of a common African ancestor and are not related to Neanderthals (Guardian, 11 July 1997).

6 The goal of the Human Genome Project is to draw up a specimen of the entire DNA code for a human being. It originated in 1991 when geneticists came together in an effort to find the clues to the evolution of the human species. Since 1993 the allied Human Genome Diversity Project concentrates on collecting (and controversially patenting) the DNA from blood samples of indigenous peoples before many of them become 'extinct'. However, the intended

subjects of the research do not see it as a benign exercise in demonstrating human unity; instead they see it as one more site of struggle (Kohn 1996).

7 In the mid-1980s the US National Library of Medicine launched a project to digitize and install on the Internet the two 'normal' corpses of a man and a woman. While documenting the external and internal human body in minute detail and thus fixing it in time and space forever, the disruption of boundaries of the body in cyberspace present a new site for old anxieties about origin and reproduction (McClintock 1997).

References:

Arnot, M., David, M. and Weiner, G. (1996) *Educational Reforms and Gender Equality in Schools* (Manchester: Equal Opportunities Commission).

CRE (1997a) *Factsheet: Employment and Unemployment* (London: Commission for Racial Equality).

CRE (1997b) *We Regret to Inform You . . .: Testing for Racial Discrimination in Youth Employment* (London: Commission for Racial Equality).

Commission for Racial Equality (1997c) *Factsheet: Policing and Race in England and Wales* (London: CRE).

CRE (1997d) *Factsheet: Racial Attacks and Harassment* (London: Commission for Racial Equality).

Commission for Racial Equality (1997e) *Factsheet: Criminal Justice in England and Wales* (London: CRE).

CRE (1997f) *Factsheet: Ethnic Minority Women* (London: Commission for Racial Equality).

Drew, D., Fosam, B. and Gillborn, D. (1995) 'Race, IQ and the Underclass: Don't Believe the Hype', *Radical Statistics* 60 (spring/summer): 2–21.

Elwood, J. (1995) 'Undermining Gender Stereotypes: Examination Performance in the UK at 16', *Assessment in Education* 2, 3: 283–303.

Elwood, J. and Comber, C. (1996) *Gender Differences in Examinations at 18+* (London: Institute of Education, University of London.

Eysenck, H. J. (1973) *The Inequality of Man* (London: Temple Smith).

Fischer, C., Hout, M., Jankowski, M., Lucas, S., Swidler, A. and Voss, K. (1996) *Inequality by Design: Cracking the Bell Curve Myth* (Princeton: Princeton University Press).

Frankenberg, R. (1993) *White Women, Race Matters: The Social Construction of Whiteness* (London: Routledge).

Fraser, S. (ed.) (1995) *The Bell Curve Wars* (New York: Basic Books).

Fuss, D. (1989) *Essentially Speaking: Feminism, Nature and Difference* (New York, Routledge).

Gardner, H. (1995) 'Cracking Open the IQ Box', in S. Fraser (ed.) *The Bell Curve Wars* (New York, Basic Books).

Gates, H. L. (1995) 'Why Now?' in S. Fraser (ed.), *The Bell Curve Wars* (New York, Basic Books).

Gillborn, D. and Gipps, C. (1996) *Recent Research on the Achievements of Ethnic Minority Pupils* (London: Office for Standards in Education (OFSTED), HMSO).

Gould, S. J. (1981) *The Mismeasure of Man* (New York: W. W. Norton).

Gould, S. J. (1995) 'Curveball', in S. Fraser (ed.) *The Bell Curve Wars* (New York: Basic Books).

Hacker, A. (1995) 'Caste Crime and Precocity', in S. Fraser (ed.) *The Bell Curve Wars* (New York: Basic Books).

Hall, S. (1996) 'The After-life of Frantz Fanon: Why Fanon? Why Now?', in A. Read (ed.) *The Fact of Blackness* (London: ICA).

Haraway, D. (1992) *Primate Visions: Gender, Race and Nature in the World of Modern Science* (London: Verso).

Herrnstein, R. J. and Murray, C. (1994) *The Bell Curve: Intelligence and Class Structure in American Life* (New York: Free Press).

Jensen, A. R. (1973) *Educability and Group Differences* (London: Methuen).

Jones, J. (1995) 'Back to the Future with the Bell Curve: Jim Crow, Slavery, and *g*', in S. Fraser (ed.) *The Bell Curve Wars* (New York: Basic Books).

Kirby, M., Kidd, W., Koubel, F., Barter, J., Hope, T., Kirton, A., Madry, N., Manning, P. and Triggs, K. (1997) *Sociology in Perspective* (Oxford: Heinemann).

Kohn, M. (1996) *The Race Gallery: The Return of Racial Science* (London: Vintage).

Lister, R. (ed.) (1996) *Charles Murray and the Underclass: The Developing Debate* (London: IEA).

Malik, K. (1996) *The Meaning of Race: Race, History and Culture in Western Society* (London: Macmillan).

McClintock, A. (1997) 'Transexions: Race, Queer and Cyber Crossings', paper presented at *Transformations: Thinking Through Feminism* (Lancaster University, Institute of Women's Studies, 17–19 July).

Mason, D. (1995) *Race and Ethnicity in Modern Britain* (Oxford: Oxford University Press).

Mirza, H. S. (1992) *Young, Female and Black* (London: Routledge).

Mirza, H. S. (1997) 'Black Women in Education: A Collective Movement for Change', in H. S. Mirza (ed.) *Black British Feminism* (London: Routledge).

Modood, T. and Shiner, M. (1994) *Ethnic Minorities and Higher Education: Why are there Differential Rates of Entry?* (London: PSI Publishing).

Modood, T. Berthond, R., Lakey, J., Nazroo, J., Smith, P., Virdee, S. and Beishon, S. (1997) *Ethnic Minorities in Britain: Diversity and Disadvantage* (London: PSI).

Murray, C. (1994) *Underclass: The Crisis Deepens* (London: IEA Health and Welfare Unit).

Phoenix, A. (1991) *Young Mothers?* (London: Polity Press).

Reay, D. and Mirza, H. S. (1997) 'Uncovering Genealogies of the Margins: Black Supplementary Schooling', *British Journal of Sociology of Education* 18, 477–99.

Reynolds, T. (1997) '(Mis)representing the Black (Super)woman', in H. S. Mirza (ed.), *Black British Feminism* (London: Routledge).

Rose, S., Lewontin, R. C. and Kamin, L. J. (1984) *Not in Our Genes: Biology, Ideology and Human Nature* (London: Penguin Books).

Stephan, N. Leys (1990) 'Race and Gender: The Role of Analogy in Science', in D. Goldberg (ed.) *The Anatomy of Racism* (Minneapolis: University of Minnesota Press).

Weiner, G., Arnot, M. and David, M. (1997) 'Is the Future Female?: Female Success, Male Disadvantage and Changing Gender Patterns in Education', in A. H. Halsey, P. Brown and H. Lauder (eds), *Education, Economy, Culture and Society* (Oxford: Oxford University Press).

Williams, P. J. (1997) *Seeing a Colour-blind Future: The Paradox of Race – The 1997 Reith Lectures* (London: Virago).

Young, R. (1995) *Colonial Desire: Hybridity in Theory, Culture and Race* (London: Routledge).

From *Race, Ethnicity and Education* 1, 1 (1998). Reprinted courtesy of Carfax Publishing Ltd).

26

UNDERSTANDING THE POORER HEALTH OF BLACK PEOPLE IN BRITAIN

Revisiting the class and racialization debates

James Y. Nazroo

Introduction

Since the early 1970s ethnic inequalities in health have become an increasing focus of research in Britain. Recently there have been national surveys of variations in morbidity rates by ethnic group (Rudat 1994; Nazroo 1997a; Nazroo 1997b) and the tradition of analysing differences in mortality rates by country of birth has continued (e.g. Harding and Maxwell 1997; Wild and McKeigue 1997). The growth of this body of research reflects, at least in part, a public policy concern with the health of and quality of healthcare provided for ethnic minority groups. Both commissioners of research and those who carry it out intend that it should lead to policy developments that improve health and healthcare provision for ethnic minority groups, but in practice this may not be the case. This is not only because research can be poorly disseminated, or because it may provide unpalatable messages to those concerned with public finance. The research itself may contribute to the racialization of health issues by identifying the health disadvantage of ethnic minority groups as inherent to their ethnicity – a consequence of their cultural and genetic 'weaknesses', rather than a consequence of the disadvantages they face as a result of the ways in which their ethnicity or race is perceived by others.

Class inequalities have also been at the centre of health research for some time, despite attempts to ignore their existence. The importance of class inequalities in health was firmly established by the Black Report (Townsend and Davidson 1982), which came to the conclusion that they were primarily a consequence of material differences in living standards. Given this relationship, it would be expected that the poorer class position of Black people in Britain would adversely affect their health. Until recently, however, with only a few exceptions (Ahmad et al. 1989; Fenton et al. 1995; Smaje 1995), class had disappeared from investigations into the relationship between ethnicity and health in Britain. Instead, work in this field has used as its starting point findings from the now classic work of Marmot et al. (1984). This used a combination of death certificate and census data to show how mortality rates varied by country of birth and occupational class. The findings indicated that class and,

311

consequently, material explanations made no contribution to the higher mortality rates found among those who had migrated to Britain (Marmot et al. 1984). Indeed, among the Black groups, there was no relationship between class and mortality rates for those born in the 'African Commonwealth', and for those born in the 'Caribbean Commonwealth' the relationship between class and overall mortality rates was the opposite of that for the general population – poorer Black people appeared to have lower death rates than richer Black people.

Rather than puzzling over why such an important explanation for inequalities in health among the general population did not apply to ethnic minorities, researchers have simply accepted that different sets of explanations for poor health applied to ethnic minority and majority populations and, that for the minority population explanations were related to assumed cultural and genetic differences. Hence the concern with racialization.

In this chapter, I will tackle some of the issues raised by the class and racialization debates using evidence obtained from the British Fourth National Survey of Ethnic Minorities (FNS). (See Modood et al. 1997; Nazroo 1997a; Nazroo 1997b, for initial reports on this survey.) The FNS was a fully representative survey of ethnic minority and white people living in England and Wales, which was undertaken in 1993 and 1994. The sample consisted of 5,196 ethnic minority people, of whom 1,205 defined themselves as having Caribbean family origins, and a comparison sample of 2,867 white people. It did not include any Africans, because of the difficulties and costs involved in obtaining a sample that was representative of and which adequately reflected the diversity of this group.

The ethnic minority respondents were identified through a process of focused enumeration, which relies on the visibility of ethnic minority people. In brief, it involves randomly selecting addresses to visit, but asking about the ethnicity of people in adjacent households, as well as in the visited household. (See Brown and Ritchie 1981, and Smith 1996, for full details.) Within households that were identified as containing people relevant to the study, one or two adults underwent a structured face-to-face interview conducted by an ethnically matched interviewer. The interview covered a comprehensive range of topics relevant to the lives of ethnic minority people in Britain. These included:

- Household structure
- Type and quality of accommodation
- Employment
- Education
- Income
- Ethnic identity
- Social networks
- Crime and racial harassment
- Physical health
- Mental health
- Health service use

In addition, in an attempt to deal with the difficulties involved in assessing mental health, some of the respondents, whose answers to initial questions suggested the

possibility of a mental illness, underwent a detailed clinical interview undertaken by ethnically matched psychiatric nurses or doctors.

The depth and range of material collected in the FNS makes it a unique resource for exploring the lives of ethnic minority people in Britain and comparing them with the white population. I shall begin by describing differences in the health of Caribbean and white people across a number of the dimensions covered by the FNS. The findings presented here will be compared with those found in other studies. I will then use the FNS to describe the socio-economic position of Caribbean people and how this compares with whites. I will go on to describe the extent of racial discrimination and harassment faced by Caribbeans living in Britain. Finally, I will use the FNS to explore the relationship between socio-economic position and health for white and Caribbean people in Britain. Again I will make comparisons with other studies.

The health of Caribbeans and whites

Respondents to the FNS were asked a range of questions to cover both their mental and their physical health. Findings for key components of these questions are shown in figure 26.1. The differences in health shown in the figure have taken into account differences in the age profiles of the Caribbean and white populations, by statistically adjusting the age of the white population to that of the Caribbean population. This means that the actual number of people in particular illness categories cannot be easily reported (see tables in Nazroo 1997a and 1997b for actual numbers and details of how the rates of illness were estimated). Instead, the comparison between the white and Caribbean populations is done using the relative risk statistic, with lower and upper 95 per cent confidence intervals calculated. The relative risk shown is simply the chance for Caribbeans to be in a particular illness category compared with whites, while the lower and upper limits give a range within which there is a 95 per cent probability that the true difference lies. These comparisons are represented graphically in the

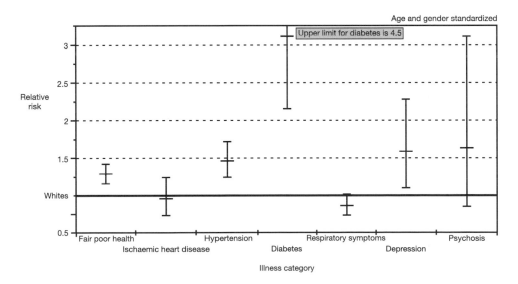

Figure 26.1 Relative risk for Caribbeans compared with whites

figure, with the white group being represented by a solid horizontal line at the value '1', and the Caribbean group being represented by one vertical line for each illness category, with the top and bottom points of the 95 per cent probability range and the mid-point indicated. Differences are statistically significant if the line representing the Caribbean group does not cross the white line.

The first part of figure 26.1 shows responses to a standard question asking for a global assessment of health on a five-point scale ranging from very poor to very good health, with respondents who said that their health was fair, poor or very poor being identified. The figure shows that Caribbeans were almost 30 per cent more likely than whites to rate their health as fair or poor and that this difference is statistically significant. This is consistent with findings from the 1991 census, which included a question on general health, and other investigations of differences in morbidity rates (Nazroo 1997a), but not with studies of mortality rates. These have shown that men and women born in the Caribbean have lower overall mortality rates than the general population (Marmot et al. 1984; Balarajan and Bulusu 1990; Harding and Maxwell 1997; Wild and McKeigue 1997).

The next part of the figure shows differences in rates of ischaemic heart disease. The questions covered both a diagnosis and symptoms (severe chest pain) of heart disease. The figure shows that Caribbeans have a slightly lower rate of ischaemic heart disease compared with whites (not statistically significant). Here the findings are consistent with immigrant mortality rates, which have consistently shown that those born in the Caribbean have lower rates than the general population (Marmot et al. 1984; Balarajan and Bulusu 1990; Harding and Maxwell 1997; Wild and McKeigue 1997).

The findings for reporting a diagnosis of hypertension, a diagnosis of diabetes and symptoms of respiratory illness are also consistent with immigrant mortality rates. Those born in the Caribbean have been consistently shown to have high death rates from diseases related to hypertension and diabetes and similar or lower death rates from respiratory illness compared with the general population (Marmot et al. 1984; Balarajan and Bulusu 1990; Harding and Maxwell 1997; Wild and McKeigue 1997). Here the data show that Caribbeans have an almost 50 per cent higher rate of hypertension and a threefold higher rate of diabetes compared with whites, and that these differences are statistically significant. In contrast, Caribbeans reported lower rates of symptoms of respiratory illness, although this difference is not statistically significant.

The rates for the two indicators of mental illness included in the figure show important differences from previous studies, which have been based exclusively on rates of contact with treatment services. Studies of treatment have consistently shown very high rates of psychosis among Caribbeans (typically three times higher than average, but sometimes even more than that) and lower than average rates of depression among Caribbeans (e.g. Harrison et al. 1988; Cochrane and Bal 1989; Van Os et al. 1996). Findings from the FNS suggest that, in fact, Caribbeans have a 50 or 60 per cent higher rate of both of these forms of mental illness, although differences for psychosis were not statistically significant (and not present at all for young men, who are the group most likely to be treated for psychotic illnesses (Nazroo 1997b)). The significance of this difference between treatment rates and rates of illness in the community will be discussed further later.

Differences in the socio-economic position of Caribbeans and whites

The depth of information collected in the FNS makes it possible to explore socio-economic position in a number of ways. Table 26.1 provides a summary of key elements of the findings from the FNS. It covers four dimensions:

- occupational class of the head of household
- housing tenure, with owner-occupiers divided into those who owned their homes outright and those who had mortgages on their homes
- unemployment and duration of unemployment
- income and standard of living. The indicator of standing of living was designed to reflect both hardship (poor housing or possession of few consumer durables) and wealth (good housing and possession of many consumer durables).

The table shows that across each of these dimensions Caribbeans did significantly worse

Table 26.1 Socio-economic position of Caribbeans and whites

	Caribbean	*White*
Registrar General's Class (%)[1]		
I/II	22	35
IIIn	18	15
IIIm	30	31
IV/V	30	20
Housing tenure (%)		
Owner-occupier with no mortgage	11	23
Owner-occupier with mortgage	41	44
Renter	48	32
Unemployment		
Per cent of economically active unemployed	24	11
Median duration of unemployment (months)	21	7
Income/standard of living		
Average income for non-pensioner households[2]	£259	£343
Per cent of households below half the average income[3]	41	28
Per cent with a 'good' standard of living[4]	23	43

Notes

1 Class was assigned using the head of the household's occupation. When it was not clear which household member was the head of household, class was allocated on the basis of gender (with men's occupations being used in preference to women's) and age (e.g. a father's occupation being used in preference to a son if the father is below retirement age).

2 Total household income from all sources and after tax deductions.

3 Net income adjusted for household size. Although there is no official poverty line in Britain, this is typically considered to be a good indicator of poverty.

4 This includes households with each of:
 - lower than 0.75 people per room;
 - sole access to a bathroom with bath or shower, and an inside toilet, and a kitchen, and hot water from a tap, and central heating;
 - either nine or more consumer durables out of these eleven: a telephone, television, video, fridge, freezer, washing machine, tumble-drier, dishwasher, microwave, CD player, and personal computer; or five or more of these consumer durables and two cars.

than whites. They were much less likely to be in professional or managerial classes (I and II) and far more likely to be in unskilled manual work; they were much less likely to own their homes outright and much more likely to rent their homes; they were much more likely to be unemployed and likely to have been unemployed for considerably longer; they had lower incomes and were more likely to be in a 'poverty' band (more than two-fifths of Caribbeans could be described as living in poverty); and they were much less likely to be categorized as in a 'good' standard of living group. The strength of these findings makes the need for an exploration of the link between health and socio-economic position for Caribbeans even more obvious.

Experiences of racism

A central element of the FNS was an attempt to assess the degree to which the lives of ethnic minority people were directly affected by racism. As part of this, white respondents were asked if they were prejudiced against certain ethnic minority groups. As many as one in five of the white respondents said that they were racially prejudiced against Caribbeans (slightly more for men and slightly less for women) (Virdee 1997). In interpreting this figure, Virdee suggested that the crudeness of the question and under-reporting probably meant that this was an underestimate of the extent of racial prejudice among white people, but that the findings nevertheless indicated that 'a current of racist beliefs is clearly evident among a significant proportion of the white population' (Virdee 1997: 278).

For the ethnic minority respondents to the survey, experience of racial discrimination and harassment was assessed in three ways. First, employed respondents were asked what proportion of employers they believed would refuse someone a job for 'racial' reasons. Almost a quarter of Caribbeans reported that they believed that most employers would do this, while a further 31 per cent said that about half of employers would (Modood 1997). Only 5 per cent of Caribbeans felt that no employers would do this or were unable to answer.

Second, respondents were asked whether they felt that they had ever been refused a job for 'racial' reasons. Among Caribbeans, more than a quarter (28 per cent) said that this had happened to them and of these two-thirds said that it had happened to them more than once (Modood 1997).

Finally, respondents were asked about their experiences of harassment. This included being physically attacked, having property damaged or being insulted for reasons to do with 'race' or colour. Among the Caribbeans, almost one in six (15 per cent) reported such an incident occurring in the preceding twelve months (1 per cent reporting that they had been physically attacked, 2 per cent that they had had property damaged and 14 per cent that they had been insulted) (Virdee 1997). Three-fifths of those who reported racial harassment had been harassed more than once and almost 3 per cent of all of the Caribbean respondents had been harassed five or more times in the last twelve months (Virdee 1997). The degree to which racial harassment is rooted in British culture is indicated by the fact that the perpetrators of such incidents ranged from neighbours to people in shops, though they were predominantly strangers, and that the incidents occurred in almost all areas of the respondents' lives, including work. The fact that the racial harassment faced by Black people is part of their everyday interaction with white cultures was further emphasized by the finding that a signifi-

cant number of those Caribbeans who had been harassed reported that the police were the perpetrators (Virdee 1997).

Impact of socio-economic position on the health of Caribbeans and whites

Figure 26.2 uses data from the FNS to show the relationship between three indicators of socio-economic position and reported fair or poor health for Caribbeans and whites, once differences in age and gender have been taken into account. The measure of health used provides a standard overall assessment, while the indicators of socio-economic position used are similar to those shown in Table 26.1, covering three dimensions. First, occupational class, where a distinction has been drawn between three groups: those where the head of the household is in a non-manual class; those where he or she is in a manual class; and those in households with no full-time worker. Second, tenure, where a simple distinction has been drawn between renters and owner-occupiers. Third, standard of living, which is based on quality of housing and number of consumer durables owned (see Nazroo 1997a for full details).

All three indicators of socio-economic position show a clear and statistically significant relationship with health for both Caribbeans and whites – there is an almost identical pattern for the two ethnic groups – with poorer people having poorer general health. And this finding is mirrored for the more specific causes of ill-health shown in figure 26.1 (Nazroo 1997a; Nazroo 1997b). It is not unexpected to find this pattern for the white group, but, given Marmot et al.'s (1984) findings, it is unexpected for the Caribbean group.

There are a number of reasons why the relationship between class and mortality rates might have been suppressed in Marmot et al.'s data. Most important is that they used occupation as recorded on death certificates to define social class. It is likely that,

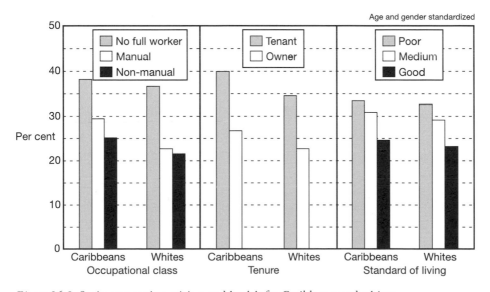

Figure 26.2 Socio-economic position and health for Caribbeans and whites

because of the well-recognized process of inflating occupational status on death certificates (where relatives declare the most prestigious occupation held by the dead person) (Townsend and Davidson 1982), this will have failed to capture the downward social mobility of members of ethnic minority groups on migration to Britain (a process that has been documented by both Smith (1977) and Heath and Ridge (1983)). So, for migrants the occupation recorded on death certificates may well place them in a higher class than that recorded at the census, inflating death rates for those in higher classes and suppressing the relationship between class and health. Interestingly, the most recent analysis of immigrant mortality data suggested that the relationship between occupational class and health for men born in the Caribbean was similar to that shown in figure 26.2, with the risk of death being higher for poorer groups (Harding and Maxwell 1997).

However, both the first two sections of figure 26.2 (occupational class and tenure) and the recent immigrant mortality analysis (Harding and Maxwell 1997) still suggest that the differences in health between Caribbeans and whites remain unexplained by class effects. Within particular class bands, Caribbeans continue to have poorer health. Here, it is important to recognize that important shortcomings remain in the statistics used. The attempt to control socio-economic factors with an indicator such as occupational class ignores how crude this measure is and how it may apply differently to different ethnic groups. In fact, there is an increasing recognition of the limitations of traditional class groupings, which are far from being internally homogeneous. A number of studies have drawn attention to variations in income levels and death rates among occupations that comprise particular occupational classes (e.g. Davey Smith et al. 1990). And within occupational groups, Caribbeans may be more likely than whites to be found in lower or less prestigious occupational grades, to have poorer job security, to endure more stressful working conditions and to be more likely to work unsocial hours. For example, Table 26.1 shows that among owner-occupiers, whites are far more likely to own their house outright, and, among the unemployed, Caribbeans are far more likely to have been unemployed for longer. Consequently, while standard indicators of socio-economic position have some use for making comparisons within ethnic groups, they are of little use for 'controlling out' the impact of socio-economic differences when making comparisons across ethnic groups.

The final section of figure 26.2 (standard of living) supports this conclusion. The measure of standard of living more directly reflects the material circumstances of respondents (see Nazroo (1997a) for full details), and within the particular standard of living bands there is little difference between the health of Caribbeans and whites. Given that this indicator is also not perfect for taking account of ethnic differences in socio-economic position (see Table 5.4 in Nazroo 1997a), such a finding suggests that socio-economic differences, in fact, make a large and key contribution to the poorer health of Caribbeans.

Conclusion

If socio-economic position is such an important predictor of health within ethnic minority groups and makes an important contribution to differences across groups, why have researchers found it so easy to ignore? There is no doubt that this is partly

related to the methodological difficulties in conducting the research. Until recently in Britain, we have had to rely on data provided by immigrant mortality statistics to explain ethnic inequalities in physical health. This presents a number of problems. Significantly, they use country of birth as a surrogate for ethnicity. They also rely on inadequate information on socio-economic position (as described above) and provide a one-dimensional indicator of health by assessing only death rates.

Methodological problems have also hampered investigations into ethnic inequalities in mental illness – they rely on studies of rates of treatment rather than actual rates of illness, which, as shown in figure 26.1, may be very different. The difficulties associated with this have been fully documented (Sashidharan 1993; Sashidharan and Francis 1993), but, to recap briefly, they contain no information about the untreated population, and so are of limited use for a causal investigation. Rooted in Western psychiatric practice, they are unable to account for possible cultural differences in the experience and symptomatic expression of mental distress (Kleinman 1987), and they simply reflect differences in pathways to treatment for different groups, rather than differences in rates of illness. In fact it is well known that, as well as being more likely than any other ethnic group to be hospitalized for psychotic illness, Caribbeans are more likely to be compulsorily treated and to be treated on locked wards. And there is some evidence to suggest that this occurs even though they are no more likely to be aggressive or suicidal prior to admission (Harrison et al. 1989; McKenzie et al. 1995; Davies et al. 1996). It may be that the apparently very high rates of psychosis among Caribbeans are simply a consequence of the ways in which they have been racialized, which leads to them being more likely to be seen to be in need of treatments for psychosis, particularly coercive forms of treatment, just as they are more likely to be imprisoned. The contrasting low rates of treatment for depression among Caribbeans may also be a consequence of such racialization, which leads to stereotypical views of the emotional experiences of Black people.

Methodological difficulties aside, the rationale that lies behind the research is equally significant. There are essentially two motives for undertaking research on ethnic inequalities in health. If we are concerned with the various forms of social disadvantage that ethnic minority groups face, then it is important to consider health. Second, if we are concerned with the causes of particular diseases, then how they are socially patterned provides important clues. If a particular (ethnic minority) group is at greater risk of a particular disease, then something about the attributes of that group must be elevating its risk. Here, the 'untheorized' ways in which ethnic groups are identified in the research process causes problems.

At first sight, ethnicity appears to be an easy tool to use for demarcating groups: when investigating causes of illness, groups can be identified in convenient but crude ways – hence the use of country of birth as a surrogate for ethnicity in much research. However, this process of identifying 'ethnic' groups is not theoretically neutral. For example, in his discussion of the analysis of immigrant mortality data, Balarajan suggests that differences could be due to 'biological, cultural, religious, socio-economic or other environmental factors' (1995: 119). However, these dimensions underlying 'ethnicity' are rarely assessed with any accuracy, if at all, and the search for clues regarding causation is typically done with a focus on the *assumed* genetic or cultural characteristics of individuals within the ethnic (minority) group at greater risk. Consequently, explanations tend to focus on *unmeasured* genetic and cultural factors based

on stereotypes. Theory is brought in surreptitiously – ethnicity, no matter how it is measured, equals genetic or cultural heritage. This then leads to a form of victim blaming, where the assumed genetic and cultural characteristics of the ethnic (minority) group are seen to be at fault and in need of rectifying. The social disadvantage that they face is consequently ignored (Sheldon and Parker 1992). The untheorized way in which ethnic and racial groups are constructed during the research process and the kinds of attributes focused on in interpreting research findings, therefore, raise the concern with racialization mentioned in the introduction.

It is worth illustrating the ease with which this happens with an example. In the conclusion to an important paper that described variations in mortality rates in Britain by country of birth, the authors briefly discussed possible reasons for the higher death rate from hypertension among those born in the Caribbean and Africa, stating:

> As migrants from the Caribbean and from West Africa have not shared a common environment for the past 300 years, a genetic explanation for the susceptibility to hypertension of people of west African descent is likely. The high mortality from diseases related to hypertension in migrants from West Africa does not support the hypothesis that black people in the United States are more prone to hypertension as a result of selective survival of slaves able to retain salt.
>
> (Wild and McKeigue 1997: 709)

This clearly shows the form of reasoning taken by the authors. They consider environmental and genetic explanations to be alternatives when they may well operate synergistically. Second, they arrive at a genetic explanation by excluding other explanations, i.e. any redundant difference between ethnic groups must be a consequence of genetics, even though there is no direct evidence for genetic effects – the assessment of other effects can never be sufficiently sensitive or comprehensive. Third, they envisage environment as operating in the past (over a three-hundred-year period), through natural selection (hence the reference to salt retention and slaves). That is, the environment is important only because over generations it leads to the differential selection of healthy or unhealthy genes in groups with different geographical roots. The contemporary environment of social disadvantage faced by Caribbeans and Africans living in London, and African Americans in the United States, is ignored.

It is of course wrong to imply that cultural or genetic factors are of no use in explaining poor health. How else would we understand the higher rates of sickle cell anaemia (which is a disease with a clearly identified genetic base, although it does not exclusively affect Black people) among Blacks, or how poor Blacks have higher rates of hypertension while poor Pakistanis and Bangladeshis have higher rates of heart disease (Nazroo 1997a)? However, cultural practices and genetic differences need to be directly assessed, rather than assumed. The contexts within which they operate and their association with health outcomes also need to be measured. For example, among those with the sickle cell gene there is great variation in the physical manifestation of the illness. The severity of symptoms appears to be at least partly related to current environmental factors, such as diet and housing, and many of the problems faced by those suffering from sickle cell anaemia are related to the inadequate care that is available to them, which, in turn, is related to the ways in which Black people are perceived in Britain

(Anionwu 1993; Davies et al. 1993; Hill 1994; Atkin and Ahmad 1996). Clearly therefore, other explanatory factors have to be considered in the relationship between ethnicity and health, particularly those related to socio-economic position.

Here, also, it is worth highlighting an important problem associated with much of the analyses on the importance of socio-economic factors to ethnic inequalities in health. Such work commonly presents data that are standardized for socio-economic position – because socio-economic position is regarded as a confounding factor that needs to be controlled out to reveal the 'true' relationship between ethnicity and health. This results in the importance of socio-economic factors becoming obscured and their explanatory role lost. The presentation of standardized data leaves both the author and reader to assume that all that is left is an 'ethnic/race' effect, be it cultural or genetic. This is despite the fact that, as shown above, it is impossible to control out socio-economic effects fully. This also gives the impression that different types of explanation operate for ethnic minority groups compared with the general population. While for the latter factors relating to socio-economic position are shown to be crucial, for the former they are not visible. Differences are then assumed to be related to some unmeasured aspect of ethnicity or 'race', even though socio-economic factors are important determinants of health for all groups.

A number of lessons can be learnt from this. Most important is to avoid reading off stereotypical explanatory factors from the ethnic classification that we have imposed on our data without bothering to assess these factors directly. The ethnic classifications we use do not reflect unchangeable divisions between groups, they have to be understood within their social context. Indeed, ethnicity does not exist in isolation, it is within a social context that ethnicity achieves its significance, and part of that social context is the ways in which those seen as members of ethnic minority groups are racialized. Indeed, as was suggested earlier, one of the most important purposes for undertaking work on ethnicity and health is to extend our understanding of the nature and extent of the social disadvantage faced by ethnic minority groups. Not only is health potentially part of that disadvantage, it is also a consequence. Understanding ethnic inequalities in health raises the need to address them. And if such inequalities are rooted in the wider inequalities faced by ethnic minority groups in Britain, as some evidence suggests (Nazroo 1997a), the impetus must be to address the wider inequalities.

It is also important to acknowledge the limitations of our assessments of socio-economic position and to remember that they do not account for the other forms of disadvantage faced by ethnic minority groups that might play some role in ethnic inequalities in health. For example, the experiencing of racial harassment and dis-crimination, and the geographical concentration of ethnic minority people in par-ticular locations, such as deprived inner cities, may have a direct impact on their health.

Acknowledgement

My current work is supported by a grant from the (UK) Economic and Social Research Council under the Health Variations Programme (L128251019).

References

Ahmad, W. I. U., Kernohan, E. E. M. and Baker, M. R. (1989) 'Influence of Ethnicity and Unemployment on the Perceived Health of a Sample of General Practice Attenders', *Community Medicine* 11, 2: 148–56.

Anionwu, E. (1993) 'Sickle Cell and Thalassaemia: Community Experiences and Official Response', in W. I. U. Ahmad (ed.), *'Race' and Health in Contemporary Britain* (Buckingham: Open University Press).

Atkin, K. and Ahmad, W. I. U. (1996) 'Ethnicity and Caring for a Disabled Child: The Case of Children with Sickle Cell or Thalassaemia', *British Journal of Social Work* 26: 755–75.

Balarajan, R. (1995) 'Ethnicity and Variations in the Nation's Health', *Health Trends*, 27, 4: 114–19.

Balarajan, R. and Bulusu, L. (1990) 'Mortality among Immigrants in England and Wales, 1979–83', in M. Britton (ed.), *Mortality and Geography: A Review in the mid-1980s, England and Wales* (London: OPCS).

Brown, C. (1984) *Black and White Britain: The Third PSI Survey* (London: Heinemann).

Brown, C. and Ritchie, J. (1981) *Focussed Enumeration: The Development of a Method for Sampling Ethnic Minority Groups* (London: Policy Studies Institute/SCPR).

Cochrane, R. and Bal, S. S. (1989) 'Mental Hospital Admission Rates of Immigrants to England: A Comparison of 1971 and 1981', *Social Psychiatry and Psychiatric Epidemiology* 24: 2–11.

Davey Smith, G., Shipley, M. J. and Rose, G. (1990) 'Magnitude and Causes of Socioeconomic Differentials in Mortality: Further Evidence from the Whitehall Study', *Journal of Epidemiology and Community Health* 44: 265.

Davies, S., Modell, B. and Wonke, B. (1993) 'The Haemoglobinopathies: Impact upon Black and Ethnic Minority People', in A. Hopkins and V. Bahl (eds), *Access to Health Care for People from Black and Ethnic Minorities* (London: Royal College of Physicians).

Davies, S., Thornicroft, G., Leese, M., Higgingbotham, A. and Phelan, M. (1996) 'Ethnic Differences in Risk of Compulsory Psychiatric Admission among Representative Cases of Psychosis in London', *British Medical Journal* 312: 533–7.

Fenton, S., Hughes, A. and Hine, C. (1995) 'Self-assessed Health, Economic Status and Ethnic Origin', *New Community* 21, 1: 55–68.

Harding, S. and Maxwell, R. (1997) 'Differences in Mortality of Migrants', in F. Drever and M. Whitehead (eds), *Health Inequalities: Decennial Supplement No. 15* (London: The Stationery Office).

Harrison, G., Owens, D., Holton, A., Neilson, D. and Boot, D. (1988) 'A Prospective Study of Severe Mental Disorder in Afro-Caribbean Patients', *Psychological Medicine* 18: 643–57.

Harrison, G., Holton, A., Neilson, D., Owens, D., Boot, D. and Cooper, J. (1989) 'Severe Mental Disorder in Afro-Caribbean Patients: Some Social, Demographic and Service Factors', *Psychological Medicine* 19: 683–96.

Heath, A. and Ridge, J. (1983) 'Social Mobility of Ethnic Minorities', *Journal of Biosocial Science*, supplement, 8: 169–84.

Hill, S. A. (1994) *Sickle Cell Disease in Low Income Families* (Philadelphia: Temple University Press).

Kleinman, A. (1987) 'Anthropology and Psychiatry: The Role of Culture in Cross-cultural Research on Illness', *British Journal of Psychiatry*, 151: 447–54.

McKenzie, K., Van Os, J., Fahy, T., Jones, P., Harvey, I., Toone, B. and Murray, R. (1995) 'Psychosis with Good Prognosis in Afro-Caribbean People Now Living in the United Kingdom', *British Medical Journal* 311: 1325–8.

Marmot, M. G., Adelstein, A. M., Bulusu, L. and OPCS (1984) *Immigrant Mortality in England and Wales 1970–78: Causes of Death by Country of Birth* (London: HMSO).

Modood, T. (1997) 'Employment', in T. Modood, R. Berthoud, J. Lakey, J. Nazroo, P. Smith,

S. Virdee and S. Beishon, *Ethnic Minorities in Britain: Diversity and Disadvantage* (London: Policy Studies Institute).

Modood, T., Berthoud, R., Lakey, J., Nazroo, J., Smith, P., Virdee, S. and Beishon, S. (1997) *Ethnic Minorities in Britain: Diversity and Disadvantage* (London: Policy Studies Institute).

Nazroo, J. Y. (1997a) *The Health of Britain's Ethnic Minorities: Findings from a National Survey* (London: Policy Studies Institute).

Nazroo, J. Y. (1997b) *Ethnicity and Mental Health: Findings from a National Survey* (London: Policy Studies Institute).

Rudat, K. (1994) *Black and Minority Ethnic Groups in England: Health and Lifestyles* (London: Health Education Authority).

Sashidharan, S. P. (1993) 'Afro-Caribbeans and Schizophrenia: The Ethnic Vulnerability Hypothesis Re-examined', *International Review of Psychiatry* 5: 129–44.

Sashidharan, S. and Francis, E. (1993) 'Epidemiology, Ethnicity and Schizophrenia', in W. I. U. Ahmad (ed.), *'Race' and Health in Contemporary Britain* (Buckingham: Open University Press).

Sheldon, T. A. and Parker, H. (1992) 'Race and Ethnicity in Health Research', *Journal of Public Health Medicine* 14, 2: 104–10.

Smaje, C. (1995) 'Ethnic Residential Concentration and Health: Evidence for a Positive Effect?', *Policy and Politics* 23, 3: 251–69.

Smith, D. (1977) *Racial Disadvantage in Britain* (Harmondsworth: Penguin).

Smith, P. (1996) 'Methodological Aspects of Research Amongst Ethnic Minorities', *Survey Methods Centre Newsletter* 16, 1: 20–4.

Townsend, P. and Davidson, N. (1982) *Inequalities in Health* (the Black Report), (Harmondsworth: Penguin).

Van Os, J., Castle, D. J., Takei, N., Der, G. and Murray, R. M. (1996) 'Psychotic Illness in Ethnic Minorities: Clarification from the 1991 Census', *Psychological Medicine* 26: 203–08.

Virdee, S. (1997) 'Racial Harassment', in T. Modood, R. Berthoud, J. Lakey, J. Nazroo, P. Smith, S. Virdee and S. Beishon (1997) *Ethnic Minorities in Britain: Diversity and Disadvantage* (London: Policy Studies Institute).

Wild, S. and McKeigue, P. (1997) 'Cross Sectional Analysis of Mortality by Country of Birth in England and Wales, 1970–92', *British Medical Journal* 314: 705–10.

BLACK BRITAIN'S ECONOMIC POWER, MYTH OR REALITY?

An empirical review and analysis of the economic reality of Black Britain

Karen St-Jean Kufour

Introduction

Britain's 'ethnic minority' community has grown steadily in the postwar era. According to the 1991 census, it totalled just over three million, representing 5.5 per cent of the British population.[1] The 1990 Labour Force surveys (LFS) pointed out that this population was heavily concentrated in the South-East region – with 42 per cent living in Greater London, compared to 10 per cent of the white population. African-Caribbeans in particular are even more heavily concentrated in the south-east, with 55 per cent living in London[2]. The 1991 census also found that 43 per cent of all 'ethnic minorities' living in London born in Britain. A later study found that over half of African-Caribbeans living in London were UK-born (Storkey 1994).

Of the first-generation African-Caribbeans now living in Britain, 36 per cent arrived in the 1950s and 48 per cent during the 1960s.[3] The *Empire Windrush* docked in Tilbury in 1948 with 482 men, mostly colonial servicemen and ex-servicemen returning from home leave or postwar demobilization. The steamer was by no means the first vessel in the postwar period to bring a significant number of Caribbean immigrants to Britain (Spencer 1997). The *Ormond* had arrived a year previously with 110 Jamaicans on board.

The immigrants were glad to leave behind a Caribbean riven by social and political strife, unemployment and a stagnant, hyperinflation economy. After war service in Britain and continental Europe, the men found little to work or hope for in the colony (Phillips and Phillips 1998). Postwar Britain offered new life possibilities.

The birth of the British welfare state coupled with postwar reconstruction created a labour shortage, which the government initially tried to solve by importing labour from continental Europe (Spencer 1997). The mass movement of Caribbean workers occurred as the war decade came to a close. The extent to which the movement was endorsed by the government is now the subject of debate. Popular accounts which position the government as 'actively' recruiting Caribbeans to fill the manpower gaps or conversely, pursuing a singular policy to stop the flow are giving way to a more complex picture of alternating reactions and contradictory tendencies over a

period of time. These range from bureaucratic panic (Phillips and Phillips 1998), racist overeaction (Foot 1965; Solomos 1993), public tolerance and private hostility, which was a deliberate policy of duplicity initiated by Prime Minister Attlee (Spencer 1997), to resistance and containment (James and Harris 1993). Most of the newcomers found low-paid jobs in the factories, in the public services as train drivers and bus conductors, and as auxiliary staff in the hospitals.

This chapter examines how far African–Caribbean dreams have been realized now that the second and third generation of postwar immigrants are full British citizens. It reviews labour market data over the past two decades and examines the varying rates of employment and unemployment and income levels between Black and white Britain. It also assesses the accumulation of capital by Black Britons, particularly in the housing market, and contrasts their standard of living with other 'ethnic minority' groups.

The labour market

A number of studies conducted in the 1980s indicated that unemployment tended to be higher amongst 'ethnic minorities' than whites (Smith 1980; Brown 1984). The 1988–90 Labour Force Survey (LFS) confirmed these earlier views. More recently, the LFS 1990 found that African-Caribbeans, with an unemployment rate of 14 per cent, were twice as likely to be unemployed as their white counterparts. Whilst the rate of unemployment amongst African-Caribbeans was close to the average (13 per cent) for 'ethnic minorities', there was much variation between the different ethnic minority groups – from a low 7 per cent for Chinese people to a high 24 per cent for Bangladeshis.[4]

Unemployment tended to be higher amongst men and more severe amongst the young. This pattern was true across all cultural groupings,[5] but more pronounced amongst the 'ethnic minority' groups. The rate of unemployment stood at 13 per cent for African-Caribbean woman compared to 16 per cent for African-Caribbean men. This compares with 8 per cent for white men and 7 per cent for white women.[6] The figure rocketed to 20 per cent for 'ethnic minority' men in the sixteen to twenty-four age group, nearly double that of white young males.[7] Young African-Caribbeans fared slightly worse than the average 'ethnic minority' youth – 24 per cent for sixteen to twenty-four year-old males and 23 per cent for young females[8]. The lower figure for Black women appear to refute arguments that they face 'double discrimination' in the job market. However, the figures did not reflect trends in the type and level of employment between the sexes.[9]

One of the current paradoxes of the labour market is that even though African-Caribbean women are relatively better qualified than white women and African-Caribbean men, they seem to have made little progress in penetrating male-dominated professions.

Unemployment undermines one of the cardinal aspirations of the immigrant – to find and to keep in employment. For those in work, their location in the economy has remained unchanged for five decades. A report from the Department of Employment in 1990 found a heavy concentration of 'ethnic minorities' in manufacturing, manual work and public sector work (the Health Service, London Transport), the same sectors immigrants were originally recruited into in the 1950s and 1960s. These sectors are

the most severely hit by recession. James and Harris (1993) argue that Caribbean workers were pushed into these sectors – the low and unskilled jobs – when they arrived in Britain because employers were unwilling to recognize skills gained in the Caribbean or train them in new technologies.

Education and the labour force

The Policy Studies Institute (PSI) survey of 1974 and 1982 found that African-Caribbeans achieved a lower educational level than whites. However, the trend is changing. The 1988–90 Labour Force Survey indicated that whilst white men were generally better qualified than 'ethnic minority' men, some 'ethnic minority' groups were better educated. Amongst African men of working-age, 62 per cent were educated to at least A level (or equivalent), compared to 48 per cent of white males. Also 20 per cent of the African men held degrees, twice the proportion of white men.[10] African-Caribbean men were as likely as white men to have completed a trade apprenticeship (11 per cent and 10 per cent respectively). They were less likely to hold a degree (4 per cent compared to 10 per cent).[11]

Black women were the best qualified, with over 30 per cent of them qualified to A level or above. Indeed, African-Caribbean women were the least likely to have no formal qualifications.[12] The 1991 census confirmed that members of some 'ethnic minority' groups were better qualified than the white population. Amongst these groups, many were gainfully employed. The implication here is that the higher unemployment amongst Britain's Black communities cannot simply be a consequence of lower education levels.

Variations in participation rates on the labour market have also been used to explain the differences in unemployment rates, but, as the Labour Force Survey statistics illustrate, white and 'ethnic minority' males exhibit similar participation rates – 81 per cent and 89 per cent respectively. More specifically, African-Caribbean men (together with African Asian and Indian men) had participation rates closer to white men – more so than Pakistani, Bangladeshi and Black African men, whose rates varied between 70 per cent and 79 per cent.[13]

Generally, women have lower participation rates than men, but the rates for both white and 'ethnic minority' women were comparable. Significantly, the data emphasized a stronger economic role for African-Caribbean women. They had the highest participation rate amongst women, at 76 per cent.[14] African-Caribbean and African women, it would seem, also became more active during the pre-retirement years whilst the participation rates for other 'ethnic minority' groups and white women fell. The tendency for participation rates to fall significantly for women with dependants was also not evident amongst African-Caribbean women. This may be due to the existence of supportive family systems within the Black community.

A notable factor affecting Black employment is residential location. Most African-Caribbeans are located in the inner cities, where unemployment is high.

In the London boroughs of Newham, Brent and Tower Hamlets in London, for example, one-third of the population belonged to 'ethnic minority groups'.[15] This concentration is expected to grow, in line with the continuing trend amongst the general population to move out of the inner cities.

Incomes

A study utilizing data for 1982 found that African-Caribbeans earned 15 per cent less than white men.[16] When income comparisons were made within the same job levels and age groups, the gap narrowed but did not disappear. These findings were confirmed by the PSI (1982) survey and later by the Living Standards Survey in 1986.

Data from the Labour Force Survey, for the early 1990s found that the average hourly earnings of full-time 'ethnic minority' workers were 8 per cent less than those of white workers. The PSI survey (1997) confirmed that earnings of African-Caribbeans still lagged behind that of their white counterparts, although the gap was narrowing. In contrast, African-Caribbean women held reasonably good jobs. Their average earnings were slightly higher than that of white women. Pakistanis and Bangladeshis faired worse, with those in work earning two-thirds the wages of white men.

Poverty

Higher rates of unemployment and lower pay for Black Britons result in lower rates of capital accumulation, and in the worst cases, higher rates of poverty. In 1990, the Child Poverty Action Group (CPAG) estimated that 10.5 million people, including 3 million children, were living in poverty in Britain.

The poor, the CPAG found, were getting poorer, evidenced by a fall in their share of income during the 1980s. These findings were confirmed by the Department of Social Security (DSS) in July of the same year. They showed that inequality had widened between 1979 and 1988, and stood at the highest level since the Second World War.[17] Oppenheim (1990) and Frayman (1991) identified the groups most at risk to be single parents and the unemployed, which features a significant section of the Black communities. The fourth PSI study found that more than half of African-Caribbean families were single-parent families. The third PSI study also found that 60 per cent of African-Caribbeans claimed child benefit compared to 34 per cent of white households.

The Runnymede Trust report (1992) examined the relationship between race and poverty and found that many Black Britons fell into what it termed the underclass, experiencing the worst poverty as a result of the cumulative effects of low pay, unemployment and racism (Amin and Oppenheim 1992). A report in 1995 published by the Rowntree Foundation confirmed the link, suggesting that one in every three Black Britons belonged to the poorest 5 per cent of the population compared with 18 per cent of the white population.

Credit

A notable factor in the relationship between Black Britons and poverty, or, more specifically, why many find it difficult to climb out of the grips of poverty, is discrimination in the credit markets. A Policy Studies Institute case study (1996) suggested that many ethnic minorities were cut off from conventional credit lines because of low income, unemployment or single-parent status. Many money lenders also discriminated against the Black communities by avoiding areas known to be heavily populated by them.[18]

A series of interviews carried out with households in Brixton by Herbert and Kempson (1996) found that the pattern of borrowing amongst African-Caribbeans was similar to that of other low income groups – those in work used high-street credit mainly to purchase consumer goods, whilst those out of work made use of the Social Fund, mail order catalogues and money lenders to make ends meet. When the unemployed were able to access high-street credit, they did so through third parties or credit facilities arranged while they were in work.

A significant line of credit for many African-Caribbeans is the informal scheme known as partner.[19] A partner[20] is a group of people who come together to make a regular saving. The banker distributes the total sum – known as 'the hand' – to each member in turn in a prearranged order. The system is informal and based entirely on trust between all the parties. It has its roots in the Caribbean, where it is still popular. In Britain, the dependence on this kind of traditional system is one way in which the Black community has sought to overcome discrimination in the credit markets and the exploitation of unscrupulous money lenders.

Capital accumulation

Despite the Thatcherite capitalist revolution of the 1980s, Black Britons lag behind their white counterparts in terms of capital accumulation – from the basic forms of capital such as home and car ownership to property and share portfolio holdings.

House ownership

In spite of the low capital accumulation within the Black community, levels of house ownership were relatively high. Initially, newly arrived immigrants tended to find accommodation in the private or rented sector of the housing market. However, racial prejudice and discrimination by landlords made this difficult. Thus, once established in work, many African-Caribbeans were keen to move on to more secured housing. Consequently, one of the astonishing facts of Black enterprise is that, by 1974, African-Caribbeans had achieved the same level of home ownership as their white counterparts.[21] Surprisingly, and in contrast to the white population, house ownership was not positively correlated with income. In fact, the proportion of African-Caribbeans buying their own homes was higher than for whites at the same job level.

The 1980s, however, witnessed a dramatic drop. The level of house ownership fell below that of whites. One explanation is that many African-Caribbeans turned to local council accommodation.[22] By the end of the decade, the LFS estimated that home ownership amongst African-Caribbeans stood at 46 per cent compared with 65 per cent for whites.[23] In contrast, house ownership amongst Asians (including African Asians) remained consistently high throughout the 1980s, at over 70 per cent. This is partly explained by the availability of required capital, in some cases accumulated abroad, as in the example of the East African Asians.

At the other end of the housing market, there is a vast amount of data showing a disproportionately high level of 'ethnic minorities' becoming homeless as a result of poverty, or falling through the local council housing net. Research undertaken by the national association of Citizens' Advice Bureaux in 1988 found that Black Londoners were four times more likely to become homeless than whites. A year later, a survey of

twenty-four London boroughs found further evidence of an escalating problem amongst Britain's Black communities. In Newham, for example, Black homeless single people accounted for 56 per cent of referrals to hostels.[24]

Education and self-improvement

The statistics discussed above suggest that numerous gaps exist in the living standards of Black Britons and their white contemporaries. Over the years, however, Black Britons have strived to bridge them. Education is one significant area. Evidence suggests that young Black Britons are more likely than their white counterparts to continue their education after the age of sixteen. The Policy Studies Institute found 56 per cent of Britain's Black sixteen-to-nineteen-year-olds to be in full-time education in the 1988–90 period, compared to 37 per cent of whites. The proportion of African-Caribbeans opting to stay in education beyond the age of sixteen also rose from 26 per cent to 39 per cent for men and from 37 per cent to 48 per cent for women between 1982 and 1990.

The PSI studies concludes that the gaps in the levels of formal qualifications between Black and white are narrowing. Unfortunately, this is not having as much impact on the conventional market as it should. Many Black Britons are opting for self-employment (Aldrich et al. 1981; Ram 1992).[25] By the end of the 1980s, self-employment was more prevalent amongst Blacks than whites. Such a pattern is well recognized and emphasizes not only the entrepreneurial nature of Black Britons (Waldinger et al. 1990)[26] but also a despondency with the conventional mode of employment. But access to loans for Black businesses is a major problem because high-street banks are reluctant to facilitate it. This is less of a problem for businesses run by Asians. Many arrived in Britain in the late 1960s and 1970s with financial capital of their own.[27]

Conclusion

Despite the barriers to advancement, there are areas in which Black Britain continues to strive forward against all the odds. Education is one key area. The commercial sector is another. The so-called 'Black pound' is becoming significant within the British economy, and Black-owned businesses such as in the hair and cosmetics trade and tropical foods are making headway. As imperative consumers, Black Britons are also beginning to be recognized in mainstream advertising and marketing. In sports, fashion and popular music, young Black Britons exert a disproportionate influence on trends. However, unlike the position in the USA, the huge potential of Black culture as a money-spinning commodity in the entertainment industry has not yet been realized.

The relationship between Black Britons and the Caribbean and Africa is also becoming significant to tourist agencies, air carriers and telecommunication companies. Money transfers and remittances are on the up. The purchase of land by the elderly Black British returning to the Caribbean has also been on the increase since the 1980s. In small islands such as Dominica, where availability of good land is limited, this has led to a huge surge in land prices, making a significant impact on construction and other sectors of the local economy.

Notes

1 Skellington (1996).
2 Jones (1996).
3 Ibid.
4 Ibid.
5 Labour Force Survey.
6 Jones (1996).
7 Ibid.
8 Ibid.
9 *The Fourth National Survey* (1997), London: Policy Studies Institute.
10 Jones (1996).
11 Ibid.
12 Ibid.
13 Ibid.
14 Ibid.
15 Skellington (1996).
16 Jones (1996).
17 Oppenheim (1990).
18 Herbert and Kemson (1996).
19 Ibid.
20 This type of rotation savings scheme is known by several names throughout the Caribbean. 'Partner' is the term most commonly used. In Trinidad it is 'Sousou' and 'box' in Montserat.
21 Jones (1996)
22 Jones Ibid.
23 Jones Ibid.
24 Jones Ibid.
25 Jones Ibid.
26 Jones Ibid.
27 Haynes (1997).

References

Aldrich, H. E., Cater, J. C., Jones, T. P. and McEvoy, D. (1981) 'Business Development and Self-segregation: Asian Enterprise in Three British Cities', in C. Peach, V. Robinson and S. Smith (eds), *Ethnic Segregation in Cities* (London: Croom Helm).

Amin, K. and Oppenheim, C. (1992) *Poverty in Black and White* (London: Child Poverty Action Group).

Barrow, F. (1997) *A Dash of Colour* (unpublished).

Berthoud, R. and Casey, B. (1997) *The Incomes of Ethnic Minorities* (London: Policy Studies Institute).

Brown, C. (1984) *Black and White Britain: The Third PSI Study* (London: Heinemann).

Engel, J., Blackwell, R. and Miniard, P. (1995) *Consumer Behaviour* (London: Dryden Press).

Foot, P. (1965) *Immigration and Race in British Politics* (Harmondsworth: Penguin).

Frayman, H. (1991) *Breadline Britain in the 1990s* (London: HarperCollins).

Haynes, A. (1996) *The State of Black Britain*, vol. 1 (St. John's, Antigua: Hansib Caribbean).

Haynes, A. (1997) *The State of Black Britain*, vol. 2 (St. John's, Antigua: Hansib Caribbean).

Herbert A. and Kempson E. (1996) *Credit Use and Ethnic Minorities* (London: Policy Studies Institute).

James, W. and Harris, C. (1993) *Inside Babylon, the Caribbean Diaspora in Britain* (London: Verso).

Jones, T. (1996) *Britain's Ethnic Minorities: An Analysis of the Labour Force Survey* (London: Policy Studies Institute).

Kempson, E. (1996) *Life on a Low Income* (London: Policy Studies Institute).

Mason, D. (1995) *Race and Ethnicity in Modern Britain* (Oxford: Oxford University Press).

Modood, T. (1992) *It's Not Easy Being British: Colour, Culture And Citizenship* (Trentham Books).

Modood, T. and Shiner, M. (1994) *Ethnic Minorities and Higher Education: Why Are There Differential Rates Of Entry?* (London: Policy Studies Institute).

Modood, T., Berthoud, R., Lakey, J., Nazroo, J., Smith, P., Virdee, S. and Beishon S. (1997) *Ethnic Minorities in Britain* (London: Policy Studies Institute).

Oppenheim, C. (1990) *Poverty: The Facts* (London: Child Poverty Action Group).

Phillips, M. and Phillips, T. (1998) *Windrush: The Irresistible Rise of Multi-Racial Britain* (London: HarperCollins).

Runnymede Trust (1992) *Bulletin 1992, 258* (London: Runnymede Trust).

Skellington, R. (1996) *Race in Britain Today*, second edition (Milton Keynes: Open University).

Smith, D. J. (1980) *Unemployment and Racial Minority Groups (London: Policy Studies Institute)*.

Solomos, J. (1993) *Race and Racism in Britain*, second edition (London: Macmillan).

Spencer, R. G. (1997) *British Immigration Policy since 1939* (London: Routledge).

Storkey, M. (1995) *London's Ethnic Minorities: One City Many Communities* (London: London Research Centre).

28

CARNIVAL, THE STATE AND THE BLACK MASSES IN THE UNITED KINGDOM

Cecil Gutzmore

Introduction

To a major extent, violence and open confrontation between what I call the black masses in the United Kingdom and the British state tend now, and in the recent past, to involve what might be called the *cultures* of the black masses.[1] That might be surprising. The explanation might be that we are not confronted by the British state, or involved with the British state significantly in a physical confrontation, or violence-producing context, in our other areas of existence, i.e. at work, precisely because there are already pre-existing forms of control there. The forms of control at work are obviously the organization of the work pattern: the role of supervision, the use of the notion of 'skill', and the trade unions. These are at least some of the significant *control mechanisms* at work. And they function more or less satisfactorily as control mechanisms for black workers except when the latter rise up against the direct effect of racism in the place of work, which has happened in a substantial number of cases, where you get specifically *black industrial action*.

These confrontations, and this violence, around the culture of the black masses, are worth looking at. They have taken place in relation to a number of aspects of black culture. First of all, in relation to *cultural events*. One thinks of the Brockwell incident – riot, affray if you like – as men were certainly charged with affray arising from that incident some years ago in Brixton. It was basically a Bank Holiday crowd, mainly black people. The police came along and tried to do certain things that people objected to and before long stones and bricks and bottles were flying across the park and hundreds of policemen were coming and trying to 'do their thing' in relation to black youths and getting repulsed.

There are other incidents like that. For example, two years earlier, there was the Leeds Bonfire Night incident which led again to an affray charge, and to the trial of several young black people, all of whom, incidentally, got off because the police used illegal violence against them once they got into the police station, and extracted confessions from them which didn't then stand up in court. The Notting Hill Carnival is perhaps the most spectacular of those cultural events that actually led to violent confrontation between the black communities and the state.

In addition to cultural events, *cultural venues* have also attracted violence, or been the scene of this sort of confrontation. I will name a few, and some of you might know them, and some of you might not. But the Carib Club incident, of late 1974, which, again, led to a massive trial – thirteen people charged, twelve with affray; none of them incidentally went down, because, here also, the police, having gone into this place, 'arrested' forty-odd people and randomly selected twelve and then stuck charges on them in the most arbitrary way, couldn't actually defend that case when it came to the reality of the courtroom and evidential proof, when it came to standing up against the quite serious and truthful allegations concerning the level of brutality the police used on the night in question. And similar things have happened in relation to clubs like the Burning Spear, which was in Harlesden, north-west London; like the Four Aces club, which is in north London; like the Mangrove restaurant in Notting Hill. Several bookshops, also in their way cultural venues, have been targets for violence – Bogle L'Ouverture, Unity and so on – although the perpetrators of violence *there* have not been the police, but other elements of the British sub-state violence mechanism.

Then *cultural forms* within the black communities have also been arenas of violence. These have included *dances*, quite ordinary dances; policemen come, and they explode. Blues dances, which are different from dances in the sense that they are heavier, the music tends to reggae, and the people tend to be 'rougher', and when there is an incident the police tend to get knifed – they are just 'rough' and 'tough'. But those things produce violence, as do ordinary *house parties*, like wedding parties. After a wedding – black people tend to have fairly lively weddings which go on late – people drink; the police arrive on the scene, and before long they are in the house bashing people over the head. People resist. These cultural forms, which you wouldn't think lead to violence, have in fact done so between the black communities and the police, over the thirty or forty years of the mass Caribbean emigration to this country.

Finally, *cultural practices*, so called, have produced violence between us and the state, though these practices have been of the most innocuous variety. For example, black youths choosing to walk on the street *jauntily* are subjected to violence from the police. Young blacks walking *in groups* on the street too have been subjected to violence by the police. Blacks choosing to *walk on the street at all* – and I'm not sure that's a cultural practice – have actually experienced violence because police officers come up and say, 'I want to search you'. They're supposed to have reasonable grounds but they can never specify these to the satisfaction of anyone except the participants in their machinery of self-investigation. What constitutes *reasonable* grounds for them is manifestly *unreasonable*; it's the fact that you have dreadlocks, or the Afro, or whatever, or are just in a black skin. And that's sufficient cause for searching blacks. The fact that young blacks choose to walk on the streets well-dressed needs to be explained – so the police think. Since they 'know' that substantial numbers of youths are unemployed, and assume that none of them ought to be able to afford to dress well, and when they do, obviously they must be stealing from somewhere, the 'flash' clothes must have been shop-lifted. The police *do* come up and say, 'Nicely dressed. . .' and, before long, there are three Black Marias and ten police cars, and there's a really heavy scene.

Now, all of those forms and appearances of black culture in this society have attracted at different times and in different degrees at different levels quite brutal responses from the police, who are the *key civil repressive agency of the British state*. But

they also attract violence from organizations like the National Front which can be regarded as *the main manipulator of anti-black non-state political violence within the UK.*

The perspective on carnival

Now, if one takes what has been said so far as a starting point in relation to the Carnival – and you will note that Carnival was mentioned as one of the cultural events that have actually produced violence – then what one is saying, in effect, is that this perspective is to be regarded as a political-theoretical standpoint for the analysis of the Notting Hill Carnival *in general*, and also, *specifically*, for the analysis of the violence in the Carnival in the years 1976 and 1977. What I am proposing to make quite explicit is this: *that there is state repression of what is perceived to be dangerous, or potentially dangerous, or disruptive, or undisciplined culture on the part of the black masses.*

If one takes that as the perspective it would produce a number of tasks, that I shall not take up. The first would be this: to establish, or at least to suggest persuasively, that *cultural repression*, or the physical repression of cultural forms of the masses by the state is, or tends to be, a general feature of the way in which bourgeois states, which might also be racist states, relate to the culture of the masses within the nation state in question.

In other words, it is useful to demonstrate or at least to suggest as persuasively as one can, that it is generally the case that within bourgeois states, which might also be racist states – which indeed tend, in the real world, to be racist states – there is cultural repression of sections of the masses, be those sections black or otherwise objectionable or potentially *threatening*. That's the first thing that would have to be, I repeat, proven, or suggested.

It seems to be that this can be done in relation to the United Kingdom, certainly, since that is the state within which we're actually functioning. Anybody who knows even a little of United Kingdom history will know that, within the urban working class – white in the main – in early capitalist England a whole series of cultural events and practices have in fact been systematically suppressed. (There were blacks here but they were never part of the urban working class, because nobody let them work – Phillips.)

I'm not particularly cultured, in European terms, but I know that, if you look at Hogarth's prints, you will see that he has some quite intriguing drawings to do with events like Southwark Fair which no longer exist. If you check out what they were, you will find that they *were occasions of jollity, mass jollity* on the part of the eighteenth-century urban working class. And you will find, if you ask what happened to those functions and fairs, that they no longer exist because they were systematically suppressed by the British state at different times. The last one to be suppressed by the British state was called the Blaydon Races, which was a northern urban working-class jollification around Newcastle-upon-Tyne. On the last occasion when there was violence, it was suppressed: they simply prevented it happening the next year, after bringing in the 'dragoons' to put down the rioters. There are several other examples of this. Indeed, it is possible, although it is no business of mine here, to analyse in similar terms the battle between so-called 'football hooligans' and the police. Remarkably, what happens to the so-called 'football hooligans' tends not to get noticed at all by the press, or to be glorified as correct. A group of white youngsters set off; when it became rumoured that

they were going to fight another group of white youngsters, the police then assembled at the railway station leading in to the particular town and confiscated the boots, shoe laces, braces and such like things that people actually need to function with – you know, when you're in public – from these youths. And the popular press glorified it. If I were a white working-class person I would really be concerned about this, and it'd actually make me angry. But since I'm not a white working person, it's no concern of mine here, okay?

I just mention it here in passing as an example. So there has been and there still is cultural repression at home by the British state.

There has also been cultural oppression or repression abroad by that state under *colonialism*. A good example actually relates to our present topic. The Trinidad carnival, which is part of the history of the Notting Hill Carnival, started off as a mode of cultural expression by, initially, white people, and then by black people, in Trinidad. Extraordinary efforts went into trying to suppress the carnival in Trinidad in the last and present century. Who was trying to repress it? Precisely the local white representatives of the British colonial state. The elements that were involved included the Church – they objected to people being jolly, in particular to black people being jolly, on Sunday. And so the first thing they did in trying to restrict carnival, historically, was to prevent it happening on Sunday. From the 1830s in fact, they brought in legislation cutting out carnival jollification on the Sunday when it was supposed to take place. This is, incidentally, very well documented in a book by a man called Errol Hill, entitled *The Trinidad Carnival* (Texas University Press, 1972). Now, Hill points out, among other things, that various administrators, governors – colonial functionaries (all white men) – tried, in the 1850s, to suppress the carnival, and came up against physical opposition. There were also riots around the defence of carnival in Trinidad in the 1880s and in the 1890s – physical violence on the street, people actually dying, the *local defence forces* actually being called out. And, I repeat, that's cultural repression by the colonial power – Britain.

Now, they also tried to suppress the drum – would you believe it? – as one of the features of musical cultural expression inside of the carnival event. Indeed they didn't just try to suppress our (African) drums, but when the Indians came to Trinidad, they tried to suppress their drums as well. And several Asians in Trinidad died in defence of the humble drum. Would you believe it? But it actually happened, in that part of the world. Because *men who are oppressors take very seriously the possibility that culture can be used as a vehicle for the organization of protest or rebellion or, dammit, revolution which is the most worrying thing of all for them*. And there is a history of all of that, and of how it happened, and of why it happened. I'm not sure that Hill has got a definitive account, but it's there and should be checked out. The fact is that in the context of Trinidad, as possibly here, I will suggest later, carnival came, for the black masses in that country, to be regarded as a period of freedom during which the maximum cultural expression would be claimed as a 'right'. It was a period, therefore, in which anybody who tried to stand in the way of that was an enemy and *deserved* to be physically cut down; and sometimes literally was. I suspect that that feeling of identification with the carnival as a period of freedom for the black masses represents, although it's not the whole basis, a political defence of the carnival within the United Kingdom. I simply mention that certainly in Trinidad that is how the carnival came to be regarded, and that in the United Kingdom an element of that either carried over from Trinidad or was built up in this context

independently of any Trinidad association. So that, I hope I've managed to suggest at least to some extent persuasively, the state represses culturally and seeks systematically to do so on historic occasion after historic occasion, which either can be or is documented.

Carnival in context: 1958–76

The second task that arises from the perspective that I'm seeking to use is this: *that it would be necessary to show that the experience of the Notting Hill Carnival is precisely such a case of state cultural repression.* And I believe that this can be shown; but it can only be shown within a historical context in this country, and I'll try to establish that context first, before attempting to look at it in some detail.

The starting point for establishing that there has been cultural repression in relation to the Notting Hill Carnival would have to be the Notting Hill race riots of 1958. Why do I say that? Because it seems to me that between 1958 and 1976, the year of the first 'Carnival riot', there were *no major attempts* in Notting Hill by the white community or state to confront or to suppress the black masses as a whole, or indeed systematically to suppress any major cultural activity of the black masses. Unfortunately, that is not to be taken as a plus for the state, as I will show in a moment. The reason is this: in 1958 the black masses responded with strikingly well-organized counter-violence to the manipulators of violence by white sub-state agencies – in that case it was Mosleyite fascists, and people like that. This 'strikingly well-organized counter-violence' has never been properly investigated. What actually happened in Notting Hill, and maybe even Nottingham in 1958, was this: the state defined that *riot* as a 'race riot'. And 'race riot' should mean two groups of people coming out in some sort of equal way and attacking each other. But no 'race riot' ever means that. Usually, it means black people rioting on their own, or well-armed white people attacking black people. And if you check the history of so-called 'race riots' in the United States you will see that's what they always are – either one of those things, never equal groups of people confronting each other. In the Notting Hill situation, what happened was that groups of white thugs, basically, with the approval – tacit and sometimes active approval – of the Metropolitan Police Force, attacked black people in brutal and destructive ways: attacked their homes, put shit through their letter boxes, put petrol through their letter boxes, chopped them up on the street, and so on. This is what happened on British streets in 1958. Black people left their homes to get to work, and never got to work; left their work to get home, and never got home, because they had been chopped up by armed groups of bicycle-chain-wielding or knife-wielding white people. After that had gone on for a little while and a number of isolated black people had got chopped up, it was decided, quite correctly, by blacks in Notting Hill and elsewhere, that they were not going to stand for this. And certainly blacks in the West Indies (and most of the blacks in 1958 were West Indians) have never stood for that sort of violence from anybody. So they organized themselves. And they organized themselves to the extent that they gathered in one house on one occasion with petrol and bottles, and started to prepare petrol bombs with a view to defending themselves. Importantly also, they got into cars and went as far afield as Southampton to sort out white people who had been physically doing up black people. Once that happened and it became clear to the British state that they weren't dealing with people who would sit

down under physical brutality from anyone, the state then decided that it had to do two things.

It had, it decided, generally to *reassure* its new labour force – because that, as far as the state was concerned, is what we were. That's the first thing it had to do. And it got into the business of so doing by grabbing hold of some of the whites who had been manipulating the violence and passing exemplary sentences. Some very fine speeches were made in court concerning what it was not right to do to black people, who were here to work, and were decent citizens and should be left alone, etc. That's what the verdicts in court against those white youths who were using violence against black people were about. They were reassurances to us generally because they needed our labour in this country to work for them, as a substitute for investment, in exactly the way I have argued elsewhere.

The second thing that the state decided was that it needed specifically to *reassure* that same labour force that we needn't organize for counter-violence against anyone because there wasn't going to be any violence to organize a counter to; they were going to stamp it out. They were extremely concerned that we should not organize for counter-violence, and never see any necessity to do so. That was the second activity involved in state reassurance, in and following 1958. A lot of white so-called liberals entered the field as race relations experts. Some of them left unfinished theses in places like Oxford . . . to engage in this business of reassurance to black people about not needing to organize for counter-violence. Institutions such as the church also took on the task of reassurance – a Methodist mission to Notting Hill was launched. At least one institution, the Notting Hill Social Council, was specially created. That's what British state and non-state propaganda was principally about during that period. Side by side with this there emerged a clear decision on the part of the state to curtail the growth in the UK of this dangerous group – the blacks from the Caribbean. The Commonwealth Immigration Act 1962 was the legislative outcome. It came into operation in mid-1962 and since then there have been further severe restrictions on entry into the country.

What 1958 showed the white manipulators of violence – and I mean the Mosley people and the fringe Mosley people and the white working class generally – is that if they *fucked* with black people from the West Indies, to use that sort of language, they were going to have some trouble coming. And it's quite important to use that sort of language, because that is precisely the way in which the thing was projected by the blacks who were on the ground, and it was precisely the way in which it was understood by the whites who needed to understand it. Basically, what happened in 1958 was that we sorted out, as a community, the manipulators of violence against us on a large and organized scale. Since then, there has been no mass-organized non-state violence against black (Afro-Caribbean) people in this country, because they know what will happen if they come against us in an organized and public way. That's important, because since 1958 we have faced no challenge by white manipulators of political violence, and our community has faced – to return to something I was saying earlier – no real attempts, no major attempts, to suppress it on the streets of Notting Hill, and probably nowhere else in the United Kingdom. The challenge of 1958 is, however, once more in the air.

I have said that this wasn't a big plus for the state, and for this reason: that our culture was expressed in extremely private ways, primarily, between 1958 and 1975

in this society. Our culture was expressed in the ways, largely, that I have already enumerated. In particular the black masses – the men and women who work for their living, or hustle for their living – in churches, in clubs, in shebeens, in 'roots'/basement restaurants, in private gambling dens, in their homes, and so on. White people, other than the police, other than the state itself therefore, left us completely alone.

It was only in 1975 that we went onto the streets in large and challenging numbers (an exception was the large political demonstration against the British invasion of the Caribbean island of Anguilla), in a way that made us look threatening to the state. And it was within that context that they called out, or so I'm wanting to argue, those large numbers of police against the 1976 Notting Hill Carnival. We are at the moment trying to document what happened: there is a commission into police brutality which is being run by some black people there, including myself – we're trying to gather evidence relating to this issue. What is known to us are these things. I've already mentioned what the police did in 1958; but throughout the 1960s, and early 1970s, blacks were systematically brutalized in shebeens and house parties and so on; the Mangrove restaurant was constantly harassed up until the period of the demonstration which led to those arrests and the trial that is now famous as the Mangrove Nine trial; the Metro youth club was also harassed, and it's still symbolically harassed – the Mangrove is again the object of regular and increasingly blatant harassment. So that, although I say there were no major confrontations, or at least no major moves by the state at suppressing major elements of culture, there were moves against all the small manifestations of *black culture*, the culture of the black masses. And that, as I say, is largely because the culture of the black masses was expressed indoors, and if it didn't particularly impinge on the white working class, and even if it had impinged on them, they had learnt the lesson in 1958 that you leave it to the police, because black people will back really heavily. It should be noted that the British state also attacked and destabilized the political organizations of the black masses in this period.

The cultural challenge of carnival

The Notting Hill Carnival started within the framework of culture – it was a cultural event. What it emphatically did not start as was *potentially challenging culture*. It never looked, until recent years, as a piece of expression by the black masses that could challenge in significant ways the state or its police force. And so, for the first several years of its life, the Notting Hill Carnival was left alone. Why was that so? A number of reasons. The police participated, incidentally, in the Notting Hill Carnival for all of those years, and they got enormous propaganda out of it: reassurance to the black community that they were nice people, although we knew differently; reassurance to the great white public that they were nice people relating enjoyably to black people – and we knew differently again. Specifically, the question has got to be asked, why was it that the Carnival didn't look threatening for its first eight years? Let's say it started in 1966. The reason is this, that it was organized in the early days by white people. A woman called Raune Laslett was one of the whites who was central to the early organization of the Notting Hill Carnival. Later white organizations like the North Kensington Amenity Trust, which is a control agency for the local borough council, then run by a white liberal, called Anthony Perry. I say he's a white liberal because I've seen him operating as a white liberal in Notting Hill; because he made a white liberal

film about the 'Mau Mau' situation in Kenya which said precisely nothing, which misrepresented the revolutionary potential of the struggle of the Land Freedom Army. So we know about him, and I call him a white liberal on the basis of some evidence.

Though organized right through, in dominant ways, by whites there were a few blacks involved, but these were largely subservient, though not necessarily being people who were subservient in themselves. The early black organizers were men and women who were black culturalists, not into confrontation with the state, who weren't necessarily into the culture of the black masses in this society. I cite one person, a Trinidadian gentleman called Junior Telfer, who was a member of the Carnival committee until he left the United Kingdom in 1977. He tells a story of being involved in the early days, of being one of the early organizers. He was fond of saying that the Carnival started in a club called the Ambiance located in Queensway which he ran in the 1960s. I have to believe him – it may be incorrect. But the key thing about him, whatever his level of involvement, however great or small, was that he, and several of the others, were culturalists, non-conflict-oriented black people who were not interested in the sort of black culture that automatically produces conflict with the white state.

There were early battles within the Carnival for control by black people, to take the thing out of the hands of white people. Later, there was competition between blacks for control of the Carnival. It's possible, for example, to name names. The man who was the most important organizer of the Carnival to date, a man called Leslie Palmer, joined in the teeth of opposition from the man who organized, or who was the director of one of the present committees, Selwyn Baptiste, and in the teeth of organized opposition from the man who organized, or who was the secretary of the Carnival and Arts Committee of 1977, Granville Pryce. They (Pryce and Baptiste) were friends at the time (I believe they remained friends) and not on opposite sides of those days – this was 1972–3. They fought and lost their battle with Leslie Palmer because he got the backing of one of the white organizations I've mentioned previously, the North Kensington Amenity Trust. That is how Palmer, who had enormous talents and skills, and not a little insight – I'm not saying he's a revolutionary, or even a radical – he's just a brilliant publicist if not so much a brilliant organizer, although he can organize. His 'successful' Carnivals of 1974 and 1975 were not technically well-organized Carnivals in the sense that they didn't flow, that everything wasn't got together on time, and so on. I mean, if you were looking at it in purely technical terms, you wouldn't say they were well-organized, although they were successful in terms of numbers – I'm coming back to that. Palmer's victory over Pryce and Selwyn Baptiste was the transforming agency in the Carnival situation. That's what transformed the Carnival from what it was in the earlier period to what it later became: from being something out of which the police could get reassuring publicity for white people and black people, into something that the whole state perceived as *threatening*.

Palmer's tools were publicity and organization. But crucially, extremely crucially, he recognized that there was another, broader, possible cultural base for the Carnival. I'll come back to that also.

What had been the cultural content of Carnival earlier? I've talked about who organized it in those days, but what had been its cultural content? Carnival was about two things, really: first, African bands, like Ginger Johnson, played an important part, and, secondly, steel and costume bands from the Eastern Caribbean, in particular

339

Trinidad, manned by men from that part of the world. That's what it was into, culturally. That was the musical space it occupied, so to speak. The African polyrhythms of Ginger Johnson like the mellifluous sounds of the steel band are totally *unthreatening* to them. And as long as the Carnival continued to be culturally about those two modes of music, everything was 'cool', 'wonderful', 'beautiful' and allowed for 'close vibes'. A few people were disturbed, there were a few fights; Granville Pryce had to tear down some fences one year because an attempt was made to stop the Carnival having use of a piece of ground that it wanted. There were the occasional battles with the police about how big an area should be covered, which streets shouldn't be part of the route, and so on. But nothing of any real significance – no conflict. And then Palmer decided that he would do something to *appeal* to a *different element* – I don't know whether he consciously or otherwise decided on this; I haven't interviewed him, but it is certainly what happened. In any event Palmer took action which raised the cultural appeal of Carnival, because it included a new cultural content. And that cultural content concerned the vast majority of the culturally Jamaica-influenced Caribbean or West Indian migrants in this country. That is to say, Palmer introduced *reggae music*, the music that moves the vast majority of the young people – and, if you check the 'blues parties', the old as well – from the Caribbean in this country. The *Sound System* is the medium of the *reggae* message. And in addition to using *sound* in great enveloping sheets dominated drum and bass rhythm, they soup up the music in all sorts of ways. Of special importance is a cultural mechanism called *toasting*.[2] So that in addition to the record being on, there is an extra microphone into which the DJ will make additional, *toasting* sounds, so as to enhance the total impact of the record. And the sound can be either *nonsense sound* – depends on what you do with nonsense. It's not always sounds in English, or even creole, although the sound always, as I understand it, has significance of some sort: it might be rebel language, it might even be revolutionary language. The sound system for all these reasons is an extremely powerful medium inside the black communities. Such is the way in which they have grown that, if you say, this sound is on here tonight, and put up some posters, many hundreds of people will come. And if they're playing in the open for free many thousands of people will come. The top, the 'baddest', the best sound in London today is *Sir Coxone*. They have that sort of pulling power and impact. Now that's what Leslie Palmer introduced into the Carnival when he came in. In addition to that, he used the media massively. Palmer used Capital Radio and Radio London. But particularly Capital Radio was used on the scene of the 1975 Carnival, inviting young people to the Carnival. He had great banks of sound systems all the way up along the Westway motorway – I don't know if you know the geography of Notting Hill – but he had great banks of sounds all the way up along there. And he had massive publicity beforehand. Naturally five hundred thousand people, or thereabout, attended the Carnival. Once that happened, five hundred thousand people – they weren't all blacks – even a quarter million black people – in those streets, the police were terrified out of their tiny little minds: they really were.

Once that had happened, the Carnival entered the domain of *threatening culture*, because it was then mass culture, active mass culture, and it had therefore, to be suppressed, or controlled. But, the difficulty about suppression is that you can't suppress anything in this society unless it's illegal or violent. It's very difficult to do so, because people will object, I mean, they'll actually ask you why, and you'll have difficulty controlling it as well. If you're talking about five hundred thousand people, or even

two hundred thousand people, on the streets of Notting Hill, there is enormous difficulty controlling that crowd. If they riot, you're in difficulty – as agents of control. And even if they don't riot, you're in difficulty, because you're worried about the possibility that they might riot. You then have to have two alternatives. You either have to move the Carnival into a space in which you can control those numbers – and there is no space of that sort in England, apart, possibly, from open parks, which incidentally, represent the same sort of danger. The largest ground in the country, I think, is the Glasgow Rangers ground, Ibrox Park; and it only holds a hundred and fifty thousand people. There are no indoor spaces that can hold those sorts of numbers. So, when you say, move the Carnival to an indoor space, you're actually talking about drastically reducing numbers. You're talking about the fact that the police have enormous experience with controlling indoor spaces, and that they have great experience with controlling even vast numbers in indoor spaces.

So once that had happened, once those five hundred thousand people – let's say, three-fifths of them black – turned up on the streets of Notting Hill in 1975, the state took the view that the cultural gauntlet had been thrown down, and that that gauntlet had to be picked up! That's what the remainder of the history of the Notting Hill Carnival is about.

Now, all my talk about non-state manipulators of violence comes into play here. You would have thought, as is usually the case in Britain, that when you want to suppress something you organize civil (sub-state) opposition to it. Such civil opposition might have a physical element to it, but it will certainly rely heavily on a propaganda element. Now, there was no physical element to call upon in Notting Hill because we, the black community, had, a decade or more before, sorted them out 'good and proper'. But there were some people, bodies, to mobilize. They were mobilized, and I've got their letters in my file. But who were they? They were old women and men, in a road called Cambridge Gardens, who said, probably quite correctly, that they'd been disturbed by aspects of Leslie Palmer's Carnival in 1975. No doubt they were. Those sound systems do make a hell of a noise. And when you have a great bank of them up along the road, not only can't you hear your mellifluous steel bands but, unless you like the music, you're pretty likely to feel affected in some way. Further, the local authority hadn't anticipated the numbers – nobody had, really – and so they made no extra provision at all for sanitary arrangements, even of the most basic kinds. There weren't any extra loos on the street, and some of the public loos were shut. And people's gardens got pissed in, people's porches got pissed in: and they objected, I mean, quite rightly. The council should have done something about it. They did in following years – in 1976, although by then we had moved away from *public cleansing* problems *to public order* problems. Once those numbers arrived, although the propaganda battle could only be articulated in terms – civilly – of public cleansing and *public disturbance*, and possibly *public control* a little bit, when you got the nitty-gritty of what the state, through the police and the council were saying, they were talking about *threats to public order*.

But there was a long battle following the 1975 Carnival, for the preservation of Carnival itself, and for the retention of it on the street. That battle involved some very weak leadership on the part of the Carnival Committee, while on the other side were some groups that were already discredited as racist. For example, there's a group in Notting Hill called the Golborne 100, which is supposed to be a local 'community

control' association. It has got publicity as such. (The man who was in charge of it at the time is called George Clarke, who's another excellent publicist, and a known racist locally, but who has a national reputation in the 'community control' movement.) It mainly used the tougher Irish element who, although they had a physical presence, and would defend themselves against anybody, were living in a sort of uneasy truce with the black community. I mean, blacks rarely fought them, and they rarely fought us because they knew that somebody would die. And it's roughly still like that, although that area, the Golborne, has been gutted: the people have largely been moved out, and it's being rebuilt. So that the physical personnel-base that George Clarke once had isn't there, for the moment. That was one of his weaknesses as a mobilizing agency against the Carnival. He did, however, get into it at the propaganda level. He offered a sort of carrot and stick. He said, the Carnival has now become a sort of 'national event': therefore move it to Hyde Park and integrate it in the Jubilee. 'What a splendid gift to the West Indian community,' he said, 'this would be.' That was the carrot. The stick was to do with him saying that 'pimps', 'spivs', 'crooks', 'wide boys' and 'hucksters', had taken over the Carnival and that it was really no longer at all a wholesome thing, and that, what is more, people were pissing on people's doorsteps, and that was naughty. You can read this thrust in his community magazine called *The Golborne*: the September issue is the crucial one.

Additionally, there were the old women, and the relatively old men, who had been genuinely disturbed, and who, some of us were concerned, should not be disturbed, certainly not in those ways – it was unnecessary for them to be disturbed so heavily. These people lived on Cambridge Gardens and they tried to mobilize. They tried to mobilize white tenants' associations, and things like that, but it never got very far. They were rather old, slightly ineffectual people; some of them were too middle-class for the people they were trying to mobilize. One or two of them were very racist Irish women. They just had no conception at all of what was happening to them in Notting Hill. We rang rings round them. One of the things one of these women – with whom I appeared on a radio programme in April 1976 – said was, 'You've already got one carnival in Trinidad, what do you want another one for?' It was sometimes at that level – just basically pathetic. They were really completely outmanoeuvred. And so it was necessary for the local state and for the state proper to be called into play. The local state – local council or local authority – has muscle. Unfortunately, since there had been no threat to public order, no disturbance proper, in 1975, the council had no basis for seeking a ban on the Carnival. Although the women I've mentioned, and the men, from Cambridge Gardens, actually thought about getting an injunction, they hadn't a clue about how to get it, nor had they the money to spend on the expensive business of getting an injunction. So much of the opposition to Carnival was either simply ineffectual, or ineffectual because discredited as racist, or ineffectual because they had not the legal basis upon which to proceed.

The state proper as represented by the police was a different matter altogether. They also had the major disadvantage that the local council had, namely that they had no legal basis on which to seek a ban by the home secretary. So all they were able to do was to try, by brute force, threats and restrictions, to force the black community off the streets for Carnival in 1976. But they also offered the 'carrot' before they came with the 'stick'. Their carrot was that money could be made out of the Carnival. The council agreed. The way to make money out of the Carnival was to privatize it – set up a

private trust. Movements were made towards that – they called it the Carnival Development Committee within the West Indian Steel Band and Cultural Association. Both were private associations with no legitimacy in the local black community. Certainly, I didn't know of their existence – and I should have done – until they came publicly into being. So that sort of privatization was going on. Like the council, the police argued that if you privatize the thing, and then move it into some indoor place, you'll be able to have gala performances – the works. We will be satisfied, they said, because you can still have your little march on the street, and then you can march the whole thing off, off our nice streets, into some park. They offered the White City, but that happened to be occupied with dog races on the relevant day. So they offered instead the Chelsea football ground – note the football crowd association. And the council was instrumental in trying to get the Carnival use of the football ground. Obviously, those of us who were in community politics in the area opposed all of that, and we're on record as so doing. But interestingly enough, they found, in those people who privatized the Carnival, support and a base for trying to move, restrict and ultimately destroy it. And we found, my organization did, as also did several people 'on the street' and community organizations with whom we work in Notting Hill, that the Carnival Committee, which by then was the Carnival Development Committee, part of the West Indian Steel Band and Cultural Association, was no longer listening to us, because they were now relating to much more important people. They were relating to the police, who were powerful, you had better believe it. And they were going to be able, because the council had money and because the police had power, to buy all the bands off the street and take them to Chelsea, whatever we said.

They proceeded to organize on that basis, until the council showed them the economics of the operation, which we had been telling them all along anyway. We said that you are going to be moving the Carnival into a space that belonged to the 'man'; that the 'man' was going to have control of the food preparation; that basically all you were going to have was control on the gates; that he was going to put his people on the gates, and that he was going to give what he wanted out of the gate receipts. And you were going to get nothing. We were telling them that. But it wasn't until the council sent them a letter which said that clearly, that they backed off the idea of going with the Carnival to Chelsea football ground in 1976. This is documented.

Now, after the Carnival Development Committee had backed off going to Chelsea, because it was no longer going to be profitable, the police brought out the big stick. The Carnival Committee had meetings with the council and the police jointly and meetings with the police on their own. The police said that they were going to enforce 'law and order'! That they were going to uphold the letter of the law. And in the context of the Carnival, that means, basically, no jollification. It represents a major challenge to every cultural space that Carnival is. And it was obvious that the black communities weren't going to like it, and I wrote a letter threatening that the black communities wouldn't stand for it. The police ignored us. We wrote, hoping . . . you know. I understand the British political system, so I wrote to the commissioner of police and I copied the letter to *The Times* – major opinion organ, you see – and to *The Guardian* – major wielder of liberal opinion; to the local community relations officer (CRO) in Westminster, the state's man on the ground; to the home office; and to Jennifer Jenkins – the home secretary's wife, who was also chair of the local North Kensington Amenity Trust. Nothing happened. The police continued to mobilize their

operation. They said, no illegal sale of drinks, no smoking ganja on the streets: basic-
ally, no jollity. They also said, no sound systems on the street; and they got support for
that from the 'Trinidadians' on the Carnival Committee, because they had been
offended, regrettably – understandably though – by being 'swamped' by reggae music,
and by all those 'Jamaicans' who really, they said, 'don't understand Carnival at all',
coming to the Carnival and just swamping their music – nobody was able to hear the
steel bands. And they really did, and still do, resent it very deeply. The Carnival
Committee was always dominated by Trinidadians – I think Mr. Chase and Mr. Bukari,
respectively past and present chairmen of the Carnival and Arts Committee, are the
first non-Trinidadians to chair any of the committees organizing Carnival. There are
never very many people from anywhere else on it, if you check down any of the lists of
members. The state, then, announced all these prohibitions. There was to be no 'illegal'
selling of drinks; but the Carnival wasn't to have a drinks licence. There was to be no
illegal selling of drinks; but publicans and off-licences/off-sales people were to be
encouraged not to sell. So it was going to be a dry Carnival, a spliffless Carnival, a
completely joyless Carnival. And what is more, it was going to be an incredibly heavily
policed Carnival. Because all of those prohibitions were going to be enforced. Indeed,
the Carnival itself was going to be controlled. They were going to organize the routes.
They did, in exactly the same way that they organize football crowds. And so they
sectored the routes, the whole area, into six parts. They said that bands should flow
inside of each sector, but there would be no movement between sectors. They said that
the most difficult area of control within the location was going to be the Acklam Road/
Portobello Road area – the geography of the area's quite important – and only one
band passed, presumably by accident, through the space during Carnival 1976.

Given that those prohibitions and controls were going to be enforced, the police
needed massive numbers on the grounds. They said to the Carnival Development
Committee that they were going to have a *serial* round each band. But its members
never understood what a serial was – it just happens to be twenty policemen. And there
jolly well were twenty policemen round most of those bands in Carnival 1976. I kid
you not – we have photographs of them. And in addition to the policemen who were
not functioning in serials, that is, not in surrounding bands, including kids' bands,
there were policemen in fours or eights with one or two sergeants on every street corner
and on most parts of most streets, throughout the two days. And towards the end of
Sunday, the numbers increased massively. Their business was enforcement of all the
prohibitions that I've mentioned. It was initially a total humiliation. I kept hoping, as
did anybody else with any spunk at all, over those two days, that, from somewhere
within the community, resistance would come.

The police enforced their thing, ruthlessly. Our organization has an office at 301
Portobello Road – and that road was not open to public traffic at all. They had a vast
ambulance unit from Weybridge, belonging to the London Ambulance Service, there.
They had several other ambulances there, as well as a police command post and several
police vans. What had been part of the heart of Carnival in previous years was occupied
in that way in that year. The officer in charge was a man called Paterson. He was
actually second in command on that day, but he planned the operation, with the full
backing of Scotland Yard. And they were filmed doing it by the BBC who have lots of
films which would be very revealing if they were not discarded. But even the stuff they
have screened is still very revealing. Paterson came to the door of our organization

344

when we'd put up a stall where we sell records outside on Saturdays and on occasions when there are likely to be people there to buy. And my colleague said, 'Who's giving this order? What legitimates that?' And the man said, 'The Carnival Committee.' The response was, 'Go and bring your chief steward, and I'll get my cutlass and one of you touch my sound and see who gets what today.' And Paterson went mumbling to the television crew filming the encounter that the stall would only make a 'normal' noise. But another sound system that was further down the road was moved on. And the Carnival chief steward came – a very muscular man – and watched them move it, and encouraged the moving of that sound system. There were very few sound systems present in Carnival 1975.

Resistance

Now, how did the violence arise? I have said that the police enforced prohibitions throughout. There was a raid on the Mangrove restaurant on the Sunday morning. There were raids on several other black centres in the locality. The whole area was full of green and blue buses packed with policemen being held in reserve. There were people who had in previous years sold beer who were just picked up and carted off. And even when one man said to the police, 'Look, take the beer, take it all, just leave me alone, I'll accept the loss, don't arrest me', he was still carted off and put into a van. Fortunately he had the gumption to give them a wrong name. They were probably too busy on that day to check. Usually, if you give them a name and address, they go and check it now, before they let you out, because lots of people have told them wrong names. But in the early part of Carnival, that man got away. Several black people were arrested in that way. And several people lost hundreds of pounds, because the police seized their goods and when you're seized selling illegal booze, you don't get it back.

The police said that pickpocketing was going on. Possibly. But because they had so much force on the ground, they didn't feel any need to arrest with any gentility. So they didn't. Several black youths went past our post, on the Portobello Road, bleeding, in the hands of policemen. And, finally, you will have heard that the flashpoint of the violence was on the corner of Acklam Road and Blagrove Road, near the Acklam Hall. It is said that was the flashpoint because pickpocketing was occurring there. Again, there might have been pickpocketing, but the flashpoint didn't happen because of pickpocketing. Rather, it was because of the massive and indiscriminate violence which the police used against black youths they thought were pickpocketing. The girl who was secretary to the Carnival Committee until shortly before the 1977 Carnival was in that corner at the crucial time on Carnival Monday 1976. She had difficulty sleeping for months afterwards because of the way in which she saw policemen use batons on the heads of black young men and women in that corner on that afternoon. Fortunately, there were enough black youths around there, and enough missiles in that space, for a resistance to be put up and supported. That resistance was not pre-organized, and it spread so fast, that nobody was able to control it. I oughtn't to say this, but as the move by the youths, throwing stones at policemen, and bloody policemen being brought out from down in that corner by their colleagues, developed, there were stalls on the Westway side of Acklam Road, one of which belonged to the Black Liberation Front. Perhaps they would have preferred to continue selling what they were selling on that stall, which was books and posters, and things like that. One person operating the stall

tried to get the black youths to stop. Indeed, one of them looked round and said, 'Stop doing that', as the half bricks were coming over. They packed up their stall and a few hours later they had a militant leaflet out against the police action on the afternoon, and supporting the youths. But at least one of them tried, temporarily, to intervene to stop the resistance happening. Just temporarily, but it was too big.

The reason why the resistance was so dramatic is that the terrain was full of weapons. Adjoining that space was, until recently, an extended building site. Indeed, on the corner of Acklam Road and Blagrove Road there is still a GLC building site. That is what I mentioned earlier when I said that the Golborne Ward area is being taken down and rebuilt, and George Clarke's Irish base is temporarily not there any more. That's where it started from, and there were bricks there, half bricks, and whole bricks, and there were also bottles in abundance, beer cans full and empty, and soft drinks cans full and empty. And the police were almost unarmed. They just had their sticks and their numbers. But numbers were absolutely no use, in effect, against those weapons. They were roundly beaten. Hundreds of them were injured. Absolutely justifiable – because what they were attempting to do seemed to us in the community to be totally unnecessary. We had warned them about what would happen. They might just have got away with it if they had attempted to do it with a little bit less brashness and a little bit less brutality. But, in fact, they did it both brashly and brutally, and they were confronted and defeated on that terrain, in the second most important single battle fought by the black masses in the UK – the first being, of course, the black resistance in 1958 . . .

Notes

1 This is the text of a talk given by Cecil Gutzmore on 20 November 1978 at the Polytechnic of Central London. The forum was the course on Black Culture. Gutzmore was invited as a worker for the Black People's Information Centre in Ladbroke Grove, Notting Hill. Though not on any Carnival committee, this 'grassroots' black organization was substantially involved with Carnival.

2 *Toasting*, in the better quality of reggae music, is improvised 'oratory' about the social structure, political and cultural class practices or sexuality. Comments on these aspects – which the toaster introduces spontaneously – usually generate certain 'phases', 'terms', and 'nonsense' sounds which can trigger off responses ranging from being 'cool' to being 'rebellious'.

These 'terms', 'phases' and 'nonsense' sounds are normally taken into everyday 'street language' of the black masses and function there as reference points against racism, cultural subordination or economic exploitation. In this way, the 'roots language' of the *toaster* is evoked in the voices of young blacks. Similarly, a toaster may affect the 'speech' patterns of *the* youth.

The greatest toasting innovators are *U-Roy*, *Big Youth* and *Prince Far I*. After them it became normal practice for every *sound system* DJ to *toast*.

From W. James and C. Harris (eds), *Inside Babylon: The Caribbean Diaspora in Britain* (London: Verso, 1993) (extracts).

VIRGINITY REVAMPED

Representations of female sexuality in the lyrics
of Bob Marley and Shabba Ranks

Carolyn Cooper

Bob Marley and Shabba Ranks represent the two major directions of contemporary Jamaican popular music: reggae and dancehall.[1] Both performers have achieved international superstar status as exponents of Jamaican music and articulators of the cultural values embedded in the music. Conventional wisdom in Jamaica, manifested in the popular press and on numerous talk show programmes, valorizes Bob Marley's politicized reggae lyrics as the peak of 'culture'. Shabba Ranks's dancehall *liriks* are stigmatized as base, misogynist 'slackness', a Jamaicanism for the English 'licentiousness'.[2] Beyond fundamentalist Jamaica, the culture/slackness binarism does have some currency, though the oppositional ideology is not often as simplistically stated as in the following case.

Tom Willis, writing in the British *Sunday Times* of 4 April 1993, attempts to establish an invidious comparison between loving Bob Marley and hateful Shabba Ranks. Rewriting history in an article entitled 'Ragga to Riches', Willis makes an absolute distinction between the love lyrics of his imaginary Bob Marley and the high-profile hate lyrics of all of the performers of contemporary 'ragga'. Shabba Ranks is demonized as 'a Black pop star who last year asserted on TV that homosexuals "deserve crucifixion", and expressed support for such peers as Buju Banton and Tippa I-Re, whose lyrics favour the quicker method of shooting.'[3] Conversely, Bob Marley is canonized as the non-threatening, emasculated singer of 'lilting love songs'.

This lovey-dovey, peace-making Bob Marley bears absolutely no resemblance to the incendiary 'Tuff Gong' Rastaman whose songs of emancipation from mental slavery are a powerful, revolutionary chant against Babylon. Babylon in Rastafarian iconography is the biblical whore of St John's Apocalypse; in the Jamaican socio-political context Babylon is, as well, the code name for the police. Frequent references in dancehall songs to the maligned 'informer' who betrays the community are an expression of a deep-rooted cultural suspicion of Babylon. The contemporary 'rude boy' subversion of the alienating political power of Babylon has its genesis in historical rituals of rebellion against the repressive policing practices of Jamaican slave society.

The relatively few Marley love songs that do exist are an essential part of the larger corpus of revolutionary texts. Indeed, one of the remarkable accomplishments of Marley's lyrics is the seriousness with which he treats sexual love, a subject that is often

trivialized in Jamaican popular music. In 'Turn Your Lights Down Low', from the *Exodus* album, sex is spiritualized by the benediction of 'Jah moon'. The Rastaman as lover *liriks* the woman in true Jamaican style:

> Turn your lights down low
> And pull your window curtains
> Oh let Jah moon come shining in
> Into our life again
> Saying, oooh, it's been a long, long time
> A get this message for you girl
> But it seem I was never on time
> Still I wanna get through to you girl
> On time, on time.

This is classic Jamaican male sweet-mouth talk. The man admits his shortcomings – 'It seem I was never on time' – and hopes for the best, or at least another chance.

The politics of noise

Willis's oversimplification aside, there is a decided continuity of subversive values between reggae 'culture' and ragga 'slackness'. For example, Bob Marley's nuanced line, 'I want to disturb my neighbour', from the song 'Bad Card' on the *Uprising* album, can be heard as an aggravatory anthem for dancehall culture: the politics of noise. Bob Marley's dis/concerting noise is not just literal, megawattage night music that disturbs a neighbour's sleep. Noise engenders a politics of disturbance and disruption; a destabilization of the moral majority's complacent rhythms of social decorum:

> You a go tired fi see mi face
> Can't get mi out of the race
> Oh man you said I'm in your place
> And then you draw bad card
> A make you draw bad card
>
> I want to disturb my neighbour
> Cause I'm feeling so right
> I want to turn up my disco
> Blow them to full watts tonight
> Ina rub-a-dub style

'Rub-a-dub style', the noisy idiom of Bob Marley's explosive class politics, is also the erotic body language of the DJs. In the 'rub-a-dub' aesthetics of the dancehall, two modes of self-expression and social protest converge: one, that of the DJs, is overtly sexual and covertly political; the other, that of the singers, is overtly political and covertly sexual. Both modes of expression are 'rhythm[s] resisting against the system', to quote Bob Marley's 'One Drop' from the *Survival* album.[4] Marley's incendiary, confrontational lyrics of class war, like Shabba's explicit references to sexuality, constitute a violation of the social space of the respectable middle class. Music is not mere entertainment but ideological weaponry, disturbing the peace. Uneasy peace cannot be

readily accomplished at the expense of social justice. In the words of Peter Tosh: 'Everyone is crying out for peace, yes / None is crying out for justice / I don't want no peace/ I need equal rights and justice.'[5]

Both Shabba Ranks's and Bob Marley's lyrics articulate an anti-Establishment class politics and a gender politics – admittedly, in different ways. The equal rights of Tosh and Marley are conceived in overtly socio-economic terms. Shabba's equal rights are largely sexual; a masculinist/feminist assertion of egalitarian (sexual) relations between men and women. In the spirit of benevolent patriarchy, Shabba exhorts women to control the 'commodification' of their body and ensure that men value them appropriately. This constitutes a radical politics and economics of the sexual body. Here I attribute to Shabba Ranks a *consciously* articulated sexual politics, though I do concede an obvious rhetorical difference between the language of Shabba's performance and the language of my analysis.

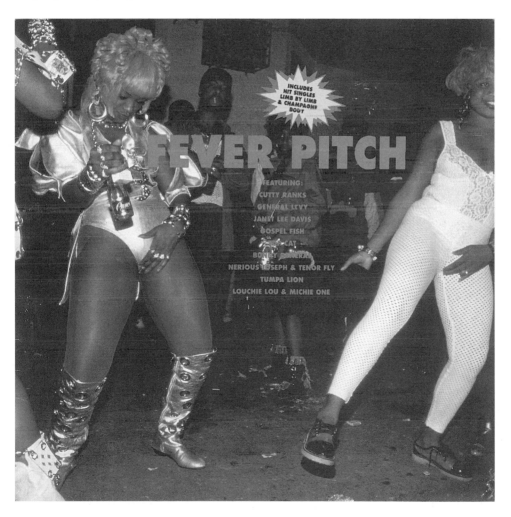

Figure 29.1 *Fever Pitch* album cover
Source: Courtesy of Wayne Tipetts

This issue of language is complicated by socio-cultural prejudices in Jamaica that would question both Shabba's ability to conceptualize, and the Jamaican language's adequacy to express, abstract concepts such as I read in(to) his lyrics. The problem of authorial 'intention' is not, of course, peculiar to oral performance contexts. But in neo-colonial Jamaica, more sceptical, class-prejudiced readings than mine would challenge any assumption of Shabba's awareness of the full ideological implications of his own lyrics. For example, a University of the West Indies student who read a draft of this paper commented, somewhat condescendingly: 'Puor Shabba no nuo se a aal dem tingz de im a se': 'Poor Shabba doesn't know that it's all of that he's saying.'

Transgressive woman

In Jamaican popular culture, sexuality, like language, is a vital domain in which a political struggle for the control of social space is articulated. The body of woman, in particular, is the site of an ongoing struggle over high culture and low, respectability and riot, propriety and vulgarity. Woman embodies the slackness/culture debate in Jamaican popular culture. Somewhat paradoxically, Marley's sexual politics is much more conservative than Shabba's apparently apolitical 'sexism', with its ample references to the female body. Marley's gender politics, rooted in a sexually conservative Rastafari ideology, articulates a rather repressive vision of female sexuality. Marginalized Rastafari, as much as respectable, mainstream middle-class culture, seeks to extend its sexist control over the body of woman.

For example in Marley's 'Waiting in Vain', from the *Exodus* album, the lover's ardent supplication modulates into definite reproof. The dilatory woman, with a long line of lovers in attendance, seems, in the man's view, to be functioning somewhat like a whore. The all-too-willing Rastaman is forced to wait patiently to negotiate a space for himself, however much he may not want to wait in vain. The tension between the wanting and the waiting defines the pathos of this song which expresses the ambivalent representation of woman – and male desire – in Bob Marley's lyrics and, more broadly, in Rastafari. Transgressive woman, synonymous with Babylon as whore, becomes an alluring entrapper, seducing the Rastaman from the path of righteousness. The biblical image of woman as fallen Eve, Babylonian whore, defines contemporary gender relations that are founded on the essential frailty of both male and female flesh. The female is duplicity represented as both deceiving and vulnerable to deception.

Marley's 'Pimper's Paradise', from the *Uprising* album, is an even more explicit example of the ambivalent Rastafari response to 'fallen' woman. The song opens with the Rastaman's indictment of the fashion conscious, pleasure-seeking, drug-addicted woman. But the enigmatic line, 'Every need got an ego to feed', suggests empathy for the woman who has perverted natural desire into self-destructive obsession. The reference to paradise subtly echoes Eve's fall from innocence, seduced by Satan, the first world pimp. The song seems to move towards a clear statement of sympathy: 'I'm sorry for the victim now.' The ambiguity of 'the victim', the woman hooked on drugs or the man hooked on the woman, complicates the issue. The singer addresses the woman directly, abandoning the initial, dismissive stance:

Pimper's paradise
Don't lose track

Don't lost track of yourself, oh no!
Pimper's paradise
Don't be just a stock.
A stock on the shelf
Stock on the shelf.

The woman becomes much more than exploited commodity; she is challenged to reclaim her humanity.

This ambivalent representation of woman in Rastafari, an extreme manifestation of the duplicitous gender ideology that pervades Jamaican society, is ultimately derived, via Victorian England, from Judaeo-Christian theology. The condemnation of promiscuous woman in Marley's lyrics, as in 'Pimper's Paradise', contrasts markedly with the looseness of woman in dancehall culture. Liberated from the repressive respectability of a conservative gender ideology of female property and propriety, women in the dancehall, as free and active agents, lay proper claim to the control of their own bodies. In the words of Shabba Ranks:

Uu se dat uman kyan don?	Who says that woman can be exhausted?
Tel dem se	Tell them that
di uman doan kom tu don.	Women don't come to be (un)done
Wan juk, wan wash	One poke, one wash
An den yu ton it doun agen	And then you turn it down again
Uopn yu fut	Open your foot
A neks man welkom[6]	Another man is welcome.

In Jamaican, the word *don*, from the English 'done', refers both to completion of an action and to depletion of resources. This line from Shabba Ranks's song, 'Ca'an Dun', is, primarily, an allusion to the proverbial sexual plenitude of woman, in contrast to man's finitude. However, a less flattering reference to woman is encoded here. 'Woman can't done' also means that there is an inexhaustible supply of commoditized women.

Sweet and sour sauce

The gender politics of the dancehall, often dismissed by outsiders as simply misogynist, can be read in a radically different way as a glorious celebration of full-bodied female sexuality; particularly the substantial body of the Black working-class woman whose body image is rarely validated in the middle-class Jamaican media where Eurocentric norms of delicate female face and figure are privileged. The recurring references in the DJs' lyrics to fleshy female body parts and oscillatory functions is not, I argue, a devaluation of female sexuality; it is a reclamation of active, adult female sexuality from the entrapping passivity of sexless Victorian virtue.

For example in 'Gone Up', from the *As Raw as Ever* 1991 CD, Shabba, playing on the proverbial association between food and sex in Caribbean culture, notes that the price of a number of commodities is going up. To a chorus of affirmative female voices, he asks women a rather pointed question:

Crotches! sausage!

Everything is going up	
Bully beef, rice	
Uman, wa unu a du	Women, what are you going to do
Fi unu lovin?	About your loving?
(Wi a riez it tu)	(We are raising [the price of] it, too)
Bifuor yu let aaf di wok	Before you have sex
Yu fi si dalas fos (?)	You must see dollars first (?)
Mek a man nuo se	Let the man know that
Ten dala kyaan bai French kot	Ten dollars can't buy French cut [lingerie]
No mek a man wok yu out	Don't let the man work over
Badi lain, uol chrok.	Your body [as if it's an] old truck.

Shabba makes it clear that he is not advocating prostitution. The relationship between the man and the woman cannot be reduced to purely economic terms of exchange. It is a question of the man assuming a measure of social and economic responsibility for his sexual partner; it is, ultimately, a moral issue:

Iz nat a mata a fak	It's not a matter of fact
Se dat unu a sel it.	That you're selling it.
Bot som man se dat	But some men say that
Dem waant it.	They want it.
Az dem get it	As soon as they get it
Dem ron gaan lef it.	They run away and leave it.
No mek a man ron gaan	Don't let the man run away
Lef it	And leave it
An yu no get prafit	And you don't profit.

Shabba challenges the stereotype of the robotic, domesticated female who doesn't question the unequal exchange of services and resources in her household:

Av som uman gwaan laik	There are some women who behave as if
Dem no wot	They have no value
Ich op ina haus	Confined to the house
Laik dem a haus ruobat	As though they are house robots
Haus fi kliin	House to be cleaned
Dem kliin dat	They clean it
Kluoz fi wash	Clothes to be washed
Dem wash dat	They wash that
An dalaz a ron	Dollars are flowing
An dem naa get inof	And they don't get enough
.
Nou yu av som man	Now you have some men
No waan du no spendin	Who don't want to spend
Dem uda du di spending	They would rather spend
Pan dem bredrin	All their money on their male friends
An naa bai dem daalin	And they wouldn't buy even an icymint for
A aisi mint	Their darling.

The DJ's compassion for female house robots and his equal contempt for sexist males who are stingy in domestic matters echo the critique of gender relations that Jamaican folklorist and poet Louise Bennett offers in 'Oman Equality'.[7] She observes that women are seeking liberation from the dominance of men who advocate that woman's place is in the home. The woman, thus imprisoned, is forced to take whatever pittance the husband throws her way while he squanders the bulk of his money carousing with his male friends. Bennett is not a writer whom one would readily identify with the 'slackness' of dancehall culture, though I do argue that her choice of Jamaican as the preferred language of verbal creativity does align her to an outlaw tradition of resistance to Eurocentric High Culture. And there are rare hints of sexual slackness in her repertoire. Mervyn Morris in his teaching notes to Bennett's poem 'Registration' uncovers the sexual double entendre in the following lines:

Lawd-amassi, me feel happy	Lord have mercy, I feel happy
For me glad fi see at las	For I'm glad to see that at last
Oman dah meck up dem mine fi	Women have made up their minds
Serve back man dem sour sauce![8]	To serve men their own sour sauce.

Morris notes that 'sauce here suggests semen; it is implied that women have decided to do to men what, sexually, men have done to them.'[9]

Shabba, underscoring the fundamental necessity of sweet and sour sauce — both sex and food — urges men to assume economic responsibility for the eating that they do:

Jos laik a man	Just as a man
Kyaan liv widout flowa	Can't live without flour
Ar a man kyaan liv widout rais	Or a man can't live without rice
A so a man	That's just how a man
Kyaan liv widout waif	Can't live without a wife
Yu a man	If you're a man
Spen nof pan ar rait	Spend a lot on her, as is only right.

Shabba's sexual politics dislocates the popular middle-class Jamaican stereotype of the irresponsible working-class 'baby-father', who assumes neither social nor economic responsibility for his woman and offspring. In 'Woman Tangle' on the *As Raw As Ever* CD, Sony, 1991, Shabba warns men:

if a uman out de	If a woman out there
Ha a biebi fi yu	Gives birth to your baby
Bwai, huol yu biebi	Boy, hold on to your baby
An no mek it rafl	Don't let it to have to be raffled.

The metaphor of the raffle suggests the dicey nature of the domestic affairs of irresponsible men.

Hottentot Venus in the dancehall

In 'Paak Yu Benz' Shabba, asserting that material possessions are not enough to seduce women, mockingly challenges impotent men who have only money to offer women. Women want sexual satisfaction as much as material security. Shabba also undermines the unequal sexual politics that allows men the presumed freedom to have numerous sexual partners, and simultaneously attempts to curtail women:

Beta paak yu Benz	You had better park your Benz
An paak yu BM	And park your BM[W]
If yu kyaan	If you can't
Wok yu uman	Satisfy your woman sexually
Shi naa stie den.	She won't stay then.
Wan man waan av	One man wants to have
Twenti gyal fren	Twenty girl friends
An im uman mos kiip	And his woman must keep
Ongl wan man fren.	Only one male friend.
If a uman shii	If a woman
Av tuu man fren,	Has two male friends,
Wan fi wok	One for sex
Wan fi spen	One for money
Dat iz nuo prablem.	That's not a problem.
Di wan we a spen	The one spending money
Im av a prablem.	He has a problem.
Di wan we kyan wok	The one who is good in bed
Im av aal aagyument.	He has all the say.
Wan man av faati-faiv gorl fren	One man has forty-five girl friends
Chruu di niebahud	Throughout the neighbourhood
Im iz a lejen.	He is a legend.
A gyal shii go kip	A girl keeps
Faiv man fren	Five male friends
Iz nuo prestiij no muor	There's no more prestige
Shii iz ongl a spweng	She's only a slut.

'Flesh Axe' from the 1991 *As Raw As Ever* CD, similarly asserts the women's desire for both money and sex. Using agricultural, legal and mechanical imagery, Shabba compares the body of woman to valuable property – land that must be cleared, seeded and watered:

Flex aks	Flesh axe
Di lan pan di badi fi chap	The bodyland must be cleared
Iz laik moni an uman	It's as though money and woman
Sain a kantrak	Have signed a contract
If yu a diil wid a uman	If you're dealing with a woman
Fi a nachral fak	It's a natural fact
Iz nat se dat shi a sel ar badi	It's not that she's selling her body
Fi ron it hat	An it's running at high speed

Bot evri uman niid megakyash	But every woman needs big bucks
Fi bai priti shuuz	To buy pretty shoes
An priti frak	And pretty dresses
Uman lov magl	Women love to show off
An dem lov fi luk hat	And they love to look hot
Shi kyaan go pan di ruod	She can't go out on the road
A luk laik jab lat	Looking like job lot goods
Evri uman a go kaal ar	Every woman is going to call her
Rif-raf	Riff-raff
Luk laik a uol kyar	Looking like an old car
Mash op an krash	All smashed and crashed.

'Muscle Grip', from the *X-Tra Naked* CD, makes it clear that women are not merely passive, desired objects. Their active interest in their own sexual satisfaction requires a high degree of physical fitness to do the work. The use of the word 'work' for sex clearly implies the stamina that is required. The skilful, acrobatic dancing that women do in serious foreplay – bending over backwards and touching the ground, for example – is not for the physically unfit. The emphasis on the mobility of the woman's bottom, the seat of pleasure, is particularly pronounced. The wearing of the 'bati-raida' emphasizes the woman's gross assets.[10] In a witty essay in the *Village Voice* (9 July 1991), entitled 'Venus Envy', Lisa Jones revives the early nineteenth century 'Hottentot Venus' as the alluring progenitor of contemporary (Euro-American) images of desirable Black female sexuality: 'A veritable butt revolution has swept America in the last two decades – brought to you by Black music, designer jeans, and MTV. (Once you've seen Janet Jackson gyrate to "Black Cat", can you really go back to Twiggy?)' The same question, asked in Jamaica: 'Once you've seen the reigning dancehall fashion queen, Carlene "skin out" to any dancehall tune, can you really go back to Miss Jamaica?'

In a highly competitive marketplace women have to ensure that they have pull. Undermining the Eurocentric, chivalric romance of woman as delicate flower, Shabba recommends a robust muscularity that grips and holds the woman's sexual partner, literally. The pun on 'hold' is multilayered. The English 'hold' loses its final consonant in Jamaican, becoming *huol* ('hole'), as both noun and verb:[11]

Uman, yu priti laka flowaz	Women, if you're as pretty as a flower
Dat aluon naa go du	That alone won't be enough
Alduo yu priti so	Although you're that pretty
Man stil a lef yu	The man will still leave you
Yu luk gud	You may look good
Fram a luk gud	From a purely superficial
Paint av viu	Point of view
Alduo yu luk gud	Although you look good
Uman dem luk gud tu	Other women look good too
If yu kyaan huol yu man	If you can't hold on to your man
A gyal a tek im fram yu	Another woman will take him from you
Av di grip, a av di mosi	Have the grip, have the muscle tone
Iim ha fi kom bak tu yu	He'll have to come back to you.

The DJ's pragmatism in matters of sexual politics is firmly rooted in Jamaican peasant values. A number of Jamaican proverbs suggest the clear correlation of love, sex and money in folk culture:

> When money done, love done.
> Man can't marry if him don't have cashew.
> When man have coco-head[12] in a barrel, him can go pick wife.
> When pocket full, and bankra[13] full, woman laugh.
> Cutacoo[14] full, woman laugh.
> Woman and wood, and woman and water, and woman and money never quarrel.[15]
> You must find a place to put your head before you find a hole to put your hood.

Comparative analysis of the representation of female sexuality in the lyrics of Bob Marley and Shabba Ranks reveals changes in Jamaican cultural politics as the society evolves from a rural, peasant-based agricultural economy to an urban, wage-earning economy. Old-fashioned peasant values of relatively settled domestic order on small landholdings give way to more modern notions of commodified exchange of goods and services in relatively unstable urban settlements. Sexual relations between men and women often reflect prevailing socio-economic conditions. It is not only sexual relations that become commodified in the urban setting. Informal, communal childcare systems in rural areas give way to the organized business of the urban daycare industry.

Marley's decidedly chauvinist Rastafari lyrics issue, in part, from the conservative, biblically grounded peasant values of his rural origins. The secular economics of Shabba Ranks's much more egalitarian gender politics may be read as an urban up-dating of the proverbial wisdom of Jamaican folk culture. It is not only woman that is inexhaustible; Jamaican popular culture keeps on renewing itself, transforming norms of sexual decorum to suit the material conditions of the changing times.

Notes

1 In the UK 'dancehall' has been dubbed 'ragga'. For a useful discussion of the terms see Mandingo (1994).
2 See 'Culture Hiding from Slackness: Erotic Play in the Dancehall' in Cooper (1994): 136–73. A note on *liriks* : the meaning of the Jamaican word *liriks* is somewhat wider than the English 'lyrics'. In Jamaican *liriks* functions as both noun and verb. It generalizes the singer's skill with lyrics into any kind of verbal skill.
3 Willis (1993). I attempt to address the issue of 'homophobia', Cooper (1994).
4 I develop this argument in an unpublished conference paper, 'Reggae to Ragga: What's Left of the Protest?', presented at the SERMAC Forum on 'Music and Society', Fort-de-France, Martinique, 22–4, July 1994.
5 Peter Tosh, 'Equal Rights', *Equal Rights*, (CBS Records, 1977).
6 Shabba Ranks, 'Ca'an Dun'. *Shabba Ranks Rough & Ready Vol. 1* (Sony Music Entertainment Inc., 1992). The reference to washing and turning down again, as of dinnerware, suggests a possible allusion to woman as vessel.
7 Morris (1993): 67.
8 Morris (1982): 58.
9 Ibid.: 142.
10 'Bati raida' means, approximately, 'pants that ride high on the bottom.'
11 See the last proverb 7, cited below.

12 'The rootstick or rhizome of the coco plant as distinct from the tuber, which is a coco.' (*Dictionary of Jamaican English*).
13 A basket, normally larger than the 'cutacoo'.
14 A field-basket used by hunters and cultivators.
15 Here literal 'firewood' which denotes material prosperity, becomes a metaphor for the erect penis – 'wood' as 'hood'.

References

Cooper, Carolyn (1993) *Noises in the Blood: Orality, Gender and the 'Vulgar' Body of Jamaican Popular Culture* (London: Macmillan; Durham, NC: Duke University Press (1995)).
Cooper, Carolyn (1994) 'Lyrical Gun: Metaphor and Role Play in Jamaican Dancehall Culture'. *The Massachusetts Review* 35, 3 & 4, (autumn–winter) 429–47.
Jones, Lisa (1991) 'Venus Envy', *Village Voice* (9 July)
Mandingo (1994) 'Dancehall & Ragamuffin', *Dance Hall* (February): 14.
Morris, Mervyn, (ed.) (1982) *Louise Bennett: Selected Poems* (Kingston: Sangster's).
Morris, Mervyn (ed.) (1993) *Louise Bennett: Aunty Roachy Seh* (Kingston: Sangster's).
Parker, Patricia (1987) *Literary Fat Ladies: Rhetoric, Gender, Property* (London: Methuen).
White, Garth (1967) 'Rudie Oh Rudie', *Caribbean Quarterly*, 13, 3.
Willis, Tom (1993) 'Ragga to Riches', *Sunday Times*, [London] (4 April).

Discography

Marley, Bob, *Exodus* (Island Records, 1977).
Marley, Bob, *Survival* (Island Records, 1979).
Marley, Bob, *Uprising* (Island Records, 1980).
Ranks, Shabba, *As Raw As Ever* (Sony, 1991).
Ranks, Shabba, *Rough & Ready Vol. 1* (Sony, 1992).
Ranks, Shabba, *X-tra Naked* (Sony, 1992).
Tosh, Peter, *Equal Rights* (CBS Records, 1977).

30

MOTHERS OF AFRICA AND THE DIASPORA

Shared maternal values among Black women

Aminatta Forna

In the spring of 1996, the story of one small boy dominated British newspaper head-lines. Sifisio Mahlangu's tale was called a 'tug-of-love' case, but it was one with an unusual twist. This was not a custody battle between two estranged parents. Instead, it was a fight between two women, both calling themselves the boy's mother. The first was his natural mother, a Black South African house worker. The other was a white woman called Salome Stopford, who was once his mother's employer and who had brought Sifisio to England and now wanted to adopt him formally.

From the appearance of the first short article giving an account of Salome Stopford's battle with Westminster Local Authority, the story swelled inspiring columns, leaders and comment. There was the drama of Sifisio's fate, which pivoted on whether he would be 'sent back' to Africa to live with his natural parents or 'allowed' to stay in Britain with his new mother.

There were issues with which to wrestle, to dissect, to decide. Here was a wealthy white woman fighting her former nanny for custody of a child. Was it really better for him to be returned to poverty, the 'politically correct' decision? Should a Black boy be raised by a white woman? Some of the facts appeared slightly bizarre. Selina Mahlangu and her husband Charles apparently had not even been aware that adoption proceedings were going ahead, until they were contacted by a local Black journalist and given free legal representation by a group of radical Black lawyers. Throughout, the spectre of apartheid hung over the main players and their relationships with each other.

In her efforts to win Sifisio, Salome Stopford and her lawyers depicted Selina Mahlangu as a 'bad' mother. What natural mother, her lawyers posited, could give up her child so easily to another woman and allow him to be taken half-way across the world to a country she was not even capable of locating on a map? Obviously she had no interest in the child. As well as sending him to a smart, private school, the court heard, Mrs Stopford also provided the roof over his head. They lived together as a family. Plus she had formed a close relationship, a bond no less, with the boy. By her own account she, Salome Stopford, had overridden Mrs Mahlangu's biological claim and she was Sifisio's 'real' mother.

By and large, the British public agreed with her. Even journalists sympathetic to the Mahlangus had trouble explaining the couple's actions. They looked for explanations

which might help their readership understand why a mother would allow herself to be separated from her child. Sifisio's case was a legacy of apartheid, *The Guardian* (7 May 1996) explained: it was impossible for a couple like the Mahlangus to challenge the whims of a white woman like Salome Stopford.

But one of the few published quotes from Charles Mahlangu points to another truth: 'My wife had no idea where England was', he admitted, 'but we thought we would be closing the door for the child if we refused him this chance.' (*Sunday Express* 10 March 1996). The arrangement that they said they agreed to was that Sifisio would return to South Africa for holidays. The Mahlangus were poor, yes – certainly compared to Salome Stopford. But that alone does not account for their reasoning entirely. In South Africa, children are often raised by people other than their parents within a system of informal adoption or wardship that has evolved out of a community sense of responsibility for children.

One of the ways people help one another out is by looking after each other's children for periods ranging from months to years. The result is that a child may have more than one family, more than one mother. One suspects that Mrs Stopford may well have been aware of all that, for she had certainly lived in South Africa long enough. But Salome Stopford wanted to make Sifisio legally 'hers'. Did she break the faith or was she simply a product of her own Anglo-Saxon culture in which a child can belong either to one person or the other, but not to both? Ultimately Salome Stopford failed to persuade the courts to allow her to adopt Sifisio, and he was returned to South Africa.

Nelson Mandela rose to prominence because of the offer of a Xhosa chief to take the boy into his household, raise him and educate him as his own son. It is a period that Mandela has written about with fondness and clarity. In his autobiography, Long Walk to Freedom, he makes this observation:

> I can hardly recall any occasion as a child when I was alone. In African culture, the sons and daughters of one's uncles and aunts are considered brothers and sisters, not cousins. We do not make the same distinctions among relations practiced by whites. We have no half brothers or half sisters. My mother's sister is my mother; my uncle's son is my brother; my brother's child is my son.
>
> (Mandela 1994)

If one chooses to look at it in another way, one could argue that, far from being 'bad' mothers, both Mrs Mandela and Mrs Mahlangu passed the 'sacrifice test' with flying colours. But in a country and culture in which what counts as good mothering is the creation of an exclusive mother/child bond, Selina Mahlangu came within a whisper of having her relationship with her son effectively cancelled. In all the editorial posturing, the daily new facts and the melodrama, none of the journalists got the real story. This really was a story about motherhood. In particular, a story about Black motherhood versus white motherhood.

Can one talk about 'Black' motherhood, as distinct from white and even as distinct from African, African Caribbean or African American motherhood? At the broadest level, race and racial oppression targeted at Black families whether in Britain or America is a specific shared experience. Black mothers in both countries have been singled out and criticized or vilified as single parents, as 'matriarchs', as inappropriate parents. In addition Black mothers in Africa and in the diaspora have a shared cultural and

historical heritage which unites them and which has been traced and described by historians. These shared cultural antecedents are displayed in the values, the beliefs and the practices that Black women bring to their mothering tasks and to the way that they think as mothers. To a greater or lesser extent all women of African ancestry, whether they live in Africa or in the West, are bound by a commonality. Western feminist historians, sociologists, scholars and writers have criticized motherhood as a culturally constructed institution. The early feminist movement rejected motherhood as women's necessary biological destiny and only role, concentrating their efforts at liberation elsewhere – the workplace. Retrospectively, several contemporary commentators have accused the feminists of ignoring mothers and dismissing motherhood (Freely 1995; Benn 1998). But it might be fairer to say that, although the movement neglected to tackle motherhood in any significant way, that omission was understandable in the context of what it was trying to achieve in that period.

Later, in the 1970s, a number of women developed new theories about motherhood, placing childrearing within the context of patriarchal social and economic relations (Rich 1977; Chodorow 1978; Firestone 1970). Together they delivered an analysis of mothering within the institution of the nuclear family, which made the woman totally responsible for her child, as historically specific and neither 'natural' nor inevitable. Their insights were both powerful and valuable, but they omitted the experience of women of colour and Black women. This failure to see motherhood also from the perspective of the Black woman was and remains one of the main reasons why Black women in the USA have, in general, remained outside the feminist movement, despite the very real efforts to bring them in by some white feminists.

Mainstream feminism sought to liberate women from the home and concentrated considerable effort in encouraging women into the workplace. The majority of African American women, on the other hand, had never known anything other than the combination of mothering and work. Often in badly paid jobs and working long hours, what many of these women wanted was time with their families, time to create a home, time to love their children.

White women wanted sexual liberation and the freedom to experiment sexually while Black women wanted protection from sexual exploitation. The contraceptive pill offered white women sexual control and freedom from childbearing; meanwhile, the emerging Black nationalist movement urged Black women to throw away the pill, to procreate and to overturn Black women's history of forced sterilization and abortion, at the hands of government policy. The ambitions of Black mothers and white mothers in America were worlds apart.

In African American neighbourhoods, the community 'mother' has in the past commanded respect, authority and real local, social and political power. Mothering could be a path to a community position. The white middle-class mother, isolated in her suburban home, has shared none of that. And while white women writers have often written about motherhood, even their own mothers, with hostility and fear, Black women writers such as Alice Walker (1989) and Angela Davis (1971) have penned eulogies to the women who bore them and to all Black mothers.

In Britain, owing to the lack of a critical mass of Black women in the 1960s and to this day, the debate around motherhood and feminism has played out less starkly. Nevertheless, the Caribbean or African immigrant mothers share many similar concerns with the African American.

Africanist historians have been more effective than white feminists in describing the experiences and concerns of the Black mother in Western society. Academics such as Niara Sudarkasa (1980) and Herbert Gutman (1977) have convincingly argued that the African American, African Caribbean and even African Brazilian families have adaptive family forms with shared cultural beginnings in sub-Saharan West Africa. Edith Clarke (1957) traces the threads of modern family structures through slavery back to the African village. Historians may disagree on exactly how much and how many practices can be attributed to an African past, on the exact effects of slavery on the Black family and the precise influence of other socio-economic factors, but few now venture to dismiss the very real West African inheritance.

Multi-generational households, co-operative child-raising, informal adoption, commitment to wider kin and even non-kin networks are all adaptations of family forms found throughout Black Africa, where children are raised in the compound by a group of related adults. Gutman (1977) has uncovered evidence of all these combined with European influences during the period of slavery. Today, for the Black mother, marriage is not necessarily the primary relationship in her life. It may be one of several bonds, parallel in significance to her relationship with her mother and other family members. Similarly one finds a greater acceptance, although notably not a greater past prevalence, of female-headed households.

In 1970, Niara Sudarkasa named the four 'cardinal values' underpinning African family life which he claimed had been inherited by families of African origin in the diaspora. They are respect, responsibility, restraint and reciprocity. Sudarkasa argues that it is the erosion of these values and their replacement with the pillars of the modern nuclear family – individualism, isolation and self-sufficiency – that have undermined Black families everywhere and left the poorest exposed and vulnerable (Sudarkasa 1997).

For African Caribbean and African American mothers, responsibility and reciprocity – the ability to share child-rearing duties with others who are willing to accept responsibility for a wide range of kin – are the core values which have enabled and still enable them to raise their children, even without a male breadwinner or in adverse circumstances. These traits have enabled the Black family to survive everywhere. It is only in recent years, in the face of a concerted effort by government welfare and social policies in Britain and America to impose the ideology and standards of the Western, nuclear family, that Black families have been faced with a crisis.

Compared to the Black mother, who ideally raises her child in a network of support and mutual reliance, motherhood for the white woman is typically a very different experience. The history of motherhood, that is the Anglo-European brand of motherhood which prevails in Britain and America, is a very particular one and relatively recent. As has been well documented (Shorter 1977), it was the Industrial Revolution that ushered in gendered divisions of labour and saw the emergence of the nuclear family. The sequence of events are more complicated and detailed than I have time for here, so I will concentrate instead on a period crucial to the creation of the modern institution of motherhood, the years following the Second World War in Britain and America.

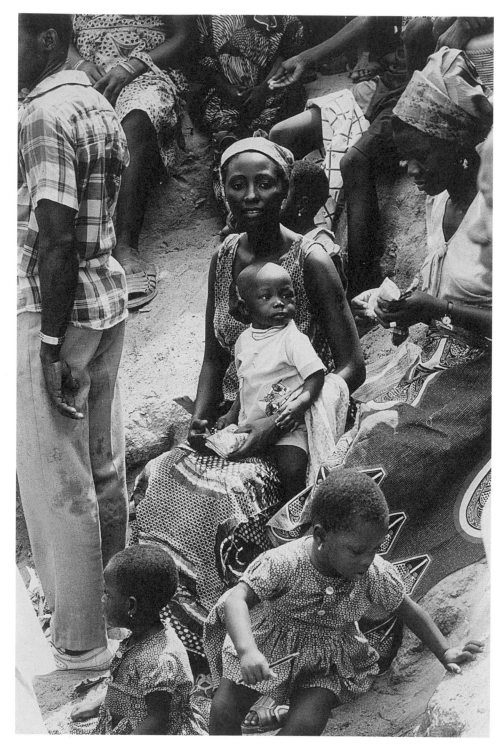

Figure 30.1 Armet Francis, *Child and Family*
Source: © Armet Francis

Postwar Freudians and 'maternal deprivation'

The postwar period saw many millions of children orphaned, families broken, women at work and men returning from the front. In 1946, a Freudian psychoanalyst named John Bowlby wrote a report entitled 'Maternal Deprivation' (Bowlby 1953) in which he outlined the devastating effects on the mental health of children who were placed in institutions during the war. He developed the theory of 'attachment', which purported to show that there was a biologically driven, special bond between mother and child which should never be broken. To do so, he said, would cause children to become delinquents and to grow up into 'affectionless psychopaths'.

According to Bowlby, maternal deprivation could occur even under such circumstances as a child's stay in hospital. Leaving a baby to cry, for example, could cause 'partial deprivation'. Later, in 1977, Selma Fraiberg, a Bowlby disciple who invented a method for measuring attachment, maintained that care by anyone other than a child's mother could be damaging. Bowlby's report was greeted with enormous concern and women rushed back, or were urged back, into the home to look after their children.

Taken to its logical conclusion, which it subsequently was, Bowlby's theory meant that women had to stay at home with their children twenty-four hours a day. In the UK, the government closed down fifteen hundred state-funded nurseries. Bowlby's work was, and still is, quoted extensively in academic and professional literature, as well as popular baby books including the famous Spock series and current texts by gurus such as Penelope Leach and Berry Brazleton. 'Attachment' is the reason why we still debate the effects on children of a mother working outside the home, whether the state should fund childcare; whether children can be removed from one caretaker and placed with another, and so on. This continues despite the fact that Bowlby's original theory has been heavily criticized, its findings scaled back and in some instances dismissed altogether.

Significantly, in the second half of this century, the prevailing view of motherhood in Britain and America has placed enormous emphasis on the mother's role, on her continual presence, her character and competence; which sees children as the parents' sole responsibility and property; and which places motherhood in the context of a nuclear family, relegating the father to the role of earner.

The Anglo-European standard of motherhood is still deemed by most social scientists, policymakers and politicians to be the norm by which all others are measured. This dominant paradigm is considered the 'right' way to mother. As a result, in the UK and in the USA, there has been a history of social workers removing Black minority children from homes considered unsuitable because different arrangements for their care are in place, or on the charge of maternal neglect.

The conviction that only mothers should care for their children is the basis of how welfare policies have been enacted. In Britain, payments to lone parents were designed to replace the absent male breadwinner and to keep women at home with their children. In the USA, the historian, Linda Gordon documents how AFDC (Aid to Families with Dependent Children) was designed with an identical purpose and how, at its inception, African American women who lobbied on behalf of single mothers wanted the cash to be used to provide affordable childcare so that women could continue to work (Gordon 1994). In both countries, critics have argued that the rules regarding welfare have contributed to the fragmentation of families, particularly

Black families, by enabling a mother to live alone with her children and penalizing her if she chooses to live as part of a household, with relatives or a partner.

The message that the dominant style of mothering is natural and desirable is carried through the media, adoption policies, theories of child development, parent education, parental leave and so on. It is the standard against which every other form is considered deviant or unfortunate. Some years ago the psychologist Stella Chess coined the phrase *mal de mère* to describe a tendency in modern society to blame every kind of social ill or private pain on mothers.

In Britain, African Caribbean mothers are blamed for the problems of young Black men and portrayed as irresponsible, sponging and overly fertile. In the USA, no one has been targeted more than African American mothers, starting with the 1965 Moynihan Report which condemned the Black family as pathological and Black women as 'too strong'. True to its Freudian overtones, it blamed the failure of Black men to find work on their overbearing mothers.

Given the widest internationalist perspective, it is evident that the extraordinary amount of labour and intent that has gone into fashioning the Anglo-Saxon mother has created a very specific maternal ideology – ideology not, frankly, found in the same form anywhere else in the world. Indeed many of the values shared by Black mothers in the West are shared by women in other parts of the world. The work of Denise Segura (1994), for example, has demonstrated a similar adherence to principles of shared care and responsibility for children in Latin families. She calls this 'the system of obligation' (I'll scratch your back if you scratch mine). Patterns of informal adoption, extended community networks and shared parenting also exist in South America, the Arab world and Asia.

The historical circumstances which created a role for the Western 'sculptress' mother, shaped by social and economic forces and backed by scientific and psychological systems, have simply not occurred anywhere else in the world. What stands out above anything else is, that irrespective of class or personal philosophy, Black women and women of colour have more in common with each other than with Western practice and ideology. In the words of bell hooks, the centre shifts, and it is Western motherhood – with its exclusive maternal role – which is unusual.

For Black mothers living in the West, there are two paradigms of motherhood – many are acutely aware that they live their lives between two co-existing scripts for motherhood: the one received through their own family and cultural heritage and the other which predominates everywhere else in society. This is revealed casually in conversation. For example a woman might say, 'well, *we* do this', or '*we* think that', which is clearly distinguishable from what is done or thought elsewhere. A woman who has recently emigrated from Africa or the Caribbean to Britain might refer to 'here' and 'home' to distinguish between the two systems. Others refer to 'they' or explicitly 'white women'.

The Anglo-European cultural script for good mothering ascribes great importance to an *exclusive* mother/child relationship; regards *the mother as the best caretaker* and places a strong degree of *emphasis on her skills* as a parent. As a result, only *one role for mothers* can be practically envisioned, leading to a *conflict with work* or other interests outside the home. It is a limiting and exacting style of mothering, and women who can't or don't mother in the prescribed way suffer a high degree of *guilt*. 'There is no such thing as a baby, only a mother/child couple' (Donald Winnicott, childcare expert: 1986). Black mothers, on the other hand, place comparatively less emphasis on the mother/

child dyad. A mother's relationship with her child, while still central, is *non-exclusive*. The child has a relationship with a number of people who act as parents, effectively *co-parents*. The most important element is the *child's place in the community*. This support system operates to minimize any conflict with work, and the mother sees herself as occupying *flexible* roles.

A mother's work

A woman's most important role is being at home to mother her small children.

(Brazleton 1981)

She might not have any money to supplement her husband's income, but were they not in the white man's world where it was the duty of the father to provide for his family?

(Emecheta 1979)

Despite the move of large numbers of women into the workforce, the dominant school of thought sees work outside the home as incompatible with the requirements of good mothering. It is asserted that mothers should be 'there' for their children, at home when they come back from school, there to put them to bed, there when they are asleep. The fact of a mother's presence is thought to be necessary to make a young child feel confident, happy and secure.

It's not difficult to trace the roots of this way of thinking back to that old chestnut, the attachment theory, and the notion that mothers should devote themselves entirely to the every need and whim of their offspring. The distractions of work are viewed as a dereliction of duty. However in the rest of the world, the fact of the matter is that mothers are hard at work. Most countries outside the West are simply not wealthy enough to allow women the luxury of staying at home to mind the children. And without an army of professionals to accuse them of damaging their children, mothers have continued to work unhindered.

While work does not necessarily relieve women of the responsibilities of mothering, there is no conflict between the *idea* of a woman working and earning, as well as being a mother. Linda, a young Jamaican mother of three, put it this way: 'My mum worked. My grandmother worked. It's how I was raised – to respect what my mother did.'

Nigerian author Buchi Emecheta's novel *The Joys of Motherhood* tells the story of the trials of Nnu Ego, a young mother struggling with the role and expectations of womanhood within the confines of tribal tradition. She has many problems, but the ability to earn a living is not one of them – at least until she joins her husband in the expanding metropolis of colonial Lagos. Throughout West Africa, women have historically been the ones who run the farms and trade, often travelling great distances to neighbouring countries to buy goods. Today a visitor to Nigeria, Sierra Leone or Ghana will find few women without the means to support themselves and their children.

In Britain, African and African Caribbean mothers are more likely to work full-time than white mothers, according to a study undertaken at Manchester University. In fact, some 60 per cent of single African Caribbean mothers work (Bartholomew et al. 1992), which is equivalent to the figure for white mothers who are married. Of African American women, Patricia Hill Collins has observed:

the assumption that motherhood and economic dependency on men are linked and that to be a 'good' mother one must stay at home making motherhood a full-time 'occupation' is similarly uncharacteristic of African-American families.

(Hill Collins 1987)

A study published in 1996 by researchers at Tufts University and the University of Michigan revealed the same finding: 'the employed mother has long been the norm for African American women' (Blum and Deussen 1996).

Black women in America have historically rarely been able to afford the luxury of not working because Black men have trouble finding work, particularly the type that can support a stay-at-home wife and a family. But even among middle-class Black women today, one finds that the work ethic is strong. Over time, the women's circumstances have fostered a maternal ideology which says a mother should work *in order to be able to* look after her children. That providing is part of the duties of motherhood.

Lakesha, a young Black mother, puts it this way: 'Otherwise you put all your eggs in one basket. I had an aunt who gave up working, then her husband had to retire early because he was ill. She hadn't had a job for fifteen years, and you just thought, why didn't she just keep on working?' (my interview with her). Ramatu, a Sierra Leonean whose husband was an engineer, said: 'If you don't work how can you take care of them? If you have children you shouldn't be dependent on anybody' (my interview with her). The women do not question their 'right' to work and have a family. Their work is seen as valuable in its own right. Christine Oppong, a West African sociologist, says that while the archetypal white, Western family divides men and women's responsibilities into two opposite camps – the public 'male' sphere of work related to financial support for the family and the private 'female' sphere of nurturing and child-rearing – most African cultures do not (Oppong 1983). Mothering is not seen as a private, individual undertaking, reserved for biological mothers who are exclusively devoted to their own children.

The problem in Britain and America is that Black women find themselves on the 'faultline' between two conflicting ideologies. Some have even come to resent the time their own mothers spent working and even embraced the idea that a woman should be at home with her own children. Anna, a young African American mother on AFDC, described herself to me as 'barely surviving in order to stay at home'. She was unhappy about her own childhood, during which her mother worked while her grandmother looked after her.

She said that she wanted her own family to be 'like *Leave it to Beaver*' (a popular American family television show set in the 1950s). Her choice to go on welfare was deeply influenced by her wish to adhere to a certain notion of 'good' mothering. She demonstrates the possible conflicts between the dominant ideology and the realities of personal situations and attitudes.

Exclusivity: one mother, other mothers

Like it or not, you are the family now.

(Leach 1989)

Childrearing is a responsibility that can be shared with other childrearers, with people who do not have children. This form of parenting is revolutionary in this society because it takes place in opposition to the idea that parents, especially mothers, should be the only childrearers.

(hooks 1984)

'Other mother', 'little mother', 'Auntie', 'second mother', 'mother' . . . these are all names for the woman whose role has no equivalent in white society but is a central figure in African, African Caribbean and African American family life. She may be a relative, a neighbour, a close friend of the natural mother, or just somebody in the community with a love of children, but she helps to care for children other than her own. She may be married or single, elderly or youthful. She may be a mother of ten or never have raised her own child. She is the mother's helpmate, support and equal. To the child she is another mother.

In the dominant ideal, a mother enjoys a one-to-one relationship with her child, at least while he or she is young. These are the moments of perfect bliss which, according to Freud, chart the course for happiness in adult life. As the child grows, they remain the individual responsibility of their mother, who only gradually encourages them to venture further afield and develop other relationships. Even so, nobody, not even the father, comes close to recreating the kind of bond which exists between a mother and her child. And, for many women, the intimacy she shares with her child is a source of great pride; indeed in our society the bonded relationship is probably the single most important measure of 'good' motherhood.

All this is not necessarily true elsewhere. There are few countries where a mother is not the most central figure in her child's life, but the degree to which that is true varies, and usually quite dramatically. She is more likely than not to share her role with several other people, including 'other mothers' (Stack 1974). Carol Stack spent years chronicling the lives of a group of urban African American women and the networks of mutual support and shared responsibility which enabled the community to survive. Children in 'the Flats' were able to look to a number of adults. Stack coined the term 'fictive kin' to cover people who are not blood relations but are treated by a child and its family as though they are.

For example, in my research, one mother was helped by her two best friends, both married women who were also 'other mothers'. Letitia, a forty-year-old dance therapist, had two children aged thirteen and five. Twice a week Alex, a newspaper columnist who worked to her own timetable, collected the children from school and took them to their sports club, while Letitia worked late. When the eldest girl was a baby, she often spent her afternoons after nursery playing under Alex's desk, because the newspaper office's atmosphere made it easy to babysit. In the evening, the girls would often call Daniella for help with homework. Letitia described the 'other mothers' as 'my big support systems'.

Daniella had actually opted not to have children herself and to carve herself a niche as 'other mother' to as many children as possible. She grew up with a local woman who acted as second mother to a number of children, and to whom she often turned. She herself commented: 'I don't see it as a secondary role, I'm just as valuable as a resource.' She had made an early decision not to try to combine children with a strenuous career with a retail organization and freelance singing engagements. 'It's a maternal thing, but it's different', was how she explained the arrangement.

The ability to divide duties among other people is thought to be one of the reasons why African Caribbean mothers in Britain have such high rates of economic participation. Researchers have hazarded that this might be because they have support networks they can rely on (Bartholomew et al. 1992). A small misunderstanding with an African woman made me aware of how different the experience of single motherhood can be depending on the culture in which the woman without a husband raises a child. She had told me that she had her first child before she was married. Later I asked her a question about being a 'lone mother'. She looked at me in confusion, so I explained that I had understood that she had a child when she was single. 'Ah yes', she replied with some amusement. 'But I was never alone.'

Adults in communities where children grow up under the care of several people argue convincingly that such a system of mothering is in the best interests of the child. They regard the attachment to the maternal figure, which we prize so highly in the West, as impractical and even stifling: 'If a woman is with her child all the time, she'll never leave that child alone again' (Jane, Sierra Leone).

Co-parenting in communities which share responsibility is also considered healthier for the child's development. Whereas the Western 'sculptress' mother tries to act as an agent of control and to direct and ration her child's experiences, a Black mother welcomes the input and combined experience of a number of people. Children often go to live with another family for a period of months or even years. Informal adoption or wardship is evidenced in all African, African Caribbean and African American communities.

The bonds created by raising a child are close, imperishable and irrespective of genetic ties. But they exist alongside blood relationships and the natal family does not give up its commitment or connection to the child. A child could move family for any number of reasons: frequently to further its education and experience, or to give parents time to set up a business, to get over an illness or just because it is considered more convenient or effective all round.

An art historian at the Royal Academy in London who is of Caribbean heritage said: 'My son lives with my mother back home. Nobody seems to understand that this suits all of us perfectly well.' Her son went back to the Caribbean while she was working hard for her Ph.D.; now he is happy at school. No one, including his mother, feels it necessary to disrupt his life simply in order to reunite mother and son.

Esther sent her seventeen-year-old son, whose unruliness she failed to control, back to West Africa to live with her cousin who she felt was better equipped to deal with the boy's temper. Esther's success or failure as a mother was not seen as an issue.

The assumption here is that motherhood is not an exclusive undertaking. Marion explained: 'A mother might say, I don't understand this child. Maybe with some other member or family or household this child might grow to learn or have a different relationship that might work more easily' (my interview with her).

A mother may be a constant throughout her child's life, but that does not mean she is necessarily constantly present. As the case of Sifisio Mahlangu demonstrated, a child might even live apart from her mother for many reasons. Among immigrants to the West the practice of sending children 'back home' to live with relatives is common, particularly among some Caribbeans and Africans who have greater faith in the school systems in the Caribbean and Africa than in the British inner cities.

Paradoxically, when parents from those regions come to Britain, they find that their

customs put them on a collision course with the authorities. In the 1970s and 1980s many Nigerian students who placed their children in private fostering arrangements while they studied found that, when those families decided they wanted to keep their children, the British courts awarded the families custody. The Nigerians were seen as having 'deserted' their children.

Other misunderstandings arise. Immigration authorities accuse Somali parents of trying to bring children into the country illegally by claiming that they are theirs, when blood tests show that they cannot be the natural parents. Caribbean women who collect their children from relatives in the Caribbean are sometimes turned down by immigration officers on the grounds that they had 'abandoned their children by leaving them with relatives'.

Overzealous social workers remove Black and ethnic minority children from their homes on the grounds of maternal deprivation, because someone other than the mother is in charge of their daily needs. And Caribbean couples in the UK have been turned down for adoption on the basis that they are 'unsuitable' because their parenting arrangements do not fit the narrow set of criteria based on the white 'norm'.

Your child, our child: at home in the community

When the day-to-day care of an infant is routinely shared among different people, including parents and non-parents, the child is free to share affections, and the notion of to whom that child is seen as belonging becomes fluid. In Western maternal thinking, the boundaries of ownership are fixed. The child belongs to the mother, not even the father who is rarely awarded custody of his child when a couple split up. It is hard for many people in the West to grasp how other people can live and govern their lives without clear lines of delineation. Mother-centric thinking seeks to make one person morally and legally responsible for a child.

An important aspect of raising a child for a Black mother is to establish a place for that child in the community by the creation of links and bonds with other people. The 'community' also has an interest in that child. A general ethic of care persists which broadly allows all adults authority over all children, although this is an attitude which is increasingly besieged in Western society. Maree, from the Dominican Republic, described life 'back home': 'You see a child perhaps somewhere it shouldn't be. You might approach it, not to upset it but to find out what is going on. If it's up to no good, you say so.' Would she do that in Britain? She laughed. 'No, they'd dial 999 and accuse me of child abuse.'

Social ties, reinforced by informal adoptions, wardship and joint caretaking are as important as genetic ties. They may replace or reinforce blood ties. An Englishwoman told me in disbelief of the experience of a colleague, a Black woman who worked at her law firm. Single, successful, her diary overspilling with commitments, she received a telephone call out of the blue from her sister. The news was that she would have to look after her sister's three children for an extended period, owing to a change in life circumstances. 'It's your turn', said her sibling. She began to clear her desk and cancelled a seminar. She grumbled a little, but not seriously. 'She can just do that to you?' asked her colleague in surprise. But for the Black woman, taking care of her nieces and nephews was a duty and a privilege.

The widening gulf in modern Western society between adults and other people's

369

children contributes to the sense of loss that people who cannot have their own children feel. Such a couple in Britain or America, with only the most restricted of relationships with the children of their friends, come to want a child of 'their own'. Adoption policies have traditionally been aimed at fulfilling this desire by placing an anonymous baby with a couple who could pass as the genetic parents.

Once we even used to erase the child's entire history and start from scratch. In the last twenty years pressure to change those policies and to give adopted people the right to information about themselves, including the right to know that they are adopted, has come from the adopted individuals themselves, not from adoptive parents, many of whom would probably prefer to maintain the illusion that the children are naturally 'theirs'.

Nowadays growing numbers of infertile couples prefer to have a child of their own by using IVF or some other form of technology. People from ethnic minority groups, on the other hand, are generally under-represented as clients seeking the services of infertility specialists. A study under way at the Institute for the Study of Social Change in America has shown that, while white women embraced the possibilities offered by science, the Black women in the group showed far less interest.

Diane Beeson, who conducted the study, says that the central issue was control, on which the white participants placed a greater emphasis. For white clients, technology is being used to do the job that adoption, with only a trickle of 'adoptable' (which generally means white) children can no longer guarantee. The very focused need for a couple to produce their very own child, or the next best thing, is less urgent within other cultures.

One of the reasons why adoption agencies in the UK say they find it hard to find adoptive couples for ethnic minority children in their care is the fact that members of Somali or Jamaican communities, say, often prefer to adopt informally, through the community or through family ties. Furthermore, what is meant by 'adoption' doesn't necessarily correspond to the Western idea: 'The child would live with you, you would be its mother. You don't sign papers to say so', explained one African woman who had raised two girls alongside her own.

The connection between the families, that is the 'adoptive' family and the child's mother or parents, is retained. When Linda, a Jamaican, says, 'I would prefer to know who the child's family is', she does not mean she wants to know what kind of stock the child comes from. Rather, she would prefer and expects the natural mother or parents to take some part in raising the child. They obviously cannot do this if they remain anonymous.

Forerunners for the future

Both Black and white women are trapped by a dominant, intransigent maternal ideal. Practice and ideology interweave in a multitude of areas, not least of all over the issue of work. A white, middle-class woman with sole responsibility for her children simply does not have the time to work. At the same time, she will hear that, in fact, she 'shouldn't' work, because it's better for her children if she is at home (the ideology justifies the practice).

Women who choose to hire a childminder or send their children to day care, soon start to hear all that 'evidence' that their relationship with their child is likely to suffer; that the child *requires* their mother's presence (the ideology becomes dogma).

For Black mothers, the emotional damage wrought by a maternal ideology which preaches one form of exclusive, bonded, stay-at-home motherhood is immeasurable. Castigated as defective mothers, many try to fit the square peg of 'ideal' motherhood into the round hole of reality. Welfare systems alongside public attitudes have conspired to break down the support networks that have traditionally been the coping mechanism for Black women, with catastrophic effects on single mothers, in particular.

To raise their children in the way that white middle-class women do has never been a possibility for Black women, or even white working-class women. It is an ideology which dictates dependence on a man and fixed gender roles, and is also built on ideas about femininity from which Black women have generally been excluded. In every way it is an ideology which is becoming increasingly impossible and out-of-step in a postmodern world in which personal expectations and the social and economic landscape are wholly different from the postwar era.

Black mothers everywhere have had to be more practical and adaptive. And this experience has had the effect of making Black womanhood, specifically Black mothers, the forerunners of feminism. A growing school of thought sees the trends and practices of Black parenting catching on in the mainstream. Judith Stacey (1996), a sociologist, says: 'Far from dying out, co-parenting is gaining new ground in communities where people have always shared childcare to meet new demands.' Partly, families are adapting to economic necessities such as the fact that childcare can be extremely expensive, and work hours long or inconvenient. But the biggest impetus of all is the number of single mothers who would otherwise be coping alone.

So what of Sifisio who was returned to his African mother and no longer allowed to see his white mother? What should the judge have done, what could he have done? Surely the best for Sifisio Mahlangu would have been for everyone to abide by the African customs: to allow him to live in Britain and to be educated with one family and seeing his natural parents in the holidays. They could all have watched him grow into a successful young man with pride. One day he would have returned to South Africa qualified in law, engineering, or computer technology to take care of his family and be part of his country's future. Instead he has been returned, probably for ever, to the shack so openly scorned by journalists. And now that the international media interest is gone, there he and his family will stay.

References

Bartholomew, R. et al. (1992) 'Lone Parents and the Labour Market', *Employment Gazette* (November).

Benn, Melissa (1998) *Madonna and Child* (London: Jonathan Cape).

Blum, L. and Deussen, T. (1996) 'Negotiating Independent Motherhood', *Gender and Society* 10, 2.

Bowlby, John (1953) *Childcare and the Growth of Love* (London: Penguin Books).

Brazelton, Berry (1981) *Infants and Mothers* (New York: Delacorte).

Chodorow, Nancy (1978) *The Reproduction of Mothering: Psychoanalysis and the Sociology of Gender* (Berkeley: University of California Press).

Clarke, Edith (1957) *My Mother Who Fathered Me* (London: George Allen).

Davis, Angela (1971) 'The Black Woman's Role in the Community of Slaves', *Black Scholar* 3, 4.

Emechita, Buchi (1979) *The Joys of Motherhood* (New York: George Braziller).

Firestone, Shulamith (1970) *The Dialectic of Sex: The Case for Feminist Revolution* (New York: Bantam).

Freely, Maureen (1995) *What About Us?* (London: Bloomsbury).

Gordon, Linda (1994) *Pitied but Not Entitled* (New York: Macmillan).

Gutman, Herbert (1977) *The Black Family in Slavery and Freedom, 1750–1925* (New York: Vintage).

Hill Collins, Patricia (1987) 'The Meaning of Motherhood', *Black Culture, A Scholarly Journal on Black Women*: 4.

hooks, bell (1984) *Feminist Theory From Margin to Centre* (Boston: South End Press).

Nakano Glenn, Chang and Forcey (eds) (1994) *Mothering: Ideology: Agency and Experience* (New York: Routledge).

Leach, Penelope (1989) *Your Baby and Child* (New York: Knopf).

Mandela, Nelson (1994) *The Long Walk to Freedom* (London: Little Brown).

Oppong, Christine (1983) *Female & Male in West Africa* (London: Allen & Unwin).

Rich, Adrienne (1977) *Of Woman Born* (London: Virago).

Segura, Denise (1994) *Working at Motherhood: Chicana and Mexican Immigrant Mothers and Employment, Mothering, Ideology, Experience and Agency* (New York: Routledge).

Shorter, Edward (1977) *The Making of the Modern Family* (New York: Basic Books).

Stacey, Judith (1996) *In the Name of the Family* (Boston: Beacon Press).

Stack, Carol (1974) *All Our Kin: Strategies for Survival in a Black Community* (New York: Harper & Row).

Sudarkasa, Niara (1988) *Interpreting the African Heritage in Afro American Family Organization, Black Families* (Newbury Park, CA: Sage).

Ugwu-Oju, D. (1995) *What Will My Mother Say* (Chicago: Bonus Books, 1995).

Umansky, Lauri (1996) *Motherhood Reconceived* (New York: New York University Press).

Walker, Alice (1989) *In Search of Our Mother's Gardens* (New York: Harcourt Brace Jovanovich).

Winnicott, D. (1986) *Home is Where We Start From* (New York: W. W. Norton).

31

BLACK MASCULINITY

Claire Alexander

Black macho: masculinity and the peer group

Very little has been written on issues of black masculinity in the British context. Although both Pryce (1967) and Cashmore (1979) remark on the significance of the male peer group in black youth culture, this remains very much an institution whose existence is assumed and significance unquestioned. Both place the peer group within the context of personal failure and frustration; a retreat to a collective identity – in each case, Rastafari – as a coping strategy in the face of racial rejection. For Pryce, the peer group is associated closely with the 'hustler' lifestyle, where older men act as role models for teenagers who are 'unemployed, homeless and in conflict with their parents'. Drawing upon the ascribed pathology of the black family, Cashmore similarly claims that the peer group constitutes the primary source of socialization for black youth; an alternative to their parents who 'provided only models of degradation and deprivation'. The black peer group thus constitutes a recoil from the forces of racism into a negative and hostile structure, which is oppositional in both form and intent. It also becomes inevitably associated with deviance and criminality.

The attitude of both Cashmore and Pryce towards black male peer groups can be seen to have its roots in traditional approaches to youth deviance. This places the peer group, black or white, within the context of social and psychological maladjustment (A. K. Cohen), in which the individual turns to a male subculture in order to compensate for social rejection. This forms an autonomous entity which is defined by 'negative polarity' to the norms of wider society, and creates an alternative value system through which marginalized youth can create the illusion of status and power. Although later studies recognize that such groups are neither inevitably delinquent (Matza; Downes), nor necessarily opposed to social norms, it is this power inequality which remains the central feature of youth subcultural groups. Peter Wilmott notes in his study *Adolescent Boys of East London* that, within the peer group, 'the adolescent boy can enjoy a freedom and equality he cannot find at school, at work or inside his family'. That the peer group constitutes a bid for power by marginalized groups lies at the centre of many studies of youth subculture; that this reach for control reinforces such marginality and re-creates the conditions for its existence has become something of a truism (Willis; Hebdige). Within this arena, black youth are seen as doubly disadvantaged – by race and by class position – and are perceived as inevitably 'contracultural' in their stance (Downes). The black peer group is thus seen more as a

cathartic expression of frustrated power and social maladjustment than of positive action and control.

Although youth culture is seen as an exclusively male arena, few studies focus directly on the construction of masculinity. Paul Willis's studies of working-class youth culture are the main exceptions in this area, although even these do not fully consider the position of women in subcultural discourse. The general dearth of material on gender relations can perhaps be explained partly by the absence of work on and by women in this area, but also by the highly structured perception of social realities which marks out subcultural theory. Subcultural groups are usually regarded as internally homogeneous and positioned in direct opposition to an overarching hegemonic order which constitutes 'Society'. Hall and Jefferson note that subcultures are not placed in simple opposition and have relation to both 'Society' and the parent culture; in practice, however, these subcultures are viewed as autonomous entities locked in conflict with an omnipresent and static social structure, by which they are ultimately subordinated. The focus has thus been placed on 'class' struggle at the expense of the multiple layers of social structure, which enable subordinated groups – both male and female – to enter into conflict with each other as part of an ongoing search for control. It is at these levels, lower than that of the ubiquitous and undefined 'Society', that black masculinity is lived out and achieves significance.

The 'living out' of black male experience has been considered more fully in relation to African–American men. In *Tally's Corner* (1967), Elliot Liebow studies an all-male, 'street corner' society, which considers the role of the man as father, lover, husband, and breadwinner, rather than as 'social problem'. His study reveals the complexity and variation within these roles in relation to the individual, and in their relation to both women and other men. However, Liebow's emphasis throughout is on problem-solving; on the expression of powerlessness rather than control. He writes, 'Here, where the measure of man is considerably smaller, and where weaknesses are somehow turned upside down and almost magically transformed into strengths, he can be, once again, a man among men'. Exploitation, or power, becomes for Liebow a 'public fiction' within the street-corner context, an illusion distorted by the inevitability of personal failure. Liebow's study is of a world largely separated from wider society, denied its concerns, and set apart from its values and structures; a vision shared by Hannerz in his study of a black 'ghetto': 'The fact about the power of the ghetto . . . is that most ghetto dwellers neither have any nor are actively working to acquire any at present'. With a lifestyle characterized by sex, drinking and women, the 'Street Corner Men' are seen as symptomatic of personal limitation and lack of control, the product and enactment of absolute powerlessness. Ronald Taylor thus argues:

> A combination of contemporary social and economic factors conspire to limit the black male's access to status and economic resources . . . The inability to function successfully in the male role . . . may be experienced as a loss in masculinity and social identity, which he may attempt to recoup by active involvement in the life of the streets.[1]

This pathologized approach to black masculinity has recently been challenged by Mitchell Duneier in *Slim's Table* (1992). Focusing on a small, loose collectivity of older black men in a Chicago diner, Duneier writes of the group affirmation of respectability,

self-esteem, and communal identity which lies at the heart of working-class black masculinity:

> They are consistently inner-directed and firm and they act with resolve; their images of self worth are not derived from material possessions or the approval of others; they are disciplined ascetics with respect for wisdom and experience; usually humble, they can be quiet, sincere and discreet, and they look for those qualities in their friends.

Duneier contrasts this with the public expressions of 'ghetto-specific masculinity' which characterize the younger black 'underclass'. He thus distinguishes between working-class 'maintainers' and the subcultural 'creators' of alternative status systems, such as drug dealers and gang leaders, who dominate the public arena. While affirming the heterogeneity of black masculinity at an individual, private level, therefore, Duneier simultaneously rehearses and reinscribes the homogeneity of 'black macho' at a public, 'street level'. Like Liebow, Hannerz, and Anderson before him, he finally adheres to a view of expressive young black male identity as a form of status-inversion; the catharsis of ultimate male powerlessness.

There is little doubt that the concept of power is central to any discussion of black masculinity. Most studies have, however, regarded black masculinity as an *alternative* to social status, rather than as an *extension* of it. 'Black macho' has been portrayed, therefore, as differing in kind rather than degree from the wider gendered power relations within Society at large. Machismo becomes a symbol of, and substitute for, the lack of power, rather than constituting an aspect of that power. It has thus been seen as inauthentic and illusory; something apart from, and opposed to, the wider structures of Society. As bell hooks argues:

> The portrait of black masculinity that emerges in this work perpetually constructs men as 'failures', who are psychologically 'fucked up', dangerous, violent sex maniacs whose insanity is informed by their inability to fulfill their phallocentric masculine destiny in a racist context.

It is, however, only within the context of wider power relations – and as an extension of them – that black masculinity can be fully understood. In *Black Macho and the Myth of the Superwoman*, Michelle Wallace argues that it is in the search for 'manliness', as defined by dominant white society, that the origins of 'black macho' are to be found. It thus constitutes, for Wallace, a 'façade of power', which is concerned with the negotiation of personal control through interaction. This control is, however, taken as a prerequisite for the attainment of social and economic power: the assertion of masculinity constituting an expression of individual worth. Lynn Segal notes, 'The issue of "manliness" was thus crucial to the confrontation between white men and black'. Black masculinity can be seen, therefore, to reify white Western notions of masculinity in the search for wider social control and to incorporate these within its creation. Kobena Mercer writes:

> There is a further contradiction, another turn of the screw of oppression, which occurs when Black men subjectively internalise and incorporate aspects of

the dominant definitions of masculinity in order to contest the definitions of dependency and powerlessness which racism and racial oppression enforce.

However, rather than a static, autonomous, and essentialized ideology, with a direct relationship to action, constructions of masculinity should be viewed as both historically and synchronically contingent, inescapably intertwined with the expression and contestation of power. Michel Foucault writes in *The History of Sexuality*:

> Sexuality . . . appears rather as an especially dense transfer point for relations of power. . . . Sexuality is not the most intractable element in power relations, but rather one of those endowed with the greatest instrumentality: useful for the greatest number of maneuvres and capable of serving as a point of support, as a lynchpin, for the most varied strategies.

Black masculinity is then perhaps best understood as an articulated response to structural inequality, enacting and subverting dominant definitions of power and control, rather than standing in for them. Rather than a hostile and withdrawn entity, the black peer group can be seen as a base for interaction and negotiation with wider society. It forms a loose collectivity, which is internally neither homogeneous nor unified, and externally disparate in its intent and attitudes. The enactment of dominant norms and the restrictions of macro-structural constraints, however, render the lived expressions of black masculinity complex and often contradictory. Such tensions question the bounds of social constructions concerning 'race' and 'masculinity' and underline the fluidity of black male identity. As Segal notes: 'Black culture is also questioning the very notion of the "Black" subject . . . In looking at the oppositional meanings inherent in Black masculinity today, the stress is on diversity' . . .

Black women, white women: 'race' and control

To a large extent, though not exclusively, the perceived division between black women and white women corresponded to the public and private divide. Black women were generally considered to be 'our' women and were exempt from the ideology of exploitation which dominated the public arena. It is significant that, when the boys [in my research group] encountered black women in the West End or other mainly white environments, they rarely entered into any interaction with them. Similarly, within black social environments, which were associated with community, the boys never attempted to pick girls up – an activity which was the central feature of their excursions into the West End. White women, by contrast, were perceived as legitimate targets for exploitation and were rarely considered for long-term relationships – at least in theory. They were thus closely associated with the public arena, and with wider society, although this did not prevent the boys from accepting white women involved with black men as 'wives'. This was largely dependent upon the man's presentation of his relationship as one in which exploitation was not an element, although this was not always easily defensible. It should be noted that, in the following discussion, the term 'black women' is taken to include 'mixed-race' women, but to exclude Asian women, who were conceptualized differently and remained largely outside this debate . . .

Black women were thus associated with notions of family and the community.

Integral to this association was the concept of 'respect'; that black women were to be revered in their roles as mothers and culture-bearers. This meant that black women were to be treated differently from 'other' women in relationships. As Shane told me: 'You tend to be more careful with a black girl, because you handle them with so much care – you don't care about the other races' (interview, 5 April 1991). Black women were seen as much 'stronger' than white women, and as less open to sexual exploitation. This was partly because of the image that most of my informants had of black women as more aggressive and more knowledgeable in their interaction with black men. Darnell explained:

> Maybe they're not more aggressive, but you treat them differently because you think they are. So you don't take as much liberties as you would if it was a white girl. To a white girl, you'd go 'I'm going out', she'd go 'No, you're not'; I'd go 'Well, watch me and see'. Whereas a black girl would go 'you ain't going nowhere' and you'd go 'oh boy, it's a hard night tonight, boy'
>
> (interview, 24 March 1991)

Black women were also regarded as sexually inaccessible, at least for casual encounters. The boys felt that they would have to work harder to meet black women and would have to commit themselves to them before any sexual interaction could take place. Darnell confided to me:

> It must be true because I'm finding it hard at the moment . . . Yeah, a lot of them are harder to get. Like with a white girl, you can go and whisper two things in their ears and within a week you're regular every night, right? With a black girl, you have to say 'Praise Allah and every thing', and then they *might* give it up.
>
> (ibid.)

It should be noted that Darnell, who had never dated a white girl, was not speaking from personal experience here, but from a generalized stereotype and from observing his friends. The young men generally agreed, however, that they never looked to black girls for casual sex. On one occasion, Frank brought a black girl, Paula, to the flat; they had been seeing each other for several months before they had sex, and Frank told me at the time that he had rarely worked so hard to get anything. During their visit, Frank told me that he had been trying to persuade Paula to cook for him, but that she had refused. Frank's insistence was a token of his supposed commitment to the relationship; her refusal was a sign that he would have to provide more evidence before she could be won over. Ricky told me later that Frank's apparent devotion, which I had never witnessed in his dealings with other women, was a ploy to overcome Paula's resistance, and that this was the only way he could ever get a black woman into bed. He also told me that, having succeeded, Frank would lose interest – which he did. This reinforced the image of black women as less promiscuous, but also undermined the assertion that they should be treated differently. As Shane told me, 'I know black girls are a bit of a handful – or dark-skinned girls generally – but if you go about it the right way you should get it' (interview, 5 April 1991). 'Respect' at an ideological level, therefore, became merely another obstacle at the level of experience.

The position of black women within the overarching ideology was not, however, unambiguous. Just as the 'wives' were also seen as 'tyrants', black women were viewed with some trepidation by my informants. This was partly due to their role as representatives of the 'community'; they were thus seen as symbols both of solidarity and of constraint. When meeting black women of my acquaintance, therefore, the boys often felt that they were being judged, particularly in their role as provider. This was consolidated by their view of black women as financially independent and therefore in economic control within the relationship. This was not necessarily articulated by the young men; they would more often refer to black women as 'feisty', 'aggressive', or simply 'ignorant'. What these terms indicated, however, was a perception of black women as strong and outside the control of the black man, and thus threatening to his masculinity. This was inevitably denied by the young men themselves. Shane assured me: 'I know that black girls, some of them are quite mouthy, but they really – I'm not being a chauvinist – they want a man to take control; they do like that superior aura from their men' (interview, 5 April 1991).

Shane's very assertion of the control of black men over black women seems to deny its certainty. Indeed, in his relationship with Marion, his last girlfriend, he admitted that she had been in control; this was also reflected in the way the boys perceived their 'wives'. It is revealing to compare the way the boys regarded black female–white male relationships in this context. Shane told me:

> Black women aren't really attracted to white men . . . but a white man will do anything for a black girl. A black girl can feel in control with a white man. With a black man, it's a different story – those [women] are the ones that won't be in control.
>
> (ibid.)

Shane places control as the central feature of these relationships; black women go out with white men because they have power over them. Similarly, black men go out with white women because 'the white woman don't [sic] argue with him, does everything he says' (ibid.); again, the main attraction is seen as the establishment of control. In relationships between black males and black females, this control is seen as contested; it is something that is constantly sought and reasserted.

It is significant that the young men did not seek to establish this control through public interaction as they did with non-black women. Their interactions with black women were thus not marked by the group ridicule and insults which characterized their contact with other women. When the young men met Angelina and Eleanor on two separate occasions, the women were treated with a respect and deference I had rarely witnessed before. Nevertheless, the young men sought to establish control in a number of ways. First, they asked what the women did, seemingly hoping to establish control at the level of occupational superiority. When they discovered both were in higher education, the boys changed tactic. They proceeded to ask about the women's personal lives and 'accused' them of dating white men. This would have allowed the young men to dismiss the women as 'traitors', and as being somehow no longer 'black'. This would have enabled them to establish a sense of personal superiority. As Shane explained, 'the black girls that go out with white men are the ones we consider as the ones we don't want. They're not good enough' (ibid.). Eleanor, who did have a white

boyfriend, was dismissed with a smug 'Yes, she looks the type' from Ricky. Angelina's boyfriend, however, was not only black, but from Ladbroke Grove – a 'black' area – and the boys could not dismiss her as a 'sell-out'. They thus retreated, literally and in some confusion, from the kitchen where we were sitting, and left the flat.

As with 'wives' and 'bitches', black and white women are defined against each other. If black women are regarded as objects of respect and non-exploitation, sexually inaccessible and strong, white women are generally held to be the opposite of this. In addition, the association of white women with the public sphere allies them more closely to the power relations reflected in wider society. White women, at least at the level of ideology, are objectified in their role as representatives of 'the other', and the control sought is the enactment of power within these wider structures.

It should be noted that all the young men had been involved, either in the past or currently, with white women. These were mainly women they had met in the leisure sphere, and they were largely confined to this arena. None of the young men had white 'wives', although some had been involved in long-term relationships with white women. Frank, for example, had dated Stephanie, an air hostess, for about two years, while the majority of Ricky's long-term women friends were white. Both denied, however, that they had ever considered taking these women seriously. Frank had dated other women while seeing Stephanie and finally split up with her when she started to demand long-term commitment; Ricky always told me that he would simply never consider marrying a white woman.

The reluctance to commit themselves to a white woman has at least as much to do with ideology as personal preference. As mentioned earlier, the ideology of exploitation surrounding white women meant that relationships between black males and white females were almost inevitably defined in these terms. To escape from this definition meant adopting a stance against notions of 'community' which most of the boys were reluctant to undertake. Such relationships were viewed generally as undermining community solidarity; Shane told me, 'It's weakening my race' (interview, 5 April 1991). White women were thus perceived as 'their' women; any involvement was seen in terms of the wider social position of black people. I was often told by men I knew that they would not date a white woman because 'the first thing she'll call you in any argument is a black bastard'. The woman is seen in relation to wider power structures, which use of the term 'black bastard' is seen to evoke. The objectification and manipulation of white women can be seen, therefore, as a response to wider social forces. This is not, I would stress, to lay claim to an Eldridge–Cleaver-style argument which sees white women as legitimate objects for attack; but that the powerlessness of black men in white society is rearticulated and contested at a street level to empower black men through the use of white women.

White women were thus conceptualized – in opposition to black women – as weak and sexually available. Relationships between black males and white females were projected primarily in terms of exploitation, either financial or sexual. Shane insisted: 'I think the back guy goes out with the white girl because it's easiest; things are much more easy. Sometimes the white girl might have money to spend on me more . . . And it's easy sex' (interview, 5 April 1991). White women were generally perceived as sexually more active and more adventurous; the boys often insisted – as did some black women I knew – that white women would do things in bed that a black woman would never do. This attitude was reinforced by a group mythology in which the vices of

white women they had known were constantly replayed. This included the woman Ricky had sex with in the toilets of the Hippodrome; one of his ex-girlfriends who had agreed to a threesome with Shane; the girl Clive had had intercourse with on a pavement outside a party; the nurse who had done unspeakable things to Satish. 'Wives' were never discussed in these terms, and, although black women were discussed, they were never taken as representative of 'black women' in the same way.

It is important to distinguish between this ideology and the realities of such relationships; a distinction of which my informants were fully aware. Darnell told me that black men often dated white women for reasons of genuine affection, 'It's probably because they think she looks nice and they love showing her off' (interview, 24 March 1991). Nevertheless, at a collective level, these images persisted and dictated the articulation of attitudes at an interpersonal level. Thus, Darnell also told me that the only reason he would accept for dating a white woman was 'One; if she's got money, that's all' (ibid.). This was, it should be noted, a reason, but not an excuse. At a collective level, amongst the black men and women I knew, such relationships were regarded as unacceptable. White women, or, indeed, white partners in general, were regarded as threatening to 'the community', and were rejected. One of the reasons the boys often told me that they did not date white women on a serious basis was that it was impossible to take them into black environments without attracting scorn and hostility. None would take them to black clubs, and few to house parties, unless the relationship were long-standing and committed. Most felt that they would have to choose between black and white arenas, and were loath to surrender their contact with 'the community'.

Thus, Darnell told me that to date a white woman would make a black man a 'social misfit in your area' (ibid.).[2] He explained:

> If you saw a black guy going out with a white girl, you hear these people calling 'traitor' or 'sell-out' . . . and why you having all that hassle? . . . My friend did – this guy Stewart – and it was like such hypocrisy. He was like a *black* guy, *black* guy through and through; but then he would go up to Sudbury, where this white girl lived and he used to go out with her. He never brought her to a party in Harlesden, never brought her to no house parties which people from our area would be at . . . Because he would get run, wouldn't he? People start to cuss him.
>
> (ibid.)

Shane similarly talked of the community pressure against mixed-race dating: 'Walking down the streets with them; holding hands and all that – I don't like that. I get dirty looks from black people and white people – you get remarks shouted out sometimes' (interview, 5 April 1991). Ricky also claimed that it was impossible to take white partners to black social environments because the girl would be harassed by black women present, who considered them to be stealing 'their men'. Moreover, should trouble occur over her presence, it would be impossible for him, as a black man, to defend her, a white woman, against other black people. It is interesting that this hostility was often articulated by denying the individual's status as a 'black man'; at least if the relationship was seen as more than purely exploitative.

This attitude was intensified in the minds of my male informants if the relationship

involved a black woman dating a white man. These women were often perceived as not only no longer black, but as permanently outside the bounds of the 'black community'. Darnell told me that neither he nor Rommell would allow Angelina to date a white man, 'She's going to have to move outside of London' (interview, 24 March 1991). He even claimed that he would call on one of their uncles, who would disapprove, to help them prevent such a liaison; this was despite the fact that the uncle involved was living with a white woman. Darnell was less vehement about Angelina's friends, Eleanor and Fenella, both of whom had white boyfriends; he told me that they had always been 'white-minded' (ibid.). Although his relationship with these women remained amicable, he refused to be seen out with their boyfriends, and once told me that if he ever saw either talking to a black man, he would feel obliged to 'warn' him of her involvement, even if it had ended. Frank, who almost exclusively dated white women and was the only one of my informants who considered marriage a possibility, similarly told me that he would never let his sister get involved with a white man.

If the boys were guilty of the objectification of white women, it is also true that this was how they saw themselves within this sphere of interaction. Most defined the relationships with 'race' as the central feature. The women thus became objectifications of 'white', and the men of 'black'. The interaction was structured, therefore, by overarching racial and sexual stereotypes, which were implemented on both sides, and created something of a self-fulfilling prophecy. White women were cast primarily within a sexual role; as Darnell once told me: 'White girls are for practice'. Similarly, the attraction of black men for white women was seen as dominated by the myth of black male sexuality; or, as Rommell called it, 'the *legend* of black male sexuality'. Shane commented: 'We're well-toned, we're physical, we're funny, we're rhythmic . . . We have nice bodies, we look good. Just look at a white man – look at a twenty-five year-old white man to a twenty-five year-old black man' (interview, 5 April 1991).

Shane's insistence is on physical attraction and supposed sensual satisfaction. Although, in other arenas, the young men were keen to move away from such stereotyping, in this sphere, it remained paramount. Indeed, the young men were insistent on the 'reality' of such stereotypes; as Shane said: 'Of course it's true. Ask a white woman who's been with a black man' (ibid.). It is revealing that Shane does not use black women as a measure of his sexual prowess. It was these images, focused on strength and power, that the boys enacted in the leisure sphere when trying to attract women. Darnell similarly testified to the mystique of the black male: 'I've been asked plenty of times, "Is it true that the black man has a twelve-inch dick?" I go, "There's only one way to find out"' (interview, 24 March 1991). Darnell was aware that this emphasis on black sexuality has been intensified through popular culture, in which black men are portrayed with physicality as their defining characteristic. He continued:

> Boy, they don't even have to use that [sexual stereotype] now; just cause they're black – that's enough. Before, like maybe a couple of years ago, they'd say 'oh yeah, the black man's well endowed, I want to go out with him'. But now it's not even that, it's that going out with a black guy is very trendy.
>
> (ibid.)

The mutual objectification involved in these interactions and the alliance of white women with the wider power structure did, however, render the image more

ambiguous than the ideology suggests. Several of the boys expressed frustration to me at various times during my fieldwork that they were unable to escape the roles that these interactions created. Nathan, for example, who often told me that he was ready to settle down, found himself consistently cast as a sex object; a role his size and physical presence made it difficult to escape. Ricky told me, 'women look at N[athan] and think, SEX!' (interview, 9 December 1990).

The experience of Frank, who was almost exclusively attracted to white women, exemplifies these tensions and conflicts. He told me that he rarely found black women attractive; this was mainly because, for Frank, they were associated with a negative image of community, and thus with downward mobility. White women, on the other hand, were seen as a symbol of individual success. This does not mean that Frank used white women because he felt it would help him to achieve or 'integrate'; more that the association of white women with the wider power structure allied them with an *image* of success that he found irresistible. He told me: 'Some black men look on it as a big image thing . . . It's a status thing, I think. Most black men see it as a big status thing, to go out with a white girl' (interview, 5 April 1991). For Frank, white women were more in keeping with his self-image of success; indeed, this can be seen as a corollary to the attitude of 'successful' black women cited by Kogbara, who do not want to go out with bus drivers. Even Shane, who was the most hostile of all the young men to white women – in theory, if not in practice – was forced to concede that white women did confer status, at least in the eyes of white society; thus, he said, 'They think "he's more whitified, he's going out with one of us"' (interview, 5 April 1991).

This association with social success was considered by the boys the only legitimate reason for being committed to a white woman. Shane told me: 'If a black man goes out with a white woman, she has to be *better* than the average white woman before he could even consider going out with her' (ibid.). With the exception of Clive, whose lack of discernment with women was legendary within the group, the young men were interested only in meeting middle-class white women. This was defined by the young men as a woman who dressed well, had well-paid employment, a car and a flat. Frank, for example, told me that he would never consider dating a woman, black or white, he felt to be 'working-class':

> I prefer a woman who's got something about her going, not just 'hi, coming down my mother's on Sunday, come down the pub on Friday, we'll have a laugh. We'll get Sharon and Tracy to come down'. I'll have none of that, *please*.
> (interview, 5 April 1991)

Frank preferred meeting women in wine bars because he felt these attracted a 'better' class of women. One evening, he met an air hostess, Shirley, at Corks in Bond Street. He started talking to her, gave her his telephone number and they met up the following week. Frank was very enthusiastic about Shirley; told us all over and over again about how she was a member of Stringfellow's nightclub and had taken him there, paid all night, and driven him home in her new sports car. She was, he insisted, a 'nice' girl – someone he could get attached to, someone who shared his interests and looked good on his arm. Despite her 'image' compatibility, Frank insisted that he was very much 'in control' and that Shirley was in danger of being too demanding of his time and attention. This was, it later transpired, more an imagined than real danger; it is significant,

however, because Frank used his supposed indifference, and her enthusiasm, as a means of establishing control – if only in his mind and the minds of his friends. The next Friday, he met Shirley again, this time taking Anne and Ricky with him, probably to impress them. Shirley was very rude to all of them, danced with other, older white men all evening and behaved, they agreed, 'like a whore'. Although this was typical behaviour by the boys, Frank was furious and they never met again.

This encounter was replicated on a number of occasions with Frank. He would meet a 'nice', middle-class white woman, they would meet two or three times, have sex, and then the woman would dump him. What this pattern illustrated was a conflict of perceived roles. Frank, on the one hand, was interested in the women because he considered them to be in keeping with his image of upward mobility and social success. This meant that he was prepared to be committed to them, although this was partly offset by the overarching ideology which cast these women as 'bitches' by virtue of race and environment. This latter aspect led him to articulate the relationship in terms of exploitation on his part, although he was clearly impressed by the status these women represented. The women, on the other hand, seemed not to see Frank in any other role than that of 'black stud'. The myth of black male sexuality does *not* cast the man in a role of which long-term commitment and equality is a part – indeed, its sexual objectification of black men precludes any equality by definition. Shirley's action on the second occasion called into being the white social power structure with which she was allied, and turned this against Frank, to deny his control and his existence beyond the stereotype.

The interaction between race and gender thus proved complex. Frank's primary purpose was to establish male control over Shirley in her role as a woman; Shirley, however, was able to assert the primacy of 'race' over gender. It would be too simplistic, then, to regard the young men's attitude to white women as purely exploitative. Within the wider social arena in which these encounters took place, a number of other pressures and role constraints were brought to bear, which rendered the whole concept of control ambiguous and shifting. It would be misleading, moreover, to regard the ideology which surrounded women and 'race' as in any way inevitable or unique. Indeed, it should be noted that the same discourses were employed internally to the black community, in which 'race' was not a defining characteristic. Darnell, for example, divided his black female friends into 'nice' and 'not nice' women, and treated them accordingly, although with less stress on financial exploitation.

Notes

1 Similarly, David Schulz writes of the 'problem' of black masculinity as a direct extension of the 'problem' of the black family: 'The problem of the Negro lower-class family is . . . the absence of an *adequate* masculine role model *enabling adaptation* to the *values* of the larger culture' (emphasis in original). This leads to the retreat into street life, where masculine roles are exaggerated and played out in what Schulz terms a 'ritualised exorcism'.

2 Some of my informants have also assured me, however, that mixed-race relationships are both more common and more acceptable in South London. The extent to which this is the case is impossible for me to assess and could reflect either the creation of territorially based community images or a different enactment of 'community' in these areas.

References

Cashmore, E. E. (1979) *Rastaman: The Rastafarian Movement in England* (London: Allen & Unwin).

Cohen, A. K. (1955) *Delinquent Boys* (Chicago: Free Press).

Downes, D. M. (1966) *The Delinquent Solution* (London: Routledge & Kegan Paul).

Duneier, M. (1992) *Slim's Table* (Chicago: University of Chicago Press).

Hebdige, D. (1976) 'Reggae, Rastas and Rudies', in S. Hall and T. Jefferson (eds) *Resistance through Rituals* (London: Hutchinson).

Mercer, K. (1988) Racism and Politics of Masculinity, in R. Chapman and J. Rutherford (eds), *Male Order: Unwrapping Masculinity* (London: Lawrence & Wishart).

Pryce, K. (1979) *Endless Pressure* (Harmondsworth: Penguin).

Willis, P. (1977) *Learning to Labour* (Farnborough: Saxon House).

From *The Art of Being Black* (Oxford: Oxford University Press, 1996).

MENTORING BLACK MALES IN MANCHESTER

Responding to the crisis in education and social alienation

Richard Majors, Vince Wilkinson and Bill Gulam

Introduction

Young African Caribbean males are over-represented within the British criminal justice system, within the ranks of the unemployed, amongst those who are academically underachieving and those subject to exclusion from school (Sewell 1997). Additionally, African Caribbean males suffer disproportionately from poverty, violence, substance and alcohol abuse and higher mortality rates (Majors and Gordon 1994; Majors and Billson 1992). The social construction of Black males as dangerous and destructive further exaggerates their current position and alienates them from the mainstream of British society.

Consequently, the prevalent negative image serves to sanction and facilitate the structural inequalities that particularly affect young African Caribbean males and contributes to the legitimization of punitive exclusions of Black school pupils (Majors, Gillborn and Sewell 1998). Currently, African Caribbean boys are between four and six times more likely to be permanently excluded from school than their white counterparts (OFSTED 1996). Black boys become isolated and alienated from the education process, reinforcing the syndrome that legitimizes the structural inequalities they face in their adult years.

One of the ways in which professionals have sought to counteract this culture of alienation and discrimination is through mentoring. This chapter aims to review developments around the various mentoring initiatives among young African Caribbean males in Britain today, focusing on the localized but significant example of Manchester. It will explore some of the gaps in present programme delivery and suggest ways forward.

Background

Historically, a significant thrust of government policy towards problems involving young people in the inner cities has been to direct funds and resources towards

containment and control. Through racist stigmatization, the focus for many of the enforcement programmes of the criminal justice system and social welfare has been the Black male (Majors and Wiener 1995; Solomos 1998). In many respects, the British response follows the American approach, where one out of every three Black males between the ages of twenty and twenty-nine is now involved in the criminal justice system (The Sentencing Report 1995). In Britain too, despite the fact that 'ethnic minorities' constitute 4.2 per cent of the population, in 1990 they made up 15.5 per cent of the prison population (Foster 1990).

Clearly then, what is arguably needed as an alternative to the current blighting of the life chances of many young Black males is a set of new policies and interventionist paradigms that acknowledge the current waste in human resources and the need to improve the social status of Black males. Rather than using crisis management strategies and punitive programmes to solve the problem, the new paradigms must be proactive and collaborative, with the emphasis on nurturing and developing the potentialities of Black males (Majors and Wiener 1995). Importantly, they require race and gender-specific strategies to obviate what is a stark and dysfunctional situation.

Most recently, the government has lent its support to mentoring as a remediative and interventionist strategy (Gulam and Zulfiqar 1998), bringing it into line with developments over the decade, which has seen a growing interest in mentoring and a proliferation of programmes over the country. There is now a slow but growing evidence that mentoring programmes, particularly those targeting high-risk youth, can make the difference between wasted and productive lives (Majors and Wiener 1995). Increasingly, they are seen as a way to arrest the underdevelopment of Black males and the underutilization of their abilities.

The origins of mentoring

Mentoring is an ancient concept. The Greek poet Homer first used the word 'Mentor' in his poem, the Odyssey. When Odysseus knew he would be away from home for many years to fight in the Trojan War, he entrusted a man named Mentor to be the guardian and tutor of his son Telemachus. Mentor's job was not merely to raise Telemachus, but to develop him for the responsibilities he was to assume in his lifetime. Thus mentor came to mean any 'trusted counsellor or guide'. In fact, mentoring is probably one of the most ancient forms of human development.

(Jeffrey 1994: 1)

In traditional African societies too, the practice was very common, with young people being entrusted to elders, heads of craft associations, societies or extended family members for personal development, job training and general guidance. A mentor is therefore someone who provides guidance and support to a younger or less experienced person over a period of time. Mentors are likely to be sources of inspiration and act as coaches, professional friends, sponsors, facilitators and role models to their mentees (Jeffrey 1994). They listen, motivate and provide constructive intervention at critical and key transitional points (Clutterbuck 1991). The mentor provides non-judgemental support and an interaction that is beneficial to the less experienced partner (Clawson 1985).

Research has found that mentoring can have a major impact on the lives of young people. In 1993, Tierney, Grossman and Resch conducted the first impact study of the Big Brother/Big Sister mentoring organisation in the USA. It found that young people who met with their mentor regularly for a year were:

- 46 per cent less likely than their peers to start using illegal drugs
- 27 per cent less likely to begin using alcohol
- 52 per cent less likely than peers to skip school and 37% less likely to miss a class
- more likely to have confidence in their abilities in school and more likely to get along with parents.

Jeffrey (1994) was commissioned by the Commission for Racial Equality (CRE) to audit mentoring schemes in Britain. A major aim of this study was to determine whether mentoring could be used as a tool to address racial equality, disadvantage and underachievement among ethnic minorities. The study found that mentoring was one of the most effective means of helping disadvantaged young people. However, it found that the majority of the mentoring schemes did not specifically address issues of race equality. This situation is currently being addressed by the development of race- and gender-specific mentoring schemes, even though too much attention appears to be focused on London initiatives. In Manchester, for example, some of the most innovative developments are taking place and making a positive impact on the lives of young African Caribbean people.

Mentoring in Manchester

In Manchester, there is now an emerging infrastructure of mentoring schemes that is unique for its dynamic interaction and collaboration amongst the professionals. This collaboration is largely informal, partly arising from the fact that the educational area within the city where many of the schemes are located is physically a series of connecting blocks bound by interest and political affinities. Irrespective of the age or subject specialism of a given professional, there is a city-wide horizontal layering produced by 'interest/affinity' groups (Stirton and Spencer, personal communication, 1997).

These groups meet at various conferences and converge frequently around specified issues, producing 'a kind of perpetual internal market in ideas and attitudes' (Marr 1998). One significant clustering or identifiable focus is race and ethnicity, resulting in various mentoring strategies specific to age and the various phases of education.

Mentoring in further education

One of the most significant mentoring schemes for 'ethnic minorities' in Manchester is offered by City College Manchester (CCM). Following the pioneering work of Jefferies (1989), CCM became in 1994 the second further education college in the UK to establish a mentor service for ethnic minority students. The CCM approach advocates a community-based mentoring model, working with young Black men at risk. It aims to ensure that disadvantaged 'ethnic minorities', both students and the unemployed, are provided with guidance, advice, support and personal, educational and professional training. It also matches Black males with role models from their own community.

This is seen as essential since Black mentors have an insider knowledge of the culture, values and attitudes of the mentee, as well as an intimate and shared understanding of racial dynamics and racism. This encourages a more rapid establishment of empathy, which is deemed crucial in the evolving relationship between mentor and mentee. The argument for such a race-specific solution partly reflects the argument developed by Stanfield (1993) and Mirza (1995) that white led initiatives on Black issues more often than not produced 'outsiders' or 'pathologized' outcomes.

The CCM initiative has been particularly successful in the mentoring of young African Caribbean females. In March 1995, for example, 66 per cent of the students using the service were female (Sheriffe 1997). The persistence of underachievement and the high numbers of school expulsions and dropouts among African Caribbean males has, however, led the CCM to focus on male recruitment and to develop new approaches to empower Black males. Two of the most important initiatives so far are the 'Pilot Project: Mentoring for African Caribbean Men' and a 'Summer Workshop Roadshow'.

A preamble to these new initiatives was a wide-ranging consultation process involving questionnaires and one-to-one in-depth interviews with students of CCM and members of the local African Caribbean community. The respondents ranged from 'those with no formal qualifications to those who have a good educational track record; from those who have never been employed, to those who may have had periods of voluntary or paid employment' (Sheriffe 1997: 2). Interviews with African Caribbean male students of CCM were conducted across all five CCM sites spread across the city. This geographical and vocational mix ensured a diverse representation of African Caribbean males.

In all, a total of 158 males between the ages of thirteen and thirty-five were contacted and either interviewed or asked to complete a questionnaire. Of these 104 questionnaires were returned (sixty-four CCM students and forty from the local African Caribbean community). Out of this total, forty-five were randomly selected and interviewed on a one-to-one basis. Nine were randomly grouped and interviewed as a focus group.

The research findings indicated that African Caribbean males benefited from the mentoring scheme at CCM when they knew about it and made use of the service. However, outside the college, only a small number of African Caribbean males knew about it, and therefore only a few used it. The research also made three other critical points:

- 85 per cent of African Caribbean males did not know what a mentor was, and 65 per cent of African Caribbean male students did not know that a mentor service was available to them.
- 50 per cent of the group reported that financial problems were the primary barriers that prevented them from attending further or higher education.
- 60 per cent of African Caribbean males said they would attend further or higher education if they received more encouragement and support from those who in their view were 'significant' others.

As a result of these findings, the CCM tested a new initiative, the 'Summer Workshop Roadshow', for African Caribbean males in the summer of 1996. The aim was to

provide them with an opportunity to discuss barriers that prevented them from attending further or higher education, and information on the CCM mentor service. The Summer Workshop found that:

- 30 per cent of the African Caribbean males who attended the workshop subsequently enrolled in further or higher education courses.
- All those who attended the workshop were in favour of being mentored.

These workshop outcomes broadly substantiated the initial research findings and led to a series of recommendations, one of which was to provide mentor services in schools. This was taken up and developed into one of the interconnecting blocks of the interest/affinity groups.

Mentoring in schools

The use of school-based mentors and role models has generally had a significant impact on the lives of young Black males throughout the UK. Some of the more successful mentor schemes are BUILD in Nottingham; the Black Mentor Scheme in Southwark, London; the Second City – Second Chance and KWESI in Birmingham. In Manchester, schemes also operate in a range of primary and secondary schools.

One of the crucial targets of these schemes is to reduce exclusions. This practice is heading towards a national scandal, with young people being excluded from school at an increasingly young age – in some cases as young as four. The *Truancy and School Exclusion Report* 1998 states that many of the excluded children – two out of three – fail to return to mainstream education. The figure for secondary school education is four out of five (*Times Educational Supplement*, 9 November 1996). It is estimated that in 1996 and 1997 the cost of the additional drain on education, police time, the courts, social and youth services involvement and remediation was in excess of £81 million (Parsons 1996).

Placing Black males in the classroom as mentors and role models to Black boys has resulted in a decrease in exclusions (*Truancy and Exclusions Report* 1998). It has also increased achievement among African Caribbean boys (Hulme 1997; Victor 1997).

Arguably, however, these mentoring interventions cannot in themselves exact significant changes to the life chances of the mentees. Institutions need to change. They need to evolve policies that reflect the cultural diversity of the school and address discriminatory practices. Only a generation ago, the Swann Report (1985) gave credence to the issue of racism in education and described how African Caribbean males were particularly affected. More recently, Sewell (1997) has described how racism leads to exclusion, poor achievement and disaffection among African Caribbean males. Sewell's contention is supported by the DfEE, with its inspection arm, OFSTED, concluding that 'African Caribbean young people, especially boys have not shared equally in the increasing rates of achievement; in some areas their performance has worsened, even when differences in qualifications, social class and gender are taken into account' (Gillborn and Gipps 1996: 2). The factors that have produced this situation include negative stereotyping and low teacher expectancy. The media have frequently portrayed Black males as drug pushers, pimps and misfits (Majors and Gordon 1994). Middleton (1983) found evidence to support this generalization in a northern

comprehensive school. He found that African Caribbean males were considered as a source of trouble to be controlled in non-academic classes. Recent media reporting on inner-city violence and gun culture, with its emphasis on Manchester, has not helped to lessen these stereotypes (*Observer* 1998).

In another study, Wilkinson (1994) found that, from a sample of three hundred parents of African Caribbean heritage children in Manchester, as many as 57 per cent felt that teachers paid less attention to Black children; 56 per cent felt that teachers had a lower expectation of Black children, and 51 per cent felt that teachers were not keen to listen to them.

These negative stereotypes and their consequencies are not limited to Britain. Foster's research (1996), based on a sample of 3,130 subjects, came to similar conclusions in the USA, in relation to African American males. Mentors and Black role models in the classroom have helped Black boys to cope more effectively with racism and negative stereotyping in schools (Holland). They have also helped to engender in Black children a greater sense of identity, security and mutual respect for each other. They can also stimulate male 'bonding' and solidarity between Black boys and Black men.

Mentoring in higher education

Complementing the mentoring efforts in schools and in further education is a new initiative in the university sector. This comes in the wake of a growing acceptance of the value of mentoring to both mentor and mentee (SEDA 1996), backed by evidence from studies supporting the value of mentoring for 'disadvantaged groups' and improved graduate retention, lowering dropout and reducing unemployment at the exit points of study (National Mentoring Consortium 1997).

The Manchester higher education sector comprises five institutions that currently have the largest concentration of students in the UK. Four of the institutions formed a consortium to launch 'Interface', a mentoring initiative that targeted final-year Black undergraduates who were also UK citizens. Initial research had confirmed that Black undergraduates faced a problematic future. Irrespective of their degree or grades, they faced poorer job prospects than their white peers. They made more job applications, faced more rejections, and, if fortunate enough to secure employment, generally started at a lower level than their similarly qualified white peers (Institute for Employment Studies 1996).

Following discussions within further education, between mentoring practitioners and employers in both the private and public sectors, and negotiations with government, the Government Office of the North West agreed to fund a pilot mentor scheme for fifty Black students to operate across the Manchester and Salford Universities.

The Interface scheme has proved popular and successful, with appreciative feedback from participating employers as well as students. This success has been partly based on the strategy of establishing a cadre of Black mentors and matching them with students via particular interest or subject specialisms. The aim was, in addition to providing role models, to engender a supportive Black network at the university and in employment to empower the mentees and increase job opportunities. It was also intended to create a 'comfort zone' for Black males, to compensate for their exclusion from mainstream networks.

Further funding was secured from the Government Office in 1998. It was intended to consolidate the progress and develop a centre of excellence in mentoring for the North-West. The centre will house various relevant resources and offer training in Black mentoring. To underpin the significance of the latter, a postgraduate certificate in mentoring has already been established in Salford University, and negotiations are under way to form a steering committee of educators from all sectors and interests. This steering group notion is an affirmation of the thesis of the horizontal inter-connecting blocks of 'interest/affinity' groups and their value to developing initiatives.

The developments in Black mentoring in Manchester are examplary. Significantly, they have developed as part of an organically evolved strategy at each level of the education system. Clearly, the existence of the 'interest/affinity' groups has helped to structure and co-ordinate the responses to the failings of the system as they coalesce and collaborate on the various initiatives. Given the added impetus of government funding, there is now the real possibility of developing a holistic Black mentoring model. Nevertheless, it must also be acknowledged that there are potential pitfalls, not least those that come with governmental intervention on race-related issues. The affinity/interest groups are also community-driven and need to remain so to maintain the momentum for change.

Social policy response and recommendations

Substantial research undertaken in the USA by Majors and Wiener (1995) to determine what factors were crucial to the successful development of African American male youth, found that nurturing and developmental programmes such as mentoring were cheaper, cost-effective and socially more beneficial than punitive strategies centred on control, maintenance and monitoring. These findings are borne out by the success of the Manchester initiatives, which have the support of the community.

Conclusion

The current situation of Black male disaffection, underachievement and unemployment in Britain is morally untenable and politically destabilizing in the long run. As the riots of the 1980s testify, occasionally it explodes into civil unrest with dire consequences. It is too costly to contain and a waste of vital human resources. Currently race- and gender-specific mentoring schemes which intervene directly in the education process, and which have the potential to impact in other areas such as employment, appear to provide a workable and effective alternative. This alternative needs to be given wider recognition and supported with adequate resources if the momentum for change such as in Manchester is to be maintained.

Note

We would like to thank Valerie Kahn and Duncan Scott of the University of Manchester Social Policy Department for their editorial assistance on an earlier draft.

References

Birmingham (1987) *Birmingham Court Social Enquiry Report Monitoring Exercise* (Birmingham: West Midlands Probation Service).

Clawson, J. G. (1985) 'Is Mentoring Necessary?', *Training and Development Journal*, 4.

Clutterbuck, D. (1994) 'Business Mentoring in Evolution', *Mentoring and Tutoring* 2, 1.

Foster, H. (1996) 'Educators' and Non-educators' Perceptions of Black Males: A Survey', *Journal of African American Men*: 37–70.

Foster, K. (1990) *General Household Survey* (London: Office of Population Censuses and Surveys, HMSO).

Gillborn, D. and Gipps, C. (1996) *Recent Research on the Achievement of Ethnic Minority Pupils* (London: HMSO).

Gulam, W. (1997) 'Paradigm Lost', *Multicultural Teaching* 15, 3.

Gulam, W. and Zulfiqar, M. (1998) 'Dr Plum's Elixir and the Alchemists' Stone', *Mentoring and Tutoring* 5, 3.

Hulme, J. (1997) *The Teacher* (January/February), news update.

Jeffrey, H. (1994) *Developing a Mentoring Strategy* (London: CPW Associates).

Majors, R. (1986) 'Coolpose: The Proud Signature of Black Survival, Changing Men' *Issues in Gender, Sex and Politics* 17: 5–6.

Majors, R. and Billson, J. (1992) *Coolpose: The Dilemmas of Black Manhood in America* (Boston: Lexington).

Majors, R., Gillborn., D. and Sewell, T. (forthcoming) 'Exclusion of Black Children: A Racialised Perspective', *Multicultural Teaching*.

Majors, R. and Gordon, J. (1994) *The American Black Male: His Present Status and Future* (Chicago: Nelson-Hall).

Majors, R. and Wiener, S. (1995). *Programs that Serve African American Male Youth* (Washington, D.C.: The Urban Institute).

Marr, A. (1998) *The Observer* (7 June): 31.

Middleton, B. (1983). *Factors Affecting the Performance of West Indian Boys in a Secondary School*, MA thesis, University of York.

Mirza, M. in M. Griffiths and B. Troyna (eds) (1995) 'Antiracism, Culture and Social Justice in Education' (Chester: Trentham Books).

Parsons, C. (1998) 'Excluded Children', *International Journal of Inclusive Education* 2.

Sewell, T. (1997) *Black Masculinities and Schooling: How Black Boys Survive Modern Schooling* (Chester: Trentham Books).

Sheriffe, G. (1997) *Pilot Project: Mentoring for African Caribbean Men. Manchester* (Manchester: City College).

Social Exclusions Unit (1998) *Truancy and School Exclusions Report* (London: HMSO).

Solomos, J. (1988) *Black Youth, Racism and the State* (Cambridge: Cambridge University Press).

Stanfield, J. and Dennis, R. (eds) (1993) *Race and Ethnicity in Research Methods* (London: Sage).

Swann, M. (1985) *Education for All: Final Report of the Committee of Inquiry into the Education of Children from Ethnic Minority Groups,* Cmnd. 9453 (London: HMSO).

Tierney, J., Grossman, J. and Resch, N. (1993) *Making A Difference: An Impact Study of Big Brothers/Big Sisters* (Philadelphia: Public/Private Ventures).

Victor, P. (1996) *The Independent* (11 July).

Wilkinson, V. (1994). *Parental Attitudes Towards the Multiracial Education Policies and Practices of a Local Education Authority*, M.Phil. thesis, University of Manchester.

Section Three

CULTURAL STUDIES AND
BLACK POLITICAL DEBATE

This section brings together seminal texts and interviews that engage the latest issues in the emerging debate between theorists within Black British cultural studies and prominent voices of Black politics. The focus is on the nature and dynamics of contemporary Black Britain.

33

OPENINGS, ABSENCES AND OMISSIONS

Aspects of the treatment of 'race', culture and ethnicity in British cultural studies

Roxy Harris

A considerable time ago, Stuart Hall, in an influential text, delineated what he called 'two paradigms' for cultural studies (Hall 1981). One was culturalism, which he identified with the work of Hoggart, Williams and Thompson; the other, structuralism, came to be encapsulated in the work of Althusser, with later additions from Gramsci. One principal characteristic of the culturalist paradigm was that:

> The *experiential pull* in this paradigm, and the emphasis on the creative and on historical agency, constitute the two key elements in the *humanism* of the position outlined. Each, consequently accords 'experience' an authenticating position in any cultural analysis. It is, ultimately, where and how people experience their conditions of life, define them and respond to them, which, for Thompson defines why every mode of production is also a culture, and every struggle between classes is always also a struggle between cultural modalities; and which, for Williams, is what a 'cultural analysis', in the final instance should deliver.
>
> (Hall 1981: 26)

On the other hand, in Hall's view, structuralism, the other half of the culturalism–structuralism binary,

> insisted that 'experience' could not, by definition, be the ground of anything, since one could only 'live' and experience one's conditions *in and through* the categories, classifications and frameworks of the culture. These categories, however, did not arise from or in experience: rather, experience was their 'effect'.
>
> (Hall 1981: 26)

Thus, in the structuralist paradigm, people became conceived as 'bearers of the structures that speak and place them, rather than as active agents in the making of their own history' (Hall 1981: 30).

Without placing every egg in the 'culturalist' basket, the contention of this chapter

is that British cultural studies, in its treatment of 'race' and ethnicity, has not fully followed through on the logic of the culturalist paradigm in relation to its analysis of Britain's Caribbean-descended black working-class population. It has tended, rather, to concentrate on those effects produced by the subcultural youth of this population and to deploy what Hall describes, in a criticism of structuralism (Hall 1981: 33), as 'strategic absences and silences', with regard to the adult section of the said black population as active and creative agents of their own history and culture, albeit not in conditions of their own making.

Before proceeding with the discussion it is worth entering a word of definition. When references are made to Britain's black population they should be taken to refer only to the people who migrated to and settled in Britain from Britain's former Caribbean colonies in the post-1945 period, particularly in the period from the mid-1950s to the mid-1960s. The references should also be generally understood to concern the working-class section of the black population which has been the overwhelming proportion and the main force in the social movements under analysis, although of course wider sections of the black population have often been involved in the same social processes. The numerous references to British cultural studies (henceforth BCS) concern principally, but not totally, the tradition of cultural studies emanating from the Centre for Contemporary Cultural Studies at Birmingham University.

Inevitably, this chapter cannot be, and is not intended to be, a comprehensive assessment of the achievements of BCS. What it will attempt to do is first to look briefly at just a few of the developed frames of analysis which have been useful to the study of Britain's black population. It will then try to identify some significant omissions and absences in this analysis, before concluding with suggestions for future work.

Legitimating preparations

What then has BCS done, in a general way, to assist the serious study and understanding of Britain's black population? In the first place it has produced an impressive body of scholarship to excavate and legitimate the vital, but once buried, fractions of culture, including mass culture, popular culture, working-class culture, youth subculture, race and ethnicity in culture, feminist culture and gay and lesbian culture. For present purposes we will look at helpful developments from the 'earlier' period of BCS, before turning to those from the moment when 'race' and ethnicity became an important category in this tradition of cultural studies. The 'earlier' period can be said to have been dominated by the publications of Richard Hoggart, Raymond Williams and E. P. Thompson. It could be argued that all three, from their 'culturalist' positions, proposed an implied fundamental overall perspective; that is, the importance of paying detailed attention to what people do, and the historical traditions and contingencies which constrain their actions. One factor which makes Hoggart's work useful for this chapter is that it assisted the break with the high-culture-low-culture (often implying high-culture-no-culture) couplet, by writing determinedly about working-class culture (Hoggart 1958). Williams, meanwhile, with his insistent references to Wales, helped to shape the possibility of a cultural analysis which was both rooted in the interests of the working class and developed from the colonized margins (Williams 1979: 296). Thompson, for his part, in his famous savage attack on Althusserian

structuralism (Thompson 1978), battled robustly to assert the importance of human experience and agency and its right to be taken seriously. In this endeavour history was important:

> History is not a factory for the manufacture of Grand Theory, like some Concorde of the global air . . . Nor yet is it some gigantic experimental station in which theory of foreign manufacture can be 'applied', 'tested', and 'confirmed'. That is not its business at all. Its business is to 'recover', to 'explain', and to 'understand' its object: real history.
>
> (Thompson 1978: 238)

And in a further defence of his kind of history against structuralist theory, he suggests that in structuralism:

> The diachronic is waived away as mere unstructured 'narrative', an unintelligible flow of one thing from another. Only the stasis of structural analysis can disclose knowledge. The flow of events ('historicist time') is an empiricist fable. The logic of process is disallowed.
>
> (Thompson 1978: 263)

This is important, precisely because for Britain's black population the recovery and conscious understanding of *their* cultural-historical narrative for the benefit of both themselves and others is an essential ingredient for their positive progress, given that their cultural antecedents were so viciously disrupted by the slave trade, slavery and colonial rule. To further understand how this project might be aided, it is now necessary, as signalled earlier, to look at some of the contributions made by interventions linking culture, 'race' and ethnicity from within BCS.

The entry of 'race' and culture

To start with, there is the simple fact that individual intellectuals buttressed by mass, radical, socio-political movement by black people in Britain had themselves to enter an intense period of struggle within the academy, in order to place questions of 'race' and ethnicity on to the cultural studies agenda. Stuart Hall has commented frankly and vividly on this moment:

> getting cultural studies to put on its own agenda the critical questions of race, the politics of race, the resistance to racism, the critical questions of cultural politics, was itself a profound theoretical struggle, a struggle of which *Policing the Crisis* was, curiously, the first and very late example. It represented a decisive turn in my own theoretical and intellectual work, as well as in that of the Centre. Again, it was only accomplished as the result of a long and sometimes bitter – certainly bitterly contested – internal struggle against a resounding but unconscious silence. A struggle which continued in what has since come to be known as . . . one of the great seminal books of the Centre for Cultural Studies, *The Empire Strikes Back*. In actuality, Paul Gilroy and the group of people who produced the book found it extremely difficult to create

the necessary theoretical and political space in the Centre in which to work on the project.

(Hall 1990: 283)

Gilroy himself signalled this moment of rupture when he attacked both Williams and Thompson for their silences or negative collusions on questions of 'race', which helped to 'reproduce blackness and Englishness as mutually exclusive categories' (Gilroy 1987: 55).

Policing the Crisis (Hall et al. 1978), using, amongst other analytical instruments, Gramscian hegemony theory, showed exhaustively how mugging came to be socially constructed as a specifically *black* crime in Britain, and was linked with theories of a British capitalism and nation-state in decline. *The Empire Strikes Back* (1982), while continuing to locate the state's developing anti-black repressive policies, practices and ideologies in 'the organic crisis of British capitalism', substantially broadened the scope of discussions on 'race' within BCS. Apart from analyses of racism, there were extended treatments of the negative characterizations of black families in British society and of the general 'pathologizing' of black people (Lawrence 1982); of the rising implacable confrontation between black youth and the police (Gilroy 1982), and of the wholesale and consistent problematizing of black children in connection with schooling (Carby 1982a). Carby also opened up a debate based specifically on a black woman's perspective on feminism (Carby 1982b). At the same time, Gilroy, taking up again the question of 'race' and class where Hall et al. had left it in *Policing the Crisis*, struggled to carve out for black people a specifically racially coded version of class struggle with Rastafarianism symbolically to the fore. *The Empire Strikes Back* clearly reflected the change of tone in BCS evinced by the forceful entry of 'race' on to the stage. The arguments in the book convey a greater sense of engagement than hitherto, undoubtedly due to the increased involvement of black scholars. There is also, and most importantly for the present discussion, a strong and integral historical dimension to the work. This is especially marked in the work of Lawrence, and leads him to pose a number of fundamental questions concerning the older generation of black people in Britain, to which we will later return.

At this point it is useful to take a brief look at Gilroy's solo work *There Ain't No Black in the Union Jack* (1987), which provided an expansion and development of a number of themes elucidated in *The Empire Strikes Back*. First, and importantly in the light of the arguments in the early part of this paper, Gilroy insists on recovering agency and historical perspective in any analysis of 'race' in order to combat the definition of blacks 'as forever victims, objects rather than subjects, beings that feel yet lack the ability to think, and remain incapable of considered behaviour in an active mode' (Gilroy 1987: 11). He rightly deprecates the fact that 'This capacity to evacuate any historical dimension to black life remains a fundamental achievement of racist ideologies in this country' (ibid.).

Gilroy also tries to further develop a theoretical position which accords 'race' a key role for black people as a basis for action, although undoubtedly in his view it is also intertwined with class and other factors in complex ways. He attempts this formulation in opposition to mainly Marxist analyses which propose that all other factors including 'race' are subsumed under the supreme organizing principle of class structure (1987: 27). In the end Gilroy finds a way forward by linking 'race' with social move-

ment theory (1987: 223). A powerful section of the book, perhaps for the first time within BCS, sees a cultural theorist writing authoritatively with evident and fully engaged knowledge of an aspect of 'race' and culture. Gilroy marshals a detailed analysis of how black music, mainly reggae and soul, together with Rastafarian ideology and practice, provide a basis for the 'black expressive cultures which spring up at the intersection of "race" and class, providing a space in which the competing claims of ethnic particularity and universal humanity can be temporarily settled' (1987: 154). The impact of this on the general British white population reminds us that 'racial subordination is not the sole factor shaping the choices and actions of Britain's black settlers and their British-born children' (1987: 153).

Gilroy is adept, too, at using memorable phraseology to encapsulate highly useful theoretical frameworks, and this book is permeated by significant examples such as 'black expressive cultures', 'ethnic absolutism' and 'diaspora'. Mention of black expressive cultures also reminds us of the longevity of the fascination they have held for BCS theorists (Hebdige 1976, 1979, 1987), although the journey from Hebdige to Gilroy could perhaps be characterized as a journey from 'outsider' to 'relative insider'. The extent of this progression can readily be seen in Hebdige's 1976 'outsider' position when he could write about the 'mythology of Rastafarianism which I have already attempted to decipher' (Hebdige 1976: 152).

The foregoing brief discussion of some of the achievements of BCS writing on culture, 'race' and ethnicity leads directly to the central contention of this chapter. This is that, despite these considerable and often exciting achievements and openings, there are also a startling number of omissions and absences.

Omissions and absences

What, then, is their nature and why have they occurred? They could be summarized as follows. First, most of the work has centred on an analysis of the highly visible, overtly rebellious, reactive section of black youth, accompanied by an absence of sustained work on the actions and perspectives of the adult black population in shaping black culture in Britain. Therefore, the main focus has been on black youth in relation to policing, crime, youth styles, music, language and schooling. Second, and consequently, the adult black population, where it is mentioned, is deprived of any sense of agency and becomes mostly a conservative counterpoint to the radical youth. Third, the concentration on black youth has masked the historical continuities of their elders which helped to set the context within which they have acted. Lawrence foreshadowed the critique offered here when he asked:

> Who were the objects of the police's 'nigger hunting' expeditions in the fifties and early sixties when many of today's youth weren't even a glimmer in their parents' eyes? Who fought the Fascists and Teddy Boys in Nottingham and Notting Hill in 1958? Who are the people who fought trade union racism up and down the country for the last thirty years and more? Who initiated the campaigns against ESN placements and 'sin-bins'? The fact that the youths have brought new understandings and different modes of struggle to bear on their communities' struggles, does not mean that they are not still following in

their parents' footsteps or that they don't stand firmly *side by side* with their parents in opposition to racism.

(Lawrence 1982: 132)

Unfortunately, Lawrence's view tends not to have been taken up. How, for instance could the serious study of culture, 'race' and ethnicity in Britain over the last thirty years or more so comprehensively ignore the active and creative cultures of achievement which have built the Notting Hill Carnival, the black churches, the supplementary schools, the International Bookfair of Radical Black and Third World Books and centres of independent black publishing, to name just a few of the distinctive institutions within Britain's black population? It is difficult and unproductive to attribute motivation in these circumstances. However, it could be argued that in its analysis the Centre for Contemporary Cultural Studies was over-reliant on youth subculture theory which it had already developed (Cohen 1972; Hall and Crichter 1976). If this line of argument is followed, an adult black working class which is in employment, often church-going, often middle-aged, law-abiding, in sustained motion, acting purposefully in its own interests, even when these from time to time bring it into conflict with the state, simply does not fit the prescribed theoretical frame. What lines of enquiry, therefore, would allow us to move towards a more comprehensive, sensitive and complex understanding of the historical trajectory, agency, achievements and setbacks of black people in Britain?

'We did not come alive in Britain'

The phrase 'We did not come alive in Britain' was used by John La Rose in an analysis which was so important that it is worth quoting at length for its clarity about the historical agency and cultural strength of the black Caribbean migrants who came to Britain in the 1950s and 1960s:

> Some of the worker emigrants to Britain were active participants in the People's Progressive Party and the People's National Congress in Guyana, the Gairy Party, the Grenada Manual and Metal Workers Union, the Butler Party, the People's National Movement, the People's National Party, the Jamaican Labour Party, the St Kitts Labour Party, the Antigua Labour Party, the Barbados Labour Party, the West Indian Independence Party and in trade unions and other more radical sections of the nationalist movement which were Marxist and stood for revolutionary social change. They were also active in trade unions and peasant organisations.
>
> *All these groupings have also been the leavening here for the early cultural, social and political activity of blacks in Britain. The encounter with white racism and the manoeuvres of the British capitalist power did not begin in England but in the Caribbean.*
>
> (La Rose 1972: 62 (emphasis added))

In this account not only did the migrants set up UK branches of their home political organizations, but many also joined left-wing British organizations. Apart from this they also developed independent community organizations in Britain such as

the independent black churches which had been a bulwark against colonial, cultural and social domination . . . 'Partners' or 'box' or 'sou-sou' were also formed to buy homes. The cricket club, the All Fours club, all the varied social forms from our past experience were reproduced here.

(La Rose 1976: 64)

What elements, then, of their creative, struggling tradition did these black Caribbean migrants instil in their children in Britain? What forms of cultural transmission occurred, and how did they occur? What alternative readings of the black population beyond those offered by the routine youth-oriented ones become available? Let us take one example. In Britain, the development of the possibilities and practices of a 'new' black cultural aesthetic from the 1960s onwards was founded not only on the activities of the 'visible youth' – the earlier Black Power movement and the later Rastafarians. It was in fact fundamentally fashioned by the Caribbean Artists Movement (CAM). CAM (1966–72), formed in Britain, was a remarkable cultural movement of mature and youthful intellectuals, artists and others who consciously

> sought to discover their own aesthetic and to chart new directions for their arts and culture; to become acquainted with their history; to rehabilitate their Amerindian inheritance and to reinstate their African roots; to reestablish links with the 'folk' through incorporating the peoples' language and musical rhythms in Caribbean literature; to reassert their own tradition in the face of the dominant tradition.
>
> (Walmsley 1992: xvii)

Linton Kwesi Johnson, commonly depicted as a leading artistic emblem of 1970s and 1980s black youth resistance, plainly states, with reference to CAM meetings, 'how stimulating they were for him, "as a young person just discovering that there was such a thing as black literature, as Caribbean literature"' (Walmsley 1992: 298). How did Johnson discover CAM? He was introduced to it by John La Rose when he visited New Beacon Books (Harris and White 1991), which La Rose had established in London in 1966 as a pioneering black publishing house in order to 'give an independent validation of one's own culture, history, politics – a sense of self – a break with discontinuity' (La Rose 1982: 3). New Beacon's name in turn was taken from a 1930s anti-colonial literary magazine in Trinidad. Once the customary narrative circuits are broken, new chains of historical continuity begin to emerge. One of the problems has been that the BCS tradition has 'read' and 'written' black culture and politics in Britain without serious reference to the key historical agents in the process. John La Rose has been one of them. This brings us back, in relation to the black population, to some earlier questions. What did they do? How did they do it? And why do *they* say they did it?

Some proposals

Even a brief look at specific areas of black cultural activity yields a myriad of further questions and reveals the enormity of the project being proposed here; but it also reveals the paucity of academic knowledge about this activity and the serious failure

to integrate it into the theories and analyses of BCS. Space does not permit anything other than the beginnings of some of the questions which might lead to fruitful enquiry.

Carnival

Why and how did black people establish the annual Notting Hill Carnival in London? How have they maintained and built it against sustained attack by the state? What symbolic meanings are they attempting to portray in their masquerade bands? How do they manage to get masquerade bands on to the road in the first place?

Supplementary Schools

Why did black working-class people in Britain refuse to accept the inferior schooling for their children that their white working-class neighbours had accepted? Why and how did they manage to create their own voluntary, supplementary schools in every black community in the country? How and why have they continued to sustain them over the last twenty-five years?

Black churches

How have the black churches, perhaps the largest black cultural organizations in Britain, been built and supported by genuinely self-help methods?

Policing and the courts

While the black youth fought the police on the streets, how did their parents come to develop a systematic method, based on a profound understanding of the workings of the state's legal apparatus, for challenging and often defeating the racist practices of police, solicitors, magistrates, judges, forensic scientists and prison officers? (*Race Today* (1976): 195–208).

One vital point should not be missed here. In all these areas, black working-class *women* have undoubtedly been the steadfast backbone of whatever movement has developed. While the sons were being analysed and credited, their mothers, too, were in creative cultural motion. Of course there are many other major institutional cultural achievements about which indicative questions could be asked; the International Book-fair of Radical Black and Third World Books is one. There are also an enormous number of tangential yet important additional questions which require investigation. How, for example, has the black population managed to so manoeuvre the categories of 'race' and class in Britain that significant numbers of the supposedly monolithically racist white population votes in and re-elects Bill Morris, a black working-class migrant from Jamaica, as General Secretary of one of the biggest trade unions in the country? Within black youth culture we still need to understand much more about how the sound systems came to be established as economic as well as purely cultural institutions, and the same questions could be asked about the ubiquitous black pirate radio stations in London.

Conclusion

To conclude, I want to reiterate some points of clarification. This chapter has not been an argument against cultural theory. It has been, rather, an argument *for* dynamic theory which pays close attention to and is shaped by the real acts of historically fashioned human agents. Nor has the article ignored the way in which the BCS tradition has created and continues to create many openings for challenging and stimulating ways of thinking about culture, 'race' and ethnicity. In recent times, Hall on new ethnicities (1992), Mercer on 'race' and representation (1994), Bhabha with his integration of psychoanalytic perspectives (1994) and Gilroy's Black Atlantic diasporic framework (1993) have, amongst others, continued this exciting intellectual tradition. As to methods, there could be some kind of synthesis of culturalism and structuralism leavened by Gramscianism (Hall 1981: 36), with or without a strong element of one kind of historiography or another (Johnson 1978; Thompson 1978), oral history, and even the BCS ethnography tradition (Willis 1976, 1978), which has been deployed on cultural questions of black and white youth interaction (Hewitt 1986; Jones 1988). Whatever route or combination of routes is chosen, it is essential that ways be found for allowing the historical agency represented in the experience of a broader fraction of Britain's black population to be genuinely integrated with the concerns of cultural studies. As E. P. Thompson said in another context: 'They cannot "speak" until they have been "asked"' (Thompson 1978: 223).

References

Bhabha, H. (1994) *The Location of Culture* (London: Routledge).

Carby, II. V. (1982a) 'Schooling in Babylon', in CCCS (eds), *The Empire Strikes Back* (London: Routledge & Kegan Paul).

——, (1982b) 'White Women Listen! Black Feminism and the Boundaries of Sisterhood' in CCCS (eds) *The Empire Strikes Back*, (London: Routledge & Kegan Paul).

Cohen, P. (1972) 'Subcultural Conflict and Working-class Community', in Hall et al. (eds) (1990), *Culture, Media, Language* (London: Unwin Hyman).

Gilroy, P. (1982) 'Police and Thieves', in CCCS (eds), *The Empire Strikes Back* (London: Routledge & Kegan Paul).

——, (1987) *There Ain't No Black in the Union Jack: The Cultural Politics of Race and Nation* (London: Routledge & Kegan Paul).

——, (1993) *The Black Atlantic* (London: Verso).

Hall, S. (1981) 'Cultural Studies: Two Paradigms', in T. Bennett et al. (eds), *Culture, Ideology and Social Process* (Milton Keynes: Open University Press).

——, (1990) 'Cultural Studies and its Theoretical Legacies', in L. Grossberg et al. *Cultural Studies* (London: Routledge).

——, (1992) 'The New Ethnicities', in J. Donald and A. Rattansi (eds) *'Race', Culture and Difference* (Milton Keynes and London: Open University Press/Sage).

Hall, S. Crichter, C. et al. (1978) *Policing the Crisis* (London: Macmillan).

Hall, S. and Jefferson, T. (eds) (1976) *Resistance Through Rituals: Youth Subcultures in Post-war Britain* (London: HarperCollins).

Harris, R. and White, S. (eds) (1991) *Foundations of a Movement* (London: Tribute Committee/ New Beacon Books).

Hebdige, D. (1976) 'Reggae, Rastas and Rudies', in S. Hall and T. Jefferson (eds) *Resistance Though Rituals: Youth Subcultures in Post-war Britain* (London: HarperCollins).

——, (1979) *Subculture: The Meaning of Style* (London: Methuen).

——, (1987) *Cut 'N' Mix: Culture, Indentity and Caribbean Music* (London: Comedia/Routledge & Kegan Paul).

Hewitt, R. (1986) *White Talk, Black Talk* (Cambridge: Cambridge University Press).

Hoggart, R. (1958) *The Uses of Literacy* (London: Pelican Books).

Johnson, R. (1978) 'Edward Thompson, Eugene Genovese, and Socialist-Humanist History', *History Workshop Journal* 6 (autumn).

Jones, S. (1988) *Black Culture, White Youth: The Reggae Tradition from JA to UK* (London: Macmillan).

La Rose, J. (1976) 'We Did Not Come Alive in Britain', *Race Today* 8, 3 (March).

——, (1982) Brochure: Firs International Bookfair of Radical Black and Third World Books.

Lawrence, E. (1982) 'Sociology and Black "Pathology"', in CCCS (eds), *The Empire Strikes Back* (London: Routledge & Kegan Paul).

Mercer, K. (1994) *Welcome to the Jungle* (London: Routledge).

Race Today (1976) 'Black Parents and Students on the Move', 8, 10 (October).

Thompson, E. P. (1978) *The Poverty of Theory* (London: Merlin).

Walmsley, A. (1992) *The Caribbean Artists Movement, 1966–72: A Literary and Cultural History,* (London: New Beacon Press).

Williams, R. (1979) *Politics and Letters* (London: Verso).

Willis, P. (1976) 'Notes on Method', in S. Hall et al. (eds), *1990 Culture, Media, Language* (London: Unwin Hyman).

——, (1978) *Learning to Labour* (London: Saxon House/Gower).

From *Cultural Studies* 10, 2 (1996): 334–44 © Routledge 1996.

34

THE FORMATION OF A
DIASPORIC INTELLECTUAL

An interview with Stuart Hall

Kuan-Hsing Chen

The colonial situation

KHC: In your later work on race and ethnicity, diaspora seems to have become a central figure – one of the critical sites on which the question of cultural identity is articulated; bits and pieces of your own diasporic experiences have, at certain points, been narrated quite powerfully, to address both theoretical and political problematics.[1] What I am interested in is how the specificities of the various historical trajectories came to shape your diasporic experiences, your own intellectual and political position.

SH: I was born in Jamaica, and grew up in a middle-class family. My father spent most of his working life in the United Fruit Company. He was the first Jamaican to be promoted in every job he had; before him, those jobs were occupied by people sent down from the head office in America. What's important to understand is both the class fractions and the colour fractions from which my parents came. My father's and my mother's families were both middle-class but from very different class formations. My father belonged to the coloured lower-middle-class. His father kept a drugstore in a poor village in the country outside Kingston. The family was ethnically very mixed – African, East Indian, Portuguese, Jewish. My mother's family was much fairer in colour; indeed if you had seen her uncle, you would have thought he was an English expatriate, nearly white, or what we would call 'local white'. She was adopted by an aunt, whose sons – one a lawyer, one a doctor, trained in England. She was brought up in a beautiful house on the hill, above a small estate where the family lived. Culturally present in my own family was therefore this lower-middle-class, Jamaican, country manifestly dark skinned, and then this lighter-skinned English-oriented, plantation-oriented fraction, etc.

So what was played out in my family, culturally, from the very beginning, was the conflict between the local and the imperial in the colonized context. Both these class fractions were opposed to the majority culture of poor Jamaican black people: highly race and colour conscious, and identifying with the colonizers.

I was the blackest member of my family. The story in my family, which was always told as a joke, was that when I was born, my sister, who was much fairer than

I, looked into the crib and she said, 'Where did you get this coolie baby from?'
Now 'coolie' is the abusive word in Jamaica for a poor East Indian, who was
considered the lowest of the low. So she wouldn't say 'Where did you get this black
baby from?', since it was unthinkable that she could have a black brother. But she
did notice that I was a different colour from her. This is very common in coloured
middle-class Jamaican families, because they are the product of mixed liaisons
between African slaves and European slave-masters, and the children then come out
in varying shades.

So I always had the identity in my family of being the one from the outside, the
one who didn't fit, the one who was blacker than the others, 'the little coolie', etc.
And I performed that role throughout. My friends at school, many of whom were
from good middle-class homes, but blacker in colour than me, were not accepted at
my home. My parents didn't think I was making the right kind of friends. They
always encouraged me to mix with more middle-class, more higher-colour, friends,
and I didn't. Instead, I withdrew emotionally from my family and met my friends
elsewhere. My adolescence was spent continuously negotiating these cultural
spaces.

My father wanted me to play sport. He wanted me to join the clubs that he
joined. But I always thought that he himself did not quite fit in this world. He was
negotiating his way into this world. He was accepted on sufferance by the English.
I could see the way they patronized him. I hated that more than anything else. It
wasn't just that he belonged to a world which I rejected. I couldn't understand how
he didn't see how much they despised him. I said to myself, 'Don't you understand
when you go into that club they think you are an interloper?' And, 'But you want
to put me into that space, to be humiliated in the same way?'

Because my mother was brought up in this Jamaican plantation context, she
thought she was practically 'English'. She thought England was the mother
country, she identified with the colonial power. She had aspirations for us, her
family, which materially we couldn't keep up with, but which she aspired to,
culturally.

I'm trying to say that those classic colonial tensions were lived as part of my
personal history. My own formation and identity was very much constructed out of
a kind of refusal of the dominant and cultural models which were held up for me. I
didn't want to beg my way like my father into acceptance by the American or
English expatriate business community, and I couldn't identify with that old
plantation world, with its roots in slavery, but which my mother spoke of as a
'golden age'. I felt much more like an independent Jamaican boy. But there was no
room for that as a subjective position, in the culture of my family.

Now, this is the period of the growth of the Jamaican independence movement.
As a young student, I was very much in favour of that. I became anti-imperialist
and identified with Jamaican independence. But my family was not. They were not
even identified with the ambitions for independence of the national bourgeoisie. In
that sense, they were different from even their own friends, who thought, once the
transition to national independence began, 'Well, at least we'll be in power.' My
parents, my mother especially, regretted the passing of that old colonial world,
more than anything else. This was a huge gap between their aspirations for me and
how I identified myself.

KHC: So you are saying that your impulse to 'revolt' partly came from the Jamaican situation. Can you elaborate?

SH: Going to school as a bright, promising scholar and becoming politically involved, I was therefore interested in what was going on politically, namely, the formation of Jamaican political parties, the emergence of the trade unions and the labour movement after 1938, the beginnings of a nationalist independence movement at the end of the war; all of these were part of the postcolonial or de-colonizing revolution. Jamaica began to move toward independence once the war was over. So bright kids like me and my friends, of varying colours and social positions, were nevertheless caught up in that movement, and that's what we identified with. We were looking forward to the end of imperialism, Jamaica governing itself, self-autonomy for Jamaica.

KHC: What was your intellectual development, during this early period?

SH: I went to a small primary school, then I went to one of the big colleges. Jamaica had a series of big girls' schools and boys' schools, strongly modelled after the English public school system. We took English high school exams, the normal Cambridge School Certificate and A level examinations. There were no local universities, so if you were going to university you would have to go abroad, off to Canada, United States or England to study. The curriculum was not yet indigenized. Only in my last two years did I learn anything about Caribbean history and geography. It was a very 'classical' education; very good, but in very formal academic terms. I learned Latin, English history, English colonial history, European history, English literature, etc. But because of my political interest, I also became interested in other questions. In order to get a scholarship you have to be over eighteen and I was rather younger, so I took the final A level exam twice, I had three years in the sixth form. In the last year, I started to read T. S. Eliot, James Joyce, Freud, Marx, Lenin and some of the surrounding literature and modern poetry. I got a wider reading than the usual, narrowly academic British-oriented education. But I was very much formed like a member of a colonial intelligentsia
. . .

I left in 1951 and I didn't know until 1957 that I wasn't going back; I never really intended to go back, though I didn't know it at the same time. In a way, I am able to write about it now because I'm at the end of a long journey. Gradually, I came to recognize I was a black West Indian, just like everybody else, I could relate to that, I could write from and out of that position. It has taken a very long time, really, to be able to write in that way, personally. Previously, I was only able to write about it analytically. In that sense, it has taken me fifty years to come home. It wasn't so much that I had anything to conceal. It was the space I couldn't occupy, a space I had to learn to occupy.

You can see that this formation – learning the whole destructive, colonized experience – prepared me for England. I will never forget landing there. My mother brought me, in my felt hat, in my overcoat, with my steamer trunk. She brought me, as she thought, 'home', on the banana boat, and delivered me to Oxford. She gave me to the astonished college scout and said, 'There is my son, his trunks, his belongings. Look after him.' She delivered me, signed and sealed, to where she thought a son of hers had always belonged – Oxford.

My mother was an overwhelmingly dominant person. My relationship with her

was close and antagonistic. I hated what she stood for, what she tried to represent to me. But we all had a close bond with her, because she dominated our lives. She dominated my sister's life. It was compounded by the fact that my brother, who was the eldest, had very bad sight, and eventually went blind. From a very early age, he was very dependent on my parents. When I came along, this pattern of mother–son dependency was clearly established. They tried to repeat it with me. And when I began to have my own interests and my own positions, the antagonism started. At the same time, the relationship was intense, because my mother always said I was the only person who fought her. She wanted to dominate me, but she also despised those whom she dominated. So she despised my father because he would give in to her. She despised my sister, because she was a girl, and as my mother said, women were not interesting. In adolescence, my sister fought her all along, but once my mother broke her, she despised her. So we had that relationship of antagonism. I was the youngest. She thought I was destined to oppose her, but she respected me for that. Eventually when she knew what I had become in England – fulfilling all her most paranoid fantasies of the rebellious son – she didn't want me to come back to Jamaica, because by then I would have represented my own thing, rather than her image of me. She found out about my politics and said, 'Stay over there, don't come back here and make trouble for us with those funny ideas.'

I felt easier in relation to Jamaica, once they were dead, because before that, when I went back, I had to negotiate Jamaica through them. Once my parents were dead, it was easier to make a new relationship to the new Jamaica that emerged in the 1970s. This Jamaica was not where I had grown up. For one thing, it had become, culturally, a black society, a post-slave, postcolonial society, whereas I had lived there at the end of the colonial era. So I could negotiate it as a 'familiar stranger'.

Paradoxically, I had exactly the same relationship to England. Having been prepared by the colonial education, I knew England from the inside. But I'm not and never will be 'English'. I know both places intimately, but I am not wholly of either place. And that's exactly the diasporic experience, far away enough to experience the sense of exile and loss, close enough to understand the enigma of an always-postponed 'arrival'.

It's interesting, in relation to Jamaica, because my close friends whom I left behind, then went through experiences which I didn't. They lived 1968 there, the birth of black consciousness and the rise of Rastafarianism, with its memories of Africa. They lived those years in a different way from me, so I'm not of their generation either. I was at school with them, and I've kept in touch with them, but they have an entirely different experience from mine. Now that gap cannot be filled. You can't 'go home' again.

So you have what Simmel talked about: the experience of being inside and outside, the 'familiar stranger'. We used to call that 'alienation', or deracination. But nowadays it's come to be the archetypal late-modern condition. Increasingly, it's what everybody's life is like. So that's how I think about the articulation of the postmodern and the postcolonial. Postcoloniality, in a curious way, prepared one to live in a 'postmodern' or diasporic relationship to identity. Paradigmatically, it's a diasporic experience. Since migration has turned out to be *the* world-historical event of late modernity, the classic postmodern experience turns out to be the diasporic experience.

KHC: But when was the diasporic experience registered, in a conscious way?

SH: In modern times, since 1492, with the onset of the 'Euro-imperial' adventure – in the Caribbean, since European colonization and the slave trade: since that time, in the 'contact zones' of the world, culture has developed in a 'diasporic' way. When I wrote about Rastafarianism, about reggae, in the 1960s, when I thought about the role of religion in Caribbean life, I've always been interested in this relationship of the 'translation' between Christianity and the African religions, or the mixtures in Caribbean music. I've been interested in what turns out to be the thematic of the diaspora for a long time, without necessarily calling it that. For a long time, I wouldn't use the term *diaspora* because it was mainly used in relation to Israel. That was the dominant political usage, and it's a usage I have problems about, in relation to the Palestinian people. That is the originary meaning of the term 'diaspora', lodged in the sacred text, fixed in the original landscape, which requires you to expel everybody else, and reclaim a land already settled by more than one people. That diasporic project, of 'ethnic cleansing' was not tenable for me. Although, I also have to say, there are certain very close relations between the Black diaspora and the Jewish diaspora – for example, in the experience of suffering and exile, and the culture of deliverance and redemption, which flow out of it. That is why Rastafarianism uses the Bible, why reggae uses the Bible, because it is a story of a people in exile dominated by a foreign power, far from 'home' and the symbolic power of the redemptive myth. So the whole narrative of coloniality, slavery and colonization is re-inscribed in the Jewish one. And in the post-emancipation period, there were a lot of African American writers who used the Jewish experience, very powerfully, as a metaphor. For the black churches in the States, escape from slavery and deliverance from 'Egypt' were parallel metaphors.

Moses is more important for the black slave religions than Jesus, because he led his people out of Babylon, out of captivity. So I've always been interested in this double text, this double textuality. Paul Gilroy's book *The Black Atlantic*[2] is a wonderful study of 'the black diaspora' and of the role of that concept in African American thought. Another landmark text for me, in this respect, is Bakhtin's *The Dialogic Imagination*,[3] which develops a range of related concepts about language and meaning – heteroglossia, carnival, or multi-accentuality, from Bakhtin–Volosinov – which we developed in cultural studies theoretically, really in the context of the question of language and ideology, but which turned out to be discursive tropes classically typical of diaspora.

Moments of the New Left

KHC: Then you went to England in 1951. What happened then?

SH: Arriving on a steamer in Bristol with my mother, getting on the train to come to Paddington, I'm driving through this West Country landscape; I've never seen it, but I know it. I read Shakespeare, Hardy, the Romantic poets. Though I didn't occupy the space, it was like finding again, in one's dreams, an already familiar idealized landscape. In spite of my anti-colonial politics, it had always been my aspiration to study in England. I always wanted to study there. It took quite a while to come to terms with Britain, especially with Oxford, because Oxford is the pinnacle of Englishness, it's the hub, the motor, that creates Englishness.

There were two phases. Up until 1954, I was saturated in West Indian expatriate politics. Most of my friends were expatriates, and went back to play a role in Jamaica, Trinidad, Barbados, Guyana. We were passionate about the colonial question. We followed the expulsion of the French from Indochina with a massive celebration dinner. We discovered, for the first time, that we were 'West Indians'. We met African students for the first time. With the emerging postcolonial independence, we dreamt of a Caribbean federation, merging these countries into a larger entity. If that had happened, I would have gone back to the Caribbean.

Several West Indian students actually lived together, for a while, in this house in Oxford, which also spawned the New Left. They were the first generation, black, anti-colonial or postcolonial intelligentsia, who studied in England, did graduate work, trained to be economists. A lot of them were sent by their governments and went back, to become the leading cadre of the post-independence period. I was very much formed, politically and personally, in conversation with that, in the early Oxford days.

At that time, I was still thinking of going back to Jamaica having a political career, being involved in West Indian federation politics, or teaching at the University of the West Indies. Then I got a second scholarship, and decided to stay on in Oxford to do graduate work. At that point, most of my immediate Caribbean circle went home. During that time, I also got to know people on the left, mainly from the Communist Party and the Labour Club. I had a very close friend, Alan Hall, to whom I dedicated an essay on the New Left in *Out of Apathy*.[4] He was a Scotsman, a classical archeologist, who was interested in cultural and political questions. We met Raymond Williams together. We were very close to some people in the Communist Party then, but never members of it – people like Raphael Samuel, Peter Sedgwick. Another close friend was the philosopher Charles Taylor. Charles was another person, like Alan Hall and me, who was of the 'independent left'. We were interested in Marxism, but not dogmatic Marxists, anti-Stalinist, not defenders of the Soviet Union; and therefore we never became members of the Communist Party, though we were in dialogue with them, refusing to be cut off by the Cold War, as the rulers of the Labour Club of that time required. We formed this thing called the Socialist Society, which was a place for meetings of the independent minds of the left. It brought together postcolonial intellectuals and British Marxists, People in the Labour Party and other left intellectuals. Perry Anderson, for example, was a member of that group. This was before 1956. Many of us were foreigners or internal immigrants: a lot of the British people were provincial, working-class, or Scottish, or Irish, or Jewish.

When I decided to stay on to do graduate work, I opened a discussion with some of the people in this broad left formation. I remember going to a meeting and opening a discussion with members of the Communist Party, arguing against the reductionist version of the Marxist theory of class. That must have been in 1954, and I seem to have been arguing the same thing ever since. In 1956, Alan Hall, myself and two other friends, both of them painters, went away for a long summer vacation. Alan and I were going to write this book on British culture. We took away three chapters of *Culture and Society*,[5] *The Uses of Literacy*,[6] Crossland's book on *The Future of Socialism*, Strachey's book, *After Imperialism*, we took away Leavis, with whose work we'd had a long engagement. The same issues were also breaking

culturally. We took away the novelist Kingsley Amis's *Lucky Jim*, new things that were happening in cinema in the British documentary movement – like Lindsay Anderson's essay in *Sight and Sound*. In August, while we were in Cornwall, the Soviet Union marched on Hungary and by the end of August, the British invaded Suez. That was the end of that. The world turned. That was the formation, the moment of the New Left. We were into something else.

Most of the people who had been in our circles, in the Communist Party left it, and the Oxford branch collapsed. For a moment in Oxford, this funny grouping, around the Socialist Society, became the conscience of the left, because we had always opposed Stalinism *and* opposed imperialism. We had the moral capital to criticize *both* the Hungarian invasion and the British invasion. That is the moment – the political space – of the birth of the first British New Left. Raphael Samuel persuaded us to start this journal, the *Universities and Left Review*, and I got caught up in that. I became more and more involved in the journal. There were four editors, Charles Taylor, Raphael Samuel, Gabriel Pearson and myself. Once I decided to leave Oxford, in 1957, I came to London and taught in secondary school as a supply teacher, mainly in Brixton and the Oval in south London. I used to leave the school at four o'clock and go to the centre of London, to Soho, to edit the journal. So I didn't leave England, at first, because I became involved, in a new kind of way, in British politics.

It's important to say what my feelings are now about that second moment. I never felt defensive about the New Left, but in a broader political sense, I remain identified with the project of the *first* New Left. I always had problems in that period, about the pronoun 'we'. I didn't know quite who I meant, when I said 'We should do X.' I have a funny relationship to the British working-class movement, and the British institutions of the labour movement: the Labour Party, and the trade unions, identified with it. I'm in it, but not culturally of it. I was one of the people, as editor of *Universities and Left Review*, mainly negotiating that space, but I didn't feel the continuity that people who were born in it did, or like people for whom it was an essential part of their 'Englishness', like Edward Thompson; I was still learning about it, in a way, as well as negotiating with it. I did have a diasporic 'take' on my position in the New Left. Even if I was not then writing about the diaspora, or writing about black politics (there weren't yet many black settlers in Britain), I looked at the British political scene very much as somebody who had a different formation. I was always aware of that difference. I was aware that I'd come from the periphery of this process, that I was looking at it from a different vantage point. I was learning to appropriate it, rather than feeling that the culture was already mine. I was always reluctant to go canvassing for the Labour Party. I don't find it easy to say, straight, face to face with an English working-class family, 'Are you going to vote for us?' I just don't know how to utter that sentence . . .

The Birmingham period

KHC: There is a widespread impression that, historically, CCCS in the beginning was only interested in the question of class. On the other hand, there is also a story that the first collective project in the Centre was one analysing women's magazines, but

somehow the manuscript of this project got lost in the production process, without ever being xeroxed.[7] Is this true?

SH: Oh yes, it's absolutely true. Both of these are true. First of all, cultural studies was interested in class, in the beginning, in Hoggart's and Williams's sense, not in the classic Marxist sense. Some of us were formed in critical relation to Marxist traditions. We were interested in the class question, but it was never the only question: for instance, you can see important work on subcultures, which was done even in the early stages of the Centre. Secondly, when you talk about cultural studies theoretically, we actually went around the houses to avoid reductionist Marxism. We read Weber, we read German idealism, we read Benjamin Lukács, in an attempt to correct what we thought of as the unworkable way class reductionism had deformed classical Marxism, preventing it from dealing with cultural questions seriously. We read ethnomethodology, conversational analysis, Hegelian idealism, iconographic studies in art history, Mannheim; we were reading all of these, to try to find some alternative sociological paradigms (alternatives to functionalism and positivism), which were not open to the charge of reductionism. Both empirically and theoretically the idea that CCCS was *only* originally interested in class isn't right. Thirdly, we got ourselves into the question of feminism, (actually pre-feminism) and the question of gender. We took on fiction in women's magazines. We spent ages on a story called 'Cure for Marriage', and all those papers, which were supposed to be written up into a book, then disappeared; which means that moment from the history of cultural studies is lost. That was the Centre's 'pre-feminist' moment.

At a certain point, Michael Green and myself decided to try and invite some feminists, working outside, to come to the Centre, in order to project the question of feminism into the Centre. So the 'traditional' story that feminism originally erupted from *within* cultural studies is not quite right. We were very anxious to open that link, partly because we were both, at that time, living with feminists. We were working in cultural studies, but were in conversation with feminism. People inside cultural studies were becoming sensitive to the gender question at that time, but not very sensitive to feminist politics. Of course, what is true is that, as classical 'new men', when feminism did actually emerge autonomously, we were taken by surprise by the very thing we had tried – patriarchally – to initiate. Those things are just very unpredictable. Feminism then actually erupted into the Centre, on its own terms, in its own explosive way. But it wasn't the first time cultural studies had thought of, or been aware of, feminist politics.

KHC: Then in the late 1970s, you left CCCS for the Open University; why was that?

SH: I had been at the Centre since 1964, and I left in 1979, it was a long time. I was concerned about the fact of the 'succession'. Somebody, the next generation, has to succeed. The mantle has to pass on, or the whole venture would die with you. I knew that, because when Hoggart finally decided to go, I became acting director. He went UNESCO in 1968, I 'acted' for him for four years. When, in 1972, he decided not to come back, there was a huge attempt by the University to close the Centre down, and we had to struggle to keep it open. I realized that, in a way, while I was there, they wouldn't close it down. They went to lots of academics to ask advice, and everyone said, 'Stuart Hall will carry on Hoggart's tradition, so don't close it down.' But I knew that, as soon as I went, they would try to close it down

again. So I had to secure the transition. I didn't think, until the end of the 1970s, that the position was secure. When I did, I felt free to leave.

On the other hand, I felt also I'd been through the internal crises of each cultural studies year once too often. New graduate students came in October, November; then there was always the first crisis, the MA not doing well, everything in turmoil. I'd seen this happen time, time and time again. I thought to myself, 'You're becoming like a typical disenchanted academic, you must get out, while the experience is good, before you are obliged to fall into these ancient habits.'

Then the question of feminism was very difficult to take, for two reasons. One is that, if I had been opposed to feminism, that would have been a different thing, but I was for it. So, being targeted as 'the enemy', as the senior patriarchal figure, placed me in an impossibly contradictory position. Of course, they had to do it. They were absolutely right to do it. They had to shut me up; that was what the feminist political agenda was all about. If I had been shut up by the right, that was OK, we would all have struggled to the death against that. But I couldn't fight my feminist students. Another way of thinking about that contradiction is as a contradiction between theory and practice. You can be for a practice, but that's a very different thing from a living feminist in front of you, saying 'Let us get Raymond Williams out of the MA programme, and put Julia Kristeva in, instead.' Living the politics is different from being abstractly in favour of it. I was checkmated by feminists; I couldn't come to terms with it, in the Centre's work. It wasn't a personal thing. I'm very close to many of the feminists of that period. It was a structural thing. I couldn't any longer do any useful work, from that position. It was time to go.

In the early days of the Centre, we were like the 'alternative university'. There was little separation between staff and students. What I saw emerging was that separation between generations, between statuses – students and teachers – and I didn't want that. I preferred to be in a more traditional setting, if I had to take on the responsibility of being the teacher. I couldn't live part of the time being their teacher, and being their father, being hated for being their father, and being set up as if I was an anti-feminist man. It was an impossible politics to live.

So I wanted to leave, because of all these reasons. Then the question was leave to do what. There was no other cultural studies department. I didn't want to go somewhere to be the head of a sociology department. Then the thing at the Open University came up. I'd been doing work with the Open University anyway. Catherine had been a tutor there from the very beginning. I thought, the Open University was a more possible option. In that more open, interdisciplinary, unconventional setting, some of the aspirations of my generation – of talking to ordinary people, to women and black students in a non-academic setting – might be just possible. It served some of my political aspirations. And then, on the other hand, I thought, here is also an opportunity to take the high paradigm of cultural studies, generated in this hothouse atmosphere of Centre graduate work, to a popular level, because Open University courses are open to those who don't have any academic background. If you are going to make cultural studies ideas live with them, you have to translate the ideas, be willing to write at *that* more popular and accessible level. I wanted cultural studies to be open to that sort of challenge. I didn't see why it wouldn't 'live', as a more popular pedagogy.

The Centre was hothouse stuff: the brightest graduate students doing their PhDs. They aspired to connect, as organic intellectuals, to a wider movement, but they themselves were at the pinnacle of a very selective education system. The Open University was not. It was challenging the selectivity of higher education as a system. So, the question was 'Can cultural studies be done there?'

KHC: Getting back to the question of the diaspora. Some of the diasporic intellectuals I know of have exercised their power, for better or worse, back home, but you have not. And some of them are trying to move back, in whatever way. So, in that sense, you are very peculiar.

SH: Yes. But remember, the diaspora came to me. I turned out to be in the first wave of a diaspora over here. When I came to Britain, the only blacks here were students; and all the black students wanted to go back after college. Gradually, during my postgraduate and early New Left days, a working black population settled here, and this became the diaspora of a diaspora. The Caribbean is already the diaspora of Africa, Europe, China, Asia, India, and this diaspora re-diasporized itself here. So that's why more of my recent work is not only just about the postcolonial, but has to be with black photographers, black film makers, with black people in the theatre it's with the third-generation black British.

KHC: But you never tried to exercise your intellectual power back home.

SH: There have been moments when I have intervened in my home parts. At a certain point, before 1968, I was engaged in dialogue with the people I knew in that generation, principally to try to resolve the difference between a black Marxist grouping and a black nationalist tendency. I said, you ought to be talking to one another. The black Marxists were looking for the Jamaican proletariat, but there were no heavy industries in Jamaica; and they were not listening to the cultural revolutionary thrust of the black nationalists, and Rastafarians, who were developing a more persuasive cultural, or subjective language. But essentially I never tried to play a major political role there. It's partly because the break in the politics there – the cultural revolution that made Jamaica a 'black' society for the first time in the 1970s – coincided with a break in my own life. I would have gone back, had the Caribbean Federation lasted, and tried to play a role there. That dream was over at the moment in the 1950s when I decided to stay, and to open a 'conversation' with what became the New Left. the possibility of the scenario in which I might have been politically active in the Caribbean closed at the very moment when personally I found a new kind of political space here. After that, once I decided I was going to live here rather than there, once Catherine and I got married, the possibility of return became more difficult. Catherine was an English social historian, a feminist; her politics were here. Of course, paradoxically, she is now working on Jamaica, and the imperial relationship, and she now knows more Jamaican history than I do, and she loves being there. But in the 1960s, it was very difficult for a white British feminist to feel anything but an outsider, in relation to Jamaican politics. My 'reconnection' with the Caribbean happened because of the formation of a Black diasporic population here. I began to write about it again in the context of the studies of ethnicity and racism for UNESCO, then I wrote about it in *Policing the Crisis*,[8] focusing on race and racism, and their internal relation to the crisis of British society, and now I write very much in terms of cultural identities.

KHC: So diaspora is defined by the historical conjunctures both personally and

structurally, and the creative energies and power of the diaspora come, in part, from these unresolvable tensions?

SH: Yes, but is very specific and it never loses its specificities. That is the reason why the way in which I'm trying to think questions of identity is slightly different from a postmodernist 'nomadic'. I think cultural identity is not fixed, it's always hybrid. But this is precisely because it comes out of very specific historical formations, out of very specific histories and cultural repertoires of enunciation, that it can constitute a 'positionality', which we call, provisionally, identity. It's not just anything. So each of those identity-stories is inscribed in the positions we take up and identify with, and we have to live this ensemble of identity-positions in all its specificities.

Notes

1 For Stuart Hall's work on race and ethnicity, see 'Gramsci's Relevance for the Study of Race and Ethnicity', *Journal of Communication Inquiry* 10, 2, 1986; 'Minimal Selves', *ICA Document* 6, 1987; 'New Ethnicities', *ICA Document* 7, 1988; 'Ethnicity: Identity and Difference', *Radical America* 23, 4, 1989, 'Cultural Identity and Diaspora', in Jonathan Rutherford (ed.), *Identity: Community, Culture, Difference* (London: Lawrence & Wishart, 1990); 'The local and Global: Globalization and Ethnicity', 'Old and New Identities, Old and New Ethnicities', in Anthony D. King (ed.), *Culture, Globalization and the World-System* (London: Macmillan, 1991); David A. Bailey and Stuart Hall (eds), 'Critical Decade: Black British Photography in the 80s', *Ten 8* 2, 3; 'What is this "Black" in Black Popular Culture?', in Gina Dent (ed.), *Black Popular Culture* (Seattle: Bay Press, 1992); 'The Question of Cultural Identities', in Stuart Hall, David Held and Tony McGrew (eds), *Modernity and Its Futures* (Cambridge: Polity Press and the Open University, 1992).
2 Paul Gilroy, *The Black Atlantic* (London: Verso, 1993).
3 Mikhail Bakhtin, *The Dialogic Imagination* (Austin: University of Texas Press, 1981).
4 Stuart Hall, 'The "First" New Left: Life and Times', in Oxford University Socialist Discussion Group, *Out of Apathy: Voices of the New Left 30 Years On* (London, Verso, 1989).
5 Raymond Williams, *Culture and Society: 1780–1950* (London: Penguin 1958).
6 Richard Hoggart, *The Uses of Literacy* (London: Penguin, 1958).
7 We thank Larry Grossberg for providing this information; personal conversation, July 1992.
8 Stuart Hall, Chas Critcher, Tony Jefferson, John Clarke, Brian Robert, *Policing the Crisis: Mugging, the State, and Law and Order* (London: Macmillan, 1978).

From Kuan-Hsing Chen and David Morley (eds), *Stuart Hall: Critical Dialogues in Cultural Studies* (London: Routledge, 1996) (extracts).

35

THE STRUGGLE FOR A RADICAL
BLACK POLITICAL CULTURE

An interview with A. Sivanandan

Kwesi Owusu

The colonial situation

KO: In your work on race, culture and political economy, the notion of agency, whether it is the conscious transformation of the colonial intellectual, workers against bosses or Third World nations against the technological might of the West, is a central concern.[1] It is an important site of your critical scholarship, the nub around which most of your theoretical and political practice revolves. How do the various trajectories of your personal history inform this?

AS: I was born into a poor family in the north of Ceylon – the arid, waterless country of the Tamils where nothing grows except children. My grandfather was a tenant farmer and the only way out of that predicament was through education. So he scrimped and saved and borrowed and stole and sent the brightest of his sons, my father, to a Catholic school in Colombo. He had to leave school at fifteen, though, and take up a post in the postal service, serving the British Raj wherever the work took him. But he still had his roots in the village and in the people of the village whom he had to support. And I grew up in that atmosphere – where a sense of responsibility was inculcated into one, a sort of feeling that people depended on you and you could not forsake them. We starved, but we shared.

When my father rose to the position of postmaster, he sent me to another, grander, Catholic school in Colombo, where I got a typical colonial education that spoke of another world and other values. And, without articulating it in this way, I felt there was a tension in me between the feudal and capitalist way of life. There were other contradictions too – like going to a good school, but living in a poor, almost slum, area of Colombo with an uncle who was a railway worker. So here I was – with my roots in a village culture, living in an urban slum, going to the best Roman Catholic school and getting an English education, but in the evenings getting up to all kinds of mischief with very poor boys – Sinhalese, Tamils, Muslims – on the streets. It was a complex mishmash of things, and it begins to unravel only later when I go to university and come across radical socialist lecturers, who themselves had studied in England and been influenced by Harold Laski and others at the LSE. It was teachers like them who gave us a feel of anti-colonialism,

taught us a kind of insurgency – through the critical study of Shelley, for instance, or Milton. Or they would discuss the independence movement in India and, from there, go on to talk about Marx and Hegel and other thinkers who were important for our understanding of dialectics and revolutionary politics.

I left university with a degree, but because I didn't come from a rich family and had no connections, I ended up teaching – the children of Indian plantation workers in the hill country and of landless Sinhala peasants in Kandy. And all that gave me a living insight into how British colonialism had underdeveloped us in different ways and shored up differences between the peoples of our country who then became defined in communal or racial terms.

Teaching paid very little, and I had responsibilities. So I finally got into a bank – as an executive officer and then a manager. But I didn't like the way management treated the workers and so I started a bank clerks' union and got into trouble with my bosses. I was also in trouble with my parents at the time because I had married a Sinhalese. Love marriages and mixed ones at that time were anathema to both Sinhalese and Tamils in our society.

Anyway, all the contradictions come to a head in 1958, when a Sinhalese government instituted the first pogroms against the Tamils. My father's house was attacked and I had to go disguised as a cop with an empty rifle in my hand to get my parents away from a screaming mob. I saw people being killed just because they were Tamils, people being burnt alive. The degradation of our people – Sinhalese and Tamil – was too much to bear. I couldn't take it any more. So I chucked up my job and came to England – only to walk straight into the riots in Notting Hill. It was a double baptism of fire.

Britain in the late 1950s

KO: You arrived in London in the late 1950s, strongly influenced by your experience of colonialism and a critical understanding of anti-colonialism. What kind of Britain did you find?

AS: I came alone first, before my family, to scout around for a job. I had an economics degree and was an associate of the Institute of Bankers, but I could not find a job easily. Even though I had some money, I could not find a house, and I went to live with two other Ceylonese families in Notting Hill. A few days later the 'riots' broke out. I remember I was seated with some Ceylonese friends in a pub in Bayswater when I heard about the 'riots' and wanted to go and see what was happening. But one of my companions, a professional as I used to be, turned to me and said, 'This is nothing to do with us, they are only attacking the Negroes'. Having come out of the 'riots' between the Sinhalese and Tamils in Ceylon and walked into the Notting Hill 'riots', to have the Ceylonese bourgeoisie talk in racist terms turned my stomach. That was, if you like, my moment of truth.

Partly that realization and partly the sheer discrimination I met with drove me out of the bourgeois life and banking. I tried for other jobs that went with my qualifications, but to no avail. And I finally ended up as a teaboy in a library in Kingsbury. But, after I qualified as a chartered librarian, I went to the Colonial Office Library and, finally, to the Institute of Race Relations in the 1960s.

KO: Your engagement with the politics of race started around this time. What kind of organization was the Institute of Race Relations?

AS: It was a posh, elitist institute in Jermyn Street opposite the Queen's perfumery and next to Fortnum & Mason. It was set up by an ex-Indian-Civil-Servant, as part of the Royal Institute for International Affairs, to reorientate British policies to meet the aspirations of the new rulers of Africa, Asia and the Caribbean, and to ease official thinking out of the outright racism of the colonial era into the kind of benevolent paternalism of the neo-colonial one. The IRR's view was that there was no such thing as racism, only race relations. The relationship between races was not one of power but of personal prejudice.

KO: So the Institute was a kind of neo-colonial think tank for the British government. Did it ever focus on race relations within Britain?

AS: That came after 1958. After the Notting Hill 'riots', race relations, or rather racism, came home to roost, and the Institute began to look at race relations in Britain. The angle was that we were all God's children under the skin, but some of us have to play God. And if you all learn to integrate or, rather, assimilate into British culture, we'll have no problems.

The radical 1960s

KO: You were instrumental in the radical transformation of the Institute. The story has been fully documented elsewhere.[2] Without recapping the precise details, can you share with us the circumstances which precipitated what in political terms was a mould-breaking transformation?

AS: When I became librarian in 1964, I was the only Black member of staff. The Institute served a very small elite of ex-colonial types and academics and was funded by large corporations like Shell which were essentially interested in safe investment in the Third World. There was no 'race relations industry' then and IRR research was used to justify government policy, for example over immigration.

Little by little, the base of IRR began to change. We got more Black members of staff and white ones who had been radicalized by Marxist ideas and struggles over Vietnam. As librarian, I was able to introduce Black radical literature – Eric Williams, C. L. R. James, the Black Panther Party newspaper from the States, the works of Frantz Fanon, writings and speeches by Nkrumah and Amilcar Cabral, the life stories of Sojourner Truth and Robeson, the poems of Langston Hughes. Because this body of Black thinking could be found only in the IRR's library, we began to attract a whole lot of Black activists and thinkers – from, say, members of the Black Unity and Freedom Party and Grassroots to Third World liberation groups. And they in turn radicalized my own thinking.

But all this passed the IRR Council by, composed as it was of lords and ladies and heads of multinationals like Marks & Spencer, Bookers, Barclays Bank. They still thought they were the lords of humankind who could control the natives. And remember it was a very hierarchical organisation in those days. They never met the staff. We were not allowed into their meetings. When the staff began to criticize the kind of policy-oriented research being carried out by the IRR's domestic research wing – a white researcher, calling it 'spying', urged Black people to tell IRR researchers to 'fuck off' – the Council decided to sack the critic for disloyalty

and the editor of *Race Today* (also white) as the magazine had lost its objectivity. (It had criticized the government for its sell-out on Rhodesia and carried a free ad for the Anti-Apartheid Movement on its back cover.) Basically, the management did not want us to speak out against the virulent racism which was clearly affecting the policing of Black communities and the education of its children or support the freedom struggles of Third World peoples.

It was over these two liberal issues of academic freedom and journalistic freedom that we took on the Council – thereby getting not only the academics and journalists on our side, but the majority of the Institute's members and a cross-section of the public as well – and, of course, the Black community. The Council was taken aback. They were so out of touch – in their boardrooms, on their plantations and in their debating chambers – that they had no idea of the overwhelming support we had in the country. And when we invaded one of their Council meetings, they panicked and hastily called an extraordinary general meeting of members to decide between the views of staff and of management as to the future of the Institute. To their surprise, they were roundly defeated. So they resigned en bloc and left the Institute to the staff, but they took their funds and their funders with them and went off to the Runnymede Trust, which had been set up by the IRR in the meantime.

The struggle was significant, not just because it was a *cause célèbre* and a rare victory for the subalterns, but because it reoriented the IRR and redefined race relations in Britain. It said that it was white society and not Black people that was 'the problem', that Black people were now the actors not the victims, and that change would come from below not above.

The politics of race and immigration

KO: In the sociology of race relations, the tendencies towards immigration controls in the post Second-World-War period have been explained by two models. The state is seen as responding either to the pressure of public opinion or to the economic interests of the ruling class. You are associated with the latter position.[3] Do you think it is enough to see the state as merely responding to public opinion or economic interests?

AS: There is no either/or about it. It's a process. Public opinion gives a fillip to policy, and policy, in turn, reinforces public opinion by the institutionalization of racism – in immigration laws, judicial decisions, administrative edicts. It is fashionable now to dismiss economic arguments about immigration as determinist. But my critics have gone to the other extreme to become culturally determinist and ahistorical. The economics behind immigration policy was crucial, and I stand by that. But that is not to exclude public opinion – it is a dialectical process. If I have emphasized one rather than the other at a particular period, it is because I am a pamphleteer writing for that time, for the struggle, not for all time. I am not a theoretician looking for models. Models are for academics.

KO: The Home Office became responsible for immigration controls whilst the task of implementing integrative measures in education, housing social services etc. was assigned to extra-governmental agencies such as the Community Relations Commission, Race Relations Board and, currently, the Commission for Racial

Equality. Do you see any rationale for this distribution of powers? How effective do you think they have been?

AS: I am not sure that I see it quite like that. These were organizations set up not to effect the integration of the mass of Black people in the country but to create a tranche of Black middle-class administrators who would manage racism. They were set up as buffering institutions to deal with potential social dislocation. Don't forget that the climate of the 1960s and 1970s was of revolution all over the world – Nicaragua, the burning of Detroit, Cabral and Mondlane in Africa, the Vietnam struggle. Here, we had the rising tide of Black Power, with protests and demonstrations, papers and parties, self-help and community initiatives. What the CRCs and Race Relations Board etc. were about was how to absorb and negate disquiet. And, to the extent that they helped to fragment the Black community and stifle Black protest, they succeeded.

Moments of community self-empowerment

KO: In the 1960s, political activist Claudia Jones suggested an alternative to state integration – Black self-organization. There emerged a multiplicity of community organizations and structures – bookshops such as Grassroots, Sabarr and Headstart, newspapers and magazines such as the *Black Liberator*, *Flame*, *Black Voice*, housing projects like Harambee and Ujima, Black information centres, the Keskidee theatre, the Black University and supplementary schools up and down the country. Almost all these structures have disappeared. Why?

AS: Black self-help came out of need because discrimination in housing, in schooling etc. was destroying the life chances of our kids. And as the 1962 Immigration Act was closing the door and children were joining parents, Black people began to look for ways out of discrimination in education (bussing and ESN), discrimination by the police ('Sus' laws), discrimination in housing (residence rules and overcrowding notices). Hence supplementary schools and summer schools in temples and churches, black law centres and training schemes, and all sorts of other projects like the ones you have mentioned.

A number of things broke up this community self-help tradition. Partly the race relations industry, partly the moneys thrown into the inner cities via Urban Aid and partly the fact that Black unity broke down as Black ceased to be a political colour. With the coming of multiculturalism, Black British political identity ceded to African Caribbean and African and Asian cultural identities and separatism. Groups began to fight one another for funds on an ethnic basis; they were no longer fired by the needs of the whole community.

But we should not forget what Black self-help did in the short term – in terms of self-worth, in terms of giving Black people a certain stature and a certain understanding of themselves. Self-organization made them feel that their fate was in their own hands. All that is a very far cry from what passes today for the Black Voluntary Sector. The self-help of the 1960s was politically based in the community and funded by the community. Today there are a plethora of groups which call themselves Black this or Black that, but such groups are usually funded by the statutory sector and work along the lines of the white voluntary sector.

On Powell and Powellism

KO: If we look back on British politics in the post-Second-World-War period, we see that the large-scale entry of Caribbean and Asian workers, a significant marker of Britain's demise as an imperial nation, aroused powerful sentiments and rupturous political debate. With his 'Rivers of Blood' speech, Enoch Powell emerges as the archetypal figure in the controversy. His recent death (in February 1998) in some respects draws a curtain of sorts on a political chapter. What do you think is his real political legacy on race and race relations?

AS: All this stuff coming out in his obituaries about Powell being a highly principled, highly educated scholar is a load of bullshit. Enoch Powell was a racist, an out-and-out racist. The question for us is not whether an educated man, a Greek and Latin scholar, saw Black people as inferior, or called our children piccaninnies, but how a man who talked in such uncivilized terms could be deemed educated at all. It is also significant that there is such a reluctance, even on the Left, to call him a racist; at best a British nationalist, but a racist, no. There is something about the English, particularly among the upper classes, which makes them want to forgive their racists, classify them as naughty boys, mavericks, bloody-minded Englishmen, who are somehow 'fetching'. Because bloody-mindedness is something quintessentially English.

Racism is not a matter of taxonomy or definition. Racism is as racism does. What Powell's speeches did was to destroy a whole lot of lives. His prophecies became self-fulfilling. Excreta and burning rags were put through letterboxes and bombs thrown into Afro-Caribbean and Asian homes. Women and children could not walk the streets in safety and the fascists had a field day.

But, ironically, he also made a positive contribution – in that he gave a fillip to the Black Power struggle in this country. He enlightened us, showed us the dangers of racism and the need for unity to combat it. The Black People's Alliance, bringing together over fifty African, West Indian, Indian and Pakistani organizations, came about because of his speech. Black Power, you could say, was the other side of the Powellite coin.

The turbulent years of the 1970s and 1980s

KO: Would you say that the 1970s and 1980s were periods of high political activism within Black communities?

AS: Yes, and there were many lessons for us to learn from those struggles, on a variety of levels. There was strike after strike in the early 1970s – at Mansfield, Crepe Sizes, Imperial Typewriters, Birmid Qualcast – which involved Black workers; and finally, of course, the Grunwick strike. Up till then Black workers had to rely, because of trade union racism, on their own communities for support. But Grunwick was a watershed. It was significant because, for one thing, it was led by an Asian woman and went on for almost two years. And second, as the strike (in film processing) went on, other trades unionists, including postal workers, got involved. The trade union movement supported a Black strike as never before because it was about union recognition and secondary picketing. But in the process, the concerns of Black workers got changed into the unions' interests, and the

421

strikers lost their community base.[4] In the end, the TUC left them high and dry and the strike collapsed.

We also had trouble in and around articulating and recording our own experience. For instance, around *Blacks Britannica*, the first Black documentary about the history of Black people in this country told from the bottom up, made by an independent American company for WGBH but with a Black co-producer and a British Black presenter. The film was so hard-hitting that it was withdrawn by WGBH. And we had to fight to get the film shown in the USA and in Britain, and get pirate copies out to community venues.

The 1970s was also the time when white anti-fascist political traditions fused with Black anti-racist ones. But the fusion itself was not without struggle. The marches by fascist groups, like the National Front, through Black areas like Lewisham mobilized thousands of Black and white people on the streets. There were contradictions, however, between groups like the Anti-Nazi League (which was anti-fascist first and, incidentally, anti-racist) and the Campaign Against Racism and Fascism (which was anti-racist and, therefore, anti-fascist). Basically Black people and local CARF groups said, let's get rid of racism, the recruiting ground of the fascists, while the ANL line was class first and race afterwards.

Then, we had the uprisings of 1981 and 1985, when the youth rebelled against Thatcher's policies of a thousand cuts and the politics of the stick, and burned down the cities. The government, terrified of the kinds of riots the USA had witnessed, sent for Lord Scarman to report on the problem. But his diagnosis was that prejudice and racial disadvantage were the underlying causes, not institutionalized and/or state racism. The solution, therefore, was to promote ethnic cures, so to speak, and equal opportunities. Already, multiculturalism had begun to break down Black unity, now we got fragmented even further. In bodies like the Greater London Council which took the Scarman line on disadvantage, funds were made available on an ethnic basis to all kinds of groups, which then began to fight one another for funds and influence. And race relations units took equal opportunities programmes (with their attendant ethnic monitoring and implicit quotas) into local authorities and government departments. In effect, it transferred Black politics from the streets to the town halls. Thus the fight itself was transformed from a fight against the system and against racism, which affected the whole community, to a fight by individuals over position and power and a place under the ethnic sun. It was the youth of the deprived areas of the inner city that rose up in revolt against the stone of their lives, but those who benefited were the middle-class Blacks who climbed on the equal opportunities and ethnic programmes bandwagon to make their way up. And the youth were left in a worse condition than ever by being deprived of whatever Black expertise was available to them before.

New Britain – new configurations

KO: It is quite fashionable these days to argue that Black people are now so integrated into the society at large that we no longer need specific initiatives or programmes to tackle discrimination or redress inequality.

AS: Where is the integration? Blacks as radio and television presenters, as MPs, as arts wallahs means nothing if the lives of ordinary Black people at the bottom of the

pile have not improved. In effect, what we have today are two racisms: the racism that discriminates (which affects middle-class Blacks bothered about those glass ceilings) and the racism that kills (which affects the workers and work-less Blacks). My concern is with the racism that kills – on the street (Stephen Lawrence, Michael Menson, Lakhvinder Reel) and in police or prison custody (Omasase Lumumba, Shiji Lapite, Brian Douglas).

KO: In a recent paper, 'Frontlines and Backyards', Stuart Hall talks about a new Black British identity.[5] He argues that unlike a decade ago when 'Afro-Caribbeans and Asians were treated by the dominant society as so much alike that they could be subsumed and mobilized under a single political category . . . today it is no longer the case'. He goes on to argue that 'today, we have to recognize the complex internal cultural segmentation, the internal front lines which cut through so-called Black British identity'. Do you agree with this position?

AS: I agree with Stuart that the objective conditions are no longer there for Afro-Caribbean and Asian unity – and therefore for a Black politics. And, as I've already indicated, the rise of multiculturalism in the last decade or more has broken down that unity and replaced it with cultural enclaves and feuding nationalisms – Afro-Caribbeans versus Asians on housing estates, for example, Sikhs versus Muslims in Southall and Slough, Africans versus Afro-Caribbeans in town hall politics. These are the more serious aspects of cultural segmentation, not all that 'internal front lines cutting through identity' stuff that Stuart speaks of.

Recognizing cultural segmentation, however, is not to accept it. Cultural segmentation, like class segmentation, was always there – except that, yes, it is deeper and more complex today. But that is the more reason to fight it, before it becomes inward-looking and reactionary and recedes into culturalism and ethnicism and self-regarding nationalism.

Stuart's preoccupation is with cultural identity and cultural politics, my preoccupation is with racial justice and a political culture that can deliver racial justice, a socialist political culture. Cultural politics tends to promote cultural segmentation, political culture attempts to cut across such segmentation.

KO: Your writing in the last ten years has moved its focus from racism to look at technology and to write a novel on Sri Lanka.[6] How do these departures connect with your overall interests in Black politics?

AS: It's not so much that I've moved away from racism as that racism itself has undergone a qualitative change under the impact of the technological revolution. For one thing, it has become more aligned with poverty. And poverty is aligned with the Third World. The colour line that Du Bois wrote of in 1906, as being the problem of the twentieth century, is today the power line and the poverty line. Second, the globalization of capital has given rise to a new imperialism, the imperialism of transnational corporations which, unlike colonial capital, is not interested in the people it exploits but in the profits it can squeeze out of them – an imperialism in which our own rulers are complicit.

As for the novel, writing for me has always been a way of fighting, whether through political analysis or creative fiction. And there was a hollow in me where my country was, and I had to fill it with its story.

Looking ahead

KO: The last question relates to the new Labour government under Tony Blair. It is probably too early to assess its attitudes and performance in relation to many of the issues we have been discussing. However, the Thatcherite 'revolution' of the 1980s and 1990s marked a significant and definitive shift to the right, a shift so radical that it can be argued that the best a radical Black politics can hope for in this conjuncture is a centrist, monetarist government. Do you think New Labour is equal to the task of breaking the circuits of poverty, racism and discrimination in the inner city – grievances which added in no small measure to the civil unrest of the 1980s?

AS: No. New Labour says nothing to the poor and dispossessed in this country. It has got nothing for that layer of society and therefore very little for ordinary Black people except palliatives. But Labour can afford to be 'nice' on the basis of 'race relations' (and so enhance the status of middle-class Blacks) because on the basis of economic relations (which speak directly to the condition of poor Blacks) they are much more tough – as tough as the Tories were.

We have moved from a politics of selfishness under Thatcher to a politics of consensus under Blair. But the market is still paramount. Hence what Labour professes – by way of helping the poor and the socially excluded – is contrary to what it delivers. You cannot have social justice with free market economics – and consensus politics cannot cover up that contradiction for ever. And it is in the interstices of that disjuncture that the seeds of revolt against New Labour lie.

Notes

1 For A. Sivanandan's work on race, culture and political economy see 'The Liberation of the Black Intellectual', in *A Different Hunger* (London: Pluto Press, 1982), and *Communities of Resistance* (London: Verso, 1990).

2 See A. Sivanandan, *Race and Resistance: The IRR Story* (London: Institute of Race Relations, 1974).

3 See A. Sivanandan 'Race, Class and the State', *Race & Class*, 17, 4 (spring 1976), and also in *A Different Hunger*.

4 See A. Sivanandan, 'Grunwick', in *Race & Class*, 19, 1 (summer 1977), and also in *A Different Hunger*.

5 Stuart Hall, 'Frontlines and Backyards: The Terms of Change' (1997) reprinted as Chapter 11 above.

6 See for example 'New Circuits of Imperialism', *Race & Class*, 26, 1 (1984), and 'Heresies and Prophecies: The Social and Political Fall-out of the Technological Revolution', in Jim Davis, T. Hirschi and M. Stacks (eds), *Cutting Edge* (London: Verso, 1998). The novel on Sri Lanka by A. Sivanandan, *When Memory Dies* (London: Arcadia, 1997), was awarded the Commonwealth Writers Prize (Eurasia Region) in 1998.

THE COMMISSION FOR RACIAL EQUALITY AND THE POLITICS OF RACE RELATIONS

An interview with chairman Sir Herman Ouseley

Kwesi Owusu

Race and the state

KO: The Commission for Racial Equality (CRE) was set up by the Race Relations Act 1976 to work towards the elimination of racial discrimination in Britain, to promote equality of opportunity and good relations among the different racial groups and keep under review the working of the Act.[1] Like its antecedent bodies (the Race Relations Board and the Community Relations Commission), the CRE is a non-governmental body – in other words, set up by government but not of government. How does this non-governmental role impact on your effectiveness, considering the fact that the Home Office, a government department, is responsible for the implementation of immigration policy?

HO: I think that one needs to look at the pattern of non-governmental agencies that were set up to deal with issues of inequality – religious discrimination against Catholics in Northern Ireland, the Fair Employment Commission, the Equal Opportunities Commission, the Race Relations Board and the Community Relations Commission etc. All these bodies were set up independently of government, so that the government was unable to directly manipulate their decisions, decisions taken in the quasi-judicial sense. In the case of the CRE, many aspects of our work end up in court or the industrial tribunals, and it is important that we pursue them independently.

Three major factors affect our effectiveness. First is the limitations of the Act itself. Many regulatory services of the state, such as the Immigration Service, are outside the scope of the Act and therefore outside our remit. We can't also touch many of the Crown's activities. We can't for example go to Buckingham Palace and say, let's look at your employment policies and practices, we don't think you employ any Black people.

Until recently, the Act also imposed limits on compensation awards in race discrimination cases. MP Keith Vaz's private member's bill, the Race Relations

Remedies Act (1994) changed that. It is important for people who are discriminating, particularly employers, to know that there isn't a ceiling to compensation awards. You don't just get a slap on the wrist and a derisory fine for discriminating. In the last year alone we have seen Goldman Sachs, one of the finance houses in the City of London settle their case with James Curry beyond the £11,000 ceiling. The settlement remains undisclosed but it runs into millions of pounds.[2]

As an organization, the CRE has severe limitations on its budget. We could do a lot more to create a climate for action if we had more money to spend – promoting our activities and raising awareness about our equality programmes for example. It'll also make it possible for us to take on more high-profile court cases. There's no point in fighting a case to the House of Lords if it wipes out your total budget. In effect, it means that you can't help others. Budgetary constraints impact on our resources, not least on the quality and quantity of the people we can recruit.

There's also the issue of CRE's relationship to the government, its main funder. Irrespective of whether we see ourselves as independent, outspoken or objective, which we try to be, there's always the question of how we criticize the government. In the past, my predecessors have had to deal with all sorts of veiled threats – ministers wondering how they could go to the Cabinet and persuade their colleagues to put money into the organization when we were busy criticizing them.

From my perspective, it is important that we clarify the limitations of what the law enables us to do. What we are capable of doing within the resources we have. You have to be able to say to people: these are the things we can do, and these are the things we can't do. We know you expect us to change the world, but we can't do it. We know you expect us to go and turn over every aspect of the Crown's activity that's discriminatory, but we haven't got the power to do so. But we'll work with you in trying to get increased legislation, better legislation, and fighting the cases individuals bring to the courts.

KO: In the areas within your legal remit – education, housing, industry, the Civil Service, the Services etc. – the discrimination indices are damning.

HO: Yes, of course, but I think you've got to look at the situation over a period of time. In an ideal world, legislation should ensure we don't have discrimination. But I'm sure you know it's not that simple in the real world. If it were, you wouldn't be talking to me today because there would be no need for the CRE.

The reality is that progress can be charted over time, and there are success stories that are often not acclaimed. Housing is one such area. From the late 1950s and early 1960s, when Caribbean immigrants started arriving in places like Notting Hill and Brixton, public housing was very much informed by a policy of dispersal whilst there was severe overcrowding in the private sector. By the late 1970s, it was clear after the Runnymede Report on housing that the situation had got worse. Urban slum clearance programmes had resulted in many Black people being moved into high-rises and prewar accommodation, irrespective of need. In Lambeth, I worked with Dan Thea, one of the chief instigators of change in local authority housing to make major changes, radical changes. We managed to get the council to acknowledge institutionalized racism in the allocation of houses and implement changes. The CRE itself did a major investigation into housing in Hackney in 1984, which led to further changes.[3]

We also saw the emergence of Black-led housing associations around the same

time. Together with the changes in local authority practice, housing allocation was made much fairer than it used to be. I can't say it's now absolutely fair. It isn't. There are still problems of homelessness and overcrowding, but this is one area where you can correlate success in terms of Black housing managers running Black associations, a growing number of Black professionals in mainstream housing associations, as well as at the top of housing departments within local authorities.

The real problem in social housing is the difficulty of turning old, declining and undesirable stock into new stock. And we must remember that over the last twenty years or so, government policy has primarily been to shift investment away from social housing driven by local authorities to the private sector, housing action trusts and associations. If you take the Borough of Wandsworth in London for instance, the whole stock of social housing was virtually handed over to the private sector.

Where there have been clear benefits, and where the differentials have started to move into balance, there have been the opportunities offered through the Black-led housing associations who have been able to develop and utilize old housing stock. There has clearly been a movement for equality in social housing which is grappling with and overturning the processes of discrimination.

KO: Is there a similar movement in education?

HO: The story here is a good and a bad one. On the bright side, further education is now packed with Black students – largely people who for one reason or another dropped out and are looking for a second chance. The percentage is also good – about 11 per cent across the universities. This is significantly above the ethnic minority percentage in the relevant age groups. It is also not uncommon these days to find young Black kids coming out of one-parent households and so-called non-achieving schools and winning places at Cambridge and Oxford. Isolated examples, one might say, but it shows there are opportunities within the system.

KO: The number of Black students, particularly Africans and Caribbeans, being permanently excluded from the school system is now quite startling. In the London Boroughs of Haringey and Brent, they represent 79.17 per cent and 57.76 per cent of the total exclusions respectively. How do we account for these figures?[4]

HO: Parts of the school system are riddled with inefficiency, racism and stereotyping. This, however, does not have to be seen as just the failure of the schools and local authorities. It's also a failure of us as communities, as parents to engage and utilize the system. Racism and stereotyping particularly affects Black boys. Low expectations to achieve lead to high expectations to misbehave – to live up to the reputation of the cool dude and be thrown out of school.

There's clearly a story of failure here. Sadly it's being replicated, to a lesser extent, amongst some Bangladeshi and Pakistani young men. Another dynamic which impacts on race relations is the failure of white working-class boys. Their parents store up a lot of resentment and too often blame minorities for their children's failures.

KO: What interventions have you made in this problematic area?

HO: Personally, I've been involved in education in different ways for a long time – in fact from the days Bernard Coard published his seminal work on West Indian children and the British school system.[5] There has been a struggle against the educationalists and we seem to be fighting the same battles. There's a real

contradiction between the home and the school – not least, in terms of parent expectations and what some state schools can deliver.

From all the available information, Black children entering the school system at five are as ready as their white counterparts.[6] In some cases they are even more advanced. They maintain a level of parity with their peers till they are eight or nine. Then they start to slip. By eleven, the slippage is pronounced and well documented.

Clearly something happens between eight and the teenage years, in the home and at school. I find it most despairing when parents say to me, 'my kid is fifteen and he can't read'. I wouldn't in any way suggest that parents neglect their children's education – in fact we know that Black parents particularly have high hopes for their children because many of them see education as a stepping stone out of poverty and social deprivation. However, there's a tendency to simply blame the schools and the teachers. Undoubtedly some are racist and there are always negative stereotypes being played through, but many other similar schools often produce good results.

KO: What then are the responsibilities of the schools?

HO: Most of the schools where Black children fail are low-achieving, failing schools. There's usually poor leadership and low-quality teaching. Unfortunately, there has been a tendency in the past to focus on Black studies and anti-racism, as a way of dealing with the issues, when in fact many of the kids need very basic education. If you can't read or write properly, all the Black studies in the world are not going to equip you for the world of work. This is not to say that schools should not encourage children to appreciate the world around them – issues of cultural inheritance, the history of the Black communities and so on.

KO: Don't you think specific initiatives are needed to tackle the issue of exclusions?

HO: I do. First, we need more Black teachers and headteachers. Many British-trained teachers from Africa, the Caribbean and Asia who came here as immigrants were driven out of the system. They were not promoted, they were marginalized and discriminated against. Second, we need focused curricula that ensure that the school environment is supportive and conducive to learning, that exclusions are really a last resort. Alternative arrangements must also always be made for the adequate education of excluded students.

We need good leadership in the schools – leadership that sets standards. All students must be reaching for high standards at every age level. And where they're not, we've got to have remedial, supplementary work programmes. Schools need to involve parents as an ongoing process of communication, not just when their children become 'problems'. Clear incidents of racism should be dealt with as part of the inspection process. Other issues such as bullying must be looked at within a policy framework that engages students in disciplinary matters. The best schools show that students must understand and be engaged in the introduction of disciplinary procedures.

Significantly, many schools have narrowed their educational remit somewhat by purporting to work only with children 'who want to learn'. With the current emphasis on academic competition, league tables and so on, it is easy to push out those you think are slipping or 'not interested'. I think we must have disincentives for schools that push students out and incentives for those who hold on to them. At

the moment it is not advantageous for a school to work with so-called difficult students. That clearly must change.

KO: Turning to some of the other institutions within your legal remit – the Civil Service and the forces. After fifty years of Black mass presence in Britain and twenty-three years of the CRE, these institutions are still starkly unrepresentative of the racial composition of contemporary Britain.

HO: There are a wide range of public institutions which have failed abysmally. You've got to look at Prime Minister Tony Blair's speech at the end of September 1997 to the Labour Party conference. He said that if Britain is to become a beacon to the world then it must utilize the talents of all of its people. When he looks around he sees no Black permanent secretaries in the Civil Service, no one at the top of our major public institutions, no one at the top of the military, no Black chief constables of police. It's such an indictment of public institutions in this country.

In an institution like the Civil Service, the career model and recruitment has largely been based on elitism – deciding who are going to be the fast-trackers and creaming them off from the country's 'elite' universities. Then there's the old boy network. When we look at British embassies across the world, do we see a Black face at the top of any of them? No way! We're actually talking about a ten-year programme that might achieve the first (Black) British ambassador using the existing criteria, even if it's made fairer.

KO: What is being done to redress these historical inequalities?

HO: Equality targets are being set by permanent secretaries. Since July 1997, we have brought them together into a leadership challenge. They have pledged to take personal action to make sure that their departments are implementing equal opportunity policies. The government is also being persuaded to ensure that performance in the Civil Service is linked to ethnic recruitment and participation.

Equality has always been a strong issue for the Civil Service but the results have not matched the hype. We want to see it included in the criteria for assessing achievement within the various departments. We are also raising awareness that Black and ethnic-minority people actually have the right qualifications and capabilities and must be actively recruited.

KO: Are you convinced that there is now the political will to engage in the kind of process that will yield tangible results? What is new about this conjuncture?

HO: There is nothing new at any given time – only different moods and swings. Presently there is a new government and a mood of optimism. The Home Office has concluded a review of its staffing and found that Black and ethnic minorities are doing very badly. They have now put into place a programme to redress the situation.

When Robin Cook arrived at the Foreign and Commonwealth Office, he said it's too white and too male. He said we've got to change it, we've got to change the culture, we've got to move the Foreign and Commonwealth Office that represents us across the world into the real world of cultural diversity and multiculturalism. We want to see Black people moving up the managerial stratae. He has brought in consultants and invested in a new programme of action. The Foreign Office is taking roadshows to the community, as well as inviting people to its departments – people who have never been there before, young, Black and ethnic-minority students.

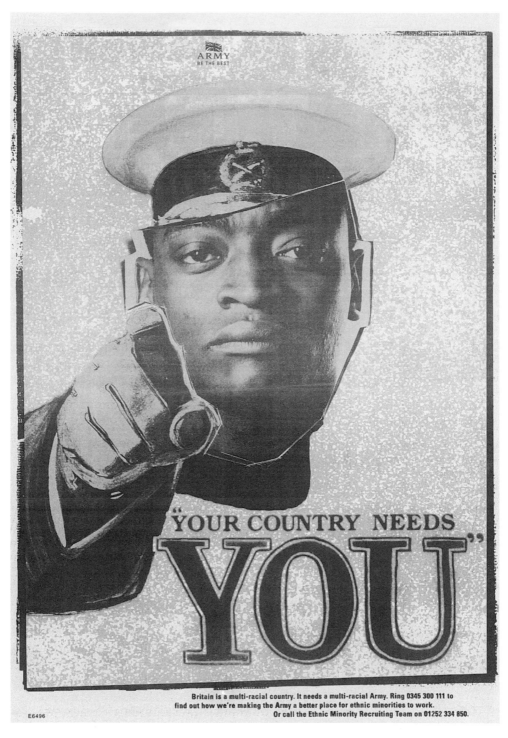

Figure 36.1 British Army recruitment advert (1997)
Source: Courtesy of Ministry of Defence

KO: Would you say there are similar developments in the Armed Services?

HO: You may have seen the recruitment blitz in the Black and ethnic media. The Army has had such a bad relationship with the Black community that it's going to take a while to turn its image around.[7] But they're seriously making an effort, taking their message to places like Brixton, Handsworth and Haringey. That's important. People now recognize that talking the good talk is not enough. You've got to make things happen.

KO: If we can address the police and prison services for a moment, how does this new optimism engage the issue of the mysterious deaths of young Black men in custody – Brian Douglas, Alton Manning, Dennis Stevens etc. etc.?[8]

HO: Racism is so ingrained and so institutionalized in the services that I don't think it's going to be washed away so easily and so quickly. There are many in the services, particularly at the top, who are enlightened and not overtly racist, and I have to say that many of them now genuinely believe there is a problem. But below them, there are examples of a collective retrenchment – the canteen culture, the sergeant's mess where they'd openly call you a nigger, a coon, a Paki or wog and virtually drive you insane.

KO: If racism cannot be dismissed so readily, is there not a case to be made for restricting, say, police powers?

HO: The difficulty about restricting police powers is that society is presently caught up in dealing with this 'overwhelming' problem of rising crime. When we pass legislation, someone's got to enforce it. This involves a certain delegation of responsibility, which in too many instances is unfortunately abused. The evidence of police brutality and malpractice are now widely documented. The Metropolitan Police has recently paid out significant sums of money in settlements to people, without admitting liability, or culpability. The system is clearly loaded – culpable officers can simply walk away with pensions after committing all sorts of mis-demeanours. The services are now recruiting more Black people but I suspect they're losing them almost as fast because the prevailing culture isn't changing quickly enough.

Race and political parties

KO: A key dynamic of British politics since the war has been the racialization of political debate. Debates on immigration, crime, law and order have particularly gained clear racial dimensions. The main political parties have played key roles in articulating this.[9] How much influence do you have with them?

HO: The reality for us is that the CRE is non-political and non-partisan. In effect we say the same things to all the parties but in different ways. You have to bear in mind that each party is different and want to hear things differently. They also have different approaches. We do our best to influence them, tell them where we think they're going wrong; but whilst they may listen, they don't have to follow our advice. These are the limitations of our remit. But we are all the time seeking to move the political boundaries within which communities themselves feel sufficiently confident and articulate to make their own demands, and not have to rely on the CRE.

KO: Am I right in saying that you don't have any real leverage on the political parties when it comes to their own conduct?

431

HO: CRE's position is clear. We always have to make sure we don't overstep our remit. Which isn't to say that myself, our commissioners or members of our staff are not political, with a small 'p'. We've got to be seen to be objective and not overtly party political. We're constantly briefing and lobbying MPs. We also feed information to campaigning organizations and the media who are in stronger positions to politicize certain arguments better than we can. At the same time, we have brought the leaderships of all five parliamentary parties together in a commitment to good practice in political campaigning. This compact – free speech and race relations in a democratic society – commits the leaders to act against their members who stir up racial hatred. It played a useful part in keeping the 'race card' out of the last general election (1997).

KO: Do you think a lobby group such as the Black Caucus could have become important allies for the CRE in Parliament?[10]

HO: Yes.

KO: Why do you think such a potentially significant parliamentary lobby group disbanded after such a brief life?

HO: When it was formed after the election of 1987, there was a more active blackness in race politics. When the first four Black MPs walked into the House, they represented a very symbolic force – not withstanding the fact they were only four out of a total of more than six hundred MPs. For the first time we were seeing people in Parliament who looked like us, and shared our aspirations and frustrations. And it was rightly felt that they could be more powerful in influencing things if they were seen to be acting together. But it was not meant to be. The fact that they were in opposition wouldn't have helped. Each would also have had a different agenda – political differences, career aspirations and so on.

Also, the whole nature of British politics changed rapidly after 1987. In the Labour Party, the efforts by the leadership to 'clean it up', make the party less radical and therefore more electable meant that race was dropped down the agenda. These developments affected the four politicians differently. It became impossible for them to remain a caucus. Looking back, it was a missed opportunity, a scaling down of Black political aspiration. Nevertheless, the pressures and demands on them must be understood.

KO: Do you think this scaling down partly explains the cynicism of the political process felt by many Black people today? Unlike the 1980s, there's a curious detachment from the political process.

HO: You must remember that we have just come out of nearly two decades of one type of government – a period of individual self-interest and looking after number one. People became severely marginalized. In some cases they allowed themselves to be marginalized. I saw it happen in local government. Ever since Bernie Grant ceased to be leader of Haringey, Merle Amery in Brent and Linda Bellos in Lambeth, Black people have been forced into ceremonial positions – wearing big chains and sitting in big limousines as mayors but wielding no real political power in municipal democratic settings.

Also when non-effective people in positions of power don't deliver, it destroys people's confidence in the system. Many people had to fend for themselves and get involved in the enterprise culture. As a result, there are now quite a few individuals

or pockets of people who are doing well but who, for one reason or another, cannot network and mobilize politically to effect change.

KO: The 1970s and 1980s produced a groundswell of political energy which impacted on the mainstream political process. The CRE itself was born out of that process. We cannot wait for this to happen again. Even if it does, it may take very different forms.

HO: I don't know that it won't happen, and I don't think you can say that we can't wait. There's a sense in which many people now think that they can't change institutions unless they're in positions of power. Once they do, they have to fight to stay there. Then they become disconnected from the struggle at the bottom and get marginalized.

KO: Would you say that this is particularly the case within high-profile white corporate structures? Many of the financial institutions in the City of London come to mind.

HO: The City is beginning to open up in different ways. It is waking up to the fact that they are sitting on talent right on its doorstep.

KO: Many people from the adjacent communities – Tower Hamlets, Islington, Hackney etc. – don't have the skills to fill the range of jobs the City offers.

HO: That's why the government's New Deal and the programmes of the TECs are so important. It makes sense to cream off corporate profits and use it to improve skills. In London alone, it's estimated that there are about five thousand jobs in information technology that are hard to fill because of skill shortages. We've got to give people the necessary skills and connect them to vacancies.

I recently met with the governor of the Bank of England, Eddie George, who convened meetings with various City organizations to discuss some of these issues. Things of course don't change overnight because people don't just step out of the board rooms and change their organizations.[11] We've recently been working with Lévi Strauss and Coca-Cola, and their managers tell us that diversity and equality were important to them because they made a difference to their performance in the market place.

Coca-Cola have been expanding their operations in the UK, and the firm of headhunters was instructed to make sure that when they brought forward candidates for appointment as regional managers there were Black candidates among the applicants. If other companies follow their lead, things will change. It's a long haul and there is no formula or panacea to produce instant success.

Race and the media

KO: Your media campaigns have been singularly successful. The CRE is never out of the news, and you've been very visible, campaigning and promoting various initiatives. There is, however, something of a lull in the campaign for change within media institutions. How do you see this?

HO: We've been playing a major role in challenging media institutions as employers and in terms of portrayal. We've been involved with the Independent Television Commission and other regulatory bodies and some of the major production companies. I think we're seeing some successes in popular, mainstream programming. In some of the flagship popular programmes such as *London Bridge* (Carlton),

Casualty (BBC), *Gladiators* (London Weekend Television/Independent Television) and so on, we're also getting better ethnic profiling.

Change is partly being driven by commercial considerations as a result of new demographics. London and some of the major cities now have significant ethnic populations. And they're projected to grow. Television advertisers want to know that the channels can reach them. The problem for them is that when ethnic viewers don't see themselves portrayed, they eventually find alternatives. Cable is an interesting example. Digitization is also approaching and it's going to broaden customer choice even further. It's in the commercial interest of the channels to change.

KO: Self-interest is the bottom line.

HO: Absolutely. It's not simply a question of the CRE saying you must not discriminate and do good for racial equality. We of course also engage them on the broader question of what sort of Britain we all want to see. The media ought to be portraying an inclusive image of Britain.

KO: Lastly, how do you see your role in the future of the CRE? In 1997, some newspapers reported you were considering quitting your job.

HO: I have signed up for a further period. There's a job to be done and I believe in what I'm doing. I never set out in life to join the CRE. When the opportunity came about, I thought long and hard about it. I talked to people in the community who said, give the CRE a boost by giving it a go. Like everything I do, I try and do it as well as I can. I was the first race relations adviser in a local authority. I also became the first Black chief executive of a local authority. Now I'm the first Black chairman of the CRE.

And you know that when you're the first in any context of work in this society, you can't afford to fail. People expect you to fail. Then they'll say we did have a Black chairman once. He was useless, so we don't want another one. As if we've never had white failures before. I work hard at what I do and give it my best honest shots. That's all you can ask of yourself and other people around you.

Notes

1 See Commission for Racial Equality (1977) *Annual Reports* (London: Commission for Racial Equality, 1977).
2 *New Nation* newspaper reported the figure to be £10m (8 December 1997).
3 See the report, *Race and Council Housing in Hackney* (London: CRE, 1984).
4 Source: Amenta Marketing Research, 1997. See also T. Sewell *Black Masculinities and Schooling: How Black Boys Survive Modern Schooling* (Stoke on Trent: Trentham Books, 1977), and G. Klein, *Recent Research on the Achievement of Ethnic Minority Children* (London: Runnymede Trust Bulletin, 1996).
5 B. Coard, *How the West Indian Child is made Educationally Subnormal in the British School System* (London: Caribbean Education and Community Workers Association, 1971).
6 See the CRE report, *From Cradle to School: A Practical Guide to Racial Equality in Early Childhood Education and Care*, 2nd ed. (London: CRE, 1996).
7 See the CRE report, *Ministry of Defence (Household Cavalry)* (London: CRE, 1996). This formal investigation of the Household Cavalry illustrates the kinds of discrimination, racial abuse and physical harassment charges some Black ex-servicemen have levelled against the army.
8 For a general discussion of the historical relationship between the police and Black people, see D. Humphry, *Police Power and Black People* (London: Panther, 1972). See also D. Dear,

Handsworth/Lozells, September 1985: Report of the Chief Constable, West Midlands Police (Birmingham: West Midlands Police, Lord Gifford, 1985); *The Broadwater Farm Inquiry* (London: Karia Press, 1986); Home Office, *Police/Immigrant Relations in England and Wales* (London: HMSO, 1973); and Lord Scarman, *The Brixton Disorders 10–12 April 1981: Report of an Inquiry by the Rt Hon. The Lord Scarman OBE* (London: HMSO, 1981).

9 See C. Harris, 'Images of Blacks in Britain: 1930–1960', in S. Allen and M. Macey (eds), *Race and Social Policy* (London: Economic and Social Research Council, 1988); see also M. Hartly-Brewer, 'Smethwick', in N. Deakin (ed.), *Colour and the British Electorate 1964* (London: Pall Mall Press, 1965); John Solomos, *Race and Racism in Britain* (London: Macmillan, 1993); M. Fitzgerald, *Black People and Party Politics in Britain* (London: Runnymede Trust, 1987); and Paul Foot *Immigration and Race in British Politics* (Harmondsworth: Penguin, 1965). For speeches by politicians which have become key signifiers in the recent racialization of British politics see Enoch Powell's 'Rivers of blood' speech (1968) and Margaret Thatcher's 'We are being swamped' speech (1979).

10 The Black Caucus was made up of Labour Party MPs Paul Boateng, Bernie Grant, Keith Vaz and Dianne Abbott. It was chaired by Lord Pit.

11 See the CRE report, *Large Companies and Racial Equality* (London: CRE, 1995).

Section Four

DIASPORA AND NEW TRAJECTORIES OF GLOBALIZATION

'Diaspora' is now a popular figure of analysis within Black British cultural studies, one that recognizes, amongst its leading theorists, discursive perspectives that enjoin the contemporary with historical narratives describing rupture and isolation, as well as continuity – consequences of Africa's co-option into European modernism through mercantile capitalism and slavery. These processes created the African diaspora in the Caribbean, the Americas and Europe – the structural bases of the current transnational articulation of Black cultures. This section features explorations of the work of major artists such as Aubrey Williams and Uzo Egonu and lively debates amongst the leading thinkers of the new trajectory.

THE BLACK ATLANTIC AS A COUNTERCULTURE OF MODERNITY

Paul Gilroy

We who are homeless, – Among Europeans today there is no lack of those who are entitled to call themselves homeless in a distinctive and honourable sense . . . We children of the future, how could we be at home in this today? We feel disfavour for all ideals that might lead one to feel at home even in this fragile, broken time of transition; as for 'realities', we do not believe that they will last. The ice that still supports people today has become very thin; the wind that brings the thaw is blowing; we ourselves who are homeless constitute a force that breaks open ice and other all too thin 'realities'.

Nietzsche

On the notion of modernity. It is a vexed question. Is not every era modern' in relation to the preceding one? It seems that at least one of the components of our modernity is the spread of the awareness we have of it. The awareness of our awareness (the double, the second degree) is our source of strength and our torment.

Edouard Glissant

Striving to be both European and black requires some specific forms of double consciousness. By saying this I do not mean to suggest that taking on either or both of these unfinished identities necessarily exhausts the subjective resources of any particular individual. However, where racist, nationalist, or ethnically absolutist discourses orchestrate political relationships so that these identities appear to be mutually exclusive, occupying the space between them or trying to demonstrate their continuity has been viewed as a provocative and even oppositional act of political insubordination.

The contemporary black English, like the Anglo-Africans of earlier generations and perhaps, like all blacks in the West, stand between (at least) two great cultural assemblages, both of which have mutated through the course of the modern world that formed them and assumed new configurations. At present, they remain locked symbiotically in an antagonistic relationship marked out by the symbolism of colours which adds to the conspicuous cultural power of their central Manichean dynamic – black and white. These colours support a special rhetoric that has grown to

be associated with a language of nationality and national belonging as well as the languages of race and ethnic identity.

Though largely ignored by recent debates over modernity and its discontents, these ideas about nationality, ethnicity, authenticity, and cultural integrity are characteristically modern phenomena that have profound implications for cultural criticism and cultural history. They crystallized with the revolutionary transformations of the West at the end of the eighteenth and the beginning of the nineteenth centuries and involved novel typologies and modes of identification. Any shift towards a postmodern condition should not, however, mean that the conspicuous power of these modern subjectivities and the movements they articulated has been left behind. Their power has, if anything, grown, and their ubiquity as a means to make political sense of the world is currently unparalleled by the languages of class and socialism by which they once appeared to have been surpassed. My concern here is less with explaining their longevity and enduring appeal than with exploring some of the special political problems that arise from the fatal junction of the concept of nationality with the concept of culture and the affinities and affiliations which link the blacks of the West to one of their adoptive, parental cultures: the intellectual heritage of the West since the Enlightenment. I have become fascinated with how successive generations of black intellectuals have understood this connection and how they have projected it in their writing and speaking in pursuit of freedom, citizenship, and social and political autonomy.

If this appears to be little more than a roundabout way of saying that the reflexive cultures and consciousness of the European settlers and those of the Africans they enslaved, the 'Indians' they slaughtered and the Asians they indentured were not, even in situations of the most extreme brutality, sealed off hermetically from each other, then so be it. This seems as though it ought to be an obvious and self-evident observation, but its stark character has been systematically obscured by commentators from all sides of political opinion. Regardless of their affiliation to the right, left or centre, groups have fallen back on the idea of cultural nationalism, on the overintegrated conceptions of culture which present immutable, ethnic differences as an absolute break in the histories and experiences of 'black' and 'white' people. Against this choice stands another, more difficult option: the theorization of creolization, métissage, mestizaje, and hybridity. From the viewpoint of ethnic absolutism, this would be a litany of pollution and impurity. These terms are rather unsatisfactory ways of naming the processes of cultural mutation and restless (dis)continuity that exceed racial discourse and avoid capture by its agents.

This book [The Black Atlantic] addresses one small area in the grand consequence of this historical conjunction – the stereophonic, bilingual or bifocal cultural forms originated by, but no longer the exclusive property of, blacks dispersed within the structures of feeling, producing, communicating and remembering that I have heuristically called the black Atlantic world. This chapter is therefore rooted in and routed through the special stress that grows with the effort involved in trying to face (at least) two ways at once.

My concerns at this stage are primarily conceptual: I have tried to address the continuing lure of ethnic absolutisms in cultural criticism produced both by blacks and by whites. In particular, this chapter seeks to explore the special relationships between 'race,' culture, nationality and ethnicity which have a bearing on the histories

and political cultures of Britain's black citizens. I have argued elsewhere that the cultures of this group have been produced in a syncretic pattern in which the styles and forms of the Caribbean, the United States and Africa have been reworked and re-inscribed in the novel context of modern Britain's own untidy ensemble of regional and class-oriented conflicts. Rather than make the invigorating flux of those mongrel cultural forms my focal concern here, I want instead to look at broader questions of ethnic identity that have contributed to the scholarship and the political strategies that Britain's black settlers have generated and to the underlying sense of England as a cohesive cultural community against which their self-conception has so often been defined. Here the ideas of nation, nationality, national belonging and nationalism are paramount. They are extensively supported by a clutch of rhetorical strategies that can be named 'cultural insiderism'.[1] The essential trademark of 'cultural insiderism' which also supplies the key to its popularity is an absolute sense of ethnic difference. This is maximized so that it distinguishes people from one another and at the same time acquires an incontestable priority over all other dimensions of their social and historical experience, cultures and identities. Characteristically, these claims are associated with the idea of national belonging or the aspiration to nationality and other more local but equivalent forms of cultural kinship. The range and complexity of these ideas in English cultural life defies simple summary or exposition. However, the forms of cultural insiderism they sanction typically construct the nation as an ethnically homo-geneous object and invoke ethnicity a second time in the hermeneutic procedures deployed to make sense of its distinctive cultural content.

The intellectual seam in which English cultural studies has positioned itself — through innovative work in the fields of social history and literary criticism — can be indicted here. The statist modalities of Marxist analysis that modes of material pro-duction and political domination as exclusively *national* entities are only one source of this problem. Another factor, more evasive but none the less potent for its intangible ubiquity, is a quiet cultural nationalism which pervades the work of some radical thinkers. This crypto-nationalism means that they are often disinclined to consider the cross catalytic or transverse dynamics of racial politics as a significant element in the formation and reproduction of English national identities. These formations are treated as if they spring, fully formed, from their own special viscera.

My search for resources with which to comprehend the doubleness and cultural intermixture that distinguish the experience of black Britons in contemporary Europe required me to seek inspiration from other sources and, in effect, to make an intel-lectual journey across the Atlantic. In black America's histories of cultural and political debate and organization I found another, second perspective with which to orient my own position. Here too the lure of ethnic particularism and nationalism has provided an ever-present danger. But that narrowness of vision which is content with the merely national has also been challenged from within that black community by thinkers who were prepared to renounce the easy claims of African American exceptionalism in favour of a global, coalitional politics in which anti-imperialism and anti-racism might be seen to interact if not to fuse. The work of some of those thinkers will be examined in subsequent chapters.

This chapter also proposes some new chronotopes[2] that might fit with a theory that was less intimidated by and respectful of the boundaries and integrity of modern nation states than either English or African American cultural studies have so far been.

on the image of ships in motion across the spaces, between Europe, _rica and the Caribbean as a central organizing symbol for this enterprise _y starting point. The image of the ship – a living, micro-cultural, micro-_al system in motion – is especially important for historical and theoretical _sons that I hope will become clearer below. Ships immediately focus attention on the middle passage, on the various projects for redemptive return to an African homeland, on the circulation of ideas and activists as well as the movement of key cultural and political artefacts: tracts, books, gramophone records and choirs.

The rest of this chapter falls into three sections. The first part addresses some conceptual problems common to English and African American versions of cultural studies which, I argue, share a nationalistic focus that is antithetical to the rhizo-morphic, fractal structure of the transcultural, international formation I call the black Atlantic . . .

Cultural studies in black and white

Any satisfaction to be experienced from the recent spectacular growth of cultural stud-ies as an academic project should not obscure its conspicuous problems with ethno-centrism and nationalism. Understanding these difficulties might commence with a critical evaluation of the ways in which notions of ethnicity have been mobilized, often by default rather than design, as part of the distinctive hermeneutics of cultural studies or with the unthinking assumption that cultures always flow into patterns congruent with the borders of essentially homogeneous nation states. The marketing and inevit-able reification of cultural studies as a discrete academic subject also has what might be called a secondary ethnic aspect. The project of cultural studies is a more or less attractive candidate for institutionalization according to the ethnic garb in which it appears. The question of whose cultures are being studied is therefore an important one, as is the issue of where the instruments which will make that study possible are going to come from. In these circumstances it is hard not to wonder how much of the recent international enthusiasm for cultural studies is generated by its profound associ-ations with England and ideas of Englishness. This possibility can be used as a point of entry into consideration of the ethnohistorical specificity of the discourse of cultural studies itself.

Looking at cultural studies from an ethnohistorical perspective requires more than just noting its association with English literature, history and New Left politics. It necessitates constructing an account of the borrowings made by these English initia-tives from wider, modern, European traditions of thinking about culture, and at every stage examining the place which these cultural perspectives provide for the images of their racialized[3] others as objects of knowledge, power and cultural criticism. It is imperative, though very hard, to combine thinking about these issues with consider-ation of the pressing need to get black cultural expressions, analyses and histories taken seriously in academic circles rather than assigned via the idea of 'race relations' to sociology and thence abandoned to the elephants' graveyard to which intractable policy issues go to await their expiry. These two important conversations pull in different directions and sometimes threaten to cancel each other out, but it is the struggle to have blacks perceived as agents, as people with cognitive capacities and even with an intellectual history – attributes denied by modern racism – that is for me the primary

442

reason for writing this book. It provides a valuable warrant for questioning some of the ways in which ethnicity is appealed to in the English idioms of cultural theory and history, and in the scholarly productions of black America. Understanding the political culture of blacks in Britain demands close attention to both these traditions. This book is situated on their cusp.

Histories of cultural studies seldom acknowledge how the politically radical and openly interventionist aspirations found in the best of its scholarship are already articulated to black cultural history and theory. These links are rarely seen or accorded any significance. In England, the work of figures like C. L. R James and Stuart Hall offers a wealth of both symbols and concrete evidence for the practical links between these critical political projects. In the United States the work of interventionist scholars like bell hooks and Cornel West as well as that of more orthodox academics like Henry Louis Gates, Jr, Houston A. Baker, Jr, Anthony Appiah and Hazel Carby points to similar convergences. The position of these thinkers in the contested 'contact zones'[4] between cultures and histories is not, however, as exceptional as it might appear at first. We shall see below that successive generations of black intellectuals (especially those whose lives, like James's, crisscrossed the Atlantic Ocean) noted this intercultural positionality and accorded it a special significance before launching their distinct modes of cultural and political critique. They were often urged on in their labour by the brutal absurdity of racial classification that derives from and also celebrates racially exclusive conceptions of national identity from which blacks were excluded as either non-humans or non-citizens. I shall try to show that their marginal endeavours point to some new analytic possibilities with a general significance far beyond the well-policed borders of black particularity. For example, this body of work offers intermediate concepts, lodged between the local and the global, which have a wider applicability in cultural history and politics precisely because they offer an alternative to the nationalist focus which dominates cultural criticism. These intermediate concepts, especially the undertheorized idea of diaspora, are exemplary precisely because they break the dogmatic focus on discrete *national* dynamics which has characterized so much modern Euro-American cultural thought.

Getting beyond these national and nationalistic perspectives has become essential for two additional reasons. The first arises from the urgent obligation to re-evaluate the significance of the modern nation state as a political, economic and cultural unit. Neither political nor economic structures of domination are still simply co-extensive with national borders. This has a special significance in contemporary Europe, where new political and economic relations are being created seemingly day by day, but it is a worldwide phenomenon with significant consequences for the relationship between the politics of information and the practices of capital accumulation. Its effects underpin more recognizably political changes like the growing centrality of trans-national ecological movements which, through their insistence on the association of sustainability and justice, do so much to shift the moral and scientific precepts on which the modern separation of politics and ethics was built. The second reason relates to the tragic popularity of ideas about the integrity and purity of cultures. In particular, it concerns the relationship between nationality and ethnicity. This too currently has a special force in Europe, but it is also reflected directly in the post-colonial histories and complex, transcultural, political trajectories of Britain's black settlers.

What might be called the peculiarity of the black English requires attention to the intermixture of a variety of distinct cultural forms. Previously separated political and intellectual traditions converged and, in their coming together, overdetermined the process of black Britain's social and historical formation. This blending is misunderstood if it is conceived in simple ethnic terms, but right and left, racist and anti-racist, black and white tacitly share a view of it as little more than a collision between fully formed and mutually exclusive cultural communities. This has become the dominant view where black history and culture are perceived, like black settlers themselves, as an illegitimate intrusion into a vision of authentic British national life that, prior to their arrival, was as stable and as peaceful as it was ethnically undifferentiated. Considering this history points to issues of power and knowledge that are beyond the scope of this book. However, though it arises from present rather than past conditions, contemporary British racism bears the imprint of the past in many ways. The especially crude and reductive notions of culture that form the substance of racial politics today are clearly associated with an older discourse of racial and ethnic difference which is everywhere entangled in the history of the idea of culture in the modern West. This history has itself become hotly contested since debates about multiculturalism, cultural pluralism, and the reponses to them that are sometimes dismissively called 'political correctness' arrived to query the ease and speed with which European particularisms are still being translated into absolute, universal standards for human achievement, norms and aspirations.

It is significant that prior to the consolidation of scientific racism in the nineteenth century,[5] the term 'race' was used very much in the way that the word 'culture' is used today. But in the attempts to differentiate the true, the good and the beautiful which characterize the junction point of capitalism, industrialization and political democracy and give substance to the discourse of Western modernity, it is important to appreciate that scientists did not monopolize either the image of the black or the emergent concept of biologically based racial difference. As far as the future of cultural studies is concerned, it should be equally important that both were centrally employed in those European attempts to think through beauty, taste and aesthetic judgement that are the precursors of contemporary cultural criticism.

Tracing the racial signs from which the discourse of cultural value was constructed and their conditions of existence in relation to European aesthetics and philosophy as well as European science can contribute much to an ethnohistorical reading of the aspirations of Western modernity as a whole and to the critique of Enlightenment assumptions in particular. It is certainly the case that ideas about 'race', ethnicity and nationality form an important seam of continuity linking English cultural studies with one of its sources of inspiration – the doctrines of modern European aesthetics that are consistently configured by the appeal to national and often racial particularity.[6]

This is not the place to go deeply into the broader dimensions of this intellectual inheritance. Valuable work has already been done by Sander Gilman,[7] Henry Louis Gates, Jr,[8] and others on the history and role of the image of the black in the discussions which found modern cultural axiology. Gilman points out usefully that the figure of the black appears in different forms in the aesthetics of Hegel, Schopenhauer and Nietzsche (among others) as a marker for moments of cultural relativism and to support the production of aesthetic judgements of a supposedly universal character to differentiate, for example, between authentic music and, as Hegel puts it, 'the most

detestable noise'. Gates emphasizes a complex genealogy in which ambiguities in Montesquieu's discussion of slavery prompt responses in Hume that can be related, in turn, to philosophical debates over the nature of beauty and sublimity found in the work of Burke and Kant. Critical evaluation of these representations of blackness might also be connected to the controversies over the place of racism and anti-semitism in the work of Enlightenment figures like Kant and Voltaire.[9] These issues deserve an extended treatment that cannot be provided here. What is essential for the purposes of this opening chapter is that debates of this sort should not be brought to an end simply by denouncing those who raise awkward or embarrassing issues as totalitarian forces working to legitimate their own political line. Nor should import-ant enquiries into the contiguity of racialized reason and unreasonable racism be dis-missed as trivial matters. These issues go to the heart of contemporary debates about what constitutes the canon of Western civilization and how this precious legacy should be taught.

In these embattled circumstances, it is regrettable that questions of 'race' and repre-sentation have been so regularly banished from orthodox histories of Western aesthetic judgement, taste and cultural value.[10] There is a plea here that further enquiries should be made into precisely how discussions of 'race', beauty, ethnicity and culture have contributed to the critical thinking that eventually gave rise to cultural studies. The use of the concept of fetishism in Marxism and psychoanalytic studies is one obvious means to open up this problem.[11] The emphatically national character ascribed to the concept of modes of production (cultural and otherwise) is another fundamental question which demonstrates the ethnohistorical specificity of dominant approaches to cultural politics, social movements, and oppositional consciousnesses.

These general issues appear in a specific form in the distinctive English idioms of cultural reflection. Here too, the moral and political problem of slavery loomed large not least because it was once recognized as *internal* to the structure of Western civiliza-tion and appeared as a central political and philosophical concept in the emergent discourse of modern English cultural uniqueness.[12] Notions of the primitive and the civilized which had been integral to premodern understanding of 'ethnic' differences became fundamental cognitive and aesthetic markers in the processes which generated a constellation of subject positions in which Englishness, Christianity and other ethnic and racialized attributes would finally give way to the dislocating dazzle of 'white-ness'.[13] A small but telling insight into this can be found in Edmund Burke's discus-sion of the sublime, which has achieved a certain currency lately. He makes elaborate use of the association of darkness with blackness, linking them to the skin of a real, live black woman. Seeing her produces a sublime feeling of terror in a boy whose sight has been restored to him by a surgical operation.

> Perhaps it may appear on enquiry, that blackness and darkness are in some degree painful by their natural operation, independent of any associations whatever. I must observe that the ideas of blackness and darkness are much the same; and they differ only in this, that blackness is a more confined idea.
>
> Mr Cheselden has given us a very curious story of a boy who had been born blind, and continued so until he was thirteen or fourteen years old; he was then couched for a cataract, by which operation he received his sight . . . Cheselden tells us that the first time the boy saw a black object, it gave him great

445

uneasiness; and that some time after, upon accidentally seeing a negro woman, he was struck with great horror at the sight.[14]

Burke, who opposed slavery and argued for its gradual abolition, stands at the doorway of the tradition of enquiry mapped by Raymond Williams which is also the infrastructure on which much of English cultural studies came to be founded. This origin is part of the explanation of how some of the contemporary manifestations of this tradition lapse into what can only be called a morbid celebration of England and Englishness. These modes of subjectivity and identification acquire a renewed political charge in the post-imperial history that saw black settlers from Britain's colonies take up their citizenship rights as subjects in the United Kingdom. The entry of blacks into national life was itself a powerful factor contributing to the circumstances in which the formation of both cultural studies and New Left politics became possible. It indexes the profound transformations of British social and cultural life in the 1950s and stands, again usually unacknowledged, at the heart of laments for a more human scale of social living that seemed no longer practicable after the 1939–45 war.

The convoluted history of black settlement need not be recapitulated here. One fragment from it, the struggle over Salman Rushdie's book *The Satanic Verses*, is sufficient to demonstrate that racialized conflict over the meaning of English culture is still very much alive and to show that these antagonisms have become enmeshed in a second series of struggles in which Enlightenment assumptions about culture, cultural value and aesthetics go on being tested by those who do not accept them as universal moral standards. These conflicts are, in a sense, the outcome of a distinct historical period in which a new, ethnically absolute and culturalist racism was produced. It would explain the burning of books on English streets as manifestations of irreducible cultural differences that signposted the path to domestic racial catastrophe. This new racism was generated in part by the move towards a political discourse which aligned 'race' closely with the idea of national belonging and which stressed complex cultural difference rather than simple biological hierarchy. These strange conflicts emerged in circumstances where blackness and Englishness appeared suddenly to be mutually exclusive attributes and where the conspicuous antagonism between them proceeded on the terrain of culture, not that of politics. Whatever view of Rushdie one holds, his fate offers another small, but significant, omen of the extent to which the almost metaphysical values of England and Englishness are currently being contested through their connection to 'race' and ethnicity. His experiences are also a reminder of the difficulties involved in attempts to construct a more pluralistic, post-colonial sense of British culture and national identity. In this context, locating and answering the nationalism if not the racism and ethnocentrism of English cultural studies has itself become a directly political issue.

Returning to the imperial figures who supplied Raymond Williams with the raw material for his own brilliant critical reconstruction of English intellectual life is instructive. Apart from Burke, Thomas Carlyle, John Ruskin, Charles Kingsley and the rest of Williams's cast of worthy characters can become valuable not simply in attempts to purge cultural studies of its doggedly ethnocentric focus but in the more ambitious and more useful task of actively reshaping contemporary England by reinterpreting the cultural core of its supposedly authentic national life. In the work of reinterpretation and reconstruction, reinscription and relocation required to transform

England and Englishness, discussion of the cleavage in the Victorian intelligentsia around the response to Governor Eyre's handling of the Morant Bay Rebellion in Jamaica in 1865 is likely to be prominent.[15] Like the English responses to the 1857 uprising in India examined by Jenny Sharpe,[16] it may well turn out to be a much more formative moment than has so far been appreciated. Morant Bay is doubly significant because it represents an instance of metropolitan, internal conflict that emanates directly from an external colonial experience. These crises in imperial power demonstrate their continuity. It is part of my argument that this inside/outside relationship should be recognized as a more powerful, more complex, and more contested element in the historical, social and cultural memory of our glorious nation than has previously been supposed.

I am suggesting that even the laudable, radical varieties of English cultural sensibility examined by Williams and celebrated by Edward Thompson and others were not produced spontaneously from their own internal and intrinsic dynamics. The fact that some of the most potent conceptions of Englishness have been constructed by alien outsiders like Carlyle, Swift, Scott or Eliot should augment the note of caution sounded here. The most heroic, subaltern English nationalisms and countercultural patriotisms are perhaps better understood as having been generated in a complex pattern of antagonistic relationships with the supra-national and imperial world for which the ideas of 'race', nationality and national culture provide the primary (though not the only) indices. This approach would obviously bring William Blake's work into a rather different focus from that supplied by orthodox cultural history, and, as Peter Linebaugh has suggested, this overdue reassessment can be readily complemented by charting the long-neglected involvement of black slaves and their descendants in the radical history of our country in general and its working-class movements in particular.[17] Oluadah Equiano, whose involvement in the beginnings of organized working-class politics is now being widely recognized; the anarchist, Jacobin, ultra-radical and Methodist heretic Robert Wedderburn; William Davidson, son of Jamaica's attorney general, hanged for his role in the Cato Street conspiracy to blow up the British Cabinet in 1819;[18] and the Chartist William Cuffay – these are only the most urgent, obvious candidates for rehabilitation. Their lives offer invaluable means of seeing how thinking with and through the discourses and the imagery of 'race' appears in the core rather than at the fringes of English political life. Davidson's speech from the scaffold before being subject to the last public decapitation in England is, for example, one moving appropriation of the rights of dissident freeborn Englishmen that is not widely read today.

Of this infamous trio, Wedderburn is perhaps the best known, thanks to the efforts of Peter Linebaugh and Iain McCalman.[19] The child of a slave dealer, James Wedderburn, and a slave woman, Robert was brought up by a Kingston conjure woman who acted as an agent for smugglers. He migrated to London at the age of seventeen in 1778. There, having published a number of disreputable ultra-radical tracts as part of his subversive political labours, he presented himself as a living embodiment of the horrors of slavery in a debating chapel in Hopkins Street near the Haymarket, where he preached a version of chiliastic anarchism based on the teachings of Thomas Spence and infused with deliberate blasphemy. In one of the debates held in his 'ruinous hayloft with 200 persons of the lowest description', Wedderburn defended the inherent rights of the Caribbean slave to slay his master, promising to write home and 'tell them to murder

their masters as soon as they please'. After this occasion he was tried and acquitted on a charge of blasphemy after persuading the jury that he had not been uttering sedition but merely practising the 'true and infallible genius of prophetic skill'.[20]

It is particularly significant for the direction of my overall argument that both Wedderburn and his sometime associate Davidson had been sailors, moving to and fro between nations, crossing borders in modern machines that were themselves micro-systems of linguistic and political hybridity. Their relationship to the sea may turn out to be especially important for both the early politics and poetics of the black Atlantic world that I wish to counterpose against the narrow nationalism of so much English historiography. Wedderburn served in the Royal Navy and as a privateer, while Davidson, who ran away to sea instead of studying law was pressed into naval service on two subsequent occasions. Davidson inhabited the same ultra-radical subculture as Wedderburn and was an active participant in the Marylebone Reading Society, a radical body formed in 1819 after the Peterloo massacre. He is known to have acted as the custodian of their black flag, which significantly bore a skull and crossbones with the legend 'Let us die like men and not be sold as slaves', at an open-air meeting in Smithfield later that year.[21] The precise details of how radical ideologies articulated the culture of the London poor before the institution of the factory system to the insubordinate maritime culture of pirates and other pre-industrial workers of the world will have to await the innovative labours of Peter Linebaugh and Marcus Rediker.[22] However, it has been estimated that at the end of the eighteenth century a quarter of the British navy was composed of Africans for whom the experience of slavery was a powerful orientation to the ideologies of liberty and justice. Looking for similar patterns on the other side of the Atlantic network we can locate Crispus Attucks at the head of his 'motley rabble of saucy boys, negroes, mulattoes, Irish teagues and outlandish jack tars'[23] and can track Denmark Vesey sailing the Caribbean and picking up inspirational stories of the Haitian revolution (one of his co-conspirators testified that he had said they would 'not spare one white skin alive for this was the plan they pursued in San Domingo').[24] There is also the shining example of Frederick Douglass, whose autobigraphies reveal that he learnt of freedom in the North from Irish sailors while working as a ship's caulker in Baltimore. He had less to say about the embarrassing fact that the vessels he readied for the ocean – Baltimore clippers – were slavers, the fastest ships in the world and the only craft capable of outrunning the British blockade. Douglass, who played a neglected role in English anti-slavery activity, escaped from bondage disguised as a sailor and put this success down to his ability to 'talk sailor like an old salt'.[25] These are only a few of the nineteenth-century examples. The involvement of Marcus Garvey, George Padmore, Claude McKay and Langston Hughes with ships and sailors lends additional support to Linebaugh's prescient suggestion that 'the ship remained perhaps the most important conduit of Pan-African communication before the appearance of the long-playing record'.[26]

Ships and other maritime scenes have a special place in the work of J. M. W. Turner, an artist whose pictures represent, in the view of many contemporary critics, the pinnacle of achievement in the English school in painting. Any visitor to London will testify to the importance of the Clore Gallery as a national institution and of the place of Turner's art as an enduring expression of the very essence of English civilization. Turner was secured on the summit of critical appreciation by John Ruskin, who, as we have seen, occupies a special place in Williams's constellation of great Englishmen.

Turner's celebrated picture of a slave ship[27] throwing overboard its dead and dying as a storm comes on was exhibited at the Royal Academy to coincide with the world anti-slavery convention held in London in 1840. The picture, owned by Ruskin for some twenty-eight years, was rather more than an answer to the absentee Caribbean land-lords who had commissioned its creator to record the tainted splendour of their country houses, which, as Patrick Wright has eloquently demonstrated, became an important signifier of the contemporary, ruralist distillate of national life.[28] It offered a powerful protest against the direction and moral tone of English politics. This was made explicit in an epigraph Turner took from his own poetry and which has itself retained a polit-ical inflection: 'Hope, hope, fallacious hope where is thy market now?' Three years after his extensive involvement in the campaign to defend Governor Eyre,[29] Ruskin put the slave ship painting up for sale at Christie's. It is said that he had begun to find it too painful to live with. No buyer was found at that time, and he sold the picture to an American three years later. The painting has remained in the United States ever since. Its exile in Boston is yet another pointer towards the shape of the Atlantic as a system of cultural exchanges. It is more important, though, to draw attention to Ruskin's inability to discuss the picture except in terms of what it revealed about the aesthetics of painting water. He relegated the information that the vessel was a slave ship to a footnote in the first volume of *Modern Painters*.[30]

In spite of lapses like this, the New Left heirs to the aesthetic and cultural tradition in which Turner and Ruskin stand compounded and reproduced its nationalism and its ethnocentrism by denying imaginary, invented Englishness any external referents whatsoever. England ceaselessly gives birth to itself, seemingly from Britannia's head. The political affiliations and cultural preferences of this New Left group amplified these problems. They are most visible and most intense in the radical historiography that supplied a counterpart to Williams's subtle literary reflections. For all their enthusiasm for the work of C. L. R James, the influential British Communist Party's historians' group[31] is culpable here. Their predilections for the image of the freeborn Englishman and the dream of socialism in one country that framed their work are both to be found wanting when it comes to nationalism. This uncomfortable pairing can be traced through the work of Edward Thompson and Eric Hobsbawm, visionary writers who contributed so much to the strong foundations of English cultural studies and who share a non-reductive Marxian approach to economic, social, and cultural history in which the nation – understood as a stable receptacle for counter-hegemonic class struggle – is the primary focus. These problems within English cultural studies form at its junction point with practical politics and instantiate wider difficulties with nationalism and with the discursive slippage or connotative resonance between 'race', ethnicity and nation.

Similar problems appear in rather different form in African American letters where an equally volkish popular cultural nationalism is featured in the work of several generations of radical scholars and an equal number of not so radical ones. We will see below that absolutist conceptions of cultural difference allied to a culturalist under-standing of 'race' and ethnicity can be found in this location too.

In opposition to both of these nationalist or ethnically absolute approaches, I want to develop the suggestion that cultural historians could take the Atlantic as one single, complex unit of analysis in their discussions of the modern world and use it to produce an explicitly transnational and intercultural perspective.[32] Apart from the confronta-

tion with English historiography and literary history this entails a challenge to the ways in which black American cultural and political histories have so far been conceived. I want to suggest that much of the precious intellectual legacy claimed by African American intellectuals as the substance of their particularity is in fact only partly their absolute ethnic property. No less than in the case of the English New Left, the idea of the black Atlantic can be used to show that there are other claims to it which can be based on the structure of the African diaspora into the Western hemisphere. A concern with the Atlantic as a cultural and political system has been forced on black historiography and intellectual history by the economic and historical matrix in which plantation slavery – 'capitalism with its clothes off' – was one special moment. The fractal patterns of cultural and political exchange and transfomation that we try and specify through manifestly inadequate theoretical terms like creolization and syncretism indicate how both ethnicities and political culture have been made anew in ways that are significant not simply for the peoples of the Caribbean but for Europe, for Africa, especially Liberia and Sierra Leone, and, of course, for black America.

It bears repetition that Britain's black settler communities have forged a compound culture from disparate sources. Elements of political sensibility and cultural expression transmitted from black America over a long period of time have been reaccentuated in Britain. They are central, though no longer dominant, within the increasingly novel configurations that characterize another newer black vernacular culture. This is not content to be either dependent upon or simply imitative of the African diaspora cultures of America and the Caribbean. The rise and rise of Jazzie B and Soul II Soul at the turn of the last decade constituted one valuable sign of this new assertive mood. North London's Funki Dreds, whose name itself projects a newly hybridized identity, have projected the distinct culture and rhythm of life of black Britain outwards into the world. Their song 'Keep On Moving' was notable for having been produced in England by the children of Caribbean settlers and then remixed in a (Jamaican) dub format in the United States by Teddy Riley, an African American. It included segments or samples of music taken from American and Jamaican records by the JBs and Mikey Dread respectively. This formal unity of diverse cultural elements was more than just a powerful symbol. It encapsulated the playful diasporic intimacy that has been a marked feature of transnational black Atlantic creativity. The record and its extraordinary popularity enacted the ties of affiliation and affect which articulated the discontinuous histories of black settlers in the new world. The fundamental injunction to 'Keep On Moving' also expressed the restlessness of spirit which makes that diaspora culture vital. The contemporary black arts movement in film, visual arts, and theatre as well as music, which provided the background to this musical release, have created a new topography of loyalty and identity in which the structures and presuppositions of the nation state have been left behind because they are seen to be outmoded. It is important to remember that these recent black Atlantic phenomena may not be as novel as their digital encoding via the transnational force of north London's Soul II Soul suggests. Columbus's pilot, Pedro Nino, was also an African. The history of the black Atlantic since then, continually crisscrossed by the movements of black people – not only as commodities but engaged in various struggles towards emancipation, autonomy and citizenship – provides a means to re-examine the problems of nationality, location, identity and historical memory. They all emerge from it with special clarity if we contrast the national, nationalistic, and ethnically absolute paradigms of

cultural criticism to be found in England and America with those hidden expressions, both residual and emergent, that attempt to be global or outer-national in nature. These traditions have supported countercultures of modernity that touched the workers' movement but are not reducible to it. They supplied important foundations on which it could build . . .

Notes

1 Werner Sollors, *Beyond Ethnicity* (New York and Oxford: Oxford University Press, 1986).

2 'A unit of analysis for studying texts according to the ratio and nature of the temporal and spatial categories represented . . . The chronotope is an optic for reading texts as x-rays of the forces at work in the culture system from which they spring.' M. M. Bakhtin, *The Dialogic Imagination*, ed. and trans. Michael Holquist (Austin: University of Texas Press, 1981): 426.

3 The concept of racialization is developed by Frantz Fanon in his essay 'On National Culture', in *The Wretched of the Earth* (Harmondsworth: Penguin, 1967): 170–1. See also Robert Miles, *Racism* (New York and London: Routledge, 1989): 73–7.

4 Mary Louise Pratt, *Imperial Eyes* (London and New York: Routledge, 1992).

5 Nancy Stepan, *The Idea of Race in Science: Great Britain, 1800–1960* (Basingstoke, Hampshire, and London: Macmillan, 1982); Michael Banton, *Racial Theories* (Cambridge: Cambridge University Press, 1987).

6 George Mosse, *Nationalism and Sexuality: Middle-class Morality and Sexual Norms in Modern Europe* (Madison and London: University of Wisconsin Press, 1985); Reinhold Grimm and Jost Hermand (eds), *Blacks and German Culture* (Madison and London: University of Wisconsin Press, 1986).

7 Sander Gilman, *On Blackness without Blacks* (Boston G. K. Hall, 1982).

8 See Henry Louis Gates, Jr, *The History and Theory of Afro-American Literary Criticism, 1773–1831: The Arts, Aesthetic Theory and the Nature of the African* (doctoral thesis, Clare College, Cambridge University, 1978); David Brion Davis, *The Problem of Slavery in Western Culture* (Ithaca: Cornell University Press, 1970) and *The Problem of Slavery in the Age of Revolution* (Ithaca: Cornell University Press, 1975); and Eva Beatrice Dykes, *The Negro in English Romantic Thought; or, A Study of Sympathy for the Oppressed* (Washington, D.C.: Associated Publishers, 1942).

9 Leon Poliakov, *The Aryan Myth* (London: Sussex University Press, 1974), ch. 8, and 'Racism from the Enlightenment to the Age of Imperialism', in Robert Ross (ed.), *Racism and Colonialism: Essays on Ideology and Social Structure* (The Hague: Martinus Nijhoff, 1982); Richard Popkin, 'The Philosophical Basis of Eighteenth Century Racism', in *Studies in Eighteenth Century Culture*, vol. 3: *Racism in the Eighteenth Century* (Cleveland and London: Case Western Reserve University Press, 1973); Harry Bracken, 'Philosophy and Racism', *Philosophia* 8, 2–3 (November 1978). In some respects this pioneering work foreshadows the debates about Heidegger's fascism.

10 Hugh Honour's contribution to the DeMenil Foundation Project, *The Representation of the Black in Western Art* (London and Cambridge, Mass.: Harvard University Press, 1989), is a welcome exception to this amnesia.

11 W. Pietz, 'The Problem of the Fetish, I', *Res* 9 (spring 1985).

12 Robin Blackburn, *The Overthrow of Colonial Slavery, 1776–1848* (London and New York: Verso, 1988).

13 Winthrop D. Jordan, *White over Black* (New York: W. W. Norton, 1977).

14 Edmund Burke, *A Philosophical Enquiry into the Origin of Our Ideas of the Sublime and the Beautiful*, ed. James T. Boulton (Oxford: Basil Blackwell, 1987).

15 Catherine Hall, *White, Male and Middle Class* (Cambridge: Polity Press, 1992).

16 Jenny Sharpe, 'The Unspeakable Limits of Rape: Colonial Violence and Counter-insurgency', *Genders* 10 (spring 1991): 25–46, and 'Figures of Colonial Resistance', *Modern Fiction Studies* 35, 1 (spring 1989).

17 Peter Linebaugh, 'All the Atlantic Mountains Shook', *Labour/Le Travailleur* 10 (autumn 1982): 87–121.

18 Peter Fryer, *Staying Power* (London: Pluto Press, 1980): 219.

19 *The Horrors of Slavery and Other Writings by Robert Wedderburn*, ed. Iain McCalman (Edinburgh: Edinburgh University Press, 1992).

20 Iain McCalman, 'Anti-slavery and Ultra Radicalism in Early Nineteenth-Century England: The Case of Robert Wedderburn', *Slavery and Abolition* 7 (1986).

21 Fryer, *Staying Power*: 216. Public Records Office, London: PRO Ho 44/5/202, PRO Ho 42/199.

22 Their article 'The Many Headed Hydra', *Journal of Historical Sociology* 3, 3 (September 1990): 225–53, gives a foretaste of these arguments.

23 John Adams quoted by Linebaugh in 'Atlantic Mountains': 112.

24 Alfred N. Hunt, *Haiti's Influence on Antebellum America* (Baton Rouge and London: Louisiana State University Press, 1988): 119.

25 Douglass's own account of this is best set out in Frederick Douglass, *Life and Times of Frederick Douglass* (New York: Macmillan, 1962): 199. See also Philip M. Hamer, 'Great Britain, the United States and the Negro Seamen's Acts' and 'British Consuls and the Negro Seamen's Acts, 1850–1860', *Journal of Southern History* 1 (1935): 3–28, 138–68. Introduced after Denmark Vesey's rebellion, these interesting pieces of legislation required free black sailors to be jailed while their ships were in dock as a way of minimizing the political contagion their presence in the ports was bound to transmit.

26 Linebaugh, 'Atlantic Mountains': 119.

27 Paul Gilroy, 'Art of Darkness, Black Art and the Problem of Belonging to England', *Third Text* 10 (1990). A very different interpretation of Turner's painting is given in Albert Boime's *The Art of Exclusion: Representing Blacks in the Nineteenth Century* (London: Thames and Hudson, 1990).

28 Patrick Wright, *On Living in an Old Country* (London: Verso, 1985).

29 Bernard Semmel, *Jamaican Blood and the Victorian Conscience* (Westport: Greenwood Press, 1976). See also Gillian Workman, 'Thomas Carlyle and the Governor Eyre Controversy', *Victorian Studies* 18, 1 (1974): 77–102.

30 Vol. 1, sec. 5, ch. 3, sec. 39. W. E. B. Du Bois reprinted this commentary while he was editor of *The Crisis*; see vol. 15 (1918): 239.

31 Eric Hobsbawm, 'The Historians' Group of the Communist Party', in M. Cornforth (ed.), *Essays in Honour of A. L. Morton* (Atlantic Highlands: Humanities Press, 1979).

32 Linebaugh, 'Atlantic Mountains'. This is also the strategy pursued by Marcus Rediker in his brilliant book *Between the Devil and the Deep Blue Sea* (Cambridge: Cambridge University Press, 1987).

From *The Black Atlantic: Modernity and Double Consciousness* (London: Verso, 1993).

38

JOURNEYING TO DEATH

Gilroy's *Black Atlantic*

Laura Chrisman

Paul Gilroy's *Black Atlantic* has received considerable international academic acclaim.[1] Within cultural studies, literary studies, black studies, Caribbean studies, American studies and anthropology, the book has been hailed as a major and original contribution. Gilroy takes issue with the national boundaries within which these disciplines operate, arguing that, as the book jacket tells us, 'there is a culture that is not specifically African, American, Caribbean, or British, but all of these at once; a black Atlantic culture whose themes and techniques transcend ethnicity and nationality to produce something new and, until now, unremarked'. Animating Gilroy's academic challenge is a political energy. He sets out to expose the dangers as he sees it of contemporary nationalism: whether academic or popular (as in US Afrocentrism), implicit or explicit, black or white in focus, Gilroy sees it as socially and politically undesirable. Gilroy's concept of a black Atlantic is then offered as a political and cultural corrective, which argues the cross-national, cross-ethnic basis and dynamics of black diasporic identity and culture.

Gilroy's formulations mesh neatly with an Anglo-American academic climate of the 1990s, which has seen the rise in popularity of concepts of fusion, hybridity and syncretism as explanatory tools for the analysis of cultural formation. The 1990s is also a decade in which, broadly speaking, postmodernist intellectual concerns with language and subjectivity have infused both academia and 'new Left' politics to create a dominant paradigm of 'culturalism' for the analysis of social relations, at the risk of abandoning the tenets and resources of socio-economic analysis. Aesthetics and aestheticism can function both as explanation of and solution to social and political processes. For these reasons, Gilroy's book (the aestheticism of which will be discussed later) is a 'sign of the times'; for these reasons too, perhaps, it has become so popular.

The book must also be seen in the live context of an international intensification of diverse kinds of nationalist movements, ethnicist, secular and fundamentalist. Gilroy's characterization of nationalism tends not to acknowledge such diversity but, rather, targets a generalized (and somewhat caricatured) ethnicist nationalism as the only kind of contemporary nationalism, one which afflicts both white and black communities in identical ways. Hence another reason for the book's (no doubt, unintended) appeal to academics: it licenses an easy armchair condemnation of black politics (and of socialism, as shall be seen); it enables academics to feel justified in not taking seriously the

challenges posed by black and Third World nationalisms to established forms of knowledge and to their institutional privilege.

If contesting nationalism is one goal of this book, intervening in debates about modernity is another. Gilroy challenges (what he sees as) Marxist, economic and philosophical accounts of the development of modernity as a self-contained European process, based on principles and practices of rationality, economic productivism, Enlightenment egalitarianism and wage labour. Slavery, he argues, was fundamental to modernity; racial terror lies within its heart. Gilroy's concern with the racial terror of slavery chimes with a burgeoning academic interest in the experience of Jews under Nazism ('Holocaust studies'), a connection which Gilroy makes explicit in the book.

In contrast to some trends in postmodern thought which equate the whole of the Enlightenment project with genocide, Gilroy does not reject modernity altogether but, rather, accentuates slavery as an unacknowledged part of it. This contestation of modernity's self-complacency by emphasizing the inhuman violence and brutality with which modernity is entwined is to be welcomed. However, the mere juxtaposition of concepts of 'freedom' with 'coercion', 'reason' with 'terror', does not amount to a reconceptualization or explanation of the relationship between the two spheres. They remain in frozen, almost mysterious, association. Gilroy's formulation has, arguably, inadvertently catered to a current academic predilection for paradox, for the sublime and the incomprehensible; a danger is that this licenses an essentially static academic mode, comforted rather than challenged by configurations of phenomena which 'defy' norms of explanation.

Of the many important concerns in *The Black Atlantic*, I want to focus on two here: Gilroy's conceptualization of the relations between nationalism, socialism and black identity; the characterization of black expressive culture in relation to slavery and political agency. I will present, as I see it, some of the problematic aspects of Gilroy's arguments. I am interested in tracing some of the implications of Gilroy's opposition to nationalism and socialism, his formulation of a black utopian aesthetic premised on a death-drive.[2]

While Gilroy's whole oeuvre is animated by a rejection of what he sees as the reductively absolutist, vanguardist, exclusivist and essentialized-purist currents of ethnic nationalism and economistic socialism, I want to suggest that the counter-model Gilroy presents, of an outer-national, hybrid blackness, itself rests on many of the same assumptions. Where Gilroy is a powerful, materialist deconstructor of the mystificatory and implicitly authoritarian agendas of other political projects and intellectuals, his own project subscribes to a decidedly mystical, idealist ideology and constructs a transcendental category of blackness, which retains the 'ethnicism' for which he castigates Afrocentric nationalism. Because his definition of this emancipatory black diasporism repudiates the potential resources of nationalism and socialism, and proceeds by way of positing absolute antinomies between these respective value systems, Gilroy's formulations become necessarily self-enclosed, hermetically sealed off, resistant to dialogism, dialectical transformation and cross-fertilization. 'The Black Atlantic' becomes, despite its immense potential, an exclusive club liner, populated by 'mandarins' and 'masses' hand-picked by Gilroy, bound for death.[3]

There ain't no black in the Union Jack: the emergence of antinomies

Gilroy's first book, *There Ain't No Black in the Union Jack*, argues Black British expressive culture to be fundamentally anti-capitalist. This anti-capitalism, he contends, derives from a wholesale rejection of productivism. The experience of slavery, and its historical memory has rendered black peoples, unlike white workers and socialists, resistant to the notion that productive labour and expansionism of productive capacities is the medium, or precondition, for human emancipation. Black music, argues Gilroy, is full of this romantic anti-capitalism expressed through lyrics which criticise the alienation of the labour system and which

> celebrate non-work activity and the suspension of the time and discipline associated with wage labour . . . In these cultural traditions, work is sharply counterposed not merely to leisure in general but to a glorification of autonomous desire which is presented as inherent in sexual activity. The black body is reclaimed from the world of work and, in Marcuse's phrase, celebrated as an 'instrument of pleasure rather than labour'.
>
> (202)

There is much to agree with here. But what I find questionable is the equation of 'wage labour' with 'labour', so that the critique of capitalist waged work structures becomes identified with a rejection of productive labour, of self-realization through labour. I think that Gilroy's stark polarization of work and recreation is also questionable. A more fruitful approach to the analysis and theorization of black anti-capitalisms, I think, might start with the premise that there is anything *but* an antinomy between work and play in this music; that (a notion of) the positive value of labour is precisely what fuels the representation of the labour-intensive process of sexual pleasure here. Gilroy even discloses such an approach but seems not to notice, when he argues that 'these tropes are supported by the multi-accentuality and polysemy of black languages. For example, in black American ghetto speech the word work can mean dancing, labour, sexual activity or any nuanced combination of all three' (203). The fact that the word 'work' can denote, equally, 'labour', 'dancing' and 'sexual activity' suggests that, far from there being an antinomy between labour and recreation, there is a strong association or even identification between the activities. That such a fluid interchangeability is possible is what needs conceptualization, and for that a methodology needs to be developed which can allow of dialectical and dialogical relationships, rather than oppositions.

If Gilroy's anti-economistic approach precludes the possibility of a dialogical relationship between blackness and labour in expressive cultures, it also here jettisons the possibility of any economic analysis of black cultures or social movements. This is, I think, regrettable, and it is also an irony, given that black music and other recreational activities like sport are exactly the media most traditionally subject to mass commodification.

I am recommending, then, that Gilroy's analysis be supplemented by an approach which holds on to the utility of economic analysis in conceptualizing black cultural productions, one which postulates these cultures as voicing a working relationship

between labour and play. I advocate, too, an expansion, not rejection, of class political conceptualization, one which is adequate to black experience, neither invalidated by it (as Gilroy alleges) nor invalidating of it. The same expansion I would urge of the conceptualization and analysis of nationalism and the nation-state. Gilroy, in *There Ain't No Black*, wants to locate blacks as falling historically outside the received versions of the nation state by cultural racism and choosing to remain outside by choice (identifying as members of diaspora and local community instead); his intolerance towards all nationalisms reaches new heights in *The Black Atlantic*, where his emphasis falls on a black trans- and anti-national identity and politics as an antidote to the pernicious exclusivisms heralded by black nationalism-as-ethnic-absolutism.

Nowhere does Gilroy reveal himself to be as First World as in this, his absolute rejection of the utility of national categories. I want to suggest that Gilroy's denunciation of a cosily racialist cultural nationalism shared by right and left might now be supplemented in a number of ways. His denunciation rests, I think, on a fatalism – there ain't no black in the Union Jack and there never can be – which, ironically, operates to leave such racially exclusive nationalism intact rather than capable of being challenged from within, the more so as he rightly sees right and left as united here. This fatalism, however, overlooks the historically highly contestable and contested constructions of British nationness and nationalism; in effect, Gilroy's analysis replicates the cultural determinism that he ascribes to cultural nationalists, by presupposing an unchangeable homogeneity of white British national ideology. The more challenging approach, I think, would be to work theoretically and politically to foreground the seldom acknowledged heterogeneity of Britishness through history, and one way to do this is by opening up a comparative, mutually illuminating analysis of the languages and practices of British nationalism, colonialism and imperialism. Gilroy, in focusing solely on the interaction of languages of 'race' and nation, forecloses such analyses.

If materialist and cultural history are useful for explaining and challenging certain exclusivist brands of nationalism, so too is the notion of utopia. Gilroy is indeed a big fan of utopianism, but his formulations appear to want to align utopianism solely with outer-national cultural impulses. The utopianism of black music, for him, appears to lie in its expression of a fundamentally migratory identity and an anti-capitalism which, as outlined above, he argues to be radically opposed to all aspects of the production process. Contemporary US black nationalism, in the form of Afrocentrism, is also grounded in a utopianism which takes the form of an affirmation of an idealized, pure African heritage, to which black Americans rightfully belong and through which they can transcend socio-economic disadvantage.

Gilroy's critique of this essentialising brand of nationalism is important for his disclosure of its intellectual fallacies and political shortcomings. Where his critique falls short, I think, is in not taking seriously enough the force of the utopianism that underlies Afrocentrism, the positive potentialities that such utopianism can hold and its critical as well as affirmative relationship to a white racist hegemony. Rather than see Afrocentrism, as Gilroy does, as a reprehensibly self-inflicted false consciousness, worthy of denunciation, and strangling other possibilities for black political imagination, it might be more productive to engage with it and look at it as a symptom, rather than as a cause. My sense is that though some, perhaps, of Afrocentrism can be explained as the product of black petty-bourgeois intellectuals in pursuit of

self-aggrandizement – as Gilroy has it – not all of it can be. One would never know, from Gilroy's account, that Afrocentrism has gained popularity among a wide range of black institutions and communities in the context of an ever-worsening socio-economic crisis for black Americans, in which white racial paranoias and hostilities towards black minorities seem to be intensifying. That broader context has to be considered to have some bearing on the phenomenon's popularity; an exclusively immanent critique will not go very far in hastening its demise.

In any case, as I have already suggested, I am not sure that I see the elimination of nationalist ideologies, nor the cancellation of national entities as objects of analysis, as possible or desirable. Gilroy's presumption, in his discussion of Afrocentrism as of British nationalism, is that nationalism can only be ethnically purist and exclusivist, and is incapable of pluralisation, which is questionable. To posit nationalism and outer- or trans-nationalism as mutually incompatible political goals, cultural values and analytic perspectives is, I suspect, less productive than to see them as interdependent.

First World blackness, intellectuals and Europe

Gilroy's whole conception of the Black Atlantic is motivated, in part, by his desire to rebut the fallacies of black nationalism and white English cultural theory. As he argues:

> In opposition to both of these nationalist or ethnically absolute approaches, I want to develop the suggestion that cultural historians could take the Atlantic as one single, complex unit of analysis in their discussions of the modern world and use it to produce an explicitly transnational and intercultural perspective. Apart from the confrontation with English historiography and literary history this entails a challenge to the ways in which black American cultural and political histories have so far been conceived. I want to suggest that much of the precious intellectual legacy claimed by African-American intellectuals as the substance of their particularity is in fact only partly their absolute ethnic property.
>
> (15)

What Gilroy then advocates and initiates is a mode of conceptualization which posits black diasporic identity to be constituted through the triangular relationship of the continents of Africa, Europe and America. He traces the path of this transnational cultural-political formation through an exhilarating series of case studies analysing contemporary black music, the formative sojourns of prominent black intellectuals W. E. B. Du Bois and Richard Wright in Germany and France respectively. Of Du Bois, for example, he argues:

> Du Bois's travel experiences raise in the sharpest possible form a question common to the lives of almost all these figures who begin as African-Americans or Caribbean people and are then changed into something else which evades those specific labels and with them all fixed notions of nationality and national identity. Whether their experience of exile is enforced or chosen, temporary or permanent, these intellectuals and activists, writers, speakers, poets, and artists

repeatedly articulate a desire to escape the restrictive bonds of ethnicity, national identification, and sometimes even 'race' itself. Some speak . . . in terms of the rebirth that Europe offered them. Whether they dissolved their African-American sensibility into an explicitly pan-Africanist discourse or political commitment, their relationship to the land of their birth and their ethnic political constituency was absolutely transformed. The specificity of the modern political and cultural formation I want to call the black Atlantic can be defined, on one level, through this desire to transcend both the structures of the nation state and the constraints of ethnicity and national particularity.

(19)

Exciting though his readings of black Americans Du Bois and Wright are, and highly insightful into the role that travel and European philosophy played in shaping their personal, political and intellectual identity, as a counter to Afrocentrism they are probably limited. Only from a very specific and academic perspective could the affirmation of black debts to European philosophy be argued to be a counter-model of social emancipation. A better way to counter Afrocentric nationalism might be to emphasize black US intellectual, political and cultural cross-fertilization with the Caribbean, Latin America, proletarian cultures (white, Hispanic, trade union), as well as Third World liberationist thought. And a way to counter the problematic racial purism of Afrocentrism might be to emphasize and explore the significance of mixed-race intellectuals and cultural texts.

My other reservation about Gilroy's exclusive focus on Europe as a space of liberation for New World blacks is that it overlooks entirely the experience of Europe as historically, and structurally, oppressive for blacks from colonies – so well charted, for instance, in the Senegalese writer and film-maker Sembene Ousmane's *Black Docker*, the novel of a young Senegalese aspiring writer who comes to Marseilles, works as a docker, and entrusts his book to a white French woman writer who, having promised to help him find a publisher, steals the book and has it published to great success under her own name. After accidentally killing the woman in anger, he experiences the humiliation of being denounced as a liar when he claims the book to be his own, and is imprisoned and sentenced to death.[4]

My reservation is less that Gilroy does not take on black colonialism in what is already a highly ambitious and broad-ranging analysis, but that the way in which he conceptualizes the Black Atlantic is one which makes totalizing claims for itself, so that the identity and experience of New World slave-descended black people is somehow, by default, seen to contain or represent all modern black experience. Slavery is consistently accorded a primacy which colonialism is not, be that primacy in constituting black identity and culture or in serving as a structural/ontological deconstructor of Enlightenment modernity.

Conceptualizing slavery

If Gilroy's *Black Atlantic* is concerned with the work of 'high' intellectual black writers, it is also concerned with the mass phenomenon of slavery and its impact on black vernacular culture and sensibility. It is this aspect that I want to focus on here, in some detail, since it is from Gilroy's conceptualization of slavery that his most

controversial, most powerful and also most problematic contributions derive. Gilroy's characterizations of slavery serve two distinct, if overlapping, aims: the first is to situate slavery and its legacy as constituting in black people a distinct 'counterculture of modernity'; the second is to argue slavery as a condition which forces a reconceptualization of Enlightenment modernity, even as it calls the project into question. I find it fascinating that Gilroy seems split between two very different, and possibly conflicting, representations of slavery's counterculture. The first is essentially holistic, in which slave subjects form a condition which refuses modernity's categorical separation of the spheres of aesthetics, ethics, politics and epistemology. As Gilroy suggests:

> Their progress from the status of slaves to the status of citizens led them to enquire into what the best possible forms of social and political existence might be. The memory of slavery, actively preserved as a living intellectual resource in their expressive political culture, helped them to generate a new set of answers to this enquiry. They had to fight – often through their spirituality – to hold on to the unity of ethics and politics sundered from each other by modernity's insistence that the true, the good, and the beautiful had distinct origins and belong to different domains of knowledge. First slavery itself and then their memory of it induced many of them to query the foundational moves of modern philosophy and social thought, whether they came from the natural rights theorists . . . the idealists who wanted to emancipate politics from morals so that it could become a sphere of strategic action, or the political economist of the bourgeoisie who first formulated the separation of economic activity from both ethics and politics. The brutal excesses of the slave plantation supplied a set of moral and political responses to each of these attempts.
>
> (39)

That slaves and their descendants are thus set up to occupy the place of humanity's emancipatory subjects is explicitly argued by Gilroy in an unabashedly utopian formulation:

> This [slave] subculture often appears to be the intuitive expression of some racial essence but is in fact an elementary historical acquisition produced from the viscera of an alternative body of cultural and political expression that considers the world critically from the point of view of its emancipatory transformation. In the future, it will become a place which is capable of satisfying the (redefined) needs of human beings that will emerge once the violence – epistemic and concrete – of racial typology is at an end. Reason is thus reunited with the happiness and freedom of individuals and the reign of justice within the collectivity.
>
> (39)

Now, there is much here that I find suggestive, notwithstanding the fact that Gilroy seems at once to assert slaves' holistic subjectivity is both something that they had to struggle to hold on to against the pressure of modernity's compartmentalizing imperatives *and* that this holism is somethig bequeathed to them by the very experience of modernity itself. What I find troubling is the next step of his argument, which

459

repeats the polarization of labour and liberation, labour and art, found in *There Ain't No Black*, and already briefly discussed here. Gilroy argues thus:

> I have already implied that there is a degree of convergence here with other projects towards a critical theory of society, particularly Marxism. However, where lived crisis and systemic crisis come together, Marxism allocates priority to the latter while the memory of slavery insists on the priority of the former. Their convergence is also undercut by the simple fact that in the critical thought of blacks in the West, social self-creation through labour is not the centrepiece of emancipatory hopes. For the descendants of slaves, work signifies only servitude, misery, and subordination. Artistic expression, expanded beyond recognition from the grudging gifts offered by the masters as a token substitute for freedom from bondage, there becomes the means towards both individual self-fashioning and communal liberation.
>
> (39–40)

I find this problematic for a number of reasons, not least being Gilroy's assumption that he can have access to the historical psyche of slave descendants and pronounce so authoritatively on the meaning that labour has for these people, a meaning that admits of no positivity whatsoever. I will return to the exclusively negative characterization of labour shortly, when I discuss Gilroy's revision of Hegel's master–slave dialectic. But here I want to focus on the description of the aesthetic activity for slaves, which is argued to function as their vehicle for individual and collective liberation. For workers, Gilroy implies, labour serves this liberatory function; for slaves, however, it is artistic expression alone which fulfils such a transfigurative role.

I wonder about this aestheticism. Whereas in *There Ain't No Black* Gilroy did go to some lengths to argue black expressive culture to be part of a broader black emancipatory, transfigurative social movement, and devoted a chapter respectively to the analysis of black music and black social movements as witnessed in the 1980s black British 'riots', by the time he writes the *Black Atlantic* he has, it seems, reached the conclusion that black art *is* black social movement, not one component but its totality.[5] He does not altogether outlaw directly political activity by blacks, but accords it no transfigurative potential, labelling it instead as expressive exclusively of a politics of bourgeois civic 'fulfilment'. Artistic activity, in contrast, performs what Gilroy terms a 'politics of transfiguration'.[6]

Now what has happened to Gilroy's contention that slave counterculture is distinguishable precisely for its refusal to segregate politics, aesthetics, ethics and knowledge as human categories and operations? From the challenge posed by this holistic formulation he moves swiftly, and, I think, regrettably, to the less challenging refuge of a traditional aestheticism, in which, it seems, black art is the only authentic repository of this holism, the only category which can contain and articulate black countercultural ethics, politics and knowledge.

Gilroy's refusal to cede political and labouring activity any social transformative capacity is embodied in his account of the master–slave relationship as represented in Frederick Douglass's autobiography. Douglass, a leading nineteenth-century black liberatory activist and thinker, was himself a slave, and wrote several versions of his autobiography. His first and most famous narrative contains a detailed account of the

turning point in his life, when he fights his slave master in a protracted physical struggle. The struggle engenders Douglass's self-respect, masculinity and the respect of his master, who cannot defeat him. Douglass concludes that 'I was no longer a servile coward, trembling under the frown of a brother worm of the dust, but my long-cowed spirit was roused to an attitude of manly independence. I had reached a point at which I was not afraid to die' (63). Gilroy argues this account to present a radical alternative to Hegel's version of the master–slave dialectic, contending that

> Douglass's tale can be used to reveal a great deal about the difference between the male slave's and the master's views of modern civilisation. In Hegel's allegory, which correctly places slavery at the natal core of modern sociality, we see that one solipsistic combatant in the elemental struggle prefers his conqueror's version of reality to death and submits. He becomes the slave while the other achieves mastery. Douglass's version is quite different. For him, the slave actively prefers the possibility of death to the continuing condition of inhumanity on which plantation slavery depends . . . This [is a] turn towards death as a release from terror and bondage and a chance to find substantive freedom . . . Douglass's preference for death fits readily with archival material on the practice of slave suicide and needs also to be seen alongside other representations of death as agency that can be found in early African-American fiction.
>
> (63)

Now, there is a lot to unravel here. I am not concerned right now with the accuracy or not of Gilroy's take on Hegel, but rather with the way he manipulates Douglass's testimony to pursue his central argument of the death-drive fundamental to slave culture, a drive maintained in what Gilroy argues to be the nihilistic orientation of contemporary black cultures. I want to remark on two things here, before going on to consider the political and intellectual consequences of such a theorization for the mapping of contemporary black counterculture. The first is that Gilroy seems over quick to convert *a willingness to risk* death into a positive orientation, a desire for, death. The second is that, even were one to grant the persistence of a death-drive in contemporary and historical black culture, such a desire is articulated, as in the Douglass narrative, within the matrix of a spiritual redemptionism. Douglass throughout his narrative stations himself as a form of Christ, for whom, one supposes, death is not quite the finite condition it is for mortals.[7] Gilroy is so determined to identify death-drive as expressive of a radical nihilism – he bizarrely links Douglass's position to Nietzsche's in its alleged godlessness – that he underestimates, I think, the significance of re-demptionism as a condition of the 'inclination towards death'. For Gilroy, I think, it matters little whether the death-drive is conditioned by 'apocalyptic or redemptive' sensibilities, as both are the same in their consequences for modernity's rationality, as he argues:

> The discourse of black spirituality which legitimises these moments of violence possesses a utopian truth content that projects beyond the limits of the present. The repeated choice of death rather than bondage articulates a principle of negativity that is opposed to the formal logic and rational calculation

characteristic of modern Western thinking and expressed in the Hegelian slave's preference for bondage rather than death.

(68)

I think, however, that it is extremely important to differentiate between the meanings of a positive and a negative utopianism in black cultures. By the time Gilroy reaches his final chapter, it is clear that his preference is for the negative, drawn from his version of Adornian thought and fused, in my view awkwardly, with a Benjaminian conception of modernity as ontological rupture. In this brand of utopianism, only the principle and representation of negativity (associated with a finality of death, absolute termination) and the rejection of any achievable and positive representations of a possible 'afterlife' or future earthly life – only negativity can indicate, gesture towards, an 'authentic' emancipatory future condition of being.

The emphasis, that is, falls on nihilism instead of optimism; a nihilism through which its opposite can emerge. To give positive expression to, and literally represent, the forms an emancipated life might take (in heaven or on earth) is to capitulate to the existing forces of actual domination which exercise control (among other things) over the notion of 'representation' itself. This I find both problematic and inaccurate, in the case of slave cultures, in which the immense explicit emphasis given to positive utopian notions of spiritual redemption, solace and the imaginings of actual future social transformation is overlooked and undermined by Gilroy's exclusive valorization of the negative and non-representable.

This emphasis on moribundity as the fundamental, and inescapable, consequence of slavery, tied in with the refusal to grant legitimacy to modern rationality, is at once politically challenging and disturbing. For all his discussion of modernity and rationality, it's never quite clear to me whether Gilroy is arguing the institution of slavery to be a form of racial terror which is obscene because it *is* rational, systematic, or whether, in contrast, he is arguing for slavery's basis in *irrationality*: the relationship and his argument are mystified and obfuscatory, and all that is clear to me is Gilroy's desire to invite scepticism towards rationality's emancipatory qualities. His own systematic isolation of slavery from any economic context adds to this ambiguity, and his argument at the end of *The Black Atlantic* for the linkage of Jewish Holocaust thinkers (including the Frankfurt School) and their experience with black diasporan experience does nothing in itself to elucidate his position further.

Since a concept of dialectics is, for him, clearly refuted by his allegorization of Hegel's allegory, the Frankfurt School's historical-dialectical analysis of the relationship between reason and unreason, and its dialectical linkage of rationality with political economy, is obviously not what Gilroy has in mind when he argues for elective affinities between black and Jewish analysis. Such a dialectical approach, based upon a structural concern with the dynamic, mutually transformative processes of political domination and intellectual production, might be a more productive basis for analysing the connections of slavery, reason and terror than the static, ontological and mystical approach taken by Gilroy.

It's the partiality of Gilroy's death-drive, however, as an account of slavery's counter-culture, that I want to consider here. Discussing contemporary black culture as derived from the primal moment of slavery (there are all sorts of issues one can take with this supposition, but that is another matter), Gilroy argues:

The turn towards death also points to the ways in which black cultural forms have hosted and even cultivated a dynamic rapport with the presence of death and suffering . . . It is integral, for example, to the narratives of loss, exile, and journeying which . . . serve a mnemonic function: directing the consciousness of the group back to significant, nodal points in its common history and its social memory . . . this music and its broken rhythm of life are important . . . The love stories they enclose are a place in which the black vernacular has been able to preserve and cultivate both the distinctive rapport with the presence of death which derives from slavery and in a related ontological state that I want to call the condition of being in pain.

(203)

Blues, blues and more blues, seems to be the conclusion. Powerful though this is and, I find, a convincing gloss on one component of black vernacular culture, I think it overlooks – actually, precludes – theorization of other impulses in contemporary black cultures, which arguably derive from more positive, resistant elements in black political history. So intent is Gilroy on emphasizing slave suicide and fatalism that he neglects other forms of violent and non-violent resistance practised by slaves, such as the regular sabotaging of plantation machinery and the practice of abortion. Both of these practices are themselves complex examples of the performance of a scientific rationality, which is presumably the reason for Gilroy's disinclination to consider them. As technological and calculated practices they do not bear out his contention of black subjectivity's scepticism towards rationality. In deploying knowledge of, and making use of, scientific reasoning, they refute his contention that slave identity is 'opposed to the formal logic and rational calculation characteristic of modern Western thinking' (68).

I would, however, be interested to consider the legacy of industrial sabotage as a component in the black political cultures of graffiti, and more generally to pronounce the iconoclastic, ironic, and scatological aesthetics alongside those expressive of pain and death. And, given that Gilroy emphasizes black convergences with Jewish history and experience, how about looking at the parallelisms of Jewish *humour* as a response to racial terror, a survival resource and a means of resistance? There is plenty of black saturnalian, ludic and trickster culture, but perhaps, as I suggest above, Gilroy's reason for eschewing these as significant or primary cultural modalities is that they are rooted in a form of intensified – and often lateral – reasoning. His interest is in arguing scepticism towards rationality as foundational to black culture.

As a means of conceptualizing New World black cultures, Gilroy's model is richly suggestive but, at the same time, limited by his determination to present antinomies – between socialist and black value systems, between nationalist and internationalist impulse – where, I would argue, it is more profitable to look at these not as antinomies but as mutually enabling. The most serious question, perhaps, to be posed of Gilroy concerns his argument for the death-drive in black cultures.

Notes

1 Paul Gilroy, *The Black Atlantic: Modernity and Double Consciousness.*
2 Gilroy's formulation of a 'turn towards death' within black subjectivity – discussed later in

this chapter — is more ontological than psychoanalytical. He argues it to have its origins in the historically specific, social experience of slavery. For a more psychoanalytic postulation and explanation of a 'death-drive', see Sigmund Freud's *Beyond the Pleasure Principle*.

3 For an important critique of *The Black Atlantic* see Neil Lazarus's 'Is a Counterculture of Modernity a Theory of Modernity?', *Diaspora* 4, 3 (1995): 323–40.

4 Many other literary examples can be given here. Two fictional accounts of black Caribbean emigrant experience in Britain are Sam Selvon's *The Lonely Londoners* and Joan Riley's *The Unbelonging*. Ama Ata Aidoo's novel *Our Sister Killjoy* charts the experience of a young Ghanaian woman sojourning in Germany. For historical and sociological discussions see, for example, Peter Fryer's *Staying Power: The History of Black People in Britain*; Winston James and Clive Harris (eds), *Inside Babylon: The Caribbean Diaspora in Britain*.

5 For an analysis of these 'riots' see chapter six of *There Ain't No Black*, 'Conclusion: Urban Social Movements, "Race" and Community', reprinted in Patrick Williams and Laura Chrisman (eds), *Colonial Discourse and Postcolonial Theory: A Reader*. See also A. Sivanandan's *A Different Hunger: Writings on Black Resistance* and *Communities of Resistance: Writings on Black Struggles for Socialism*.

6 See, for example, p. 37 of *The Black Atlantic*, for Gilroy's distinction between what he calls a 'politics of fulfilment' — 'the notion that a future society will be able to realise the social and political promise that present society has left unaccomplished' — and his notion of a 'politics of transfiguration', taken from Seyla Benhabib, which 'exists on a lower frequency where it is played, danced, and acted, as well as sung'. While the 'politics of fulfilment' are, he argues, 'immanent within modernity', the 'politics of transfiguration' 'partially transcend modernity, constructing both an imaginary anti-modern past and a postmodern yet-to-come'.

7 I am grateful to Robert Chrisman whose insight this is.

From *Race & Class* 39, 2 (1997): 51–64, © Laura Chrisman.

39

A CONVERSATION WITH
AUBREY WILLIAMS

Rasheed Araeen

RASHEED ARAEEN: Aubrey, could you tell us something about your life in Guyana before you came to Britain, particularly in relation to your aspirations to be a professional artist. Where did the aspirations come from?

AUBREY WILLIAMS: Your opening is so complex; it's mind-boggling. To start with we in Guyana have no true concept of inspiration. It's too modern. It's synthetic and too romantic in the English romantic sense. It has very little to do with making images . . .

RA: I'm sorry. I meant aspirations.

AW: Oh, *aspiration*! It's also a Western concept that I believe is only coming into active reality now in Guyana in relation to professional artists. In my boyhood an artist was a person who sculpted or painted, doing something creative, you know, outside the norm . . . I was born into a world in which there was a natural appreciation of excellence, and this permeated the whole society. It went down to the grassroot peasants in the country. An Indian farmer would make his rice-paddies in certain ways what we call today 'artistic'. His mud fireplace would be like a piece of sculpture. It's only now with the coming of modern technology and so on that these art forms or making of art have become part of professional activity . . . I must explain here that by 'Indian' I mean East Indian people who were brought to Guyana from the Indian subcontinent as indentured labour to work on sugar plantations. They have their own profound concepts and behaviour patterns and iconography which give them tremendous insight for handling the environment beautifully.

RA: Are you saying then, Aubrey, that the inspiration to paint came from the East Indian people in Guyana?

AW: No, no! I'm trying to get you to realize the early environment in which I found myself. Now it's different. But in my time what we called artistic was part of my natural environment . . .

RA: Were you not taught drawing at school?

AW: In some ways, yes. But I was a child who found himself drawing. I was very good at drawing. In fact, I'm a child prodigy who never grew up . . . I will give you an early incident, the earliest incident I can remember when I made a drawing that my father kept all his life. Think of me as a very precocious three-year-old sitting on the front steps of our little cottage in a street called Bourda Street. 'Bourda' is a

Dutch word. The Dutch once owned Guyana. Across from us was an old cemetery, an early colonial cemetery. Many of the tombstones in that cemetery have very British colonial names. It was more or less a park at the time . . . As I was sitting there in front of my house I saw a turkey vulture pick up a dead rat from the grass verge of the road and fly over into the cemetery. I quickly ran up into the house, got my little drawing pad and came back, and made a drawing of the vulture tearing the rat apart on a white tombstone. This was about four in the afternoon, and my father who worked at the post office at the time came home riding his bicycle. He parked his bicycle under the house – the house was built on the stilts, you know, and he came up and saw me drawing: 'what are you doing, son?', and he looked at the drawing and said, 'what's all this'. He snatched the drawing from me, rather viciously I thought, ran down the steps and hopped on his bicycle and vanished around the corner. My mother then came out and said to me, 'didn't I hear daddy come'. I said 'yes', and I told my mother what happened. You see, I was in a state of shock. I thought I did something wrong. About an hour later I saw my father coming back with another man, a European. This was the first time I saw this European man; his name was Mr De Winter and he did restoration work in churches. He was a very skilful restorer. He came into my life this way and he was in our lives for about five years. So, if you talk about an early teacher, he was a teacher. But he never taught me as a matter of fact, the way art is taught in this country. I myself as a teacher go back to the way De Winter guided me because it's up to now the best method I have come across. He never taught me how to draw things. He would give me a task to perform, say, ask me to draw some animals or fruits. He would then take the drawing and see if it was good. He would never correct the drawing. He would instead make another drawing . . .

RA: Have you still got those things you did when you were very young or have they been lost?

AW: Not lost, man! My whole family has them. It's a large family – aunts, uncles, cousins and so on. They were like predators, man! As fast as I did anything, it vanished. Whenever they visited our home, the first thing they did was to look for my drawings.

RA: So, in fact, right from the beginning you had a very encouraging environment.

AW: But I didn't understand at the time that I was an artist and I had a clientele.

RA: But there were people around you who appreciated what you were doing. I think you were very lucky.

AW: I know I was very lucky. I have been very lucky all my life.

RA: So, at what age did it come home to you that you were going to be a professional artist?

AW: Oh, no, I didn't understand the concept of professional artist for a long time. What I mean to say is that I did not paint because I knew I was going to be a professional artist.

RA: Even though you don't like to use the word 'professional', you were involved from an early age with people who considered art or painting a serious business, a profession. I'm here referring to Burrowes and his Working People's Art Group. You were closely associated with Burrowes before you came to England. Could you tell us something about the Working People's Art Group and what was your own relationship with it?

AW: I joined the Group first as a boy when I was still in school. Burrowes used to hold classes at night in a school where he was kindly given premises by some people to run his classes.

I was one of many students. The Working People's Art Group comprised old people, toddlers, anybody who was interested in art. This man Burrowes was a genius. He opened the Guyanese eyes to art, in its aesthetic sense. In the beginning he didn't call his classes by any name. He was only interested in taking art classes in his free time. You must remember Burrowes was a tailor by profession. He was one of the finest tailors in Guyana. He picked up painting as a hobby, but he was always a brilliant painter. I would place him, say, in European Impressionism. But he never saw the originals. What he saw were reproductions until he came to Europe about ten years before he died.

RA: But, that was the kind of situation common to all colonized countries. We are all taught through reproductions, through the casts of Greek or Roman busts . . .

AW: But in Guyana we did not even have that kind of art teaching. We didn't have anything. It's very important what I'm saying here . . . I have told you about my first acquaintance with the Group – 'acquaintance' is the best word to describe my relationship with the Working People's Art Group. I stayed with them from say twelve to about fifteen when I had to take up my academic studies seriously again because I had an apprenticeship to a special course in agriculture. So, that was the end of my first association with the Group.

When I became a qualified field officer in the department of agriculture, I made acquaintance again with Burrowes and started art classes in the agriculture districts I was working in. From time to time Burrowes would leave Georgetown and would come up to me wherever I worked and we would start new classes, and this way we set up Working People's Art Groups everywhere; which by that time had become an established sort of institution in Guyanese society. He began to get government help to the extent that he was sent over here on a two-year course. Anyway, with the help of school masters and important people in different villages we managed to spread art classes all over along the east coast of Guyana.

RA: So, you really got involved in a big way – no longer as a student but as a contributor . . .

AW: Yes, as a lecturer, as an organizer. I carried on with the work even when Burrowes could not come up into the country. I myself established new groups and worked with people using the teaching methods of Burrowes. He would come up once a month or so, but we held the classes regularly at least twice a week.

RA: What was the philosophy behind the Working People's Art Groups? Was there any ideology?

AW: It was an automatic sort of thing. It was for the enhancement of what we call beauty or something that is basic to human life. The drawing classes helped people realize this and realize their own abilities. The purpose of the Group was to spread the importance of art among the masses. In the classes we had retired people, middle-aged people, young students who wanted to go to an art college and needed a certain amount of preparatory course. So the classes helped different people in different ways. We never taught anything specific, and most people found their own way according to their different aptitudes.

RA: So what you were doing was not really telling the people who joined the Groups

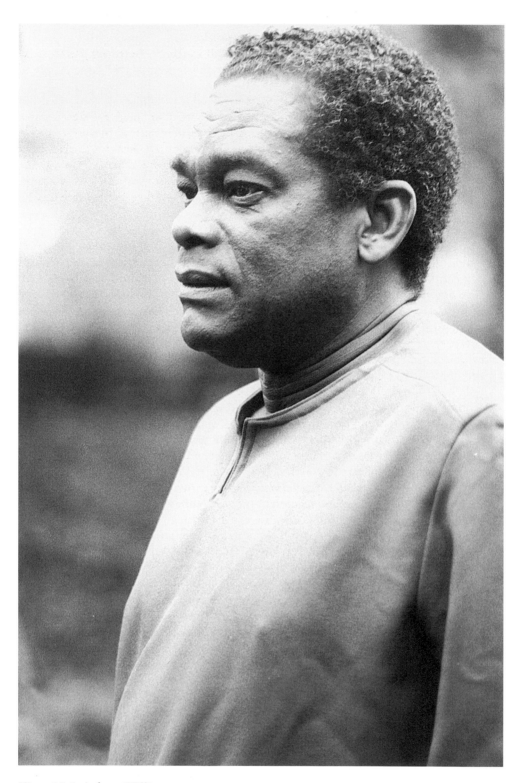

Figure 39.1 Aubrey Williams
Source: © David Rowan

what to draw or paint but somehow helping them to realize their own potentials as creative human beings.

AW: Now you have got it.

RA: Tell us something about your life as an agricultural field officer.

AW: Think of Guyana at the time. It was a British colony. It was at that time a boiling cauldron; Guyana coming out of colonial bondage. It was the time when the seed of independence began to germinate. At that time I became a cane-farming officer for the colony, acting as an agricultural superintendent for the whole east coast and also as a field officer. In fact, I was doing three jobs in the department of agriculture, and at the same time breaking the rules right left and centre. I was battling with the government for the farmers, and that is how I became a cane-farming officer. I became the arbitrator-cum-organizer for sugar cane farmers . . .

Now I must explain to you all this in some detail. Think of demerara sugar. It was produced in Guyana by Bookers McConnell & Co.; the same Bookers who are now known in this country for the Booker Prize for literature. In Guyana they then owned everything, from sugar production to shops in the high streets. Sugar was the main produce of Guyana and the whole economy was dependent on it. And thus Bookers controlled everything in the country. They were in fact the representatives of Britain in Guyana.

Demerara Sugar and Demerara Rum! You must have heard these words many times. About 90 per cent of the demerara sugar came from Bookers' own sugar estates, and the remaining 10 per cent was produced by farmers on their own small plots adjacent to the estates. The demerara sugar produced by the farmers was very important because it gave a higher quality to overall demerara sugar production and was essential for the production of best-quality rum. The farmers knew about it, but they were getting the rough end of the stick all the time. They were manipulated by the estates, cheated and exploited. They were always on their own, and there was nobody to intervene and help the farmers . . . So, one day we got this new post in the department of agriculture, created by some visionary civil servant who saw the trouble coming because the farmers began to realize their importance and they also knew that they were being cheated. The post of cane-farming officer was created chiefly to maintain normal relations between the estates and the farmers. You can see the strange dichotomy here!

Now, here you have me as a young agricultural officer trained in sugar production and coming into this terrible set up; and put into this complex situation in which I was given a certain mandate only to smooth out relations. I was expected to liaise between the farmers and the estates, but also not to rock the boat. It was like being given a contract as a hit man: you couldn't come back to the government and be defended against the sugar barons. But I was not a stupid person. Politically, I was pretty astute for that time. I wasn't a fool. I understood things like social change and land reforms and all the sins of colonialism. I was not active politically though, and up to now I'm not active politically. I have never been on the forefront of fighting for direct revolutionary change.

RA: You mean you are not a political activist?

AW: Ah, activist! That's a lovely word. But I had strong views about my country, about the ideas of independence, about self-respect and, you know, to have a chance for it to be an entity in the world. I had very very strong views with the madness of

a youth and also had a wild energy. And I did too good a job, because the sugar estates at the time were using various subtle means of controlling and exploiting the farmers. The farmers had to come to the estates for chemical manure, and the whole transport system was built into the sale of farmers' sugar to the estates. Before I took up the job of the cane-farming officer, the farmers had nobody with ability to tell them what their labour or product was worth. So, I began to check the whole thing; the figures, the yield and what farmers were actually getting and so on. I knew I had the rights and I exercised my rights. This upset the sugar managers and the trouble started.

RA: You mean they were cheating the farmers?

AW: Not outrightly. They had developed a system by which farmers were being cheated all the time. And I suddenly came as a bloody thorn in their side, demanding correct figures, fair play and all sort of things. But the sugar barons had other means of manipulating and controlling the farmers. For example, they would flood some fields at a wrong time and destroy a whole year's production; and then they would claim that it was an accident. They wouldn't flood all the fields around because they always needed the farmer's cane. They would pick up only those fields from where they had some 'trouble'. So, I started paying attention to the sluices and watergates and putting in mud-blinds wherever we had seepage. The estates didn't like it and frowned upon me to the extent that they would not let me use their tractors to dig the blinds. I had to get the government help to do the job. So, it was a war! It was a time of great tension for me, which actually informed and affected my art work because I continued painting even during this difficult time. My work was fairly social realist at the time, which also became therapeutic in all my anxieties.

RA: So, there was an organic relationship between what you call 'social realism' and the way you were involved with the farmers?

AW: Even if I did a landscape it showed the stress and tension of the time.

RA: Wasn't this the time when you were sent away to work among an Indian tribe, Warrau, living inside the rain forest of north-west Guyana? This aspect of your life was particularly the focus of a film about you, *The Mark of the Hand*, made by Imruh Caesar. You actually went to visit the tribe again, after forty years, during the making of the film. Could you tell us something about your experiences of living among the Warrau people and what impact they had on you?

AW: It played a major part in my life, in my realization of self as an artist. Nothing that happened accidently had ever contributed to my art. But my contact with the Warrau was a happy accident, which at the time I considered a personal tragedy . . . As I told you before, I was beginning to have too much trouble with the agricultural department because I started fighting openly, and the people in the department thought I was becoming a nuisance. I should have been more diplomatic. In the end they got so fed up that they sent me to work in the jungle. My posting in the jungle was really a punishment for what I was doing. It was like sending someone to Siberia. They said to themselves, 'let us get rid of the bastard'. But they did it in such a way that it looked like a promotion, because they put me in charge of the experimental agricultural station in the north-west jungle. For me it was either resigning or going. I have always been interested in my country, my relationship with its earth and my interest in its ecology. So I went.

My arrival in the jungle was traumatic. I thought I would be lost in it for ever,

and it took me six months to get used to it. First, I kept to myself and my work, but then I slowly began to come to terms with the social environment, particularly of the Warrau tribe. Most of these people were already converted to Christianity and were being used as labourers on the plantation. Although I had a Catholic background, I was agnostic. And I didn't like what the Church was doing to them. So I was drawn to the Indian way of life, their artefacts and rituals.

RA: You stayed there for two years, and I believe that the Indian way of life had tremendous impact on you. What kind of relationship did you have with the Warrau people and did it influence you in your work as an artist?

AW: A total relationship! And my language of expression completely changed. In fact it was there that for the first time I discovered myself as an artist. Before that it was all an amateur activity. It was only after I came into contact with the Warrau that I knew what I would do with my life. I have to thank the Warrau people now for my work as an artist. I can't be more profound than that. My interest in pre-Columbian culture was intensified as a result of living there. They still kept the old artefacts with them which they used in their rituals.

RA: Did they make new artefacts when you were there?

AW: Yes, but secretly, because they were afraid of being found out by the priest. They used beautiful colours in their work, which was totemic, and the colours were derived from natural substances.

RA: Did they use 'fire' in their rituals?

AW: Yes, all the time. In all the rituals, four elements were used: fire, water and earth, and the fourth element was variable – it could be wood or any other thing.

RA: On your return to the city, Georgetown, you made contact again with Burrowes and resumed your activities as part of the Working People's Art Group, as well as continuing your work as an agricultural officer with the government. How did you find things on your return?

AW: By that time all my intellectual friends had joined People's Progressive Party (PPP), which was on the forefront of the struggle for independence. I knew Cheddi Jagan personally and I was very close to him, and he in turn always interjected his presence into everyday work, so much so that it provided the sugar barons with a colonial excuse to implicate me with the politics of PPP. I was not even an ordinary member of the Party. It came out that I was investigated, without me even knowing about it, for creating farmers' communes on the east coast of Guyana. The foreign service here thought I was a political activist. But I never aligned myself with PPP, never attending their meetings or they attending farmers' meetings – although the PPP's presence was profound all over the place. It is true that farmers' associations began to be called farmers' communes. Okay, but they were just associations, little brotherhoods where problems could be shared. We didn't have to run to sugar barons every time we had some problem. But they thought we were becoming independent, which to some extent was true. We began to get compensations for cheating or any damage done by the sugar estates. It was the time of great political struggle and tension. It was a very dangerous time.

RA: Soon after in 1952, when you were twenty-six, you found yourself in Britain and since then you have lived here most of the time. What were the real motives behind your leaving Guyana at that time? Was it an ambition as an artist or were there other factors involved?

AW: As I told you before, it was the time of great political upheaval. At the peak of all that a shooting took place at a sugar estate where eleven people died. During this time a friend from the PPP came to see me one day, and he said: 'Listen Aubrey, you will never be a politician; you are not a politician. You are hardly an agricultural scientist now. You are really a painter. You have a lot of leave coming [I had not taken much leave during my government service]. So, why don't you go to Europe and paint there. And you must go quickly.' Three months after I had left Guyana, the whole top leadership of the PPP was in jail.

RA: So this friend of yours did a favour to you by asking you to leave.

AW: He saved my life! Otherwise my whole life would have taken a different direction. I would have been incarcerated along with the politicians, which would have been an embarrassment to them as well as to me. I'm fairly political, but my politics are very simple, very basic. You understand? Fight for your rights! If you don't have your rights you are not a human being. It's as simple as that. Protect the under-privileged, protect the people who don't yet know how to fight. But, above all, fight for your rights.

RA: Before you came here you must have had some perception of this society. What was that perception? And how did you actually find this society when you arrived here?

AW: This society! This society was also a society in a drastic change at that time. It was a postwar society. When I came here I had a ration book. In London there were bomb sites everywhere. The south embankment was just getting tidy. It had just come out of the Festival of Britain. And the Festival Hall was just finished . . . I came to a London where in the pub they would touch a black man for luck. There were not many black people around. I could walk a week without seeing a black brother. This was the London I came to, man! And I realized that I had to know this country, even if I hated it . . . In the beginning I took many things for granted, and in some respect it was not bad. In fact, I did it in grand style because I had my salary coming to me from Guyana. It was a lot of money. I was very excited but somehow I didn't feel very comfortable. How could I? I was a young artist then. My whole life was spent in some kind of enquiry: seeing, feeling, looking and finding new things, you know. And this was not an easy place.

When I came here I entered at the top. I went first to live at Hans Crescent, which was then used by the colonial elite – the sons of maharajas, the upper middle classes. They all stayed at Hans Crescent until they had entrance to Cambridge or Oxford. Hans Crescent at that time was run by the British Council, but not openly . . . Most of the time we watched television. The television was just in its infancy at the time and the place used to be crowded all the time, in spite of the facts that we were allowed only two guests . . . Sometimes we were invited to stately homes: lord so-and-so and lady so-and-so would entertain guests from Hans Crescent on weekends. We went to many stately homes and we were often entertained with tea and biscuits, and we sometimes existed on that. It was a top-level British brain-washing and indoctrination; because after living like this for a few months you would begin to despise your own people back home, man! Your letters would change. It was a very subtle kind of thing. They were actually making up with colonial friends at that time, and only now I can see that with hindsight. Think of a wide-open colonial mind! No wonder mortalities were so high! Think of the

number of brothers that got lost inside that trap, that early colonial trap called Hans Crescent. I think that we lost a lot of leaders. But Hans Crescent was only one colonial institution. There must have been places like this all over the country.

I somehow always felt uncomfortable. I couldn't put my finger on what was wrong. It was an instinctive gut feeling that something was wrong. Little hints and signs were there: the smiling people from the nobility; the colonial cronies coming up to you and telling you that they knew more about your country than you knew yourself ... By this time I had left Hans Crescent and was living among the broken-down nobility in Artilery Mansions in Victoria Street. We called it, rather irreverently, 'the Mausoleum'. You know why we called it 'the Mausoleum'? Because it was there where the cronies from the House of Lords went to die. Most of the people I met there are now dead and gone. I mean you can't mention names, but they were weird, weird cats, man!

RA: At this time you went around travelling in the country. You also went to Europe; and in Paris you met Albert Camus, whom you found to be very friendly. He took you to see Picasso. Could you tell us something about this meeting with Picasso?

AW: There was nothing special about meeting Picasso. It was a meeting like many others, except that meeting Picasso was a big disappointment. It was a disappointment for stupid little things: I didn't like how he looked; I didn't like how he behaved. I never thought I would not like people like that. But the total of the whole thing is that I *did not like Picasso.* He was just an ordinary past-middle-aged man. I remember the very first comment he made when we met. He said that I had a very fine African head and he would like me to pose for him. And I felt terrible. In spite of the fact that I was introduced to him as an artist, he did not think of me as another artist. He thought of me only as something he could use for his own work.

RA: On your return to London, you joined St Martin's School of Art. How long did you stay there?

AW: About two and a half years, maybe three. But, you know, after the second year I didn't sign in. I just went there and worked all day by myself. I told them that I didn't want the diploma. I just wanted to use models, use the general facilities, cheap paint and material etc. I also had my first exhibition at the Archer Gallery while I was still at St Martin's, in spite of the fact that in those days it was forbidden for a grant-receiving student to have an individual show in a commercial gallery.

RA: After you left St Martin's you did many jobs for living, such as working in factories, doing dishwashing in cafés, etc. It was your wife, Eve, who persuaded you to give up these jobs and concentrate fully on your work as an artist. Could you say something about this aspect of your life?

AW: Yes, Eve has been supportive all along.

RA: Your first public showing was at the Archer Gallery in 1954, which introduced you to the art world. How was the general art scene like at that time?

AW: It was rich, man! No doubt. Socially, it was no problem. We all went around to gallery openings and to the pubs. People like Dylan Thomas and John Minton were around. And it was fun!

RA: Your first success came with your show at the New Vision Centre in 1958, in which I believe you sold almost everything. How was your work received by art critics?

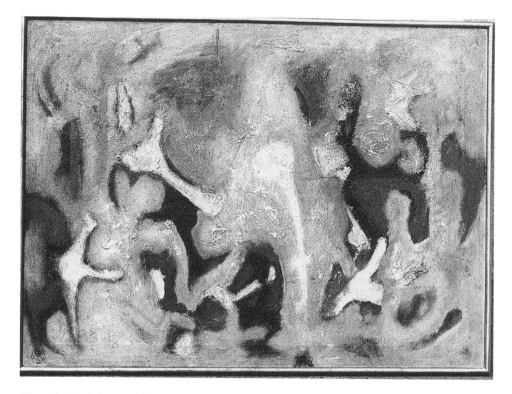

Figure 39.2 Aubrey Williams, *Tumatu Mari* (*Sleeping Rocks*) (1959)
Source: Photo by Rasheed Araeen

AW: Oh, very well. I don't know if you remember Eric Newton. He was an important art critic, and I have still kept clippings of his writing about me. I was surprised at the depth of his knowledge and understanding of my work, in the sense that he understood from where my work was coming. Critics in general at that time were very complimentary and helpful.

RA: Looking back now, how do you feel about your first success about thirty years ago? You must have then built a lot of hope for the future

AW: Man! Well, I was so naive in those days. I thought it was it. It was *the* life of the artist. I thought I made it. Following that show I had about six or seven more shows in that year in various places. But then, after two years, whenever I had a show it was not received in the same manner. All my shows were ignored, and I felt terrible. I began to ask myself what was wrong with me, what was wrong with my work. For the next five years I was in a terrible confusion. You know, I thought I had hit the level which would see me through both economically and respectably as a recognized artist in the British community. At that time I was still very respectful to the British – not that respectful now. Now I know more and understand more. But in those days it was the mother country, you know; I felt I was privileged to be in Britain and doing my art in the mother country.

RA: Did you feel that you were British at that time?

AW: Not British! I could never feel British. A black man can't be British! How can

black man feel British? No, I don't feel British. In those days I did feel privileged to be here, though.

RA: You did once say that subsequently you felt that there was no intellectual space in Britain in which you could place yourself, and you felt terribly isolated from the British art scene . . .

AW: It was when I really started to think. In the beginning I suppose I was a novelty, but when the novelty began to wear off and I was being nicely put in my place I started to realize my 'blackness'. You must remember that the emotional, even spiritual, impact of coming to this country was traumatic. But then one did not see everything in those days. One had hope even when things were difficult.

In the beginning there were so many things happening. I lived most of the time in museums, looking at the paintings which I had seen only in reproductions. A day was never long enough! I did not then have the time to assess my position in this country. I did not have the time to realize that I was a little black boy from the colonies. I did not at that time think how the British really felt about black foreigners as compared to white foreigners . . . But when it really started to hit me, my sensitivity began to grow or became more manifest in my life from day to day and I started to think all the time about my self-respect to which I had not somehow paid much attention in the past. I began to sus my position in this society. It was a terrible time and I began to feel terribly isolated, physically and intellectually.

RA: Wasn't it the time when you joined the Caribbean Artists Movement?

AW: Yes, but in the beginning CAM wasn't a movement. It was just a gathering together of brothers (and sisters?) involved in creative activities, to exchange ideas and to give each other company. But then those who were more active intellectually turned it into an organized entity, a platform. In fact it was badly needed then. CAM was not an exclusive or restrictive club. We had everybody involved in it – it was not exclusively black. We were of course predominantly black, coming from the colonies or ex-colonies, but at that time not everybody used this word. It's only now that we know that people from the Indian subcontinent are also black people. Thank heaven for the racism of this country – it made Indians discover that they are also black! In those days an Indian person was an Indian, not a black person. He would be insulted if somebody called him black.

CAM was very important at the time. It helped create an intellectual atmosphere for everybody to be creative and relate to each other. It was something from which even the native British benefited. CAM was an important part of the British intellectual life, but since it was predominantly of Caribbean people it was categorized, isolated and eventually destroyed. And it was the BBC which played a major role in its destruction, by isolating black intellectuals and giving them separate exposure.

We needed an identity; we needed something to which our painters, musicians, writers, etc. could relate to, but we did not think of CAM as something operating only here. When a lot of us returned to the Caribbean CAM really flourished there. In fact most of the important contributions to our journal came from Jamaica, although we had people contributing to it from all over the world. As an international platform CAM was very important because it was how we came to know what was happening in the rest of the Commonwealth. It was through CAM that I met many artists from Africa, from India and from many parts of the world.

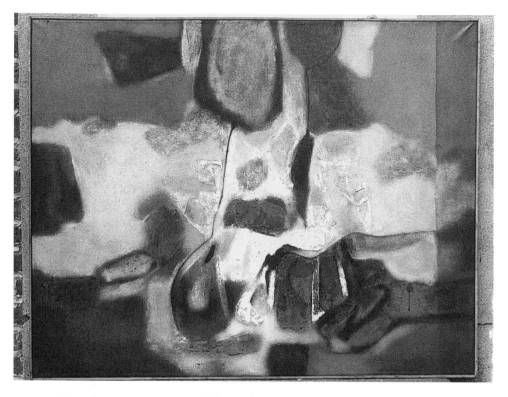

Figure 39.3 Aubrey Williams, *Visual Idea* (1963)
Source: Photo by Rasheed Araeen

RA: Now I want to get back to the 1950s. When you began to exhibit in London, were you still doing figurative work?

AW: I never abandoned figurative work.

RA: Okay, when did you move to what began to be called abstract work?

RA: I stay on with figurative work whenever I want to. I would say that I did concentrate intensely on abstraction for about ten years, at the time of New Vision Centre.

RA: You were somehow part of those artists who in the late 1950s and early 1960s were associated with New Vision Centre, and the main concern of the gallery was with the promotion of international abstract art. The importance of this position can be understood only in the light of traditional English hostility towards anything which is not figurative (a hang-up from European realism), notwithstanding the different position of some people (such as John Berger) who saw some kind of figuration as essential to 'revolutionary' art. I'm not suggesting that your work of that period – and its continuation right into the Shostakovich series that you completed in the early 1980s – should be read only as 'abstract'. But I believe you started doing 'abstract' work in London, which was a shift from the kind of work you were doing when you were in Guyana. How did this change take place and when?

AW: Oh, it was at the time of the exhibition in London of German Expressionism. It was around the mid-1950s. Also then American Abstract Expressionism was

known. We had a great regard for the American work, man! Pollock was every-
thing. Pollock was our god! You understand? All those artists – Kline, Newman,
Rothko, De Kooning . . .! They were all great! But for me the most important was
Gorky. He fitted in some way with my own perception which was basically
informed by pre-Columbian Indian iconography of Guyana.

When I left my country to come here it was about two years after I had come
back from living with the Warrau tribe. So I came here already loaded with ideas,
how to put all those ideas into my expression. But then I realized that what I was
facing here was a European desert. It was a desert because the museums that I went
to were just big monuments. And I was not impressed with the kind of work being
done in London at that time. It was nice to see studios and see how other artists
worked, because in my own country if you had a little area you could call a studio
you would be bloody lucky . . .

RA: So what you are saying is that the ideas were already there before you came here
and those ideas came from your fascination with pre-Columbian art . . .

AW: No, no, no. Not fascination. Fascination sounds very superficial. The core of my
activity is in my interest in pre-Columbian culture and in my involvement with
pre-Columbian artefacts . . .

RA: And somehow the German Expressionism exhibition in London helped you
discover or find a form or methodology to express those ideas.

AW: Perhaps the German exhibition was a starting point. But I was always interested
in German Expressionism, as I came face to face with it during my travels in
Europe.

RA: Didn't you say that you were also influenced by American Abstract
Expressionism?

AW: Greatly influenced, I said that at the time. Greatly influenced.

RA: And yet you say that the core of your work is in your interest in pre-Columbian
art. How would you explain the meeting point of these two different sources,
because it is not very evident in the work you began in the 1950s?

AW: It's not something I can explain in words. That's why I paint. If I could express it
in words I would write and I would write lucidly . . .

RA: People can clearly see the connection with Abstract Expressionism, although I
personally believe that your work has little to do with it. Most of your work appears
to be 'abstract', and that's how your work has always been seen and written about –
as far as I know. What is not clear is what you call the pre-Columbian core of your
work. What is this core? Is it iconographic, formal or conceptual? Where is it and
how is it expressed?

AW: Listen, it is not my position to explain everything. If I were to use words I
wouldn't be an artist . . . All my life I have been involved with mystery. Now
mystery is a very bad word, especially in this environment. It connotes hocus-pocus
occult, witchcraft, etc. And that's not what I'm talking about. For me pre-
Columbian culture is still full of mystery. It's a no-man's land even to the scientists.
There are things in Maya civilization which are not yet clear to us. They can't be
explained rationally. And that's what I mean by mystery. I'm not ashamed of using
this mystery in my work.

RA: I'm not denying the element of mystery in your work. And I'm not against
mystery. But if a work remains shrouded in mystery, if it remains without being

decoded, then it has no function as a medium of expression or communication. There has to be a clue, even if it is a difficult clue, which can help penetrate this mystery, and which can help the audience understand the work. I admit your work is not simple. It's not transparent. It doesn't have to be. It's the complexity of your work which makes it significant; and that's why I'm interested in your work. But I'm curious to know what *you* mean by the pre-Columbian core of your work.

AW: In my little way I'm trying to go as far back as possible in order really to understand that part of my own history . . .

RA: Yes, that may be your intention, Aubrey. That may be your desire . . .

AW: Desire! But not intention.

RA: Maybe it is your desire to go back five hundred or thousand years and relate yourself to that period in human history what we call pre-Columbian civilizations. Maybe it is your desire to identify yourself with a specific period in human history and pick the fragments of that history and give them some expression in the context of our own time. But how is this desire actually expressed in your work and what is its significance today?

AW: I see parallels. And I see repetitions.

RA: Let me refer to a concrete example: your painting called *Guyana*, which won the first prize in the Commonwealth Abstract Art Exhibition, held in London in 1963. How would you explain that painting in terms of what we are now talking about?

AW: Minimally. Minimally. It's more of a comment on my country in which I was brought up and I still had the memory of the profound experiences I had there; and the word 'Guyana' was a convenient word. It comes out of my interest in geology and topography, particularly of Guyanese landscape – the earth, the animals, water, and so on, and I found it easy to name it *Guyana*. It does rather have expressionistic rendering, but if you could put an X-ray on it you will see the heavy drawing coming out of it. The painting is clinically constructed before it comes up with that apparent freedom. It has to be like this or else you end up with chaos.

RA: But doesn't the work belong to the period which was called Abstract Expressionism?

AW: Why are you so concerned about labelling my work or compartmentalizing it?

RA: I'm not compartmentalizing your work. Not at all. You have yourself accepted that you have been influenced by Abstract Expressionism . . .

AW: I also admit that I'm influenced by pre-Columbian artefacts. And I'm going to continue to go on being influenced by all sorts of things.

RA: I accept that. I have myself never said that your work is Abstract Expressionistic. On the contrary, I believe that it is important to go beyond Abstract Expressionism in order to understand your work. At first glance some of your work may appear to be 'abstract' or 'abstract expressionistic', and therefore some people may read your work this way. But to me the influence of Abstract Expressionism is superficial, it's only a camouflage. It's a beautiful camouflage beyond or within which there is something more . . .

AW: I hope so. I hope so.

RA: There are specific shapes and forms which you have consistently used in your work. These shapes and forms might have been derived from pre-Columbian artefacts, but their symbolic meaning is not very clear. They become significant only when one realizes their fragmentary nature, the way they float in space as if they have

been thrown out into it with a big explosion. Your use of colours, brush strokes, and the way the whole thing is constructed, all add up to this realization; as well as create a style which is peculiarly yours. But we must see if there is anything more beyond an individual style.

In most of your work, particularly that which is often described as 'abstract', there is frequently a centre surrounded by glowing, out-of-focus colours which often move upward. The rest of the canvas is filled with what appears to be broken or burnt pieces of wood, mixed with fragments of things which are not easily recognizable. But, these are the kind of things one would see when there is a fire or a destruction taking place due to fire. Am I right then in seeing the existence of 'fire' in your work, particularly as an icon used in various ways to signify multiplicity of meaning? This may be the central clue not only to the understanding of your insistence that the work is informed by your interest in pre-Columbian culture but also its significance as a modern work of art.

AW: Good. Good. Very perceptive.

RA: I think your discomfort with the European presence in your work is understandable. It is part of our desires to get out of the colonial past, and yet we remain caught in its continuing legacy producing new forms of domination. We can't get rid of it even when we want to. It's a situation which prevents us being what we want to be. The question of identity often crops up in this situation. Are you also concerned with this question?

AW: It's more than just a question of identity. The human predicament in the post-colonial environment is so profound that it is a double negative. One can feel a private tragedy of being manacled, and still with a bandage around your mouth. And outside oneself there is this whole colossal problem of social and ecological nature. In this respect I think that the post-colonial artist is the true voice of the world. But he often not only fails to recognize this, he is unable in nearly every case to put on the mantle. Even if we put on the mantle, the establishment has the means of still making us fail . . . Only the Mandelas are still their true selves. But the day Mandela is let out, he is doomed. We have this incongruity. You see, what I mean.

RA: But that does not mean to say that we should give up the struggle.

AW: No, the struggle is part of our lives. To breathe, to drink water you have to struggle. So it is already part of our lives. It is not something we take on. With our inheritance of chaos we have no choice.

RA: You mean the colonial inheritance.

AW: Yes. Within this inherited chaos, we still have to work inside the environment of the home ground of the overlords. So, we automatically find ourselves fighting on two fronts: fighting the complicity of our own people and fighting the overlords at the same time. If this is not a plan for failure, then I don't know what it is. And yet we have to continue with the struggle. We are saying to the establishment here in Britain: this is what you have ignored. This is what you have purposefully tricked our people, into not realizing what we have achieved in this country. And at the same time I say to our people: this is what you had all the bloody time and what the fuck did you do about it? I'm not here only talking about myself and my work. Think of all those artists who came from Africa, from Asia and from the Caribbean. They all thought this was their mother country. What happened to them? But I

have not lost hope. This is why I find myself keeping on painting . . . Now you understand something about my work and you know there is not much romance involved in it. I don't allow the economic factor to affect my work. And I don't subscribe to the isolation of the artist and the cult of the artist's suffering – like the artist who is drunk all the time. Never, never in my life have I allowed these concepts to enter into my life. My life now is a growing realization of attempting the impossible; and yet I do it every day. The economic deprivation is no longer a shame or embarrassment. It's a great source of justified anger, man! I can say I have done something significant for which I deserve recognition. Like Othello. I can say I have done the state some service and I demand some payment.

RA: I want to get back to the question of identity, if you don't mind. It looked like the question of identity was not very crucial to you. It was perhaps not the cause in creating a shift in your work, from what has been described as 'abstract' to your recent work in which you have explicitly used iconographic material from pre-Columbian cultures . . .

AW: There has been no shift. It's only an emphasis, a return to the emphasis of what I have always considered fundamental to my work.

RA: Okay, I accept it was a shift in emphasis.

AW: It happened because I said to myself: what the fuck are you hiding? What are you doing, man? Why don't you put the damn thing down there? Why are you dressing it up?

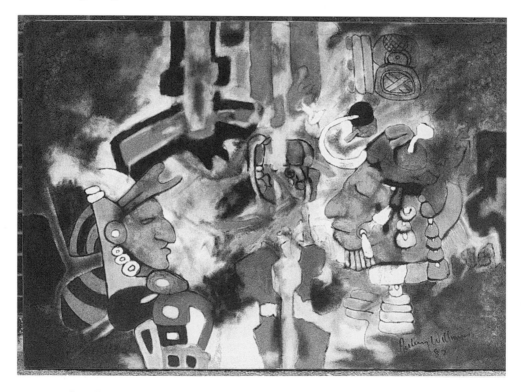

Figure 39.4 Aubrey Williams, *Maya Confrontation II* (1982)
Source: Photo by Rasheed Araeen

RA: But why the Maya or Aztec? Why not Africa?

AW: Because this is my field of study. This is my subject. Now let me tell you something about the Maya. Let me tell you something vital about the Maya . . .

RA: No, no. You don't have to go into all this. The point I'm raising is different . . .

AW: It's very crucial what I'm saying. *Why the Maya?* like those people who say to me, *why Shostakovich?* And I have to answer. I have all the five races inside me, but the dominant one is West African – Ghanian or Nigerian. Flowing through me are all these things, but the question is to which pole I give my identity direction. I have to give it to Africa, because that's the predominant part of me. My history is the black history, by 'black' I mean those who have been persecuted as slaves: fifty millions in the middle passage that nobody bloody well talks about. We hear of holocausts and we hear of six millions and we hear this and that, but who talks about fifty millions. You know, around fifty millions were thrown into the middle of the Atlantic. Don't worry about that odd millions killed on the plantations. That is my black history . . . But when a Guyanese or a Jamaican puts on that dashiki or a fez and says 'I'm African', he is synthetic. He is so synthetic, it isn't true. You understand? It's fake. Africaness is put on with the dashiki and it is taken off with the dashiki . . .

RA: There is nothing wrong with 'synthetic' identity. And it is also understandable why so many people turn to their countries of origin for roots and identities. The problem with this kind of identity is that one gets trapped in what I call 'ethnicity'. Okay, you are not putting on an African dashiki. But it can be said that you are putting on a pre-Columbian dashiki. How would you answer to that?

AW: I don't have to answer to that. What else have I got? I have come out of South American earth, South American history and South American happening. I have drunk that water and I have eaten out of that earth. No, I'm just being myself. But nobody will accept that. Not even you: you question it, you see. But there is no other driving force in my art. The other things are ancillary to the burning urge inside here, to draw parallels between the Maya mistakes and what I find happening in the modern humanity.

RA: I didn't mean to say that you were putting on a dashiki. Not at all. For me your use of pre-Columbian iconography is profoundly significant. I wanted to disentangle this from the question of identity, both racial and cultural. There are complex layers of metaphors but they are not easy to separate . . .

AW: So you agree with the use of . . .

RA: Yes.

AW: No, the Maya metaphor. Especially the Maya metaphor, when I say we are involved in the repetition of the Maya mistakes.

RA: It's not a question of my agreement or disagreement. The choice of metaphor is yours, and its significance should come out from the reading of the work I think we can learn things from past history. If in the past we have made mistakes as human beings, it would be stupid to repeat them. What I'm interested in here is to find out how these things are articulated in your work and what the significance is of your work for us today.

AW: But what I'm saying here is that it's too late. Even if you try to learn today, it's too late.

RA: But then what is the point of all this?

AW: Now listen. Here is what I see when I say we are involved in making the Maya mistakes. The Maya civilization could not keep up with its technology, and the technology took control of the environment and destroyed it. We are doing the same thing today. We are fast running behind our technology. Now my work is a synthesis of these two things, a modern consciousness that incorporates our Maya past and also considers our human future.

RA: I can see that your work alludes to some kind of destruction, even when it apparently looks very sensuous and beautiful. This was something I was hinting at when I pointed out the existence of fire in your work. Fire is something which is very beautiful to look at. It is warm and it's the fundamental source of energy. But it's also destructive and signifies destruction. Your work has this duality. This is something which was lacking in Abstract Expressionism . . .

AW: Not even Pollock? You won't even give Pollock that?

RA: No, I don't think so. Pollock had nothing to do with destruction.

AW: Not even Matta?

RA: Oh, yes, Matta is different. I was actually going to ask you if there is any relationship of your work with Matta. I mean in formal terms. I ask this question because some of your work does sometimes remind one of Matta, though superficially. And I know you have been interested in Matta's work.

AW: I have always found Matta in common terms. A big brother! We were both suffering from the effects of the same virus, and I felt comfortable with the work of Matta. But I didn't really see an original Matta until he showed his work in London in the 1950s.

RA: What interested you in Matta's work?

AW: I think it was a colonial thing. Maybe not colonial; it was something coming from South America. If you can equate it with German Angst, I don't know. I will give that to you.

RA: I don't think there is German Angst in Matta's work.

AW: No, no, no; if you can *equate* it? I'm not talking about German Angst in Matta. I'm talking about the thing that I have in my work as well, the fire in the belly: this anxiety. It's a South American thing. I feel it.

RA: I think you have used the word 'anxiety' before in relation to your own work. Now you are talking about this anxiety in relation to Matta. You are also saying that this is very specific to Latin America.

AW: It's the smell of old blood. I think so. It's the smell of the presence of the conquistadors. It's the smell of a loss, and a replacement of lesser than what was destroyed. It's a quality coming out of forced change, a displacement of identity. Violation and yet new growth asserting itself, but never profoundly, never being able to overcome what it's up against. It's a whole lot of things. It's a big galaxy of human consciousness.

RA: It has been suggested by some critics that Matta's vision is apocalyptic, which is to do with our modern industrial and technological world. Sometimes I find it too obvious in Matta. Your own work is somehow more difficult to read in this manner, although I think you have a similar vision. How do we relate this apocalyptic vision in your work to our fear of the destruction of our own present world, the earth.

AW: Good, good. I give you that. It's coming into the technological world, rapidly, and more and more. If there is any change in my recent work it's because of my

preoccupation with parallel situations in human history; the parallel between the dynamic of early human positions and the incongruity of our modern technological age. There is a strange dichotomy because the separation between these positions is slightly fanciful and romantic. However, at the core of my work is the information which is pragmatic . . . You will see all sort of things in my work: water, fire, debris – physical and terrestrial, bones of dismembered skeletons, fragments of things and so on. There are burning structures and flying ashes as part of cataclysmic explosions. You will see things decaying. There is also ever present something that I can't get rid of, because of my years of preoccupation with volcanoes, with magna volcanic erruptions, molten rocks, lava etc. I'm still interested in astronomy and cosmology. All these things are there.

RA: There is no reason to deny any of these things you have talked about. But in the end these things become significant only when they have to do with what you yourself call your anxiety, and this anxiety is about living in the modern world. You are not talking about the destruction of cosmos. You are talking about this earth and what is happening on it at the present time . . . The anxiety you talk about is the anxiety about the destruction on earth, the destruction of human civilization. You have said in one of the catalogues of your exhibitions and I quote here: 'a people who produced a technology and cosmology from which we are still learning; these people vanished in a very short span of time . . ., exactly the position we found ourselves in today'. You were referring to the Maya civilization. However what I find interesting and puzzling in your work is the strong sensuous element, the beautiful sensuous colours which somehow camouflage the full impact of the horrors of the colossal destruction you perceive. Are you suggesting by this that we have the capability to correct the whole thing?

AW: I don't see it that way . . .

RA: Are you then a pessimist?

AW: If you want to give it a word. I feel I'm an actualist rather than a pessimist.

RA: Let us imagine a burning house, with flying debris all over the place. If we take colour photographs of the various parts of this burning house, some of the photographs might look like some of your own paintings. I find this connection between your work – particularly the one which is often described as 'abstract' – and photography very interesting. In some of your work colours look like out-of-focus colours in photography, which to me imply a 'distance'. You need to take a distance while watching a burning fire. However, it appears that you are somehow *attracted* to this burning house, in a way that takes pleasure from watching its destruction. This comes out from the way the sensuous aspect of the whole thing is enhanced by beautiful glowing colours.

AW: Now you must be careful. It's not pleasure. It's excitement. Excitement is not pleasure. It's a tragic excitement.

RA: Whose house is on fire?

AW: How could you ask this question when we don't own anything in the first place. So whose house? The question is irrelevant.

RA: Let me put this differently. I'm sorry if I'm being persistent. Your work is complex: it appears to have a lot of what you yourself call incongruity. It is full of paradoxes. What I'm trying here is to try to disentangle some of them. So, please bear with me. In your recent work, what you call the Olmec-Maya series, you have

recreated characters from pre-Columbian civilizations, and you have re-presented these characters by superimposing them upon or in conjunction with the images of burning and destruction. This reminds me of burning Rome being watched by Nero. Who is Nero here? Are we all implicated here? Are you saying that we are all watching a destruction and doing nothing? In fact, from the enhanced sensuous aspect of the work it appears that we are involved in taking a narcissistic pleasure in this destruction.

AW: I feel that we are waiting for the big bang, racing towards the death with galloping speed . . . The analogy with Rome is a weak one, but it's true. I don't think that the loss of Rome was such a big thing.

RA: My reference to Rome was only to point to what appears to be an aspect of celebration in your work.

AW: Oh, oh!

RA: Why is the work so beautiful, *decoratively* beautiful? That's what I mean by the paradox . . .

AW: Oh, it's very Zen! It's yin and yang! Let us look at it as a real thing. To me it is a real thing. It's something you can hold, you can come to grips with. The dynamics in my work are automatic. I have no control over them. But I have some control on expression. If you see many negative facts, they are predominantly with me. They are on the top of my consciousness. This anxiety is growing everyday. Now, if at the same time you see beauty, it is the beauty of fire, it's the beauty of a storm at sea, it's the beauty of lightning . . . It's the beauty which is very dangerous, because it's the beauty of things which are out of your control. This is the paradox; this is the incongruity. You can't parcel it away, and put it in a safe category.

RA: What do you expect from the audience when they look at your work?

AW: Anything. Negative or positive. To hate my work or to love it. To be excited by the work. But to understand, that's different. Understanding incorporates interpretations, identity, examinations, isolation and description of all sort of things . . .

RA: The understanding bit is not easy. I know. It took me a long time before I was able to pick up the bits and pieces. My first response to your work was an excitement. It was in 1971, when you showed your work at the Camden Arts Centre. My first impression was that it was an original work, which at the same time was beautiful – although this 'expressionistic' thing is not my cup of tea. But I don't allow such things to interfere in my appreciation and understanding of other artists' work. I now want to talk to you something that I felt then, about which I did talk to you sometime later (perhaps in a pub), but you were not interested. You just shrugged your shoulders.

One of the things which I felt then, in 1971, was that the size of your canvas was not large enough; as a result of which things were compressed. They wanted to explode, but somehow they couldn't within a small space. In a strange way the work contained repressed energy, and somehow you were keeping the lid on.

AW: I'm glad you have used the word 'felt'. Yes, it was like a prison, like a dream. But it was also due to economic reasons. Eventually I had to come out off the small canvas.

RA: I know you have been using large canvases all the time, and you have also done large-scale mural works – in Guyana, America, Canada, Jamaica . . . But it seems that the real explosion came with your work that was inspired by Shostakovich's

music. Was this because of the large canvases you have used in this series or was it the music?

AW: It's news to me that you see a great liberation in my work with the Shostakovich series. I never thought of it that way. I thought my work had become more free slowly and slowly without the big jump you are talking about. I admit that the Shostakovich series was a big breakthrough for me, but it was not *the* breakthrough. I feel that the development of my work has been slower; there has been nothing sudden. It has been a growing thing all the time. And I hope it will go on this way all the time, even if I find myself in my nineties . . . My work on the music of Shostakovich was not due to my discovery of something new in Shostakovich's music. It was more a realization of common concerns and perceptions in *our* work. I always found myself in sympathy with his vision, which became a source of inspiration for me. Shostakovich's music did not give me a new direction; and the basis of my work has always remained my interest in pre-Columbian culture.

RA: Is there anything apocalyptic in Shostakovich?

AW: There is; there is a great apocalypse in Shostakovich, all the time. That is why I say, there are parallel anxieties involved in both of our work.

RA: So, it was the meeting of two similar minds. Actually, I didn't myself think that there was anything new in your Shostakovich series, except that the work had become bigger and much more confident. The size of the canvas looks the right size, and what I called the repressed energy has fully exploded. One can now see the disintegrating and fragmenting structures surrounded by fire more clearly.

AW: When I was doing the series, which took me ten years to finish, I was in a wild unknown world of sound. I have carried on with large canvases in my Olmec-Maya series, which is the recent work you have seen, but I still feel restricted by the size. I feel I would have done better with bigger canvases. I don't know where I will be going from here. I might eventually need a whole large wall to paint. Inside me I have always felt myself a muralist. I feel that my creative revolution will come in mural painting. This yearning for bigger space may be a lack of control, but I'm not worrying too much about it.

RA: One of the points I made earlier was that the relationship of your earlier work with pre-Columbian culture was not clear. At least I didn't first see it. I now know that you have consistently used 'fire' as a symbolic icon from that culture, and this may partly be due to your stay with the Warrau tribe before you came here. We also know that 'fire' was an important part of pre-Columbian mythology – such as the 'Sun God'. In your recent work, the Olmec-Maya series, this relationship is much more direct. If this emphasis on your relationship with pre-Columbian culture is also to do with a need for cultural identity, why was this not so important in your earlier work?

AW: There has always been this relationship.

RA: But somehow it was not expressed so explicitly, as in the recent work.

AW: Now, you have stumbled on the edges of the crux of the real matter. The crux of the matter is that inherent in my work since I was a boy has been the human predicament, specifically with regard to the Guyanese situation. The Guyanese people who in their strange way have been sort of living in the emerging Third World, and wherever you go you will find them part of the struggle. What I'm now

talking about in the case of the Guyanese is that this Guyanese diaspora is active in the arrowhead of change in strange countries they find themselves in. . .

RA: Yes, you will find them all over the world. Isn't that because in Guyana itself they cannot realize their full creative potential?

AW: All right. Good question, very good question. But when you start to think of it you will find that this is really a Third World incongruity. It's part of the continuing colonial syndrome. Do you see what I'm driving at?

RA: Yes.

AW: Mainly due to their own efforts and with very little bloodshed they have the country back, and now the problem is in their laps. They now have the problem of identity. They also have the problem of isolation, purpose of existence and so on. A high percentage of inheritance we have is from the colonial landlords. In other words, what we have inherited is chaos. You know, it is convenient to be handed back what was originally yours but only after the life blood has been squeezed out of it. You have been given back the garbage and you are being held up to the world as being incapable and useless, a drain upon other people and so on. You have this terrible tragic incongruity, and then the world – including your own people – is demanding from you a profound identity and dignity. Added to this is the feeling of guilt for allowing yourself to be put into that situation in the first place, because we have to bear some responsibility. We can cry out that we were badly done by, but at some point it would have been better to have been dead than to have survived out of that nastiness. If I were now in South Africa I would go against the gun. It's better to be dead than to be a non-entity on your own earth, you know . . . These are tragic things. So, if you accuse me of the tragic and pessimistic in my work, it's being fed by the recognition of all these things. My work is sometimes pessimistic. I can't help it.

RA: I'm not *accusing* you of pessimism or anything else. I have been trying to point out various things in your work, which I think are the dynamics of the work.

AW: You have seen, in the film, what a beautiful country Guyana is. You know, it has been raped. But not completely – it's still beautiful. Now all the faults are with us, with humanity.

RA: I agree with your explanation, Aubrey; why there are tragic and pessimistic aspects in your work. Why the things are in a state of breaking up, fragmentation, and why things are on fire. It's very much to do with the post-colonial situation and the diaspora it has created for so many people, like us who cannot stay at home and identify with the system that has been forced upon us and under which it is not possible to realise one's creative potentials.

AW: In this game you could be killed, just maintaining yourself and your dignity. Survival then becomes a very important thing.

RA: Okay, that means there is nothing mystical or mysterious in your work. Your work relates to the concrete human situation and a particular period in our own history. However you haven't fully answered my earlier question: why did the question of identity became so important *only* in the recent work?

AW: I'm only trying to recognize the problem here. It can't be isolated, from other things. I have purposefully made a step backward. Oh, I can see you don't sympathize with this! This is very difficult and I have to be very careful. I should be very emotional about the whole thing, but I have to be careful. Now listen, about ten

years ago I suddenly realized that I was only *making* paintings. It became hard, you know, realizing that one was in danger of making paintings, like making wall furniture, making things career-wise, making things out of ego and hiding it with borrowed plumes. You know, hiding it with a gloss of that borrowed Germanic mannerism, being skilful out of what you had learnt, and not telling the real story and not being honest with yourself. I said to myself, 'why are you doing this?' So, I drastically decided: 'ah,what the hell! I will go right back so that my work is no longer recognizable. I will go right back and do figuration in painting, rendering into it the symbolic artefacts of my own past culture.' One could go into an old barrel and pull out things, dress them up and present them under different aspects. But one can't just do that, if one is a child of one's own time. This big jump, this wonderful artistic jump, I know that it's not total. It's not total because I had to deny many things to do this, but I have come out of it with something which is the best of both worlds.

I came out of it and I stand where I am now. It's a revitalization because I'm feeling assertive and knowing more of where I am now, and where I am now is a bigger total than where I was before. It's the biggest total I have had so far, because it incorporates my many interests in life – astronomy, topography, geology etc. as well as the various happenings in my life, my interest in modern technology and the change it is creating, the anxieties and tragedies of our time. I know that the sea now is 38 per cent polluted. We live off the sea and we can't now turn the clock back. It's getting worse everyday. Our resources of oxygen are shrinking, and it can't be reproduced. We have now also punctured the last source of oxygen which is the South American Selvas by building that stupid road through the Amazonas. We have done colossal ecological damage: turtles are laying their eggs in the sea, whales are beaching themselves everywhere. Pollution is beyond our ability to reverse. Cosmic rays bombardment is growing and we have no shield against its harmful effects; so leukemia will be like the common cold. Already we have respirators in the biggest cities of the world. And we are only waiting to see the first one put down here: push in 25p and you get ten breaths of pure oxygen. We are seeing the terrible catastrophies of man-made diseases. What more do you want? When the AIDS count becomes 50 per cent the next step would be total. All these anxieties inform my work all the time. That's my living. Why am I then putting colours on to surfaces and saying this is important? It's only important what it makes people realize from it. This is why it's also my anger to be stratified as an artist in this society. Why my work is not seen in important places? A painting which is faced against the wall, is a dead painting. It might as well not exist. And I feel a shame, because if I want my paintings seen I should have the nerve to put them up against the pavement for people walking along to see them.

RA: So, you wanted to make your anxiety, your fear and anger, more explicit and more direct, and in order to do that you found it necessary to use a metaphor from the destruction of a past civilization. It was not merely the question of search for cultural identity, but the search for an identity which has very much been part of the whole creative process. You have used images, iconographically, which can be historically related to a Guyanese person. But what is more important, as far as I'm concerned, this relationship is not predetermined nor is it taken for granted. And that is why there are so many different things in your work, and the significance of

the work does not come out of only reading the images in terms of a specific iconography – Maya or whatever. There is an important paradox involved in the way two different traditions are juxtaposed, but at the same time there is also a parody involved here: as if Maya gods have resurrected themselves in order to witness the destruction of our modern civilization. Are they now taking revenge on us? Anyway, would you have used iconography from European traditions?

AW: That would have been borrowing. I'm not borrowing when I go back to pre-Columbian artefacts. However, the images are altered in a European way. They are Europeanized. In other words, they are lying gracefully.

RA: Why do you say that the images are altered in a European way?

AW: They are glossed over with European angst, European psychology, European everything, because I'm still a captured individual.

RA: Yes, but we can't escape from not being part of our time, not being part of the dominant culture – which is Western culture. So, you can't really say: 'okay, I will turn my back to everything that is European and produce something which has nothing to do with it'. I don't think this is possible.

AW: Well, we use Western material. I can't go back to grinding pigments and using fats. It would be stupid. You have to use modern material.

RA: But, Aubrey, I don't see anything wrong with the European connection. It's not inauthentic. And I don't see that there is any compromise in terms of the work being related to Western culture whatsoever.

AW: You mean the Western presence is not there?

RA: There is a European presence, of course.

AW: There is. I can't get rid of it.

RA: You don't have to. The significance of your work is in fact in the interrelationship between the European presence and what you call part of your own cultural history. It's a *critical* relationship.

AW: I'm not interested in the European adherence. I'm not interested. I pay respect to European achievement in visual arts as I do to other cultures such as Egyptians, Indian or Chinese.

RA: Why do you find 'the adherence' to European art in your work disturbing?

AW: Because of the historical background.

RA: Are you trying to get rid of it?

AW: All my life I have been trying to get rid of it.

RA: Can you really get rid of it?

AW: I don't know. If we can get rid of it in ourselves, it will be a great achievement. I don't think getting rid of economic structures or changing them is enough. We have to find new values, new directions, which we can now do only with the coming generations. Not so much with ourselves. We have to get the machinery to do this, a platform, you understand?

This article was originally published in *Third Text* 2 (1987) © Rasheed Araeen.

40

WRITING HOME

Reconfiguring the (English)–African diaspora

Jayne O. Ifekwunigwe

> We cannot escape our origins, however hard we try, those origins which con-
> tain the key – could we but find it – to all that we later become.
>
> (Baldwin 1955: 27)

'Where are you from?'
On an empowered day, I describe myself as a Diaspora(s) daughter with mul-
tiple migratory and ancestral reference points in Nigeria, Ireland, England,
Guyana and the United States. On a disempowered day, I am a nationless
nomad who wanders from destination to destination in search of a singular site
to name as home.

An important and ongoing discussion among historians provides the theoretical back-
drop for this chapter. That is, certain scholars deny the notion that it was the dispersal
of continental Africans during the transatlantic slave trade which created the first and
only significant African diasporic rupture (Cohen 1997; Segal 1995). Although argu-
ably the most socially and culturally disruptive, the forced migration of continental
Africans for the purposes of labour exploitation was not the first African diaspora.
Cheik Anta Diop (1990), Ivan Van Sertima (1976) and Runoko Rashidi (1992) among
other revisionist scholars have provided ample historical and archaeological evidence
that continental Africans circumnavigated the globe – the New World in general
and the Americas in particular – many centuries before the celebrated journey of
Christopher Columbus among other explorers. These scholarly interventions pave the
way for reconceptualizations of contemporary (pre- and post-Columbian) African dia-
sporas. In turn, these periodized reformulations of African diaspora(s) carve out cogent
spaces for contemporary discourses on the English–African diaspora. In particular,
as I have defined it, the English–African diaspora conventionally comprises African
post-colonial constituents from the Caribbean, North and Latin America and con-
tinental Africa who find themselves in England for labour, schooling, political asylum,
and frequently by birth.

In kaleidoscopic fashion, this chapter turns as a series of narratives of home. In the
English–African diaspora, the idea of home has layered, textured and contradictory
meanings for 'mixed-race' individuals whom I prefer to refer to as *métis(se)*.[1] In a travel

essay chronicling his rediscovery of Britain, Nigerian and English writer Adewale Maja-Pearce wages existential war with the meaning of home:

> I had to learn as best I could to be at home, but even the word 'home' had complex connotations. Where was home? Was it Nigeria, my father's country? Or was it Britain, my mother's country? And how far did allegiance to the one involve a betrayal of the other? My inability to see was inseparable from the sense of betrayal. If I didn't look, if I didn't admit the reality of the particular corner of the world in which I happened to be, in this case Britain – 'The blessed plot, this earth, this realm, this England' – then I couldn't properly live here. This in turn meant that I was released from the necessity of confronting the nature of my allegiance because to admit Britain, to say that I was British was to deny Nigeria. I was like a man married to one woman but trying to remain faithful to another. If I wasn't careful I would lose both, and in the end I would be the one to suffer for it: to live like this is to condemn oneself to a half-life, which is the predicament of the outsider.
>
> (Maja-Pearce 1990: 12–13)

Although it is by no means definitive, in this text photopoetic chronicles of childhood, the retelling of pivotal moments which have shaped complex subjectivities, and frozen snapshots of experiences reconstituted as structural anecdotes collectively recapture particular complex, evolving everyday lived realities for *métisse* women in the English–African diaspora. However, as cumulative texts these individual evocations also illustrate the collective psycho-social problematics of a wider African diasporan angst in its specific geopolitical manifestations. Ultimately, these narratives of self locate the specific feminist standpoint of auto-ethnography: 'The notion of traveling through space is integral to the unfolding of history and the development of the individual's consciousness with regard to the past. The voyage over geographic space is an expanded metaphor for the process of one person's coming to know who she is' (Willis 1985: 220).

Points of entry/sites of convergences

Despite or perhaps because of my own itinerant *métisse* African diasporic family background, prior to 1989, my cultural perception of my birthplace and former home was, if not exclusively White, most definitely English.[2] However, in the summer of 1989, I flew to England. This time, I returned on my own and on my own terms. At the point of my arrival, I did not realize that I would depart three years later with the beginnings of a critical autoethnography:

> critical ethnographies provide another genre wherein the represented culture is located within a larger historical, political, economic, social and symbolic context than is said to be recognized by cultural members . . . autoethnographies have emerged in which the culture of the writer's own group is textualised. Such writings often offer a passionate, emotional voice of a positioned and explicitly judgemental fieldworker and thus obliterate the customary and

ordinarily, rather mannerly distinction between the researcher and the researched.

(Van Maanen 1995: 9–10)

Nor could I anticipate the profound ways in which I would be forced 'to step in and step out' (Powdermaker 1966: 15–16) of roles while simultaneously resisting the insider/outsider label of 'inappropriate Other' (Minh-Ha 1990: 374–5). For the first time my plan was not to visit family but rather to conduct exploratory research for my impending Ph.D. thesis which at that stage would be examining the emergence of political consciousness among Black youth in England. This work would take me out of the supposedly lily-white English working-class and middle-class communities which reflected my childhood, and into the more ethnically and so-called racially mixed but not necessarily more harmonious heterogeneous communities and their permutations in Manchester, Birmingham, London and Bristol. It was then that I first experienced the English–African diaspora. In short, according to Marcus and Fischer (1986: 11), what I was attempting was an anthropological 'repatriation' with cultural critique as my motivation.

My favourite expression while living in Bristol and one which I still use today is: 'As you see, so are you seen'. I think this revelation is the most fascinating aspect of doing ethnographic fieldwork. For me, it became the turning point of my research. When I returned to England, I did not have a clear sense of how I would refer to myself, whether I would identify as American or British. Until I got to know people, they decided for me. I was 'that American gyal'. Having said that, the injuries of race and colour were omnipresent in the inner-city Bristolian community where I lived and worked for two years. I was also referred to as 'that red-skinned American gyal' or less frequently 'that half-caste American gyal'. These last two expressions were meant to mark my light-skinnedness and my presumed *métisse* status. Because of the bi-racialized politics of colonialism, the residents assumed, and usually rightly so, that any light-skinned person was *métis(se)* – although this popular assumption was complicated by the fact that, in a genealogical sense, most of the residents from the African Caribbean were themselves *métis(se)*.

Who is marginalized depends on who is defining the centre. On my daily travels, I found myself meeting people representative of every facet of Bristolian life. However, I found that I made the most profound connections with individuals who lived life at what Anzaldua (1987) would refer to as 'the borderlands'. Deemed 'marginal' people, those presumed to be on the edge, seemingly unbelonging, these men, women and children were generally *métis(se)*. Some of them I never even actually spoke with. We communicated in our silences.

I eventually decided to go with the proverbial flow and focus on the poetics and politics of what I was then calling 'mixed-race' identities, thereby producing a micro-ethnography:

> Also known as focused or specific ethnography, micro-ethnography zeroes in on particular settings (cultural events or 'scenes'), drawing on the ways that a cultural ethos is reflected in microcosm in selected aspects of everyday life but giving emphasis to particular behaviours in particular settings rather than attempting to portray a whole cultural system.
>
> (Wolcott 1995: 105).

After some thought, more than twenty-five *métis(se)* people wanted to testify. However, demands of daily life affected each person's ability to commit to the project. The primary twenty-five testimonies (sixteen women and nine men) of redemption came from, first, *métis(se)* people from diverse social worlds whom I had met along the first year of my journey; second, from people I knew such as social workers, teachers, youth workers, artists who were not necessarily *métis(se)* but who knew people who might want to participate; and, third, from other *métis(se)* friends of participants.

Project participants' local synthesized individual and collective voices represent the significant part of a greater multigenerational whole comprising people in England with Black continental African or African Caribbean fathers *and* White British or continental European mothers. More pointedly, we map the specificities of the local, yet we also problematize the parameters and boundaries delimiting the local and the global:

> the local exists nowhere in a pure state . . . the local is only a fragmented set of possibilities that can be articulated into a momentary politics of time and place . . . this is to take the local not as the end point but as the start. This is not to idealise the local as the real, but to look at the ways in which injustices are naturalised in the name of the immediate. In conceiving of the local as a nodal point, we can begin to deconstruct its movements and its meanings.
>
> (Probyn 1990: 187)

Multiple occupancies: locating home base

To be *métis(se)* is to occupy several subject positions at the same time. The flesh on the bones of this section is a critical discussion of interrogations of cultural paradoxes of 'race', nation and gender by three of the twenty-five *métis(se)* participants in my two-year-long ethnographic research project in Bristol, England. The men and women who told me their stories are all of Black continental African or Black African, Caribbean (fathers) *and* White British or White continental European (mothers) parentage. They were born between 1945 and 1975 in Britain, West Africa and the Caribbean. A remarkable number have Black Nigerian fathers and White English mothers. With an increasingly bi-racialized Britain as the contextual backdrop, their narratives illuminate myriad configurations of place and belonging for *métisse* women and *métis* men in the conceptually contested English–African diaspora. However, within this conceptual space, there are no official sociocultural demarcations which either acknowledge or affirm the lived realities of *métis(se)* people. Although I spoke with both men and women, as feminist critique, here I invoke the stories of three women. By naming their gendered, class-bound, regionally specific and generation centred experiences as those of *métisse* women, their individual identity narratives become collective political testimonies:

Ruby

Marie Garson, an African Caribbean social worker, had introduced me to Ruby. Ruby is a forty-three-year-old social worker of Nigerian (paternal) and English (maternal)

parentage and the only one of the original twenty-five participants whom I spoke with exclusively in my home. This deprived me of a contextualized sense of who she was. None the less, profound sadness laced with occasional happiness are the two words that best capture my sense of her. Like many *métis(se)* people, she is a survivor – a warrior on the frontlines by virtue of her bloodlines.

She was a roll-ups smoker and coffee drinker. These indulgences helped to alleviate some of the tension during our initial talks. We sat at my kitchen table, which, along with much of the rest of the furniture in my flat, was a gift from my Igbo friend Chedi. His Oxfam shop – a second-hand shop – was closing down at the exact moment I was moving in to my place. Beyond its utilitarian functions, that table, covered with a tablecloth fashioned from a piece of African cloth I acquired at another second-hand shop, was the site for many late-night into early-morning reasoning sessions involving individual members of all segments of the community, including what a White English sociologist referred to as the Young Black Intelligentsia. However, the most provocative and stimulating exchanges usually involved *métis(se)* narrators such as Ruby:

> What is Black and what is White for me? In simplistic terms, it comes down to the colour of the skin as far as I'm concerned. I do distinguish between 'race' and culture. So, I would call myself Black and I would call myself British. Britishness is my culture, but because I'm Black I will identify more from a 'racial' point of view with other Black people. Having said that, a lot of Black people have different cultural backgrounds. Whether it's West Indian or Caribbean, African, American, there are those differences within that. I think that as Black people, I would be very surprised to come across anybody, who hasn't had some personal experience of racism somewhere in their life. In a way that a White person could not have. There's that shared understanding; that shared culture of racism that makes me feel closer to the Black community in that respect. But, I am also British, so I guess that my values, my lifestyle, way of being are informed a lot by English culture. I used to feel uncomfortable about that at one time. But, as I get older, I realize now that is the way it is, Ruby, so why apologize for it. I can't turn myself into a Black American or West Indian or something that's not who I am. Once I came to the realization that 'race' and culture are two different things, I found my own place in it more easy to define. Quite often people muddle the two together.
>
> If you're 'mixed race', if you're not careful, you can fall between two stools. Where you're English, but you're not quite, 'cause you're Black, aren't you? Or, you're not really Black are you, because you're English. You're not one of us. So, certainly if I'm talking to Caribbean friends or colleagues, or not even friends or colleagues, it comes up more with people I don't know. Where there's a taken-for-grantedness that I must be Caribbean in some way, and are amazed when there are facets of the culture that everybody knows, and I say, 'I've never come across this before.' And it's like, 'Weehhh, where do you come from?' I say, 'London.' I've found myself in life having to explain to people that I might be Black, but I'm not Caribbean. I am English. These days I don't have a problem with that.

Akousa

When I first met Akousa, I remember thinking how much she sparkled – her eyes, her smile and her presence. Her mother is White Irish, her father is Black Bajan (from Barbados). She is a Rastafarian, and yet is not seen as a typical Rasta woman. She sees herself as a Black woman and yet not everyone sees her as a Black woman.

The lack of fit between the multi-layered and textured complexities of Akousa's narratives and their flattened reduction to text reinforce for me the extent to which our lived realities cannot be contained by the four sides of the page. However, with Akousa's evocations, I have tried as much as possible to capture and preserve her Scouse (Liverpudlian) accent, her vibrant sense of humour, her ability to 'reason' (wax philosophically about life's issues) and the natural rhythm of her testimonies about 'race', colour, class and gender politics:

> I think my mother has been good. As a White woman in this society and comin' from where she comes from, I think my Mum has done really well. Because I have seen other people who have had dire problems with their White mother. Their mother has turned them against their father because their father wasn't around – he took off. I mean, my father wasn't much good, but my Mum didn't prevent us from seein' him. She didn't heavily influence how we decided our relationship would be with him.
>
> The other thing was that me Mum cooked Caribbean food. We got a mixture of Caribbean and English or Irish stew. We got rice and peas every Sunday like everybody else, and afterwards on Monday. The soup on a Saturday sort of syndrome. Culturally me Mum did take on certain aspects of Caribbean culture. She didn't have a lot of White friends around her. She had one or two. The people we knew were Caribbean people. Also I didn't have a White extended family in the same way a lot of other people did. So, I didn't have all that to deal with. My extended family was a Black extended family rather than havin' this other White family. I didn't have those issues that other people might have to deal with within their own family structure. My Mum was the only White person within the family. She took on board a lot of Caribbean culture. We went on all the trips with the cricket team and we brought our cooked rice and peas and chicken. Basically there was a Caribbean upbringin' in some respects – not totally. Because at the end of the day, my Mum is not a West Indian woman. So there were certain aspects to Caribbean culture that I didn't start on, because she didn't have that. My Aunt Hyacinth provided certain aspects of that instead. I had two that were there growin' up.

Bisi

I met Bisi through an American woman in exile in Bristol who by virtue of our similar backgrounds and accomplishments in the arts thought we would enjoy meeting each other. However, Bristol being a very small city, Bisi had already heard about me through mutual friends. Her father is Yoruba (Nigerian) and her mother is from Northumberland, near Newcastle. What Englishness means to Bisi as well as the other individuals I worked with shifts, changes and is renegotiated as they progress through

life's stages. At the same time, Bisi has matured as a visual artist. This maturity necessitates accepting the lived impact of certain Eurocentric influences which in turn creates space for artistic production, which is quintessentially a synthesis of cultures:

> All the conscious input I had about art until very recently was from Europe. It's only now that I have been in Bristol and I am much more conscious of a Black identity in myself than I was then. Very much more conscious. I have been able to see a relation in the way I'm thinking and the tradition of African art. To be able to see that there is a real, not a false relationship, an organic relationship. That I'm influenced by these things rather than something I was really impressed by and thought, gosh, I must learn how to do this. If you're a 'mixed-race' child growing up in an African country, you are told in no uncertain terms that you are White. White is what you are and will remain, and there is nothing you can do about it. It doesn't matter, even if you did speak the language. Even if you did wear the right clothes. Even if you had nothing distinguishing culturally, you still know very well that White is what you are.[3]
>
> Whereas, coming to terms with a Black identity in Bristol, you have a lot of things within you to cope with. One of the things you have as a coping mechanism is your identity as a member of a family, as a child of a family, who has been given a name more or less by the head of the family. You have a place there. You have that, which is actually not a part of your 'racial' identity. What the 'race' of the family is is incidental. The fact that it was a Black African family has certainly . . . Let's see, supposing I had grown up in Britain, except I had a White extended family and I knew my place in that family. I had been given a name say by my mother alone, which my grandmother had then changed, say, to a pet name. Then I think a Black identity would have been a lot more problematic. One gets to the point where one realizes that you cannot a hundred per cent identify with a White culture.[4] You have to go and look and find and seek that Black culture from somewhere. If you can't find it, then you have to synthesize it, which I think many people here have done.[5]

Conclusion

Depictions of *métisse* existences of this kind rarely if ever appear on the pages of sociological or even ethnographic studies. Ruby's, Akousa's and Bisi's reflections are poignant and potent examples of what is possible when we disaggregate 'race', ethnicity and culture and work with them as mutable, negotiable and interactive analytical categories with inseparable relationships to gendered dynamics of power.

At the same time, their normalizing accounts of private familial relationships as well as their critiques of public social interactions place gender at the centre and correct pathological distortions of *métis(se)* family lives and individual circumstance. Overall, the women's rememberances, located in both colonial and post-colonial contexts, shed light on the complexities of continental African and African Caribbean diasporic social and cultural life too often distorted by historians. Their transnational identities represent their family constellations as well as their individual experiences. These trans-nationalities challenge the very notion of the English–African diaspora as a static and

unitary formation which obviates cultural, national, ethnic, regional, and class differences, among others and, of course, ignores interracial collaborations. The *métisse* women reinsert themselves as active subjects, creating their own place in the retelling of English–African diaspora histories. A mosaic of cultures and histories is emblematic of their multiple reference points. This multicultural and diachronic scheme reflects the complex realities of all post-colonial, transnational people in the English–African diaspora and beyond.

Acknowledgements

As my intellectual ideas continue to evolve in their maturation they take on new conceptual shapes and forms. However, I extend sustained and endless gratitude to all the *métis(se)* women and men who generously gave their time and excavated sites containing painful and joyful memories in order to force a public/private join of ideology and praxis. The final reworking of this chapter has benefited from critical insights and feedback from both Kwesi Owusu and Tunde Jegede.

Notes

1 The term *métis(se)* is a 'French-African' in particular Senegalese, reappropriation of the continental French *métis(se)*. In translated continental French, *métis(se)* is synonymous with the derogatory English 'half-caste' and 'half-breed'. See Pierre Henri-Cousin *Diamond French Dictionary* (London: Collins, 1994): 160. However, redeploying this term demonstrates the portability and mutability of language as well as its potential reinterpretation across national borders. My linguistic informants, comparative literature professor Samba Diop and cultural critic and ethnomusicologist Henri-Pierre Koubaka are Senegalese and Senegalese/Congolese respectively – that is Black continental African. What they suggest is that alternative translations of *métis(se)* both include and can extend beyond bi-racialized, that is Black/White, discourses to encompass diasporic convergences across ethnicities, cultures, religions and nationalities.

 In an English context, I offer *métis(se)* in part as a specific shorthand stand-in response to what I believe are the inadequacies of previous terms. In other publications (Ifekwunigwe 1997; Ifekwunigwe 1999), I have discussed the shortcomings of the extant terms such as 'mixed race', 'mixed parentage', 'bi-racial', 'dual heritage', etc. However, the primary reason for installing *métis(se)* as a lexical intervention is to free me momentarily from the tangle of terminology so that I may address more pressing and in fact derivative concerns such as racism and bi-racialization. Perhaps from this we may imagine a future entirely free of the reinscribing badges of bi-racialized differences.

 In short, for purposes of analyses, in the English–African diaspora, *métisse* (feminine) and *métis* (masculine) refer to individuals who according to popular folk concepts of 'race' and by known birth parentage embody two or more worldviews or, in genealogical terms, descent groups. These individuals may have physical characteristics which reflect some sort of intermediate status *vis-à-vis* their birth parents. It is more than likely that at some stage they will have to reconcile multiple cultural influences.

2 Two of the major assumptions challenged by the narratives of home are that Whiteness is the normative and naturalized signifier by which deviations of Blackness are determined and that Englishness is synonymous with Whiteness.

3 As they appear in my book-length publication (Ifekwunigwe 1999), in her stories, Bisi's sister Yemi recounts several examples wherein she was treated as a White woman. The most comical and ironic incident, since Yemi speaks and understands Yoruba, occurs when she and her White American friend go to the local market to buy haberdashery. A young Yoruba woman, speaking in Yoruba, is making a play at the darkness of her own skin and the

lightness of theirs – these two 'White women'. This example illustrates the ways in which many Africans have internalized the colonial complex of Black inferiority and White superiority. As Fanon states: 'Out of the blackest part of my soul across the zebra striping of my mind surges this desire to be suddenly White' (Fanon (1967), 63).

4 Like many *métis(se)* people, Bisi has reached that critical point wherein she can recognize the ways both within her family and in society at large – in which White English culture has been privileged. She also knows for the most part that White English society does not notice nor rather care that her birth mother is White English. This biological fact has no cultural capital in a bi-racialized society which designates entitlements on the basis of phenotype. Unless, of course, as she mentions, they are looking for a token 'good nigger' then as a 'light-skinned' woman with a White English husband and four 'White' children, she is more acceptable than someone deemed 'full Black' by appearance. In short, she is considered less threatening than a person with two Black parents. Most importantly, Bisi's individual awareness of endemic bi-racialization in England in general and Bristol in particular has also made her collectively conscious of the ways in which English society writ large systematically denies her and other Black people access to certain resources – jobs, education, utilization of the arts etc.

5 Bisi's notion of a 'synthesized' Black culture corresponds with my ideas about 'Additive Blackness'. Many *métis(se)* people, as well as perhaps those who have grown up in care, or in predominantly suburban areas, have grown up in a social context wherein Whiteness is qualitatively and quantitatively valued at the expense of Blackness. When the forces of bi-racialization, leaving home or other transformative factors lead a person to question their predominantly White English upbringing, that individual frequently reacts by seeking out what they perceive to be an oppositional at times 'hyper Black' identity. However, this act of reconciliation is most successfully accomplished after the individual has accepted the fact that their psychocultural starting point has been for the most part White English. Unfortunately, many *métis(se)* individuals feel they must abandon both their White English parentage and their White English cultural roots in order to 'become Black'. When in fact, most project participants' testimonies reveal that a reformulated Black identity with an acknowledged White English reference point – a 'synthesis' as Bisi says – is generally in less conflict with the overall process of self-transformation than a process wherein White English parentage and White English cultural influences are denied.

References

Alibhai-Brown, Yasmin and Montague, Anne (1992) *The Colour of Love: Mixed Race Relationships* (London: Virago).

Anzaldua, Gloria (1987) *Borderlands, La Frontera* (San Francisco: aunt lute press).

Appiah, Anthony (1990) *In My Father's House: Africa in the Philosophy of Culture* (New York: Oxford University Press).

Baldwin, James (1955) *Notes of a Native Son* (Boston: Beacon Press).

Benson, Sue (1981) *Ambiguous Ethnicity: Inter-racial Families in London* (Cambridge: Cambridge University Press).

Brah, Avtar (1996) *Cartographies of Diaspora* (London: Routledge).

Camper, Carol (ed.) (1994) *Miscegenation Blues: Voices of Mixed Race Women* (Toronto: Sister Vision).

Chrisman, Laura (1997) 'Journeying to Death: Gilroy's *Black Atlantic*', *Race & Class* 39, 2: 51–64.

Cohen, Ronald (1997) *Global Diasporas* (London: UCL Press).

Colker, Ruth (1996) *Hybrid* (New York: New York University).

Davies, Carole Boyce (1994) *Black Women, Writing and Identity* (London: Routledge).

Diop, Cheik Anta (1990) *Civilisation or Barbarism: An Authentic Anthropology* (New York: Lawrence Hill).

Diop, Samba (1993/1998) Personal communication.

Fanon, Frantz (1967) *Black Skin, White Masks* (New York: Grove Press).

Gerzina, Gretchen (1995) *Black England: Life Before Emancipation* (London: John Murray).

Gilroy, Paul (1993) *The Black Atlantic* (London:Verso).

Ifekwunigwe, Jayne O. (1997) 'Diaspora's Daughters, Africa's Orphans?: On Authenticity, Lineage and "Mixed Race" Identity', in H. Mirza (ed.) *Black British Feminism* (London: Routledge): 127–52.

Ifekwunigwe, Jayne O. (1999) *Scattered Belongings: Cultural Paradoxes of 'Race,' Nation and Gender* (London: Routledge).

Jones, Lisa (1994) *Bulletproof Diva*, New York: (Doubleday).

Keith, Mike and Pile, Steve (eds) (1993) *Place and the Politics of Identity* (London: Routledge).

Koubaka, Henri-Pierre (1993) Personal communication.

Lavie, Smadar and Svendenburg, Ted (eds) *Displacement, Diaspora and the Geographies of Identity* (London: Duke University Press).

Maja-Pearce, Adewale (1990) *How Many Miles to Babylon?* (London: Heinemann).

Malik, Kenan (1996) *The Meaning of Race* (London: Macmillan).

Mama, Amina (1995) *Beyond the Masks: Race, Gender, and Subjectivity* (London: Routledge).

Marcus, George and Fischer, Michael (1986) *Anthropology as Cultural Critique* (Chicago: University of Chicago Press).

Minh-ha, Trinh T. (1990) 'Not You/Like Your: Postcolonial Women and Interlocking Questions of Identity and Difference', in G. Anzaldua (ed.) *Making Face, Making Soul: Creative and Critical Perspectives by Women of Color* (San Francisco: aunt lute press): 371–5.

Mirza, Heidi (ed.) (1997) *Black British Feminism* (London: Routledge).

Powdermaker, Hortense (1966) *Stranger and a Friend* (New York: W. W. Norton).

Probyn, Elspeth (1990) 'Travels in the Postmodern: Making Sense of the Local' (London: Routledge), in L. Nicholson (ed.) *Feminism/Postmodernism*: 176–89.

Pryce, Ken (1974) *Endless Pressure: A Study of West Indian Lifestyles in Bristol* (Bristol: Bristol Classical Press).

Rashidi, Runoko (1992) *Introduction to the Study of African Classical Civilisations* (London: Karnak House).

Rogers, J. A. (1944) *Sex and Race,* Vol. III (St. Petersburg, Florida: Helga Rogers).

Root, Maria (ed.) (1996) *The Multiracial Experience* (London: Sage).

Russell, Kathy, Wilson, Midge A. and Hall, Ronald (1992) *The Color Complex* (New York: Anchor).

Segal, Ronald (1995) *The Black Diaspora* (London: Faber & Faber).

Tizard, Barbara and Phoenix, Anne (1993) *Black, White or Mixed Race?* (London: Routledge).

Van Maanen, John (ed.) (1995) *Representation in Ethnography* (London: Sage).

Van Sertima, Ivan (1976) *They Came Before Columbus* (New York: Random House).

Willis, Susan (1985) 'Black Women Writers Take a Critical Perspective', in G. Greene and S. Khan (eds), *Making a Difference: Feminist Literary Criticism* (New York: Methuen): 211–37.

Wilson, Anne (1987) *Mixed Race Children* (London: Allen and Unwin).

Wolcott, Harry (1995) 'Making a Study More Ethnographic,' in J. Van Maanen (ed.), *Representation in Ethnography* (London: Sage): 79–111.

Young, Robert (1995) *Colonial Desire: Hybridity in Theory, Culture and Race* (London: Routledge).

Zack, Naomi (ed.) (1995) *American Mixed Race* (London: Rowman and Littlefield).

FOOTPRINTS OF A MOUNTAINEER

Uzo Egonu and the Black redefinition of modernism

Olu Oguibe

No artist in the late twentieth century can lay greater claim to representing a particularly significant yet hardly acknowledged constituent in the history of modernist art – namely the non-white, non-formalist – and conceptually engaged theatres of modernist practice than the painter and print-maker Uzo Egonu who died in London in 1996 after living and working in England for fifty-one years. Though only one of a stellar cast of hugely talented, most accomplished and inimitably sophisticated artists of non-European descent who made their mark in the West in the 1960s and 1970s, Uzo Egonu was the first of these artists to move there with the sole aim of becoming an artist.[1]

In his wake, important figures like Francis Newton Souza from Goa, the Guyanese Frank Bowling and Aubrey Williams, and much later Avinash Chandra from India, Iqbal Geoffrey from Pakistan and David Medalla from the Philippines would come to England[2] and establish themselves as artists and active participants in the making of late modernism as well as the beginnings of what would eventually be known as postmodernism.[3]

Background to a new modernism

In 1945, as the Second World War drew to an end, Uzo Egonu left Nigeria for England. He was thirteen years old. The practice of sending their children abroad to acquire knowledge and grounding in the ways of Empire and its people was an increasingly popular one among a new indigenous elite in the colonies at the time. From India, colonial Africa and other parts of the European imperial realm, young men and women travelled to the centre of Empire to study and prepare themselves for leadership roles in their own countries. This practice proved particularly fatal for Europe, as many of the arrivants used the opportunity to ready themselves for the most concerted challenge to colonial rule in history, a challenge that would in less than two decades bring about the collapse of the European colonial project.

Writing about the Guinean anti-colonial leader Amilcar Cabral, who arrived in

Lisbon the same year to study at the Higher Institute of Agronomy, and eventually dealt a decisive blow to Portugal's colonial mission in Africa, Mario de Andrade describes the immediate postwar period in Europe as 'the great era of the affirmation of differences, of cultural reclaim, of the defiance of those who, after admittance to the privileged enclosure of the alma mater of the dominant world, called it into question and thus opened the way to the challenge of that very world'.[4]

In England, the challenge against imperialism took form under the leadership of George Padmore, and, not long before the young Egonu arrived in England, the famous 1945 Pan African Congress was held in Manchester. In attendance were two of the most influential figures in the collapse of British colonialism in Africa, Gold Coast politician Kwame Nkrumah, and the future leader of independent Kenya, anthropologist Jomo Kenyatta. Two years hence, in 1947, Nkrumah returned to West Africa to begin what C. L. R. James described as 'preparations for the revolution that was to initiate a new Africa'.[5] In ten years, he forced the most significant crack in the British Empire since its loss of India, one that eventually led to the loss of its colonies in Africa.

Egonu might be considered too young to have found much significance in the above developments upon arrival. However, by his late teens, when he moved to London from Norwich to enrol at the Camberwell School of Arts and Crafts, he was ready to identify with a generation of what Andrade called 'sensitive Africans', a new wave of young immigrants, mostly students, for whom the atmosphere of determined and organized global opposition to imperialism now served as a bedrock of pride and self-discovery. By 1949, the example of India and Nkrumah's persistent successes with the anti-colonial struggle in the Gold Coast introduced a new feeling of empowerment to colonial subjects in the metropolis, and engendered in them a new attitude towards Empire and themselves. They would no longer define themselves in the role of passive victimhood, but recognize their own active agency in the making of history.

Egonu described the period as one of great excitement and anticipation, during which he spent considerable time at the offices of the West African Students Union close to his student accommodation in Camden Town. The Union 'was the place to read newspapers and get news from home, to engage in long discussions about the times . . . and generally feel at home'.[6] As I have observed elsewhere, this association with the anti-colonial struggle was crucial to the process of cultural self-definition for the young artist,[7] and to his relationship with artistic practices in Europe. It was also to influence his attitude towards the Western canon and its negation through modernism.

Whereas earlier modern artists in Africa had affirmed European neoclassicism and Renaissance aesthetics as a way of validating their claim to universality and civility,[8] the political and cultural atmosphere under which Egonu emerged as an artist was different. It became unnecessary to employ such strategies of validation, and necessary to demand instead that the Western canon be brought to question, along with the equally problematic canon of formalist modernism, especially as it was beginning to be defined in America.[9]

In addition to the political opposition that Nkrumah and the rest represented, the era was characterized also by a new cultural awareness among the colonized articulated by the leaders of what came to be known as the Negritude movement. Aimé Césaire's uncompromising celebration of the Negro essence in *Cahier d'un retour au pays natal* appeared in Paris in 1939. In 1945, Leopold Sedar Senghor published his collection of

youthful poems *Chants d'ombre*, quickly followed by *Hosties noires* in 1948 and *Chants pour Naëtt* in 1950. Over the next decade and a half, Senghor would follow these with a number of key essays and cultural interventions that defined a politics of cultural self-articulation, establishing considerable influence on expatriate Africans as well as on the European modernist movement.

In *Cahier d'un retour*, a formidable work of free verse, Césaire confronted the tradition by which Africans are disparaged or discountenanced as a race, playing between irony and validation, and recasting aspects of that tradition in a positive and affirmative manner. The Negro may not be an inventor, he argued, but the Negro sure has contributed and continues to contribute, to global culture and human civilization. In *Cahier*, Césaire placed the Negro opposite the European, as humanity's source of spiritual rejuvenation, poetic and cultural knowledge, and wisdom. Africa, he elaborated, was the answer to the self-destructive proclivities of industrial Europe; the inevitable opposite of Europe's cultural aridity. In an interesting venture that would become and remain influential for the rest of the century,[10] Césaire conceded science and technology to Europe, while claiming dance, poetry and rhythm for Africa, thus arriving at a balance which he believed to be a reasonable and acceptable representation of the nature of things.

In *Chantes d'ombres*, Senghor reiterated this dichotomy as an act of affirmation, to inspire cultural pride and a love of the self in the Negro. As V. Y. Mudimbe points out, the original and overriding intent of these acts of affirmation and the movement that arose from them, was cultural rather than explicitly political, complimentary to the anti-colonial struggle of the period.[11] They would find precise articulation beyond the cultural and take on a political edge with Jean-Paul Sartre's intervention in 1948. In the essay 'Black Orpheus', his introduction to Senghor's anthology of Negro poetry, Sartre defined the movement for the affirmation of Negroness, or Negritude as Césaire had christened it in 1939, as an anti-colonial affront, a political gesture.

Another significant moment of articulation for Negritude was the founding of the journal *Présence Africaine* by Alioune Diop in Paris in 1947. Diop's journal provided an open forum for an intellectual and philosophical discourse, and the construction of Africanness in a climate of self-redefinition. Through their poetry, Césaire and Senghor gave formal expression to these nascent ideas of the cultural self, although they continued to draw heavily from European canons and traditions.

The effect especially on young Africans in the metropolises of Empire was remarkable. Negritude and its proponents indicated possibilities for the formulation of a cultural sensibility that was at once inspiring and liberating, ambiguous and eventually questionable though it was. Its greatest attraction and resonance lay perhaps in its origins in the centres and discourses of Europe itself, while it employed nostalgia as a thematic pivot.

Over the next decade, Senghor produced a string of essays that attempted to explicate and situate an African sensibility of otherness. Remarkably, this did not preclude or contradict his advocacy of significant elements of the Western tradition, such as his exhortation of French civilization, his promotion of European classics or his adoption of Marxism.[12] Speaking to this years later in his contribution to debates at the first International Congress of Black Writers at the Sorbonne in 1956, Senghor pointed to the Cartesian sources of Francophone thought including Negritude, noting that 'much of the reasoning of French Africans derives from Descartes . . . [and that all] the

501

great civilizations are civilizations that resulted from interbreeding, objectively speaking'.[13]

Césaire's poetry, however, indicated a less compromising disposition towards Europe, even though, politically, he maintained a more conciliatory posture towards France, one that was in line with his country, Martinique's unique relationship with it. This marriage of cultural opposition and political pragmatism led both Senghor and Césaire and many other leading figures of Negritude into an ambiguous relationship with the European left. Through the relationship, however, they were able to exert a significant influence on some of the emergent forms and discourses, of modernism. André Breton acknowledged this in his, 'Speech to Young Haitian Poets' in 1945, when he said, 'the greatest impulses towards new paths for surrealism have been furnished by . . . my greatest friends of colour – Aimé Césaire in poetry and Wilfredo Lam in painting'.[14] The alliance also encouraged the anti-colonialist tendencies within the modernist movement.[15]

Negritude and modernism

Through the inteventions of the Negritude artists, an aesthetic emerged which in spite of its political vagueness constituted a decisive moment in modernist history; an appropriate entry into the history of Black agency in European cultural history. It encouraged a decided look towards African culture. At the same time, it was positively disposed to select trajectories and elements from Western intellectual and cultural canons, just as it proffered cultural romanticism alongside political realism.

It can therefore be argued that the ultimate marker of Black modernist expression in Europe may not be sought in the adoption of 'Western' or conventional, formalist strategies by artists but in the insertion of a decidedly Black cultural agenda and the fabrication of an ambivalent rhetoric of difference and visibility. Negritude made Black cultural nationalism an integral aspect of European modernism. It inscribed difference as a reconciliable and essential part of the avant-garde.

It may also be argued that this strategic plank of cultural difference worked hand-in-hand with the intensification of the anti-colonial struggle. Its gains generated an atmosphere of creative and political excitement. Together, they inspired a spirit of nascent greatness and pride in Black Europe. The milieu thus shaped furnished young artists like Egonu, Andrade's 'sensitive Africans' with a point of entry and an exploratory platform within the parameters of modernism. The participation of colonial expatriates – especially the Negritude writers – as key players in European modernism reaffirmed the movement's history as a project beyond form, a cultural and political sensibility built on dedicated social activism.

There is an emergent inclination to locate Black modernist artists merely through the frame of formal affinities with the so-called modern masters.[16] One would argue, however, that this is far too simplistic, since it is almost impossible to articulate their oeuvre, or indeed their significance within modernism or their role in the advent of postmodernist aesthetics and practice, without proper awareness of the specific historic and political circumstances under which they arrived and began their professional interventions in Europe. Such careful contextualization allows us to discover the underlying and oft enduring currents in their work, and their formulation of an appropriate aesthetic for individual practice within a nascent, post-colonial Europe in which the

power of Empire is brought under considerable check and, with it, the philosophical structures of Caucasian heroism upon which subsequent myths of modernism would be built.

It is little surprise that Egonu's earliest surviving professional work as a painter should replicate the themes of nostalgia and cultural nationalism that we find in Senghor's and Césaire's poetry, and at the core of Negritude rhetoric, or that his initial grappling with these themes should draw its formal strategies from prevailing streams of modernist practice framed, however, by a desire to negate the canons and demands of the Western tradition, such as we find in Césaire's surrealist free verse and in Senghor's combination of early modernist forms with those of West African orature.

Nation and nostalgia

Egonu graduated from Camberwell School of Arts and Crafts in 1951, having studied painting and printing. At Camberwell, he was instructed in the forms and canons of the Flemish school which were favoured by his instructors at the college. As he sarcastically said in a conversation with this writer in 1989, of the nature of instruction at Camberwell, 'Twenty years ago, they would insist that they look at things in a particular way, as if you were competing with second-century art. And you wonder, why don't they engage a photographer and be done with it?'[17] The instruction, though in line with the prevalent taste at such influential institutions as the Royal Academy and the Royal Society of Arts, was nevertheless inconsistent with developments in modern British art of the time. Also, they could not provide the young Egonu with the right tools to configure himself for a place within the frame of cultural nationalism described above.

To extricate himself from the strictures of his training, Egonu decided to travel in Europe, visiting museums and collections where he came into direct contact with major works from the Western tradition, as well as those from Africa and other art-producing cultures. He also wanted to acquaint himself first-hand with the work of the modernists beyond what he was exposed to in London. These trips took him to Paris and Rome and the Scandinavian countries between 1952 and 1958. They would prove instrumental in furthering his efforts at self-definition and his search for a proper voice within modernism, as much did his exposure to Negritude philosophy.

Egonu moved to Paris after his initial continental trip. There he lived and practised for a year, paying regular visits to museums and galleries, especially the Musée de l'Homme, where he visited the African and Oceanic collections. Egonu's encounter with Paris, like Jackson Pollock's a decade earlier, had a decisive impact on his ultimate direction as an artist. Divergent and often conflicting as these influences were, he found them at once frustrating and challenging.[18] Though he paid attention to moments and figures from the Renaissance through to Post-impressionism, cubism and surrealism, he was also deeply fascinated by and dedicated to a methodical understanding of classical African sculpture.

During his period in Paris in 1956, Senghor's book of poems, *Ethiopiques*, was published along with a reissue of *Chants d'ombre*. The same year, Senghor's definitive treatise on African art and aesthetics, 'L'Esprit de la civilisation ou les lois de la culture negro africaine', appeared in *Présence Africaine*. Senghor and the Negritude writers came closest to his personal circumstances as an artist and an African immigrant in Europe. For a young African artist searching for a place in modernism, Senghor's authority as a

Figure 41.1 Uzo Egonu in Paris, 1955

recognized figure within the movement, and his articulation of the imperatives for the modern African artist especially in 'L'Esprit de la civilisation', had the force of a revelation. Many of the themes and ideas that Senghor dealt with in his essay and his poetry would eventually appear in Egonu's work and long inform his thinking.

Egonu's travels in Europe and his acquaintance with these disparate art traditions, rather than inspiring a cosmopolitan indifference to the fact of his Africanness, made him even more aware of it. His experiences challenged him to seek ways of forging a personal aesthetic informed by his new awareness. His contact with classical African sculpture prompted a more critical and comparative approach to the European

tradition. For the young artist, confronting the wealth of the world's artistic heritage brought a concreteness to the postulation already marshalled by the Negritude writers, namely that each artistic tradition rivets on itself and derives its greatness largely from within its own space and dictates. It also became clearer to him that, as Senghor had argued, such seeming ethnocentricity must be accompanied by a selective eclecticism in order for a culture to transcend its past and realize its modernity.

Egonu set up studio in North London in 1959, and went through a period of considerable turmoil as he struggled to give form to the cultural and conceptual resolutions that he reached as a result of his travels. He destroyed numerous canvases, as many as thirty in 1959 alone, as he battled to pull it all together, as it were. However, by 1960, when he executed his first major commission, a market scene commissioned for the Nigerian government house in London, it would seem that he had resolved his creative crisis by taking the route of nostalgia; a conscious appeal to memory and recollection as a tactic of relocation while finding his form through the free chromatic and post-academy strategies of the Fauvists, allusions to Gauguin, and, to a certain degree, formal references to the Kitchen Sink school of British painting.

That same year he painted *Boy with a Budgerigar*, a filial homage which also served as an attempt at 'a return to his native land', to use Césaire's title. *Boy with a Budgerigar*, Egonu explained, was inspired by memories of his father and brothers in Nigeria,[19] the budgerigar representing his father's parrot which was much loved by the boys. Of another painting from 1960, *A Boy Eating Sweet Corn*, he said: 'I chose the subject

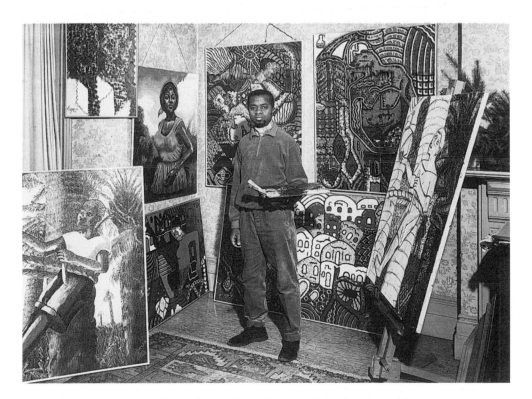

Figure 41.2 Uzo Egonu in his studio in West Hampstead, London, in 1964

because of nostalgic feelings for my country; the feeling of being far away from home evoked these images in my mind'.[20] In using childhood memories as his frames of reference, these early works register the artist's rather tenuous yet crucial link with home at the time. Over the next three years he painted *Village Blacksmith in Iboland*, as well as a series of celebratory, almost heroic portraits of African women including *Portrait of a Nigerian Girl* and *Portrait of a Guinea Girl.*

These genre pieces work at the level of the romantic, reclaiming and valorizing 'home'. The portraits of African women inevitably remind us of Senghor's celebration of the African woman in *Chants d'ombre*, where the woman, a figure of nostalgic longing metaphorically becomes mother Africa. His choice of the metalsmith as subject, though inspired according to the artist by recollections of his own childhood experiences in Igboland, remind us also of the prominence of the village metalsmith in another work that was inspired in part by Negritude thought, Guinean writer Camara Laye's classic childhood memoir, *L'Enfant noire.*

Egonu's choice of themes and subject matter at this point reveals strong influence of

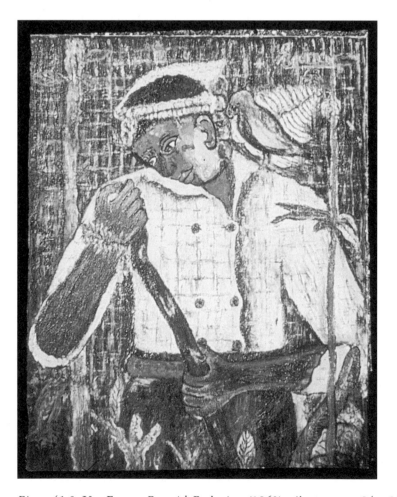

Figure 41.3 Uzo Egonu, *Boy with Budgerigar* (1963), oil on canvas, 84 × 98 cm

Figure 41.4 Uzo Egonu, *Northern Nigeria Landscape* (1964), oil on board 107 × 178 cm

Negritude thought and imagery, and a certain identification with Negritude romanti cism and its celebration of the pastoral. At the same time, it is important to note Egonu's allusions to early modernist language, especially Fauvist expressionism. His contours are woolly and his anatomy imprecise. In the works so far mentioned, he makes an almost indiscriminate use of polychrome in a manner that also reminds us of Matisse. Like the Negritude poets, he selects his formal strategies from within modernism, but brings to it those emblems of cultural difference and nationalist distinctiveness that characterised Negritude poetry.

In a number of works from 1963, Egonu turns to other themes prominently featured in Senghor's writings also. The use of African masks and musical instruments to represent African culture and humanism is one. The mask, we may recall, is the central motif and subject of Senghor's poem, 'Prayer to Masks' from *Chants d'ombre*. Speaking of his paintings *African Masks* (1963) and *Still Life with Mask in Landscape* (1963), in which he places masks against a pastoral background, Egonu described the mask as a 'symbol of the African past' and an inseparable part of African art. He chose the subject, he further explained, because he was 'thinking of the influence that African masks [have] had on European modern art, especially on Cubism'.[21] This point Senghor had made quite strongly in 'L'Espirt de la civilisation' where he pointed out that 'After the failure of Greco-Roman aesthetics at the end of the nineteenth century, artists and writers came at the end of their search to Asia, and even more important, to Africa.'[22] 'Through Africa', Senghor argued, 'they have been able to justify their discoveries and

confer human value on them.' While enjoining them not to 'choose to betray not only Africa but our reasons for living', Senghor insisted that the logical and proper future of modern African artists lay in an awareness of African culture. 'Insofar as they are aware of African culture and draw inspiration from it, they rise to international status. Insofar as they turn their backs on Mother Africa, they degenerate and are without interest.'[23]

Egonu's statement on the debts to Africa is both an acknowledgment and a claim on modernism. It indicates his growing confidence within its aesthetic, which he justifies in part through this reference to affinities. While he insists on the centrality of African sources to modernism, it is pertinent to note, also, that he does not restrain himself from making reference to the European tradition. It is this ambivalence, which is fundamental to Negritude aesthetics, that saves Egonu's propositions from descent into cultural essentialism.

Egonu's late nostalgic period in the mid-1960s prepared him for a progressive departure from many of the predictable problems associated with nostalgic evocation. By 1964, he had begun a discernible transition which formally distinguishes his subsequent work from the earlier paintings mentioned here. Evidence of this transition we find in a series of paintings interpreting familiar monuments of the British landscape. These included *St Paul's Cathedral* (1965), *Westminster Abbey* (1966), *Trafalgar Square* (1968) and *Tower Bridge* (1969).

Nevertheless, he also continued to draw from African tradition and influences. For instance, while in *Woman Combing Her Hair* (1964) Egonu makes thematic reference to

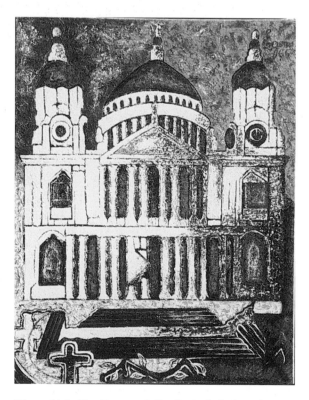

Figure 41.5 Uzo Egonu, *St Paul's Cathedral* (1965), oil on canvas, 71 × 92 cm

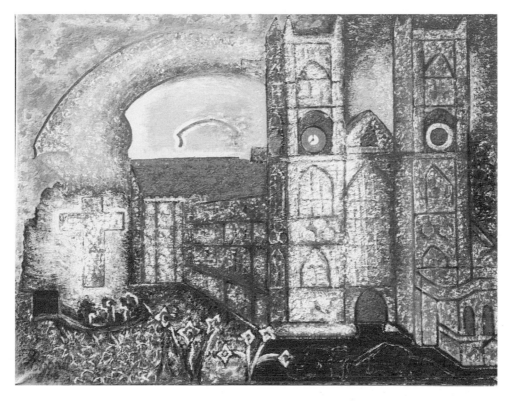

Figure 41.6 Uzo Egonu, *Westminster Abbey* (1966), oil on canvas, 71 × 92 cm

Degas, and as I have argued elsewhere, to Hogarth and his theory of 'the line of beauty',[24] his treatment of line and texture in the work indicates African references such as we also find in *Houses in Northern Nigeria* (1963). In the later work, there is a strong consciousness of the nature and texture of northern Nigerian adobe architecture and the art of the Nok civilization, which Egonu had begun to study by this period. His studies of Nok led to his unpublished treatise on the subject, 'The Reproductions of Nok Culture Terracottas Showing: Spherical shape, Cylindrical Shape, & Conical shape.'[25] Though *Woman Combing Her Hair* indicates familiarity with Hogarth's theory of beauty, during this period Egonu nevertheless also spoke of the 'aesthetic beauty' of Nok sculpture and how his observations of Nok pieces and the formal principles of the Nok artists inspired him to experiment.[26] In *Collage: Cuttings from Magazines* of 1965, he experiments with a quintessential modernist form, yet the piece is informed by his studies of geometric forms in Nok sculptures. Whatever his other sources might be at the time, therefore, it is impossible to ignore the fact that his major intellectual pre-occupation, nevertheless, was to understand the complexity of classical African art and to use it as a frame of reference while employing contemporary techniques of the period.

It is important to observe that during the 1960s, several other artists in different parts of the world were also engaged in this *return to the source*. In Britain, artists such as Avinash Chandra and later Li Yuan Chia were preoccupied with factoring elements

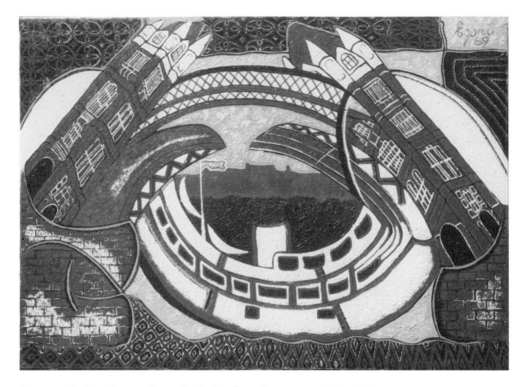

Figure 41.7 Uzo Egonu, *Tower Bridge* (1969), oil on canvas, 81 × 112 cm

from their cultures of origin into modernist expression. Chandra fielded eroticism as a dominant trope, deriving his strategy from Indian religious imagery and thought, whilst Chia deployed the stringent economy and form of Chinese calligraphy. Aubrey Williams, who enjoyed relative prominence at the time, was also in the process of introducing a new genre of abstractionism, informed by his studies of pre-Columbian, Guyanese forms, in the same way that many earthwork artists of the decade looked to pre-Columbian art for ideas and inspiration. For such artists, the ascendance of American high-modernist aesthetic and rhetoric, and its attempts to strip modernism of its humanist element, held little appeal. If anything, it made it more imperative for them to seek sources of deeper meaning for artistic practice after the mid-century.

In *The Other Story*, Rasheed Araeen calls our attention to the place and politics of humanism in modern art. He rightly points out that at different points in our time, artists have sought resolution, meaning, even profundity through humanism. Artists like Egonu, Williams, Chandra as well as those earthwork artists who shunned the analyticism of high-modernist sculpture, all reaffirmed a humanist sensibility within modernism, one that sought meaning not in pure abstractions or the formal sciences of the period but in beliefs, knowledge, and forms from older cultures.

Egonu's preoccupation with Nok culture may be seen as a second phase of his cultural nationalism, by which time he had replaced nostalgic imagery with formal ciphers of difference. This was in line with developments in European modernism as well as in African art and literature of the period.[27] In his paintings, the lines became

thicker and more prominent. Manipulation of texture and space also became conscious, formal principles. Though figurative still, Egonu's work nevertheless became more planar and decorative, relegating depth and perception. This made his venture into print-making in the 1970s a natural progression.

Compared to indigenous, European modernists of the mid- and late 1960s, Egonu's work stands apart with those of Chia and a few others in consistently fuelling elements of a different cultural identity and awareness into British modernism. If David Hockney's interpretations of home photographs represented the heights of indigenous, British figuration, and William Turnbull and Bridget Riley were the most prominent abstractionists, artists such as Chandra, Williams and Egonu maintained a different cultural vocabulary and significatory richness within British modernism, even when their vehicle was only formal.

Egonu described his discoveries from studying Nok sculptures and other African art traditions as a 'bridge' beyond which lay clarity and certainty of language. In his notes for an exhibition catalogue in 1970 Egonu states: 'My aim was to utilise the decorative symbols which I was used to as a child in Igbo-land, to express myself and to communicate my thoughts to others.'[28] By articulating and adopting those formal strategies that appealed to him as an artist, he developed the freedom and confidence to approach the diversity of themes and subjects which would define his career, while firmly locating himself within an identifiable sensibility in contemporary practice.

Modernism and the *Globalpolitik*

In same manner that the Negritude poets brought the politics of race into early European modernism, so did artists like Egonu make the discourse of global politics and, especially, of the post-colonial condition part of the humanist imperative of late modernism. Aubrey Williams had stated that pertinent to his work as an artist was 'the human predicament, especially with regard to the Guyanese situation'.[29] While this preoccupation may be regarded as the precursor to the wider concern with the global human condition in the work of European postmodernist artists of the late 1960s and 1970s, it may be distinguished from the latter, nevertheless, for its very focused and personal nature. For instance, Egonu's work from the mid- and late 1960s, unlike much of the art of the 1960s inspired by a rather vague, flower-generation *Gestaltpolitik*, focused instead on the politics and human condition of a specific geography which had consistently factored in his formal and cultural strategies prior to that moment.

Egonu's transition from a cultural agenda to a political one was indeed less premeditated than it was imperative, hoisted upon him, as it were by the rather precipitous if predictable collapse in the late 1960s of Nigeria, his country of origin. In 1966, the military attempted to seize power in order to arrest widespread corruption and impending disintegration in the newly independent country. This was followed by pogrom in which sections of the country turned against citizens from the country's eastern region, killing tens of thousands. Many of them were Igbo like Egonu. The massacre and ensuing chaos precipitated a great exodus of the persecuted to the east and the declaration of an independent state, plunging the country into civil war. The war between Nigeria and the new Republic of Biafra lasted three years and claimed over two million lives.

These developments had a great impact on Egonu, who had great expectations for

his country. Nigeria, the most populous nation in Africa with the highest concentration of skilled manpower and significant natural resources, held significant promise as a postcolonial state. For reasons of its unique attributes, it came to represent an opportunity to prove the abilities of the African for successful self-governance and an opportunity to build a modern state out of the dislocations of colonialism. Like India, Nigeria represented a chance to prove the colonial project wrong, and to encourage all those who sought self-determination from Empire. When the young democracy began to flounder, it threatened to put into doubt the validity of colonial disengagement. With a significant portion of the African continent still struggling for self-determination and independence from colonial domination, the example of Nigeria had many negative implications.

The civil war brought enormous human suffering. Many people in Biafra, including Egonu's family, were cut off from the outside world for the duration of the war (1967–70). Some of his relatives were drafted to fight on the side of the fledgling republic. Others were casualties. This was an agonizing experience for Egonu. His partner, Hiltrud, suggests that the enormous anxiety that Egonu went through during the period contributed in no small measure to his health problems in later life.

As an artist Egonu was equally faced with the question of how to respond effectively to the human tragedy. How does the artist maintain aesthetic integrity in the face of such trial? What are the moral and social responsibilities of the artist? Since mid-century, modernist schools of thought had been deeply divided over whether art should be a solitary, individual spiritual pursuit, or a vocation with broad, social responsibilities. Even as dedicated and influential a propagator of social consciousness in art as Harold Rosenberg ultimately questioned the potency of art and the place of the artist in society. In one of his last essays in the 1970s, Rosenberg concluded that 'taken by themselves . . . painting and sculpture are politically impotent'.[30] This realization was none the less never enough to expunge social passion from modernist art because, as we have already observed, modernism had its beginnings in the humanist ideal and the recognition that the modern artist, free of all allegiance to monarch, state or Church, enjoyed more freedom than any other in history to engage issues of social import, and the state of the human condition.

In the case of British art, the human suffering during the Second World War and the inception of the nuclear threat after the war had occasioned responses from artists as varied as Henry Moore, Paul Nash and Graham Sutherland. In the 1960s, however, there was little of such social consciousness to be found in British modernism.[31] The tragedy of the Nigerian civil war challenged Egonu to respond as one closely affected by the developments. Inadvertently, he succeeded in bringing into late British modernism a renewed interest in the human condition. Significantly, Egonu's war paintings still represent the only formidable body of work on the human condition in late British modernism.

Beginning in 1966 until the early 1970s, Egonu preoccupied himself with reflections on the war in his homeland: allegories on war and conflict, images of suffering, and of the possibility of peace. Interestingly, despite global sympathy for the people of Biafra, the embattled Republic failed to attract the same level of attention from artists around the world that the Spanish Republic achieved earlier in the century. Artistic response to the Biafra situation came to involve only a handful of artists, prominent among them Egonu himself, the novelist Chinua Achebe and the dramatist Wole

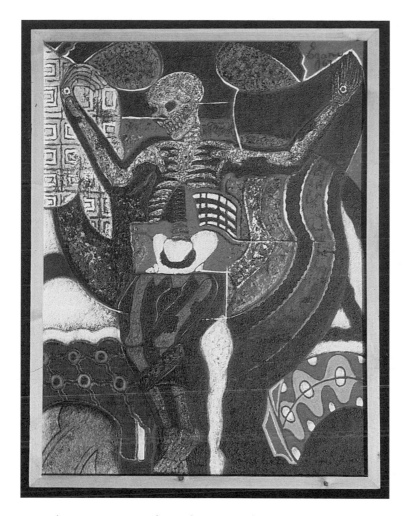

Figure 41.8 Uzo Egonu, *Thirty Thousand* (1967), oil on canvas, 92 × 112 cm

Soyinka, who was incarcerated in Nigeria for his opposition to the war. Some of Egonu's paintings from the period challenged the traditional dichotomization of art and politics, emphasizing instead the correlation between human tragedy and the language of its articulation. In *Thirty Thousand* (1967), a skeleton represents victims of the 1966 massacres of the Igbo in northern and western Nigeria. *Blind Eye to Tragedy* (1967) combined the skeleton motifs with the iconic image of the mother and child, with Egonu employing the allegorical strategies in the tradition of Goya and Daumier to capture the horror of the war. In other paintings from the period, he moves freely between principles from both within and outside the modernist tradition in order to enhance effective communication in his work.

During this period, Egonu also produced his only known body of sculpture, a group of statuettes dominated by images of fallen figures. Together with some of his paintings on the war, these were exhibited in a solo show at the Upper Grosvenor Galleries in London in 1968. Proceeds from the exhibition were donated to a charity

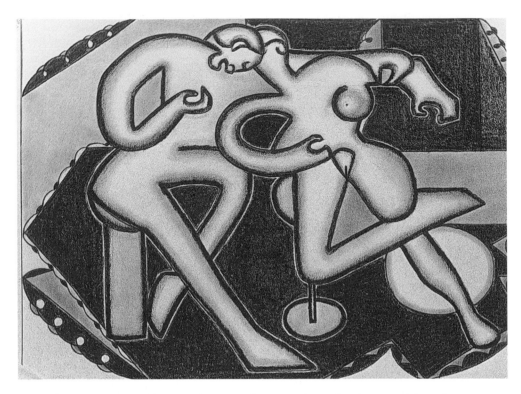

Figure 41.9 Uzo Egonu, *Two Friends* (1979), drawing, charcoal and crayon, 56 × 76 cm

for humanitarian work in Biafra. Through this work, Egonu not only registered his personal anguish at the suffering of his people but tried to call the world's attention to that suffering with a passion and dedication that was rare in British modernism. Such passion would remain rare even in contemporary British art until the late 1970s and the 1980s when a generation of younger artists revitalized contemporary British art by injecting social consciousness into it. In this regard, Rasheed Araeen's work from the 1970s, and those of Keith Piper, Eddy Chambers, Mona Hatoum and their contemporaries in the 1980s, follow in the tradition that Egonu began.

In the 1970s, Egonu made another transition, this time from his contemplation of war and human suffering to philosophical and religious themes, as well as an engagement with contemporary social experiences in Europe. In *Stateless People*, a series of paintings that he produced in the early 1980s, Egonu reflects on the themes of being and nationhood. In the paintings he further underlined the humanistic underpinnings of his modernist vision by introducing a subject hitherto explored only in post-colonial literature, namely, the colonial immigrant in the Western metropolis. With statelessness and the virtual collapse of the post-colonial nation state as foci, *Stateless People* prefigured contemporary concern for the post-colonial subject at whether at home and in exile. In the series, Egonu represents the alienation of relocation and exile through his characters; lonely and nostalgic, or herded together into little groups, bonded by the tools of their trades, yet very much adrift, each nursing an indeterminable loss.

In his last body of work in the 1990s, *Past and Present in the Diaspora*, Egonu

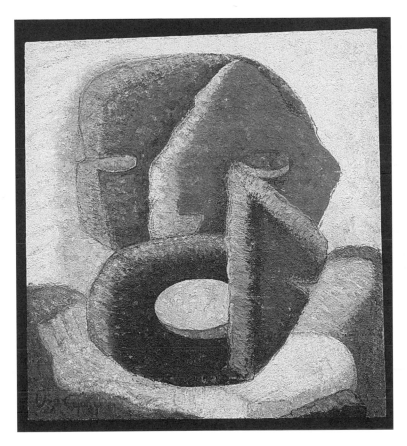

Figure 41.10 Uzo Egonu, *Past and Present in the Diaspora '8'* (1991), oil on paper, 102 × 110 cm

produced a monumental reflection on slavery, the legacy of Christopher Columbus and the indefatigable nature of the human spirit. Stepping back in time to engage history and its social and philosophical ramifications, he continued to make modernism responsive to both the past and the immediate. Egonu chose in his own words to ponder 'the bewilderment of human behaviour' and find the right metaphor to 'represent spiritual strength'.[32] The result is an impressive conclusion to a career dedicated to technical mastery, stylistic brilliance and, most importantly, the pursuit of meaning and historical relevance.

Conclusion

Egonu described his synthesis of formal principles from the cultures of his origin and those from modernist precedents as footprints, and likened his career as an artist to the progress of a mountaineer, with challenges as an expatriate, a colonial in the centre of Empire, a humanist at a time when modernism wavered between the formal vacuity promoted by American critics, ascendant triviality fed by popular culture, and the

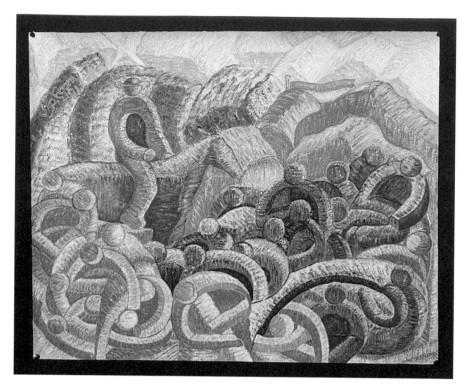

Figure 41.11 Uzo Egonu, *Past and Present in the Diaspora '13'* (1991), oil on paper, 63 × 79 cm

humanism of its beginnings. Like a mountaineer, he left his footprints on postwar British art by introducing a privileged understanding of those non-European sources which shaped its origins and informed his own individual style.

Even more importantly, Egonu was a pioneer among those artists who made their entry into modernism from the outposts of Empire, and remained dedicated to the humanist ideals that formed its initial platform. Egonu informed modernism with his experiences and passions as an African expatriate in Europe, a tradition rooted in the marriage of form and function, and in the legacies of anti-colonial struggle. He was able to utilize that tradition as a framework for the visual exploration of questions and passions that at once spoke to his immediate experiences and environment, as they did to history. Idealistic, even stoic, his was a truly modernist vision anchored not in the evacuation of social concern, or in the indeterminate prevarication that have come to characterize postmodernist cultural production, but in the unequivocal idea of the artist as a visionary; as the propagator of a larger, more positive social reality.

Uzo Egonu – and artists like him – broadened the boundaries of modernism by representing a non-European contingent within it. They gave it edge, expanded its formal vocabulary, and ensured that it engaged a broad range of ideas and issues relevant to the human condition. Together with the formal innovations that they brought, they also made it invalid to ask: did modernism fail?

Notes

1 According to Araeen, 'Uzo Egonu was perhaps the first person from Africa, Asia or the Caribbean to come to Britain after the War with the sole intention of becoming an artist' (Araeen, *The Other Story: Afro-Asian Artists in Post-war Britain*. London: The South Bank Centre, 1989) 86.

2 Although the South African Ernest Mancoba had gone to Paris in 1938, and would be followed not long after by another South African, Gerard Sekoto, neither of these artists may be said to have left an appreciable mark on practice in the locales of their abode or indeed produced work of the nature to earn the visibility that Egonu and his colleagues in England did.

3 For the timeline on these developments see Araeen, *The Other Story*: 128–41.

4 Amilcar Cabral, *Unity and Struggle* (London: Heinemann, 1980): xxii.

5 Paul Buhle (ed.), *C. L. R. James: His Life and Work* (London: Allison and Busby, 1986): 107.

6 See Olu Oguibe, *Uzo Egonu: An African Artist in the West* (London: Kala Press, 1995): 19.

7 Ibid.: 19.

8 See Olu Oguibe, *Uzo Egonu: Twentieth Century Nigerian Artist* (doctoral dissertation, University of London, 1992).

9 As has increasingly been pointed out, the strictly vacuous and formalist definition of modernism that has come to dominate our understanding of the epoch is at best a myopic aberration which misrepresents the history, purposes and nature of modernism. For the latest view of this question see David Craven, 'The Latin American Origins of "Alternative Modernism"', *Third Text* 36 (autumn 1996): 29–44. If we should pay close attention to Craven's narration of modernist history and his acknowledgement that the term itself was in fact first used by the Latin American poet Ruben Darios, under whose subsequent influence in Spain and Barcelona in particular Picasso produced his earliest modernist work, we may indeed conclude that the modernism later propagated in America by Greenberg and the formalists is the 'alternative', a fringe corruption of true modernism.

10 Arguments such as may be found towards the end of the century in the teachings of the AfroCentric school of American thought belong to and are obviously derivative of this dichotomy of racial gifts. See for example the work of such authors as Molefi Asante and numerous others especially beginning in the 1970s.

11 V. Y. Mudimbe, *The Invention of Africa: Gnosis, Philosophy and the Order of Knowledge* (Bloomington: Indiana University Press, 1988): 84

12 See Leopold Sedar Senghor, *Nation et voie africaine du socialisme* (Paris: Présence Africaine, 1961).

13 Leopold Sedar Senghor, 'We are All Cultural Half-castes', First International Congress of Negro Writers and Artists, special issue, *Présence Africaine* 8–10 (1956).

14 André Breton, in Franklin Rosemont (ed.), *What is Surrealism?* (New York: Pathfinder, 1978): 259.

15 Césaire, particularly, was closely allied with the rest of the influential modernists, including Picasso, who illustrated his fourth book, *Corps perdue*.

16 See Everlyn Nicodemus and Kristian Romare, 'Africa, Art Criticism, and the Big Commentary', *Third Text* 41 (1997–8): 53–66.

17 Interview with the artist, South Kenton, November 1989.

18 See Oguibe, *Uzo Egonu*.

19 Hiltrud Streicher, 'Reflections of Uzo Egonu: Contemporary Nigerian Artist, Interviewed by Hiltrud Streicher', unpublished manuscript, 1966, revised 1975: 8–9.

20 Ibid.: 30.

21 Ibid.

22 Senghor, 'Cultural Roots and the Modern African Artist', excerpts from 'L'Esprit de la civilisation ou les lois de la culture negro africaine', in L. S. Senghor, *Prose and Poetry*, ed. and translated by John Reed and Clive Wake (London: Oxford University Press, 1965): 77.

23 Ibid.: 76.

24 Oguibe, *Uzo Egonu*: 52.

25 For a detailed discussion of this point, see ibid.: 64–78.

26 Oguibe, interviews with the artist, November 1989.

27 The appeal to Igbo linguistic traditions in Chinua Achebe's novels in English, for instance. Achebe has been credited with doing for the novel in English what James Joyce did for it earlier in the century by inflating it with the energy and peculiarities of literary and speech patterns from his own heritage. Joyce's and Achebe's use of English both represent significant modernist projects, each denoting the localization and humanization of modernism. The 1960s also witnessed the emergence of the boom generation in Latin American literature, and their popularization of phantasmagoria and formal convolution, both defined as peculiarly Latin American.

28 Uzo Egonu, 'On Myself and My Work', notes for a speech, 1970. Published in *Egonu, 22 Prints*, exhibition catalogue, 1985.

29 Rasheed Araeen, 'A Conversation with Aubrey Williams', *Third Text* 2 (1987–8). See Chapter 39 above.

30 Harold Rosenberg, 'Art and Political Consciousness', in Rosenberg, *Art and Other Serious Matters* (Chicago: University of Chicago Press, 1985): 288.

31 The only significant social element evident in British modernism in the 1960s would be found in David Hockney's introduction of the gay question into his work which, for the greater part of the decade, anyhow, was produced in America. Not until the political upheavals in the America and the movements that spearheaded the civil rights campaign made their appearance in Britain, especially in the form of the Black Panther Party, did British artists begin to deal with pointed social or political issues. The earliest examples of this revival, which is to be found in the work of such migrant British artists as Rasheed Araeen, occur in the early 1970s at the advent of postmodernism. Much of the work, such as Araeen's, was inspired also by Black American art and aesthetics.

32 Uzo Egonu, 'Past and Present in the Diaspora', explanatory notes on series of same title, 1991. In Oguibe, *Uzo Egonu*: 159.

42

HARVESTING THE FOLKLORIC INTUITION

Ben Okri's *The Famished Road*

Ato Quayson

There is a growing critical consensus that Ben Okri's work operates within the same tradition of writing as Tutuola's and Soyinka's.[1] *The Famished Road* operates in this tradition of writing in an even fuller and more suggestive way than the short stories. In this work Okri produces what might be termed new mythopoeic discourse with the invocation of myths, folklore and other aspects of indigenous beliefs. Particularly interesting is the range of esoteric passages in the novel and the variety of ways in which they are connected to events in the putative real world of the story. But, because the novel is yet to accrue critical research, the precise terms by which to relate it to the literary tradition remain vague. The novel represents a vast arena of interdiscursivity not only with earlier literary works but also with various indigenous beliefs to do with the relationship between the real world and the supernatural. One of the concerns of this chapter will be to trace the nature of that interdiscursivity in both directions. In addition, attention will be paid to the various ways in which these indigenous beliefs become transvaluated in the body of the narrative to hint at a validation as well as a critique of the indigenous belief system. Finally, an attempt will be made to show how Okri's work articulates a particular perception of events in post-colonial Nigeria that brings the literary tradition into a direct engagement with the ambit of the socio-political while remaining steadfastly in the realm of the mythopoeic.

The interdiscursive relationship with earlier writings is suggested from the very title of the novel. In south-western Nigeria, there are special prayers said to the road asking it not to swallow up suppliants on their journeys. In Soyinka's latest autobiography, *Ibadan*, the name of his *alter ego* Maren is a contraction of such a prayer: *We nu ren n'ojo ebi n'pona*, meaning 'May you not walk when the road waits, famished' (*Ibadan*: 100). Soyinka elaborates this supplicatory attitude to the road at several places in his *Idanre* collection of poems. Such a supplication is lodged in the poem 'Death in the Dawn', which directly invokes the prayer that lies behind the name Maren:

> The right foot for joy, the left, dread
> And the mother prayed, Child
> May you never walk
> When the road waits, famished
> (*Idanre*: 11)

The notion of the famished road is re-echoed in the Ogun praise-poem 'Idanre' and there is even a direct reference to the road's hidden belly: 'And the monolith of man searches still/ A blind hunger in the road's hidden belly' (*Idanre*: 69). As a symbol, the road is highly suggestive and Soyinka elaborates it even further in *The Road*, a play which centres on the relationships between various people from the underclass and the road in both its technological and metaphysical significatory dimensions.

In Okri's novel, the famished road has multivalent significance. On the one hand it has an umbilical connection to the genesis of creation itself as hinted in the very first sentence of the novel: 'In the beginning there was a river. The river became a road and the road branched out to the whole world.' It is because it was once a river that the road remains 'always hungry'. Later in the novel, a story is told that relates the road's hunger for appeasement to its having been reduced from a ravenous god to a mere belly. It is also possible to suggest another application of the symbol with reference to the human hunger for journeys and movement. It is not by accident that Azaro is persistently on the move, with an itinerary traversing both the real and spirit-worlds. But this hunger for movement is also a hunger for completion and meaning, something which the novel suggests is extremely difficult to reach. For one thing, given its genealogy, the road is unending. Furthermore, it always has two and possibly four sides to it, all of which manifest themselves at different times: its two side edges, its surface and its belly. Thus in *The Famished Road*, the road itself is hungry as well as transferring its existential hunger to humans. It ensures that closure and completion remain highly problematic even though constantly desired. With his title, Okri makes an important ritual gesture towards the literary tradition he is elaborating as well as to the indigenous traditions and beliefs. From the very outset he pays homage to both.

Another important symbol of dominant interest in the novel is that of the *abiku*. The *abiku* phenomenon refers to a child in an unending cycle of births, deaths and rebirths. The belief in the *abiku* phenomenon is widespread in southern Nigeria with the name 'abiku' being shared by the Yorubas and Ijos while the Igbos refer to them as *ogbanje*.[2] The concept of *abiku* is what may be described as a 'constellar concept' because it embraces various beliefs about predestination, reincarnation and the relationship between the real world and that of spirits. However, in terms of the rituals that are geared towards appeasing the *abiku*, the concept also implies a belief in the inscrutability and irrationality of the Unknown. It is of the utmost importance to be able to locate where the *abiku* child hides the charms that link it to its spirit companions on the other side for the proper rites to be carried out to snap that connection. Until that is done, the *abiku*'s parents, and, indeed, the community at large, are at the mercy of the disruptive and arbitrary cycle of births, deaths and rebirths of the spirit-child. Chidi Maduka (1987) points out that in fact the word *ogbanje* in the Igbo language is used to denote a person who acts in a weird, capricious, callous and even sadistic way.

The phenomenon itself has exercised the imagination of Nigerian writers from different backgrounds. Soyinka (a Yoruba), Clark-Bekederemo (an Ijo) write poems directly addressing the *abiku*, while Achebe (an Igbo) has a long section in *Things Fall Apart* devoted to the tracking of the hidden charms of Ezinma, one of Okonkwo's children who was an *ogbanje*.[3] Though all three writers draw on the same set of concepts, their explorations of the significance of the phenomenon show varying

emphases that signal the suggestiveness of the *abiku* concept for the literary imagination. Achebe's treatment is largely ethnographic, with a careful detailing of the belief about *ogbanje*. There is a measure of irony attached to the human efforts at coping with the *ogbanje*, signalled in Ezinma's supreme nonchalance in taking her fuming father and the rest of the village on a circuitous journey before agreeing to show them where she has buried her charms. There is therefore a measure of suspense and balance between the forces of chaos and those of order. Ezinma's charms are recovered and her connection to the spirit-world seems to be broken. As Maduka rightly suggests, Achebe resolves the conflict between order and chaos in favour of order. What must be added is that in the mode of realism Achebe operates in *Things Fall Apart*, the conflict can be resolved only in favour of order because his project is to validate the coherence of Igbo beliefs and the efficacy of the structures built by the culture as security against the irrational. This is in spite of his careful delineation of the tensions in the social fabric of the culture and in some of its beliefs, one of whose consequences is the speed with which social outcasts become bridgeheads of the invading Christian religion. The culture is shown to have a resilience that ensures its survival despite these tensions.

In Clark-Bekederemo's poem, the power of *abiku* is acknowledged. The concept is personified and Abiku is addressed in supplicatory tones. It is seen as capricious but there is a suggestion that the proper attitudes and modes of address can stem the tide of the irrational and entice Abiku to stay. In a sense, Clark espouses the same logic grounding the rituals around the phenomenon because the rituals imply that it is possible to arrest the cyclical process and please the *abiku*. With Soyinka matters take a decidedly different turn. Not only is Soyinka's poem articulated in the voice of Abiku itself, it is registered in a mocking and magisterial tone to suggest that humans are at the mercy of the irrational lodged in the Unknown. For Soyinka it is the nonconformism of the recalcitrant Abiku that fascinates him.[4] The important thing to note about Soyinka's handling, however, is the attempt to locate the organizing consciousness of the literary artefact within the realm of the spirit-world. All the ritual gestures of the real world are perceived from the vantage point of the spirit-world and declared puny and futile. This edge of irony suggests that man is wholly at the mercy of the Unknown and that, perhaps, the only way to cope is through an aesthetic empathy with that which is most feared.

Okri's handling of the concept in *The Famished Road* reproduces aspects of all three positions: in many ways it is partly ethnographic in the lavish descriptions given about rituals to do with claiming the *abiku* child for the real world; the timbre of supplication dominates the mode by which Azaro's parents address him, even though they sometimes veer from this, much to their discomfiture; and the entire human landscape is viewed through the eyes of the *abiku* child. One important difference, however, is that the context in which the real world and that of spirits is explored is not in an either/or framework as is implied by the treatment of the concept in the reflections of the earlier writers. Rather, because Azaro desires to stay in the real world while at the same time refusing to break links with that of his spirit companions, both real world and that of spirits are rendered problematically equivalent in his experience. Since the narration is in the first person, with all events being focalized through the consciousness of Azaro, the universe of action is located simultaneously within both the real world and that of spirits. The question of a suggested equivalence between the real

world and that of spirits cuts across various levels of the text and is one we shall pay attention to later in the chapter. The *abiku* concept can be said to be a constellar one and its constellar status is particularly relevant to *The Famished Road* because of the range of indigenous beliefs traversed by the novel, something that will also be examined in our discussion.

The form of *The Famished Road* is radically determined by locating the narrative in Azaro's consciousness. This leads to a peculiar contradiction relating to the point in the life of Azaro when he experiences events and the later time in the narrative when he tells us the story. We are not told at which precise point in time Azaro decides to narrate his childhood, and though the narrative resides firmly in the consciousness of a child, the first intimations of a maturer sensibility are to be glimpsed in the observable contradictions between the 'I' of the narrating instance and the 'I' of the narrated events.

The impression is generated early in the narrative that Azaro is a child, possibly seven years of age:

> One of the reasons I didn't want to be born became clear to me after I had come into the world. I was still very young when in a daze I saw Dad swallowed up by a hole in the road. Another time I saw Mum dangling from the branches of a blue tree. I was seven years old when I dreamt that my hands were covered with the yellow blood of a stranger.
>
> (7)

The impression of events filtering through the mind of a child is sustained throughout the novel but, because of the adoption of a predominantly preterite tense mode of narration, the question as to whether Azaro is still a child when he narrates these events seems to be relevant. At several points the impression of a child's consciousness is undermined by the generalizing comments that Azaro makes in the course of the narrative. He often launches into confident assertions and generalizations of a gnomic and proverbial character

> In the beginning there was a river. The river became a road and the road branched out to the whole world. And because the road was once a river it was always hungry.
>
> (3)

> The world is full of riddles that only the dead can answer.
>
> (75)

> During the harmattan we always forget the rainy season. That's why it rains so viciously on the first day, reminding us of its existence.
>
> (286)

> There are many riddles of the dead that only the living can answer.
>
> (427)

> History itself fully demonstrates how things of the world partake of the condition of the spirit-child.
>
> (487)

These seem to be the pronouncements of a mature wisdom, certainly sharing kinship with that available to the wizened narrators of folk history. If these are explained away as possibly available to the *abiku*'s uncanny sense of its community's values, then this child's mind encases a more nebulous and mature consciousness. Further evidence that this Azaro is no child (or even if he is, his narrating self inhabits a temporal plane different from the narrated self) is also perceptible from the nature of the analogies he draws in his descriptions of human nature. Once, when his mother sighs despondently, he remarks: 'Her sigh was full of despair, but at the bottom of her lungs, at the depth of her breath's expulsion, there was also hope, waiting like sleep at the end of even the most torrid day' (93).

He receives a flogging at his father's hands and likens his father's manner to 'the way a master boxer beats an inferior partner, with rage and methodical application' (324–35). His father's creditors huddle conspiratorially together 'talking in low business tones as though they were about to form a limited liability company' (54). These analogies seem much too sophisticated for a child's consciousness, and the analogy of a limited liability company clearly resides in areas of experience not available to Azaro. It is very tempting to rapidly dismiss these contradictions as deriving from the improper relationship between the implied author and his narrator, for these seem to be veritable signals of an implied author's omniscience attempting to break the limitations on it imposed by the limited perspective of a first person narrator. Appealing though this explanation seems, it is none the less inadequate.

Do we settle for the explanation of there being adult recall and generalization? This would have been extremely plausible if the text had not been scrupulously silent over the exact point in Azaro's life which he decides to narrate the story. There is no reference whatsoever within the text to these narrated events being related from the vantage point of adulthood. This is no *Great Expectations* or *Ibadan*. An argument too that would use Azaro's privileged access to both spirit and real worlds as an explanation of omniscience to explain away these contradictions is bound to flounder when confronted with the fact that he frequently expresses amazement at some experiences of both worlds.[5] Is this not a sure sign of an inherent limitation of awareness that would preclude the wide-ranging knowledge he is allowed to affirm in analogies and gnomic generalizations?

What these contradictions signal is the uneasy location of the perceptual modes of a communal narrator within the largely childlike consciousness of the narrator of the novel. The contradictions illustrate the problems of such a fusion very forcefully. Okri allows Azaro to take up the narration and thereby activates a folkloric paradigm available to a communally held culture from within the framework of a childlike consciousness. This position is even more plausible when we recollect that Azaro relates some of his experiences with a clear etiological emphasis, as if the reader is conceived of within the context of a communal audience requiring the same rationalizations of experience as himself.[6] The reader is thus continually socialized into a narrative situation that combines the gnomic and proverbial affirmations of communal worldviews with the growing and provisional perceptions of a limited narrative perspective. This may be said to derive from Okri's drawing on mythopoeic discourses that reside pre-eminently in contexts of orality. He reproduces the oral narrator's mode of relating to the audience even as this is inscribed within a new literary domain. Azaro's consciousness is automatically and irretrievably framed by the mythopoeic paradigm it articulates. The

contradictions emerge not merely because he is a child who sometimes speaks like an adult, but because he is made simultaneously to speak as himself as well as a communal intuition in which he is vitally implicated by *being* (in the sense of living the essence of) *abiku*.

It is evident that drawing on a mythopoeic framework for writing the novel puts the narrative discourse within the purview of dual organizing paradigms, one of which is grounded in orality and the other in the literary. Indeed, this simultaneous articulation of the oral-folkloric and the written-literary is also displayed in the area of the novel's organization of time and temporality. The plot of real events in the novel is a fairly uncomplicated one devoted to tracing the life of Azaro, his family, and their small compound community and the gradual changes that occur in their lives due to the growth of political activities in their area. Additionally, there is a focus on Madame Koto and the development of her career as bar owner, political sympathizer and, finally, dominant owner of capital and spiritual power in the area. This plot of events in the real world is structured around a number of temporal indices which are often vague but useful as a means of tracing the sequence of events. However, there is a constant interruption of the chronological sequence to enter into the esoteric realm.

The novel opens with a time reference evocative of myth and thoroughly a-temporal in the invocation of quasi-biblical beginnings: 'In the beginning there was a river.' Using a formulaic opening pushes the events of this opening section far beyond the realm of the events that will later follow and also beyond any recognizable time scheme. The mythical opening gives way to a more time-bound scheme of temporality in Chapter 2 where Azaro plots his early childhood. Even here his childhood is plotted in the iterative, showing isolated examples of repeated events. Thus the events are an embodiment of repeated time located within moments in the temporal flow of the narrative proper. They are a tissue of the repeated and the habitual:

> When I was very young I had a clear memory of my life stretching to other lives . . . Sometimes I seemed to be living several lives at once.
>
> (7)

> As a child I could read people's minds. I could foretell their futures. Accidents happened in places I had just left. One night I was standing in the street with Mum when a voice said: 'Cross over.'
>
> (9)

These references to iterative incidents within a generalized time frame resolve themselves into a specific frame when the text focuses on one of the various incidents and expands it to become the trigger for the rest of the events in the narrative. A nocturnal conflagration and the ensuing riots offer such a frame. Time indices are employed to locate the incidents that ensue after the riots in relationship to that inaugural event. The conflagration and the riots occur the same night:

> On another night I was asleep when the great king stared down at me. I woke up, ran out of the room, and up the road. My parents came after me. They were dragging me back when we discovered that the compound was burning. On that night our lives changed . . .

It was a night of fires . . . Three policemen . . . fell on us and flogged us with whips and cracked our skulls with batons . . .

(9–10)

The narrative undertakes a massive digression shortly after this section to relate Azaro's adventures at the hands of the 'cult of women' who capture him when he is separated from his mother by the milling and riotous crowd that gathers due to the fires.[7] Azaro manages to escape the women, is later taken into custody by a policeman and his wife, and is finally rescued by his mother. He has stayed in the policeman's house for 'several days' when his mother comes for him. As a means of bridging the gap between the time of their separation during the riots and their coming together again, his mother later relates the incidents that occur after his being lost on the night of the riots, thus updating us on all the events that have transpired and also locating the mass of events in relation to the main frame of the fires and riots.

Throughout all these myriad events, no specific time indices are given. All the time indices are vague references to 'that night', 'the next morning', 'during that time' and so on. Subsequently, the narrative makes concessions to temporality by referring to a sequence of days such as 'Saturday' and 'Sunday' as a frame for the occurrence of certain events.[8] It is clear that the narrative imposes a framework of temporality on the narrated events rather reluctantly, for, as it progresses temporal indices become less and less prominent. The central operation of the narrative in this respect is to recall significant events that come to mind without necessarily noting time's passage. This mode of organization has a telling effect on overall plot structure, rendering it loosely episodic not only because of the massive esoteric digressions, but also because of the marked absence of temporal indices.

There is an even more complex implication of the relative paucity of temporal indices in the text. Because we are not given an indication of what period of time each event spans, it is difficult if not impossible to define the relative duration of each event. Narratologists have mapped out how duration is grasped by the reader, linking it to the relationship between the clock time consumed in reading a passage and the temporal frame given by the passage itself.[9] If three hundred years is plotted in three paragraphs, it signals a short duration and the telescoping of a long time span. The lavish description of an hour's incident in thirty pages shows a long duration, slowing down the pace of the narrative. In *The Famished Road*, however, the lack of definite temporal indices in relation to events ensures that a mode of equivalence is insinuated as definitive of the relationships between various events. In other words, no event is subordinated to another in terms of temporal duration. Thus, a homogenous sense of a-temporality, relieved only by the vaguest time indices, is spread throughout the narrative.

Yet another formal textual feature that helps enforce a sense of homogeneity is the relative absence of character recall of earlier events. At no time, for instance, do any of the characters ever refer back to the conflagration of the earlier stages of the narrative in constructing a sense of life in the ghetto. After the food poisoning brought on by the powdered milk of the Rich People's Party (13–2), no reference is made later in the narrative to this traumatic event as a means of defining the character of the party. That the Party is populated by hooligans is never forgotten, but this is continually demonstrated by the text rather than being recalled. As a third instance of this structural

feature, we must note that even at the second house-party thrown by Azaro's father there is no reference whatsoever to Azaro's welcoming party which occurs much earlier in the narrative and seems to be a narrative precursor of the second one. There are also no flashbacks or what Genette calls 'anachronies' in the novel in the sense of an event appearing later in the sequence of the narrative but indicated to have occurred earlier in the story.[10] It is as if there is an effort not only to disperse a series of discrete events across time but also to enforce a sense of a continual forward narrative movement. But, at the same time, this seeming teleological narrative impulse is disturbed by the constant recurrence of extended esoteric moments that do not follow any teleological trajectory. Furthermore, there is a pervasive sense of the interpenetration of the essence of the two realms of the real and the spirit.

How are these various contradictory movements in the narrative strategy of the novel to be explained? And what effect do they ultimately have on the reader's response to the universe of the work? Perhaps the contradictions can only be explained in relation to the novel's evocation of an orality paradigm within the space of a literary one, so that there are, properly speaking, two sets of expectations that it relies on for its conduct. Joseph C. Miller (1980) offers an interesting discussion of structuring in oral traditions which can act as a basis for groping towards an explanation of Okri's erasure of temporal indices in *The Famished Road*. Miller notes that oral narrators structure their tale around clichés and that these are often grouped together in epochal sets. In societies where the state is central to social structure, oral historians commonly represent these epochs as the reign of kings. However, though the logical status of epochs seems to parallel that of years in Western history, it is misleading to infer chronology from the reign of kings because of the numerous irregularities that can be shown to inhere in the sequence of epochal sets. The important thing to note is that:

> The creation of 'epochs' by oral historians resembles 'structuring' in that narrators collect clichés (and thereby appear to associate with each other the events the clichés represent) together according to *non-temporal criteria*: cultural preferences, cosmological tenets, or the unconscious tendencies of the human memory.
>
> (Miller 1980: 14; italics added)

Here seems to be the key to understanding the principle of association working in oral narratives. Though Miller's focus is on the significance of this structuring for deriving history from oral traditions, it seems possible to draw implications for oral narratives in general. Clichés include songs, proverbs, thematic sequences and even specific heroic tropes (Miller 1980: 7). They are themselves important elements in an oral culture's mnemonic system. Strung together in epochs they become a textual encoding of the site of a culture's memory ready to be activated for different purposes. The stringing together of clichés in non-temporal significatory frameworks produces a paratactic structure to many oral traditions. One of Michel Doortmont's observations about Rev. Samuel Johnson's work was that it was 'a collection of not very well-connected praise songs engineered into a seemingly coherent epic.' Apart from the prominence of songs in Johnson's historiography, what this points to is the essentially paratactic movement of his work. The paratactic quality of oral narratives seems to derive directly from the fact that they are constructed as a collection of items that have

been secreted in collective memory as expressive of significant cultural or social insights. These become nodal points for the organization of discourse in oral contexts and need not be tied to temporal criteria.

The same operation is discernible in folktales. Tutuola's narratives have few temporal indices. His narratives rush forward as rapid recollections of exciting encounters between heroes and spirit-figures, making them episodic and largely paratactic in structure. With Tutuola, the reliance on oral forms of narration is quite obvious and impacts on several levels of his narrative scheme. One thing that prevents his narratives from becoming like novelistic discourse is the fact that he strings together a series of etiological and other cultural fragments while retaining their points of closure in proverbial sayings or etiological explanations. Furthermore, there are no flashbacks in Tutuola. Nor are there 'anachronies' in Genette's term. The narratives trace an inexorable forward movement. It is obvious that, unlike much novelistic discourse, Tutuola's narratives and the folktales upon which he draws do not shuffle with the notion of temporal sequence, even though they are frequently digressive. Rather than being vertical and imposing a structure of subordination between events, the digressions in oral narratives are horizontal and reside on the same lateral plane as the events or incidents in the story they depart from. Subordination is cued from a wider context of signification such as the moral difference between good and bad or from other cultural contexts of immediate material reference.

Ben Okri relies on this mode of discourse, but, because he writes in a self-consciously literary mode, he replicates the structures of oral discourse while at the same time generating literary expectations. *The Famished Road* is evidently episodic with little attempt to link events to one another in any but a sequential framework. With the frequent gnomic generalizations, proverbs and even etiological speculations, a sense of reaching for the closures of oral narratives is evoked as a means of socializing the reader into the discourses of orality. This is further deepened by the lack of all but the vaguest temporal indices and the lack of recall or of anachronies. The flow of the narrative is paratactic and episodic with Azaro moving from one incident to the other in a bewildering framework of arbitrary shifts between the real and spirit-worlds which all seem to reside on a lateral plane. However, the important thing to note about the narrative here is that these communal referents are raised as literary surrogates of what pertains in a context of orality. It is as if Okri conceptualizes the narrative in the context of a communal orality before looking for the best way of rendering that consciousness in a literary mode. The contradictions emerge because not only does he seem to conceptualize his narrative in that way, he grounds it completely within a mythopoeic paradigm by routing it through the mind of the *abiku* child.

Despite *The Famished Road*'s a-historical narrative structure, the events are supposed to take place within a specific historical setting, indeterminable though it often seems to be. It is that of Nigeria at the verge of Independence. The vague references to political activity are all supposed to derive from that period. Even in this putative historical grounding, history is problematized by the fact that, unlike most other references to that period, the novel inscribes a sense of disillusionment into the events. It is as if the mood of post-Independence disillusionment is transferred onto the period before Independence when the mood was supposedly more euphoric and hopeful. In this way, Okri separates the historical referents from the affective corollaries to which they are usually conjoined, suggesting that history is as much a construction as the

fiction he is writing. Additionally, this splitting could also relate to his deployment of the *abiku* motif to stand for the history of his country. Since the *abiku* is caught in a cyclical web of births, deaths and rebirths, it fractures history and problematizes the unity of the materiality of events and their putative affective referents. If the country is like the *abiku*, the affective status of its history is thrown into doubt precisely because it is trapped in a grid of non-progressing motion. When Okri suggests this, however, it is not to postulate an ineluctable determinism, but rather to suggest that his country has not done enough to transcend the trauma of unending underdevelopment or the nausea of confusion in its unfocused attempts to escape it. As is pointed out in the novel:

> Things that are not ready, not willing to be born or to become, *things for which adequate preparations have not been made to sustain their momentous births*, things that are not resolved, things bound up with failure and with fear of being, they all keep recurring, keep coming back, and in themselves partake of the spirit-child's condition. They keep coming and going till their time is right. History itself demonstrates how things of the world partake of the condition of the spirit-child.
>
> (487; italics added)

The pointer to improper preparations for momentous births links up with Soyinka's own reminder to his nation of the cyclicality of political irresponsibility in *A Dance of the Forests*, a play commissioned specifically to mark Nigeria's Independence celebrations in 1960. The nation is partly figured in that play as a half-bodied child, alluding suggestively to an *abiku* condition and also to the fact that the country's nation-status is not something to be taken for granted in euphoric celebrations of a new birth. By splitting history from its affective referents thirty years later, Okri gives the allusion an even more disturbing slant by showing that the cyclicality is one that becomes endemic if not recognized for what it is.

This takes us to what promises to be the most contentious aspect of the novel, that is the 'spirit' or 'esoteric' passages, their relationship to the passages of realism and the implications these have for the meaning of the work. The narrative is constructed out of a dense weaving of esoteric and reality passages, but a close examination reveals several manners of weaving and differing relationships between the two.

It has already been noted that the nocturnal conflagration and the ensuing riots of the first night provide the initial impetus for the flow of all the narrative events in general. More importantly, the incidents of that night provide a take-off point for the first of numerous digressions into spirit passages. In the confusion of the riots, Azaro is separated from his mother and begins wandering belatedly in search of her. He is suddenly kidnapped by several women 'smelling of bitter herbs' who carry him off to a strange island in the middle of a river along with a wounded woman they pick up on the way. After being warned by a 'cat with jewelled eyes' about the threat to his life continued stay on the island would bring him, Azaro decides to escape in a canoe and does so accompanied by the wounded woman. The events of this digression run pell-mell for four pages to the end of Chapter Three (11–14). But at the opening of Chapter Four (15), Azaro materializes under a lorry: 'That night, I slept under a lorry. In the morning I wandered up and down the streets of the city.'

We must pause to examine the relationship of this digression to the first narrative of the conflagration and riots. The esoteric digression seems to have rejoined the first narrative almost at the same point from which it departed. It is still night and since there are no other time indices we have no way of knowing whether it is a different night from that of the riots. At least we know that the events of the 'cult of women' digression all take place at night so we can venture to imagine this reference to be to the same night but in a different part of the city. If that is granted, then it means that what the digression has accomplished is a filling of the interstices between two discrete moments in the narrative with a myriad of esoteric events. This seems plausible also because the incidents of the first narrative do not have any relationship whatsoever with those of the esoteric digression. What this particular form of linkage suggests is that the spirit-world remains a vital life operating *between* the arena of real events. And yet it is not a betweenness that interferes with the space or temporality of the real world. The only direct link between the esoteric events of these passages and those of the reality plane is that they are both experienced through the consciousness of Azaro.

Another digression follows after that of the cult of women, and it also offers insight into another method of interweaving the esoteric and reality passages. Azaro's emerging from underneath the lorry in the morning to resume his wanderings becomes a subsidiary frame for the pursuit of yet another esoteric digression within the narrative. He arrives at a marketplace, gets a loaf of bread from a man with a 'severe face' and 'four fingers' and continues his wandering in the market. Looking at the people who have come to the market, he realizes most of them are strange spirits who have also come to buy and sell:

> I shut my eyes and when I opened them again I saw people who walked backwards, a dwarf who got about on two fingers, men upside-down with baskets of fish on their feet, women who had breasts on their backs, babies strapped to their chests, and beautiful children with three arms.
>
> (15)

He gets a momentary scare when some of these strange creatures discover he can see them, and runs off to another part of the market. He decides out of curiosity to follow some of the strange creatures when they are departing to their homes and settles on a 'baby spirit' which leads him into a clearing in the forest, apparently the beginning of an expressway. Trees have been levelled, and at places the earth is red, but what fascinates Azaro most is a 'gash' in the earth. As he stares at the gash, he hears a sharp noise, as of something sundering, shuts his eyes in horror, and discovers on opening them that he is somewhere else. Azaro is in the belly of the Road! He is quizzed by an irate giant turtle as to his presence and purpose there, but, dissatisfied with his answers, the turtle lumbers away leaving him to cry himself to sleep on 'the white earth of the land'. It is when he wakes up that the esoteric narrative rejoins the previous narrative frame, and that is what is of interest to us here: 'When I woke up, I found myself in a pit from which sand was excavated for the building of the road. I climbed out and fled through the forest' (17).

The rest of the narrative is located within the reality plane. The 'belly of the earth' is in fact an excavated sand pit. In the switch from the esoteric to the real in which the same space is simultaneously within both realms, the narrative suggests that Azaro

(and by implication the rest of nature and existence) is in a continually shifting space, and partly at the mercy of those arbitrary shifts. It is interesting that, unlike the first type of digression in which he has to escape the esoteric realm through his own effort, in this case the change occurs without regard to his own volition. A second impression that this particular method of weaving the esoteric with the real suggests is that in the narrative, reality and the spirit-world relate to each other in a kaleidoscopically shifting relationship in which the same phenomenon takes on different accents and hues depending on its location on the reality-esoteric axis at any one moment.

In both these instances, Azaro is alone in experiencing the dual realities and the two planes do not interfere with one another. They seem to be strictly dichotomized. At other times, however, the dichotomy is blurred when Azaro, though ostensibly sharing the same experiences with other characters, perceives aspects of the experience from which the other characters are excluded. This sometimes leads to comic situations, as is the case when in Madame Koto's bar with his father he falls off his seat in reaction to the violent sneezing of a 'three-headed spirit'. His father does not see the three-headed spirit, and, imagining his son has fallen off due to the sneezing of one of the bar girls, rounds on him scathingly:

> 'What is wrong with you?' Dad said.
> 'Nothing.'
> 'A woman sneezes and it blows you away? Are you not a man?'
>
> (298)

Only Azaro has the dubious privilege of perceiving the dualities in the experience. In such sections the two planes coalesce in subtle ways that differentiate the manner of construction of these sections from the other sections examined

Another form of linkage, which this time establishes a calibration of perspectives between the two realms, is offered in the section in which Azaro travels to the under-world in the company of the three-headed spirit. He decides to depart to the under-world in violent reaction to being flogged by his father. In this particular digression the narrative is orientated towards both planes simultaneously, but it is mainly focal-ized from the vantage point of the esoteric plane. All the human gestures that occur in the reality plane are simultaneously correlated with the events in the esoteric zone in terms of the action of elemental forces. When Azaro's father crouches beside him, his breathing 'manifests itself as a strong wind in the world in which I was travelling' (327); and when his mother sheds tears over his prostrate body, these become 'rainfall which wiped away most of the labours of the people' in the spirit realm (331). Our perceptions have to undergo frenetic shifts getting to the end of the section because the gestures of his parents and those of the herbalist brought to revive him all take shape within his dream-journey as a frantic struggle between his three-headed spirit guide and an old woman with the feet of a lioness:

> The weapon of the old woman with the feet of a lioness had become golden-red. One of the heads of the spirit had rolled onto the river of mirrors and its eyes stared at the eternity of reflections in a bad-tempered astonishment . . . Dad's knife, full of reflections, was lifted above me, as if I was to be the sacrificial victim of my own birth. I screamed. The knife in Dad's hand descended

swiftly, slashed the air twice. The herbalist released a piercing cry. The old woman struck the spirit at the same moment, with a mighty swipe of her weapon. Dad slashed the chicken's throat. The old woman severed the spirit's last head. The spirit fought vainly in the canoe as the chicken twitched. Its blood dripped on my forehead.

(339)

The strength of this section lies in the rapid translation of events in one plane into events on the other thus calling on us to orientate ourselves to both planes simultaneously. The section also becomes a masterly literary adumbration of the relationship between dreamwork and sensory stimuli, permitting us to perceive the dreamwork and its external stimulus frame interacting continually one with the other.[11] This, however, is no ordinary dream because it requires an adjustment in attitudes about the relationship between the real world and that of spirits. A form of equivalence is hinted at in the calibration of events between the two worlds. In this episode the mundane world exerts power over the spirit-world. Seeing that the episode is about the beliefs and practices of traditional medicine, it can also be read as an endorsement of indigenous medical practice which attaches great importance to the physical as well as the spiritual prognosis of disease. From the point of view of Azaro's position, however, the episode further emphasizes his powerlessness in the face of the relationships between spirit and real worlds because he is totally at the mercy firstly of the three-headed spirit and then of the herbalist for his entry and exit from the spirit-world. He is the victim of forces beyond him.

In this section as in other sections in which the distinction between the esoteric and the real are deliberately blurred, the narrative suggests that in its universe of discourse it is difficult to differentiate the one from the other. And because these coalesced sections are juxtaposed with other methods of weaving the esoteric with the real, the narrative works to undermine any easy conclusions that may be arrived at from an examination of any one method of interweaving. The novel's formal strategy may be related to other elements of the narrative to show that an important interest of the story is to demonstrate the fantasy inherent in any experience of real life. In the particular destitution, impoverishment and brutality in which the people in the novel are caught, the realities of existence are frequently tinged with an eerie light. It is instructive to remember that at a crucial stage in the narrative when thugs attack the ghetto and spread mayhem, the events of the night are described in highly poeticized images to bring out the essential 'ghostliness' of the experience; the brutalities seem so unreal that in spite of the fact that several people lose their lives the people later begin to think they 'had collectively dreamt the fevers of that night' (183). We see then that the narrative insists on the essential 'ghostliness' of reality not only in terms of its formal strategies of esoteric weaving but also in terms of the delineation of squalor and destitution, these being the new seats of hallucination.

Certain implications derive from the specific interweaving of the reality and esoteric planes in *The Famished Road*. In the narrative shifts from the reality plane to the esoteric plane in which the same space is simultaneously located within both realms, there is a suggestion that Azaro, and by implication the rest of nature and existence in general, is in a continually shifting conceptual space and partly at the mercy of those shifts. This affects the general notion of time and space and therefore the liminal

thresholds and transitions that operated in Tutuola's narratives. Liminal thresholds are no longer conceived of as medial points within a process of transition from one status to another of perhaps greater significance. Those processes of transition are normally marked by acts of volition in the narrative space of the indigenous folktale, and, within a larger cultural context, by acts of ritual self-preparation. The possibility of accessing the spirit-world through ritual acts of volition or self-will is frustrated within the narrative of *The Famished Road*. And this is mainly because the shifts from one experiential plane to the other are no longer within the control of the central characters. Unlike what we saw operating in Tutuola's narratives, the spaces of reality and of the spirit-world are no longer demarcated so that men can move from one to the other through their own volition. The logic of arbitrary shifts seems to take precedence over the volitional acts of the central characters.

The nature and scope of the spirit-world of the novel further establish the similarities and contrasts between Okri's mythopoesis and Tutuola's by suggesting a dispersal and redistribution of the anxiety-generating potential lodged wholly in the ghostly realm in the work of the earlier writer. The esoteric in Okri has a wide-ranging scope and incorporates several elements that are not wholly reducible to any single cosmogony, though that of southern Nigeria remains the central impulse. It is difficult to escape the impression of biblical echoes in the opening lines of the novel. And it is also noticeable that the denizens of the spirit realm of *abikus* have a king who has undergone several incarnations on earth shape of good and holy men and thus automatically establishes kinship with the leading figures of world religions.

> Our king was a wonderful personage who sometimes appeared in the form of a great cat. He had a red beard and eyes of greenish sapphire. He had been born uncountable times and was a legend in all worlds, known by a hundred different names.
>
> (3)

The *abikus'* spirit-world can only be described as celestial. They play with 'faunas, the fairies, and the beautiful beings'. 'Tender sibyls, benign sprites and the serene presences' of their ancestors are always with them. The children's spirits make vows to return to the enchanted existence 'in fields of flowers and in the sweet-tasting moonlight' of that world (4). This world's kinship to paradise is unmistakable. Interestingly, Okri veers significantly from the tissue of beliefs to do with the *abiku* phenomenon in suggesting that Ade, another *abiku*, had previous incarnations as a 'murderer in Rome, a poetess in Spain, a falconer among the Aztecs, a whore in Sudan, a priestess in old Kenya, a one-eyed white ship captain who believed in God and wrote beautiful hymns and who made his fortune capturing slaves in the Gold Coast' (481). Clearly, the *abiku* concept is partially filiated to conceptions of the afterlife not wholly African. The multiple dimensionality of afterlife remains as a potential in the narrative and is not developed as a coherent dimension of the *abiku* phenomenon.

When he comes into the real world, the spirits Azaro encounters come in a variety of categories. Some are spirits who have 'borrowed' parts of the human body but not the human body's symmetry. Thus, they frequently appear incongruous. At Madame Koto's bar spirits enter who have misshapen heads 'like tubers of yam', or eyes not properly co-ordinated. Azaro is often amazed at their deformities. Another set are

thoroughly grotesque in their constitution. Such are the three-headed spirit and a spirit Azaro encounters in the forest described as 'a creature ugly and magnificent like a pre-historic dragon, with the body of an elephant and the face of a warthog' (247). Many of these spirits are dangerous and seek to kidnap him to enhance their own potencies

Yet at various other times it is humans who take on the manifestations of spirits, thus problematizing the distinction between humans and spirits. In the two instances when Azaro encounters lunatics, there is the suggestion that they share a curious kinship with the grotesqueness of spirit figures. Witness the description of the first lunatic whom Azaro meets at the market-place and who expresses an uncanny interest in a piece of bread he is holding.

> There was a man standing near me. I noticed him because of his smell. He wore a dirty, tattered shirt. His hair was reddish. Flies were noisy around his ears. His private parts showed through his underpants. His legs were covered in sores. The flies around his face made him look as if he had four eyes. I stared at him out of curiosity. He made a violent motion, scattering the flies, and I noticed that his two eyes rolled around as if in an extraordinary effort to see themselves.
>
> (17)

The impression that this lunatic's eyes have undergone multiplication because of a swarm of flies is unsettling enough, but what is even more distressing is that his eyes, much like the flies that surround them, cannot keep still. A second lunatic is encountered in front of Madam Koto's bar. His description is also striking:

> He had on only a pair of sad-looking underpants. His hair was rough and covered in a red liquid and bits of rubbish. He had a big sore on his back and a small one on his ear. Flies swarmed around him and he kept twitching. Every now and then he broke into a titter.
> . . . He had one eye higher than another. His mouth looked like a festering wound. He twitched, stamped, laughed, and suddenly ran into the bar.
>
> (84)

Once again we should take note of the odd nature of this man's eyes. And his mouth itself is like a festering wound, referring as much to its raw look as to the overpowering stench of putrefaction that can be thought to emanate from such a mouth.

To grasp the true significance of the relationship between these lunatics and the other grotesque spirit figures in the formal strategy of the novel, it is necessary to turn again to Tutuola's handling of the folktale form and the ways in which *The Famished Road* simultaneously evokes and differentiates its mythopoeic discourse from it. As was noted earlier, in Tutuola's narratives there is a clear boundary between the real world and that of spirits with the suggestion that it is the crossing into the world of spirits that triggers the experience of the esoteric and the anxiety-generating forces inherent in nature figured in the form of grotesque spirits. In this novel, however, the boundary is progressively erased with a redistribution of the grotesque among figures in both the reality as well as in the spirit plane. Whereas in Tutuola's narratives the anxiety-generating forces are encoded as dominantly inherent in the 'Other', here there is a

suggestion that real world existence, especially in the context of squalor and dispossession, shares in the absurdity of that other. Thus the dichotomizing gestures of mythopoeia are turned towards showing reality in a new light.

The refocusing of the nature of the spirit-world ramifies at other levels. The specific nature of the spirits in *The Famished Road* also implies alterations to the notion of heroic vocation that dominated the form of the folktale as exercised by Tutuola. In terms of the heroic vocation of the central protagonist, Azaro, there is a decided diminution of the hero here in relation to the spirit encounters. In the dominant discourse of mythopoeia, the protagonist is usually an articulation of titanic grandeur and heroic energy. Azaro has none of these characteristics. He partially subsists within the mythopoeic framework by having access to the spirit-world but no longer is this access volitional and part of an epic quest. Since entry into the spirit-world is purely arbitrary and not due to conscious choice, the esoteric adventures that Azaro undergoes seem purely fortuitous. It is Azaro's unfortunate existential condition that he must perceive the dual aspects of reality whether he likes it or not. And, unlike the heroes of Tutuola's novels, Azaro remains utterly powerless against the spiritual forces he encounters; he retains crucial human limitations right through to the end.

There is a strategic refocusing on heroic energy in the novel away from the central mythopoeic domain to be reinscribed in the arena of real world actions. The diminution in the stature of the mythopoeic protagonist in the novel is accompanied by a displacement of the heroic potential onto the character of Azaro's Dad, also known in the novel as Black Tyger.[12] That Dad has titanic stature is left in no doubt. He is continually referred to either as a giant or a titan (see pages 28, 34 and 94). From the very beginning Black Tyger is portrayed as a man full of energy burdened by the struggles imposed by an impoverished existence. He carries this burden with much grumbling and is not beyond outbursts of domestic violence. But at the same time there are suggestions that his struggle against poverty borders on a titanic struggle with elemental forces that would destroy man's soul. An Ogun genealogy is posited behind this titanic stature and he is filiated to the god of war in several subtle ways. Black Tyger's own father was a priest of the God of Roads and he was supposed to have succeeded him but left to pursue a boxing career. Dad is further linked to an Ogun essence by his telling of the story of the 'King of the Road', the only full-length etiological story in the novel. Significantly too, he is shown to be a good hunter, suggested in his trapping of the wild boar early in the narrative. He is also a great lover of palm-wine, the favourite drink of Ogun himself. Given the array of such references and the fact that he has a ferocious fighting energy, he seems almost to fall directly in line with the essence of Ogun as defined in indigenous Yoruba discourses. These references are, however, linked to another set of references that encode Black Tyger as Shango-like as well, hinting at the necessity for justice and suggesting a gradual shift in tutelary references to make them more appropriate to the concerns of the dispossessed in the novel.

At several points Dad is linked to a gentle or dark wind by which he 'materializes':

> [A] gentle wind came into the room and turned into a dark figure, towering but bowed . . . The figure was Dad.
>
> (199)

Then the wind blew a man to the front door. He stood outside, visible behind the strips of curtain. He came in and looked round and two of the women rushed to him and led him to a seat. It was Dad.

(296)

Dad's being somehow linked to the elements is further deepened by his continual association with thunder and lightning. This becomes most evident when he is angry; it is demonstrated when he comes home one evening to discover his creditors have seized his boots and centre table in his absence:

He growled like an enraged lion, drew himself up to his fullest titanic height, stormed out of the room, and began raging down the passage so loudly that it seemed as though thunder had descended amongst us.

(96)

In another incident at Madame Koto's bar, the association is made even more explicitly in a fight he has with thugs. One of the thugs rounds on Black Tyger and is bragging about the powers stored in his amulet: "'So what do you want to do?" the man asked, fingering his amulet. "Do you know this thing I have here, eh? If you touch me you fall down seven times and then . . ."'
The braggart is not allowed to complete his sentence. Something fantastic happens:

Suddenly – it seemed like a flash of lightning was lost in the bar – Dad had hit him in the face. It happened very fast. The next moment the bar door was wide open and the man had disappeared. We heard him groaning outside in the dark. The lightning vanished back into Dad's fist.

(301)

The associations with thunder and lightning subtly inscribe a Shango essence which is further grounded in the fact that Dad is a stickler for justice. This is evident from his inarticulate but determined opposition to the Party of the Rich. He opposes them even at the risk of falling foul of his landlord and of endangering his family. It is as if, despite the problematization of the heroic stature of the folklore hero as signalled in the diminished potential of Azaro, the narrative incorporates an index of grandeur and heroic stature by linking Black Tyger to deity references. However, the way this is done shows that the mythopoeia is eclectic to accommodate the complexities of real world existence. There is a subtle shift from allegiance to the particularities of a single deity. This represents a strategic elaboration of what Soyinka does in his persistent invocation of Ogun. Okri reaches for the eclecticism inherent in polytheistic cultic dispensations and in this reproduces the temper of indigenous attitudes to the gods. The eclectic temper of Okri's inscription of multiple deitic qualities can also be said to mark a sense of the hybridity which is a function of the multicultural environments in which he grew up. The filiation to the indigenous resource-base, then, is a strategic filiation to its hybrid and eclectic potential as much as to its specific motifs and images.
If it is postulated that, unlike Azaro's, Black Tyger's development defines the trajectory of a rite of passage, then it is important to trace the specific mode by which his experiences may be said to constitute a rite of passage that contrasts with the

a-teleological experiences of his son. There seem to be three phases in his development. The first phase involves his struggles for existence amidst the squalor and dispossession of the ghetto. He has to take up all sorts of jobs to make ends meet, including porterage at the lorry park as well as surreptitious latrine carrying.[13] This phase is often punctuated by his expressions of bewilderment at the harsh ways of the world. The second phase involves a definition of his relationship to politics, notably in his fierce onslaught against the Party of the Rich despite dire consequences for himself. The third phase is the most complicated because it involves the affirmation of his titanic stature in various fights, yet the consequences of exercising this potential are shown to be highly problematic for the definition of an appropriate social role for himself.

Confirmation of his titanic stature starts with his fight against the spirit of Yellow Jaguar, a boxer whose body felt like a tree and who had a mighty voice, 'speaking with the power of darkness' (356). His defeat of Yellow Jaguar is succeeded by a period of serious illness in which he lingers in 'a curious state of shock, between agony and amnesia' (359). Interestingly, he is said to become like 'the biggest newborn baby in the world' (ibid.). The suggestion of a potential rebirth is, however, not picked up by the text, because in terms of the development of Black Tyger's character, the defeat of Yellow Jaguar only serves to make him self-centred and swelled up in the belief in his invulnerability. After his recovery, he moves further and further into a definition of a social role based on strength and violence. The value of his ferocious strength is problematically affirmed in his battle with Green Leopard, a huge thug who had been menacing the streets and was now on the payroll of the Party of the Rich. Again he accomplishes an impressive victory over his enemy (395–42). At this point, however, new realities make themselves felt which test Dad in other directions.

Earlier on, during a training session at one of his secret bases prior to the encounter with Green Leopard, he undergoes an epiphanic experience when a strange old man 'carrying something invisible' on his head comes to test his charitable impulses. Crucially, he passes the test and the old man tells him how lucky he is to have passed. It is an important experience for him as he later tells his son: 'I am beginning to see things for the first time. This world is not what it seems. There are mysterious forces everywhere. We are living in a world of riddles' (388). The encounter introduces a second aspect to his quest for an appropriate social role and his development after the bout with Green Leopard fuses these two dimensions. Black Tyger progresses in the direction of charitable impulse even as his titanic stature is affirmed through fights. He enters into a phase of idealism in which he desires to create a socialist utopia in which, among other things 'everyone must learn music and mathematics and at least five world languages, and in which every citizen must be completely aware of what is going on in the world, be versed in tribal, national, continental and international events, history, poetry and science' (409). In terms of his quest for a mode of social existence this idealism is important because it leads him to attempt to organize his neighbourhood into a greater awareness of their surroundings, even though his initial efforts at neighbourhood cleaning attract only derision and insults. Secondly, the idealist drive moves him to contemplate hijacking the machinery of politics as a means of enabling the achievement of his utopian ideals. These efforts are shown to be cranky and severely limited because of the seriously debilitating structure of underprivilege of which he is clearly a victim. All this phase of idealism gives him is a devoted constituency of

deformed beggars who gatecrash a party he organizes and become permanent append-
ages of his political plans.

The constituency of beggars becomes the objective test of the charitable impulses we
noted earlier. Not only are the beggars a rather trying group, the attitude that other
people in the neighbourhood adopt towards them is decidedly different from Black
Tyger's. In fact, it is precisely in relation to these beggars that he has his final titanic
fight. His decisive intervention to avert the nasty fate that would surely have befallen
them at Madame Koto's party finally joins up the two movements in his characteriza-
tion, one towards violence and the other towards charitableness (467–71). Black Tyger
enters this fight precisely because he espouses the cause of the dispossessed represented
by the beggars. It is the first time he fights not to make money for himself but in a
principled defence of others. When bets are collected during this last fight he insists he
wants the money to build a university for the beggars, thus adding the provision of
social welfare to that of social justice.

Black Tyger is no richer at the end than he was at the beginning of the novel, but his
character undergoes a decided enrichment in terms of the definition of a form of social
existence appropriate to the condition of the dispossessed. The vast 're-dreaming' of the
world he has in the delirious aftermath of his last fight might be construed as unduly
homiletic in tone, but the point is that it marks the achievement of a prophetic and
humanistic mode of understanding the world for him. Thus it can be said that, unlike
Azaro, Black Tyger's experiences constitute a rite of passage in the terms often reserved
for the heroes of mythopoeia. What this strategy achieves is the problematization of
the heroic vocation in the Tutuola type of narrative to suggest that it is the processes of
real-life existence that must define the heroic vocation and that this vocation depends
on the resources of the real world as well as that of spirits.

The deflection of heroic energy from Azaro onto his father might be read as un-
satisfactory in terms of the implicit validation of a masculine mode of heroism. That
seems to be a valid point considering Mum's relative self-effacement in the text.
Hers is a harried and difficult existence. In relation to the characterization of Madame
Koto, however, there is a partial challenge to any notion of heroism being a masculine
preserve. The indigenous resource-base for Madame Koto's characterization renders her
a massive challenge to a masculinist notion of heroism, though, it must be said, a
notable ambivalence attaches to her character which undermines her as a potential
centre of heroic significations.

Madame Koto is shown to be highly resourceful, independent and ambitious. When
she is first introduced to the narrative, her credentials are rapidly established by her
wrestling with a drunken customer who tries to make trouble after being defeated at
draughts in her bar by Dad. At several other points, she takes decisive action against
recalcitrant customers as well as Azaro. She shows a strong dissatisfaction with the
conditions of squalor and deprivation she has to bear and, as she expresses it to Azaro,
her dreams are to one day escape the cycle of poverty to become a rich and influential
person (251). The nature of her dissatisfaction with her circumstances is not much
different from the nature of dissatisfaction of all poor people. Dad frequently expresses
such dissatisfactions, though his ambitions are shown to be substantially different from
hers. Significantly, however, the narrative poses Madame Koto's dissatisfaction as a
problem linked to witchcraft. Three different perspectives are given into her potential
witchcraft and all three serve to pass judgement on her. The first perspective is offered

by the rumours that circulate about her. Much of the knowledge about Madame Koto's character is woven out of rumours from the very beginning. When she throws out the recalcitrant drunken customer, her legend, 'which would sprout a thousand halluci-nations', is born. But of stories and rumours, it would in time 'become some of the most extravagant realities of our lives' (37). The subtle and gradual concretization of rumours into reality is implied in this statement but we are not sure whether it is meant that the rumours would later have the status of fact or whether it is her actions that would confirm some of the worst rumours about her. The narrative itself leans towards the second rather than the first explanation.

The rumour mill turns out an elaborate and coherent understanding of Madame Koto's character based entirely on beliefs in witchcraft:

> They said of Madame Koto that she had buried three husbands and seven children and that she was a witch who ate her babies when they were still in her womb. They said she was the real reason why the children in the area didn't grow, why they were always ill, why the men never got promotions, and why the women in the area suffered miscarriages. They said she was a bewitcher of husbands and seducer of young boys and poisoner of children. They said she had a charmed beard and that she plucked one hair out every day and dropped it into the palm-wine she sold . . . and that she belonged to a secret society that flies about in the air when the moon is out.
>
> (100–1)

Each item in this barrage of rumours is a direct affirmation of the belief that she is a witch. If they are isolated, they fall into three distinct sets of beliefs about witchcraft: the first set asserts that she is incapable of marriage and is a destroyer of fertility, suggested in her burying of several spouses and her destroying children in the womb. This set of assertions is tied to a popular belief that all women are potentially vessels of fertility or their opposite. As soon as a woman either fails to marry or have children she is seen as the inverse of fertility. The second set of assertions relates to the witch's carnal status. They are believed to have strong sexual urges. These urges are believed not to be exercised within the ambit of the socially permissible because of the witch's natural predilection for transgressing the socially acceptable. The third set links women's enterprise to esoteric power. The assertion that her beard is charmed and is used to sell palm-wine is a clear linking of her commercial success to negative power (see Hallen and Sodipo 1986: 102–7). The tissue of popular beliefs asserted by the rumours are variously affirmed by the narrative. Though Madame Koto is not shown to be wanton, she is surrounded in the later parts of the narrative by prostitutes. That she is pregnant with three *abiku* children she refuses to give birth to is a clear sign of the inversion of fertility. And we are left in no doubt that juju is behind her commercial enterprise and that she immerses herself in dubious spiritual practices.[14]

It is evident that Okri defines Madame Koto in an ambivalent light. On a purely sociological reading, this serves as a literary inscription of some of the ambivalent atti-tudes to strong-willed and successful women in Nigerian society. Southern Nigerian women are generally noted to be highly independent in spirit. Yoruba women are noted to be vigorous traders and have a highly independent disposition. However, they have to operate within a predominantly patriarchal social structure. Because of their

perceived independence, a process of demonization of women is inscribed in Yoruba culture along with a great respect for their resourcefulness. The first level of this process involves linking the marketplace, the very seat of women's commercial activities, to Eshu, the god of mischief. Even more importantly, the commercial progress women make is seen as linked to witchcraft, something generally believed to be an immense threat to society. The witch is said to prosper through her dominion in the world of spirits. But, as Judith Hoch-Smith (1978: 265) points out, this demonization of women's power symbolizes 'the struggle between the sexes for power on many levels: sexual, social, political, the derogatory female image being related to the normative ethos of the patrilineage'.

Madame Koto is posited as a potential centre of heroic energy in parallel with Black Tyger, and we are meant to admire her. She frequently has him drink palm-wine without charge and shows numerous kindnesses to his family. It is she who rushes to bring Mum herbal medicine when she lies ill and at the verge of death, and her warmth towards Azaro is unmistakeable. However, there is a dichotomy between Black Tyger's heroic potential and hers because of the different directions in which their filiation to the spirit-world leads them. Whereas he moves to greater social conscience, she moves towards self-interest. The narrative suggests there are sociological reasons to rationalize the exercise of her particular options. Being a trader and owning some capital in the form of the palm-wine bar gives her a distinctly more privileged status than the rest of the neighbourhood and defines her primary motivations. Because of her ownership of capital it is not difficult for her to drift towards The Party of the Rich as a means of consolidating her class position. Unfortunately, the narrative suggests that consolidation goes hand-in-hand with the negative use of spiritual power, thus justifying the worst popular suspicions held about her. With this trajectory, Okri joins a potential sociologically based stereotype to the moralizing predilection of mythopoeia to inscribe Madame Koto as the obverse of Good. Though the ambivalence with which she is defined prevents the text from plunging into a full-blown manichean typology, all doubts as to her status in Okri's mythopoeic schema are removed in *Songs of Enchantment*, where the mythopoeisis takes a decided plunge into the moralism of indigenous myth and folktale and the central conflict in the novel is between the forces of Good, championed by Dad, and those of Evil, spearheaded by the Jackal-Headed masquerade and Madame Koto. In *The Famished Road*, though the potential moralism of mythopoeia is not entered into, the narrative nonetheless leaves its inherent masculinism intact because the energetic character of Madame Koto is not allowed to disrupt the articulation of Black Tyger as the legitimate inheritor of the heroic vocation of mythopoeia. Basing her characterization on indigenous beliefs of witchcraft has a decidedly different effect from what we saw operating in relation to Maria in 'When the Lights Return'. Whereas in the short story the text allowed a moral ambivalence to Maria's characterization, here the balance tips against Madame Koto. The stereotype of the witch gains greater intensity as it is progressively transposed onto the implicit moralism of the later novels.

How do we relate Okri's literary practice to the literary formation? How does it articulate particular stresses in Nigerian society and culture in general? What does it signal about potential directions in literary production in his country?

Ben Okri grew up in the period after Independence when the coherence of the

Nigerian nation state was in doubt. The country had entered into a period of rapid disillusionment with the constitution of the country and by 1966 it had erupted into a full-scale secession bid by the Igbos. For Okri's generation the unfolding events had a drastic effect. By the time of the Biafra war, Okri was only seven years old and at school in Minna. 'Laughter Beneath the Bridge', a story set in a time of war and centring on the experiences of a young boy, tells something about the bafflement that must have afflicted any person of his age at the time. The effect of the war was to shake the foundations of the sense of national unity in the minds of both old and young. Another and perhaps more profound effect on those close to the theatre of war was the shock of seeing and hearing about the death and putrefaction of human bodies all the time. It can be conjectured that in such conditions stories about spirits and their relationship to the real world would take a greater urgency.

Another process which was to have a decisive effect on Okri's generation was the gradual but sure emergence of graft and corruption as a dominant feature of national life. Older Nigerian writers such as Soyinka and Achebe had already attempted to engage with the emerging problems in works like *The Interpreters* and *A Man of the People*, both of which express a growing dissatisfaction with the rise in corrupt tendencies in Nigeria. The stories that circulated in the 1970s and 1980s about embezzlements in the country have literary treatment in Okri's 'Disparities', a story that tells of the pauperized existence of the narrator in the knowledge that a Nigerian state official had 'forgotten' a quarter of a million pounds in the back of a cab in London. Okri had a particularly bitter taste of the effects of the corruption due to growing up in the ghettos of Lagos where social amenities were always uncertain and people were forever at the mercy of their landlords. In fact, his first bid at writing was to relate in fictional form some of the problems in the ghettos of Lagos (see Jane Wilkinson 1992: 77–9). What the corruption did to the psyche of many young Nigerians was to give them a permanent distrust of received ideas from authority figures. But more important for an analysis of Okri's work is that the state of corruption made it impossible to write about events with the rationalism of prevailing protocols of realism. He gives an inkling of his preoccupations in answer to the question as to whether he was thinking of a possible new way of writing when working on *The Landscapes Within*:

> I wasn't, no. But I've come to realize you can't write about Nigeria truthfully without a sense of violence. To be serene is to lie. Relations in Nigeria are violent relations. It's the way it is, for historical and all sorts of other reasons . . . [I]n an atmosphere of chaos art *has* to disturb something. For art to be very cool, very clear – which, in relation to chaos, is a negative kind of disturbance – or it has to be more chaotic, more violent than the chaos around. Put that on one side. Now think of the fact that for anything new, for something good to come about, for it to reach a level of art, you have to liberate it from old kinds of perception, which is a kind of destruction. An old way of seeing things has to be destroyed for the new one to be born.
>
> (in Wilkinson: 81)

It is interesting that these concerns were on his mind as early as his second novel published in 1981. *The Landscapes Within* tells of the ennui of the artist-protagonist Omovo in his search for objective correlatives in the social landscape to help organize

his artistic impressions. That novel is unsettling enough in many ways, but Okri's sense of liberating his art form from older perceptions cannot be said to really take off till the short stories. It is evident from his answer that he sought a way of engaging with the irrational logic of Nigerian life from the very start. Biodun Jeyifo (1986) traces an extensive genealogy in African writing for this type of dissatisfaction. He points out that Nigerian works like Achebe's *A Man of the People* and Soyinka's *The Interpreters* along with works by other African writers such as Ayi Kwei Armah's *Fragments*, Ngugi's *Petals of Blood* and Dambudzo Marechera's *The House of Hunger* share the same dissatisfactions:

> In all these works, in varying levels of technical self-assurance and competence, the narrative and stylistic organization of the material is informed by a *problematic* which assumes that the work of fiction can no longer complacently proffer a fictional 'reality' axiomatically at variance with the socio-historical reality of alienation, degradation, chaos and instability for the vast majority of its living generations.
>
> It is necessary to clarify that what is implied here in the aesthetics of these novels, as in all the previously published works now intertextually 'revised', is not merely a thematic exploration of social malaise but the insinuation of this sense of social disjuncture into the very form and structure of these novels.

For Okri, the problem is tackled by harnessing all levels of his narrative to indigenous forms of knowledge centring on beliefs in the intercourse between the world of spirits and that of living beings. The particular form of his harnessing poses new questions about protocols of representation which are yet to be answered. Harry Garuba (1993) comes closest to providing a new terminology for discussing Okri's later work when he refers to it as dominated by 'animist realism'.[15] Unfortunately, he leaves this highly suggestive term unexplained thereby allowing it to be drafted into other frames of analysis without being defined.[16]

Animism is the belief in a spiritual vitality lying behind all natural objects. It formed the basis of conceptions of African culture by early Western anthropologists and has come under serious attack by Africanist philosophers and scholars.[17] Animist realism would be realism constructed with such a belief as its basic tenet. It would not have the same semantic field as that of anthropological usage, though it would borrow something of that conception. *The Famished Road* and *Songs of Enchantment* imply a belief in such an animist realism. The impression that all things from trees to photographs have a potential spiritual vitality is inescapable on reading the novels. The literary expression of such animism is clearly meant to stand as a surrogate for indigenous beliefs in spirits, but it should be read more as a literary defamiliarization of indigenous beliefs than a true replica of such beliefs in reality. Okri's postulation of a universally pervasive animism can only be read as a magnification of certain indigenous beliefs for the purpose of problematizing the relationship between reality and the other-worldy in literature. It is, as Eileen Julien (1992) holds, the negotiation of an aesthetic problem, in this case to do with the dominant protocols of realism. All the different aspects of realist narrative such as character and setting are based on the implicit belief in the knowability of the real as it unfolds its meaning in linear time. To postulate realism based on a pervasive animism is to fracture that basis of belief by

suggesting that not only is the real decentered because of its permanent interplay with the esoteric, but that neither is reducible to the other. Standard realism, then, promotes a view of reality which is inadequate to engaging with the problematic fusion of the real with the other-wordly (see Hawley, 1995; Ogunsanwo 1995).

Okri's animist realism has important implications for the direction of the literary expression of indigenous beliefs as well as for the relationships that are established with readers. The first problem lies in the suggestion that *every* narrative detail has potential symbolic value. Since such an animist generalization suggests that any item is capable of manifesting an intrinsic 'spiritual' potential at any given time, the implication is that a reader requires a much greater alertness to the potential symbolic value of all narrative elements. This can easily lead to reader fatigue, particularly in the context of long novels that eschew explicit teleological patterning. In a way, it enforces a regime of constant reader participation in constructing the meanings of the text while at the same time ensuring that the reader cannot completely enter the process of creation because there are not enough cues for predicting the precise moment of the articulation of the spiritual behind things. The problem is much less pronounced in the context of the short stories, not only because of their length but also because Okri avoids infusing animism into all the narrative levels of the text. It is decidedly different in *The Famished Road* and in *Songs of Enchantment*, where the narrative agency is taken over by a spirit figure. How are we to know the principles by which an *abiku* decodes the spirit potential of things?

In another sense, the animist realism implies a quasi-religious attitude to reality. It is difficult not to think that Okri's enterprise has affinities with what we noted to be the case with Tutuola and Fagunwa: that the gradual dominance of a world religion generates a sense of attraction to the more frightening aspects of indigenous religion and its practices. Since this is done with recourse to the mythopoeisis of indigenous culture, and myths harbour an implicit moralism necessary for the socialization of the community, it is not difficult for the deflected religious feeling to find a fairly coherent discourse that can challenge the dominant from of Christian religious expression while at the same time replicating the grand and generalizing tendencies of the world religion.

The implied interface between different modes of belief, between orality and literacy and between modernity and an indigenous resource-base are well attested to in Okri's writing. The resources of the indigenous conceptual system are refracted at several levels simultaneously and their strategic invocation is in order to problematize not only received modes of narrative representation but also the indigenous resource-base itself. Okri projects the folkloric intuition earlier exercised by Tutuola onto a new plane of significance. By setting much of his work in the urban ghettoes and producing a sense of the fluid interchange of various subjectivities, he captures in his own peculiar way a conundrum of the modern African condition. For, in entering into the modern world, the present-day African activates different processes of socialization that combine ritual gestures towards indigenous beliefs with an acceptance of a more Western paradigm imbibed through education and the media. The issue can be said to be most acute precisely at the level of ghetto existence, since the denizens of the ghettoes are never fully integrated into dominant social and economic structures and reside problematic-ally at the liminal interstices, often eking out an existence from what has been called the informal or parallel economy in Africa. It seems, however, that Okri arrives at this

important intuition through his own placement at another conjuncture of increasing importance in the constitution of identity for the Nigerian and, indeed, the African; that is the condition of exile or residence in the diaspora where the need to negotiate multiple identities becomes most acute. Though he had first-hand experience of life in the ghettoes of Lagos and so shared in their liminal conceptions, it is residence in a Western capital that heightens the sense of liminality. That he can draw on the indigenous resource-base already activated by Johnson, Tutuola and Soyinka goes to show the versatility of the resource-base and its applicability to fresh problems and experiences.

Notes

1 It is curious to note that Okri does not seem to have been influenced by the work of J. P. Clark-Bekederemo, whose Ijo people share the same area as Okri's own ethnic group. Clark-Bekederemo has also attempted to give a national dimension to the mythology of his own people, through his play *The Raft* and especially in his dramatic version of the Ijo oral epic *Ozidi*. It is evident that Okri is drawn to the Yoruba system as actualized by Soyinka and others rather than to the Ijo/Urhobo closer to his own ethnic origins. For a discussion of Clark-Bekederemo and the multiple dimensions of the Ozidi saga, see Dan Izevbaye, 'J. P. Clark-Bekederemo and the Ijo Literary Tradition', *Research in African Literatures* 25, 1 (1994): 1–21. I wish to thank Professor Abiola Irele for bringing this point to my notice in private communication.

2 The belief is by no means limited to these ethnic groups. Edos, Efiks and Kalabari peoples all have different names for the same concept.

3 Wole Soyinka, 'Abiku' in *Idanre*: 28–30; J. P. Clark-Bekederemo (then J. P. Clark), 'Abiku' in *A Reed in the Tide* (London: Longman, 1965): 5; Chinua Achebe, *Things Fall Apart* (1958; London: Heinemann, 1986): 53–61.

4 Maduka suggests that the Abiku's non-conformism gets woven into Soyinka's definition of a heroic vocation in his later writings. It seems Soyinka is always attracted to rebels and nonconformists, something which accords well with his own political temperament; this is regularly illustrated in *Ibadan*. See Maduka, 27; also Quayson, 'Soyinka's autobiographies as political unconscious' and Obi Maduakor (1993).

5 A typical example occurs in the first few pages, when, in reaction to the various strange images that he perceives, he laments in bewilderment, 'I had no idea whether these images belonged to his life, or to the previous one, or to one that was yet to come' (7); see also 291 for an expression of a desire to escape the bewildering esoteric visions.

6 Examples of etiological explanations of some of his experiences: 'That was the first time I realized it wasn't just humans who came to the marketplaces of the world' (16). See also page 136 for an explanation of spirit rationale for 'borrowing' parts of the human body.

7 The word 'digression' in this context is somewhat clumsy since it insinuates a normative scale with the events of the putative real-world of the novel being the point from which the esoteric digresses. This is inescapable because it is only the texture of real-world events that remains recognizable and to which we are always returned after forays into the esoteric. However, the novel ensures that all such notions of priority remain provisional and I stick to the word only as a means of imposing an organizational perspective on the discussion.

8 The events that occur from Azaro's homecoming party on page 41 to the end of Book 1, page 71 take about four days, but it is impossible to be sure. Again, Chapters 5 and 6 contain references to the Rich People's Party's milk distribution on a Saturday evening; on Sunday all the neighbourhood people react to food poisoning. After that there is an abandonement of this temporal framework, with Chapter 7 opening on page 133 with a vague 'The next time I went to Madame Koto's bar . . .'.

9 Gerard Genette gives the most exhaustive analysis of the relationship between narrative time and clock time, and it is his model I draw upon here. See his *Narrative Discourse*, trans. Jane E. Lewin (London: Blackwell, 1980): 86–112; also Meir Steinberg, *Expositional*

Modes and Temporal Ordering in Fiction (Baltimore: Johns Hopkins University Press, 1978): 236–305.

10 Genette, *Narrative Discourse*, 35–6; and for an excellent discussion relating to Chinua Achebe's *Things Fall Apart* see Majorie Winters, 'An Objective Approach to Achebe's Style', *Research in African Literatures* 12, 1 (1981): 55–86.

11 It is generally believed that the process of naturalizing sensory stimuli within dreams is a mechanism to ensure the continuance of sleep. This dates from Freud and *The Interpretation of Dreams*. Though it falls outside the ambit of this study, the psychology implied by Azaro's esoteric experiences would be interesting to research.

12 He is referred to simply as 'Dad' by his son, but with the progress of the narrative and the increasing affirmation of his violent energies, he is called 'Black Tyger'. I shall be using the two names interchangeably as a signal of the novel's own multiple usage.

13 The references to porterage are widespread, but for a particularly poignant description of what this involves see pp. 144–9. 'Masquerades' in *Incidents at the Shrine* is the best guide to what psychological stress the carrying of latrine involves. The particular stress for Dad is depicted in pp. 199–201 of *The Famished Road*.

14 Two of the esoteric digressions deal directly with the question of Madame Koto's involvement with juju.

15 Harry Garuba, 'Ben Okri: Animist Realism and the Famished Genre', *The Guardian* (Lagos), 13 March 1993.

16 The pages of *The Guardian* of Lagos have been the most active in grappling with the writing of Ben Okri along with those of other younger writers. For an attempt to define Okri's work in relation to Gestalt psychology and taking into account Garuba's new terminology, see John Otu, 'Beyond Surrealism: A Gestalt Perspective', *The Guardian* (Lagos), 10 April 1993.

17 The most controversial of these seems to have been Fr. Placide Tempels's *Bantu Philosophy*. For critical evaluations of Tempels as well as of that type of anthropology in general see Hountondji (1983), Valentin Mudimbe (1988) and Christopher Miller (1990) earlier cited.

References

Hallen Barry and Sodipo, J. O. (1986) *Knowledge, Belief, Witchcraft: Analytical Experiments in African Philosophy* (London: Ethnographica).

Hawley, John C. (1995) 'Ben Okri's Spirit Child: *Abiku* Migration and Postmodernity', *Research in African Literatures* 26, 1: 30–9.

Hoch-Smith, J. (1978) 'Radical Yoruba Female Sexuality: The Witch and the Prostitute', in J. Hoch-Smith and Anita Spring (eds), *Women in Ritual and Symbolic Roles* (New York: Plenum): 245–67.

Hountondji, Paulin (1983) *African Philosophy: Myth and Reality*, trans. Henri Evans and Jonathan Rée with an introduction by Abiola Irele (Bloomington: Indiana University Press).

Jeyifo, Biodun (1986) 'The Voice of a Lost Generation: The Novels of Ben Okri', *Guardian* (Lagos), 12 July.

Julien, Eileen (1992) *African Novels and the Question of Orality* (Bloomington: Indiana University Press).

Maduakor, Obi (1993) 'The Political Content of Wole Soyinka's Plays', *Journal of Commonwealth Literature* 28, 1: 82–96.

Maduka, Chidi (1987) 'African Religious Beliefs and the Literary Imagination: *Ogbanje* and *Abiku* in Chinua Achebe, J. P. Clark and Wole Soyinka', *Journal of Commonwealth Literature* 22, 1: 17–30.

Miller, Christopher (1990) *Theories of Africans: Francophone Literature and Anthropology in Africa* (Chicago: Chicago University Press).

Miller, Joseph C. (1980) 'Introduction: Listening for the Past in Africa', in Joseph C. Miller (ed.), *The African Past Speaks* (Kent: Dawson): 1–60.

Mudimbe, V. Y. (1988) *The Invention of Africa: Gnosis, Philosophy and the Order of Knowledge* (London and Bloomington: James Currey and Indiana University Press).

Ogunsanwo, Olatubosun (1995) 'Intertextuality and Post-colonial Literature in Ben Okri's *The Famished Road*', *Research in African Literatures*: 40–52.

Okri, Ben (1991) *The Famished Road* (London: Vintage).

Soyinka, Wole (1967) *Idanre and Other Poems* (London: Methuen).

Soyinka, Wole (1994) *Ibadan: The Penkelemes Years, A Memoir, 1946–1965* (London: Methuen).

Wilkinson, Jane (1992) *Talking With African Writers* (London: James Currey).

From Strategic *Transformations in Nigerian Writing* (Oxford: James Currey, 1997).

NOTES ON CONTRIBUTORS

Faisal Abdu' Allah obtained an MA in Fine Art Print Making at the Royal College of Art in London in 1993. During his previous degree, he spent a year at Massachussets College of Art in Boston, USA. He has exhibited widely in Britain and internationally and is represented in the collection of the Victoria and Albert Museum. He has appeared in several film and television programmes including Channel 4's *The Word* and BBC's *The Day That Changed My Life*, which focused on his conversion to Islam in 1991.

Claire Alexander is a British Academy Post-Doctoral Fellow at the Open University. She was previously at the Institute of Social and Cultural Anthropology, Oxford.

Rasheed Araeen is an artist, writer and Founding Editor of the art journal, *Third Text*. He has curated exhibitions such as *The Essential Black Art*, Chisenhale Gallery, 1987, and *The Other Story: Afro Asian Artists in Post War Britain*, Hayward Gallery, 1989. He is the author of *Making Myself Visible* (1984).

Imruh Bakari teaches media and film studies at King Alfred's University College, Winchester. As a film-maker, his credits include *Riots and Rumours of Riots* (1981), *The Mark of the Hand* (1986) and *Blue Notes and Exiled Voices* (1991). His publications include the co-edited *African Experiences of Cinema* (British Film Institute, 1996).

Kamau Brathwaite is Professor in the Department of Comparative Literature at New York University. His books include *History of the Voice* (1984), *X-Self* (1987) and *Spring Cleaning* (1992).

Hazel V. Carby is Chair of African and African-American Studies and Professor of American Studies at Yale University. She is the author of *Reconstructing Womanhood* (1990), *Race Men* (1998) and *Culture in Babylon: Black Britain and African America* (1999).

Ben Carrington is lecturer in sociology at the Chelsea School, University of Brighton. He has published on aspects of identity, 'race' and popular culture, particularly in relation to sports, and is co-editor of *Racism and British Sport* (Routledge, 1999).

Bob Carter is a senior lecturer in sociology at Worcester College of Higher Education. He has written extensively on issues concerning education, 'race' and national identity.

Eddie Chambers is an artist and curator. His exhibitions include *Black Art: Plotting the Course* (1988), *History and Identity: Seven Painters* (1991) and *Black People and the British Flag* (1993). He is the author of *Run Through the Jungle* (1999). He has contributed to *Art Monthly* and *Third Text*.

Kuan-Hsing Chen teaches at the Centre for Asia Pacific Cultural Studies, National Tsing Hua

University, Hsinchu, Taiwan. He is the author of *Media/Cultural Criticism: A Popular Democratic Line of Flight* (1992) and the co-editor of *Cultural Studies: The Implosion of McDonalds* (1992), *Stuart Hall: Critical Dialogues in Cultural Studies* (Comedia, 1996), and *Trajectories of Inter-Asian Cultural Studies* (Routledge, 1998).

Laura Chrisman is co-editor of *Colonial Discourse/Postcolonial Theory* (1994) and *Post Colonial Theory and Criticism* (1999).

Carolyn Cooper is a Senior Lecturer in the Department of Literatures in English, University of the West Indies, Mona, Jamaica, and the co-ordinator of the university's International Reggae Studies Centre. She is the author of *Noises in the Blood: Orality, Gender and the 'Vulgar' Body of Jamaican Popular Culture* (1993; 1995). She is currently completing a book-length manuscript: *Border Clash: Jamaican Dancehall Culture (a yard an abroad)*.

Fred D'Aguiar teaches in the English Department at the University of Miami, Florida. As a novelist, his credits include *The Longest Memory* (1994), *Dear Future* (1996) and *Feeding the Ghosts* (1997). His collections of poetry include *Mama Dot* (1985), *British Subjects* (1993) and *Bill of Rights* (1998).

Ferdinand Dennis was born in Kingston, Jamaica and grew up in London. He has worked as a journalist and broadcaster. His books include *The Last Blues Dance* (1996) and *Duppy Conqueror* (1998).

Obi Egbuna is the author of *Destroy this Temple: The Voice of Black Power in Britain* (1971).

Aminatta Forna is a writer and broadcaster. She is author of *Mother of All Myths*, a cultural critique of the ideology and politics of motherhood (1998). She has presented and reported many programmes and series on social affairs and politics for BBC Television. She is also a frequent contributor to the *Independent on Sunday* newspaper.

Henry Louis Gates Jr is Chair in the Department of Afro-American Studies at Harvard University. He is editor of *Reading Black, Reading Feminist* (1990) and *The Norton Anthology of African-American Literature* (1997), and his publications include *The Signifying Monkey* (1990).

Beryl Gilroy's publications include *Frangipani House* (1986), *Sunlight on Sweet Water* (1994) and *Gather the Faces* (1996)

Paul Gilroy is the author of *Ain't No Black in the Union Jack* (Routledge, 1987), *The Black Atlantic* (1993), *Small Acts* (1994) and *The Culture Line* (1999).

William Gulam is a senior lecturer in the Education Development Unit at Salford University, Manchester. Until 1993, he was an Inspector of Education. He has also taught in schools, FE Colleges and John Moores University in Liverpool.

Cecil Gutzmore is an African-Jamaican who spent over three decades in the UK before returning to Jamaica in 1997. In the UK he was engaged in developmental and political work in and with the UK Caribbean community. He lectured in Caribbean Studies at the University of North London and ran the Garvey–Rodney Archive and Action Centre which offered consultancy services including Training and Management Development. He now combines research at the University of the West Indies with preparing for publication a collection of his papers on Caribbean Popular Culture in the UK and the Caribbean.

Stuart Hall is Professor Emeritus of Sociology at the Open University. He was Director of the Centre for Contemporary Cultural Studies, University of Birmingham, during the 1970s. Key texts include *Policing the Crisis* (1978), *New Ethnicities* (1988), *What is Black in Popular*

Culture? (1992), *Cultural Identity and Diaspora* (1994) and *Stuart Hall: Critical Dialogues in Cultural Studies* (Comedia, 1996).

Clive Harris is Senior Lecturer in race and ethnic studies in the Centre for Research in Ethnic Relations, Warwick University. He has written on Caribbean history, 'race' and identity.

Roxy Harris is co-editor of *Changing Britannia: Life Experience with Britain* (1999).

Jayne O. Ifekwunigwe lectures in anthropology and sociology at the University of East London. She is the author of *Scattered Belongings: Cultural Paradoxes of 'Race', Nation and Gender* (Routledge, 1998).

Maya Jaggi is a journalist and critic who works for the *Guardian* in London and writes widely on literature and culture. She was the National Newspaper Writer of the Year in the CRE Race in the Media Awards for 1996 and 1998 and Best Feature Writer in the EMMA awards for 1998 and 1999. Educated at Oxford University and the London School of Economics, she was formerly Literary Editor of the journal, *Third World Quarterly*, and is a contributor to the *Bloomsbury Guide to Women's Literature* and the *Salon Reader's Guide*.

Gavin Jantjes is a practising artist.

Claudia Jones is the author of *I Think of My Mother* (1985).

Shirley Joshi teaches in the Faculty of Law and Social Science at the University of Central England, Birmingham.

George Lamming is Visiting Professor of Creative Writing in the Department of English Literature at City University of New York. His books include *Of Age and Innocence* (1958), *The Pleasures of Exile* (1960) and *Narratives of My Person* (1972).

Michael McMillan is a writer and theatre practitioner. His performance pieces such as *Invisible*, based on Ralph Ellison's novel *Invisible Man*, and *Brother to Brother* have toured the UK. He is the author of *Living Proof: Views of World Living with HIV and Aids* (1992), and the editor of *The Black Boy Pub & Other Stories: The Black Experience in High Wycombe* (1997) and *If I Could Fly: An Anthology of Poetry and Prose from Boys and Young Men* (1998).

Richard Majors is an African American academic and former clinical fellow in Psychiatry at Harvard Medical School. He is the founder of the *Journal of African American Men* and author of a number of books, including *Coolpose: The Dilemmas of Black Manhood in America*. He is currently a fellow at the University of Manchester in the Department of Social Policy.

Amina Mama is Visiting Lecturer at the University of Bradford. She is the author of *Beyond the Masks: Race Gender and Subjectivity* (Routledge, 1995) and *The Hidden Struggle* (1996).

Mustapha Matura is a playwright. He co-founded the Black Theatre Co-operative with the director Charlie Hanson in 1978. His plays include *Black Pieces* (1970), *As Time Goes By* (1971), *Rum an' Coca Cola* (1976), *More, More* (1978), *Welcome Home Jacko* (1979), *A Dying Business* (1980), *One Rule* (1981), *Meetings* (1982), *Trinidad Sisters* (1988), *The Coup* (1991) and *Playboy of the West Indies* (1985). He was the co-writer of *No Problem*, the popular Black comedy series for London Weekend Television and Channel 4.

Kobena Mercer is Visiting Professor in the African Studies Program at the Institute of Afro-American Affairs, New York University. He is the author of *Welcome to the Jungle* (Routledge, 1994).

Heidi Safia Mirza is Professor of Racial Equality Studies at Middlesex University, London, where she is also Head of the Centre for Racial Equality Studies. Her academic career includes teaching African-American Studies at Brown University, USA. She has been appointed to the Government's Schools Standards Task Force, the Metropolitan Police Racial and Violent Crime Task Force Advisory Committee and the Joseph Rowntree Racial Justice Committee. She is the author of *Young, Female and Black* (Routledge, 1992) and the editor of *Black British Feminism* (Routledge, 1997).

James Y. Nazroo is Senior Lecturer in Sociology in the Department of Epidemiology and Public Health at University College, London. He has published on the relationship between ethnicity, class and health, and on gender differences in mental illness. He has worked as a researcher in the Department of Sociology and Social Policy at Royal Holloway and the Policy Studies Institute.

Olu Oguibe is Stuart S. Golding Endowed Chair in African Art at the University of South Florida and author of *Uzo Egonu: An African Artist in the West*, as well as three volumes of award-winning poetry. His contributions have appeared in many important volumes including *The Dictionary of Art and Art History and its Methods*, as well as numerous journals and literary anthologies. Oguibe coedits *Nka: Journal of Contemporary African Art*.

Sir Herman Ouseley is the chairman of the Commission for Racial Equality (CRE). His most recent previous posts include Chief Executive of the London Borough of Lambeth between 1990 and 1993; Chief Executive of the Inner London Education Authority (ILEA) 1988–90; and Director of Education ILEA 1986–8. He is also involved with many organizations, including being a fellow of the Institute of Personnel and council member of the Institute of Education at University of London.

Kwesi Owusu is an Associate of the African Studies Centre at the University of Cambridge. He is the editor of *Storms of the Heart: An Anthology of Black Arts and Culture* (1988) and author of *The Struggle for Black Arts in Britain* (Comedia, 1986). His work as a film director includes *Ama* (1992, Channel 4 Television/Artificial Eye) *Ouaga. African Cinema Now* (1986, Channel 4 Television).

Caryl Phillips has written for television, radio, theatre and cinema. He is the author of two books of non-fiction, *The European Tribe* and *Extravagant Strangers*, and six novels, *The Final Passage*, *A State of Independence*, *Higher Ground*, *Cambridge*, *Crossing the River* and *The Nature of Blood*.

Hugh Quarshie is an award-winning actor of stage and screen and best known for his work with the Royal National Theatre and the Royal Shakespeare Company, where his roles have included Mark Antony in Shakespeare's *Julius Caesar* and Mephistopheles in Goethe's *Faust*. He worked as a journalist before becoming an actor.

Ato Quayson is a Lecturer in English, Director of the African Studies Centre and Fellow of Pembroke College, University of Cambridge. He is the author of *Strategic Transformations in Nigerian Writing* (1997) and *Postcolonialism: Theory, Practice or Process?* (1999).

Karen St-Jean Kufour is an economist specializing in the commodities market. She is the commodities editor with the Economist Intelligence Unit (EIU) in London. Her research interests include the Caribbean, and she has undertaken economic business and political research on the Windward and Leeward islands for the EIU.

Mark Sealy is director of Autograph, the association of Black photographers in Britain. He has curated major international photography exhibitions, including the first retrospective on the works of Gordon Parks in London. He lectures on the university circuit and has published in various photographic magazines. He was a member of the 1977 jury of the Nikon–UNESCO awards based in Paris.

A. Sivanandan is the director of the Institute of Race Relations and founder editor of *Race & Class*. He has been active in the Black movement and in campaigns against racism for over three decades. His two collections of essays, *A Different Hunger* and *Communities of Resistance*, were landmark books providing deep insight and coherence to the political struggles engaged in by Britain's Black communities. His novel *When Memory Dies*, published in 1997, was shortlisted for the Commonwealth Writers Prize.

Carol Tulloch is a lecturer on visual culture, specializing in dress at Middlesex University. She has written for several academic journals and contributed to Barbara Burman (ed.) *Home Dressmaking: The Culture of Sewing* (1998).

Vince Wilkinson is an educational adviser for the Open University. He has worked for many years in further education as a Section II appointee. He is currently researching in school exclusions, under-achievement and disaffection amongst Black children.

Aubrey Williams was born in Georgetown, Guyana and trained as an agronomist before joining the Working People's Art Group set up by William Burrowes. He came to England in 1952, and after a brief stay at St Martin's School of Art and travels around Europe, joined the Caribbean Artists' Movement. His work has been exhibited widely and represented in many collections including those of the Arts Council of England, York City, St Catherine College, Oxford, and the universities of York, Kent and Sussex, as well as in Guyana. The film *Mark of the Hand* (Dir. Imruh Bakari) celebrates his life and works.

Beth-Sarah Wright is currently a doctoral candidate at New York University, in the Department of Performance Studies. She obtained her master's degree in social anthropology from Cambridge University. Currently her research focus is on the female body, history and sexuality in the Jamaican dancehall music culture.

INDEX